AISNE 1914

THE DAWN OF TRENCH WARFARE

The author is always looking to gather more information about the Battle of the Aisne for revised editions of this volume. If you are related to any of the participants of the battle and have photographs, personal testimonies, letters, diaries or any relevant information, please contact Paul Kendall at paul.kendall193@btinternet.com.

This book is dedicated to my uncles Ted Whiley and John Whiley and to the Old Contemptibles who fought at the Battle of the Aisne in 1914.

It was in the fighting on that river that the eyes of all of us began to be opened.

Field Marshal Sir John French

The river is 50 yards wide and we had to cross on a single girder about 9 inches wide. It was a feat of tightrope that never fell to the lot of a British soldier before. The bullets were as numerous as hailstones and the shells, well, they defy description. The cries of the wounded who had been knocked off the girder and drowning enough to turn a man's brain.

Private Heys, 1st King's (Liverpool) Regiment

The Victoria Cross is won over and over again in a single day. They are brave! What if you were to see how the wounded act after the excitement of battle! They suffer their wounds, great and small, without a murmur; they get their wounds dressed, take chloroform, give consent to have their limbs amputated, just as if they were going to have their hair cut. They are gloriously brave.

MO of the 14th Field Ambulance

AISNE 1914

THE DAWN OF TRENCH WARFARE

PAUL KENDALL

SPELLMOUNT

First published 2012

The History Press
The Mill, Brimscombe Port
Stroud, Gloucestershire, GL5 2QG
www.thehistorypress.co.uk

British Library Cataloguing in Publication Data.
A catalogue record for this book is available from the British Library.

ISBN 978 0 7524 6304 9

Typesetting and origination by The History Press
Printed in India
Manufacturing managed by Jellyfish Print Solutions Ltd

CONTENTS

PART 3 DESCENT INTO STALEMATE AND TRENCH WARFARE

ACKNOWLEDGEMENTS

This volume is the result of several years of research. I am indebted to many individuals without whose assistance producing such a work would be impossible. I would like to thank Yves Fohlen, battlefield guide, Caverne du Dragon Museum, for proofreading and for his continued friendship and support. I have known him as a friend for many years and I have spent time walking the Chemin des Dames with him. I value his guidance, knowledge and tutelage regarding the Aisne and all First World War subjects. Walking the Aisne battlefield with Yves was an awe-inspiring experience, to follow in the footsteps of the soldiers of the BEF brought home to me the enormity of their task – to cross the Aisne and assault the ridge of the Chemin des Dames when they were totally exhausted and under constant, heavy enemy fire. Even today, the Chemin des Dames is a dangerous place to walk; there are wooded ridges, bluffs and spurs that conceal deep dugouts. I was glad to have Yves as my guide, who was able to show me these extraordinary places safely.

I would like to thank the Trustees of the Imperial War Museum, London, for permission to use material from the Department of Documents and Sound Collections, in particular Anthony Richards and Simon Offord at the IWM Department of Documents and Margaret Brooks from the IWM Sound Archives for assisting me in contacting copyright holders. Every effort has been made, but if anyone has not been credited the publishers apologise and will correct the omission on reprint.

I am grateful to Nicholas Coney at the National Archives for advising me on copyright and Judy Noakes of the Office of Public Sector Information for confirming copyright status of *London Gazette* material.

I thank Richard Davies at the Liddle Collection for assisting me in contacting copyright holders for the material within their archives and for arranging for transcripts of interviews to be sent to me.

I would like to thank Ann Dennison, Community History Manager, Preston District, Shona Milton, History Centre Officer, Brighton History Centre, John-Paul Carr, Northamptonshire Studies Manager, Gail Priddice at Inverness Library, Eileen Moran at Dundee Central Library, Edith Wemyss at Aberdeen Central Library, Nigel Lutt at the Bedfordshire and Luton Archives, Adrian Wilkinson at Lincolnshire Libraries, Gwilym Games, Local Studies Librarian at Swansea Library & Information Services and Mary Bradley of the Ballymena Library.

I extend my thanks to Pamela Clark, Registrar, Royal Archives, for allowing me to quote from a letter written by Field Marshal French to King George V.

The administrators of the website www.memoiredeshommes.sga.defense.gouv.fr kindly gave permission for reproduction of a map of Soupir.

I also thank Major W.H. White, DL at Cornwall's Regimental Museum, Thomas Smyth, archivist at The Black Watch Museum and for the Trustees of the Black Watch Museum, Mr I.G. Edwards from the Sherwood Foresters Museum, Colonel Seymour at the RHQ Grenadier Guards Archives, Major Robert de L. Cazenove at the RHQ Coldstream Guards Archives, Dominic Kearney at the RHQ Irish Guards Archives, Major Ken Gray (ret'd.) at the Royal Green Jackets Museum, Jane Davies, curator and Dorothy Williams, researcher, at the Museum of the Queen's Lancashire Regiment, Terence Nelson, curator at the Royal Ulster Regiment Museum, Oliver Fallon, Chairman and archivist of the Connaught Rangers Association, Karen O'Rourke, Curator of Social History, National Museums Liverpool, Rachel Holmes at the Royal Hampshire Regiment Museum, Major (ret'd) J.H. Peters MBE at the Rifles (Berkshire & Wiltshire) Museum, Martin Everitt at the Museum of the Royal Welsh and Lauren Jones at the Royal Engineers Museum, Library and Archive. (We have had a debate as to how the Welsh Regiment, known as the Welch in the Great War and beyond, should be spelled in this book and were advised by a curator of the Royal Regiment of Wales that the spelling 'Welsh' is more commonly used today, regardless of period. There is no easy answer and if anyone is offended by the adopted spelling we apologise.)

The reader will find short biographies and photographs of soldiers who fought at the Battle of the Aisne throughout this book. While it is perfectly possible to follow the narrative without reference to these, it is hoped that they will provide the reader the opportunity to take time to reflect upon their lives and their sacrifice. The short entries are intended to be a kind of wholly inadequate memorial to these men in themselves.

I am indebted to all the following relatives who have kindly provided photos and information, as well as giving their time to review the relevant draft pieces. I thank them for their generosity and for allowing me to pay homage to their brave forebears.

LANCE CORPORAL ALFRED ALDRIDGE, 2nd Royal Sussex Regiment: Neil Aldridge, (grandson).

PRIVATE JAMES BALLARD, 2nd Royal Sussex Regiment: Paul Ballard (grandson).

PRIVATE HERBERT BARKS, 1st Coldstream Guards: Trudie Brace (great granddaughter)

PRIVATE ERNEST BUCKLAND, 2nd Coldstream Guards and Private William Buckland 1st Coldstream Guards: Dick Monk (relative)

SERGEANT ARTHUR BURCHETT, 3rd Coldstream Guards: Keith Burchett (great nephew) and Debbie Jackson (great niece).

PRIVATE THOMAS CLULOW, 2nd South Lancashire Regiment: Steven Thompson (great grandson).

DRIVER THOMAS COFFIN, 11th Field Company, Royal Engineers: Kelly Howie (great niece)

PRIVATE WALLACE CLISSOLD, 2nd Grenadier Guards: Martin Clissold (great nephew).

PRIVATE HARRY DUNCOMBE, 3rd Coldstream Guards: Cynthia Bone (granddaughter). Derek Duncombe (nephew).

SAPPER ALBERT GUMM, At Cable Section, Royal Engineers: Brian Gumm (son).

CAPTAIN A.H. HABGOOD, 9th Field Ambulance: The Right Reverend Lord Habgood (son).

PRIVATE HEYS, 1st King's Liverpool Regiment: Mrs S. Palin (granddaughter).

RIFLEMAN JOHN ILES, 2nd King's Royal Rifles Corps: Keith Iles (grandson).

PRIVATE ERNEST KEATES, 2nd Royal Sussex Regiment: Mary Miles (great niece).

SERGEANT ARTHUR LANE, 2nd Coldstream Guards: Arthur Lane and Brian Lane (sons).

PRIVATE MICHAEL LEE, 1st Cameron Highlanders: Maureen McAuley (great niece).

SERGEANT WALTER LEDBURY, 1st Loyal North Lancashire Regiment: Shelia Linton (relative).

CAPTAIN L.A. KENNY, 47th Battery, 44th Brigade, Royal Field Artillery: Jenny Ballantyne (great niece).

PRIVATE HENRY MACKENZIE, 1st Cameron Highlanders: Stuart Kilminster (great nephew) and Margaret Mackenzie (great granddaughter).

LANCE CORPORAL HARRY MCGREVY, 1st Northumberland Fusiliers: Theresa Newbegin (granddaughter).

SERGEANT JOHN MCLLWAIN, 2nd Connaught Rangers: Mrs M. McIlwain (granddaughter).

SAPPER CLAUDE MERCHANT, 5th Field Company, Royal Engineers: Robert Merchant (great nephew)

SAPPER EDWARD MERCHANT, 11th Field Company, Royal Engineers: Robert Merchant (grandson).

PRIVATE ROBERT MILLAR, 1st Cameron Highlanders: Scott Millar (great nephew).

LIEUTENANT BERNARD MONTGOMERY, 1st Royal Warwickshire Regiment: Viscount Montgomery of Alamein (son)

CAPTAIN HUBERT REES, 2nd Welsh Regiment: Diana Stockford (granddaughter).

CORPORAL JOHN STENNETT, 1st Northamptonshire Regiment: Peter Statham (great grandson) and Brian Statham (grandson).

PRIVATE FREDERICK STOTTER, 2nd South Lancashire Regiment: Michael Stotter (grandson).

LIEUTENANT RICHARD WELBY, 2nd Grenadier Guards: Sir Bruno Welby (nephew).

PRIVATE ARTHUR WIDDOWSON, 3rd Coldstream Guards: Roy Widdowson (grandson).

PRIVATE CHRISTOPHER WHELAN and PRIVATE THOMAS WHELAN, 2nd Royal Irish Regiment: William Whelan (grandson).

2ND LIEUTENANT ALEXANDER WILLIAMSON, 2nd Battalion Seaforth Highlanders: Dr James Williamson (great nephew).

PRIVATE ALFRED YARHAM, 2nd Battalion 1st Queen's (Royal West Surrey Regiment): Mike Yarham (grandson).

I am grateful to Mark Hifle, Patricia and David Shackleton for the information that they have provided and to Sandy Sell for the photos and information that she sent to me regarding Private Ernest Keates. I acknowledge the generosity of Jean-Pierre Boureux who kindly allowed me to use images of Vailly Bridge prior to the Battle of the Aisne.

I extend my thanks to Shaun Barrington and the team at Spellmount for their continued support and enthusiasm for my third project. I appreciate the support given by my friends and colleagues Gary Shaw and Peter Metcalfe, who have taken a keen interest in this project. Peter kindly took on the daunting task of proofreading the manuscript. I thank my parents, David and Sylvia, for the wonderful decade we have spent touring the battlefields of the First and Second World Wars in Europe. I also thank my partner Tricia Newsome for her continued encouragement and support.

Please note that when referring to the men who took part in the Battle of the Aisne I have referred to the ranks that they held at the time of the battle.

INTRODUCTION

The British Expeditionary Force arrived at the southern banks of the river Aisne on 12 September 1914 after marching approximately 160 miles over three weeks from Mons in Belgium. They endured their baptism of fire at Mons on 23 August, fighting rearguard actions as they retreated south towards the banks of the Marne. Between 5 and 10 September they assisted the French Army in turning the tide of the war and inflicted a defeat upon German forces, compelling them to withdraw to the river Aisne. The Germans entrenched themselves along the wooded heights of the Chemin des Dames, north of the river Aisne, which is approximately 60 miles north east of Paris. It was an arduous journey for the soldiers serving with the BEF who were demoralised, suffering from exhaustion, hunger, sore backs and blistered feet by the time they reached the banks of the river.

The majority of crossings over the Aisne had been destroyed or partially destroyed by German engineers with explosives, so it was a massive engineering challenge for the sappers of the Royal Engineers to either repair damaged bridges or build pontoons, which they did under enemy shell fire. It was also a great challenge, mindful of the physical condition and mental state of the soldiers of the BEF, to get across the river and establish a bridgehead on the north banks. The odds were heavily stacked against these soldiers of the 'contemptible little army'.

The exhausted soldiers of the BEF had to cross this swollen river under German artillery shells and machine guns. The 11th Infantry Brigade led the BEF during the night of 12/13 September, with only a single lamp to guide them from the north bank. One wrong step could result in these weary soldiers, who had endured so much during the first weeks of the war, falling into the river and drowning.

By the morning of 14 September General Sir Douglas Haig's I Corps and General Sir Horace Smith-Dorrien's II Corps had successfully crossed the river Aisne. It was an enormous gamble for Field Marshal Sir John French, commander of the BEF, to push his soldiers perhaps beyond their limits of physical endurance to cross the Aisne and establish a bridgehead. French did not know whether General von Kluck's First German Army was going to continue to withdraw northwards or establish a defensive line amongst the Chemin des Dames ridge and hold its ground.

Unbeknownst to Field Marshal French, he was sending his exhausted troops into a battle where the enemy were entrenched on the high ground, supported by heavy howitzers. The calibres of these guns ranged from 15cm to 21cm (6 to 8 inches). German 8-inch howitzers were deployed to the Aisne sector and were concealed along the Chemin des Dames or behind its northern ridge. Fired at a high angle, the projectiles could reach targets behind crests and drop into trenches or enemy positions behind a hill or ridge, causing craters 20 feet wide and 10 feet deep. These howitzers could reach targets not reached by flat trajectory guns. The German defences, concealed from the eyes of the BEF along the wooded ridges, would prove impregnable. Waves of British soldiers advanced uphill through muddy beet fields, as heavy rain blew into their faces and shell fire of an unprecedented magnitude was brought down on them. The first day of the Battle of the Aisne was 14 September; it would last until the end of the month.

The Battle of the Aisne was significant because it brought the war of movement to an end. It was a ghastly show stopper. With German forces strongly fortified along the wooded heights, the British and French forces could not break through. Every wave of infantry sent forward would stumble through a maelstrom of machine-gun fire and high explosive shells. The Battle of the Aisne would end in the stalemate of trench warfare. It was here that the first trenches of the Western Front were dug, the starting point of the line of trenches that would eventually stretch from the Swiss frontier across France and Belgium to the North Sea. Trench warfare had been conducted during the American Civil War of 1861–65 and during the Russo-Japanese War of 1902–05; but this time it would be fought on an enormous, unprecedented scale. One line of trenches would prevent all sides from moving forward across the entire continent of Europe. The Western Front was born at Aisne and the trenches would determine the defensive strategy of the war for the next four years. The battle demonstrated to commanders that the spade would be as important as the rifle.

The appearance of lines of trenches, defended by machine guns and heavy artillery, would force commanders on both sides to reconsider their strategies. This was the first major war fought by British soldiers in Europe since the Battle of Waterloo. British commanders could not foresee the impact that modern

weapons would have on how the war would be fought. They had been brought up during the Victorian era; they were trained to fight colonial wars with weapons from the Victorian age. They were taught offensive tactics and that the only way to win a battle was to advance and attack. British commanders in 1914 had no conception of how to use the modern rifle, machine guns, heavy calibre artillery and aeroplanes to fight and win a war.

At Aisne, the allied commanders would send their troops into futile assaults up slopes devoid of cover to attack the hidden lines. Each assault would fail with heavy casualties and an inevitable retreat to start lines. The BEF officially lost 561 officers and 12,980 men during the battle, over ten per cent of the force. It would leave their commanders lost for a solution or strategy to deliver a decisive victory.

The loss of 13,541 cas-ualties was difficult for communities in Britain to comprehend. Many homes in Britain would receive news that their loved ones had died during this awful battle via telegrams or in letters from comrades who saw them fall in battle. Journalists reported from the battlefield and from the hospitals where the wounded were taken across Britain. Their articles would appear in British newspapers daily,

on occasion detailing potentially strategically sensitive information relating to the progress of the campaign.

The losses incurred jeopardised the operational effectiveness of the BEF. Some battalions who fought at the Aisne were completely annihilated and their losses equalled the tragic casualty rates seen during the first day of the Somme two years later, in July 1916. It was indeed a national tragedy. The battle was etched into the consciousness of the British public to such an extent that many babies born during the last months of 1914 would be christened with 'Aisne' as a middle name. As the Battle of the Aisne was being fought, Lord Herbert Kitchener, who could foresee that it would take years to defeat Germany, was already

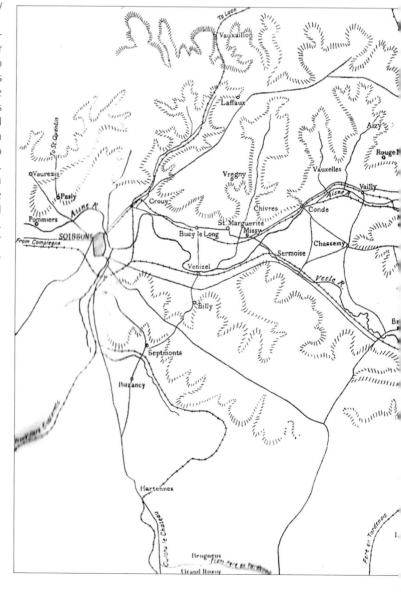

proactive in the recruitment of soldiers to replace those men lost at Mons, during the retreat to the Marne and at the Aisne.

The Battle of the Aisne was fought on a 100-mile front from Compiègne to Tahure, east of Rheims. The French 6th Army led by General Maunoury held the line along the Compiègne-Soissons sector. The British Expeditionary Force led by Field Marshal Sir John French advanced upon the Soissons–Vauxcéré sector. General Franchet d'Esperey's French 5th Army held the line between Vauxcéré and Berry-au-Bac; the 9th French Army commanded by General Ferdinand Foch advanced along the front near Rheims and the French 4th Army led by General Ferdinand Langle de Cary held the line close to the upper Suippe.

They were opposed by four German armies. The German 1st Army, commanded by General Alexander von Kluck, held the Compiègne-Soissons sector. The German 2nd Army commanded by General Karl von Bülow was deployed between Soissons and Craonne. The German 3rd Army led by General Max von Hausen formed a defensive line between Craonne and Rheims; The German 4th Army commanded by the Duke of Württemberg held the line between Rheims and Suippe.

This book focuses upon the efforts of the BEF to cross the Aisne within their sector and their brave but futile attempts to dislodge their enemy from the Chemin des Dames. Six Victoria Crosses were awarded to individuals serving with the BEF for their courage during the battle, four of those for heroic acts carried out on 14 September. The Victoria Cross was surely earned by many other soldiers during those terrible weeks, unrecognised by any award. This is a story of endurance, fortitude and courage and demonstrates the determined spirit of the British soldier in the face of overwhelming odds. Perhaps the massive losses suffered by the British Expeditionary Force at Neuve Chapelle and Loos in 1915, the Somme in 1916 and Passchendaele in 1917 have overshadowed the carnage at Aisne. I hope that this book highlights the importance of the battle and raises awareness of the sacrifices of those men who fought and died on the Chemin des Dames.

BATTLE OF THE AISNE

PART ONE
THE ROAD TO THE AISNE

THE OPPOSING ARMIES IN 1914

The British Army in 1914 was a small, professional army comprised of volunteers. It was a tiny army in comparison to other European powers, which relied on conscription. The officers were almost exclusively from affluent backgrounds, motivated by patriotism, a sense of duty, and family reputation. The ranks were recruited from the poor, for whom the Army offered a rough sanctuary. Providing they could pass through the training they could look forward to a uniform, being fed three meals a day, accommodation and after completion of 20 years service, a modest pension.

When war broke out in August, the British Army would assemble a force of six infantry divisions and one cavalry division – the British Expeditionary Force – amounting to 100,000 soldiers. Many of the officers and men who would form the BEF had served during the Boer War of 1899–1902. The British campaign in South Africa had highlighted weaknesses within the British Army. Field craft skills were lacking and the men could not even shoot effectively. The cavalry were tactically limited and did not fight with the same flexibility as the South African horsemen, who were trained to

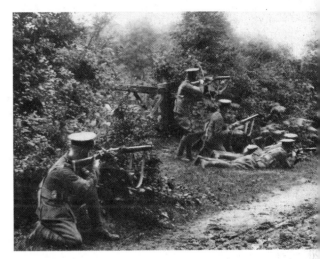

British troops on manoeuvres. These soldiers were trained to fire their Short Magazine Lee Enfield rifles at fifteen rounds per minute. (Author)

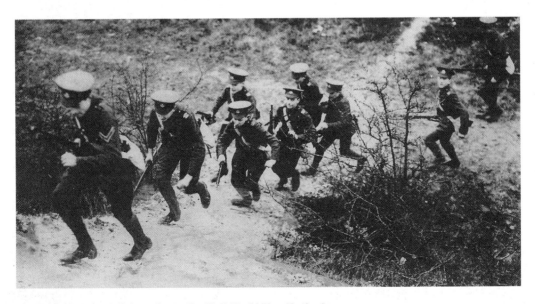

Grenadier Guards training prior to the First World War. (Author)

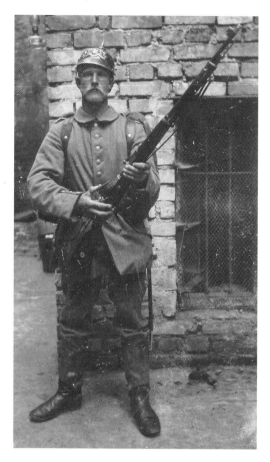

German soldier wearing the uniform worn during the 1914 campaign including the Pickelhaube helmet. These helmets worn in 1914 would be used by British and French riflemen as targets. (Author)

The German Army was not strictly a single unified force. Each monarchy, such as the Dukedom of Baden, had its own army, though the Kaiser was commander-in-chief. Dfferent units even had their own *seitengewehr* (bayonets). (Author)

dismount and fight. The Boer War had demonstrated that the British Army was not prepared for modern warfare. As a consequence, during the first decade of the new century, there would be a restructuring and transformation of training. A General Staff was created to coordinate command and operational planning. Soldiers were trained to shoot at a target at a rate of 15 rounds per minute. Cavalry were trained to fight while dismounted, the artillery was modernised with updated artillery pieces. The Royal Horse Artillery used the 13-pounder and the Field Artillery was equipped with the 18-pounder and the 4.5-inch howitzer.

The opening months of the war in 1914 and in particular the experience at the Battle of the Aisne would show that the initiatives taken were not enough. The impassable Western Front demonstrated that both sides were unable to win a modern war. It would take

four years for the Allies to find a way of making a decisive breakthrough.

The British Army from which the BEF was drawn had a strength of 250,000 in 1914, 50 per cent serving overseas in the colonies. In a time of national crisis the British Army was reliant upon reserves and territorial forces. Just over 60 per cent of the BEF that was sent to France were reservists. Reservists were soldiers who had completed their service as regulars and returned to civilian life who could be called to serve at the outbreak of war. Territorial units were civilians who trained at weekends and their primary role was to defend the British Isles while the regular army fought overseas. The Territorial units comprised six divisions and 140,000 men in 1914.

In 1914 the French Army consisted of 76 infantry divisions and ten cavalry divisions, which numbered 2 million men. These men were conscripts. On

mobilisation in August the German Imperial Army amounted to an awesome 9.9 million men. The German Army was also of course formed of conscripted men. On reaching the age of 17 German males were liable for conscription to serve between two to three years in the army. After completing this mandatory service they joined the reserves.

The European armies were dressed in the uniforms of the previous century. British officers, like French and German officers, continued to carry swords during the first months of the war. The officers and men serving with the French Army wore blue tunics, bright red trousers and red caps covered with a blue cover, easily identifiable targets for German machine gunners and snipers. Similarly, the German infantry were not dressed for trench warfare. The Pickelhaube helmet, originally designed in 1842 and made from leather, afforded no protection from flying shrapnel and made a good target.

The three armies used different rifles. The Tommy was armed with the Short Magazine Lee-Enfield rifle. Each magazine carried ten rounds. Regarded as an effective service weapon in both the First and the Second World War, British infantrymen were trained to fire this weapon at 15 rounds per minute and hit their target at an effective range of 550 yards. The

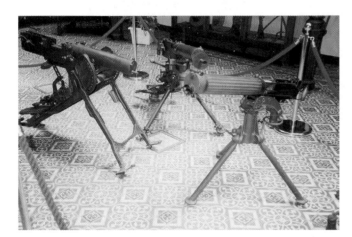

A German Maxim machine gun and British Vickers machine gun on display at the Mons Museum. These guns were used at the Battle of the Aisne to devastating effect, and would play a major part in enforcing a stalemate on the Western Front. (Author)

This image of a German machine-gun crew was taken in a studio in 1914. These soldiers were regarded as the elite of the German Army. (Author)

British artillery
at the Battle
of the Aisne.
(Author)

375 GUERRE 1914-1915. — L'Artillerie anglaise à la Bataille de l'Aisne.
The War. — With the British Army at the battle of the Aisne. — LL.

French Army was armed with a magazine rifle which contained 8 cartridges in the butt, the Lebel Rifle. German soldiers used the Mauser Gewehr 98 rifle, which had been in service since 1898 and was the most common armament throughout the First World War. Its bolt action precluded rapid fire and it was limited to five rounds per magazine. Bullets fired from these rifles would travel at twice the speed of sound and the unfortunate soul who was hit would not have heard the sound of the bullet until after it had hit him.

Machine guns would dominate the battlefield and help to instigate the stalemate of trench warfare. This formidable weapon was developed by American inventor Hiram Maxim in 1884, and demonstrated its deadly capability to stop waves of advancing infantry during the Battle of the Aisne. The British Army placed an order for three machine guns to test during 1887, and surprisingly, despite a successful demonstration, the British never adopted the Maxim.

The German Imperial Army placed orders for the Maxim machine gun in 1887 and after testing, Kaiser Wilhelm II realised the potential of the machine gun and placed further orders. In 1901 the Germans had established a machine-gun branch. When war broke out the German Army had 12,500 Maxim machine guns in operation. The official name was the Maschinen Gewehr 08. It was fixed on a tripod, belt fed, water-cooled and fully automatic. The disadvantage was that these water-cooled machine guns would emit steam, which gave away the machine-gun's position. British and French soldiers would then target the barrel jacket. The Maschinen Gewehr 08 could fire 7.92 mm rounds at a rate of 600 rounds per minute to a maximum distance of 4000 yards, but was deadly at 2200 yards. The bullets travelled at three times the speed of sound. Their crews

were specially selected and were regarded as an elite force.

The British Army were late in realising the potential of the machine gun. When war broke out there were only two Vickers machine guns allotted to each infantry battalion. The Vickers machine gun was an advanced, lighter version of the Maxim, with improved mechanisms. However British soldiers did not receive adequate training in how to operate the Vickers. The Vickers used .303 ammunition and could fire 450 rounds a minute, but with few of these guns available, being operated by inexperienced soldiers, they did not make any impact during the early stages of the war and especially at the Aisne. If a Vickers machine gun was fired continually for an hour the barrel would be worn out and had to be replaced, a difficult operation in the heat of battle. It was not until October 1915 that the British Army established the Machine Gun Corps, training soldiers to specialise in the use of the machine gun.

Modern artillery would of course have an enormous impact on the course and conduct of the war. All field artillery guns were flat trajectory and their purpose was to subdue enemy assaults and to support infantry advances at short range.

The British Army used the 18-pounder, which was produced in 1904. It was developed from lessons learnt during the Boer War and would become the standard British field gun. By August 1914 the British Army had 1226 in service. By the end of the war 9424 were in operation. The 18-pounder had a calibre of 3.3 inches; it could fire shells weighing between 4.6kg and 8.4kg and had a range of 6525 yards. It had a rate of fire of 8 rounds per minute.

The French Army used the 75mm (2.9 inch) field gun, which incorporated a buffer recoil action that enabled

British Artillery in Action on the Aisne.

The British flat trajectory field guns used by the Royal Artillery during the Battle of the Aisne were no match for the German howitzers. It was also impossible for the British guns to locate and target these formidable German weapons. (Author)

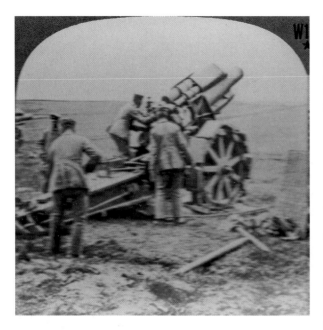

150 mm (6 inch) German howitzer used at the Battle of the Aisne. The high angle elevation meant that these large calibre artillery pieces could be positioned beneath a ridge and could fire upon enemy targets on the other side. (Author)

it to fire repeatedly without relaying. The French 75 mm field gun was first produced in 1897 and by 1914 the French Army had approximately 4000 in service. The gun weighed 1,143kg and had a range of 7500 yards. It was able to fire a 5.2kg high explosive shell and a 7.2kg shrapnel shell. It could fire at a rate of 15–20 rounds per minute and was used throughout the war.

The German Army used the 77 mm (3 inch) field gun, which could fire high explosive shells with a range of 11,264 yards. However they also possessed

more formidable examples of artillery in the form of howitzers, which could project heavy shells that could cause large craters. German artillery used the 10.5cm (4 inch) *Feldhaubitze* 98/09 during the Battle of the Aisne, which fired the *Feldhaubitzgranate* 98, a 15.8 kilogram high explosive shell, or the *Feldhaubitzschrapnel* 98, a 12.8 kilogram shrapnel shell. German artillery also used the 21-cm *Langer Morser* (long mortar) with a calibre of 8.3 inches and range between 10,280 and 11,155 yards. It could be fired at a high angle of elevation, which meant that it could be positioned behind hills and ridges. It would fire various types of shell during the Battle of the Aisne including high explosive shrapnel, small, high-velocity shells known as 'whizz-bangs' or 'Jack Johnsons'. The HE shell fired by German 21cm howitzers, which would emit black smoke, would cause the most devastation. Causing an enormous impact, they could destroy villages, level trees and vapourise men.

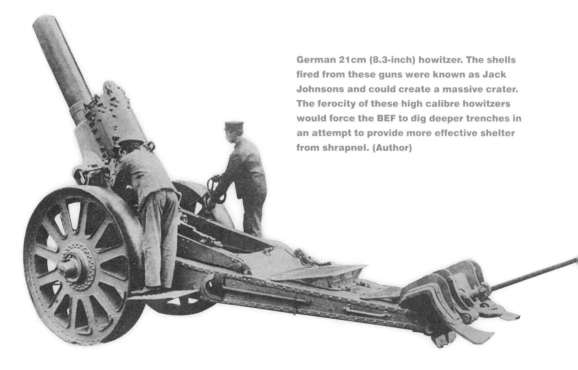

German 21cm (8.3-inch) howitzer. The shells fired from these guns were known as Jack Johnsons and could create a massive crater. The ferocity of these high calibre howitzers would force the BEF to dig deeper trenches in an attempt to provide more effective shelter from shrapnel. (Author)

THE COMMANDERS

FIELD MARSHAL SIR JOHN FRENCH
COMMANDER-IN-CHIEF BRITISH EXPEDITIONARY FORCE

John Denton Pinkstone French was born in Deal, Kent, on 28 September 1852. French joined the Royal Navy as a cadet in August 1866 when he began his training on HMS *Britannia* at Dartmouth. On completing his training he served as a midshipman on the iron-clad HMS *Warrior*, which is now moored in Portsmouth Dockyard. Life at sea did not agree with French and after resigning from the Royal Navy he joined the Suffolk Artillery Militia and on 28 February 1874 joined the Army. French was gazetted to the 8th (Queen's Royal Irish) Hussars as a Lieutenant. He would transfer to the 19th Hussars weeks later. In 1885 he was promoted to Major and was in command of a squadron from the 19th Hussars in the Sudan during the Gordon Relief Expedition. He took part in the action at Abu Klea during January 1885 against Mahdist forces. French was promoted to Lieutenant-Colonel the following month and was mentioned in despatches for his role in the campaign. In 1895 French was transferred to a post in the War Office where he produced a cavalry training manual and became acquainted with a junior officer, Douglas Haig. During 1897 French was appointed commander of 2nd Cavalry Brigade with the rank of temporary Major-General. At this period in his life

Field Marshal Sir John French, commander of the BEF.

French was facing financial difficulty and had to borrow money from his affluent subordinate, Haig, in order to pay his debts. French was appointed commander of the Cavalry Division in 1899 and commanded them during various actions during the Boer War. In July 1900 French was awarded the KCB and was now Sir John French. French returned home during 1902 and on 15 September he was appointed commander of I Army Corps and promoted to Lieutenant General. Appointed as Chief of the Imperial General Staff in March 1912, French oversaw changes to the structure of the British Army and was responsible for the transformation of infantry battalions from eight small companies into four large companies. On 3 June 1913 Sir John French was elevated to the rank of Field Marshal.

French was appointed commander of the British Expeditionary Force on 4 August 1914. He sailed from Dover aboard HMS *Sentinel* arriving in Boulogne on 14 August. Within ten days his force was engaged with the German Army at Mons. Vulnerable to being overrun by the far larger German army, French became unnerved and ordered a retreat from Mons. Another battle was fought at Le Cateau on 26 August and the BEF continued its retreat to the Marne. Devastated by the casualties at Mons and Le Cateau, French decided to preserve his force and retire from the area of operations to buy time to refit and reorganise. The British Government disagreed with French's decision and sent Lord Kitchener, the Secretary of State for War, to Paris to order French to keep the BEF in line with movements made by their French allies.

French was instructed to take orders from General Joffre, his junior in rank and with less combat experience. Resentful, Field Marshal French nevertheless complied with orders from London and from General Joffre. He ordered the BEF to pursue the German Imperial Army to the river Aisne. It was here that the BEF's advance came to an immediate halt. He had to reorganise his force and introduce reinforcements into their ranks swiftly. It was an incredible logistical and organisational challenge. French was deeply worried about the lack of battlefield experience of the officer replacements. He was also deeply frustrated in not being able to advance beyond the Chemin des Dames. When there was no prospect of further advance he ordered the BEF to dig in. Anxious to shorten lines of communication and supply from

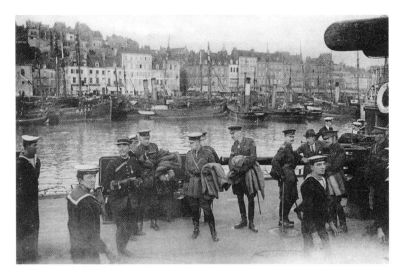

Field Marshal Sir John French sailed from Dover aboard HMS *Sentinel*. He is pictured arriving at Boulogne at 5.00pm on 14 August 1914.

the Channel Ports, he convinced General Joffre that it would be prudent to transfer the BEF to the left flank of the French Army and during October 1914 they were deployed to the Flanders sector at Ypres.

At the beginning of 1915, Joffre pressured French into launching offensives despite a shortage of shells and the inability to launch preparatory barrages. French launched an assault at Neuve Chapelle in March 1915. Haig's British First Army took the German Army by surprise and broke through German lines to capture Neuve Chapelle. The initiative was lost when Haig hesitated and refused to send infantry into the breach until reinforcements arrived. While Haig waited for reinforcements, General Erich von Falkenhayn sent in his own reinforcements to secure the German line. British infantry tried to recapture the ground gained but to no avail. They had lost the momentum. The British Army lost a further 13,000 casualties. Field Marshal French blamed a lack of resources and a shortage of shells. The lack of artillery ammunition caused a scandal in Britain and seriously undermined Lord Kitchener's role as Secretary of State for War. The Ministry of Munitions, led by David Lloyd George, was established as a result of the 'Shell Scandal'. Infantry reinforcements poured into France and by August 1915 Field Marshal French was in command of 28 divisions, some 900,000 men.

During the period 25 September to 8 October 1915 French launched another offensive in the Artois sector at Loos. General Joffre chose the ground for this assault without considering the viability of launching such an operation across coalfields and the ruins of houses and mining equipment. Field Marshal French was ordered to comply with Joffre's decision despite having reservations. This was the first occasion when poison gas was used by the British Army upon German forces. The initiative was disastrous because a change in wind direction

blew the gas upon the British infantry, but despite this, battalions from Haig's First Army managed to capture some ground, breaking through the first German line and making limited gains in the second line. Haig requested more reinforcements in order to consolidate their gains, but Field Marshal French kept the reserves so far back from the front that they were too late to assist Haig and when the Germans counter attacked, the initiative was lost. The Battle of Loos resulted in the loss of 50,000 British troops. General Haig was critical of Field Marshal French's poor performance and blamed the failure at Loos on French holding the reserves too far back. Sir Douglas Haig was corresponding with King George V, Herbert Asquith, the Prime Minister and Lord Kitchener and expressed his opinion that Field Marshal French did not have the capability to deliver a victory; that he was out of his depth and was not fit to command the British Army in France. French was regarded as erratic and indecisive. Within weeks of sustaining heavy losses at Loos he was ordered to relinquish command of the BEF and hand over command to General Sir Douglas Haig. The relationship between French and Haig would become one of mutual contempt. French continued to serve in other military positions throughout the war. He was appointed Commander-in-Chief Home Forces and in February 1916 he was given a peerage as Viscount French of Ypres and High Lake. On 22 May 1925, Viscount French died of cancer of the bladder at Deal Castle in Kent.

GENERAL JOSEPH JOFFRE
CHIEF OF STAFF, FRENCH ARMY
Joseph Jacques Joffre was born in Rivesaltes, Roussillon in the Eastern Pyrenees on 12 January 1852.He studied at the Ecole Polytechnique from 1870 and would serve in the French Army as a career officer. Joffre saw active

General Joseph Joffre, Chief of Staff of the French Army.

Vers la Victoire.!
La Marne.
L'Aisne.
L'Yser
1914

Généralissime JOFFRE
À qui les destinées de la France sont confiées

valley. Desperate to make a breakthrough and force the German invaders from French soil, Joffre launched assaults upon German lines in Artois in May 1915 and in Champagne during September 1915; both failed. In order to secure the French lines he ordered the dismantling of the heavy artillery guns that defended the fortress at Verdun and their distribution along the French lines. This proved to be Joffre's greatest error of judgment, when German forces attacked Verdun in 1916. On 13 December 1916 the French Prime Minister Aristide Briand dismissed Joffre from his position and General Robert Nivelle was appointed Commander-in-Chief of the French Army.

Joffre was appointed Marshal of France, which was no more than a ceremonial role. In June 1917 he was appointed Head of the French Military Mission to the US and during the final year of the war Leader of the Supreme War Council. Joffre died in Paris on 3 January 1931.

service at the siege of Paris during the Franco-Prussian War. Joffre was a military engineer and spent much of his career serving in the French colonies. He saw action during the Keelung Campaign in the Sino-French War from August 1884 until April 1885. With no experience of commanding an army or knowledge of the workings at Staff level, Joffre was appointed Commander-in-Chief of the French Army during 1911. Joffre established Plan XVII, which was an offensive strategy to be implemented in the event of a future war with Germany. The plan would be implemented if Germany invaded Belgium and involved driving a French assault through the Ardennes at Sedan and at Mulhouse into the bitterly contested territory once owned by France called Alsace Lorraine and then into Germany. Joffre launched Plan XVII, which in effect was the Lorraine Offensive, during the middle of August 1914. Overwhelmed by superior German forces Joffre had to withdraw. When the war began Joffre had in mind 'the cult of the offensive'. His strategy would result in severe losses for the French Army, which he commanded from August 1914 until December 1916. French losses on his watch amounted to about 454,000 men killed or missing. His worst day was 22 August 1914, with 27,000 official fatalites.

Joffre was able to maintain composure despite the heavy losses and the mounting pressure of the German invasion advancing towards Paris. He was technically minded and successfully planned the logistical movements of French infantry and kept French artillery supplied. This enabled him to regroup and reorganise his forces for a victorious counter attack on the River Marne. This would be his only victory and he would be credited as the individual responsible for saving France during those dark days. The French Army, together with the BEF, would pursue the German Army to the Aisne

GENERAL SIR HORACE SMITH-DORRIEN
COMMANDER BRITISH II CORPS

Horace Smith-Dorrien was born near Berkhamstead, Hertfordshire on 26 May 1858. He was educated at Harrow and Sandhurst. On 26 February 1876 he was gazetted as a Lieutenant to the 95th (Derbyshire) Regiment of Foot. Smith-Dorrien fought in the Zulu War, distinguishing himself at the Battle of Isandlwana on 22 January 1879.

As Zulu forces overwhelmed the British lines, Smith-Dorrien escaped from the battlefield and was recommended for the Victoria Cross for helping others to escape. He was one of approximately 50 survivors from this battle, but the recommendation for the prestigious award was never processed and he never received it. He was mentioned in dispatches when he

General Sir Horace Smith-Dorrien, Commander British II Corps.

took part in the Battle of Ulundi on 4 July 1879, which resulted in defeat for the Zulus.

He was an observer at the Battle of Glennis on 30 December 1885, which was the last time that the British Army fought wearing scarlet tunics. During the following day Smith-Dorrien was involved in an action which resulted in him being awarded the Distinguished Service Cross.

In 1898 he fought at the Battle of Omdurman in Sudan and during the following year he was sent to South Africa to fight in the Boer War. On 2 February 1900 Smith-Dorrien was appointed commander of the 19th Brigade and seven days later he was promoted to Major-General. In 1911 he was appointed Aide-de-Camp to King George V. On 1 March 1912 he was appointed GOC Southern Command and later that year he was promoted to General.

At the outbreak of the First World War Smith-Dorrien was appointed commander-in-chief of the Home Defence Army, but after the death of Sir James Grierson Lord Kitchener offered him the role of commander of II Corps. Kitchener advised Smith-Dorrien that Field Marshal Sir John French nursed a vehement dislike for him and asked if that would pose a problem. Smith-Dorrien was a professional soldier and told Kitchener that he did not bear any ill feeling towards French and it would not interfere with him carrying out his duty. French had requested Sir Herbert Plumer, but Kitchener appointed Smith-Dorrien because he had the strength of character to stand up to French when the need arose.

The animosity that French felt for Smith-Dorrien was apparent when French accused him of jeopardising the BEF by fighting a rearguard action at Le Cateau. French had ordered II Corps to retire earlier that morning, but Smith-Dorrien ignored French's orders and fought. Smith-Dorrien would continue to command II Corps during the Battle of the Marne, the Aisne and at Ypres during the 1914 campaign.

On 26 December 1914 Smith-Dorrien was given command of the British Second Army. The second Battle of Ypres began on 22 April 1915 when German forces unleashed poison gas upon British and French lines in Flanders.

This was the first use of gas in war and would cause a breach in the allied lines. On 27 April Smith-Dorrien recommended that the Second Army withdraw to a better defensive position. Field Marshal Sir John French used Smith-Dorrien's recommendation in contravention of his orders as a reason to remove him from his command and replace him with Sir Hubert Plumer as commander of Second Army. French's decision was based on his own personal feelings towards Smith-Dorrien – Sir Hubert Plumer recommended a course of action similar to Smith-Dorrien's withdrawal strategy, which French accepted.

Smith-Dorrien was sent to serve in the East African Campaign but illness meant that he could not continue. He returned to Britain where on 29 January 1917 he was appointed Lieutenant at the Tower of London. After the war he served as Governor of Gibraltar from 1918 until May 1923.

Smith-Dorrien died on 12 August 1930 after being injured in a car accident at Chippenham in Wiltshire. He was aged 72 when he died and was buried at Three Close Lane Cemetery, Berkhamsted.

GENERAL SIR DOUGLAS HAIG
COMMANDER BRITISH I CORPS

Douglas Haig was born in Edinburgh on 19 June 1861. He was educated at Clifton College and in 1880 went up to Brasenose College, Oxford. Haig was a diligent student and excelled in horsemanship, particularly polo. He joined the Army and went to the Royal Military College at Sandhurst in 1883. On 7 February 1885 he was commissioned as a lieutenant in the 7th (Queen's Own) Hussars. He served nine years in India. He took part in the campaign to reconquer Sudan in 1898 and fought at the Battle of Omdurman. He saw active service during the Boer War from 1899 when he acted as assistant adjutant general to General John French who commanded the Cavalry Division. He was mentioned four times in despatches during that war.

When the First World War broke out he was appointed commander of I Corps. Haig's I Corps covered the retreat from Mons and took part in the advance to the Aisne. The battalions under his command secured a bridgehead north of Bourg-et-Comin during the Battle of the Aisne during September 1914. When the BEF

Lieutenant General Sir Douglas Haig, Command British I Corps.

were transferred to Flanders his single Corps resisted four German Corps and prevented them from making a breakthrough at Ypres. Haig was promoted to General on 16 November 1914 and with the restructuring of the BEF into two armies, Haig was appointed commander of the First Army, which was comprised of I, IV and Indian Corps. In March 1915 Field Marshal French deployed Haig's First Army in costly, ineffective attacks upon German lines at Neuve Chapelle on 10–13 March 1915, at Festubert between 15–25 May and at Loos during the period 25 September to 14 October.

The failure of these operations during 1915 resulted in French being dismissed by Prime Minister Herbert Asquith and replaced by Haig as Commander-in-Chief of the BEF on 19 December 1915. On 1 July 1916 during the first day of the Somme Campaign Haig lost 57,470 casualties, which is remembered as, unsurprisingly, the greatest loss ever suffered by the British Army in a single day. The campaign was fought for a further four months resulting in the loss of approximately 420,000 for small gains. On 1 January 1917 Haig was elevated to Field Marshal and promised the British Cabinet a victory over Germany that year. Instead he committed the BEF to another arguably wasteful campaign at Ypres with the loss of 400,000 men.

Haig held onto his command until the end of the war. He retired from the British Army in June 1921 and was elevated to the peerage as Earl Haig of Bemersyde. He died on 30 January 1928 in London and was buried at Dryburgh Abbey, Bemersyde.

GENERAL OBERST ALEXANDER VON KLUCK
COMMANDER FIRST GERMAN ARMY

Alexander von Kluck was born on 20 May 1846. He saw active service with the Prussian Army during Austro-Prussian War in 1866. He sustained two wounds at the Battle of Colombey-Neuilly in the Franco-Prussian War during 1870. He was a career officer and when war broke out in August 1914 General von Kluck was appointed commander of the First German Army.

General von Kluck's First German Army swept through Belgium capturing Brussels before driving forward through the BEF's position at Mons on 23 August and at Le Cateau on 26 August. Instead of advancing into France south of the Channel ports and enveloping Paris

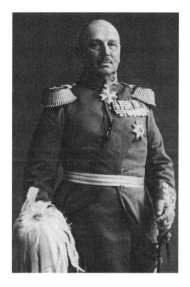

General von Kluck, Commander of the First German Army.

as per the Schlieffen Plan he ordered the First Army to advance east of the French Capital in a drive to meet the French armies at Sedan. It was originally intended that the First Army would attack Paris from the west while General von Bülow's Second Army would attack from the east. Von Kluck had changed the plan and left his flank and the flank of von Bülow exposed. Von Kluck was not aware that the French General Michel-Joseph Maunoury had assembled and organised the French Sixth Army in Paris. On 1 September a French patrol had seized a German dispatch car with a map containing General von Kluck's plans showing he had discarded the original Schlieffen Plan and was advancing southeast. Bypassing Paris, the German First Army and Second Army were exposed during September as General Maunoury's French Sixth Army and General Louis Franchet d'Esperey's French Fifth Army seized the opportunity to attack and defeated them at the Marne. The German armies withdrew 40 miles north to the heights overlooking the river Aisne. It was here that General von Kluck's First Army defended the ridges of the Chemin des Dames against the determined efforts of the BEF. General von Kluck suffered a serious wound to his leg from shrapnel in March 1915 and was retired from active service. Alexander von Kluck died in Berlin on 19 October 1934.

THE PATH TO THE AISNE

A brief reminder of just why the BEF found itself crossing the Channel might be of benefit to some readers; to those for whom this summary is redundant, I apologise. Following the assassination of Archduke Franz Ferdinand, Kaiser Wilhelm II had proclaimed the *drohende Kriegsgefahr* on 31 July, which alerted Germany to the imminent danger of war. Precautionary measures were implemented within all German Army Corps districts, which meant all German soldiers on leave were recalled to barracks. All important communication infrastructures such as roads, railway lines, bridges and tunnels, together with railway stations, received protection. Soldiers guarding the German border were put on a state of high alert and vigilance.

On that same day Kaiser Wilhelm II warned Russia that Germany would mobilise her forces to counter any acts of aggression directed towards Austria. Russia was hoping that a diplomatic solution to the impending crisis could be achieved, but this hope was extinguished when Germany declared war upon Russia on 1 August. France was a Russian ally and Germany requested that she remain neutral in the eventual Russian–German conflict. France declined and on 3 August Germany declared war on France on the false premise that French patrols had violated their borders and that French aeroplanes had crossed into German airspace.

The Belgian Army was mobilised on 1 August 1914 in anticipation of an attack. At 7.00pm on 2 August the German ambassador to Belgium gave an ultimatum demanding free access for the German army through Belgium and to its railway network, with a 12-hour time limit for a response. If Belgium agreed to the German proposal, she would no longer be considered a neutral country, making her vulnerable to a French attack. If she refused the German demand, there was the inevitable risk that Germany would send her armies through Belgium anyway. Belgium was trapped in a precarious, no win situation. At 8.02am on 4 August, advance columns of the German Army comprising six infantry brigades and the German II Cavalry Corps commanded by General Otto von Emmich entered Belgium. They were implementing the Schlieffen Plan and by sweeping across the Belgian frontier they were securing the right flank of the German First and Second Armies. The Schlieffen Plan was devised by German General Count Alfred von Schlieffen and involved the mass movement of four German Army Corps by rail to the German frontier. Each Army Corps would require 280 trains to expedite the mobilisation. This meant that a rigid, precise timetable had to be devised to ensure that they would be moved to the German frontier, together with supplies. These trains would travel at 20

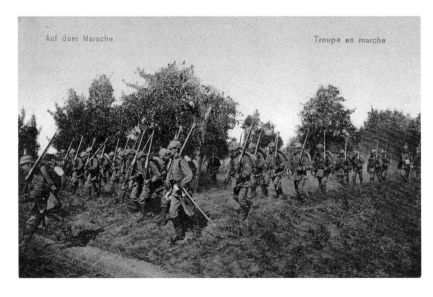

Auf dem Marsche Troupe en marche

German infantry advance during the 1914 campaign. (Author)

German soldiers dressed in the uniforms worn during the 1914 campaign with Mauser 98s. (Author)

miles per hour and there was a precise ten-minute gap between each train moving west.

They would swiftly sweep through neutral Belgium in an attempt to outflank the French Army's fortifications along her eastern border. After passing through Belgium into France they would cut off the Channel ports at Dunkirk, Calais and Boulogne, then turn south in an audacious drive for Paris. German commanders hoped that the implementation of Schlieffen's plan would mean the capture of the French capital 39 days after the initial mobilisation, which would result in the capitulation of France within six weeks. Count Alfred von Schlieffen died aged 80 in 1913 and did not live to see his plan being implemented.

Britain did not have any formal treaties or alliance with France and was under no obligation to get involved in this international crisis on her behalf. However, the German invasion of Belgium would draw Britain into the First World War. Britain had signed a treaty in 1839, the Treaty of London, which meant that she would stand by Belgium against an aggressor. Kaiser Wilhelm II did not relish going to war with Britain and made an unsuccessful attempt to prevent General von Moltke's armies from invading Belgium in order to avoid one.

The German armies were mobilised on trains adorned with political slogans and flowers; their troops were confident that the French Army would be defeated and the war would be over before the autumn leaves dropped.

The speed with which these men could be mobilised meant that once the button for mobilisation was pressed, it was virtually impossible to reverse the decision. As soon as Germany entered Belgium, Britain honoured its obligations under the Treaty of London signed six decades before and declared war upon Germany. At 4.00pm on 4 August 1914 the British Army was ordered to mobilise.

Anticipating war, Prime Minister Herbert Asquith had sent a message to Lord Kitchener on 3 August offering him the position of Secretary of State for War, with responsibility for that role shared with Lord Richard Haldane, the Lord Chancellor. Asquith was conscious of people's wariness of unelected soldiers holding positions in government, ingrained since the days after the English Civil War when Oliver Cromwell governed the country. He therefore offered dual responsibility with a cabinet member to allay public alarm.

Kitchener was aged 64 and something of a national hero after his victory at the Battle of Omdurman in 1898. He was British Consul-General of Egypt when war broke out. He was in London on leave at this time. Kitchener initially declined Asquith's offer of dual appointment with Lord Haldane as Secretary of State for War, for he could foresee the enormity of the job ahead of him and it was his view that he could only succeed in this role and do what was necessary to win the war if he had total control. Kitchener then headed for Dover to embark for Egypt on 4 August to return to his role as British Consul-General. Just before embarkation he received a telegram from Asquith recalling him to London. Kitchener was offered sole responsibility as Secretary of State for War, which he accepted. He was the first serving officer in the British Army to be a member of the British Cabinet since George Monck, Duke of Albemarle, in 1660. There was no political opposition to Kitchener's appointment and the nation greeted his appointment with enthusiasm.

A Council of War was convened at Number 10 Downing Street on 5 August chaired by Herbert Asquith, the Prime Minister, with the majority of his cabinet in attendance including Winston Churchill in his capacity as First Lord of the Admiralty. Military leaders were ordered to attend the meeting including Field Marshal Sir John French, Lord Roberts, Lord Kitchener, Sir

Charles Douglas, Sir Douglas Haig, Sir James Grierson and General Henry Wilson. It was at this meeting that Kitchener forcibly argued that millions of men would have to be recruited and deployed for the war, which might take several years to win. Kitchener foresaw that the British Army would need to initiate a recruitment campaign on a massive and unprecedented scale immediately. It was his opinion that the war would be fought for at least three years and would require 70 divisions in order to fight it. The cabinet was shocked by Kitchener's view and thought that the war would only last from three to six months, but they placed their trust in him at this time of international crisis.

The Council of War continued and the agenda focused upon the composition of the British Expeditionary Force and where it should be deployed once it had arrived in France. There were concerns that they would need to keep a force in Britain to defend the homeland. Churchill provided reassurance that the Fleet had been partially mobilised three weeks before the outbreak of war and the Royal Navy was able to defend British shores, which meant troops who would normally be held back to defend Britain could be

released and form part of the BEF. It was decided to retain one cavalry division and two infantry divisions for home defence and that the BEF would comprise one cavalry division and four infantry divisions and would be dispatched to France as soon as possible. After much deliberation they came to the conclusion that it was most effective to send the force on the French Army's left flank and deploy between Maubeuge and Le Cateau. Le Cateau was therefore designated as the headquarters of the BEF in France.

On that same day, 5 August, mobilisation of Regulars, Special Reserves and Territorial soldiers was ordered. The BEF's Headquarters were established at the Hotel Metropole in London while the force was being assembled prior to embarkation for France.

Together with the cavalry division, the four infantry divisions were the 1st, 2nd, 3rd and 5th Divisions. The 4th Division would arrive after the BEF had engaged the enemy at Mons. Each division contained 18,000 men, which included 12,000 infantrymen with only 24 machine guns. 4000 artillerymen accompanied them, who brought 76 guns – 54 18-pounders, 18 4.5-inch howitzers and 4 6-pounder artillery pieces. A

Left: 1st Grenadier Guards leave Wellington barracks for Waterloo Station. (The War Illustrated, 26 September 1914)

Below: Scots Guards marching to Waterloo Station bound for France. Private Wilkinson carries his 3-year-old daughter. (The War Illustrated, 26 September 1914)

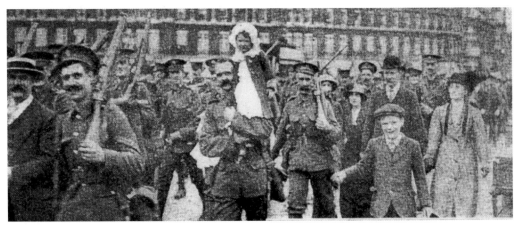

division was formed of three brigades that contained four battalions. A cavalry division consisted of 9000 men, 10,000 horses with 24 machine guns and 24 13-pounder artillery pieces. Assembling such a force and deploying them to France within nine days was a challenging logistical task. Each train would carry complete units so that they would sail to France on the same ship and would be disembarked ready to be transported. Infantry units would sail from Southampton. The designated ports of disembarkation were Le Havre, Rouen, Boulogne and St Nazaire. Within five days, 1800 trains were specially commissioned to transport troops and equipment to ports on the south coast. The majority of these trains were converging on Southampton Docks, which on its busiest day received 80 trains carrying an entire division.

Those soldiers who had retired from the British Army and who were on the reserve list were summoned to return to military life for the duration of the crisis. Sixty per cent of the 1st Duke of Cornwall's Light Infantry, for example, were reservists. Reservists were recalled to the colours and reported to post offices across Britain to claim their travel allowance to enable them to report to their allocated depots. They returned to their old battalions. The 2nd Welsh Regiment, for one, was under-manned. Captain Hubert Rees of the 2nd Welsh recorded:

> The Battalion was greatly below strength and a large percentage of those men actually serving were too young to take the field. The result of this shortage on mobilisation was to fill the ranks with reservists, who had not time to get physically fit before being called upon to endure the terrific strain of the Retreat.[1]

It was widely considered at the time that the war would be over by Christmas. Some men thought that serving in the war would be a short break, an adventure that would only last a few months. Little did they know that it would be fought over four years, consuming the lives of millions of men from across the world.

Private Frederick Bolwell was one reservist then living on the south coast. He had received orders to report to the depot of the 1st Loyal North Lancashire Regiment in Lancashire. Bolwell was an old soldier who, despite returning to civilian life and becoming a family man, was keen to go away for a little while. He wrote:

> Being a Reservist, I was naturally called to the colours on the outbreak of war between England and Germany on August 4th 1914, so I downed tools; and, although a married man with two children, I was only too pleased to leave a monotonous existence for something far more

exciting and adventurous. Being an old soldier, war was of course more or less ingrained into my nature, and during those few days before the final declaration I was at fever heat and longing to be away.[2]

After the long journey via London in train carriages that were crowded with other reservists, Bolwell arrived in Lancashire to receive his uniform and medical, then within days he was training in Aldershot.

Arthur Lane was a policeman in the City of London Police Force and posted mobilisation notices on both ends of London Bridge and at Mansion House at 6 o'clock on 4 August 1914. Thirty minutes later he handed in his police uniform at the police station after receiving notification to rejoin the 2nd Coldstream Guards the following day. By the end of the week he was training for war in Windsor Great Park with the rank of Sergeant. On the 8th, Sergeant Lane had to fetch Private Powell, another reservist, who was then an inmate residing at His Majesty's pleasure at Wandsworth Prison, who had also been mobilised.

John McIlwain was a postal worker in Newcastle and as soon as the order to mobilise was issued, with great enthusiasm he headed off for the Connaught Rangers barracks in Dublin. He later recalled his fervour and commented upon the efficiency of the railway network as it transferred called-up reservists across the country.

> At all stations on the way crowds of reserve men like myself, keen and alert, promptly mounted the trains. Every indication that the railway companies were applying themselves to the primary purpose of rapid mobilisation. Years after, my wife spoke of that morning of the 5th August – 'You seemed so eager to get away.'[3]

He arrived at the Connaught Rangers barracks at Renmore on 6 August where he joined the 2nd Battalion. McIlwain had served in this battalion for several years and had left the battalion seven years previously when it was based in Poona, India. After being fitted out with uniform and equipment he and the battalion were dispatched to Aldershot where they practised on the rifle ranges. McIlwain was promoted to full sergeant while the battalion was preparing for war.

The BEF was split into two corps, both containing two divisions. I Corps was commanded by Sir Douglas Haig. Sir James Grierson, a veteran of the Sudan campaign and the Boer War, was appointed commander of II Corps.

On 7 August, while the BEF was assembling and preparing for mobilisation, Kitchener issued his appeal for 100,000 volunteers to join the British Army. Posters of Kitchener's imposing face, his piercing eyes looking

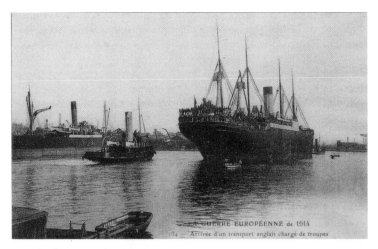

Left: A BEF troopship arrives in France. (Author)

Below: 'Les braves soldats anglais' arrive in France, 1914. (Author)

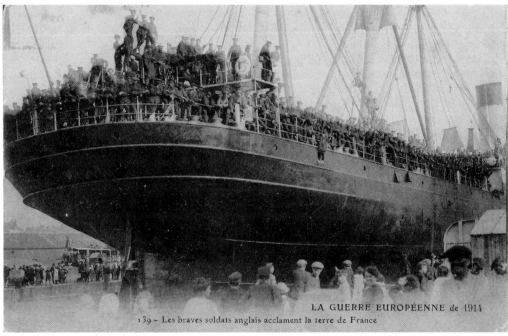

into the souls and consciences of potential recruits, pointing an assertive finger with the words 'Your country needs you' were plastered across Britain. This famous image of the First World War was an incredibly effective piece of marketing – or it really could not fail, preaching to the converted – within 18 months 2,467,000 British men came forward to enlist. Many of these men were anxious to play their part in this impending crisis. Some wanted to get trained as quickly as possible and get to the front before the war ended. The men that answered Kitchener's war cry would replace the regular soldiers and reservists of the BEF who would perish during the 1914 campaign, including those lost at the Battle of the Aisne.

As hundreds of thousands of civilians descended upon recruiting countries across the British Isles, the soldiers of the BEF were preparing to go to war and boarding troopships. The BEF embarked from Southampton from 12–17 August. The soldiers who embarked were given various messages to motivate them and make them aware of the reasons why they were going. They were given the following message from King George V:

You are leaving home to fight for the safety and honour of my Empire. Belgium whose country we are pledged to defend, has been attacked, and France is about to be invaded by the same powerful

foe. I have implicit confidence in you, my soldiers. Duty is your watchword, and I know your duty will be nobly done. I shall follow your every movement with deepest interest and mark with eager satisfaction your daily progress; indeed your welfare will never be absent from my thoughts. I pray God will bless you and guard you, and bring you back victorious.[4]

Every man would hear or read the King's message. The soldiers of the BEF would also be given words of motivation and encouragement by their commanding officers. Private Frederick Bolwell, a reservist from the 1st Loyal North Lancashire Regiment recalled the solemn and pessimistic speech given by his commanding officer, Lieutenant-Colonel Guy Knight. Its motivational effectiveness is questionable.

Men of the 1st Loyal North Lancashire Regiment! I wish to bring home to you the fact that we have a hard task before us. We are out to fight a great nation and men who are out for blood. This regiment have always been top-dogs, even with the boys [time serving men]. What are we going to do now that we have the men? [the Reservists] None of you men will come back – nor the next lot – nor the next lot after that, nor the next after that again; but some of the next might. But we'll give those Germans something to go on with, and we'll give a good account of ourselves! Remember men, the eyes of the world are upon us, and I know that you will perform whatever task is allotted to you, like men.[5]

Lieutenant Guy Knight's prophetic message of doom would become reality very soon, for within four weeks he would be killed, before the battalion took part in the Battle of the Aisne.

For the most part, the soldiers of the BEF had no idea of the ordeal they were about to undergo. Sergeant David Lloyd-Burch serving with No. 10 Field Ambulance wrote of his feelings as he left Southampton docks: 'We left the docks happy, and little did we know the hardships that were in front of us.'[6]

As the BEF sailed across the Channel they were protected by the Royal Navy. Although many soldiers sailing on the troopships never saw the Royal Navy during the passage, the ships were deployed in strategic positions that would prevent the German High Seas Fleet from launching an attack.

Field Marshal Sir John French sailed from Dover aboard HMS *Sentinel* and arrived at Boulogne at 5.00pm on 14 August. Lord Kitchener had given Sir John the remit to support the French Army against the German oppressor, but to be aware that the BEF was a small force and that any decisions on how to deploy this military resource should be made so as to ensure minimum losses. This was a professional army and would be hugely outnumbered. He was asked to consider the needs of the French, however Kitchener had emphasised the fact that the BEF was an independent army and would not come under the orders of an Allied general.

The soldiers of the BEF received a rapturous welcome from the French people as they arrived in French ports. The Mayor of Boulogne requested the people of the port to display the flags of France and Britain to welcome

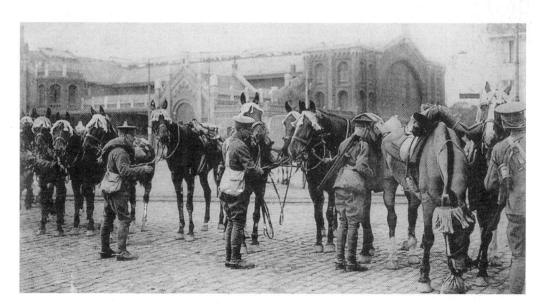

British Hussars arrive in France, 1914. (Author)

them. The 2nd Connaught Rangers arrived in Boulogne on 15 August and Sergeant John McIlwain recalled 'marching through the town cheered by the populace'.[7] When they landed they sang 'It's a long way to Tipperary' and it became a famous and popular tune in France.

As the troopships sailed into the French ports of Boulogne, Le Havre and Rouen, the soldiers of the BEF could hear the sounds of the appreciative French locals singing 'La Marseillaise'.

No.10 Field Ambulance was amongst the first units to arrive in France at Rouen. As they sailed down the River Seine they were warmly greeted by the people. Sergeant David Lloyd-Burch remembered 'a very pretty sight all the way up this river, for 10 miles people were welcoming us as we were the first contingent of British troops "Vive l'Angleterre" were their cries, to which we responded "Vive la France".'[8]

The French welcomed them with flags, flowers and wine. The women offered the soldiers embraces and kisses as they disembarked from the troopships. They were genuinely pleased to see these men who had sailed to help defend their nation.

Private Heys of the 1st Kings (Liverpool Regiment) travelled to France in a troopship from Southampton bound for St Nazaire. He acknowledged the warm welcome: 'I cannot speak too highly of these people, they are the most generous and warm hearted people it is possible to imagine.'[9]

Private W. Barker arrived in Le Havre with the 1st Northamptonshire Regiment on 13 August: 'Here the residents gave us a most rousing reception, and decorated all of us with flowers and ribbons representing the colours of the Allies.'[10]

The 2nd Welsh Regiment also arrived in Le Havre on 13 August and as they marched through the streets of the port they were adorned with flowers by euphoric locals. Captain Hubert Rees recalled: 'The enthusiasm of the French at Havre knew no bounds. The Battalion was decked with flowers, stuck in caps and rifle muzzles before we had gone a mile from the docks.'[11]

The 1st Coldstream Guards arrived in Le Havre during the early hours of 14 August. Despite their early arrival, the French were waiting. Lieutenant-Colonel John Ponsonby recalled the reception: 'Arrived at Havre about 1am, disembarking about 4am, we marched through the town along the Harfleur Road, our drums playing, and the inhabitants enthusiastic in that welcome, rushing up and presenting all the men with flowers.'[12]

Sergeant C.S.A. Avis recalled the experience of the 1st The Queen's (Royal West Surrey) Regiment, comprised of 26 officers and 1000 men, as they disembarked from the SS *Braemer Castle* and marched through the port of Le Havre: 'The Battalion disembarked the following morning and marched through part of that seaport to a plateau outside that town with drums beating and fifes playing martial music and La Marseillaise repeatedly to the cheering crowds that lined the streets.'[13]

The 1st Queen's (Royal West Surrey) Regiment were marched to the plateau above Le Havre where they camped for the night. During the following morning the battalion paraded before the Commanding Officer who read the King's message to the troops, and sections of the Army Act relating to looting and molesting women, emphasising the punishments for such breaches in Army discipline.

There were concerns that German spies were operating in France and soldiers were advised to be careful of what they drank for fear of it being poisoned. Private Harland from the 2nd Royal Sussex Regiment:

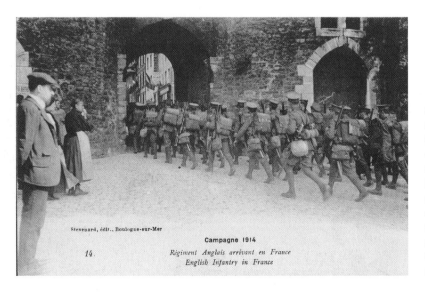

Stevenard, édit., Boulogne-sur-Mer

14.

Campagne 1914

Régiment Anglais arrivant en France
English Infantry in France

French citizens observe as BEF soldiers – armed with Short Magazine Lee-Enfield Rifles and carrying packs – march through Boulogne after disembarking from their troopships. (Author)

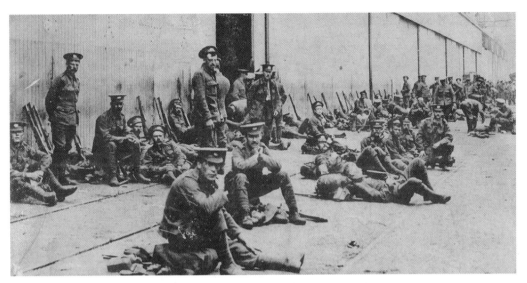

Above: BEF soldiers waiting for orders at Le Havre after disembarking from a troopship, August 1914. (Author)

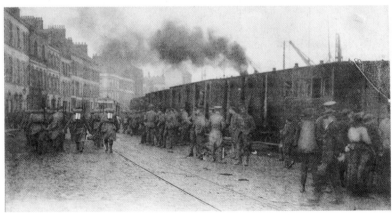

Right: BEF troops boarding trains for the frontline at Boulogne harbour, August 1914. French troops can be seen marching on the left. (Author)

'We were warned not to drink wine offered to us, for there was no saying but what there might be German spies there to put something in our wine. But these French people would have given us anything.'[14]

The French railway authorities had organised rolling stock and devised a timetable to transport the BEF in trains to the Belgian–French border. These soldiers had a 200-mile train journey, which took 24 hours. Private Frederick Bolwell recalled that the 1st Loyal North Lancashire Regiment spent one night in Le Havre before being herded into cattle trucks en route to Belgium. He remembered being 'packed into horse-boxes, 36 men and N.C.Os in each box, the total often reaching nearly 50 men'.[15]

Private F.G. Pattenden wrote of the journey that the 1st Hampshire Regiment endured in these sweltering trains from Le Havre to Le Cateau in his diary:

It is very hot here. We started at 12pm and after 16 hours of grinding and bumping, roar and rattle we

have now reached the town of Le Cateau about 30 miles from the frontier. We do not know where we move to next.[16]

On the journey the trains stopped many times and the welcome was just as effusive along the line. Private W. Barker recalled:

At every station we stopped as there were crowds of people on the platforms and we were presented with more cigarettes, food and drink than we could possibly manage. We were continually pestered for souvenirs, and some of the more daring of the crowd did not hesitate, if they got the chance, to cut off a soldier's buttons or numerals or to commandeer his cap badge. We all took these attentions in good humour, and I lost my cap badge and my numerals.[17]

Sergeant Arthur Lane recalled the welcome received by the 2nd Coldstream Guards in his diary on 15 August:

On arrival at Rouen coffee was given by French soldiers. Great crowds on all stations cheering and shouting 'Vive l'Anglais' continued through Amiens.[18]

Lane continued to praise the French support by declaring, 'French people do all they possibly can for English soldiers.'[19]

Field Marshal Sir John French arrived at his headquarters at Le Cateau late on 16 August and during the following day he met General Joseph Joffre and General Charles Lanrezac (Commander of the French Fifth Army). Field Marshal French would suffer a tremendous setback when on that same day Lieutenant General Sir James Grierson, commander of II Corps, died from heart failure while on a train close to Amiens. Aged 55, Grierson was obese and unfit. The stress of command during the opening days of the war brought on a heart attack which killed him on the way to the assembly area. French informed Lord Kitchener by telegram and requested Sir Herbert Plumer as a replacement. In a telegram to Lord Kitchener he reported:

My tour has left a satisfactory impression on my mind. The concentration of the troops is proceeding satisfactorily and is up to time. I recommend that Lieutenant-General Plumer may be appointed to command the Second Army Corps to fill vacancy caused by the unfortunate death of General Grierson.[20]

Despite his lobbying for the appointment of Plumer as replacement commander of II Corps, and much to French's consternation, Kitchener chose Smith-Dorrien as Grierson's successor. French was tremendously disappointed when Kitchener sent Sir Horace Smith-Dorrien to command II Corps, for as mentioned earlier,

the relationship between French and Smith-Dorrien was poor.

At Boué on 17 August, Brigadier-General Ivor Maxse convened a meeting with his battalion commanders from the 1st Guards Brigade. At this meeting Maxse expressed concerns about poor discipline, especially amongst the reservists. These men would have served for several years in the distant past, but many had forgotten or may not have cared for military discipline now. Lieutenant-Colonel John Ponsonby commanding the 1st Coldstream Guards recorded in his diary:

Maxse had a conference at his Headquarters at the Mairie. He spoke about march discipline, and I think he is quite right, as with all this influx of reservists, the discipline has been bad. I think, however, that it is nonsense to forbid the men to smoke cigarettes on the march. This is an Aldershot order and intended for young soldiers. All C.O.s – Lowther – Grant-Duff – O'Meagher, and myself, are agreed about this.[21]

On reaching the Belgian frontier the BEF alighted from the trains and began the long march east in the direction of the oncoming German Army. Elements of II Corps disembarked at Landrecies, which was 40 miles from Mons. Field Marshal Sir John French did not know where they would engage with the Germans. As they headed towards the massing German Army the BEF passed the memorial commemorating the Duke of Marlborough's victory at the Battle of Malplaquet on 11 September 1709 during the War of the Spanish Succession, when Britain was allied with Prussia, Holland and Austria against France and Spain.

The BEF was not taken seriously by Germany or France. It was considered a tiny token force, which would not make any impact or significant contribution

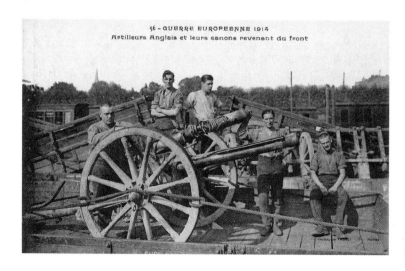

British artillery on a railway carriage at a French station, en route to the frontline. (Author)

to the war; France and Germany had approximately 70 divisions a piece. The French Army numbered 1,071,000 men in the field. Germany had mobilised 1,485,000 men. Kaiser Wilhelm II had little regard for the BEF or its soldiers, for on the 19 August he issued this famous directive to General Alexander von Kluck, Commander of the First German Army:

It is my Royal and Imperial Command that you should concentrate your energies for all the immediate present upon one single purpose, which is to address all your skill and all the valour of my soldiers to exterminate the treacherous English and walk over General French's contemptible little army.

The Kaiser (not recognising that Sir John French was a Field Marshal) has actually been mistranslated: rather than 'contemptible', he actually wrote 'insignificant'. Nevertheless, from then on the British soldiers who fought the 1914 campaign would be affectionately known as the 'Old Contemptibles'. The Kaiser had grossly underestimated the British Army, its professionalism, its capabilities and the qualities of its soldiers. They were highly trained, in the main well disciplined and they were volunteers. The BEF would prove to be a competent, formidable and determined fighting force. Anyone lucky enough to have survived the battles at Mons, the Marne, the Aisne and Ypres, would feel proud and honoured to be known as an 'Old Contemptible'.

By 20 August, General von Kluck's First Army numbering 320,000 soldiers had crossed the German border at Aachen and had swept through Belgium and triumphantly marched into Brussels, the Belgian capital. They then headed west towards positions north of Mons. They were unaware of the exact position of the BEF and thought that they were landing at the Channel ports of Calais and Dunkirk. They were unaware that the BEF had already disembarked and were crossing the Belgian border. Although he had no precise information as to the whereabouts of the BEF, General von Kluck held the massive advantage of superior numbers, three to one.

During the evening of 22 August Smith-Dorrien's II Corps was positioned along the western bank of the Mons-Condé Canal while Haig's I Corps was positioned in front of the Belgian fortress at Maubeuge. During that day the French Fifth Army commanded by General Lanrezac south of their position was being overwhelmed by the German Third Army at Charleroi. German forces were implementing the Schlieffen Plan. The First German Army was heading west towards positions north of Mons. The German Second Army had captured Liège and was causing problems for Lanzrezac's Fifth French Army south east of Mons. If the

Fifth Army line collapsed then the BEF would become vulnerable to being cut off from French forces and from access to the Channel ports. Field Marshal French was informed of this dangerous situation during the night of 22 August.

A meeting was convened by Field Marshal Sir John French at the chateau at Sars la Bruyère at 5.30am during the morning of 23 August with his Corps commanders, Haig and Smith-Dorrien. He ordered that the outpost line along the Mons canal be reinforced and that the bridges crossing the canal be prepared for demolition in the event of there being rushed by German forces. There was very little communication between the Field Marshal and his French counterparts, which meant that he knew very little about the strategic situation and could not make provisional plans for the way forward. French was extremely vague and told Haig and Smith-Dorrien to prepare to move in any direction, be it to advance or retreat. French left his Corps commanders to fight their first engagement of the war at Mons, while he headed for Valenciennes, far from the impending confrontation with the German Army.

It seemed like a normal Sunday morning on 23 August in the mediaeval town of Mons as the church bells rang and the local Belgian civilians dressed in their finest were walking to church. Trains were steaming towards Mons carrying holiday makers to the town. They were oblivious to the fact that the British and German armies were heading for a collision at Mons. The day started off misty with rain falling.

When II Corps engaged the German First Army at the canal at Mons, the unplanned action was the first time in 99 years, since the Battle of Waterloo in 1815, that British soldiers had fired a shot in anger on European soil. The 4th Duke of Cambridge's Own (Middlesex Regiment) and the 4th Royal Fusiliers were holding the Nimy–Obourg Salient east of Mons and would bear the brunt of the German vanguard. Within three weeks these two battalions would cross the Aisne and play an active role in the Battle of the Aisne.

At 6.00am the 4th Middlesex Regiment, the 'Die Hards', engaged in rifle fire with a German cavalry patrol. They were occupying positions at Obourg Station, which was on the eastern bank of the Mons Canal. They were responsible for the defence of four bridges and two railway crossings. The 4th Middlesex Regiment were ordered to 'delay the enemy as much as possible'.[22]

German cavalry patrols also approached positions held by the 4th Royal Fusiliers who were adjacent on their left flank. It was fate that put the 4th Royal Fusiliers in the vanguard at Nimy, not planning. Private William Holbrook from the 4th Royal Fusiliers explained why this particular battalion was at the forefront of the German onslaught at Mons:

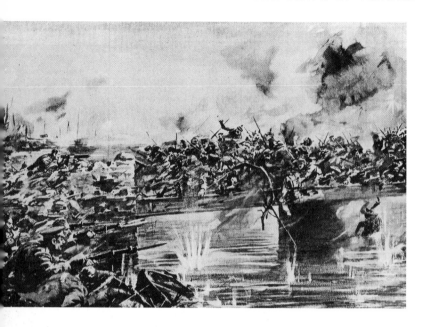

The 4th Royal Fusiliers hold the bridge at Nimy during the Battle of Mons on 23 August 1914. Three weeks later the remnants of the battalion would take part in the Battle of the Aisne. Private Sidney Godley can be seen manning a Vickers machine gun on the west bank. Private Godley together with Lieutenant Maurice Dease would be awarded the first Victoria Crosses of the war for defending this position. (*Deeds that Thrill the Empire*)

We used to take turns, a different battalion had to lead the way. The day we got to Mons, it was our turn to be at the front, we were at the front the day before, but as our second in command, Major M_____ took us on a wrong journey, the wrong route, as a punishment we had to lead the next day and that of course led us straight into Mons.[23]

Holbrook remembered 'we lined the bank'[24] and mentioned that local children were standing close to the machine-gun position established by Lieutenant Maurice Dease and Private Sidney Godley at the railway bridge at Nimy. These inquisitive children were told get out of the way as the firing began.

At 9.00am German artillery was in position on high ground east of Mons and began firing upon the line held by the 4th Middlesex Regiment and the 4th Royal Fusiliers. During the Battle of Mons, Holbrook was runner to Major Barnes Smith:

I could see the Germans coming down in waves. They were not in formation. As far as I could see there was quite a number of them, more men than we had. I only fired a bit because I was behind the company with the officers. I don't think I was nervous when the action started, everything happened so suddenly. But it was all new to me – it was new to all of us. You didn't really think about that. Shells seemed to worry me a bit, the bursting of shells.[25]

At 9.00am as the German shells were falling and German infantry approached the eastern bank of the Mons Canal. Reinforcements from the 2nd Royal

Irish were brought in to support the rear of the 4th Middlesex Regiment. By 10.00am the German IX Corps was advancing in waves along the banks of the Mons Salient from Nimy to Obourg.

The British bullets tore into the advancing ranks of the German First Army, but they were unable to hold their positions. German infantry began to cross the Mons Canal after midday and by 1.30pm the 4th Middlesex Regiment were forced to withdraw. Lieutenant T. Woollcombe, adjutant, recalled their experience at Obourg Station.

There were a lot of buildings on our side of the railway which were placed in a state of defence by the R.E. D Company was to hold Obourg Station and the two bridges near there and B Company, the other two bridges linking up the line between the 9th Brigade and D Company. The latter had trenches to dig to retire to if forced to do so, but the unfortunate D Company had bad country behind them where defence of this kind was impossible, being very thickly wooded. This should have lent itself to an easy retirement but apparently this company did not think of retiring, for of the 6 officers and 213 other ranks who went into action there, only 32 other ranks got back after the battle next day. The 32 fortunate ones who got back were in small bunches, in ones and twos, to join the rest of the battalion in the evening. The Germans apparently got across the canal somewhere away to the right of the battalion front and pushed up the rear of this company. However it took them nearly all day to do it and cost them many hundreds of lives.[26]

With the line of the 4th Middlesex Regiment broken, 30 minutes later the 4th Royal Fusiliers line faltered as German infantry swarmed across the canal. Lieutenant Maurice Dease and Private Sidney Godley from the 4th Royal Fusiliers had held onto the western bank throughout that morning. Dease was killed and Godley continued to fire his machine gun, positioned on the Nimy Bridge, until he was captured later that day. Both Dease and Godley would receive the Victoria Cross, the first recipients of the war.

Smith-Dorrien realised that his men were being overwhelmed by a superior force and brought II Corps to a defensive position south of Mons. Haig brought I Corps to Smith-Dorrien's right flank. The first day of fighting cost the BEF approximately 1600 casualties. Von Kluck lost about 5000 men. One unidentified soldier commented: 'I can tell you this, when we British went into the Battle of Mons there was nobody more surprised than the Germans. From what their prisoners said I knew they hadn't the least idea they were going to fight the British.'[27]

The 2nd Connaught Rangers were held in reserve two miles north of Bougnies and could see the flames and smoke from the battle that were billowing from the town of Mons. Sergeant John McIlwain wrote:

Two views of Nimy Bridge at Mons. (Author)

> March all day. In the evening formed up on the summit of a position overlooking Mons, part of which was in flames. The first division and others in front of us. Artillery exchanges. We entrenched in a beet field. Support trenches of course, in case the Germans <u>might</u> drive the first army back. Plenty of enthusiasm.[28]

Later that night news came through confirming that Lanrezac had ordered the French Fifth Army to retreat. Field Marshal French could try to hold the ground south of Mons and risk the prospect of a total collapse of the line and a complete annihilation. Or he could deploy the BEF at the Belgian fortress at Maubeuge; however they would have been vulnerable to being entirely surrounded by German forces. The BEF could only slow down the might of the advancing German Army. The sensible strategy was to retreat, like their French Allies. The retreat from Mons began on 24 August. Marching south, the BEF was hotly pursued by the German Army.

Soldiers of the BEF were aghast, appalled by the prospect of retreating. They had come to Belgium to fight and repel the German invaders. To retreat was regarded as a defeat. Sergeant John McIlwain wrote of his indignation at retreating: 'Stand-to before dawn. At sunrise, to our disgust, ordered to retire from our beautiful trenches. Retiring all day.'[29]

The 2nd Coldstream Guards would see their first action on 24 August. They fought all that day. Sergeant

Arthur Lane provides a detailed account of the battalion's actions:

> We left trenches at 3 o'clock am, went through village and had to return at the double to our original position. Fought a rearguard action all day and only the bad shells that the Germans used saved the Company. One shell struck ground about ten yards in front and one twenty yards in rear … Again shelled during day but no damage done. People all leaving home; very pitiable sight. Guns shelled an aeroplane, and shells burst all round, but she succeeded in getting away. Germans when attacking Middlesex forced women from Mons to go in front to shield; could not fire and lost heavily. South Lancs and Berks had casualties. German spy caught attempting to bribe gunners.[30]

Private John Cowe, a Coldstream Guard recalled 'we got further down country and different places were on fire, farms and that.'[31]

The summer heat that bore down on them as they marched would intensify their discomfort during the

Belgian refugees fleeing their homes. (The Church in the Fighting Line)

retreat. Private Frederick Bolwell from the 1st Loyal North Lancashire Regiment affirmed: 'Most of the next ten days remain in my mind as a nightmare. The weather was exceedingly hot, the long roads with stone sets stretching as far as the eye could see were very wearisome, and the men were utterly exhausted.'[32] Sergeant C.S.A. Avis from the 1st The Queen's (Royal West Surrey) Regiment:

> During the retreat from Mons we endured very long marches wearing full marching order equipment in the summer heat. When we halted we were ordered to sit or lie down to rest. When the battalion was the rearguard orders were given to fix bayonets and prod along any stragglers. Very few fell by the wayside. We marched for nearly 36 hours without respite or sleep in very hot weather and finally in drenching rain to Landrecies.[33]

Whenever rearguard units came under attack, reinforcements were sent back along the road to support them. Here they would dig shallow trenches and fight off the enemy under the intense summer heat. Private Frederick Bolwell:

> The hardest time of all was when one's particular regiment found rearguard: then we often had to march back for a few miles along the way we had come, dig trenches, hold the enemy the whole of the day, and then at night continue the march until we picked up the main body again. Oftentimes on reaching the main body it was found that they were just ready to start again, so the rearguard would be obliged to continue their march without intermission.[34]

German patrols would sometimes advance ahead of retreating elements of the BEF and would wait for them to approach in concealed positions. Bolwell remembered a pilot from the Royal Flying Corps landing close to the road where the 1st Loyal North Lancashire Regiment were marching to warn them that in a wood miles ahead, German troops were waiting to ambush them. This vital piece of information meant they skirted the position.

By 25 August the BEF had reached the Forest of Mormal. Here Field Marshal French decided to separate the two Corps as they took two different roads either side of the forest. If he had kept the BEF as a single force the route might have become congested. There would have been a greater risk of being overrun and surrounded. The movement of a division, whether advancing or retreating, was an enormous logistical undertaking. The one British division made up of 18,073 ranks, 5592 horses, 76 guns and 24 machine guns would occupy 15 miles of road space. By separating his forces Field Marshal French ensured that the BEF kept moving.

French refugees were on the roads used by the BEF and so impeding the retreat. On 25 August the 1st Hampshire Regiment were close to Le Cateau waiting for the enemy to appear, while displaced French citizens were moving south with all the possessions they could carry, in a state of despair. Private F.G. Pattenden recalled the pitiable scene in his diary:

> After a hurried breakfast during which we stood by for orders we moved off through Le Cateau. We have now retired and at 11.50am we are waiting for the Germans to appear. All the poor refugees are going by us, crying bitterly, also a few of our wounded. What a terrible thing it is at present, what will it be like later on? We all have good brave hearts with us and all are prepared to help our good friends the French. What a fine country this is, they would give you their shirts.[35]

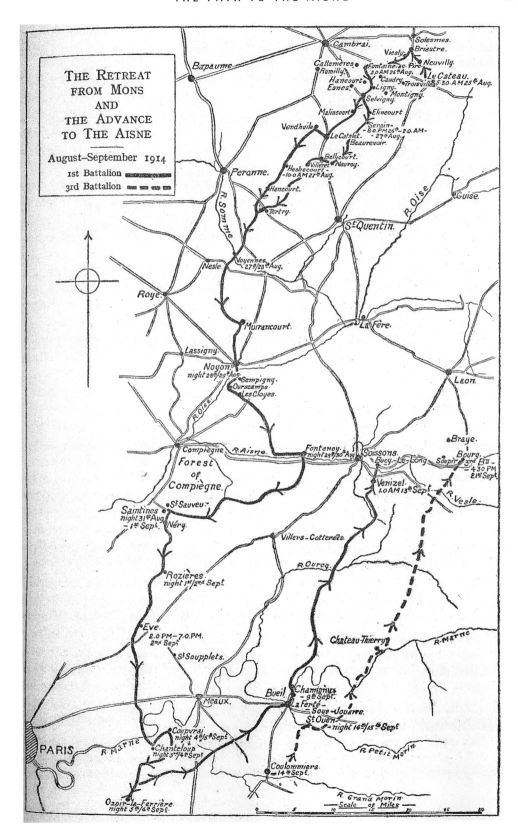

THE RETREAT
FROM MONS
AND
THE ADVANCE
TO THE AISNE

August–September 1914

1st Battalion ▬▬▬▬▬
3rd Battalion ▬ ▬ ▬ ▬

Field Marshal French was becoming frustrated with French commanders who failed to communicate their positions and strategies. French conveyed his feelings to Lord Kitchener from his HQ at Le Cateau on 25 August.

> It is, of course, always difficult to work with an ally, and I am feeling this rather acutely. The French do not keep me sufficiently informed as to the general situation, and they evidently try to conceal reverses or compulsory retirements.[36]

German forces held the upper hand and were dictating events on the battlefield. French could not implement the strategy of offensive which had been instilled in all British Army officers at Sandhurst. The BEF was forced to move in response to the enemy's movements and was unable to launch an offensive.

> Had the advance commenced on Sunday, as I was led to suppose it would, we should had got well into Belgian territory before we came to close quarters with the Germans.
>
> We should have probably have hampered their deployment and secured many advantages which this unfortunate delay has made now impossible.
>
> In fact, we seem to be making the old mistake of conforming to the enemy's movements rather than compelling him to conform to ours'.
>
> But that was not the worst aspect of what has happened. Whilst I took up a forward position which would have enabled me to jump off easily, the French 5th Army were actually retiring, and doing so without giving me any warnings, so that on Sunday night and Monday morning (24th) I found myself almost in the air with three German Corps and two Cavalry Divisions.
>
> As regards what you say about Joffre in your telegrams, it is very difficult to induce these French Generals to consider any modification of the views they have formed, but I will do what I can with him. Indeed, through using Huguet as a means of communication, I have consistently tried to bring home to the French Commander-in-Chief the necessity for vigorous offensive.
>
> Regarding my own immediate plans, as the French still seem to be so supine I am continuing my retirement tomorrow morning from the line LE CATEAU-CAMBRAI towards PERONNE. I do not wish to risk a battle with the Germans against greatly superior forces, and the men, although in the highest spirits, want some rest.[37]

On the 25th, as the day of marching and fighting rearguard actions was drawing to a close and when the men of the BEF were hoping for some rest and sleep, those soldiers who were in the vicinity of Landrecies would take part in further engagements with their pursuing enemy, when a German patrol made contact with the 4th Guards Brigade. The 1st Irish Guards, the 2nd Grenadier Guards and the 2nd and 3rd Coldstream Guards from this brigade would play a prominent role in the Battle of the Aisne at Soupir in the weeks ahead. The 4th Guards Brigade reached the town of Landrecies, a village south of the Forest of Mormal, at 4.00pm, where General Haig had established his headquarters two hours previously. News that German forces were advancing in their direction was brought by alarmed French civilians who reported seeing units in the forest of Mormal at 5.30pm. Guardsmen from this brigade were ordered to stand to but with no sight of the enemy they were stood down.

Sergeant C.S.A. Avis from the 1st Queen's (Royal West Surrey Regiment) was not far from Landrecies on that day:

> The battalion arrived at a hamlet near Landrecies nearly exhausted; a halt was called as it seemed impossible to move on. Just as we were bivouacked at dusk there was an alarm that we were about to be attacked. There was confusion and sharp rifle fire which was quickly controlled. It proved to be false, nerves![38]

Lieutenant N.H. Huttenbach who belonged to 41st Brigade Royal Field Artillery:

> On reaching Landrecies settled down for a little sleep. Even there respite was not to be, as in the late afternoon it was rumoured falsely, but in the evening feared to be correct, that Germans were on the outskirts of the town.[39]

The 14th Infantry Brigade of the German 7th Division had marched south across the forest of Mormal from Le Quesnoy towards Landrecies. This brigade was comprised of the 27th and 165th Regiment, the 10th Hussars and 4th Field Artillery Regiment. Advance parties from the 27th Regiment accompanied by an artillery battery had the intention of looking for billets. They were ordered to seize the bridge crossing the Sambre Canal at Landrecies and set up billets within the town for the night. They were unaware of the British presence in the town, but as they got closer they realised that Landrecies was occupied and advance units then quietly positioned themselves 500 yards away from No.3 Company, 3rd Coldstream Guards, commanded by Captain the Honourable C.H.S. Monck. They had established two machine-gun positions on either side of the approach road from Le Quesnoy into

the town. Monck had been advised to expect French troops to come along this road.

At 7.30pm on 25 August Monck's men could hear the noise of horses and wheels and footsteps of marching infantry approaching them. It was a German regimental transport, which was ordered to get to the billets in the town. They were unaware that Landrecies was held by British forces and they were approaching close to a machine-gun position, protected by barbed wire entanglements, of the 3rd Coldstream Guards. A sentry challenged the approaching German convoy and received a reply in French. Some of the soldiers were singing songs in French; when a torch was flashed in their direction the British could see soldiers dressed in French uniforms, but German infantry with fixed bayonets were following close behind. As they drew closer they lowered their bayonets and charged towards the Coldstream Guards. Monck immediately ordered his men to open fire but before the order was carried out Monck was knocked to the ground. Private Thomas Robson who was manning the machine gun guarding the right side of the road into Landrecies was killed and the gun captured by Germans who managed to drag it away. They brought the machine gun ten yards before they were cut down by rifle fire from the ranks of the

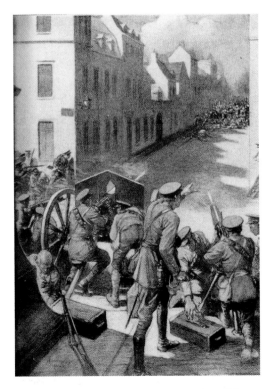

The action at Landrecies, 25 August 1914. (The War Illustrated, 19 September 1914)

Coldstream Guards who mounted a counter attack and recovered the machine gun.

The other battalions of the 4th Guards Brigade raised the alarm and every soldier reached for his rifle and stood to. Major T. Matheson with No 1 Company commanded by Captain E. Longueville rushed forward to support Monck's company. Bullets had pierced Monck's cap and coat but he was unscathed. No. 2 and No.4 Companies were dispatched to protect the northern perimeter of Landrecies.

The 2nd Grenadier Guards established defensive lines on the western approaches to Landrecies aided by a howitzer and a field gun, while the 2nd Coldstream Guards protected the eastern and southern perimeters of the town. The 1st Irish Guards prepared to defend Landrecies. The 3rd Coldstream Guards bore the brunt of the German efforts to capture Landrecies during that night. Wave after wave of German infantry charged forward to be thwarted by the deadly accurate rifle fire of the Guardsmen. German infantry managed to crawl behind some hedges and outflank the 3rd Coldstreamers line on the right, which forced them to fall back to obtain some cover from a nearby cottage.

At 8.30pm German artillery brought their guns to bear upon the town causing damage and fires. When a haystack was set alight by an incendiary bomb it illuminated the British positions and German observers could see that only a thin line was defending Landrecies. With the British position exposed the Germans brought up a field gun and began firing at them point blank at a range of 25 yards. Under heavy German shell fire and despite the close proximity of the enemy, Private George Wyatt of the 3rd Coldstream Guards made two daring attempts to extinguish the flames that were revealing their position. Wyatt was awarded the Victoria Cross for his valiant efforts.

Street fighting ensued within the town and the Guards secured their positions behind barricades erected across the streets. At 1.00am on 26 August Lieutenant-Colonel G.P.T. Feilding, the commanding officer of the 3rd Coldstream Guards, ordered a howitzer from the 60th Battery to be brought into the town and positioned behind one barricade. A flash of a German field gun could be seen in the darkness and the howitzer fired three rounds in that direction, silencing the gun. The 1st Irish Guards launched a counter attack at 3.00am, which provided the 3rd Coldstream Guards with an opportunity to withdraw. A bitter street battle was fought and very shortly the German forces had had enough and withdrew into the night. Lieutenant N.H. Huttenbach:

During the night fierce street fighting, successfully repulsed by the 4th Infantry Guards Brigade under Lord Cavan's command, supported by 9th Battery

**The 14th Field Ambulance
march through a French village.
(*The Church in the Fighting Line*)**

RFA, a howitzer battery with guns in the barricades and so enabled us to extricate ourselves and continue the retreat at dawn.[40]

Sergeant W.J. Cook from the 2nd Coldstream Guards had arrived at Landrecies after a 14-hour march in intense heat during the afternoon of 25 August:

Resumed march at 3.30am to French barracks at Landrecies, again dead beat owing to the distance & heat, arriving about 5pm. At 9.00pm the alarm sounded, when we turned out and barricaded the streets and had an exceedingly hot time (our 3rd Bn. suffered heavy lesson).[41]

The action at Landrecies bought the 4th Guards Brigade sufficient time to withdraw and escape south. Continuous marching from Mons for the past two days and the fighting of rearguard actions prevented them from taking any rest. They had no choice but to keep on moving. The 2nd Coldstreams left the town during the early hours of 26 August. Sergeant W.J. Cook:

We moved out of Landrecies, with much difficulty, 2.30am. Immediately we left, the town was all in flames. This Batt'n fought a rearguard action as far as Etreux where we bivouacked, completely exhausted. From 3am 23rd till 2pm 26th, we covered 100 kilometres, spent one night digging and one night fighting, making a total of 5 hours sleep out of 63 hours.[42]

The 4th Guards Brigade had suffered significant casualties and the action at Landrecies would be a foretaste of the Battle of the Aisne. The 3rd Coldstream Guards sustained 120 casualties, while the 14th German Infantry Brigade lost 127 men.

As the 4th Guards Brigade were fighting the rearguard action at Landrecies, fresh reinforcements from the 4th Division had arrived at Le Cateau from England during the night of 25 August and had prepared a defensive position. 250,000 German soldiers were descending upon Le Cateau. Smith-Dorrien realised the impossibility of continuing the retreat in daylight and decided to hold the ground long enough at Le Cateau to stop the German advance and gain enough time for the worn-out 3rd and 5th Division to continue the withdrawal.

The battle at Le Cateau began at dawn on 26 August and German attempts to go forward were thwarted by approximately 50,000 men from Smith-Dorrien's 1st Corps, which held back 250,000 German infantry. The Germans should have overwhelmed these brave British soldiers but they doggedly held on for eight hours. The 14th Infantry Brigade holding the right flank of the 5th Division had capitulated with the 2nd Suffolk's completely wiped out.

The 1st Rifle Brigade was ordered to wait in a sunken road during the Battle of Le Cateau and prepare to launch a surprise ambush upon advancing German infantry. They were unable to launch any attack because German artillery fire was targeted upon a line of trees behind the sunken road and shells and shrapnel decimated the battalion. With the battalion bunched up in one location, exposed to this fire, officers learned that it was necessary to thin the line to limit the casualties. The casualties amounted to 8 officers and 350 men who were so severely wounded that they were unable to be evacuated from the sunken road. The majority of these wounded men were left under the supervision of Captain Garland. They were captured by the enemy as the remnants of the battalion withdrew to Ligny.

The BEF were in retreat and in a state of chaos. There were no organised facilities to tend to the wounded and they had to be bound with field dressings at the side of the road. With the enemy so close it was essential that the wounded were dealt with quickly and that they kept moving. Major C.L. Brereton from the 68th Battery, 14th Brigade Royal Field Artillery, recalled the situation after the battle of Le Cateau:

While marching along the Ligny-Haucourt road, shells were bursting on the Le Cateau-Cambrai

Ridge, infantry were coming hurriedly down the slopes towards us and through us. Most of them looked quite exhausted, and it was evident that they had been badly cut up. There was a block on the road and while waiting, we were bracketed by a couple of percussion shells. I thought we were 'for it' but nothing further happened. Wounded were being hurriedly dressed by the side of the road, but it was obvious there were no ambulances, and practically no medical arrangements.[43]

The BEF could not sustain a permanent defence of Le Cateau because they were greatly outnumbered and during that afternoon Smith-Dorrien ordered II Corps to withdraw. II Corps lost 7812 soldiers and 38 artillery pieces.

As the BEF withdrew south towards the River Marne, General Hubert Gough's 3rd Cavalry Brigade came under the command of Haig's I Corps and their orders were to cover the rear of I Corps. Gough's brigade was intact, but he was not told how to execute his orders to cover the I Corps retreat. Gough requested orders from Sir John French's General Headquarters as to where he was to deploy his brigade. Sir Henry Wilson advised him to use his own discretion. 'Oh, you are on the spot, do what you like, old boy.'[44] This vague response left Gough incensed. 'Such orders left me to do what I liked, certainly, but did not tell me how to do it or indeed what was wanted! – and I may add, positively infuriated me.'[45]

There was also a lot of confusion and a lack of decisive orders from BEF Staff Officers. Captain A.H. Habgood from the 9th Field Ambulance, 3rd Division:

There was a general absence of orders; many officers and detachments asked us the way to their units; we did not know, and the only answer we got from the staff officers we encountered was 'Get on', so we followed the rest.[46]

As the retreat continued southwards errors were made by tired officers who in some cases did not have any orders. The 2nd Connaught Rangers had to move back to Laval on 26 August and continue the retreat through Taisnières. Sergeant John McIlwain:

About 4.00am our officers, who were as wearied as ourselves, and apparently without orders, and in doubt what to do, led us back to the position of the night before. After some consultation we took up various positions in a shallow valley. Told to keep a sharp look-out for Uhlans. We appeared to be on some covering movement.[47]

The men were continually on edge, their nerves strained by the slightest sound in the dark. By the end of 26

August the 2nd Connaught Rangers could only muster 50 per cent of battalion strength. Lieutenant-Colonel Alexander Abercrombie was mortally wounded and 280 men were listed missing, presumably captured. Sergeant John McIlwain:

The prospect of being taken prisoner in our miserable condition – for we could never elude such an immense force – made the situation peculiarly tense and memorable. For all the years of the war after that time, and years after that, if, in the silence of night, I heard a horse calling, at once there would come to my mind again a picture of that waiting in uncertainty in the rain, while the clatter of a thousand hooves and the pathetic neighing of the horses came over the quiet fields under the lit-up sky. But it was the French Army.[48]

Laden with heavy equipment the BEF men were ordered to dispense with items that were not vital. In the heat, one item discarded by many soldiers was their overcoat. Sergeant C.S.A. Avis recalled: 'Later we were ordered to discard the valises of the webbing equipment containing our overcoats and other necessities.'[49]

The decision to abandon their overcoats was one which BEF commanders and soldiers would regret weeks later, when the hot summer days were replaced by torrential, cold rain at the river Aisne.

There was evidence of a breakdown in discipline as the retreat from Mons was conducted. Some weary soldiers who were extremely hungry fell out at the side of the road for rest and then joined other units. There was a collapse in structure and organisation as units became intermingled. The men looked ragged, and standard military dress was replaced with practical clothing that would shield them from the sun. Sergeant John McIlwain:

Much has been written about slackening of discipline about this time. One wonders was it some of the comfortable looking staff officers riding about the roads who commented upon this. Men were observed staggering about and straying on the roads, falling out apparently as they wished, and rejoining, often with units not their own. Men threw away equipment and clothing. Men lost their caps, and girls' sun hats became quite a fashionable article of wear. These were looted from houses and shops. Special instructions were afterwards issued condemning this eccentricity of the British soldier.[50]

McIlwain did comment that some officers gave leeway to their exhausted soldiers and were confident that discipline would kick back in when it was required.

But so far as the retreat was concerned at this period; everybody was exhausted. Sleeplessness and hunger wore out the officers, who were quite contented to let the men keep loosely together on the march. But on the notable occasions when these same weary men had to turn and fight they roused themselves and did well, sometimes fighting to a finish. Their officers knew they could trust them to do that.[51]

Officers and their battalions became lost at times during the retreat. At Chaconin on 2 September, officers from the 2nd Connaught Rangers lost their bearings and contact with their brigade, much to the dismay of the troops, who would consequently have to march farther than necessary.

This day we appeared to have lost the brigade again. Our commanding officer, Major Sarsfield, is a wearied, anxious man, riding up and down with the adjutant, Captain Yeldman. We seem to be cut off from the army altogether. French civilians are being questioned by our officers who, with maps in hand, look as doubtful as Sarsfield. The men, in their uneasiness, are abusing the officers.[52]

As they advanced farther into France they were hindered by congested roads and were vulnerable to German cavalry attacks. Sergeant C.S.A. Avis:

The progress of the withdrawal was slow owing to the roads being congested with vehicles of all sorts, refugees and our own broken-down commercial lorries containing food supplies. We were continually harassed by enemy cavalry patrols.[53]

Some men were so malnourished they lost their appetite altogether. Lieutenant-Colonel H.R. Davies commanding the 2nd Oxford & Buckinghamshire Light Infantry recalled in his diary:

Between 24th August and 5th September we did 178 miles in 12 marches and 1 halt a day. Not a very long distance, but very long hours under arms, hardly any sleep and boiling hot weather. Never in my life have I felt anything like the degree of tiredness that I felt on this retreat. Everyone felt it like this. I remember that we wondered if we should ever feel rested again and whether it would not leave some permanent effect upon us. The worst thing was the want of sleep. The next worst thing the heat of the sun and the thirst. I think the extreme fatigue brought on a sort of unnatural thirst. I don't think one felt hungry much. I remember sometimes trying to eat some biscuits and bully beef at a halt on the march and failing to

manage more than a few mouthfuls. What helped us more than anything was getting apples. When we halted near apple trees I always ordered the apples to be picked and eaten.[54]

Field Marshal Sir John French recognised that his men were exhausted and hungry. If there were any trenches that were needed to be dug for preparing a defensive rearguard line, local people would be used to dig them. French reported to Lord Kitchener on 27 August:

The men were exhausted and wanted food. I wanted to keep all their power for marching and not to fatigue them with digging, but we had previously got some local labour and done a certain amount of entrenching.[55]

Many of the soldiers under Lieutenant-Colonel Davies' command in the 2nd Oxford & Buckinghamshire Regiment were reservists and were not in a fit condition to march. Many soldiers succumbed to sun-stroke while some of the soldier's feet were so sorely blistered that they had to be carried along. Davies wrote:

More than half the men were reservists who in spite of some route marches had not got into proper condition for marching and consequently there were a good many sore feet. A few of these were so bad that they had to be sent to hospital but the large majority of the sore-footed men stuck to it splendidly. We usually had no ambulances with us so that even the men who fell down unconsciously with sun-stroke had to be got along on transport of some kind or artillery limbers.[56]

Many of the reservists did not have the chance to get physically fit when they were mobilised and it would cause them immense problems during the retreat from Mons. Their feet would become blistered and were bleeding due to continuous days of marching. Some men resorted to marching along the hard cobbled stones with their puttees wrapped around their feet to ease the pain. Although these men were struggling to put one foot before the other, they continued with grim determination. Captain Hubert Rees wrote of the poor physical condition of the men from the 2nd Welsh Regiment under his command:

The determination of our men during the retreat passed all belief. The reservists, as I remarked before, were not in any way fit for such a terrific test of endurance. Between the 22nd August and the 5th of September, we marched about 240 miles and only on one day did we have any semblance of rest. The men were absolutely tired out before the actual

retreat began on the 24th. At the end of some of the marches, it was impossible to maintain our formation and the column became merely a crowd flowing very slowly along the road, the men looking as if they neither saw nor felt anything. Almost without exception, their feet were raw and bleeding and many marched with puttees wrapped round their feet. Their one desire was to halt and fight the enemy and not being allowed to do so was the cause of bitter complaint.[57]

Sergeant John McIlwain was a reservist serving with the 2nd Connaught Rangers who struggled with the physical demands of the retreat. Only weeks before he was working as a clerk.

Dropping for want of sleep. Felt the lack of sleep badly, unlike the young regular soldiers, perhaps because of my long period of orderly civil life. But I soon got used to the ups and downs. Our retirement was mostly across country. Now and again a halt, when we turned about, lay down, and were asleep almost at once in the warm air, sometimes slept for a full hour. The only fire we experienced was long distance shrapnel generally well behind us. Between the sleepy shells and musing I recollect marvelling that it was really true that I had been years away from the army; that I held the rank of sorting clerk and telegraphist in the Post Office; that only twenty days before I was working in Newcastle, whereas now, I reflected looking down at my dirty and sunburned hands, it was as if I had never been away from the service, this kind of manoeuvring, and in the company of these Irish lads I had known so long.[58]

Lieutenant-Colonel Davies of the 2nd Oxford & Buckinghamshire Regiment managed to sleep on average 4 hours a night during the 15 nights as they retreated from Mons to the Marne. It is a wonder that these men could function mentally as well as physically without adequate sleep. The officers under Davies command struggled to wake their men when they were about to move off after a brief halt.

The officers all worked magnificently. Tired to death as they were themselves they kept their companies together. Whenever there was a halt men dropped to sleep on the road. One had to allow extra time at each halt to wake them up before we could get on the move again. Sometimes a company commander going along his company to wake them up would find when he had finished that some of the men he had awakened first had dropped off to sleep again.[59]

2nd Lieutenant C.A.B. Young had graduated from the Royal Military College at Sandhurst weeks before the war broke out and was commissioned into the 2nd Welsh Regiment in early August 1914. Young later recalled the fatigue: 'Walking and not sleeping. That was the chief drawback that I found, of never getting sleep. We were on the move the whole time and we were all so tired'.[60]

Dehydration was another major problem. Marching under a blistering sun, thirst was a torment. It was necessary to conserve water as they marched. An anonymous 2nd Lieutenant from the 1st Loyal North Lancashire Regiment recalled in his diary on 28 August 1914:

We are ordered to retire and move off. We can see shells bursting on our left where some French infantry are being shelled. They are very steady. The town we are to go through is shelled, so we leave it on our right and make a short detour. We march for about two hours without a halt and manage to get clear of the shelling; we have to thank our Colonel [Knight] for having had no casualties. We halt and get water. The water question was very serious. The men always started drinking it at the first halt, and the result was that they were always short. Orders were issued that no one was allowed to drink until the fourth halt, that is, after four or five hours' marching.[61]

The soldiers at times were forced to eat what little rations they had while marching. They picked fruit as they withdrew. Lieutenant H. Robinson from the 8th Field Ambulance recalled an incident close to Cambrai involving a martinet of an officer:

At Vendegies we out-spanned on an orchard which I had selected when sent forward for the purpose. As soon as we get into the orchard both officers and men began to eat ripe fruit – plums, and apples and pears – off the trees. Hardly had we begun to do this when Colonel Caton Jones, the A.D.M.S., came into the orchard. He did not see that the officers were eating the fruit but he saw some of the men doing so, and he immediately made a great fuss, berated the men unmercifully, and shouted at the top of his voice 'Don't you know the Duke of Wellington had men shot in the Peninsular War for less than this!' Just at this point one of the officers, I forgot which, came forward and told the A.D.M.S. that the owner of the orchard had given free permission for the troops to take his fruit.[62]

Displaced Belgian and French civilians continued travelling south along the roads being used by the

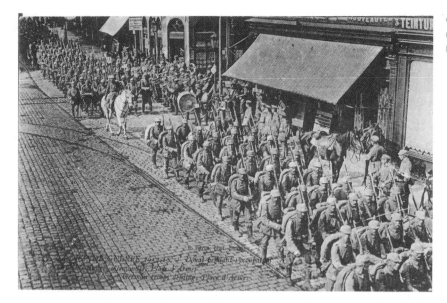

German troops march through Douai. (Author)

BEF. The old struggled along these paths, as did young mothers carrying children. Private Joe Cassells, a scout from the 1st Black Watch, summed up the feelings of those on the retreat from Mons:

> In this exhausted state we began the furious fatal struggle against an overwhelming and irresistible enemy which is known in history as the Retreat from Mons. Of that fearful time, I have lost track of dates. I do not want to remember them. All I recollect is that, under a blazing August sun – our mouths caked, our tongues parched – day after day we dragged ourselves along, always fighting rear-guard actions, our feet bleeding, our backs breaking, our hearts sore. Our unmounted officers limped amongst us, blood oozing through their spats.[63]

In 14 days, the Duke of Cornwall's Light Infantry had marched 240 miles. The 1st Rifle Brigade had covered 156 miles. All battalions from the BEF had marched similar long distances without rest. They had fired their fifteen rounds per minute at the advancing enemy, fusillades that would only hold back the huge German Army for enough time for them to withdraw under a hail of artillery fire. They would then be expected to march 20 miles, and if they were fortunate were given three hours to get some sleep before they started the whole process again. Despite the chaos and confusion of the retreat and lack of food, somehow ammunition supplies were maintained.

The retreat from Mons demonstrated the strength of spirit and determination of the soldiers of the BEF. Sergeant C.S.A. Avis from the 1st Queen's (Royal West Surrey) Regiment wrote:

> During the retreat from Mons the Battalion marched some 200 or so miles in 13 days, nearly exhausted, always short of food and sleep; but never demoralised. We often heard the sound of guns, sometimes near and sometimes far away.[64]

Some dejected soldiers yearned for a way out. Private F.G. Pattenden wrote in his diary on Sunday 30 August:

> Written in neighbourhood of Mont du Tracy. This is supposed to be God's day of rest and we have been marching since 5am. We had three hours sleep and are now just going to have breakfast, we are still retiring. My God it is heart breaking this weary slog, slog on the roads. Peace or even a wound would be better. We are all done up, heart sick and weary ... We hope to advance tomorrow for retiring is sickening for all. My feet are jolly bad and I can hardly walk.[65]

In some instances units from the BEF became surrounded by advancing German forces and had to fight their way through the enemy to continue the retreat. On 1 September, the 1st Irish Guards found themselves in this predicament. Lieutenant Neville Woodroffe wrote:

> We have been trekking hard all these last days. Heat and dust terrible. We were in action the day before yesterday. We got in a wood with only the Coldstreams and were surrounded by Germans. The wood was very thick and the enemy was no more than 100 yards off sometimes. We lost considerably including nine officers, three of whom only can be accounted for.[66]

The chronicler of the Rifle Brigade's history would later comment that the stalemate of trench warfare after the Battle of the Aisne was a welcome relief after the weeks of marching and that when the mobile war ground to a halt, the officers and men of the BEF were so drained that they fell asleep in the shallow trenches they had just dug:

> This respite came none too soon. The excitement of the retreat and the subsequent advance had acted as a mental and bodily stimulus sufficient to overcome fatigue. But when the line stabilised and the routine of the trenches began, sheer weariness asserted itself. Officers and men found themselves unexpectedly dropping asleep – in the middle of a sentence, at meals and even standing up.[67]

Lieutenant-Colonel John Ponsonby leading the 1st Coldstream Guards felt demoralised by the relentless withdrawal. 'This perpetual retirement seems to knock the heart out of us all, and we all hope it may soon come to an end.'[68]

France was in a state of crisis as the retreat continued towards Paris. The French Government had left the French capital. By 1 September Field Marshal French had lost his resolve to the extent that he was considering withdrawing the BEF from the line to St Nazaire in order to allow it to rest and replenish. They had been caught by surprise and at that time French, fearful that the Channel Ports would be captured by German forces, also considered withdrawing to St Nazaire to ensure the BEF could be evacuated to England if necessary. Kitchener dashed to Paris to prevent French from withdrawing the BEF from the line. Kitchener, wearing the uniform of a Field Marshal, summoned French to a meeting at the British Embassy in Paris, where he emphasised that the situation for the BEF was determined by the fate of the French armies. Kitchener ordered French to keep his troops in the line, and from that point to take orders from General Joffre and to move in alignment with the

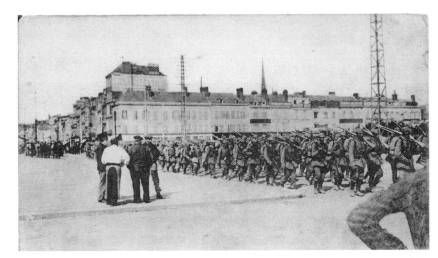

The Germans enter Amiens, 31 August 1914. (Author)

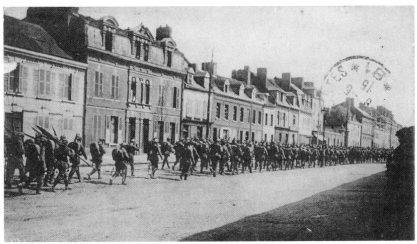

French Army. The German First Army was positioned east of Paris and approaching the French capital. General Manoury's French 6th Army was in position to meet them. Despite General Lanrezac inflicting a bloody setback upon the Germans at Guise on 29 August and securing a local French victory, General Joffre was not impressed with the performance of General Lanrezac during the first weeks of the war and dismissed him as commander of the French 5th Army, appointing General Franchet d'Esperey as a replacement. General Lanzerac had interpreted orders given by Joffre in his own way and it seems that Lanrezac and Joffre were not on good terms, so his dismissal may have been based on personal differences and not professional ability.

The Germans had penetrated deep into France, but they would become victims of their own success. By early September 1914, soldiers of the German Imperial Army were exhausted in their pursuit of the BEF and French troops. General Alexander von Kluck's German 1st Army was marching at a rate of between 20 to 25 miles each day and the farther they advanced the farther they stretched their lines of supply. Without regular supplies they would be unable to continue the advance upon Paris or engage in battle.

Furthermore, the German advance through northern France had been so rapid that German cable companies were unable to keep pace with the advance and establish communication lines, which meant that German commanders were dependent upon travelling wireless stations considered unreliable for communication with frontline commanders. This would become the only means of communication between German General Headquarters and commanders in the field. This meant that orders issued by GHQ, which had been moved forward to German-occupied Luxembourg, would take 5 to 6 hours to reach commanders in France. Staff in Luxembourg would be so far removed from the impending Battle of the Marne during September that it was difficult for them to assess the constantly changing operational situation and impossible to issue directives quickly.

There was also friction within the upper echelons of German command. The appointment of General von Moltke as Chief of General Staff, based on his name and not his capabilities, was not a popular decision and exasperated many German officers, including General Von Bülow, who was considered to be the most fitted commander for the role.

It was General von Kluck's initial intention to outflank the allied line and cut them off from Paris by advancing west of the French capital, forcing the BEF and French forces to continue to retire south towards the Swiss border. Instead of following orders from General Headquarters in Luxembourg and acting in accordance with the Schlieffen Plan, acting on his own initiative,

von Kluck ordered his army to advance east of Paris. This would prove to be a reckless strategy because von Kluck had exposed his right flank to the Army of Paris, which was comprised of the garrison of Paris commanded by General Joseph Gallieni, the military Governor of Paris, and the French 6th Army commanded by General Michel-Joseph Manoury. On 4 September, General Gallieni, realising that von Kluck was in a vulnerable position, went to Field Marshal French's headquarters to propose a joint attack upon the German 1st Army. French was not there when Gallieni rushed to his headquarters with the proposal, so the BEF continued to retire.

Sappers of the Royal Engineers worked to destroy bridges across the River Marne in an effort to delay the German advance. Lieutenant-Colonel Ponsonby wrote: 'The bridges over the Marne were blown up at 3.00am. Terrific explosions, but the iron bridge was not completely destroyed. Schrieber and Pritchard must have miscalculated the strength of it.'[69]

Within days, Major H.L. Pritchard from the 26th Field Company, Royal Engineers would be building pontoon bridges across the Marne, close to the bridges that he had previously destroyed, when the BEF turned around in pursuit of the Germans towards the river Aisne.

Some British soldiers now felt deceived by their officers and their confidence in their leadership had been seriously undermined by the events of the past two weeks. Private F.G. Pattenden wrote:

We are halted here by the roadside and have been since 12am, we don't know where we are or where we go, we are worse off than sheep. Written at 2.30pm in the town of Gretz-Armainvilliers after 9½ hours marching. We have once more been deceived. For a fortnight we have been fed on lies, lying tales buoying us up with false hopes as to mileage and results of battles. They have told us our marches have been strategical, all lies, it is nothing more or less than a complete retreat and for a fortnight we have had to flee, because we fear to be utterly outclassed and beaten and now if we are attacked what hopes do we have? We could not run a dozen yards and the result would be a bloody slaughter. Has the British public been told of our movements, of the disgraceful mistakes made by regiments, not much I guess? August 26th we began to retreat and have not finished yet, can flesh and blood stand this, no there is even a limit to human endurance and I have reached my limit and to go farther for a time I cannot. We are alone here in this place as reserves. I hope all will be safe.[70]

As the BEF continued to withdraw south, General Gallieni initiated his plan to attack General von Kluck's

right flank. He summoned every available French soldier to confront the invaders east of Paris close to the banks of the River Marne. Parisian taxicabs brought about 6000 French soldiers from the French capital to the frontline, such was the urgency of the situation. This was a battle not only to defend the French capital, but a battle to save France. General Maunoury's French 6th Army advanced north of the River Marne towards the River Ourcq and engaged the German 1st Army between St Souplet and Meaux. This attack took place 20 miles north west of the BEF's position.

Manoury stopped von Kluck's advance upon Paris. The German 1st Army were within 25 miles of the city when General von Kluck decided that he could go no further, halted and began to withdraw north. He feared that his lines of communication would be severed. This gave Joffre an opportunity to go on the offensive. 5 September 1914 was a turning point in the campaign for on this day Joffre gave the order to advance north and pursue the fleeing enemy. Field Marshal Sir John French in turn ordered the BEF to advance. At 7.00pm on the same day II Corps Headquarters directed that 'The British Army will advance against the enemy tomorrow.'[71] The BEF could only harass the fleeing German forces across the Grand Morin, then across the Petit Morin, then across the River Marne and the Ourcq. They were unable to draw the enemy into a confrontation, because the Germans had no intention of fighting.

The BEF had been told that they were marching to a place where they could rest. During the early hours of 6 September when the order to advance was conveyed to the ranks, these exhausted soldiers were nevertheless willing to forego the chance of rest and welcomed the chance to do what they were trained to do. The battalion war diary of the 1st Rifle Brigade commented that 'it was a very pleasant surprise to find ourselves facing north again.'[72]

The Battle of the Marne (6–12 September) consisted of a fearsome artillery duel between French and German guns. It confounded the German's audacious aspiration to capture Paris within six weeks of implementing the Schlieffen Plan.

On the 6th the 1st Duke of Cornwall's Light Infantry drew stores and reorganised with a draft of reinforcements. At 8.00am they began to advance north. The move to the river Aisne had now begun. Captain Arthur Nugent Acland, Adjutant, recalled feelings of elation:

... at 8am on 6th September – (Sunday) we got the short but very welcome order: – 'Army is advancing. Be prepared to move at a moment's notice.' We moved almost at once. I think all the weariness left us; it was such a joy to know that

we were going to push our late pursuers back over their own footsteps! Perhaps what pleased us most was that these Germans were now going to suffer exceedingly for the way in which they had burnt and pillaged on their way south. We had hardly ever held an outpost position, or formed a rearguard without having had the hours of darkness lighted by the volume of flames issuing from one of the huge close-stacked hay and straw barns, or from some of the perfectly kept farm buildings which the savages (called generally 'Uhlans') had delighted in setting alight. It seemed to be their invariable practice. Perhaps they thought that their entry into Paris was a foregone conclusion and that they would never have need of the fodder and food they destroyed. Whatever their idea, now that they began to move back – I say 'move' – but it was a very rapid move – along their own tracks, they must have felt the result of their earlier practices very severely. This knowledge pleased us not a little and we set out northwards full of spirits.[73]

Another officer from the 1st Duke of Cornwall's Light Infantry wrote:

The difference was wonderful in the way that it affected the spirits of officers and men: of course we were so sceptical about everything by then that it took us several miles to really believe that we were advancing.[74]

Field Marshal French issued the following Special Order of the Day:

After a most trying series of operations, mostly in retirement, which have been rendered necessary by the general strategical plan of the Allied Armies, the British forces stand today, formed in line with their French comrades, ready to attack the enemy.

Foiled in their attempt to invest Paris, the Germans have been driven to move in an easterly and south-easterly direction with the intention of falling in strength on the Fifth French Army. In this operation they are exposing their right flank and their line of communication to an attack from the combined Sixth French Army and the British forces.

I call upon the British Army in France to now show the enemy its power and to push on vigorously to the attack beside the Sixth French Army. I am sure I shall not call upon them in vain, but that, on the contrary, by another manifestation of the magnificent spirit which they have shown in the past fortnight, they will fall on the enemy's flank with all their strength and, in unison with their Allies, drive them back.[75]

On 7 September French issued orders that on the following day the BEF was to establish a foothold across the Petit Morin, the Grand Morin and the River Marne and then advance from the Marne from Nogent L'Artaud to La Ferté-Sous-Jouarre. They would advance in between the French 5th Army on their right and the French 6th Army on their left flank. The French 6th Army was ordered by Joffre to advance towards the north west of Ourcq. The French 5th Army would move forward on the right flank supported by the French 9th Army. On 8 September General Louis Franchet d'Esperey's French 5th Army launched an attack upon von Kluck's 1st German Army at the Marne and he was supported on his right flank by General Foch's newly formed 9th French Army.

The 2nd Royal Sussex Regiment was a mere 20 miles from Paris on 6 September. Private Harland of the battalion regarded this date as a crossroads in the 1914 campaign: 'We began to advance. We were glad enough to advance and do the attacking ourselves but we fairly got in the thick of it'.[76] The 1st King's Royal Rifle Corps engaged German forces in a savage battle at Firoy. Corporal J. Jolley recalled:

> Instead of retiring as we had been doing on 5th Sept. we advanced five miles to Firoy. There was very fierce fighting, the German infantry advancing to within 800 yards of our artillery, and also in good rifle range. They were practically slaughtered and hundreds of dead lay everywhere. Early in the morning of the 6th we were up and on the scent, the Guards being the advance guard for a change. Towards the afternoon they got in touch with the German rearguard at a place called by us and the Germans 'The Valley of Death'. All the artillery possible was brought onto the ridge overlooking this valley, and played on the enemy, who could not get out of it in a hurry, and consequently got many casualties, the Guards capturing eighty men and five Maxims, and losing only twelve men. We kept on going until we reached the heights overlooking Charly-sur-Marne. Here we took up a post about two miles from the enemy without knowing it.[77]

The Battle of the Marne was the first action for some men of the BEF, including Private Hey from the 1st King's (Liverpool) Regiment:

> When an Army is retreating they leave behind what is called a rearguard, and it is the duty of these men to stop the enemy from overtaking the main body. Whilst our rearguard was doing this we set off towards Paris. After 2 days and nights marching, only stopping now and then for a rest we arrived

at the River Marne 15 miles north of Paris ... no time was wasted but picks and shovels were handed out and we started navvying or trenching and we worked for 30 hours without cessation and then we manned. At dawn the following morning, the fun, or the slaughter, began, it was nothing else. That battle in my estimation was the decisive battle in the whole war. The Kaiser was so sure of entering Paris he had 10,000 Prussian guards ready to march in with their favourite goosestep but after the Marne we had a good reason to know that these big fellows were manning their trenches. That battle was a case of those who could stand shell fire best won, and we won. That was my first experience of the deadly accuracy of their artillery, in my opinion they are perfect. It made a ghastly picture, men blown to pieces, men with terrible wounds asking for water and moaning, horses neighing and stampeding and the crack of thousands of rifles along with the Maxims and the roar of the artillery. The memory will remain as long as I live. The Scots Greys made one of the most brilliant charges that cavalry have ever made and it was owing to this charge that we got the Germans on the retreat. We managed to attend to our own wounded and bury our dead. The sight of the unfortunate fellows nearly drove me silly but after a time I got indifferent and could bury a dead soldier like an old veteran.[78]

Near the village of Bellot the 1st Black Watch came into contact with French cavalry on the 8th. Captain Axel Douglas Campbell Krook wrote: 'They were dressed as at the time of Waterloo, the cuirassiers in dark blue, with cuirasse, and plumed steel helmets or casques – the Hussars in sky blue tunics and red breeches – a wonderful sight'.[79] This French cavalry unit advised Captain Krook of a German presence in woods close to the village at Bellot. Krook recalled:

> This cavalry reported a battalion of German Guards in the woods ahead, and would not move until they were cleared out – would not even move round the woods to cut them off when we drove them out – so we went through the village, and found the walls spattered with blood, showing that there had already been some fighting.
>
> 'B' Company went to the left with 'C' in support – and 'D' and 'A' to the right. We went right through dense wood, and up hill, and found no one, but heard firing on our left as we got out into the open on top of the hill, we extended and lay down overlooking the wood – soon, the Germans came running out, being driven by 'B' and 'C' Companies, and we caught them running out; two or three went down at once, and the others went back into

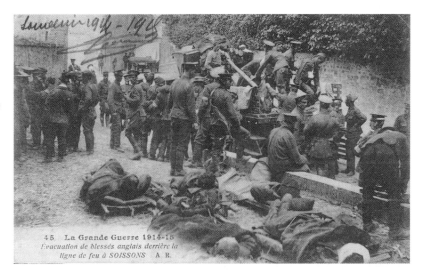

45 La Grande Guerre 1914-15
Évacuation de blessés anglais derrière la
ligne de feu à SOISSONS A R.

the wood, when we were told to go and aid 'B' Company; on the way we came across a party of about ten Germans who surrendered at once – all Guards Jager battalion.[80]

The 2nd Connaught Rangers were north of Pézarches. Sergeant John McIlwain:

Hurried off at 7.30am. No doubt of the confusion and disorder of the Germans. They leave rifles, ammunition, rations, broken down guns and wagons behind. About 11am we pressed forward into the zone of rifle fire for the first time since Mons. We got into skirmishing order in a wood. The Germans seem to be making a skilful rearguard fight. We learned later on how stubbornly they could do this. Some of our companies go forward to root the enemy out of their shelters amongst the trees; but our company lies down behind the artillery who are shelling the main body of Germans falling back. In the afternoon we advanced to the left of the position. In the military sense things are looking ship shape again. Somehow, our brigade had come together again and co-ordination under a proper command is reported to be taking place. We have joined with the 4th Guards Brigade. This we learned after is the Battle of the Marne. This day I saw my first dead German. He was lying sprawled in a wheelbarrow with his head hanging grotesquely sideways. He was packed like a sausage tightly in his grey uniform. Some other German prisoners there were, in charge of the Guards; some were wounded, all showing signs of great hardship. We exchanged a few shots with Germans we could not see. But we were pointed out the correct targets for the positions. It got too hot for the few Germans left as

sacrifice by the main body, at a certain stage these few surrendered.[81]

As the 2nd Connaught Rangers passed northwards through Charly-sur-Marne on 9 September they found graffiti on the walls written by German soldiers in English confidently proclaiming. 'We will dance the tango in Paris on September 13th.'[82]

Major C.L. Brereton led the 68th Battery, 14th Brigade, Royal Field Artillery into action during the Battle of the Marne on 9 September. The German infantry were now on the run and the guns of the 68th Battery positioned close to Signy-Signets were shelling them. Brereton came to the conclusion that 'it was rather nice shelling when you are not being shelled yourself'.[83] Later that day Brereton was ordered to La Ferté to destroy a house. While there he met members of staff and was not convinced that they knew what they were doing:

Found General Hunter-Weston and staff just having some tea in which I joined. The General told me that they we were going to cross the Marne at 6.30pm and wanted all the artillery support that he could get. Told him I only had one section of the artillery back by that time. Struck me he hardly knew what he was talking about.[84]

The 68th Battery had gone back and forth and travelled twelve miles on 9 September. The horses that pulled the gun carriages were exhausted, shoeless and lame. After a brief rest during that night the 68th Battery rose at dawn and crossed the River Marne by a railway bridge which had not been destroyed. Major Brereton recalled the crossing of the River Marne and how they continued to pursue the enemy northwards under an intense sun.

This is a long bridge and rattling over the railway sleepers very heavy work. Our horses were very exhausted when we got to the main road the other side. We marched all day in great heat, and without getting any water for our horses. The whole road was strewn with remains of German camps etc. and the smell intolerable.[85]

The 68th Battery experienced another tough day on the 10th, not helped by the fact that their own staff had directed them to the wrong village. Major Brereton is critical of the Staff Officers that were leading the advance. He had every reason to be critical, the officers, men and horses of the 68th Battery had travelled far that day and were in dire need of food and sleep. They were being pushed to the extreme limits of their endurance without significant support or supplies:

About 6.00pm we halted at a small place called Certgny. The facilities for watering were very scanty, and it was well after dark before we got back to our lines to find that, owing to a mistake on the part of the Staff, we had been sent to the wrong place; and had to move at once to Coulombs. We got there about 9.00pm to find the place blocked with French troops, transport etc. It was about 1.00am before we finally reached our bivouac. It was quite evident that the French had had a terrible battle, as there were dressing stations and doctors hard at work everywhere. Heard a report that they had 10,000 casualties. Very tired we lay down without baggage or supplies as usual, and only just what little food we had managed to bring along with us. We had gone about 12 miles since morning.[86]

The 2nd Royal Sussex Regiment fought a tough battle at Preiz on 10 September. They were wearing grey waterproof sheets and British artillery observers mistook them for German soldiers and ordered a barrage on their position. B Company were within 750 yards of German positions when they were shelled by their own guns. German soldiers opened fire at the same time and the remnants of the battalion were forced to withdraw. Private Harland recalled that 'for a time it was hell.'[87] The battalion lost 14 men killed and 85 wounded.

Sergeant Thomas Painting describes the action on the 10th at Hautesvesnes against a German Jager Battalion. The 1st King's Royal Rifles Corps advanced across 1500 yards of open ground to overwhelm the enemy.

When we got to 200 yards of them my company went in with the bayonet. We were flanking them and Jerry put white flags up and surrendered. We said after we roped them up and disarmed them,

'Why did you surrender?' Their casualties were about 180 and we took 450 prisoners. We had 12 killed and 60 wounded. So we said to them 'Why did you pack up while you had so much ammunition?' They said 'Your fire was so accurate; we could not put our heads up to shoot at you.'[88]

The 1st King's Royal Rifle Corps were outnumbered and out machine-gunned by their opponents at Hautesvesnes. Painting attributed their success, which he described as 'a set piece operation', to training. They adopted the 'fire and movement' tactic which was drilled into them during basic training. 'You put as much fire into them as you could.'[89]

The Battle of the Marne claimed some high ranking officers amongst the British casualties including Brigadier-General Neil Findlay, commanding 1st Division, who was killed by shrapnel. Findlay is buried today at Vailly British Cemetery, near Chemin des Dames. Lieutenant-Colonel Guy Knight commanding the 1st Loyal North Lancashire Regiment was also killed.

As the Battle of the Marne was drawing to a conclusion, Field Marshal French received the following order from French General Headquarters at Châtillon sur Marne:

The German forces are giving way on the Marne and in Champagne before the Allied Armies of the centre and left wing. To confirm and take advantage of this success, it is necessary to follow up this movement with energy so as to allow the enemy no rest. The offensive movement will, therefore, be continued along the whole front in a general north–north-east direction.[90]

By 10 September the German 1st and 2nd Armies were in danger of being encircled. The Schlieffen Plan had collapsed. General von Moltke had suffered a mental breakdown as a consequence of his failure to capture Paris. His subordinate generals took command of the situation and ordered a retreat to the Aisne valley. The principal reason for the failure of the Schlieffen Plan was that German commanders had made grave miscalculations when planning the assault and had made insufficient provision for the resupply and replenishment of the fast advancing troops. They overstretched their lines of supply.

As well as feeding the men, the horses that accompanied these armies had to be fed too. General Alexander von Kluck's 1st Army advancing on the right flank of the German invasion had 84,000 horses, which required one million tons of fodder each day, all (or most) to be brought up the line. Like their counterparts in the BEF and the French Army, the men of the German Imperial Army were exhausted and hungry. If they had

The dead of the Battle of the Marne. (Author)

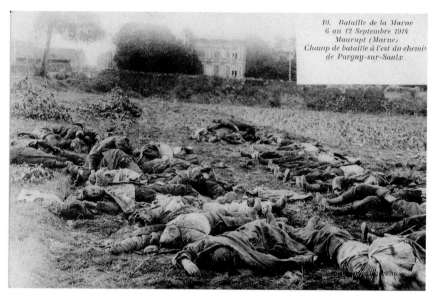

*10. Bataille de la Marne
6 au 12 Septembre 1914
Maurupt (Marne)
Champ de bataille à l'est du chemin
de Pargny-sur-Saulx*

reached Paris it is very doubtful that they would have had the energy, resources and supplies to fight a battle to capture and hold the French capital.

On 10 September, Lieutenant-Colonel Hentsch arrived at General von Kluck's First Army Headquarters at Mareuil with pessimistic reports on the current situation and orders to withdraw from German General Headquarters in Luxembourg. *Generalmajor* Baumgarten-Crusius described details of this important meeting:

> Lieut-Colonel Hentsch brought the following information: The general situation is not favourable. The Fifth Army is held up in front of Verdun, and the Sixth and Seventh Army in front of the line Nancy–Epinall. The Second Army has gone to pieces, and the retreat behind the Marne cannot be checked. The right wing of the Second Army has been forced back and has not retired voluntarily. It is therefore necessary to withdraw the whole line immediately, the Third Army to the north of Châlons, and the Fourth and Fifth Armies, through around Clermont in Argonne, towards Verdun. The First Army must therefore also retire, in the direction Soissons–Fère en Tardenois and, if necessary, farther, even to a line Laon–La Fère. He drew the lines the Armies were to take up with a bit of carbon on the map of the Chief of Staff of the First Army, General Hermann Von Kuhl. At St Quentin, he added, a new Army was being formed, so that a fresh campaign could be begun.[91]

This is an important testimony, which shows that German High Command was then considering pulling

General von Kluck's First Army farther beyond the river Aisne and the Chemin des Dames, to Laon. The order to withdraw would prove to be a logistical nightmare for von Kluck.

The French Army had suffered heavy casualties, but the Battle of the Marne was a turning point for the allies. French and Joffre were confident that they would drive the Germans from French soil. Field Marshal French wrote: 'We fully believed we were driving the Germans back to the Meuse if not the Rhine, and all my correspondence at this time with Joffre and the French generals most closely associated with me, breathed the same spirit.'[92]

An offensive thrust to achieve that objective, across destroyed coutryside, when soldiers from the French Army and the BEF were drained, would not be so easy – whatever the 'spirit' breathed by the commanders. Captain Charles Paterson, Adjutant for the 1st South Wales Borderers:

> All the villages are broken and signs of the retreating enemy are met with everywhere. Dead horses, graves, etc, etc. Nasty sights. An occasional hole where a shell has dropped with perhaps some blood about it. Ugh. There is a certain amount of fighting with our advance guards and the Germans, and we see ambulances coming back full of wounded. However, one is accustomed to such sights.[93]

German forces fought over every inch of ground as they withdrew from the Marne. German units were positioned in strategic positions to put up rearguard defences. Machine-gun positions were concealed in farm buildings and haystacks in the fields.

The pursuing Allies were confronted by atrocities and sabotage inflicted by the invading army upon the French villages and its inhabitants. Private Heys:

> After the Battle of the Marne it was the Germans turn to retreat and we all appreciated being top dog for the first time since the war began. As the Germans retreated they looted almost every village they came to and poisoned the wells and the atrocities they committed were terrible, too terrible to mention. It was a terrible march from the Marne, nearly always raining and we had to sleep on the road or in the field, it just depended where we were, all this was intermixed with very frequent skirmishes with the German rearguard.[94]

German forces also poisoned food supplies such as grapes. The British soldiers were thirsty and to pick grapes along the roads was tempting. Private Joe Cassells, a scout from the 1st Black Watch wrote:

> Discipline in the British Army is second to none; and we were commanded to observe it strictly while on the retreat. One of our orders was not 'to pluck fruit', as it came under the category of 'Looting'. Very soon the few fellows who disobeyed that order were rolling on the ground, holding their stomachs. Later we were told that the grapes on both sides of the road had been poisoned by the Germans. This was punishment enough for those who had eaten the fruit, and a lesson that every one of us 'took home'.[95]

There was a lack of communication and coordination amongst allied staff officers. There was no provision for the soldiers to rest or to ensure that they received food and water supplies. Staff officers were rousing their men in the early hours of the morning after a couple of hours sleep, but then were unable to move because of the congested roads. There was a lack of co-ordination between French and BEF commanders and clearly there was evidence of poor planning and organisation amongst the staff officers of the BEF. Major C.L. Brereton:

> We were roused at 3.00am but did not move till about 5.30am. How we wished the Staff would take the trouble to work out time and space problems. Had a longish halt in the middle of the morning and then continued our way along evil smelling roads till we again got blocked by the French somewhere near Dommiers. Our Division and a French Division were apparently allotted the same road.[96]

As they advanced north towards the Aisne, the horses from the 68th Battery were now shoeless and the artillery crews had to take shoes from dead German horses that were lying along the road.

11 September saw a break in the hot weather. It began to rain heavily. As mentioned earlier, during the retreat many of the BEF had been ordered to discard their overcoats. Major C.L. Brereton later remembered:

> Just then the weather changed, and it started to pour and turned quite cold. We had a most miserable march through Billy-sur-Ourcq to Le Plessier-Huleu. Met Nugent of the Rifle Brigade. He told me that not one of them had got an overcoat or anything to keep the rain out as they had thrown away all their kit at Voyennes. Told him I would give him a coat if I ever saw my baggage again, as I had one spare.[97]

It is apparent that Major Brereton had no confidence in the leadership and command decisions of his superior staff officers. During that night the officers and men from the 68th Battery would suffer from the lack of organisational skills displayed by their commanders. Brereton recalled a conversation that he had during the night of 11 September:

> Then passing through Le Plessier-Huleu I said to Jones Bateman, with whom I was riding, 'I bet you anything they send us to the wrong place again tonight'. Sure enough, we soon after got the order – just in the narrowest part of the road – to reverse and return to the town. Pitch dark by the time we got to bivouac. No water for horses, and it rained all night. We had come another 16 miles and had had no rations or forage since leaving the Marne. Our emergency rations were eaten, and we were just managing to collect odds and ends.[98]

General von Kluck's command of the retreat to the Aisne was a great logistical achievement. He got his 1st Army across the Marne and turned them about 180 degrees to head north. This great mass of soldiers, whose units had become intermingled after two days of battle, arrived at the river Aisne switched from right to left from the order they crossed it the week before.

It was here that German commanders had prepared a defensive line where they could utilise the high ridges, woods, quarries and caves. German companies owned several quarries based in the river Aisne and passed on details of the terrain and the potential to militarise the region prior to the war. After the Aisne September battle they were able to establish step by step a defensive position consisting of trenches and gun emplacements. However, following the retreat from the River Marne the Germans were on the run and the units ordered to hold the ground north of

the Aisne did what they could with what they had, or what they found in farms or villages. They dug shallow trenches and made use of requisitioned furniture to erect barricades.

The German strategy was to permit the Allied armies to pursue them to the Aisne valley and allow them a small foothold across the Aisne, then deliver a decisive counter attack; after which, Paris and victory.

Guns from the siege at Maubeuge, heavy howitzers of calibres 8 inch, 11 inch and 12 inch were sent to the Aisne, bolstering German artillery and giving them a numerical advantage over the British and French guns. They were positioned amongst the wooded ridges along the Chemin des Dames north of the river, ready and waiting for the BEF and French forces to come within range.

NOTES

1. IWM 77/179/1: Captain Hubert Rees, 2nd Welsh Regiment
2. Bolwell, F.A., *With a Reservist in France* (E.P. Dutton & Co., 1917)
3. IWM 553796/29/1: Sergeant John McIlwain, 2nd Connaught Rangers
4. Edmonds, Brigadier-General J.E., *The Official History of the War Military Operations: France & Belgium 1914* Volume 1 (Macmillan & Co, 1933)
5. Bolwell
6. IWM 87/26/1: Sergeant David Lloyd-Burch, No.10 Field Ambulance, 4th Division
7. IWM 553796/29/1
8. IWM 87/26/1
9. IWM MISC 223 (3210): Private Heys, 1st King's (Liverpool) Regiment
10. *Rushden Echo*, 9 October 1914
11. IWM 77/179/1
12. Lieutenant-Colonel John Ponsonby's Diary, Regimental Headquarters Coldstream Guards Archives
13. IWM 84/58/1: Sergeant C.S.A. Avis, 1st The Queen's (Royal West Surrey) Regiment
14. National Archives: WO 95/1269: 2nd Royal Sussex Regiment War Diary
15. Bolwell
16. National Archives: WO 95/1495: 1st Hampshire Regiment War Diary
17. *Rushden Echo*, 9 October 1914
18. IWM 81/14/1: Sergeant Arthur Lane, 2nd Coldstream Guards
19. Ibid
20. National Archives: Field Marshal Sir John French's communication with Lord Kitchener PRO 30/57/49
21. Lieutenant-Colonel John Ponsonby's Diary, Regimental Heaquarters Coldstream Guards archives
22. WO 95/1422, 4th Middlesex Regiment War Diary
23. IWM: Sound Archives Reference 9339: Interview with Private William Holbrook, 4th Royal Fusiliers
24. Ibid
25. Ibid
26. WO 95/1422: 4th Middlesex Regiment War diary
27. *Brighton Herald*, 26 September 1914
28. IWM 553796/29/1
29. Ibid
30. IWM 81/14/1
31. Liddle Collection: tape 165: Private John Cowe, Coldstream Guards
32. Bolwell
33. IWM 84/58/1
34. Bolwell
35. WO 95/1495
36. National Archives: PRO 30/57/49
37. Ibid
38. IWM 84/58/1
39. Liddle Collection: interview 66/92: Lieutenant N.H. Huttenbach: 41st Brigade, Royal Field Artillery
40. Ibid
41. IWM P278: Sergeant W.J. Cook, 2nd Coldstream Guards
42. Ibid
43. IWM 86/30/1: Major C.L. Brereton, 68th Battery, 14th Brigade, Royal Field Artillery
44. Gough, General Sir Hubert, *Soldiering On* (Arthur Baker, 1954)
45. Ibid
46. IWM Con Shelf: Captain A.H. Habgood, 9th Field Ambulance, 3rd Division
47. IWM 553796/29/1
48. Ibid
49. IWM 84/58/1
50. IWM 553796/29/1
51. Ibid
52. Ibid
53. IWM 84/58/1
54. WO 95/1345: 2nd Oxford & Buckinghamshire War Diary
55. National Archives: PRO 30/57/49
56. WO 95/1345
57. IWM 77/179/1
58. IWM 553796/29/1
59. WO 95/1345
60. Liddle Collection: interview tapes 599 and 600, 2nd Lieutenant C.A.B. Young, 2nd Welsh Regiment.
61. WO 95/1270: 1st Loyal North Lancashire Regiment War Diary
62. WO 95/1407: 8th Field Ambulance War Diary
63. Cassells, Scout Joe, *The Black Watch: A Record in Action* (1918, republished by BiblioBazaar, 2009)
64. IWM 84/58/1
65 WO 95/1495
66. IWM 95/35/1: Lieutenant Neville Woodroffe, 1st Irish Guards

67. Berkeley, R., *The History of the Rifle Brigade 1914–1918* (The Rifle Brigade Club, 1927)

68. Lieutenant-Colonel John Ponsonby's Diary

69. Ibid

70. WO 95/1495

71. Wyrall, E., *The History of the Duke of Cornwall's Light Infantry 1914–1919* (1932, republished by Naval & Military Press, 2004)

72. Berkeley

73. Captain Arthur Nugent Acland's diary: Courtesy Cornwall's Regimental Museum

74. Wyrall

75. Edmonds

76. *Brighton Herald*, 26 September 1914

77. De Ruvigny, Marquis, *De Ruvigny's Roll of Honour, 1914–1918* (1922, republished by Naval & Military Press, 2007)

78 IWM MISC 223 (3210)

79. Krook, Captain Axel, *1st Black Watch Memoirs* (Black Watch Museum)

80. Ibid

81. IWM 553796/29/1

82. Ibid

83. IWM 86/30/1

84. Ibid

85. Ibid

86. Ibid

87. *Brighton Herald*, 26 September 1914

88. IWM Sound Archive: Interview Thomas Painting, 1st King's Royal Rifles Corps

89. Ibid

90. French, Field Marshal Viscount, *1914* (Houghton Mifflin Company, 1919)

91. Baumgarten-Crusius, Generalmajor Artur, *Die Marneschlacht 1914* (1919, republished by Kessinger Publishing, 2010)

92 French

93. WO 95/1250: 1st South Wales Borderers War Diary

94. IWM MISC 223 (3210)

95. Cassells, *op cit*

96. IWM 86/30/1

97. Ibid

98. Ibid

ARRIVAL AT THE RIVER AISNE

Low cloud and heavy rain during the morning of 12 September had prevented the Royal Flying Corps from taking to the air, which meant no aerial reconnaissance of the retreating German forces assembling in the Aisne valley, nor could they search for German divisions advancing from the north. Allied commanders were aware of the possibility that German forces might hold a defensive line along the Aisne, but were uncertain of the strength of the defence and whether it was a temporary rearguard or something more permanent.

The Rifle Brigade chronicler reported that 'Throughout the 12th there were abundant signs of the haste with which the enemy was retreating. On all sides were abandoned wagons, abandoned equipment and, in some places, even freshly killed meat.'[1]

The 1st Bedfordshire Regiment had escorted a group of German prisoners of war to Hartennes, many of whom could speak good English. One of those German prisoners knew his English captor very well and had worked with him prior to the war in the Old Kent Road in London. Another German captive recognised a General who had once served as a waiter in a London Hotel.

The 50 miles advance by the BEF from the Marne halted at the Aisne and a series of heights known as the Chemin des Dames. The Chemin des Dames or 'the ladies way' was the name of the road that runs from Soisson to Laons. It ran along the ridge and was named after the daughters of King Louis XV, who ordered its construction to make the journey more comfortable between Compiegne and the Chateau de la Bove.

The Aisne valley was two miles across, through which the river Aisne flowed. The heavy rain that fell that September had swollen the river. Both sides of the valley were protected by high ridges, ravines and woodlands. The Aisne valley was located between Rheims in the east and Soisson in the west. The terrain was comprised of a series of high spurs and ridges that descended from the Chemin des Dames ridge projecting south towards the river. In the east, the Paissy-Pargnan and Bourg Spurs, with the village of Moulins sandwiched between them at the top of the valley, extended close to the Aisne. Moving west, the village of Vendresse was sandwiched between the Vendresse Spur in the east and Beaulne and Chivy Spurs to the west. Farther west were three spurs, Moussy, Soupir and Chavonne.

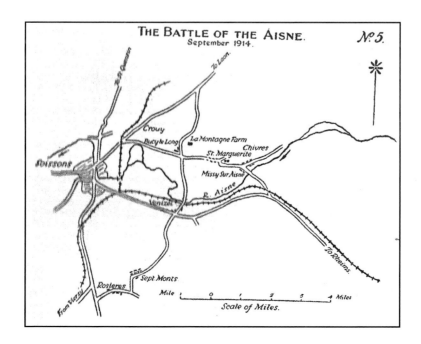

During 12 September, German forces assembled along the northern heights overlooking the valley. They were exhausted by the time they arrived and did not have enough material or men to construct deep trenches. They were limited to digging shallow trenches and placing machine guns in concealed positions. In 1915/16 the shallow trenches would be strengthened and incorporated within the natural features of the terrain and the heights along the Chemin des Dames turned into a formidable fortress. The first Battle of the Aisne would bring the war of movement to a dramatic end. The BEF and French Army would learn during September 1914 how futile it was to attack an enemy securely entrenched on a high position.

Before the BEF reached the southern banks of the river they had to cross the river Vesle and would fight further engagements. During the morning of 12 September patrols from the 1st Cavalry Brigade were ordered to capture the village of Braine on the banks of the river Vesle, which was strategically important because the only road running to Missy on the northern bank of the river Aisne ran through it. The river Vesle ran north west to join the river Aisne at Condé. A German infantry battalion had fortified the village with barricades and knocked holes in the walls of the houses so that they could have easy access through the village. They also had possession of the bridge that crossed the river Vesle at Braine. The 1st Cavalry Brigade had advanced from Cerseuil and on reaching the edge of the valley, all three regiments dismounted leaving their horses on high ground and proceeded to launch their attack on the village on foot. Launching their attack at 11.00am, they were met with strong German resistance and sustained casualties, including Captain George Springfield, serving with the 2nd Dragoon Guards (Queen's Bays), who was killed. Bitter house-to-house fighting ensued for two hours.

As the battle for Braine was being fought, the 1st Division was closing in on Bazoches and its bridge and the 5th Brigade from the 2nd Division drove an advance to Courcelles. At 1.30pm the Worcestershires and Oxfordshire Light Infantry pressed ahead to capture Monthussart Farm 1 mile north east of Braine. At that time the 9th Infantry Brigade was leading the 3rd Division thrust upon Braine and was engaging with the enemy on the outskirts of the village, while elements of the 1st Cavalry Brigade succeeded in clearing the enemy from buildings within. With Braine in British hands, the 1st Cavalry Brigade secured the hill beyond and advanced along the road to Brenelle. The remnants of the German forces that had been forced from Braine were thus caught between fire from the 5th Dragoon Guards positioned on their western flank and from the Oxfordshire Light Infantry in the east. The retreating Germans had no choice but to surrender and 130

soldiers laid down their arms. Most of these captured men came from the 13th and 25th Landwehr Regiments, which were attached to the Second Army and had been rushed to the Aisne front.

On the 12th, the 1st Queen's Cameron Highlanders of the 1st Division were ordered to take out a German position south of the river Aisne. With bayonets fixed they charged towards the enemy trenches. An anonymous Cameron Highlander wrote:

> On Saturday afternoon, September 12th, my company of the Camerons was ordered to take up a position about half-a-mile from where the German artillery was posted. The shells were falling like rain, and we were posted in trenches which had been dug by the enemy, but vacated. We were without water for ten hours. Then came the order to fix bayonets and charge, which was a hard job, seeing that the trenches were 5 ft deep and stray bullets and bombs were making things lively. Anyhow, we fixed bayonets and clambered out, and we, being first out, somehow got together some kind of formation and rushed towards the hedge. All we could see were a few strange uniforms a quarter of a mile away. Away we went and one of our officers was bowled over straight away, whilst many on my right and left dropped out. We shouted out our slogan and went at them as fast we could. At last we arrived with a yell at the ditch where the German riflemen were concealed and they fired at us at point blank, but not one of us went down. Then we went at them with the steel, and the Germans, being 6 feet below us had no chance. When we had each 'done' our man we had to jump over the ditch and on towards the German guns. All of a sudden machine guns poured into us from both sides knocking dozens of us over in heaps. The officers gave the word to retire, and we came back at a run. When we came to the trench we had already jumped we found we had not killed all the Germans in it, and as we passed over it again we were shot at, and my pal was nearly bayoneted. We got back, and did not much good. We killed a few hundred Germans, it is true, but we lost 150 men! The Germans will do anything to get away from the cold steel.[2]

The Gordon Highlanders launched a further attack. A participant from the battalion wrote: 'After the charge of the Camerons we (the Gordons) rushed the German trenches and went for their guns. Many of the Germans actually went on their knees, and holding their hands together beseeched our lads not to kill them.'[3]

The 3rd Division advanced to Brenelle and the 5th Division passed through the village of Braine to Sermoise. On the right flank, the 1st and 2nd Divisions advanced to Courcelles and Vauxcéré.

The 4th Division was the first British division to engage German forces. They had crossed the River Ourcq without opposition and arrived at Buzancy during the morning of 12 September. Artillery from the 6th French Army was bombarding German positions occupying Mont de Paris, located south of Soissons. Brigadier-General Henry Wilson commanding the 4th Division ordered the divisional artillery to open fire in support of the French guns. An artillery duel was fought that resulted in German forces evacuating the town of Soissons. Before leaving they destroyed the bridge crossing the Aisne. Further eastwards along the Aisne valley the south side of the river was clear of German forces.

Conditions still prevented effectual aerial reconnaissance. The fall of Maubeuge on 7 September meant that the German VII Reserve Corps could rush south towards the river Aisne and support the German divisions that were falling back. From the prisoners captured the allies could see that the German Army on this front was in disarray after their defeat at the Marne, their organisation in a state of collapse, their units mixed and their morale severely battered. Joffre and French had no decision to make; the allies were to continue the pursuit and deny the enemy the opportunity to reorganise and establish a defensive position, which would buy time for them to regroup and fight another day. General Joffre's Special Instruction No.23 ordered the BEF to continue with the advance along with the French 5th and 6th Armies and to cross the Aisne. However, there was no indication of how far they could exploit their success at the Marne. The war diary of the 1st Bedfordshire Regiment reported 'roads a sea of mud'.[4]

With their soldiers exhausted, their supplies and ammunition running out, and their mobility significantly restricted by the muddy ground, the allied generals were unable to predict how far they could go. Joffre and French were unaware that German commanders were assembling their units and were fortifying their position along the Aisne valley.

The immediate problem for the BEF was to cross the Aisne. If the Germans had destroyed all the bridges in the Aisne valley then the advance would be severely hampered. French needed to know the state of the bridges. The bridge at Missy was important. Lieutenant James Pennycuik from the Royal Engineers volunteered to carry out a reconnaissance on a raft along the river. He confirmed that the bridge at Missy was completely destroyed. The bridge at Condé was intact, but German machine gunners were guarding the crossing. The Germans had in effect created a trap for the BEF. French and Dorrien-Smith deliberated over the risks and benefits of launching an assault upon Condé to capture the bridge and the village. They decided that they would leave the bridge alone.

At the BEF General Headquarters at Coulommiers, French issued an order at 7.45pm to continue the pursuit of the German Army across the Aisne the following day at 7.00am. I Corps and the Cavalry Division were ordered to cross at Bourg-et-Comin, Pont Arcy, Chavonne. II Corps, the 3rd and 5th Cavalry Brigades were allocated the crossing at Venizel. The objective was for the three British Corps to secure the line Lierval–Chavignon–Terny, which was five miles north of the river. The BEF was tasked with the capture of the road known as the Chemin des Dames and the plateau the road ran along. French was not aware that German units were in possession of the Chemin des Dames and were waiting for them.

Squadrons from the 1st Cavalry Division played an important role in reconnaissance and leading the vanguard of the BEF to the river Aisne. Private D.G. Holmes from the 15th (The King's) Hussars provides an interesting account of his experiences on patrol in the approach to the river. It is difficult to be sure which bridge and which section of the river Aisne he was writing about because A Squadron was attached to 3rd Division, B Squadron was attached to 2nd Division and C Squadron was assigned to 1st Division; he could have been referring to any of the crossings. Nonetheless, he provides a fascinating narrative of his experience. In a letter home to his minister in Melrose, Private D.G. Holmes wrote:

A section of us were taken out by our intelligence officer one afternoon to find our firing line and shown the position of the enemy, and also the Allies, and then he asked for a volunteer to go at night and try to get on a bridge which was held by the enemy. I volunteered, as I thought I could do it. We came back to our billets and at 10pm we started on our journey with the good wishes of our 'boys'. We rode about two miles, and, leaving our horses, four of us went onto our front line dismounted. I was unarmed, and without jacket and cap, as I expected I would perhaps have to swim. After the officer warning the officers commanding the firing line about our mission, we left the British lines, and had about a mile to go for the bridge. When we got to about 1000 yards from the bridge I set off by myself. I had to do a snake-crawl, and got on very well until 300 yards from the bridge, when I saw lying in my path a man (the time was about 12.30 and very dark). I thought he was a German sentry asleep and as the only thing I had was a small penknife, I opened it, and went very quietly forward to discover he was a chap of the 4th Hussars dead. I had to crawl over him, as the road was white, and the only other way round him was to get on the top of a small bank, where I would have been easily seen. The

next obstacle I encountered was a dead horse, which had been killed nine days before, as I afterwards learned. I had just got my hands on his back to crawl over him when up went one of the enemy's rockets which lit up the country for miles. I had to lie there for about twenty minutes, and a dead horse is not much of a chum. I got on pretty well after that, and could hear the Germans speaking. I got to within 25 yards of the bridge, when I saw it was impossible to get on it, as two sentries were walking about, and also some directly on my right. So I lay still for a while, and having obtained the information I wanted, got back to join my officer without incident. I volunteered to conduct him up again, so he gave the information to a sergeant, and I led him to about 10 yards from where I had been. On our right front the German sentry was standing, and he walked past us on the opposite side of the road, but never saw us. We lay there for about an hour, which seemed to me a month, with nine of the enemy within 20 yards. Eventually they retired, and we followed them up, but finally we retired and got back to our billets about 4am. I was complimented by my commanding officer on my work, as I got all the information which was wanted. The name of the officer was Lieutenant Cornwall of the Field Artillery who was recently mentioned in dispatches.[5]

BEF Unit	Distance Covered on 12 September 1914
1st Cavalry Brigade	11.5 miles
2nd Cavalry Brigade	13.5 miles
3rd Cavalry Brigade	12 miles
4th Cavalry Brigade	10 miles
5th Cavalry Brigade	7.5 miles
1st Division	19 miles
2nd Division	17 miles
3rd Division	15 miles
4th Division	15 miles
5th Division	8 miles
19th Infantry Brigade	14.5 miles

The entire BEF travelled many miles under heavy rain on 12 September before they reached the river Aisne. The table above shows the distances that the units travelled that day on foot.

Leading cavalry units engaged German opposition as they got closer to the river Aisne along the Vesle between Ciry and Bazoches. Infantry battalions from the 1st, 2nd and 3rd Divisions succeeded in overwhelming this German resistance and assisted Cavalry patrols to secure the high ground south of the Aisne.

The 5th Division had reached Hartennes and Billy sur Ourcq. General Gough's 3rd and 5th Cavalry Brigade covered the march on 12 September, but the harsh weather slowed the advance. The head of the 5th Division had reached Serches and the rear column was at Nampteuil when it was decided to halt and rest for the night, with no attempt to cross the Aisne. Cavalry patrols ventured as far as Condé where they found the bridge to be intact but as mentioned earlier, strongly defended.

The 4th Division despite the need for rest continued to push ahead during the evening of 12 September. The 12th Infantry Brigade led the advance of the 4th Division and by 3.00pm had secured a high ridge north of Septmonts, which was 3 miles south of the river and overlooked the Aisne valley. Cavalry patrols sent to search along the southern bank reported that despite being damaged, the bridge at Venizel could be used. They also confirmed that German infantry were dug in in trenches just to the north of the bridge at Venizel and that a German column was moving north east from Soissons. The 31st Heavy Battery positioned 1 mile north east of Septmonts began bombarding this withdrawing column at 4.30pm.

If the pursuit was to maintain momentum the bridges had to be taken. The 12th Infantry Brigade advanced towards Venizel supported by artillery from 29th Brigade Royal Field Artillery at Billy sur Ourq. With the light fading any bombardment would not be accurate. It was decided to suspend the operation to reach Venizel and to establish outpost positions on the high ground at Septmonts. Acting without orders and upon his own initiative Major C.A. Wilding, commanding the 2nd Royal Inniskilling Fusiliers, sent a patrol to the bridge at Venizel. As they approached German soldiers holding the bridge made an unsuccessful attempt to destroy it with four charges. Only one of the four exploded causing slight damage. Captain S.A. Roe of the Inniskilling Fusiliers removed the fuses from the other three charges by the light of an electric torch while exposed to entrenched German infantry along the north bank.

The remainder of the 4th Division set up billets in Septmonts during the night. Brigadier-General Sir Henry Wilson had been appointed commanding officer of the 4th Division succeeding Major-General Thomas D'Oyly Snow, who was injured on 9 September at La Ferté-sous-Jouarre in an accident when his horse fell on him, cracking his pelvis. Wilson summoned Major D.M.F. Hoysted, commander of 9th Field Company, Royal Engineers, and ordered him to send a patrol to assess the damage at Venizel. Captain F.C. Westland went to Venizel bridge at 8.00pm and returned to 4th Division HQ reporting that only two charges had gone off and that the bridge was passable in single file. He could not elaborate because he viewed the bridge in the dark.

At 9.00pm that evening a meeting was convened at 4th Division Headquarters at Septmonts chaired by Wilson, where Brigadier-General Aylmer Hunter-Weston commanding 11th Infantry Brigade was ordered

Venizel Bridge.
(Author)

Venizel (Aisne). – Le Pont sur l'Aisne

to capture the bridge at Venizel and proceed north of the river. Wilson gave Hunter-Weston assurance that if he secured a bridgehead that evening, his brigade would have the complete support of the 4th Divisional Artillery at daybreak.

The order to stand to and prepare to march after days of marching for the soldiers of 11th Infantry Brigade must have been extremely unwelcome. The 1st East Lancashire Regiment had reached their billets after marching 20 miles over bad roads in rain since 8.00am. It was still raining when they reached Septmont at 7.00pm and found it difficult to secure billets. The 1st East Lancashires finally settled for the night inside the church at Septmonts, but there were no rations for them. Their well earned rest ended when they received orders to advance at 10.00pm that night.

The 1st Rifle Brigade also had their respite cut short. They had spent only two hours in their billets that night before they were called to arms again. The Rifle Brigade chronicler recorded:

> Soon after 8pm a halt was made in an abandoned village, and the men went into what billets they could find. It had been pouring with rain for some hours and everyone was wet through. It was thought that the night would be spent in billets, but at 10pm orders was received to continue to march. All ranks were then told that the Germans were really 'on the run,' and that the German officers were beating their men in order to get them along the road. The rain continued.[6]

The 1st Hampshire Regiment had been settled in their billets for three hours before they were told to move out and led the 11th Infantry Brigade from Septmonts towards the banks of the river at Venizel three miles away.

At 11.00pm as rain continued to fall incessantly, Brigadier-General Hunter-Weston personally led the 11th Infantry Brigade from their position at Septmonts down into the valley and to Venizel. Hunter-Weston sent two officers, Lieutenant im Thurn and Lieutenant Knocker, on a reconnaissance to the bridge. Here they found that by now one of four large charges placed on the bridge had failed to explode and that although the principal girders on each side of the bridge span had been severed, the central girder that reinforced the concrete of the roadway was stable and strong enough to enable troops to pass over it, providing great care was taken. This information slightly differed from the report given by Captain Westland of the 9th Field Company, Royal Engineers, who thought that two charges had gone off. They also found German trenches had been recently dug in positions south of the river but they were unoccupied at that time. The only contact they had with the enemy was when a German Uhlan patrol fired upon them from the north bank but they withdrew as Lieutenant im Thurn was cutting the fuses of a charge that had failed to explode. One of the officers remained by the bridge to assess its condition, while the other returned to the 11th Infantry Brigade with the intention of guiding them to the bridge. The main body of the 11th Infantry Brigade was heading for Venizel and met this officer at Carrière L'Evêque Farm but he was too exhausted to continue. Hunter-Weston listened to this officer's report and with the aid of a map personally led the brigade to the bridge. Rain fell heavily as they arrived at the bridge at 1.00am. A German party holding trenches south of the river fired some shots and withdrew. Hunter-Weston met the officer from the Royal Engineers who had remained at Venizel and surveyed the state of the bridge. Hunter-Weston was confident that a crossing could be made safely.

Private F.G Pattenden, 1st Hampshire Regiment, was exhausted and could go no farther:

> We are still in the dark as to our movements and I am nearly fed up again. We marched all day passing though several villages and had plenty of rain all day and at night it poured throughout. We had to go all night and I collapsed and laid up in Venizel.[7]

Hunter-Weston was conscious that his men were exhausted and hungry but he was anxious to carry out his orders to establish a bridgehead and seize the heights north of the river. Within four hours it would be daylight, so Hunter-Weston took advantage of the cover of darkness and ordered the 11th Infantry Brigade to cross. A crossing in broad daylight would have been impossible because the bridge was within close range of high ground occupied by German guns. They crossed silently in single file at five paces distance across the central girder of the bridge. All they had to guide them was a flash lamp on the north bank of the river. The 1st Hampshire's were the first battalion to cross the bridge and hastily set up covering positions. The structure was unstable. 'To cough on the bridge was to set the whole structure shaking.'[8]

1st East Lancashire Regiment followed them in single file across the river and both battalions assembled in open ground to the north of the bridge. Ammunition was removed from the boxes and carried across the river by hand. The entire 11th Infantry Brigade had successfully crossed the Aisne by 3.00am on 13 September, unopposed. With his brigade safely on the northern banks, Hunter-Weston ordered an advance north towards the ridges 300 feet above the valley.

Hunter-Weston consulted his map and assessed the terrain on the north bank. He could see that the ground was flat just north of the bridge and realised that this was a poor starting point to launch assaults upon the high ridges during daylight. Hunter-Weston made the extraordinarily brave decision to push his brigade farther and ordered them to secure the high ground north of Venizel. He was asking them to cross two miles of water meadows and flat ground that had not been reconnoitred. They had to cross this terrain in the dark and they did not know whether they would come across any German patrols or entrenched positions. Hunter-Weston was aware that his troops had not eaten for 24 hours and had marched 30 miles in 24 hours in driving rain, and were frozen, soaked and exhausted. But he also knew that it was vital to get his brigade on high ground to ensure that his men would be able to defend those ridges instead of losing heavy casualties in an uphill assault in daylight.

The 1st Hampshire Regiment advanced towards Bucy-le-Long where D Company, commanded by Captain Johnston, found the village to be unoccupied by the enemy. The chronicler of the Rifle Brigade:

> The Brigadier's orders for this attack rank perhaps amongst the briefest in the history of war. 'You see,' he said to his commanding officers, referring to their maps which were almost illegible with wet – 'You see that there are three "bumps" in front of you.' He then detailed a battalion to each 'bump' and kept the fourth in reserve.[9]

The 1st Hampshire's were to take the spur at Montagne Farm, the 1st Somerset Light Infantry were designated the spur west of Crouy on the left flank and the 1st Rifle Brigade was ordered to secure the spur north of St Marguerite on the right flank. Hunter-Weston left Lieutenant Dowling's platoon from the 1st East Lancashire Regiment to guard the bridge at Venizel and retained the rest of the battalion in reserve at Bucy-le-Long. As daylight was breaking these battalions could see the outline of the spurs. With fixed bayonets they proceeded to their allotted objectives. The few German infantry outpost positions on the crest of the wooded ridge were completely taken by surprise. Offering no resistance, they abandoned their trenches and withdrew to the German main line several hundred yards to the rear.

The 1st Rifle Brigade advanced in column of fours towards the high ridge a mile away. They reached St Marguerite beneath the ridge. As they entered the village they were confronted by a barricade of carts across the road. They found no enemy presence as they proceeded carefully though the village. Captain Riley led the battalion and by daylight they had reached the heights north of St Marguerite. A Company, commanded by Captain Nugent, and B Company, commanded by Captain Prittie, were sent to search for outposts and the other two companies waited just beneath the crest of the ridge. By 9.00am the 1st Rifle Brigade had secured the wooded heights north of St Marguerite, where they stopped and began to dig in.

Hunter-Weston had pushed his men to the limit. His unit could claim to be the first to cross and secure positions north of the Aisne but they share that accolade with the 4th Division cyclists who had seized the bridge at Missy at 1.00am that morning and had secured the high ground north of St Marguerite west towards La Montagne Farm. Though Hunter-Weston's 11th Infantry Brigade was the first entire formation to cross the river. The Germans had evacuated their trenches. The gamble had paid off. They had established a line from the spur north of the village of St Marguerite to a position two miles north of Soissons. By dawn the 4th Division had established a bridgehead that stretched from the edge of the spur north of St Marguerite running west through La Montagne Farm towards Crouy, which was located

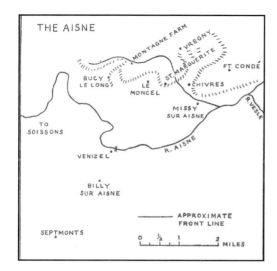

two miles north east of Soissons. The 1st Rifle Brigade had secured the ridge north of St Marguerite; the 1st Hampshire Regiment had secured the spur where La Montagne Farm was positioned and the 1st Somerset Light Infantry were in control of the spur 1400 yards east of Crouy. They had established contact with soldiers from the French 6th Army on their left flank.

It was a great achievement. If other British divisions had pushed forward during the night of 12/13 September then the BEF might have won a significant victory. The official history commented: 'Had other divisions been equally enterprising – and their marches on the 12th had been shorter than those of the 4th Division – the fighting on the 13th might have had a different result.'[10]

The 1st Rifle Brigade sent out reconnaissance patrols during the morning of 13 September, which reported two parties of German soldiers entrenching positions on their left flank, north west at a distance of 1500 yards. It was initially thought that they were soldiers from the 11th Infantry Brigade, but on closer observation through a telescope they were identified. Lieutenant-Colonel Biddulph immediately prepared two of his companies for a surprise assault upon this position, which consisted of scattered outposts and a main trench line. Two platoons did open fire on one of the German parties but Hunter-Weston rode up to the position and immediately stopped the attack. He was not prepared to launch an attack on entrenched German positions without support. He thought it necessary to refrain from any offensives until more British forces had crossed the river. He ordered the 1st Rifle Brigade to continue to entrench.

The morning was quiet for the 1st Rifle Brigade holding the ridge north of St Marguerite, however at 4.30pm German snipers opened fire upon the section

of the battalion holding the edge of a wood that faced the Maubeuge Road. B Company, 1st Rifle Brigade, was sent to deal with them. Captain Prittie reported seeing a large number of German infantry close by. German snipers continued to fire upon their position and they were supported by a small German field gun firing shells into the wood. At 5.00pm a section from the Royal Field Artillery brought up two guns from Venizel and placed them in an exposed position in front of the wood on the left flank of the 1st Rifle Brigade. B Company was sent forward to protect these guns together with I Company, commanded by Captain Morgan-Grenville. There was a gap in the line in between the 1st Rifle Brigade and the 1st Hampshire Regiment's position and two platoons from C Company, 1st Rifle Brigade, were ordered to fill it.

Once the Royal Field Artillery section had these two guns deployed and firing, German infantry and artillery met them with a response of rifle, machine-gun and shell fire at close range, which blasted both out of action. B Company, 1st Rifle Brigade, was offering covering fire for the Royal Field Artillery section behind a small ridge in front of the two guns and as a consequence suffered 53 casualties. Amongst them were Major C.E. Harrison (second in command) and Captain Nugent commanding A Company, both wounded. Sergeant J. Roberts carried the wounded Major Harrison under fire to safety. Despite being wounded five times, Roberts returned to man his post until ordered to retire. Sergeant Roberts was awarded the Distinguished Conduct Medal.

The gun crews and the 1st Rifle Brigade were forced to withdraw to the edge of the wood where they stayed for the rest of the night. B Company was sent into reserve, but they were mistaken for German forces and were shelled by British guns. Fortunately, a large cave was found where they sheltered from this friendly fire, together with the entire brigade of the Royal Field Artillery, including all horses and limbers. The German guns ceased fire around 6.00pm and the front held by the 4th Division was quiet during the night.

The 1st Somerset Light Infantry, another one of Hunter Weston's battalions, crossed the Aisne at Venizel and took part in the assault on Bucy-le-Long. They advanced north west and captured the village without opposition. They established positions along a sunken road opposite Crouy, where the men ate their first meal for 24 hours.

BRIGADIER-GENERAL AYLMER HUNTER-WESTON
COMMANDER 11TH INFANTRY BRIGADE
Aylmer Gould Hunter-Weston was born in 1864. He was commissioned into the Royal Engineers in 1884 and saw active service on the Indian Northwest Frontier where he was wounded. He also saw active service in Egypt and in South Africa during the Boer War 1899–1902.

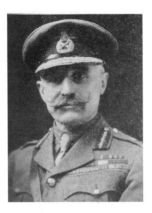

Brigadier-General Hunter-Weston. (*The Great War, I Was There*)

Private Samuel Bryars, 2nd Royal Inniskillen Fusiliers. (*Larne Times*, 17 October 1914)

When war broke out he was commanding the 11th Infantry Brigade. Despite his troops being hungry and exhausted he pushed his men to cross the Aisne and secure the heights on the north bank. Hunter-Weston was appointed commander of 29th Division in 1915 and was deployed to Gallipoli. The Division sustained heavy casualties during this campaign, it is thought by many through his continually committing his troops to futile attacks, which gained no ground. During July 1915 he succumbed to sunstroke and suffered a nervous breakdown owing to the demands for results that he could not deliver. He was taken off the line and was sent back to England. On his return he was knighted and although a serving officer in the British Army he embarked upon a second career in politics, being elected as Unionist Member of Parliament for the constituency of north Ayrshire in October 1915. Hunter-Weston was appointed commander of 8th Corps and sent to France in 1916. On 1 July 1916, during that first disastrous day of the Somme Campaign, his 8th Corps suffered the highest number of casualties. Hunter-Weston ordered the detonation of two large mines on his sector minutes prior to the attack, which alerted German forces that his infantry was about to attack and gave them sufficient time to ascend from their deep dugouts and assemble their machine guns. Hunter-Weston continued to serve throughout the war. When the war ended he continued his career in politics and died in 1940.

PRIVATE SAMUEL BRYARS 7892

2ND ROYAL INNISKILLING FUSILIERS

Private Samuel Bryars was born in Londonderry in 1886. He served with the 2nd Royal Inniskilling Fusiliers during the 1914 campaign and saw action at Mons, Cambrai and the Aisne. In a letter home to his mother he wrote, 'On one occasion the Germans were only 200 yards in front of us, so the ball was always rolling ... They try to rush our trenches, but they don't like the bayonet nor our shooting.'[11]

Bryars is an example of the men who marched many miles over three weeks to fight in several battles and pushed forward on the night of 13 September despite exhaustion and hunger to secure a passage across the Aisne. Bryars received bullet wounds to his neck and left ear while in trenches on the Aisne and was evacuated to England and a hospital in Lincoln. He returned to active service in France and died from wounds on the Somme on 8 May 1916 while serving with the 1st Royal Inniskilling Fusiliers. He was buried at Auchonvillers Military Cemetery.

SUMMARY: 12 SEPTEMBER

Brigadier-General Hunter-Weston commanding the 11th Brigade had reached the river Aisne at Venizel on 12 September. The bridges at Venizel and Missy were in British hands. The bridge at Condé was undamaged and held by a strong German force. The bridge at Vailly was destroyed by the German forces.

By nightfall I Corps and the Cavalry Division had reached Dhuizel, Longueval and La Courcelles. The 3rd and 5th Cavalry Brigades had occupied Chassemy and Ciry. II Corps was in control of Brenelle, Braine, Chacrise and Serches. III Corps were in possession of Billy, Septmonts and Buzancy.

The French 6th Army had marched from Compiègne and had arrived at the river at Soissons on the left flank of the BEF during the night of the 12th. On the BEF's right flank, the French 5th Army had pushed back the German 6th Army and was in control of the Vesle from Beaumont to Fismes. By the evening of the 12th the French 5th Army had forced back the German Second Army in line with the British I Corps. With its left flank exposed, General Von Bülow made the decision to evacuate Rheims and redeploy his forces north of the Aisne at Berry-Au-Bac.

Unbeknownst to the French and BEF, the night of 12/13 September saw the end of the German First and Second Armies retreat from the Marne. Before midnight

von Kluck ordered the 3rd and 5th Divisions from IV Corps and half of the IX Corps which were holding a line from Billy, south of Venizel and Cuise Lamotte, south west of Attichy, to withdraw north across the Aisne.

During that night von Kluck's began to restore order and the ranks regrouped into their original units, which fought at the Battle of the Ourq and prepared to stop the French and BEF's advance at the Aisne valley.

NOTES

1. Berkeley, R., *The History of the Rifle Brigade 1914–1918* (The Rifle Brigade Club, 1927)
2. *Ayrshire Post*, 2 October 1914
3. Ibid
4. WO 95/1570: 1st Bedfordshire Regiment War Diary
5. *The Scotsman*, 1 December 1914
6. Berkeley
7. WO 95/1495: 1st Hampshire Regiment War Diary
8. Atkinson, C.T., *Royal Hampshire Regiment 1914–1918* (Naval & Military Press, 2004)
9. Berkeley
10. *Official History of the War: Military Operations: France & Belgium 1914* Volume 1 (1933)
11. *Larne Times*, 17 October 1914

CROSSING THE AISNE, I CORPS SECTOR

Corps was ordered to continue the advance on 13 September. The 1st Division was ordered to cross the Aisne at Bourg-et-Comin, the 2nd Division at Pont Arcy and Chavonne. Patrols were sent to the river. They were ordered to pursue the enemy or to launch an attack in the event of encountering German resistance. Field Marshal French had issued these orders the day before, without knowing German intentions and he did not know how the day would evolve. He was unaware that German forces were massing along the heights of the Chemin des Dames, north of the river, and it follows of course that he did not know their strength. Would they hold their positions on 13 September, or withdraw further northwards?

Captain Hubert Rees described how his men looked and felt on 13 September:

> Next morning was warm for which we were truly thankful. We carried nothing in the way of a coat

and heavy rain soon goes through a khaki coat and shirt. We were all as hard as iron but a most disreputable gang. Possibly not as appallingly filthy as we were after the 1st Battle of Ypres, but all the men and most of the officers wore beards through the impossibility of finding time to shave, and it would have puzzled most of us to remember the last time we had had a bath.[1]

1ST DIVISION FRONT: CROSSING AT BOURG-ET-COMIN

Various reports were being received by Field Marshal French's headquarters about the state of the crossings across the Aisne during the early hours of 13 September. At 4.30am a sergeant reported that the bridge at Villers et Prayères had been completely demolished and that the Royal Engineers were constructing a pontoon bridge close by.

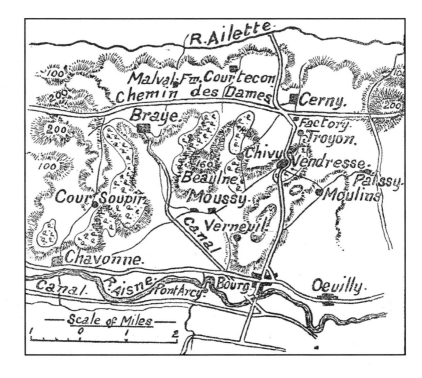

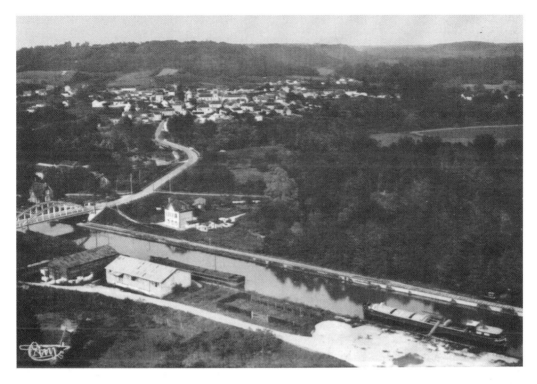

Bourg-et-Comin. (Archives Departementales de l'Aisne)

Road bridge from the north-east bank of the Aisne at Bourg-et-Comin, taken in September. (Author)

Lieutenant A.L. Schreiber, Commander Royal Engineers attached to 1st Division and his Adjutant found at Bourg-et-Comin that the road bridge had been destroyed, but a canal bridge and an aquaduct which carried the Aisne-Oise Canal had been slightly damaged. German engineers had tried to destroy the canal bridge and aquaduct but failed. After assessing the situation Schreiber concluded that if the aquaduct could be repaired, the 1st Division could cross. Sappers from the 23rd and 26th Field Companies swiftly repaired the aquaduct and it was decided to initiate a hasty drive towards Bourg-et-Comin in order to secure the crossing to enable infantry from the 1st Division to pass and establish a bridgehead. At 5.00am cavalry from the 4th (Royal Irish) Dragoon Guards and the 9th (Queen's Royal) Lancers, both belonging to the 2nd Cavalry Brigade, were ordered to capture the crossings at Bourg-et-Comin.

As they led the advance upon the river bank at Bourg-et-Comin they found that the river bridges were damaged, but the bridges crossing the canal were intact. British forces were able to cross by using the tow path on the canal aquaduct. German artillery had failed to destroy this aquaduct, which was strong enough to carry artillery guns.

The cavalrymen dismounted and dashed across the canal bridge. The aquaduct was on their left flank and from behind its embankment a German machine-gun crew was waiting for them. Despite British artillery fire, they were untouched and left to pour machine-gun fire from behind as the British cavalrymen charged across the bridge. Captain Gerald Fitzgerald and five men from the 4th (Royal Irish) Dragoon Guards were killed as they rushed this enemy position. The 9th (Queen's Royal) Lancers also sustained some casualties.

The White House adjacent to the bridge at Bourg-et-Comin was occupied by German forces who offered some resistance, but infantry from the 2nd Infantry Brigade, consisting of the 2nd Royal Sussex Regiment, 1st The Loyal North Lancashire Regiment, 1st The Northamptonshire Regiment and 2nd Kings Royal Rifle Corps confronted and overwhelmed this opposition around 11.00am. The 2nd Royal Sussex Regiment lost 1 killed and 7 wounded at Bourg-et-Comin.

The 1st Gloucestershire Regiment also crossed the river there. The French villagers had a particular reason to be happy to see the British arrive. One of the villagers had shot a German soldier. German forces

View from road bridge at Bourg-et-Comin looking towards the north-east bank, taken in September. (Author)

View from the road bridge at Bourg-et-Comin looking towards north-west bank, September. The railway and canal bridge was located farther west along the Aisne from Bourg-et-Comin. (Author)

holding the village had gathered men from the village to execute them in reprisal. As the men were about to be shot, news that British soldiers from the 1st Division were close by arrived and the Germans withdrew from the village without carrying out the revenge execution.

As soon as Bourg-et-Comin was captured, German artillery launched barrages upon the village. While infantry were securing Bourg-et-Comin amidst the shell fire the 2nd Cavalry Brigade advanced north to establish positions on the Bourg Spur. The 1st Cavalry Brigade, which followed across the Aisne advanced east towards Pargnan, where they established contact with French forces on the right flank.

German infantry was observed moving north from Vendresse village. The 1st Battery Royal Horse Artillery fired upon this column. This in turn attracted retaliatory fire from German artillery, which forced the 2nd Cavalry Brigade to withdraw to positions south of Bourg Spur.

The 2nd Infantry Brigade having crossed at Bourg-et-Comin was entrenching positions on the Bourg Spur, which allowed 2nd Cavalry Brigade to advance another two miles to reach Moulins village.

German forces positioned along the Vendresse Spur began to fire upon their positions and stopped their advance. Reports from reconnaissance aeroplanes of the RFC reported German troops from the VII Reserve Corps assembling north of Courtecon village, while another concentration of enemy forces was seen moving from Chivy and descending upon Bourg-et-Comin.

With the prospect of German forces massing in force upon the Aisne valley, the 1st Guards Brigade and 3rd Infantry Brigade were hastily deployed and crossed the Aisne using the damaged aquaduct at Bourg-et-Comin. The 1st Guard's Brigade was comprised of the 1st Coldstream Guards, 1st Scots Guards, 1st Black Watch (The Royal Highlanders) and 1st Queen's Own Cameron Highlanders. The 3rd Infantry Brigade consisted of the 1st The Queen's (Royal West Surrey Regiment), 1st The South Wales Borderers, 1st The Gloucestershire Regiment and 2nd Welsh Regiment.

Captain C.J. Paterson wrote: 'We cross the river with shells dropping round us. The Germans have destroyed most of the bridges and are shelling or trying to shell the ones they have left, hoping to catch us on them.'[2]

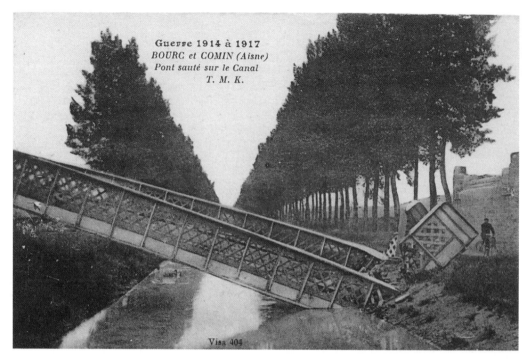

Guerre 1914 à 1917
BOURG et COMIN (Aisne)
Pont sauté sur le Canal
T. M. K.

Visa 404

The damaged footbridge across the canal at Bourg-et-Comin. Soldiers from the 1st Division may have used this crossing on 13 September. (Author)

At 1.00pm the 2nd Infantry Brigade was holding the high ground above Bourg-et-Comin as German reinforcements were reported to be heading towards this position by the RFC.

The 1st Guards Brigade and the 3rd Infantry Brigade crossed the Aisne at Bourg-et-Comin quickly and were ordered to advance north east from Bourg-et-Comin towards Paissy village and establish positions on the right flank of the 2nd Cavalry Brigade. By 4.00pm the 2nd Infantry Brigade had reached Moulins, where they established a position that allowed the 2nd Cavalry Brigade to retire to billets set up in Bourg-et-Comin.

The 1st Division continued to cross the Aisne at Bourg-et-Comin during that afternoon, under shell fire. Private Alexander Miller from the 1st Black Watch recalled: 'When we reached the Aisne we discovered that the enemy had blown up the bridge. This was an effective check to our artillery, but the infantry crossed the river by means of a low narrow erection used by the villagers.'[3]

German snipers concealed in the trees along the northern banks of the river posed a serious threat to the British battalions as they crossed. Private Joe Cassells, a scout from the 1st Black Watch, also witnessed the brave attempts by the Royal Engineers to get battalions from the 1st Division across at Bourg-et-Comin:

We were held up for a while on the Aisne while our engineers constructed pontoon bridges. The Germans had the range, and they almost wiped out our entire battalion of engineers before our troops could cross.

I saw a working raft swing out into the river with about 12 men on it. A single burst of shrapnel exploded in their midst and there wasn't a single man left standing. One of them crawled to the stern and began pushing the raft toward the shore with a pole but he was so weak that the current kept swinging him downstream. A sniper got him.

The raft was drifting away. Nobody expected to see the men on it again, but, in the face of shrapnel and a nasty fire from snipers, three men, stark naked, jumped into the stream and struck out for the raft. The water around them was whipped by bullets, but our boys located the snipers and got the range and quietened them. The first man reached the raft. His hands were over the edge. He had just pushed his head and shoulders over the side when a rifle snapped and he slipped back into the water, then I saw the German who had fired at him topple out of a tree. A dozen shots must have struck him. The two other swimmers were alongside the raft now and climbed upon it. I could see that one was bleeding at the shoulder.

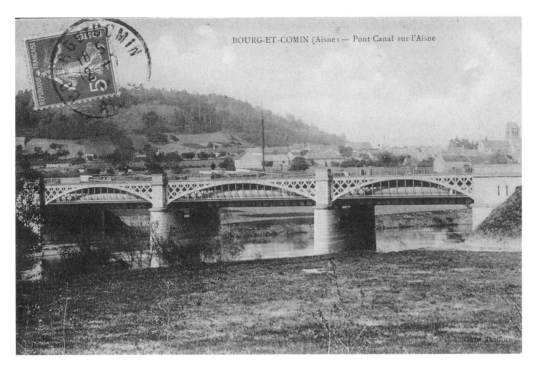

BOURG-ET-COMIN (Aisne) — Pont Canal sur l'Aisne

The canal and railway bridge at Bourg-et-Comin. (Author)

The damaged railway bridge at Bourg-et-Comin. (Dick Monk)

Our men pulled the wounded man upon the raft, and brought it to the shore. Their heroism saved the lives of five men who otherwise would have drifted away and probably died.[4]

After successfully crossing, the 1st Black Watch headed towards positions north east of Paissy on the right flank of the 2nd Cavalry Brigade. Private Alexander Miller serving with the 1st Black Watch reported: 'We advanced under the cover of the artillery fire and took up our position. Then came the order to fire at 600 yards range. The advance was continued over a number of ploughed fields. That advance had a peculiar effect on our rifles. The ground was sodden, and as we dropped for cover a lot of dirt got in about the bolts of our rifles and in many cases rendered them useless.'[5]

Miller was unable to fire his rifle and had to scrounge for another from a wounded comrade. He had to take cover behind a haystack to avoid the enemy rifle fire.

I couldn't use mine, but the fellow next to me was wounded, and I took his rifle. Right in front of where I was lying there was a haystack and a great many German bullets found a billet in it. The stack interfered with my shooting, however, and I moved aside to clear it. I had scarcely taken up my position when I was wounded in the right shoulder by a bullet.[6]

Private Miller was lying wounded exposed to German fire. Lance Corporal McLeod, a Cameron Highlander, came to Miller's rescue and got him out. As he carried out this gallant act McLeod received three wounds.

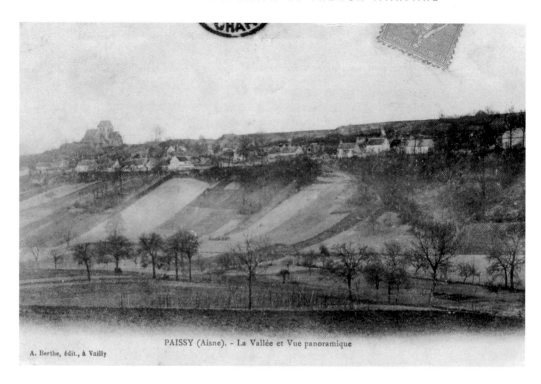

PAISSY (Aisne). - La Vallée et Vue panoramique

A. Berthe, édit., à Vailly

The village of Paissy. (Courtesy Jean-Pierre Boureux)

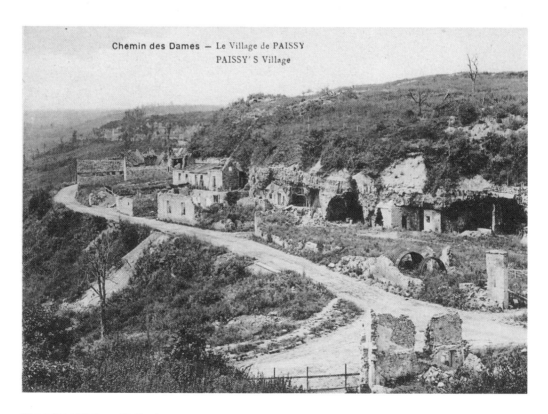

Chemin des Dames — Le Village de PAISSY
PAISSY'S Village

The ruins of Paissy. (Author)

The 1st Black Watch continued their advance and were ordered to occupy positions along Paissy ridge. There was a four-mile march from the valley to this ridge. As they proceeded northwards the battalion came under heavy German shell fire causing four casualties. On arriving at the village at Paissy they established contact with a company of French Zouaves. (The Zouaves were originally a troop of natives belonging to an Algerian tribe called 'Zouaoua' from Kabylie country and were created in 1831. As recruits diminished the draftees were then found amongst French-born civilians living in France or Algeria, Tunisia and Morocco. In July 1914 there were 23 battalions of Zouaves. They belonged to the Armée d'Afrique and were regarded as elite troops. Well known for their exotic uniform, the *sarouel*, pantaloons, and *chechia*, red cap, in June 1915 they were given helmets and adopted khaki.)

The village of Paissy was perched just south of Paissy Ridge. Small parties from B Company were ordered to set up outposts on Paissy Ridge just above the village while the remainder of the battalion sheltered in the limestone caves inside the village.

As the 1st Black Watch were advancing towards Paissy Ridge the 1st Queen's (Royal West Surrey) Regiment was crossing the river at Bourg-et-Comin. Sergeant C.S.A. Avis described the crossing:

> We continued to advance and near Bourg had to scramble along the girders of a destroyed iron bridge over the river Aisne under heavy fire from the enemy. The hot weather had now broken, we advanced in heavy rain up the slopes of the river bank. It was an unlucky day when the Battalion forced the passage of the river with a loss of nearly 100 killed and wounded on September 13.[7]

By 4.00pm the 2nd Infantry Brigade had established a defensive line from Moulins south west towards Bourg. This enabled the 2nd Cavalry Brigade to withdraw and retire to billets east of Bourg-et-Comin.

By 6.00pm the last soldiers from the 1st Division were crossing the Aisne. During that night the 1st Division was able to advance four miles north from the river. The 1st Guards Brigade was in control of the village of Paissy and the Paissy Spur. The 2nd Infantry Brigade was in possession of Moulins and positions along the Bourg-et-Comin Spur. These two Brigades had established a bridgehead across the Aisne without artillery support.

The terrain and caves at Paissy have not changed since 1914. (Author)

Artillery supporting the 1st Division was brought across the Aisne at Bourg-et-Comin during the evening, The XXV Brigade RFA and 30th Battery positioned on the spur north of Pargnan began firing upon German positions at Troyon village. As the British and German artillery fell silent during that night the 1st Division and 2nd Cavalry Brigades settled into their billets north of the river.

2ND DIVISION: CROSSING AT CHAVONNE AND PONT ARCY VILLAGES

The 2nd Division were ordered to cross the Aisne at Chavonne and Pont Arcy. The 5th Infantry Brigade comprising the 2nd Worcestershire Regiment, 2nd Oxford & Buckinghamshire Light Infantry, 2nd Highland Light Infantry and 2nd Connaught Rangers led the 2nd Division and had reached Pont Arcy by 9.00am.

German forces had demolished the bridge at Pont Arcy except for a solitary partially submerged girder. British troops were able to cross the river in single file, initially unopposed, however as rear columns of the 5th Infantry Brigade crossed the girder they came under heavy artillery fire.

While the 5th Infantry Brigade was crossing, sappers from the 5th and 11th Field Company, Royal Engineers, were securing other crossing points. The 11th Field Company concentrated on trying to repair the road bridge, while sappers from 5th Field Company established a pontoon bridge east of the remaining girder of the bridge at Pont Arcy and half a mile west of Bourg-et-Comin. Sapper J. Woodhead was one of the Royal Engineers from 11th Field Company who worked on the pontoon bridge. He thought the French had destroyed the original bridge:

> It rained in torrents the whole day long on the 13th, we advanced over the plain to the south of the Aisne and on the Pont Arcy, now we stayed in that same position until the 19th of Sept as we had constructed a pontoon bridge across the river to get our troops and transport to get across. The French had blown the bridge up when they retired from there. Now this was a very trying time for us as we were under a very heavy shell fire the whole time we were making the bridge, but I'm pleased to say we didn't have any casualties. Now the Germans shelled that place from morning to night, day after day, to try and locate the position of our bridge but they was unsuccessful and could never get a direct hit on it. Of course our other work while in that position was barb wiring and making difficult obstacles etc. On the 14th Sept we had rather a heavy casualty list as the Germans dropped some very heavy shells amongst us; we lost one officer killed and several sappers killed and wounded.[8]

The 2nd Oxford & Buckinghamshire Light Infantry waited for most of the day for this crossing to be built. This pontoon bridge was completed by 4.30pm and was used by remaining elements of the 5th Infantry Brigade. By that time German artillery was shelling the river at Pont Arcy intensively. At nightfall the 5th Infantry Brigade moved north and set up positions on the left flank of the 1st Division. They held a line which ran from Verneuil to the Moussy and Soupir villages. The 2nd Oxford & Buckinghamshire Light Infantry established a line from Ferme-de-Metz to Soupir. D Company was held in reserve with HQ near the canal bridge west of Moussy. 2nd Worcestershire Regiment crossed the Aisne at 2.30pm at Pont Arcy and headed for Moussy and the Tilleul Spur. They reached the crest of this spur at 10.00pm. It was from this position that they covered the advance of the 6th Infantry Brigade the following day.

Divisional Cavalry patrols from the 2nd Division at dawn had reported that the bridge over the Aisne at Chavonne had been destroyed; however the canal bridges at Cys La Commune were undamaged. The southern approaches to the ruined bridge at Chavonne were covered by German snipers on the north bank. The 4th Guards Brigade consisting of the 2nd Grenadier Guards, 2nd Coldstream Guards, 3rd Coldstream Guards and 1st Irish Guards, was detailed to cross the river at Chavonne. They had left Courcelles at 7.00am during the morning of 13 September. There was only one narrow street through the village and heavy traffic congestion meant it took them two hours to get clear of Courcelles. Once again exposed to heavy rain, the clothes of the soldiers were already sodden after the previous day's march. They advanced to high ground above St Mard, where they tried to shelter from the cold wind under corn stooks in surrounding fields.

At midday on 13 September the 4th Guards Brigade were ordered to capture the crossing at Chavonne. Intelligence reported that this village was occupied by a small contingent of Germans. The 2nd Coldstream Guards were the vanguard. Those leading the battalion were met by German rifle fire on arriving at Cys La Commune. Captain Follet led No.2 Company towards the canal, which ran south of the river Aisne and the perimeter of Cys La Commune and which was an adequate firing position, but heavy German fire from the heights above Chavonne north of the river prevented them from getting there. The ground was not conducive to an assault because there was no adequate cover between the village of Cys La Commune and the south bank of the Aisne. The battalion would be decimated if it made an attempt to cross the 800 yards of flat ground. Lieutenant-Colonel C. Pereira, commanding the 2nd Coldstream Guards, deployed Captain Gregge-Hopwood's No. 1 Company and Captain Pryce-Jones No.3 Company along the canal bank, with Major

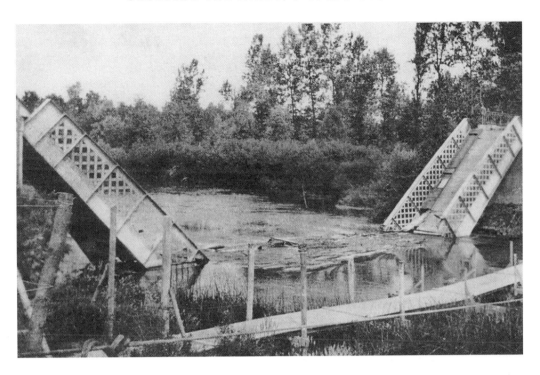

The damaged bridge at Pont Arcy. The 15th Infantry Brigade crossed the sole girder of the bridge that spanned the Aisne on 13 September. (Author)

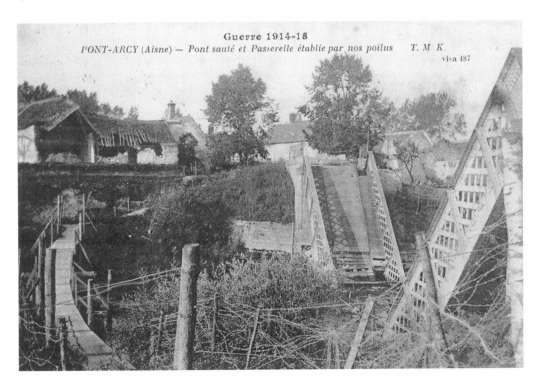

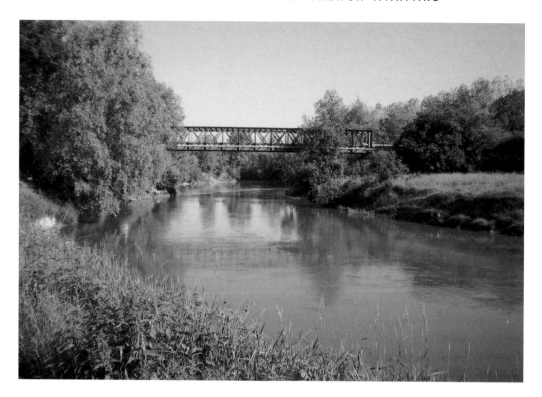

Pont Arcy Bridge today, from the southern bank of the Aisne in the autumn. (Yves Fohlen)

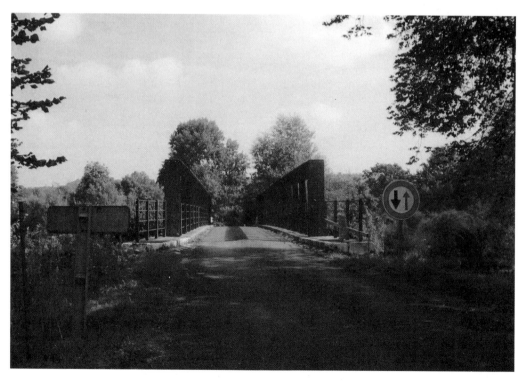

Pont Arcy Bridge today. (Author)

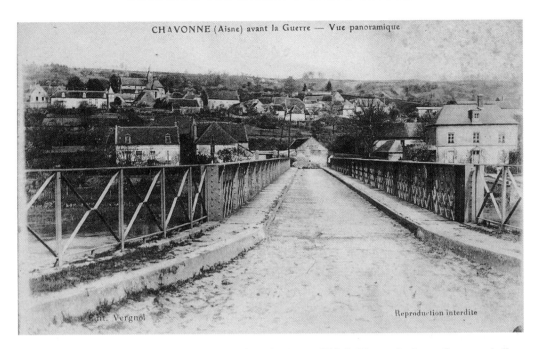

CHAVONNE (Aisne) avant la Guerre — Vue panoramique

Edit. Vergnol

Reproduction interdite

The bridge at Chavonne. The 2nd Coldstream Guards stormed this bridge under heavy German shell fire on 13 September 1914. German infantry and artillery occupied the heights north of Chavonne. (Author)

Macgregor and No.4 Platoon held in Cys La Commune in reserve. British artillery directed shrapnel fire along the heights above Chavonne. By 4.00pm German infantry was observed retiring from Chavonne. Captain Pryce-Jones led No.3 Company from the canal bank at Cys La Commune north towards the southern bank. Covered by rifle and machine-gun fire from the remaining three companies of the 1st Coldstream Guards holding Cys La Commune, they reached the Aisne. A limited German presence was still occupying Chavonne and fired upon them. Supported by artillery fire from the 34th and 44th howitzer Brigades positioned south of the Aisne, they overwhelmed the German riflemen.

Lance Corporal Milward found a boat and transferred most of No.3 Company across the Aisne. The three other companies from 2nd Coldstream Guards reached the south bank and by using a trestle across the breach in the bridge made by the Germans they were able to cross at Chavonne. Captain Follet with No.2 Company and Major Macgregor with No.4 Company advanced from Chavonne and by 5.30pm had secured Les Grinons, the ridge behind Chavonne. They were seen by German artillery observers and a heavy German bombardment soon descended.

Sergeant W.J. Cook from the 2nd Coldstream Guards wrote: 'At noon we were ordered to advance and seize the crossing of the Aisne at Chavonne. Here

was a very difficult problem as the villages and slopes were strongly held by the enemy. The bridge was also destroyed, but we accomplished the task with a great number of casualties, by about 6pm.'[9]

While the 2nd Coldstream Guards were crossing the river and establishing a bridgehead at Chavonne, the 2nd Grenadier Guards were ordered to make an attempt to cross the river a mile east upstream. They first came across four small boats of dubious quality. Getting the entire battalion across the Aisne in them would have been a lengthy process and it was decided not to use them. The battalion moved farther east. Major Lord Bernard Gordon-Lennox and Major Gilbert Hamilton went ahead of the battalion and found a bridge that could be suitable. As soon as they set foot upon the bridge shrapnel fell around them, indicating that artillery observers had the exact range of the bridge and were ready for them. They returned to the battalion to report their findings.

The 2nd Coldstream Guards on the north bank came under heavy German artillery fire. British artillery was unable to respond because the German guns were out of range. Major-General Charles Monro, commanding 2nd Division, assessed the situation from the bridge at Chavonne. The Royal Engineers companies assigned to the 2nd Division were preoccupied with establishing a pontoon bridge at Pont Arcy, so there was no chance

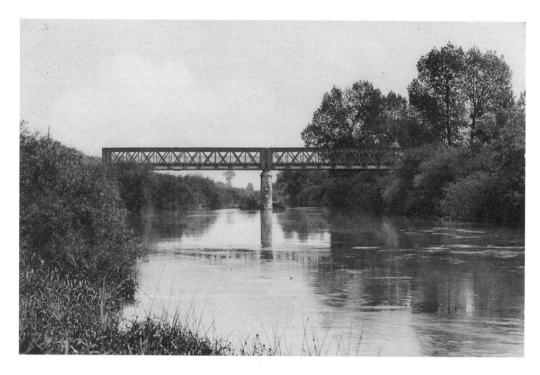

Chavonne Bridge before the war (above) and today (below), taken in the autumn. (Author)

of repairing the bridge at Chavonne in the short term. It was getting dark and rain was falling heavily. With no prospect of repairing the bridge or getting further reinforcements on the north side of the Aisne, Monro thought that it was a bad risk to leave the 2nd Coldstream Guards north of the river. He did not want to leave the battalion cut off and exposed to German counter attacks and therefore ordered the battalion to withdraw to positions south of the Aisne.

No.1 Company from the 2nd Coldstream Guards commanded by Captain Gregge-Hopwood remained on the north bank to guard the northern approaches to the bridge at Chavonne while the remainder of the battalion held positions on the south bank at Cys

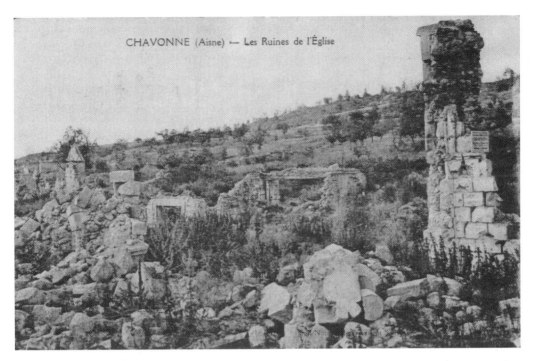

CHAVONNE (Aisne) ← Les Ruines de l'Église

After four years of war the village of Chavonne had been reduced to rubble. (*Archives Départementales de l'Aisne*)

La Commune. Sergeant William Ainsworth of the 2nd Coldstream Guards was killed during the action that day, with 22 wounded, three of whom would later die from their wounds. There were no officer casualties within the battalion during the day.

The 2nd Grenadier Guards were also recalled to billets at St Mard, south of the river. These men were glad to take shelter from the torrential rain while the villagers cooked their rations, which were supplemented with omelettes and vegetable soup. Lieutenant-Colonel Sir Frederick Ponsonby wrote: 'Thus began the Battle of the Aisne, and had the men only known that it was to go on, not for months, but years, and that the same ground would be occupied by the Allies during all that time, they would hardly, I imagine, have shown quite the same dash as they did during the days that followed.'[10]

The 5th Infantry Brigade was the only infantry unit from the 2nd Division to be positioned on the north bank of the river on 13 September. They had come under heavy German artillery fire. At dusk the brigade moved to a position between Verneuil and Moussy on the left flank of the 1st Division, establishing outpost positions along the Beaulne Spur.

NOTES

1. IWM 77/179/1: Captain Hubert Rees, 2nd Welsh Regiment
2. WO 95/1280: 1st Battalion South Wales Borderers War Diary
3. *The Weekly News* (Dundee), 10 October 1914
4. Cassells, Scout Joe, *The Black Watch: A Record in Action* (1918, republished by BiblioBazaar, 2009)
5. *The Weekly News*
6. Ibid
7. IWM 84/58/1: Sergeant C.S.A. Avis, 1st The Queen's (Royal West Surrey) Regiment
8. IWM 80/25/1: Sapper J. Woodhead, Royal Engineers
9. IWM P278: Sergeant W.J. Cook, 2nd Coldstream Guards
10. Ponsonby, Lieutenant-Colonel Sir Frederick, *The Grenadier Guards in the Great War 1914–1919* (Macmillan & Co., 1920)

CROSSING THE AISNE,
II CORPS SECTOR

THE 3RD DIVISION FRONT: CROSSING AT VAILLY

The 3rd Division was ordered to cross the Aisne and canal at Vailly. The 8th Infantry Brigade began its advance towards the river at 7.00am on 13 September. As they reached the edge of the high ground above the village at Chassemy and within a mile and a half of the southern banks of the river, they were spotted by German artillery observers on the ridges to the north who directed howitzer fire from Chivres Spur.

The 49th Battery of the 40th Brigade Royal Field Artillery fired their guns south of Chassemy, but they too came under heavy shell fire, resulting in two of their guns being destroyed. German shell fire meant that the 3rd Division could only deploy their artillery batteries as far as the southern edge of the Brenelle plateau, which was two miles behind the infantry they were meant to be supporting. The unavailability of cables meant that forward artillery observers had to resort to flag signalling to co-ordinate barrages, with poor results. As

Above: Vailly and the Chemin des Dames ridge. (*Highland Times*)

Right: Vailly, seen from the south bank of the Aisne. (Author)

the 49th Battery was preparing for action they came under heavy German fire, forcing the crews to abandon their guns.

The BEF was entering the unknown. Weary British infantrymen were heading towards the river Aisne and the Chemin des Dames but they were unaware that German forces were preparing to make a stand in this region. During that evening on 13 September an ominous warning was received from a pilot who had landed in a field close to the 2nd Royal Irish Fusiliers as they marched towards the river. Corporal John Lucy recalled: 'The flying officer climbed slowly out of his heavy kit, did not wait to find an officer, but shouted to us all: "They are waiting for you up there, thousands of them." And he waved his right arm towards the wooded heights, across the river Aisne, some three miles away.'[1]

Earlier that day, at 10.00am, the 2nd Royal Scots (Lothian Regiment) began to descend from the woods towards the canal close to the bridge at Vailly. They passed the light railway bridge a mile upstream from Vailly and they found the canal bridge south of the Aisne was intact, but the road bridge crossing the river had been completely destroyed by German engineers.

On arriving at Vailly they found that although this road bridge had been severely damaged, they could still cross the Aisne by a single plank that spanned a gap in the bridge that was left in haste by withdrawing German forces. Major-General Hubert Hamilton commanding the 3rd Division personally inspected the bridges at Vailly at 1.00pm. He could see that the damaged bridge

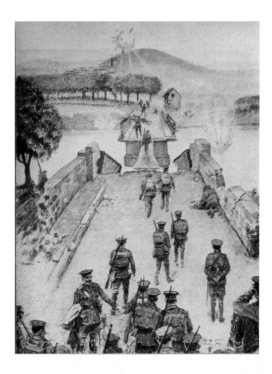

Right: An artist's impression of the BEF crossing at Vailly using a sole plank across the breach in the bridge. (*The Great War*)

Below: Panorama of Condé-Vailly-Rouge Maison. (War Office, 1934)

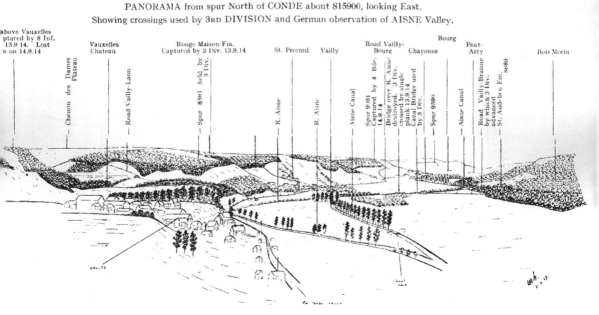

SKETCH No. 5.

PANORAMA from spur North of CONDE about 815900, looking East.
Showing crossings used by 3RD DIVISION and German observation of AISNE Valley.

A postcard showing the village of Vailly. The photograph was taken north of Vailly looking south into the Aisne Valley. German soldiers holding this position would be able to see the BEF approaching the Aisne. (Author)

View of the heights above Vailly. (Author)

could be crossed using the plank and he immediately ordered the 8th Infantry Brigade to cross.

At 3.00pm the 2nd Royal Scots and 2nd Royal Irish Regiment began to walk the plank. They were harassed by shell fire. They were also targeted by German machine gunners positioned on the north bank from a range of 1000 yards causing several casualties. It was extremely difficult to balance while crossing the river under such circumstances. Major E.H.E. Daniell commanding the 2nd Royal Irish Regiment was amongst the first from the battalion to cross at Vailly. On successfully reaching the north bank he was able to direct the soldiers from the battalion getting over. They had to judge the appropriate moment to make the dash. There would be a brief opportunity to dash across the plank once the German machine guns stopped to reload. Daniell wrote of the perilous crossing in a letter home to his mother:

> Our last action in crossing the Aisne cost us over 1000 men ... The actual crossing of the river looks rather hazardous and yet rather amusing. The bridge had been blown up. But a plank bridge for infantry over the gap had not been removed by the Germans. We had to run over this while a German gun played on us at about a range of 1000 yards, it was alright if one bolted just after the gun had fired, but it more often happened that the men miscalculated the time. Often I saw the guns blaze into a crowd

of men as they were running over and yet only one of my men was hit. I was directing them, as they arrived on the far side where they had to bolt down under cover.[2]

They reached the north bank and settled in positions on a ridge north west of Vailly. The 7th Infantry Brigade also crossed the Aisne at Vailly using rafts. They could only ferry three men at a time and the brigade spent the whole day crossing the river.

By 4.00pm the 2nd Royal Scots from the 8th Infantry Brigade were on the north bank and were establishing positions at Vauxelles Chateau (which was a mile away north west from the Vailly Bridge) and had established forward outposts on the southern slopes of the Jour Spur. Later that afternoon, German forces launched a counter attack on the 3rd Division positions at Vailly. The 5th Cavalry Brigade helped to repel the attack; however, they came under heavy shell fire as they retired across the pontoon bridge. As shells exploded close by in quick succession the horses became distressed and confusion reigned. Sergeant Taylor from the 57th Field Company, Royal Engineers came forward to calm the situation and clear the horses from the bridge under heavy German artillery fire. Taylor would receive the Distinguished Conduct Medal for his work at Vailly. During that night the remainder of the 8th Infanty Brigade were occupying St Pierre, west of Vailly.

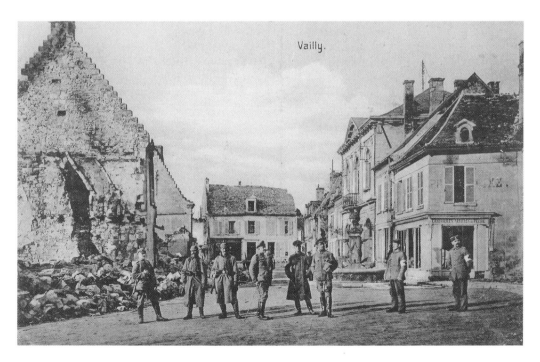

German soldiers occupying Vailly, 1915. (Author)

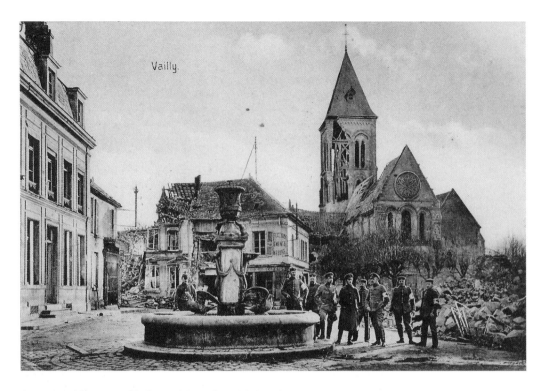

German soldiers stand in front of the ruins of Vailly church, 1915. (Author)

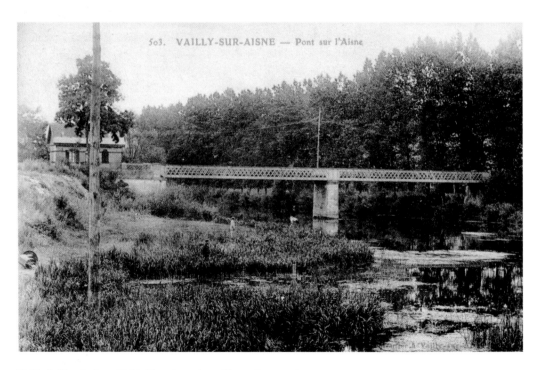

Vailly Bridge before 1914. (Courtesy Jean-Pierre Boureux)

**Vailly Bridge today.
(Yves Fohlen)**

**The Aisne, east of Vailly
Bridge. (Author)**

The 9th Infantry Brigade began to cross at Vailly at 9.00pm. The 4th Royal Fusiliers (City of London Regiment) crossed at 11.00pm. X and Z Companies surged forward to secure positions on the heights north of Vailly, known as the Rouge Maison Spur, and arrived at Rouge Maison Farm after midnight. One of the outposts set up by Captain Arthur Byng was so close to German positions they could hear them talking. The other two companies, W and Y Companies from the 4th Royal Fusiliers, established a position in a road behind Rouge Maison Spur.

While they were crossing the river, sappers from 56th and 57th Field Companies, Royal Engineers, were constructing a pontoon bridge and a footbridge across the damaged light railway bridge while under German fire. The remaining battalions from the 9th Infantry Brigade crossed the Aisne under the cover of darkness

in single file. They then advanced northwards and set up a series of outposts westwards from Rouge Maison. The 1st Lincolnshire Regiment crossed the river at Vailly around midnight, with only a lamp to guide them across in the dead of night. The chronicler of the 1st Lincolnshire Regiment unit history wrote:

> It was near midnight before the Lincolnshire's began their hazardous crossing. The advance was by sections, each section crossing the first bridge over the canal and then over the single plank spanning the gap in the broken bridge over the river in single file. A single false step to the right or left would have meant certain death by drowning. Every now and then a bursting shell would throw the weird scene into prominence, but not a single man was hit, neither did anyone fall into the river.[3]

Left: The Aisne, west of Vailly Bridge. (Author)

Below left and right: Two views of the ruins of Vailly. (Archives Départementales de l'Aisne)

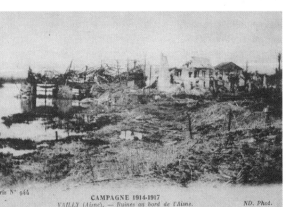

CAMPAGNE 1914-1917
VAILLY (Aisne). — Ruines au bord de l'Aisne. ND. Phot.

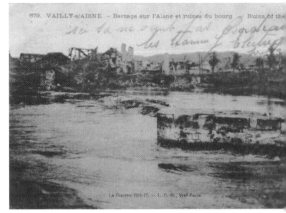

The 1st Lincolnshire Regiment then marched through Vailly and secured a high ridge south west of Rouge Maison Farm. A Company patrolled close to Rouge Maison Farm to link up with the 2nd Division. This patrol confirmed that Rouge Maison Farm was not occupied by German forces. The remainder of the 1st Lincolnshire Regiment used their entrenching collapsible spades together with 40 requisitioned picks and shovels to dig trenches in the pitch darkness as the rain fell upon them.

THE 4TH DIVISION: CONSOLIDATING THE BRIDGEHEAD AT VENIZEL

The 4th Division exploited the previous night's successful crossing of the Aisne at Venizel by sending reinforcements to consolidate their position on the heights above the valley. Hunter-Weston's 11th Infantry Brigade was holding ridges on the north bank by the early morning of 13 September. The 12th Infantry Brigade followed them and began to cross the Aisne at Venizel at 6.00am. The 12th Infantry Brigade comprised the 1st King's Own (Royal Lancaster Regiment), 2nd Lancashire Fusiliers, 2nd Royal Inniskilling Fusiliers and

the 2nd Essex Regiment. German artillery 8-inch and 5.9 inch batteries on the Chivres Spur poured shells upon them as they crossed. Hunter-Weston's 11th Infantry Brigade covered their crossing from their position on the ridge above Bucy-le-Long. The 2nd Essex Regiment arrived at Venizel at 9.00am and waited in a field outside the village until it was their turn to cross. The battalion war diary recorded: 'Enemy began shelling village with heavy guns dropping one shell into line "B" wounding Lieutenant Read and 8 men. "B" crossed the river by girder, which was partially blown up.'[4]

Once the 12th Infantry Brigade had crossed they advanced north towards Bucy-le-Long under heavy artillery fire. The 2nd Essex Regiment advanced in sections in extended lines at least 100 yards apart and with 10 paces between each man. Spreading the line was of course an attempt to minimise casualties. They then went onto St Marguerite and established contact with the 11th Infantry Brigade who had spent most of the day on 13 September digging and fortyifing their trenches, unmolested by the enemy.

One company from the 2nd Royal Inniskilling Fusiliers remained at the bridge to ensure that the British guns

Below: Soldiers from the BEF crossing the Aisne on a single girder. (Author)

Right: Bucy-le-Long before the war. (Author)

BUCY-LE-LONG — Vue Générale

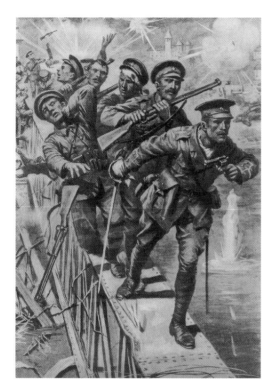

A big battle is being fought in a field next to us, only fifty yards away. Shells are bursting all around. The King's suffered severely. The wounded and dead are now being taken back by ambulance but several wounded also walking. A very sad sight, which once would have startled me but I am used to it now.[7]

Pontoons were brought to Venizel and the sappers constructed a pontoon bridge adjacent to the damaged bridge. Work to build these pontoons across the Aisne began at 10.30am, but immediately German artillery fire poured down upon their position, preventing them from working until midday. They worked throughout the afternoon and despite the German artillery, they succeeded in building the bridge, which spanned 195 feet and was comprised of three trestles, four pontoons and five barrel piers. By 6.00pm it was completed and the 4th Division had two bridges to use in getting to

from the 68th Battery, 14th Brigade, were brought across the river. Major C.L. Brereton led the 68th Battery across the Aisne at Venizel around 2.00pm. 'There was only one girder of this bridge left standing, so we had to get limbers and wagons across by hand.'[5]

During that morning sappers from the 7th and 9th Field Companies attempted to repair the bridge at Venizel. German artillery continued to target them as they worked. Sapper Albert Gumm was one of the sappers:

We were sent out by motor to start an office on a bridge named Venizel which the Germans had failed to blow up on their retreat. We commenced office at 9.00am and the Germans opened fire on the Major and myself, five shells bursting just overhead. The Germans are still trying to blow up the bridge, but have failed up to now – 5pm.[6]

Sapper Gumm continued to work, establishing communication wires as shells fell and as a battle was fought. By the time he reached the Aisne he had become accustomed to such terrible sights.

L'AISNE DEVASTEE.

Visé Paris Nº 2071

BUCY-LE-LONG. — Route de Venizel.

B. Noucarède, Édit., Soissons

The ruins of Bucy-le-Long. Soldiers from the BEF would have passed along this road from Venizel to enter the village. (Author)

PANORAMA from CHIVRES SPUR about 802886, looking South-west.

Showing crossings used by 4TH and 5TH DIVISIONS and German observation of the AISNE Valley.

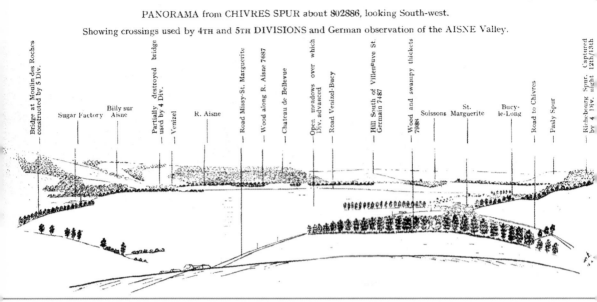

Panorama of the Chivres Spur. (War Office, 1934)

the north bank. During the night of 14 September, 2nd Bridging Train would bring forward the material for 9th Field Company to build a third crossing at Venizel.

North of Venizel the 4th Division set about consolidating their bridgehead. As the day progressed the 10th Infantry Brigade made up of the 1st Royal Warwickshire Regiment, 2nd Seaforth Highlanders, 1st Princess Victoria's (Royal Irish Fusiliers) and the 2nd Royal Dublin Fusiliers had established a covering position along the railway embankment between Villeneuve and Venizel.

The 12th Infantry Brigade was involved in some heavy fighting during the afternoon of 13 September. The 2nd Lancashire Fusiliers had crossed at Venizel and advanced to Bucy-le-Long, then proceeded to St Marguerite. They set up positions in a wood east of the village under machine-gun and rifle fire from trenches in front of the Chivres Spur.

At 2.30pm the 12th Infantry Brigade launched an assault upon the Chivres Spur from the direction of St Marguerite. The 2nd Essex Regiment attacked right of the road, while the 2nd Lancashire Fusiliers advanced on the left. Hauptmann Walter Bloem serving with the 12th Brandenburg Grenadiers was positioned on the Chivres Spur and could see these British battalions trudging their way through two miles of waterlogged fields and thick undergrowth in the woods towards the foot of the heights at Bucy-le-Long. These two battalions

were assaulting a position with scant knowledge of the terrain, enemy positions, or strength. German artillery concealed under the cover of the wooded ridges poured fire upon them as they advanced. Bloem could observe the 12th Infantry Brigade massing on the hill. 'Our own artillery was also taking up its positions, heavy and field batteries scattered about in every depression and behind every stretch of wood, their iron mouths raised high in the air and already spitting out their deadly poison across the valley.'[8]

The heavy shell fire that descended upon the 2nd Essex and 2nd Lancashire Fusiliers caused minimal casualties and made no impact upon their advance because they were widely spread out. Bloem:

We could not see the Aisne itself, but a line of willows away on the far side marked its course, with here and there groups of houses and church towers along its green banks. Stretched out across the broad expanse of meadows between us and the river was a long line of dots wide apart, and looking through glasses one saw that these dots were infantry advancing, widely extended: English infantry, too, unmistakably. A field battery on our left had spotted them, and we watched their shrapnel bursting over the advancing line. Soon a second line of dots emerged from the willows along the river bank, at least ten paces apart, and began to advance. More of our batteries came into action; but it was noticed that a shell, however well aimed, seldom killed more than one man, the lines being so well and widely extended. The front line had taken

Chivres in the 1950s.
(Author)

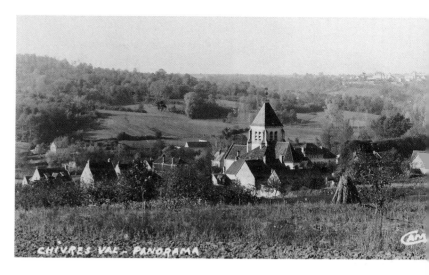

cover when the shelling began, running behind any hedges or buildings nearby, but this second line kept steadily on, while a third and fourth line now appeared from the river bank, each keeping about two hundred yards distance from the line in front. Our guns now fired like mad, but it did not stop the movement: a fifth and sixth line came on, all with the same wide intervals between men and the same distance apart. It was magnificently done.[9]

The 10th Infantry Brigade remained in the rear after stabilising a position behind the railway embankment west of Venizel to provide covering fire if a withdrawal had to be executed. The 68th Battery followed the 2nd Essex and 2nd Lancashire Fusiliers. Bringing up their artillery pieces piecemeal, they were not affected by the German bombardment. Despite the heavy shell, rifle and machine-gun fire the 2nd Essex and 2nd Lancashire Fusiliers continued to advance. Hauptmann Bloem:

The whole wide expanse of flat meadow-land beneath us was now dotted with tiny brown-grey men pushing on closer and closer, their attack obviously making for the position of the corps on our immediate right, from which rifle fire was already hammering into the advancing lines. Nevertheless they still moved forwards, line after line of them, and gradually disappeared from our view behind the wooded slopes at the southern end of the Chivres valley.[10]

With German forces entrenched in positions between 800 and 1500 yards away, Hunter-Weston's 11th Infantry Brigade held onto positions along the heights above Venizel unmolested throughout the day. Parties from the 1st Rifle Brigade were able to move through the woods and were able to reach the eastern side of St Marguerite and support 12th Infantry Brigade at 3.00pm. Here they could provide enfilading fire on German troops occupying trenches on the Chivres Spur. 12th Infantry Brigade requested them to attack the position from the south, but they were unable to do so because they were coming under heavy shrapnel fire.

The 2nd Royal Inniskilling Fusiliers also got across the Aisne at Venizel around 3.00pm. As soon as they broke cover and emerged from the wood at Moulins des Roche they came under heavy fire. They headed in the direction of Le Moncel and Missy.

Chivres. (Author)

A German field
gun positioned
along the heights
of the Chemin
des Dames in
the Aisne sector.
(Author)

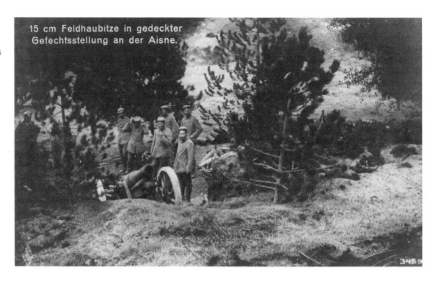

15 cm Feldhaubitze in gedeckter
Gefechtsstellung an der Aisne.

Three hours after they began their attack upon the Chivres Spur the 12th Infantry Brigade's advance was becoming bogged down in the thick undergrowth and swampy ground. German soldiers were firing upon them from trenches south of the village and from Chivres Spur above. At 5.00pm the 2nd Lancashire Fusiliers could advance no farther. Two guns from the 68th Battery Field Artillery positioned at Le Moncel were hastily put into action and provided covering fire, but this attracted heavy retaliatory machine-gun and artillery fire. Major C.L. Brereton:

> We were then ordered up about 4.00pm to support the infantry at the top of the hill. Found the Rifle Brigade there. We brought a section into action, and immediately got shelled like fury from two places. Went back and got up another section on the right. Noise appalling and could not make my orders understood. First rounds from the right section hit the crest, and by the time we had run these up it was getting dark. The shelling was by now quite furious, and we were only 800 yards from the German infantry, who turned machine guns onto us as well. Luckily it got dark, and we were able to withdraw with only the loss of one wagon, about six men wounded, and fifteen horses killed.[11]

The gun crews of the 68th Battery had to withdraw the guns to a sheltered position north of Venizel.

The 12th Infantry Brigade continued to hold onto the bridgehead they had secured. The action on 13 September was a costly affair for this brigade. The 2nd Essex Regiment at St Marguerite dug into positions on the ridge north of this village during that night. They had lost 10 killed, 32 wounded but despite coming under heavy fire they held onto their position. During

the period 15–30 September they lost 4 killed and 51 wounded. Captain Charles de Bohun Boone was mortally wounded and died on 23 September.

The 2nd Lancashire Fusiliers lost heavily during their attempt to wrest the Chivres Spur from determined German resistance. When the 2nd Lancashire Fusiliers were relieved by the 2nd Manchester Regiment during that night, they had lost 6 officers and 170 men. Lieutenant Cecil Stuart was amongst the dead. 2nd Lieutenant John Paulson was mortally wounded and died on 17 September.

The 2nd Royal Inniskilling Fusiliers had left one company to guard the bridge at Venizel. The remainder of the battalion advanced under heavy shell fire to St Marguerite where they established their line. They lost 5 other ranks killed, 44 wounded and 12 missing.

The 11th Infantry Brigade led by Hunter-Weston also settled into their positions along the ridge that overlooked Bucy-le-Long. The 1st Rifle Brigade had established positions at St Marguerite. A and B Companies held positons which skirted the northern perimeter of the village in a line that ran west then north towards the Le Moncel ravine. As C and I companies relieved A and B Companies, British artillery thought that they were German soldiers and shelled their position. The 1st Rifle Brigade lost 13 officers wounded, 4 other ranks killed, 33 wounded and 6 missing. During the period 14–18 September their casualties included Lieutenant-Colonel Biddulph and Captain Brownlow wounded, 17 other ranks killed, 58 wounded, 3 missing.

The BEF was greatly disadvantaged by the lack of artillery. However, some units of artillery did manage to get to the Aisne valley and provide limited support. The 126th Battery from the 29th Brigade supporting the 4th Division had set up their guns close to Billy-sur-Aisne

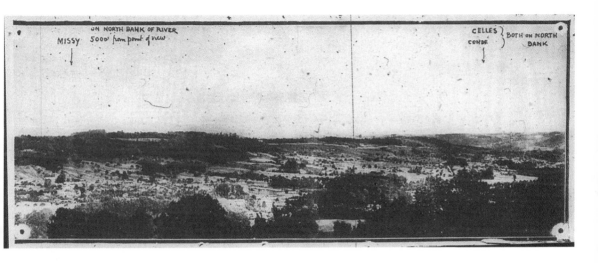

MISSY ON NORTH BANK OF RIVER 5000' from point of view CELLES CONDE } BOTH ON NORTH BANK

Above: View of the Aisne valley at Missy.
(*Highland Times*)

and fired 220 rounds at German batteries at long range. The 125th and 127th Batteries from the 29th Brigade fired from Le Carrier. The 14th Brigade Field Artillery and the 35th Howitzer Battery had reached positions south west of Acy by 4.30am where they were able to support the 4th Division.

The 68th Battery set up a position close to the Moncel ravine. After opening fire upon the Chivres Spur they attracted German counter bombardment and were forced to retire north of Venizel. They were joined by 39th Battery and 1 section from 88th Battery at nightfall. By then, the 88th Battery had four guns in position at La Montagne Farm, but did not fire any rounds. By 8.00pm the 35th Howitzer Battery was firing rounds behind the wood west of Moulin des Roches. The 31st Heavy Battery positioned 1 mile north west of Carrière l'Evêque Farm fired effective barrages upon German batteries attached to the German 3rd Division.

After another hectic day of movement and action the 68th Battery, 14th Brigade, returned to the village of St Marguerite where they were ordered to entrench in positions close to the Aisne for the night. Major Brereton:

> In the pitch dark we deposited our guns in the open plain just north of the Aisne. A very feeble effort to dig ourselves in, as we were all too tired, and then lay down wet and exhausted. I looked at our position and then said to Loch 'What a terrible a place to put us; we will catch it all right tomorrow.'[12]

5TH DIVISION FRONT: CROSSING AT CONDÉ AND MISSY

The 5th Division was ordered to capture the bridges at Condé and Missy. These bridges were four miles apart. It was found that the approach to Condé was exposed and it was considered imprudent to cross the Aisne there. German commanders had deliberately left this bridge intact in order to entice the BEF into a position where they would be obliterated by artillery. The decision was made to concentrate efforts on capturing the bridge at Missy.

The Cyclist Corps from the 4th Division had seized control of the bridge at Missy at 1.00am during the early hours on 13 September. They had left a small party to defend the captured crossing, but at 4.00am a German counter attack regained control and destroyed the bridge. Three German artillery batteries positioned on the Chivres Spur were able to fire upon Missy, but there was some cover afforded by trees that screened the bridge.

At 4.00am B and C Companies from the 1st Royal West Kent Regiment leading the 13th Infantry Brigade set off from Sermoise on the road that led down the valley towards the bridge at Missy. As B Company approached the bridge they came under heavy German machine-gun and rifle fire from concealed enemy positions close to the bridge. The Royal West Kent's suffered many casualties including Captain Frank Fisher. Fisher had been ordered to reconnitre the southern approaches to the bridge and was regarded as one of the battalion's 'most capable junior officers, a man of real character and great promise'.[13]

Despite the heavy fire No.6 and No.8 Platoons reached the southern bank where they established a firing line. British artillery provided some support as they pressed forward. The Germans were holding the northern approach to Missy Bridge in great strength, so strong in fact that it was futile for No.6 and No.8 Platoons to hold

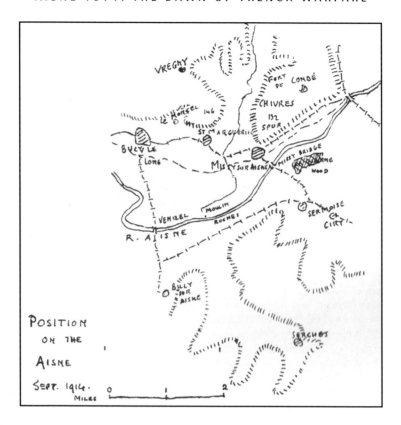

onto their exposed position. They were therefore ordered to retire to the railway embankment east of Sermoise. As they withdrew, Lieutenant Horatio Vicat was killed.

At 3.00pm the German soldiers occupying Missy withdrew. They may have heard that the 14th Infantry Brigade was currently crossing the river at Moulin des Roches and were advancing towards St Marguerite, which would threaten their position, or they might have wanted to retire out of range of British artillery. It was more likely that they were in fear of being outflanked by 2nd Lieutenant Holloway, who had led a party of men to the river bank unnoticed by the German machine gunners on the far bank. Holloway concealed a machine gun in a position with a clear line of fire and knocked out a German machine-gun position. Holloway reported to battalion HQ that the Germans had withdrawn from

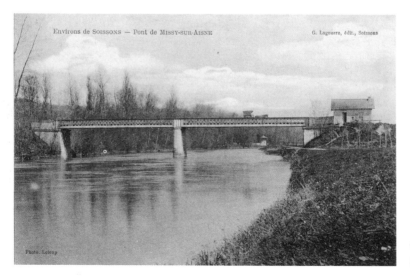

The bridge at Missy. (Author)

Missy and the 1st Royal West Kent's pushed forward to the bridge.

Holloway found a small rowing boat without oars along the river bank that could carry five men. Holloway, Sergeant Hodge and three other men clambered into this boat and using sticks poled across. One man took the small boat back to the south bank to pick up another four men. Holloway led his party into a wood and at the farthest perimeter they overwhelmed a German position. By 6.30pm 40 men from the 1st Royal West Kent's had crossed in the boat. These men were all under Holloway's command and were ready to advance from the wood when a German patrol was seen approaching along a road. It was getting dark and these German soldiers could be clearly seen, with a burning village in the background. The Royal West Kent's opened fire and broke up the patrol.

The Aisne west of the bridge at Missy. (Author)

Sappers from the 59th Field Company assessed the damage to the bridge at Missy and confirmed that three spans with cast iron lattice girders carried on piers 50 feet high above the river had been severely damaged. The Germans had destroyed the northern section of the bridge and there was a 50-foot breach, leaving the piers intact.[14] The river Aisne was 12 feet deep and 70 feet wide at Missy. The Royal Engineers immediately set up a raft to assist the transportation of the remaining elements of A and C Companies from the 1st Royal West Kent's across the Aisne. The 59th Field Company War Diary reported:

> The enemy was driven from MISSY bridge about 5.00pm and the company rushed on down to the river bank. Work was at once commenced preparing rafts for the passage of the 13th Brigade and by 8.00pm crossing was in full swing, one small boat, one timber raft and two hay bag rafts being employed.[15]

The bridge at Missy today. (Author)

The 5th Division were attracting heavy German artillery fire as they crossed the flat ground in the approach to the river at Missy. The other three battalions of the 13th Infantry Brigade, the 2nd King's Own Scottish Borderers, 2nd Duke of Wellington's (West Riding Regiment) and the 2nd King's Own (Yorkshire Light Infantry) were unable to reach the river bank due to the severity of the enemy fire and were forced to remain throughout the day at the village of Sermoise.

The 14th Infantry Brigade – the 2nd Suffolk Regiment, 1st East Surrey Regiment, 1st Duke of Cornwall's Light Infantry and 2nd Manchester Regiment – accompanied by the 121st Battery reached the south bank at Moulins des Roches, close to Venizel, on the morning of the 13th. The 17th Field Company were following close behind and were ordered to bring forward pontoons. It was extremely difficult for the sappers to come forward

The Aisne from the bridge at Missy looking east. (Author)

with the pontoons and necessary equipment to build a crossing because of the congestion of troops, carts and horses on the road. The 17th Field Company war diary recorded:

> At 9.00am received orders to take pontoons to the front, the company being, as usual, behind all the fighting troops, this was done with considerable difficulty, owing to the narrowness of the road, and the bad morale discipline of the troops in the front.[16]

The sappers reached Serches at 10.00am and Major Singer went forward to liaise with GOC 14th Infantry Brigade and discuss the options. Together they decided on a pontoon ferry and that a suitable position to cross would be at Moulin des Roches, where the river was 150 feet wide and 15 feet deep. The 17th Field Company reached the southern bank at 11.00am and they immediately constructed two pontoon rafts on a cable. A subsidiary ferry was built using a tarpaulin filled with hay. By midday the sappers had completed building the two pontoon rafts and the hay raft. At 12.15pm the task of ferrying the 14th Brigade began. Each pontoon raft could transport 60 men or 4 horses and 30 men during

each passage. The hay raft could accommodate 29 men on each trip. The sappers had done a tremendous job at Moulin des Roches, enabling infantry from the 2nd Manchester Regiment followed by the 1st East Surrey Regiment from the 14th Infantry Brigade, 5th Division, to cross during the early afternoon. Their crossing was concealed from the eyes of German artillery observers by the wood on the north bank. By 6.00pm the entire 14th Infantry Brigade had crossed the river except for the small arms ammunition carts.

By 3.00pm the 1st East Surrey Regiment and the 2nd Manchester Regiment had crossed with their equipment and pack animals. Without waiting for the remainder of the brigade to cross the river, these two battalions pressed ahead and advanced towards St Marguerite to support the 12th Infantry Brigade defending the village. As they left the cover of the trees at the river bank they came under a barrage of shrapnel from the Chivres Spur. This barrage prevented the two battalions from reaching the 12th Infantry Brigade and they had to take cover. They reached St Marguerite and linked up with the 12th Infantry Brigade later that day, when the moment of danger for the 12th Brigade had passed.

The 1st Duke of Cornwall's Light Infantry were still waiting to cross the Aisne when their sister battalions from the 1st East Surrey and 2nd Manchester Regiments were dodging the German artillery fire on the north bank. The Duke of Cornwall's had completed the crossing by 6.30pm that evening. German observers were unable to see them crossing and they attracted minimal artillery fire. The war diary of the 1st Duke of Cornwall's Light Infantry stated: 'The enemy showed little signs of opposing our crossing. A few rounds of shrapnel were fired at us as we debouched from the trees which hid our crossing.'[17]

The 14th Infantry Brigade was ordered to secure St Marguerite. The 1st East Surrey Regiment and the 2nd Manchester Regiment led the advance towards the village followed by the 2nd Suffolks and the 1st Duke of

Above and right: Two views of Condé. (Author)

The bridge at Condé had been deliberately left intact to lure British infantry into a trap where they would be cut down by well positioned German machine gunners in the village. (Author)

CONDE-SUR-AISNE. — Vue Panoramique.

Cornwall's Light Infantry in support. They encountered little resistence and entered St Marguerite at dusk, 7.30pm. However, they were unaware of the strength of the German forces fortified on the heights above them. Captain Arthur Nugent Acland:

> The other regiments in the Brigade came under shell fire as soon as they came out on the other side of a belt of trees behind which the rafts were working and our men were willing to raise the odds on a fight at any price. As a matter of fact we had hardly any trouble. We came under a fairly heavy shell fire as the other regiments had, but we only lost about six men wounded and, by the time we came to the mile of open ground across which we had to move to gain our objective – which was the village of St Marguerite – it was dusk and the enemies gunners could do little harm. We did not know in what strength the Germans were on the high ground above our village but the leading battalions had met a pretty severe fire in the valley on our right, so we knew there were some of them about. The brigade which had crossed the river on our left had swung across our front in some way, so that when we reached St Marguerite we found a certain amount of confusion reigning. However, that was put right and by 8.00pm, we had out our outposts all along the line. For ourselves, we slept in the street of the village, in reserve.[18]

The East Surrey's and the Manchester's held outposts around the village while the 1st Duke of Cornwall's Light Infantry remained in St Marguerite in support. The Suffolks were held in reserve at a farm north of Missy. Some of the men from the Duke of Cornwall's not on duty slept in the streets of the village. Captain Arthur Nugent Acland, Adjutant to the battalion recorded in his diary:

> And so ended the first day of the great Battle of the Aisne. If only we had been able to push right

on up and over the big hills and valleys facing us that night the whole course of the great battle might have been changed, but all the bridges were blown down and the crossing could not be effected rapidly enough by the means at our disposal to allow of a further general advance. I rather fancy that if we had been able to push on we should have kept the Germans on the run, for unless fresh troops had prepared the positions for days before their people had been pushed back from the Marne, I am sure they had not had time to dig themselves in thoroughly by the time we arrived on the scene.[19]

The 14th Infantry Brigade was aware that battalions from the 4th Division had secured the high ground north of St Marguerite. They thought that the 15th Infantry Brigade had crossed and were billeting at Missy. They had been crossing the Aisne since 9.00pm and the crossing took place throughout the night of 13/14 September. They did not reach Missy, which meant that the 14th Infantry Brigade's flank was totally exposed throughout the night. By 6.00am on 14 September the 14th and 15th Infantry Brigades consolidated positions around St Marguerite.

The 17th Field Company stopped work at 6.30pm on 13 September for a brief rest, then resumed the work of transferring the 15th Infantry Brigade across the Aisne throughout the night. By 6.00am on the 14th the 15th Infantry Brigade had successfully crossed to the north bank.

LIEUTENANT HORATIO VICAT

1ST BATTALION QUEEN'S OWN ROYAL WEST KENT REGIMENT
Horatio John Vicat was born on 24 June 1885 in Melbourne, Province of Quebec, Canada on 24 June 1885. On completing his education at Cheltenham College he went to the Royal Military College at Sandhurst. He was gazetted as a 2nd Lieutenant to join the Royal West Kent Regiment in January 1905 and

joined the 1st Battalion who were currently stationed in Malta. Vicat was promoted to Lieutenant in 1908 and for fourteen months during 1910–11 he was seconded to the Gold Coast Regiment where at Zonagara he took part in actions against native tribes. During the Battle of the Aisne on 13 September Vicat led a company from the 1st Queen's Royal West Kent Regiment to secure the bridgehead close to Missy occupied by German forces. Vicat was wounded and exposed to enemy fire. Vicat was highly respected by the men that he commanded. He was regarded as a 'valuable and popular officer'.[20] Four men from his company volunteered to brave machine-gun and shell fire to reach the wounded Lieutenant and

bring him to safety. They managed to reach Vicat but as soon as they lifted him they were targeted by a German machine-gun crew. Vicat and two of the men carrying him were killed instantly while the other two men were wounded. Vicat was buried 300 yards south east from Missy Bridge, but his grave was lost and he is therefore commemorated on the memorial at La Ferté-sous-Jouarre.

Lieutenant Horatio Vicat, 1st Royal West Kent Regiment. (*Bonds of Sacrifice***)**

SUMMARY: 13 SEPTEMBER

Later during the day the rain eased and the weather conditions improved. I Corps met considerable opposition when the German VII Reserve Corps reached the Aisne front to halt their advance.

Field Marshal French was unaware that there was a significant gap of 18 miles between the German 2nd Army at Berry-Au-Bac and the German 1st Army at Ostel village (north of Vailly). General von Bülow decided to make a stand along the Aisne valley. There they could hold the advancing French and British Armies and buy some time to ensure that reinforcements could plug the gap in the line between the German First and Second Armies. 17th Reserve Corps commanded by General Hans von Zwehl had been released after the fall of Maubeuge on 8 September and arrived at Braye en Laonnois on 13 September and took up positions on Von Kluck's left flank.

On 13 September a British foothold had been established across the Aisne. On the I Corps sector, battalions from the 1st Division were in control of the villages of Paissy, Moulins and Bourg-et-Comin. On the 2nd Division front the 5th Infantry Brigade had

captured Verneuil and Soupir, while one company from the 4th Guards Brigade was holding Chavonne.

On the II Corps front, the 8th and 9th Infantry Brigades from the 3rd Division were holding the line at Rouge Maison and Vauxcelles. There was a 3-mile gap between the 3rd Division and 5th Division, where two battalions from the 13th Infantry Brigade were in control of Missy. The 14th and 15th Infantry were holding the village of St Marguerite. On their right flank the 4th Division held the line from St Marguerite to Crouy.

The German 17th Reserve Corps was converging upon the Chemin des Dames from the north. By 2.00pm the entire German 13th Reserve Division, commanded by General von Kuhne, was in possession of the Chemin des Dames and was fortifying positions on the ridge as the men of the BEF were either approaching or crossing the river. At 4.00pm, the German 14th Reserve Division, commanded by General von Unger, also arrived at the Chemin des Dames, as its 27th Reserve Brigade together with three batteries were deployed adjacent to the 13th Reserve Division at Cerny preparing to confront the British 1st Division. Both the 13th and 14th Reserve Divisions belonged to the 17th German Reserve Corps, commanded by General Hans von Zwehl. Once the Belgian fortress at Maubeuge had capitulated on 7 September, the 17th Reserve Corps was ordered to move north to the Flanders coast where four battalions from the Royal Marines Light Infantry had landed at Zeebrugge. They set off on 8 September, but on 10 September these orders were revoked and 17th Reserve Corps was ordered to move south to join the German 7th Army. At 9.40am on 12 September their orders were again changed and they were told to march with great urgency to Laon. Aware that the BEF were approaching the river Aisne, General von Zwehl allowed his troops a two-hour rest at 6.30pm before pressing on through the night beyond Laon towards the Chemin des Dames. At 5.00am on 13 September the 17th Reserve Corps was 5 miles south of Laon. They had marched 40 miles in 24 hours and were given time to rest. Later that morning General von Zwehl received orders from General Von Bülow, commander of the 2nd German Army, to move onto the left of the First German Army, which was positioned along a Vailly–Soissons–Attichy line. At 9.30am General von Zwehl ordered his troops to advance towards Chavonne and the Chemin des Dames, sending the 13th Reserve Division to Braye en Laonnois and the 14th Reserve Division to Cerny. With the French advancing to 15 miles east of Chavonne, at 11.00am Von Bülow ordered Zwehl to send the entire 17th Reserve Corps to meet them. It was Zwehl's view that his force was committed to reaching the Chemin des Dames close to Chavonne and he made the decision to ignore Von Bülow's order and continue towards Chavonne. This was bad luck for the BEF because had Zwehl carried out Von Bülow's order and advanced

southeast to meet the French advance, there would have been a gap in the line and the BEF would have secured the Chemin des Dames; an ideal position to launch advances towards Laon, which could have caused the German line to the west to collapse near Soissons.

By the evening of 13 September, the 13th and 14th Reserve Divisions, which were severely weakened and exhausted, were defending the Chemin des Dames.

German forces held the advantage towards the end of that day. They were able to consolidate their positions along the high ground. From east to west the following German forces were deployed: II Cavalry Corps, VII Reserve Corps, III Corps, the 34th Brigade of the IX Corps, the II Corps and part of the IV Corps.

General von Moltke was relieved of his command and replaced as Chief of the General Staff by Lieutenant-General von Falkenhayn. Falkenhayn had been forwarned on 10 August that he would be appointed Chief of the General Staff if Moltke failed.

By the evening of 13 September General Franchet d'Esperey's troops had crossed the Aisne and were in contact with the British on the left flank. The French 6th Army had crossed and had made advances at Soissons under heavy German fire.

As the BEF was establishing a bridgehead across the Aisne General Sir Douglas Haig was convinced that the gap in the line between the German 1st and 2nd Armies had not closed since the Battle of the Marne.

By the end of the day Field Marshal Sir John French was ambivalent as to whether German forces were still retreating northwards. He wrote in his official dispatches (giving the date as 14 September, which should have been the 13th):

On the evening of the 14th, it was still impossible to decide whether the enemy was only making a temporary halt, covered by rearguards, or whether he intended to stand and defend the position. With a view to clearing up the situation I ordered a general advance.[21]

This contradicts his orders quoted below. The German opposition experienced on the Aisne could have been rearguard actions. French had been brought captured documents which indicated that the German Army was retreating. Joffre shared the same opinion. 'The enemy was retreating on the whole front without serious resistance on the Aisne and the Marne.'[22] Joffre ordered the pursuit of the enemy northwards with the objective of reaching a line between Laon, Suzy and Fresne. The only information at his disposal was that German forces had put up a strong rearguard action. He was unaware that German forces had entrenched their position along the northern ridges of the river. Joffre ordered the pursuit to continue from 6.00am on 14 September. Without adequate detailed intelligence and poor weather restricting aerial reconnaissance, Joffre was sending the BEF and French armies in pursuit of German forces that had already decided to defend the imposing and almost impregnable heights of the Aisne valley. Field Marshal French cascaded Joffre's orders to his BEF commanders and he reiterated the perception of the Allied commanders that the German Army was in retreat. In Operation Order 24 he ordered 'The Army will continue the pursuit tomorrow at 6am, and act vigorously against the retreating enemy.'[23]

NOTES

1. Hammerton, Sir John (ed) *The Great War, I Was There* (The Almalgamated Press, 1938)
2. IWM 87/8/1: Major E.H.E. Daniell, 2nd Royal Irish Regiment
3. Simpson, Major-General C.R., *The History of the Lincolnshire Regiment 1914–1918* (The Medici Society, 1931)
4. WO 95/1505: 2nd Essex Regiment War Diary
5. IWM 86/30/1: Major C.L. Brereton, 68th Battery, 14th Brigade, Royal Field Artillery
6. IWM 04/5/1: Sapper Albert Gumm, Royal Engineers
7. Ibid
8. Bloem, Walter, *The Advance From Mons 1914* (Peter Davies Ltd, 1930)
9. Ibid
10. Ibid
11. IWM 86/30/1
12. Ibid
13. Atkinson, C.T., *The Queen's Own Royal West Kent Regiment, 1914–1919* (Simpkin, Marshall, Hamilton, Kent & Co., 1924)
14. WO 95/1535: 17th Field Company Royal Engineers War Diary
15. Ibid
16. Ibid
17. WO 95/1564:1st Duke of Cornwall Light Infantry War Diary
18. Captain Arthur Nugent Acland's diary, Courtesy Cornwall's Regimental Museum
19. Ibid
20. Atkinson
21. Wyrell, Everard, *The History of the Duke of Cornwall's Light Infantry 1914–1918* (Naval & Military Press, 2004)
22. Edmonds, Brigadier-General J.E., *The Official History of the War Military Operations: France & Belgium 1914* Volume 1 (Macmillan & Co, 1933)
23. Ibid

THE CROSSING CONTINUES, 14 SEPTEMBER

German forces had successfully damaged the bridges at Venizel, Missy and Vailly. German infantry and artillery were entrenched on the ridges overlooking the valley and could observe all approaches to the river. The approach to Missy from the south was exceptionally vulnerable because the ground for three quarters of a mile south was flat and exposed. German artillery observers could easily direct fire upon British soldiers as they advanced towards it.

The role of the Royal Engineers had been grossly underestimated when war broke out. Brigadier-General G.H. Fowke of the Royal Engineers was sent to France with a staff of one clerk! He also brought with him two field companies for each infantry division and a field squadron for the Cavalry Division. En route to France Major-General Lindsay, artillery adviser to the BEF, commented to Fowke: 'I don't suppose that you will have much to do in this war!'[1] In reality the Royal Engineers were in the thick of things from the outset, preparing the crossings across the Mons-Condé Canal for demolition to delay the German advance at Mons in August; and at the Aisne a month later, repairing

damaged bridges and constructiing pontoons to cross the river.

At Missy one sapper swam across the Aisne and secured a small boat moored along the north bank and brought it to the south bank. Sappers from the 59th Field Company, Royal Engineers, used their initiative to build five rafts from straw, planks, and the material used to cover wagons to enable men of the 1st Royal West Kent Regiment to get to the north bank. Each boat could carry five men. When 40 men had crossed the river they fought off a German patrol and ensured that the crossing took place without harassment. When dawn broke on 14 September the 1st Royal West Kent Regiment and the 2nd Kings Own Scottish Borderers had successfully crossed and dug trenches in woods on the north bank. The 59th Field Company Royal Engineer's war diary recorded that by 6.30am on 14 September:

Two battalions of the 13th Brigade had been got across the river during the night and work had just been commenced on taking a section of the bridge when the enemy decided to attack. The south bank

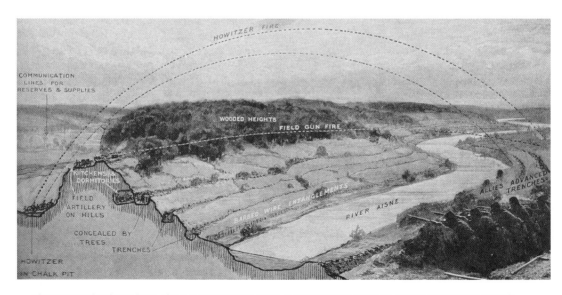

Diagrammatic view of the Aisne valley during 1914. It shows how German artillery positioned their large calibre howitzers behind the ridges of the Chemin des Dames. (*The Great War*)

British soldiers crossing the Aisne under heavy shell fire, 14 September 1914. (Author)

of the river where the rafting was being done was under rifle fire and no more troops crossed, but communication was kept up all day across the river and the battalions in the firing line kept supplied with ammunition, while the wounded were got back across the river.[2]

German artillery targeted the southern banks of the Aisne at Missy and bombarded the village of Sermoise, where the 59th Field Company were billeted, causing casualties and panic amongst the horses. The war diary reported:

The farm in which the company was billeted was wrecked by shell fire. One driver was killed, six men wounded, six horses were either killed or so badly hurt they had to be destroyed. Some of the horses stampeded. Work was continued throughout the night of the 14th and 15th getting over supplies and ammunition to the 13th Brigade and evacuating the wounded.[3]

The 17th Field Company were also transporting soldiers, supplies and horses across the Aisne using two rafts

farther along the river from Missy at Moulin des Roches. The 15th Infantry Brigade used these ferries to get across in the early hours of 14 September. Lieutenant Jimmy Davenport, 1st Bedfordshire Regiment, was detailed to surpervise the crossing of the Brigade horses from 2.00am. Despite the dark and the screen of a cluster of trees on the northern bank the crossing was vulnerable to heavy German shell fire, which not only shook the nerves of the soldiers crossing the river but disturbed the brigade horses, which bolted during the passage. Davenport was in charge of 60 riding and pack animals:

The battalion crossed over on two rafts, or the old Crow's Nests, being pulled from side to side by ropes and got over about 3.30am, the 13th Brigade crossing at Missy. I started with the horses at 4.30am assisted by the 17th Company RE under Major Singer.

We had an awful time getting them across as the banks were very steep and the current pretty strong although the river itself was no breadth. We lost and eventually recovered 5 horses including the General's pet charger and nearly drowned Major Singer. It happened as follows: He was pushing off one of the rafts when he slipped and to save himself falling into the river had to cling on to the raft and half in the water was dragged across with it. His head was on a level with the edge of the raft and within a few inches of one of the horse's hoofs.

Going over the horse got frightened and started to kick and we held our breath, expecting every minute to see him catch a kick on the head. By skilful wriggling he however managed to escape them and got over safely, but it was a near thing.

Those horses that did kick themselves into the river had a bad time as the stream was very strong and they were carried downstream at once. We got a boat going and saved them after much difficulty but even then did not recover one for some hours afterwards.[4]

The 2nd Royal Irish Rifles of the 7th Infantry Brigade were initially told to prepare to march at 3.30am, then told to stand down. They received the same orders four times throughout that morning and were told to stand down three times. It must have been extremely wearisome and frustrating for these soldiers to be kept up for hours in such atrocious weather conditions and to be told to stand to and then stand down continually. They received the fourth set of orders to move at 7.00am and headed for woods east of Chassemy. They were then ordered to follow the 1st Wiltshire Regiment to the southern banks of the river at Vailly and cross. German artillery fired heavy bombardments at the Vailly

Horses and ammunition being ferried across the Aisne. (*The Church in the Fighting Line*)

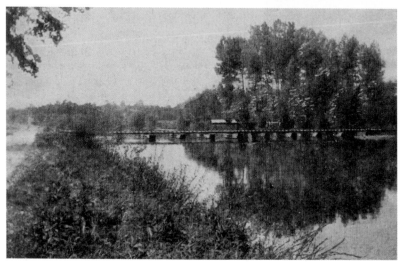

A pontoon bridge constructed by the Royal Engineers across the Aisne near St Marguerite. (*The Church in the Fighting Line*)

crossing point and the two battalions were ordered to turn eastwards along a track that ran parallel to the river. The track was covered by trees and within a mile they reached a railway bridge that had been destroyed. Next to it, the Royal Engineers had built a footbridge consisting of a single plank in width. As the 1st Wiltshires approached this 'bridge', soldiers from the 1st Lincolnshire Regiment who were withdrawing from an engagement at Rouge Maison Farm were rushing back to get across it from the north bank. The 1st Wiltshires used the footbridge to get across the river first. The 1st Wiltshires drove the enemy back at Rouge Maison.

The 2nd Royal Irish Rifles followed the 1st Wiltshires and came under heavy shell fire. Captain Gifford and Lieutenant Cowley were amongst the wounded. The chronicler of the Royal Irish Rifles wrote: 'It was an uncomfortable performance, this passage of a wide, swollen river on a crazy plank, with shrapnel

bursting overhead and shells plumping into the water below, but it was accomplished with singularly small loss.'[5]

On reaching the other side of the Aisne they moved on to the left flank of the Wiltshires' position at Rouge Maison. The 1st Lincolnshires were ordered to go back across the river to the north bank.

The 2nd Duke of Wellington's Regiment and the 2nd King's Own Yorkshire Light Infantry from the 13th Infantry Brigade held their positions south of the river at Ciry-Salsogne and Sermoise despite the artillery bombardment. The 59th Field Company laboured for the rest of the day repairing the approach road to Missy that was badly damaged by German shell fire to enable reinforcements and supplies to get to the banks of the Aisne.

Sappers continued to make frantic efforts to repair and construct bridges across the Aisne under German shell fire. Considerable casualties were sustained as

they worked. By midday on 14 September they had successfully repaired the road bridges at Venizel, Missy and Vailly. The railway bridge east of Venizel was also repaired. The Royal Engineers skilfully created eight pontoon bridges across the Aisne. It was a tremendous achievement under horribly difficult and dangerous circumstances.

Brigadier-General Henry Wilson had set up 4th Division headquarters in a café close to the south end of the bridge at Venizel. Although this position was vulnerable to German shell fire it remained untouched for some time. The Royal Engineers had completed a pontoon bridge near to the Venizel road bridge at 5.30pm and this allowed the 10th Infantry Brigade to cross. The entire 4th Division was on the north side of the river by that evening.

The 1st King's (Liverpool) Regiment crossed the river Aisne at Pont Arcy. Private Heys:

The river is 50 yards wide and we had to cross on a single girder about 9 inches wide. It was a feat of tightrope that never fell to the lot of a British soldier before. The bullets were as numerous as hailstones and the shells, well, they defy description. The cries of the wounded who had been knocked off the girder and drowning enough to turn a man's brain. But worse was to follow. I shook hands with myself when I got over but I was just a little too previous, no sooner had we got over than thousands of Allemandes swept onto us and we had to beat a hasty retreat on improvised rafts. These rafts were made to hold about a dozen men but owing to the scarcity of them we got 30 and even 40 men on them and the consequences were that we were a good 4 ft in the water and drenched up to our chests. By this time we could hardly put our own feet down without treating on a dead comrade. It was estimated that 10,000 dead were lying about after we had taken the river. It was a ghastly sight that I don't wish to see again. After we retired on the rafts we had about 5 minutes wind and then re-crossed only to be driven back by a perfect stream of bullets and shells. However, the river had to be taken so we went farther down and crossed by a pontoon bridge that the RE had erected. Smith-Dorrien who was our General said we must stick it this time or go under. We got safely over. It was however nothing but a death trap, there seemed to be millions of the grey-clad figures but we stuck it, although it cost us dearly. There were enough discarded rifles to equip 2 or 3 regiments.[6]

Shells falling around the crossings propelled fountains of water into the air, this and the falling rain made the girders of the bridges extremely slippery.

The 1st Irish Guards had to march from Bourg-et-Comin along the southern banks of the river to Pont Arcy where they used the pontoon bridge. The 1st Irish Guards had to dash across. Private L. Kilcoin recalled: 'Pontoon bridge erected, however was being shelled incessantly by the Huns – we had to cross in small parties at the double. All got across safely, under shell fire all the time.'[7] 2nd Lieutenant Neville Woodroffe of the 1st Irish Guards recalled one moment at the Pont d'Arcy when 'the pontoon went smash, killing 9 horses and farriers who were on it at the time.'[8]

By the end of the 14th the Royal Engineers had built eight pontoon bridges and one footbridge. They had also repaired five of the damaged existing bridges, making it possible for troops, horses, artillery pieces, equipment and ammunition to cross to the north bank.

CAPTAIN WILLIAM JOHNSTON VC
59TH FIELD COMPANY, ROYAL ENGINEERS

William Henry Johnston was born on 21 December 1879 in Leith, Scotland. He came from a military family and attended the Royal Military College at Woolwich. In 1897 he married Mary Edwards at Emmanuel Church in Sheffield. Johnston received a commission to serve with the Royal Engineers on 23 March 1899. He served in Gibraltar and for five years worked in intelligence. Johnston was promoted to Lieutenant on 19 November 1901. He then spent a few years in England with the survey department in England. He was sent to China in 1908 to survey the border between China and the British colony of Hong Kong. In 1912 he worked for the Geographical Section of the War Office. In 1913 he attended Staff College and began a course there In January 1914. When the war started, Johnston, who by that time had attained the rank of Captain, joined the 59th Field Company, Royal Engineers. Initially, Johnston was in command of a mounted section. Johnston supervised the construction of a pontoon bridge across the Haine to enable infantry to withdraw across the river in southern Belgium.

Captain Johnston and his colleague Lieutenant Robert Flint from the 59th Field Company organised the construction of crossings over the Aisne on

Captain William Johnston VC. (De Ruvigny's Roll of Honour, 1914–1918)

13 September between Missy and Venizel, near to Moulin des Roches. During the next day Johnston and Flint helped transfer troops from the south bank to the north bank of the Aisne at Moulins des Roches using two rafts. These rafts had a capacity of 60 men together with boxes of ammunition.

This work was carried out throughout 14 September from dawn until 7.00pm during that evening. Johnston and Flint must have suffered terribly from strained muscles and blistered hands as they continued to row across the Aisne throughout the day. On return journeys they brought back the wounded from the north to the south bank. As they ferried reinforcements with much needed ammunition to support the bridgehead and evacuated the wounded they were under constant German shell fire.

Brigadier-General Count Gleichen commanding the 15th Infantry Brigade remembered Johnson as 'a wonderful fellow all round ... and if there was a dangerous piece of work on hand, he was always first in giving the lead.'[9]

Johnston and Flint's actions that day enabled battalions from the 14th Infantry brigade on this section of the river to consolidate their bridgehead. It was through their strenuous efforts that the 14th

Infantry Brigade was able to make contact with the 4th Division and help in repelling a strong German counter attack, which took place at 3.00pm. Johnston was awarded the Victoria Cross for his valiant efforts to get men, supplies and the wounded back and forth across the Aisne His VC citation reads:

> At Missy on 14th September under a heavy fire all day until 7pm, worked with his own hands two rafts bringing back wounded and returning with ammunition; thus enabling advanced Brigade to maintain its position across the river.[10]

King George V presented Captain Johnston with the Victoria Cross on 3 December 1914 at General Headquarters in France. Johnston was appointed commander of 172nd Company in March 1915. Two months later he was appointed Brigade Major, but on 8 June 1915 he was killed by a German sniper close to St Eloi in Flanders. Brigadier-General Count Gleichen commanding the 15th Infantry Brigade was with Captain William Johnston on the day he died:

> Johnston, V.C., R.E. was in charge of our trenches. (Poor fellow, he was killed by a sniper near St Eloi

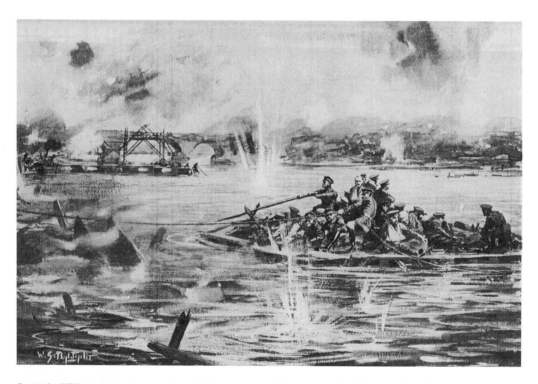

Captain William Johnston rowing soldiers and supplies across the Aisne at Moulin des Roches under heavy German fire on 14 September. His bravery earned him the Victoria Cross. (*Deeds that Thrill the Empire*)

on April 15). He must have worked something like eighteen hours out of the twenty four. For by 9am he was collecting material near Dranoutre and receiving reports, and settling his company administrative work. At 11.30 he came to see me, and we discussed and settled the ensuing night's task. Then back to his farm to give out instructions to his sappers, and fifty other things to do before he rode out about 6pm to the trenches remaining there till 3am or even 6am – to superintend the work and struggle about in the mud all night. He never spared himself an ounce. He was occasionally so nearly dead with want of sleep that I once or twice ordered him to take a night's sleep; but he always got out of it on some pretext or other ... His death was a very heavy loss to the Brigade.[11]

Johnston was buried at Perth Cemetery (China Wall), Zillebeke.

LIEUTENANT ROBERT FLINT DSO
59TH COMPANY, ROYAL ENGINEERS
Robert Bradford Flint born in 1891 at Blackheath, London. He was educated at Lindisfarne, Blackheath and at Cheltenham College. He joined the Royal Engineers on 20 July 1911. During the retreat from Mons Lieutenant Flint blew up a bridge across the River Haine. He was mentioned four times in dispatches and was awarded the Chevalier of the Legion of Honour for gallantry during the operations

Lieutenant Robert Flint DSO. Flint operated a raft across the Aisne on 14 September, and was awarded the Distinguished Service Order for his courage. His actions, and those of Captain William Johnston, enabled the 14th Infantry Brigade to establish a bridgehead on the north bank of the Aisne. (*The Distinguished Service Order 1886–1915*)

21–30 August 1914. During the Battle of the Aisne Flint distinguished himself by rowing reinforcements of men and ammunition to the north bank of the Aisne on a raft throughout 14 September under enemy shell fire. Flint was awarded the Distinguished Service Order. His citation stated:

> At Missy on 14th September, under a heavy shell fire, assisted Captain W.H. Johnston in working all day until 7pm with their own hands two rafts bringing back wounded and returning with ammunition, thus enabling the advanced brigade to maintain its position on the other side of the river.[12]

Flint was working in the trenches on 22 January 1915 in Flanders when he was mortally wounded. He died a few hours later and was buried at Dranouter Churchyard.

CAPTAIN THEODORE WRIGHT VC
57TH FIELD COMPANY, ROYAL ENGINEERS
Theodore Wright was born in 1883 in Brighton. Educated at Clifton College he then attended the Royal Military Academy, Woolwich. He excelled at cricket and represented the Army in a match against Hampshire. After passing out in October 1902, he joined the Royal Engineers. During his initial service with the corps he served in Gibraltar and Cairo. By the time the war began he had attained the rank of Captain.

During the opening Battle for Mons, Captain Theodore Wright acted as Adjutant and was ordered to prepare the destruction of several bridges across the Mons-Condé Canal for the eventual retreat from Mons. Wright was wounded by shrapnel while overseeing the 57th Field Company laying charges to blow these bridges. During the afternoon Wright received notification of the order to withdraw, but he had to destroy five bridges on a front of three miles. A car was used to drive him between the bridges. German shells

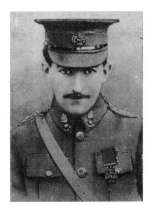

Captain Theodore Wright VC. (Author)

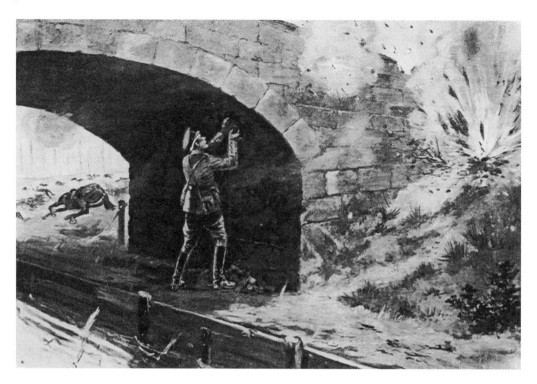

Captain Theodore Wright preparing charges to destroy the bridge at Jemappes during the Battle of Mons on 24 August. (*Deeds that Thrill the Empire*)

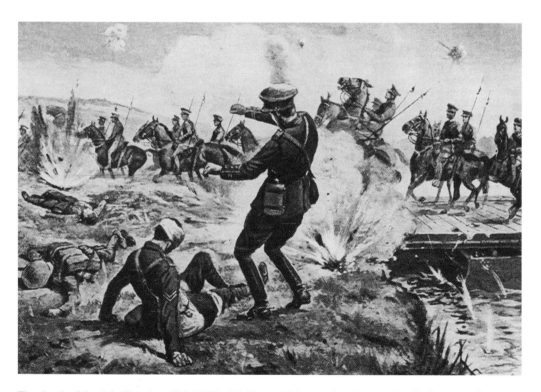

The death of Captain Theodore Wright VC at Vailly on 17 September. (*Deeds that Thrill the Empire*)

were exploding all around the car, which was carrying eight boxes of dynamite. He was first driven to the bridges at Jemappes and Dayos Bridge around 3.00pm. Corporal Charles Jarvis was working the bridge at Jemappes. He testified: 'The work on the bridge was done under fire from three sides. Near the bridge I found Captain Theodore Wright, V.C., wounded in the head. I wished to bandage him, but he said, "Go back to the bridge! It must be done" – and so I went.'[13]

The bridge at Jemappes was blown. Wright did not make an attempt to blow the bridge at Lock 2 and the one adjacent to it through lack of time. Working against the clock, Wright decided to target the bridge at Mariette, which carried a main road. If this bridge was blown then it would seriously delay the mighty German Army. Wright's driver between the bridges along the Mons–Condé Canal recalled:

Poor Captain Wright got killed here the other day. He was the officer who got wounded in the head while I was driving him at Mons. When I was under fire there I took a wounded soldier to the hospital, and returned into the fire for the captain. It was a bit risky with eight cases of dynamite on the car. But he was a brave man.[14]

Despite sustaining a head wound Wright carried on with the task of setting charges under the Mariette Bridge. Aided by Sergeant Smith he was able to connect electricity leads to a power supply from a local house. The current did not activate the detonator. German infantry were close by, firing at him from 30 yards. He made several attempts to connect other leads but failed. Exhausted from his attempts to blow the bridge and from his own wounds he fell into the canal and had to be recovered by Sergeant Smith. Infantry from the 1st Northumberland Fusiliers provided covering fire from behind barricades on the southern bank of the canal. Wright and the Royal Engineers were the last units from the BEF to leave the canal around 5.00pm. Of the eight targeted bridges across the canal only the bridge at Jemappes was completely destroyed.

Three weeks later Wright was involved in the Battle of the Aisne which was a completely different scenario. This time it was the job of Wright and sappers from the 57th Field Company to repair bridges and build pontoon bridges. Under heavy German shell fire Wright and his sappers achieved their objective.

Three days later, on 17 September at Vailly, German artillery were bombarding the north bank. There was no prospect of the 5th Cavalry Brigade advancing during that day and it was decided that they should be withdrawn across the Aisne to the south bank for safety. As the 5th Cavalry Brigade was crossing the pontoon bridge at Vailly, German artillery targeted them as they withdrew. Captain Wright was killed by a shell as he was helping a wounded casualty crossing the pontoon bridge.

Wright was posthumously awarded the Victoria Cross for his actions at Mons on 16 November 1914. His citation:

For gallantry at Mons on 23rd August in attempting to connect up the lead to demolish a bridge under heavy fire. Although wounded in the head he made a second attempt. At Vailly, on the 14th September, he assisted the passage of 5th Cavalry Brigade over the pontoon bridge, and was mortally wounded while assisting wounded men into shelter.[15]

Colonel Wilson of the Royal Engineers was greatly affected by the death of Wright and wrote the following tribute to him in a letter of condolence to his mother:

No one has earned a V.C. better, and I have always been very fond of him. He was one of the finest officers I have ever had, and I feel his loss every day … I enclose a cutting you may not have seen from a letter of one of the Scots Greys officers, and I can endorse every word of it.[16]

The testimony that Colonel Wilson was referring to was written by an officer present when Captain Wright was killed at Vailly.

We got across the river … the day before yesterday, a bit before our time, and had to get back over a pontoon bridge considerably quicker than was pleasant – under a very unpleasant fire, too. At the head of the bridge was a gallant Engineer officer, repairing bits blown off and putting down straw as cool as a cucumber – the finest thing I have ever seen. The poor fellow was killed just after my troop got across. No man ever earned a better V.C.[17]

King George V wrote a letter of condolence to his mother:

It is a matter of sincere regret that to me that the death of Captain Theodore Wright deprived me of the pride of personally conferring upon him the Victoria Cross, the greatest of all military distinctions – George R.I.[18]

Captain Theodore Wright was buried at Vailly British Cemetery. His epitaph reads: 'Until the Day Dawn'.

SAPPER EDWARD MERCHANT 14562

11TH FIELD COMPANY ROYAL ENGINEERS

Edward Merchant was born in 1889 in Ipswich, Suffolk. Edward joined the Suffolk Royal Garrison Artillery Militia on 25 July 1905. He gave his age as 17 years and 6 months, but in fact his real age was 15 years and 10 months and he was of course under age to serve. Affectionately known as 'Big Ted' by his Army comrades, he excelled at sports, boxing and playing football for the Army. He was later transferred to the reserve and found employment as a foundry worker. When war broke Edward Merchant was mobilised. He left Aldershot by train on 15 August bound for Southampton where he boarded the SS *Minnesota*. Attached to the 11th Field Company Royal Engineers as a Sapper he arrived in France at midnight on the night of 16 August. The 11th Field Company was attached to the 2nd Division and on 13 September they supported the efforts to cross the Aisne at Pont Arcy where they

constructed a pontoon bridge under German shell fire. During the operation on the Aisne Sapper Edward Merchant sustained a severe wound to his head from shrapnel. He did not receive medical attention for three days. He was left for dead until he was found suffering from the effects of double pneumonia, in addition to his shrapnel wounds.

Evacuated to England he recovered from his wounds at a military hospital in Eastbourne. He gradually lost sight in one of his eyes and never completely recovered from the wounds he suffered during the Battle of the Aisne. He carried the scars from the battle in the decades after the war, for his son recalled his picking little pieces of shrapnel from his head 20 years later. Edward's wife would die prematurely of tuberculosis in 1930, and he would later remarry. He had a series of jobs after leaving the Army including working at Ipswich Docks. Edward suffered from heart problems and frequently received treatment in hospital. Such was the ordeal that he experienced on the Aisne that he never spoke of his involvement in the war. His son found out about his father's experiences from his uncle.

Edward Merchant died aged 53 in Ipswich in 1943. His death certificate stated that he was an Army Pensioner. His son Arthur went AWOL in 1943 to attend his father's funeral. He would discover to his horror that his stepmother had disposed of Edward Merchant's Mons Star and other medals. Arthur had followed his father and joined the Royal Engineers during the Second World War. He served with R Force, a secret branch of 21st Army Group, whose commander Colonel David Strangeways reported directly to General Bernard Montgomery, who during the First World War had also been present at the Battle of the Aisne. Arthur was covertly landed at Arromanches, Normandy at 2.12am on 6 June 1944, acting as guard to the frogmen who were sent in to disconnect some of the mines before the caissons and pontoons were assembled to construct the Mulberry Harbour, named Port Winston, at Arromanches. The frogmen got back to their ship but Arthur had to hide amongst the cliffs as British warships bombarded the coastline in preparation for the landing.

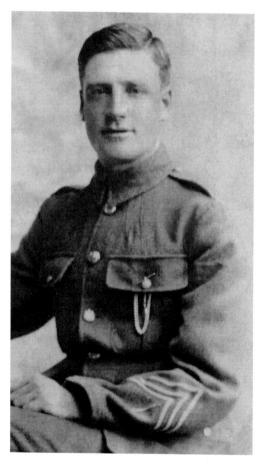

Sapper Edward Merchant. (Courtesy Robert Merchant)

2ND LIEUTENANT HENRY RENNY-TAILYOUR

5TH FIELD COMPANY ROYAL ENGINEERS

Henry Frederick Thornton Renny-Tailyour was born in 1891 at Homebush, Sydney, New South Wales. He was educated at Rugby and at the Royal Military Academy, Woolwich. He was gazetted as a 2nd Lieutenant with the Royal Engineers on 20 December 1912. He went to France on 15 August 1914 with the 5th Field Company. Despite being wounded during the Battle of the Aisne he

2nd Lieutenant Henry
Renny-Tailyour.
(Bonds of Sacrifice)

continued to carry out his duty under shell fire. Renny-
Tailyour was killed at Ypres on 11 November 1914 and
his name is commemorated on the Ypres (Menin Gate)
Memorial. He was mentioned in French's Dispatch on
14 January 1915 for gallant and distinguished service
in the field.

SAPPER CLAUDE MERCHANT 14509
5TH FIELD COMPANY ROYAL ENGINEERS

Claude Stephen Merchant was born in 1888 in Ipswich,
Suffolk. Claude joined the Royal Engineers in 1905. He
left the Corps on 22 July 1912 and was transferred to
the Reserve. He worked for the Great Eastern railway
until he was mobilised when the war broke out. He
joined the colours on 5 August 1914 and was sent to
France with the 5th Field Company Royal Engineers. On
13 September the 5th Field Company built a pontoon
bridge at Pont Arcy to enable the 5th Infantry Brigade
to cross. Claude's brother Edward Merchant was serving
with the 11th Field Company who worked with the 5th
Field Company on the same bridge. Claude Merchant
participated in the Battle for Nonne Bosschen. Claude
never discussed his experiences with his family. He
served in France and Flanders throughout the war. After
being demobilised in March 1919 he returned to work
for the Great Eastern Railway. Claude Merchant died in
1958 in Ipswich.

Above: Sergeant Claude Merchant. (Courtesy
Robert Merchant)

SAPPER ALBERT GUMM 27135
AT CABLE SECTION, ROYAL ENGINEERS

Albert Edward Gumm was born in 1890 in Ilfracombe.
He worked as a postal clerk before the war. Gumm
served with the AT Cable Section, Royal Engineers and
worked on the bridge at Venizel during the Battle of the
Aisne. In 1917 Gumm received the Military Medal. After
the war he returned to the Post Office at Illfracombe.
During the Second World War he worked in Oxford and
later Luton and performed fire watching duties at the

**Sapper
Albert Gumm.
(Courtesy
Brian Gumm)**

R.E. CAMP. CHERITON. 1914. 164.

Above: Sapper Albert Gumm is far left in this 1914 picture of the RE at Cheriton. (Courtesy Brian Gumm)

General Post Offices in these towns. When he retired he was Deputy Postmaster at Brighton. Albert Gumm died in Reading on 18 February 1982.

2ND LIEUTENANT JOHN MANLEY
26TH FIELD COMPANY, ROYAL ENGINEERS

John Dundas Manley was born in West Bromwich, Staffordshire in 1892. He was educated at Cheltenham College and at Emmanuel College, Cambridge, where he graduated with a Mechanical Science degree. While at university he served with the Officer Training Corps. In June 1913 he received a commission in the Special Reserve of Officers,

2nd Lieutenant John Manley. (*Bonds of Sacrifice*)

Royal Engineers. In 1914 he was given an appointment in the Indian Public Works Department. He was intending to sail to Bombay to take up this position in September 1914, but with the outbreak of war he joined 26th Field Company, Royal Engineers and was given command of No.4 Section. They sailed for France on 14 August. He was killed on 26 September 1914 during the Battle of the Aisne. He was in the front line, supervising the construction of trenches and barbed wire defences close to Vendresse when a shell killed him instantly. Colonel Schreiber, Royal Engineers wrote the following words in a letter of condolence to his mother, Alice:

I feel I must write and tell you of my sympathy and of the high opinion that had been formed of your boy. He had been in charge of a section of his company detached with the front line of the 3rd Brigade, and the General and his Staff Officer both expressed to me their great sorrow at his loss, and their appreciation of the excellent work he had done for them. I had personally come especially in contact with him several times since he was detached, and was much impressed with the excellent spirit in which he was carrying on his independent duties. There must be this consolation, that his death must have been instantaneous, as he was apparently killed by the burst of the shell without actually being hit, and also there is the feeling, of which you should be proud, that he was killed actually on the

field of battle while on the execution of his duty. He had borne his share of the great hardships the company had gone through, and was very much appreciated by his brother officers.[19]

Major H.L. Pritchard also wrote a letter of condolence to his mother:

I cannot tell you how much all the officers of the 26th Company sympathise with you in your bereavement, and how we mourn the loss of your son, while to me, his commanding officer, it is a serious handicap to lose such a keen and valuable officer. It will also, I hope, be some consolation to you to know what the General under whose orders he was working (having been detached from me) had several times on days just prior to his death told me how much your son was helping him and what a good fellow he was. In fact, the General appreciated his services as much as I did. Your son has died for his country in the very front line, and has done his part nobly to serve his country at a time of great crisis.[20]

The body of 2nd Lieutenant Manley was brought down from the trenches during the night when the German barrages had subsided. He was buried that night at Vendresse Churchyard in the presence of his section. Manley was highly regarded by the men that he commanded.

We could not bring your son down from the trenches until that night when myself and two more sappers carried him down to the hospital until the grave had been dug. We buried him that night with full military honours, our section turning out in respect for poor Lieutenant Manley, who was thought the world of by his section, and highly respected by everyone. In a country graveyard in Vendresse there is a stone, just a plain graveyard stone, marking the burial place of an officer and a gentleman.[21]

Manley rests in Vendresse Churchyard. His epitaph reads: 'OURS NOT TO REASON WHY, OURS BUT TO DO AND DIE'.

NOTES

1. Brown, R. Baker, *The History of the Corps of Royal Engineers* Volume V (Institution of Royal Engineers, 1952)
2. WO 95/1535: 59th Field Company, Royal Engineers War Diary
3. Ibid
4. Lieutenant J.S. Davenport Account, Bedfordshire & Luton Archives
5. Falls, Captain Cyril, *The History of the First Seven Battalions: The Royal Irish Rifles in the Great War* (Gale & Poleden, 1925)
6. IWM MISC 223 (3210): Private Heys, 1st King's (Liverpool) Regiment)
7. Pte L.L. Kilcoin, 1st Irish Guards diary, Irish Guards Regimental Headquarters Archive
8. IWM 95/31/1: 2nd Lieutenant Neville Woodroffe, 1st Irish Guards
9. Gleichen, Brigadier-General Count, *The Doings of the Fifteenth Infantry Brigade* (William Blackwood & Sons, 1917)
10. *London Gazette* 28985, 24 November 1914
11. Gleichen
12. *London Gazette* 29001, 8 December 1914
13. Clutterbuck, L.A., *Bonds of Sacrifice: August to December 1914* (1915, republished by Naval & Military Press, 2002)
14. Ibid
15. *London Gazette*, 13 November 1914
16. Clutterbuck
17. Ibid
18. Ibid
19. Ibid
20. Ibid
21. Ibid

PART TWO

BATTLE OF THE AISNE

A very heavy mist had descended upon the Aisne valley during the morning of 14 September. Joffre had issued Special Instruction No.24 directing the pursuit of the German armies to continue energetically. The expectation was that they would only encounter small German parties in rearguard actions. British and French forces were unaware that the German armies had fortified themselves on the ridges north of the Aisne and were supported by howitzers. British commanders were unable to see the German positions on the spurs and ridges covered by trees and foliage. The BEF did not know if the crest of the ridge of the Chemin des Dames was held by German forces offering a rearguard defence for the retreating main force or was defended by a determined enemy ready to make a more permanent stand.

This thick mist that covered the Aisne valley would enable the British divisions to cross the Aisne without being unduly troubled by German artillery fire during the early hours of the morning. Once the mist lifted, German artillery observers knew the ranges so that as soon as the British set foot on them they would be met with a torrent of shell fire. German artillery was positioned on the Craonne plateau, on which the Chemin des Dames road ran from east to west. Guns were concealed along the wooded ridges and behind them. More artillery was positioned on the Ailette Ridge farther north. German forces did not have time to settle and develop a deep defence system on 14 September. The troops had little knowledge of the ground that they were defending. There existed gaps in their lines and German High Command was eager to see the arrival of fresh troops, who were marching from Maubeuge.

After the battle, Field Marshal French recognised and described the advantages of Chemin des Dames as a formidable defensive position in his dispatch of 8 October 1914:

> The position held by the enemy is a very strong one, either for a delaying action or for a defensive battle. One of its chief military characteristics is that from the high ground on neither side can the top of the plateau on the other side be seen, except for small stretches. This is chiefly due to the woods on the edges of the slopes. Another important point is that all the bridges are under either direct or high angle artillery fire.

Maps of the Aisne region were poorly distributed within the BEF at a regimental level and British soldiers also did not know the ground. They would be advancing uphill, with reinforcements introduced piecemeal without any artillery support. The weather was against them as cold, persistent rain blew in from the north west into their faces. The fog caused confusion in identifying friend or foe during the battle that day. Artillery observers were also unable to register German targets because of the fog.

It was on 14 September that the main Battle of the Aisne took place, comprising four actions – at Chivres, Soupir, Verneuil and Troyon. This, the first day of successful entrenchment of the war, would see the BEF attack to no avail, and the German forces launching counter attacks without taking any ground. It was at the Aisne that the line stabilised. 14 September marked the dawn of trench warfare and the Western Front.

BATTLE FOR THE SUGAR FACTORY AT CERNY

Reconnaissance parties from General Sir Douglas Haig's I Corps had ventured north from the banks of the river. At midnight on the night of 13 September the 2nd King's Royal Rifle Corps commanded by Lieutenant-Colonel Pearce Serocold sent a patrol of eight men from C Company, led by Lieutenant Balfour, north of Troyon to search for the location and ascertain the strength of German positions along the Chemin des Dames. Before the battle, the hamlet of Troyon consisted of 4 farms and 30 cottages and was situated in a valley north east of Vendresse at the foot of the Cerny-en-Laonnois Plateau. There was a steep ridge north of the village. Troyon was destroyed during the war. All that is left of this village is the pitiful remains of Troyon Churchyard.

The patrol from the 2nd King's Royal Rifle Corps encountered a German position during the early hours of 14 September. The battalion war diary reported:

> The patrol moved straight up the road on to the high ground north of Troyon and succeeded in locating a German picquet at the point where the road turns north-west immediately north of Troyon. Five Germans were seen, and apparently they heard the approach of the patrol, owing to a man slipping down the bank, which caused his mess-tin to rattle.

Some of the enemy followed down the road, but the patrol got away on the grass siding and returned at 2am, their report reaching Battalion Headquarters about 40 minutes later.[1]

Another party reported the German occupation of the Sugar Factory, north west of Troyon, and the enemy entrenched in positions at a crossroads close by. The Sugar Factory, which since 1903 had operated as a distillery, was positioned on the junction of the Chemin des Dames with the road leading to Troyon and Vendresse at Cerny. It consisted of two storeys and a high chimney, which made it a conspicuous landmark on the ridge. Although it had been operating as a distillery, it was always known by the soldiers and to the people of Cerny as the Sugar Factory. The factory held commanding views of the Aisne valley and the Chemin des Dames. It afforded a clear view of the slope towards Vendresse and the chimney was used by German observers to direct artillery fire upon the BEF that day. German forces within the factory were heavily armed with machine guns and flanked by two German artillery batteries. Two German trenches branched out for a quarter of a mile from the Sugar Factory. One sector of the trench was dug along the Chemin des Dames

The village of Troyon nestled beneath the Cerny-en-Laonnois Plateau. (Dick Monk)

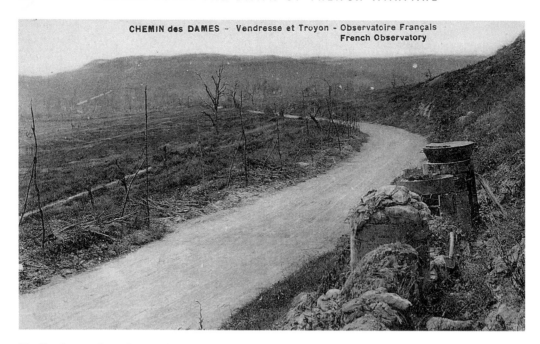

The Vendresse–Cerny Road skirted south east of the Vendresse Spur up to the Cerny-en-Laonnois Plateau. (Author)

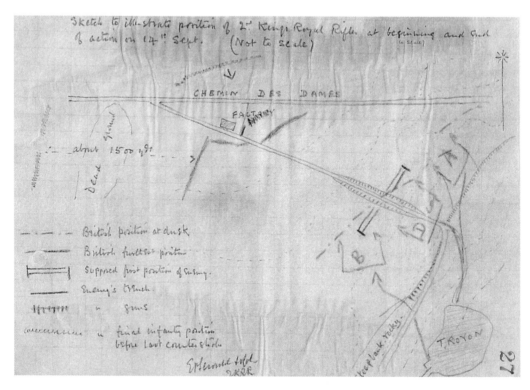

The positions of the 2nd King's Royal Rifle Corps on the Cerny-en-Loannois Plateau at the beginning and end of 14 September. This sketch shows the cutting where German forces ambushed Lieutenant Riversdale Grenfall and his patrol from the 9th Lancers. (National Archives WO95/1272, 2nd King's Royal Rifle Corps War Diary)

ridge, while the other sector ran along the Chivy Road. The trenches met at the Sugar Factory and formed a protruding defensive position. Four heavy 11-inch guns were positioned behind this line and were able to out-range British batteries and could fire upon British infantry advancing towards the heights of the Chemin des Dames.

If General Haig commanding 1 Corps was to carry out Field Marshal French's order to take the Chemin des Dames ridge then his soldiers would need to take the Sugar Factory. Therefore their prime objective at Troyon was to charge across the Cerny-en-Laonnois Plateau and capture the Sugar Factory and the village at Cerny. (Cerny is today called Cerny-en-Laonnois.) Cerny and the Sugar Factory were defended in strength by three battalions, 16th Reserve Regiment, 53rd Reserve Regiment and 39th Fusilier Regiment from the 27th Reserve Brigade, 14th Reserve Division.

In order to safeguard the advance of the 1st Division upon the Chemin des Dames the 2nd Infantry Brigade commanded by Brigadier-General Edward Bulfin supported by two batteries from the 25th Brigade Royal Field Artillery was ordered to capture the ridge from Cerny to Tilleul de Courtecon before sunrise. The 2nd Royal Sussex Regiment and 2nd Kings Royal Rifles Corps were holding the ridges of the Vendresse Road, and were covering the advance of the 1st Guards Brigade. The 1st Guards Brigade led by Brigadier-General Ivor Maxse formed the vanguard of the 1st Division ordered to assault the heights of the Chemin des Dames and to advance through Cerny onto Chamouille village.

The 2nd Infantry Brigade was comprised of the 2nd Royal Sussex Regiment, 1st The Loyal North Lancashire Regiment, 1st The Northamptonshire Regiment and the 2nd Kings Royal Rifle Corps. The men were so exhausted that NCOs and commanders had difficulty in rousing their men from sleep. Private Frederick Bolwell from the 1st North Lancashire Regiment recalled:

> We were roused next morning with kicks from the platoon commanders, and, after much struggling and putting on the wrong equipments, we marched out, but not before each man had received two ounces of Gold Flake tobacco, the first English tobacco we had seen since leaving home.[2]

The battalions from the 2nd Infantry Brigade left their billets at Moulin at 3.00am and led by the 2nd Kings Royal Rifle Corps with the 9th (Queen's Royal) Lancers, supported by the 1st Loyal North Lancashire Regiment followed by the 2nd Royal Sussex Regiment, marched uphill to Vendresse. Heavy rain and mist persisted as they advanced along the road that wound past Vendresse uphill towards the high ground above Troyon, which was located in a valley on their right flank.

Lieutenant-Colonel Pearce Serocold commanding the 2nd King's Royal Rifle Corps was ordered to advance to Vendresse and then ascend the steep, winding road which passes where Vendresse British Cemetery now stands. They were then to proceed north east and secure the high ground above the village of Troyon. This high ground formed the southern extremity of the Cerny-en-Laonnois Plateau, which encompassed the ground between Cerny, the Chemin des Dames and Troyon. The 2nd Royal Sussex Regiment was ordered to follow them in support. The 1st Northamptonshire Regiment was ordered to secure the spur east of Troyon.

The 2nd Royal Sussex Regiment had arrived at Vendresse at 4.15am and its commander, Lieutenant-Colonel Ernest Montresor, was ordered to remain in the village as reserve battalion to stand by until needed. Here they took cover amongst the houses. B and D Companies from the 2nd King's Royal Rifle Corps, together with the 9th (Queen's Royal) Lancers, were ordered to capture and secure the spur north of Bourg-et-Comin while A and B Companies were ordered to move towards Vendresse and beyond. They had passed through Vendresse and had reached Troyon by 4.00am. On arriving at Troyon they found that the village had been evacuated hastily by a German Cavalry patrol, as they left some of their helmets and lances behind.

The leading D Company secured the hilltop overlooking the village of Troyon. The German position had been discovered by Lieutenant Balfour's patrol earlier that morning. Looking at the map in the 2nd King's Royal Rifle Corps war diary, it is apparent that this German party was positioned on the Cerny-en-Laonnois Plateau at the north end of a cutting that led from the Vendresse Road towards Cerny and the Sugar Factory. Troyon was concealed to the south below the ridge. The road was protected by steep banks either side of the Vendresse–Cerny Road and the Germans could launch a rearguard action from the cutting against British forces advancing along the road towards the factory and Cerny. As soon as the British appeared at the top of the ridge that was above Troyon and Vendresse they could be fired upon.

When the 9th (Queen's Royal) Lancers galloped up the hill from Vendresse they were unaware that they were riding into a trap; the Germans could direct their fire in between the banks that shielded the Vendresse–Cerny Road. It was daybreak and there was a morning mist. A trooper from the 9th (Queen's Royal) Lancers appeared and said that the road ahead was clear. German soldiers were probably hidden behind the bank. D Company from the 2nd King's Royal Rifle Corps proceeded up the hill and then descended silently into a sunken lane 80 yards from the German position. This lane still exists. Here they met a patrol from the 9th (Queen's Royal) Lancers. An officer from the 2nd King's

Royal Rifle Corps was aware of enemy presence in the area following the patrol sent out earlier that morning and had warned the 9th (Queen's Royal) Lancers. The officer commanding this patrol from the 9th (Queen's Royal) Lancers replied 'That's alright, we will go on.'[3] They galloped up the hill north-eastwards. At the crest of the hill the road turns at right angles in a north-westerly direction. Today the road is protected by two high banks either side. These banks are clearly marked on a map in the war diary of the 2nd King's Royal Rifle Corps. The Lancers advanced up this road directly into the gun sights of the German machine guns and rifles. Some reports suggest that Lieutenant Riversdale Grenfall and his advance party were allowed by German forces to pass through their line before they were fired

upon. They certainly rode very close before the German machine gunners opened fire and cut some of them down. Lieutenant Riversdale Grenfall was killed outright by this machine-gun fire and the remnants of the patrol galloped back along the road. The 2nd King's Royal Rifle Corps war diary reported:

> They had not gone more than 30 yards when the German piquet opened fire straight down the road. They hit some of the patrol, including Lieutenant Riversdale Grenfall, who was killed on the spot. The patrol at once turned and galloped straight back, taking some of our men with them. The Riflemen however, stopped when they got to the bank on the edge of the high ground.[4]

The cutting between Vendresse and Cerny, along which Lieutenant Grenfall and his party from the 9th Lancers were channelled into the path of German machine guns. (Author)

The cutting as seen from the German barricade. (Author)

The road from
Vendresse from the
cutting, looking south.
(Author)

D Company from the 2nd King's Royal Rifle Corps, commanded by Captain Augustus Cathcart, secured a bank close to the high ground astride the Vendresse–Cerny Road in front of the cutting. They lined the bank while their commanders appraised the situation. The 9th (Queen's Royal) Lancers were held up on the main road from Vendresse. A couple of minutes passed, then D Company made a brave attempt to advance. They moved 100 yards before they were stopped by enfilade fire from three positions. Through the mist they could be seen by German forces holding the Sugar Factory at Cerny directly in front of them and by German machine gunners on the Chemin des Dames Road in the north east. They held their ground despite the German fire. As dawn broke, German reinforcements were entering the line and the rate of fire from the German lines increased. As they advanced to the crest of the ridge above Troyon, the 2nd King's Royal Rifle Corps became aware that German forces were holding the line in strength. The battalion war diary recorded:

> Daylight now appeared, but the mists still held, and the enemy, to judge by the amount of firing, were evidently increasing in numbers, and had brought some machine guns into action. It was tolerably certain that we had struck an advance portion of the enemy's main line and it was obviously impracticable to drive them from the position they were holding with the numbers available.[5]

D Company had reached the ridge and was engaging German forces on the high ground. Two German machine guns were hidden in a haystack ten yards from their position and caused several casualties amongst D Company. Captain Augustus Cathcart was hit by this machine-gun fire. One bullet went through the cap worn by Sergeant Bradlaugh Sanderson, 2nd King's Royal Rifle Corps, and another struck the safety catch of his rifle. D Company were forced to keep their heads down. Each time the Maxim stopped to reload, Sanderson rose to fire a few shots and ordered the remnants of the company to keep on firing on the left flank of the haystack. Eventually, Sanderson crept to a position where he could get a clear shot of the machine gunner and killed him.[6]

Before he died, Captain Augutus Cathcart sent Lieutenant Seymour Mellow down into the valley to request reinforcements from Lieutenant-Colonel Pearce Serocold. Serocold was with the commander of A Company before the slope of the ridge below D Company. It was becoming apparent that the Germans were going to hold their line along the Chemin des Dames and had no intention of retiring. Serecold listened to Mellow's report and realised that the situation was critical. D Company was in desperate need of support, so Serecold immediately sent two more companies to the ridge to extend the line and try to break through. A Company ascended the ridge from a position north of Troyon and secured a line on the right flank of Cathcart's D Company. A Company climbed up a steep, chalky bank to reach the ridge where they took up a line to the left of D Company. The 2nd King's Royal Rifle Corps noted the determination of D Company:

The crisis was only momentary, for D Company, with the tenacity of the best traditions of the regiment, doggedly clung to their position until the arrival of A Company, who were sent to reinforce them, and to counter an attempt on the part of the Germans to outflank our right.[7]

At times the mist lifted and revealed the positions held by the 2nd King's Royal Rifle Corps to German machine gunners perched on the Chemin des Dames. The 2nd King's Royal Rifle Corps were suffering heavy casualties from machine-gun fire and the howitzers and field guns massed on the Chemin des Dames. There was a great danger that the enemy fire would become so overwhelming that they would be unable to hold their position on the lip of the Cerny-en-Laonnois Plateau above Troyon. The battalion war diary reported:

The Battalion was now more or less in line astride the sunken road, the right being thrown back. The mist was driving across the hill, at times lifting and exposing the action of the troops to view, at times coming down and concealing them, but the movements unfortunately caused us heavy

casualties, as, being on the forward slope of the plateau, we were exposed to heavy artillery fire, whilst our own artillery were able to give us very little support. There were twelve German field guns in action, partially entrenched, about 600 yards to our front.[8]

By 5.30am artillery shells were falling upon the ridge and the Germans were successfully repelling the assault made by the 2nd King's Royal Rifle Corps.

By 6.00am the entire 1st Division had crossed the river and was heading towards the Chemin des Dames. British infantry had to cross fields of turnips and beet up towards the Sugar Factory. The ground was of sticky clay churned by incessant rain. As soon as the battalions from the 2nd Infantry Brigade ascended the slope they would become vulnerable to the fire of the German defenders holding the Sugar Factory.

The 2nd Royal Sussex Regiment commanded by Lieutenant-Colonel Ernest Montresor had reached Troyon by 6.30am. Serocold summoned the assistance of the 2nd Royal Sussex Regiment to extend the line on the left flank of the 2nd King's Royal Rifle Corps line when they started to arrive. D Company from

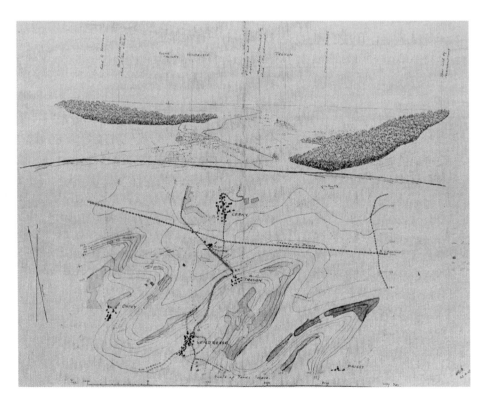

A panorama of the terrain covered by 1st Division on 14 September 1914, showing Vendresse, the Vendresse Spur, Troyon and the Sugar Factory at Cerny. (War Office, 1934)

2nd Royal
Sussex Regiment
positions on
14 September.
(National
Archives: WO
95/1269, 2nd
Royal Sussex
Regiment War
Diary)

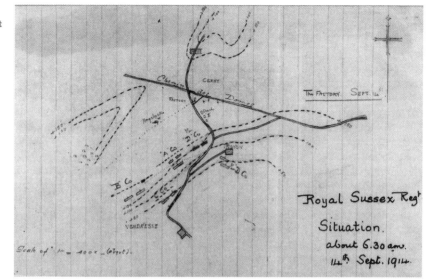

The starting
position of the
2nd Royal Sussex
and 1st Black
Watch. (Author)

the 2nd Royal Sussex was sent to bolster the lines held by the A and D Companies from the 2nd King's Royal Rifle Corps, thus relieving the pressure upon the right flank.

At the same time the 1st Northamptonshire Regiment was moving forward on the spur to the east of the positions held by the 2nd King's Royal Rifle Corps to protect the right flank. Private H. Corooran from the 1st Northamptonshires was wounded by a bullet and crawled to a barn where he lay unconscious for three days until found. He was evacuated and from his hospital bed in Brighton he told a journalist:

They were all stray bullets that killed and wounded us. We killed hundreds of them and captured thousands of the dogs. I will have another cut at them when I am better. It was their artillery that does the damage ... I fought at Mons and every other battle and I never thought that there was a bullet for me after that.[9]

The 1st Northamptonshire Regiment succeeded in securing a ridge north west of Paissy. They were unaware that the 2nd King's Royal Rifle Corps was holding onto the ridge above Troyon, which was west of their position. There was a disastrous breakdown in communication between these two battalions because soldiers from the 1st Northamptonshire Regiment began to fire upon the 2nd King's Royal Rifle Corps, who were already being harassed by German fire from their front and from their right flank. Lieutenant-Colonel Serocold ordered Major Philips to go to the ridge north west of Paissy to tell the 1st Northamptonshire Regiment they were firing upon their own troops. Philips found the 1st Northamptonshire Regiment entrenched on the ridge and let them know. Philips went farther east to relay the same information to a battalion of French Turcos belonging to the 38 Division positioned east of Paissy. ('Turcos' was a familiar name given to Algerian riflemen since 1854 during the Crimean War.)

The 2nd Royal Sussex Regiment was ordered to move along the road which ran from Vendresse north east towards the Sugar Factory. They advanced half a mile along this road before they turned left and ascended the wooded slope. On reaching the top of this hill, A and B Companies came under fire from German forces entrenched 400 yards from their position.

The 2nd Infantry Brigade struggled uphill across the sticky clay ground, which was two feet deep in beet and turnip plants. The morning mist meant that the advancing infantry could only see 200 yards ahead. They sustained many casualties from rifle and machine-gun fire. It is debatable whether the German soldiers could actually see their targets, but they hit them nonetheless. The 2nd Royal Sussex Regiment advanced on the left flank to assault German trenches that skirted the Chivy Road. The remnants of the 2nd Royal Sussex moved westwards reached a sunken lane. Here they could outflank the German trenches and were able to position a machine gun that poured enfilade fire upon the Chivy Road trenches, pinning down their occupants.

Some elements of the 2nd Royal Sussex Regiment were positioned in a nearby wood, lying down and firing at the enemy when they appeared. German shells were fired in the direction of the wood. Many casualties were inflicted by shells exploding when they hit tree trunks. Private Harland was one of the casualties:

> We'd got quite used to them and we lay there talking and telling each other when a shell was coming. One great 90-pounder shell went over us. If it hadn't hit anything it wouldn't have mattered for those shells do not explode unless they hit something. This shell hit a tree just behind me. It exploded. That shell killed three men and wounded seven, of whom I was one. A piece of shrapnel went right into my foot. I thought at the time that my leg was gone. There was a chap lying next to me – I think he was one of the men at a Brighton brewery. He lay quite still. A piece of the shell had gone through his head and killed him.[10]

The site of the Sugar Factory at Cerny. This photograph was taken north of the railway cutting and shows where A and D Companies from the 2nd King's Royal Rifle Corps advanced during the assault on the factory. (Author)

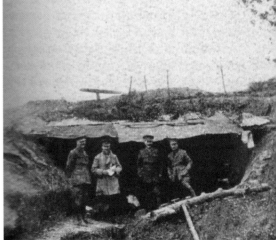

Lieutenant-Colonel Sercold's 2nd King's Royal Rifle Corps HQ beneath the plateau at Cerny-en-Laonnois. (*Mons to Ypres with General French*)

Eventually a white flag was raised and hundreds of German soldiers walked towards the 2nd Royal Sussex positions with their hands up. Lieutenant-Colonel Ernest Montresor, together with several officers and men, left cover in the sunken road and walked towards them to accept the surrender. Suddenly, German machine gunners positioned in the Sugar Factory and in the trenches to the left and right opened fire upon the men from the 2nd Royal Sussex Regiment, and upon their own men, indiscriminately.

The 2nd Royal Sussex War Diary reported:

> Fire was opened and continued for some minutes, then it was seen that large numbers of the Germans were putting up their hands to surrender. Many of our men got up to receive the surrender when Germans in rear opened fire on friend and foe. This fire was replied to by the part of the line who had not participated in the surrender.[11]

It was a terrible massacre. Those who were positioned in between the two opposing lines were in the line of fire of German machine gunners in the north, British rifles from the south and west and shells were descending upon them from German batteries in the east. The 2nd Royal Sussex Regiment lost 6 officers and 11 other ranks killed, 3 officers and 79 other ranks wounded, 114 missing.

Despite their losses, the 2nd Royal Sussex Regiment was able to take charge of 250 German soldiers who managed to get into the sunken lane and evade the bullets fired by their comrades. They were rounded up and escorted to the rear.

The 2nd Royal Sussex right flank had got across the Vendresse Factory Road and used the bank along this road as a line from where they opened fire upon German forces who at that moment were engaged in battle with the 2nd King's Royal Rifle Corps. Outflanked, more German soldiers raised their hands. German shell fire from artillery positioned east of the factory fell on their position. The 2nd Royal Sussex opened fire, cutting down the German infantry in their sights.

At one point the 12 German guns from the two batteries positioned east of the Sugar Factory fell silent as accurate British marksmanship hit every gunner, driver and horse in the vicinity.

The 2nd Royal Sussex Regiment had sustained heavy casualties, so in order to maintain momentum, Brigadier-General Bulfin sent two and a half companies from the 1st Loyal North Lancashire Regiment into the fray. The Loyal North Lancashires were being held at brigade reserve and were brought forward to replenish the ranks at 8.30am, with orders to assault the Sugar Factory. An anonymous 2nd Lieutenant from the 1st

Loyal North Lancashire Regiment recalled events as they moved towards Vendresse.

> Rain began to fall and continued to do so for the remainder of the battle. We hear firing towards Vendresse. Move down road to Vendresse and lie under cover of hedge. Things are beginning to liven up and bullets are falling all round us. Two men are wounded. One in foot and another in leg. Captain Body, who has taken over the company, calls all company officers and explains situation. We are shortly moved up to Troyon to support attack on factory. While he was explaining all this, the bullets kept singing by, some fairly close.[12]

Private Frederick Bolwell of the 1st Loyal North Lancashire Regiment:

> It was the fourteenth day of September, and raining. Leaving the village, we marched down a road for about five hundred yards, bordered on each side by high banks. There a halt was called. On our right we could hear the sound of shots, and the Corporal in charge of the range finder was sent to the top of the bank to take the range. He could not see very far, on account of a heavy mist, but reported the King's Royal Rifles advancing. We then doubled by platoons through an avenue of trees exposed to the enemy's fire, and gained some fields on the further side of the road, lining the hedges. From there into the valley led one road which was little more than a narrow defile; and then it wound away to the right front over the crest which the Germans held. Halfway up this road was a village called Troyon. At the rear and facing the crest held by the enemy was another and smaller hill, thickly wooded. Before taking us through the defile and into the valley, the words of the Brigadier [Brigadier-General E. Bulfin] were: 'That ridge has to be taken by nightfall – otherwise we shall be annihilated.'[13]

As the 1st Loyal North Lancashire Regiment was about to launch an assault upon the Sugar Factory, Lieutenant Herbert Loomes rejoined the battalion. Loomes had been taken ill as the battalion passed through Soisson on 1 September and had to fall out. He had been ordered back to England to receive medical treatment, but refused and made an effort to reach his battalion. The 2nd Lieutenant of the battalion wrote:

> Lieut. Loomes turned up and rejoined; we were all glad to see him. He was delighted at being back. When he had reached the base he was told to go to England, but not liking the idea he had got on a train and, by changing trains and living from hand

to mouth, had succeeded in joining up just before going into action.[14]

As the 1st Loyal North Lancashires set off to assault the Sugar Factory they passed some captured German soldiers. These German prisoners were dejected and miserable. The 2nd Lieutenant recalled: 'Pass about 350 prisoners, a welcome sight. They were in tears. They had been told all they had to do was to march through to Paris, which had already been captured. They were surprised at their reception.'[15]

Before they got sight of the Sugar Factory they had to ascend a hill. At this point they could not be observed from the Sugar Factory. As they climbed the slope they could see the signs of battle. 'On approaching crest of hill we come on signs of conflict. Helmets lying all over the place, and also rifles. A good deal of blood, and several wounded and dead lying about.'[16]

They reached the crest of the hill and rested briefly before launching an attack upon the Sugar Factory. As they waited just below the crest of the hill, German bullets were flying above their heads.

> We reach crest and halt just under it. The bullets seem to be coming from all directions. After a short rest we are ordered forward to attack factory. I extend my platoon after Loomes (he is far in front of his platoon waving them on; this was the last I saw of him). Loomes is on my right, Goldie on my left.[17]

Once the 1st Loyal North Lancashires had moved over the crest of the ridge onto the Cerny-en-Laonnois Plateau, they had to cross open ground for a quarter of a mile in order to get to the Sugar Factory. B and D Companies advanced into the line of fire on both sides of the road leading to the factory. They were cut down by murderous machine-gun fire from the factory and from the trenches that extended from it on their left and right flanks. A Company followed and they sustained many casualties in the maelstrom of bullets and shell fire.

> Had only gone about a hundred yards under a perfect hail of bullets when I heard a singing sound on my right. Two eight-inch shells had pitched 20 yards to my left and blew sky high a few of my platoon. The shells emitted a tall cloud of black dust and smoke. Truly terrible missiles. We go on forward, but as yet I can see nothing. At least we reach the firing line. How anyone reached it is beyond comprehending. And such a line. All manner of regiments are there, and the dead and wounded are lying round in scores.[18]

Private John Harvey from the 1st Loyal North Lancashire Regiment was a reservist from Lancaster. He was

wounded during this advance. In an interview with a local newspaper reporter in Preston he recalled:

> It was a hot time, there were fellows being knocked out all round and wounded crying out for help. When we got within 50 yards of the Germans we could not charge, our ranks had been so thinned. A shell burst within 50 yards of me. My puttees were ripped, and I thought that I had lost both legs. I lay down as quiet as I could, and started crawling towards a hay stack. On arriving at the hay stack – after much agony – I found more wounded there. There was one man who was not wounded and he was attending to the others. Just then six or seven Germans came up, and I thought my time had come. They told the man who was not wounded to run, and when he got about 15 yards he was shot dead through the head. The Germans then made off and left us.[19]

The battalions of British infantry that were advancing upon the factory were not supported by adequate artillery fire. The Germans defending the Chemin des Dames held a tremendous advantage in heavy artillery. Private Frederick Bolwell from the 1st Loyal North Lancashire Regiment:

> That day witnessed one of the worst battles I have ever experienced, as we were badly equipped with guns, having mostly eighteen-pounders – 'pop guns', as the boys called them whilst it was the first day on which we met the really big guns of the Germans – those promptly dubbed 'Jack Johnsons'.[20]

Lieutenant-Colonel Walter Lloyd and his Adjutant Captain Richard Howard-Vyse led from the front in the initial waves of the 1st Loyal North Lancashire Regiment and were killed by German machine-gun fire. The assault upon the Sugar Factory was a savage and costly action. An estimated 50 per cent of the assault force became casualties as a consequence. They stood no chance. Private Frederick Bolwell wrote 'Our particular front was facing a sugar-beet factory just off the main road, and there the fighting was furious.'[21]

A and D Companies from the 2nd King's Royal Rifle Corps also advanced towards the factory. They were terribly exposed to German positions entrenched along the Chemin des Dames road in the north east. As the morning mist lifted they could be clearly seen. The 2nd King's Royal Rifle Corps reported:

> About the same time the North Lancashire Regiment arrived and pushed straight on the Sugar Factory, D and A Companies also progressing on their right, and we succeeded in making good our position and

thoroughly establishing ourselves on the plateau digging in on the reverse slope. The firing line was built up from time to time, and as men were driven back they were collected and taken up again after a little rest.[22]

Those that survived from the 1st Loyal North Lancashire Regiment miraculously reached the Sugar Factory with remnants of the 2nd Royal Sussex Regiment and 2nd King's Royal Rifle Corps, who cleared the enemy with the bayonet towards the factory. They charged through the German artillery batteries that were positioned close to the factory. A savage action ensued amongst the machinery inside the Sugar Factory, where they overwhelmed the German defenders.

Capturing the Sugar Factory was one thing, to hold it another. With the Sugar Factory in British hands the battle for Cerny had reached a critical point for German commanders. If the British battalions could hold the Sugar Factory then Cerny would be at risk and Field Marshal French would have a foothold on the Chemin des Dames ridge from which to break out northwards towards Laon and destroy the plan to hold along the north banks of the Aisne. General Hans von Zwehl received reports that 27th Reserve Brigade was being overwhelmed by a superior British force and immediately brought forward the 25th Reserve Brigade, 13th Reserve Division, to confront them, with the 25th Landwehr Brigade carrying the left flank.

The 25th Reserve Brigade made an attempt to advance from Cerny towards Troyon with orders to regain possession of the Sugar Factory, but failed. They were prevented from advancing by their own artillery barrages that fell in front of them.

German observers were aware that soldiers from the BEF were holding the factory and could direct artillery and machine-gun fire onto their position. It was imperative that if the Sugar Factory could not be recaptured, then the building and its chimney, which was a superb observation platform, was destroyed. Two German 8-inch howitzers had reached a position south of Chamouille in the Ailette Valley and were firing upon the Sugar Factory and around the Cerny-en-Laonnois Plateau. This artillery support created havoc amongst the British lines. It caused the battalions from the 1st Guards Brigade advancing west of the Sugar Factory to deviate into the line of advance of Bulfin's 2nd Infantry Brigade. Small parties from the 1st Cameron Highlanders, 1st Black Watch and 1st Coldstream Guards were converging upon the Sugar Factory as German shell fire tore through their ranks.

The survivors of the British battalions that had bravely fought for the Sugar Factory and who were now inside defending this bastion would become sitting targets; with diminished numbers and their supplies of ammunition close to exhaustion. The anonymous 2nd Lieutenant from the 1st Loyal North Lancashire Regiment continued to describe their defence of the factory.

We carry the factory and hold on like grim death. Allason is a little to my right, and Goldie landed up to me. He shortly afterwards moved off to the left by rolling on his side, and that was the last I saw of him. The man next to me, just as he was getting down, suddenly pitched forward and lay in front moaning the whole of the time we were there. We open a sharp fire on the German line, but are

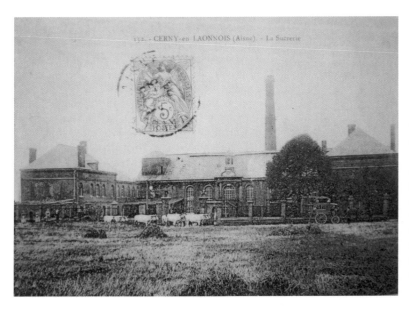

The Sugar Factory at Cerny. It became an important position on 14 September because it afforded commanding views of the Aisne valley. The chimney was used by German observers for directing artillery fire on the advancing BEF. (Yves Fohlen)

not able to see very much. Allason on my right is bandaging up a wounded Guards officer. He was a fine example and seemed to show no fear. He would not lie down properly. The German machine guns are nasty. They keep traversing up and down our line. A great increase in the noise of cracking whips overhead always heralded their return. Many men are hit and the casualties become truly appalling. We get no reinforcements or ammunition, and soon exhaust our supply. Germans heavily counter attack. I noticed their way of carrying machine-guns on stretchers. [In fact these were not stretchers; MG teams unclamped the Maxim gun from its 'sledge' mount or pivoted the mount's leg to allow it to be carried stretcher-fashion]. We used not to fire at these until we knew their contents. Goldie sends back word that he has been wounded in the leg and is going to crawl back to the rear. That was the last news I heard of him.[23]

Horses were brought forward to try and evacuate the two guns of the German battery east of the Sugar Factory, but they were all shot down. The guns were destroyed as the battle continued. (According to the 2nd King's Royal Rifle Corps War Diary these guns were left and German soldiers later recovered them, leaving the limbers during a counter attack at 4.00pm that day.) German guns from other locations continued to fire upon the Sugar Factory. At some point during the morning, German artillery

CERNY Zuckerfabrik

The remains of the Sugar Factory at Cerny. Soldiers from the 1st Guards Brigade and 2nd Infantry Brigade fought courageously to wrest control of from its German occupiers. To deny their enemy an observation platform to direct fire into their lines, the Germans shelled it to rubble. (Courtesy Yves Fohlen)

succeeded in destroying the chimney. Advancing infantry from the 1st Guards Brigade deviated on the left flank as they became intermingled with the advance of the 2nd Infantry Brigade. Elements from the 1st Black Watch, 1st Cameron Highlanders and 1st Coldstream Guards had lost their way in the fog, smoke and shell fire and found themselves outside the perimeter. Lieutenant-Colonel John Ponsonby, leading the 1st Coldstream Guards, recalled:

> We reached a brick wall round the factory. I saw here that Granville Smith was wounded, also Lane. Drill Sergeant Otway [sic] fell and I believe was killed outright; Charlie Grant and John Wynne Finch had arrived at the wall with various Platoons of their Companies. The wall, however, appeared to be a target for the enemy's guns, so Grant dashed forward to the road beyond. The others extended to the right of the factory, the shells seemed to be coming thicker and thicker and I could only see what the actual men round me were doing. Soon afterwards down came the big factory chimney with a crash.[24]

Soldiers from the 1st Loyal North Lancashires and other units, including soldiers from the 1st Black Watch and 1st Cameron Highlanders from the 1st Guards Brigade, continued to hold on until the thunderous German barrages made their position untenable and they were compelled to retire.

> Allason orders me to retire, and I do so with two Loyal North Lancs., three Black Watch, two Cameron Highlanders. We move back at a fast double, and coming to a donga, take shelter there. We are subject to a terrific bombardment and it is death to show a hand. The shells seem to come right in and sweep the hole out. We lie there for some time and then move a little farther back. I strike the Gloucester Regiment, who are the 3rd Brigade. They have come up to support and have had no casualties. They are all very eager to go on. I have already lost my Loyal North Lancs., and the Highlanders go off to try and find their regiment. I decide I will attach myself to the Gloucesters. I am absolutely done. 2nd/Lieut. Harding and I settle down to eat something. I supply the jam, he the bread. This revives us. The fire is still tremendous, but we are sheltered under a steep cliff and do not suffer. It is not safe to go on top. A party tried to bring in a wounded man, but all of them were either killed or wounded.[25]

Although the 2nd Infantry Brigade could not consolidate their hold upon the Sugar Factory, Captain Ernest Hamilton of the 11th (Prince Albert's Own)

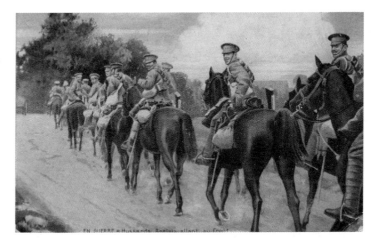

British Hussars in 1914. Cavalry had played a prominent role in military operations carried out by the British Army for centuries, but their role disappeared with the advent of machine guns and howitzers. (Author)

Hussars regarded this action as 'an achievement which must undoubtedly rank as one of the finest of the war.'[26]

Private Jack Miller from the 1st Loyal North Lancashire Regiment was knocked unconscious when a shell exploded. After regaining consciousness he found that he had been captured and was a prisoner of war. Later during that day he managed to escape from his captors and rejoin his regiment.

East of Troyon, the battle intensified. The 1st Northamptonshire Regiment moved forward on the right flank at 11.30am, but could not make headway against German infantry and artillery entrenched with machine guns and field guns in positions north and east of the Sugar Factory. Corporal John Stennett from C Company, 1st Northamptonshire Regiment, wrote: 'The battle commenced at day break and became very fierce and continued the same all day, the losses being heavy on both sides.'[27]

Some parties from the 2nd Infantry Brigade had reached the crest of the ridge and were entrenching in positions north of the Chemin des Dames. C Company from the 2nd Royal Sussex Regiment and elements from the Coldstream Guards entered the Cerny sector and reached a lane north of the village. The war diary recorded: 'Everywhere signs were apparent that the Germans had been completely surprised, and had hastily left their bivouacs to rush up to the firing line.'[28]

Cerny had been abandoned by German forces except for a contingent of snipers. The 2nd Royal Sussex held their position in the sunken lane as German shells poured down around them. At 1.00pm German infantry was seen advancing east of Cerny abreast of the lane. With no sign of support and the failure of a French advance on their right flank, the British decided to withdraw to a position beyond the Sugar Factory. The retirement was carried out without any losses and the survivors were able to form a defensive line 200 yards south west of the Sugar Factory facing north.

At 2.30pm, companies from the 2nd Royal Sussex Regiment advanced along the Vendresse–Sugar Factory road and dug into positions 150 yards north of the road. At 3.30pm they advanced northwards to the top of a ridge. Several counter attacks were launched by German infantry with considerable numbers, but were repelled. The battalion held onto this ridge until dusk, but German artillery fire forced them to retire to trenches they had dug close to the Vendresse–Sugar Factory road. Captain Hubert Rees of the 2nd Welsh Regiment could see the battle that ensued around the Sugar Factory from the Chivy Valley. He refers to it as the Troyon Factory. 'We watched some desperate fighting going on round the Troyon factory where the ground was literally covered with bodies.'[29]

Towards the end of the day the soldiers of Brigadier-General Bulfin's brigade were forced to withdraw to the edge of the Cerny-en-Laonnois Plateau above Troyon and hold. The brigade had managed to advance and capture the Sugar Factory but were unable to consolidate their position owing to their own losses and the failure of French forces east of their flank to capture German trenches along the Chemin des Dames ridge.

Reconciled to the fact that there was no chance to find his unit while German artillery shells were bombarding their position, the 2nd Lieutenant from the 1st Loyal North Lancashires remained with the 1st Gloucestershire Regiment throughout that day. At dusk the Gloucesters were ordered to advance through Troyon and capture the Sugar Factory. They asked this 2nd Lieutenant to accompany them and act as a guide, as he knew the location and the terrain. As they advanced in the darkness the Gloucesters encountered a Welsh Battalion who mistook them for German forces and opened fire. The Welsh battalions were positioned to the west of the Sugar Factory and it is highly likely that the 1st Gloucerstershire Regiment had lost their way because they were far from the factory. The 2nd Lieutenant wrote:

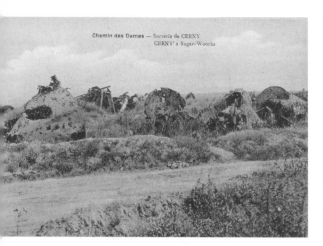

Chemin des Dames — Sucrerie de CERNY
CERNY's Sugar-Woorks

The ruins of the Sugar Factory at Cerny. (Author)

We move off and have several escapes from 'Jack Johnson' and move up the road. Reach top of road when half the battalion in front get panicky. The General's escort bolted and half the Welsh battalion opened fire on us. Luckily they fired high, so no damage was done. The Gloucester Regiment's leading company had scattered, and it seemed as if we were in for another fight, for we did not know who was firing at us. The officers exerted themselves and quickly succeeded in getting the regiment together again. We then lay down and shouted to those in front to cease fire. It ceased as suddenly as it had begun. We all thought that the thing closed, but no, suddenly a black wall seemed to rise in front of us and a crowd of of charging men came through us. They were the Welsh. They bayoneted two Gloucesters in their passage through. They went on a couple of hundred yards and lay down, and once more opened fire on us. Again no one was hit and it stopped. After a good deal of not knowing what to do we got orders to retire down to the bottom of the road and entrench. This we did, moving a platoon at a time from the head of the column.[30]

Amidst the confusion of the fire fight and bayonet charge launched by the Welsh Regiment the 2nd Lieutenant was able to help recover some wounded from his own company, however it was heart rending for him to leave many others where they fell, despite hearing their calls for help:

I am glad to say I was able to help several of our wounded down. They were lying very thickly up there. Of my Company, no fewer than 3 officers out of 5 and 175 out of 220 were either killed or wounded. It was terrible not being able to help them and still to hear them cry out 'North Lancs'.[31]

During that day, soldiers from the 2nd Infantry Brigade consolidated their positions by digging shallow trenches large enough for them to crouch in, in anticipation of further German artillery barrages. They ended the day in the position from which they had started.

After an exhausting day of bitter fighting, German attacks subsided and the soldiers from the 2nd Infantry Brigade held their fragile defensive line around Troyon along the southern extremity of the Cerny-en-Laonnois Plateau. They had not eaten all day and as night fell, rations were brought to them. The distribution of food was poorly organised, for it was taken close to the British lines and dumped in various locations. Those men who were close by were able to draw rations, while others went without. There was no time for rest and many of these fatigued and hungry men were ordered to dig trenches on hard ground. Again, there was poor organisation; some men spent many hours digging trenches and then were ordered to a different position along the line. This meant that these men would have to dig another trench, while men who took over their position just entered the line and rested. Private

Frederick Bolwell, of the 1st Loyal North Lancashire Regiment:

> During the night we dug our one-man trenches six foot long and as deep as we could make them; it was hard work at times, the soil being very rocky. I got fairly well down nearly four feet by daybreak, when my Platoon Sergeant came along and ordered me to join my section farther along the line, another man whose section was near me taking over my trench. It couldn't be helped, as we had all got mixed up in the action the day before. When I joined my section I found the trench I had to take over only about a foot deep, and the whole week following, although I was digging on every possible occasion, I could not get down more than six inches, as I had to go through sheer rock.[32]

The 1st Loyal North Lancashire Regiment held these trenches for several days after the battle for the Sugar Factory. Wounded men from that battle would drift towards the British trenches during the following nights. Private Frederick Bolwell recalled a badly wounded soldier from the Black Watch coming in three nights later:

> That night a man of the Black Watch came in having been left out since Monday's battle; he had nearly every toe shot off and was almost blind. He had – so he told us – been in one of the boilers of the Beet-Sugar Factory, and a German had fired several shots into the boiler, killing some more men who were in there with him. A Guardsman also came in, shot all over.[33]

The Cerny-en-Laonnois Plateau. Vendresse British cemetery is to the left, while the site of the Sugar Factory is to the far right, where now there are only trees. It was here that the first trenches of the Western Front were dug. (Author)

Many wounded British soldiers were left where they fell; losing blood, suffering considerable pain, exposed to the harsh weather, dehydrated. German soldiers held ground that commanded good observation of the entire ridge that led to the Sugar Factory at Cerny and it was almost impossible for stretcher bearers to recover these men. The 2nd King's Royal Rifle Corps war diary recorded:

> Towards evening it was recognised that the trenches on the reverse slope would have to be occupied at night. This necessitated a withdrawal, and it was represented that many of our wounded were lying out in front. The stretcher bearers had done what they could and had continually been shot at, but it appeared useless to communicate with the enemy with a view to collecting the wounded, as they probably would have ignored any message of that sort.[34]

Private A. Burke from Preston was amongst the casualties of the 1st Loyal North Lancashire Regiment. He suffered a severe chest wound and was left on the battlefield where he fell. Passing German soldiers took his food. He was suffering excruciating pain, was hungry and suffering dehydration. Help came after three days and he was evacuated from the Aisne to England, where he was admitted to Fazakerley Hospital in Liverpool. In a letter home to his brother he wrote:

> I have had a terrible time of it all the eight weeks out in France and Belgium. I have seen sights which will ever be in my memory. At Aisne was shot through the chest, but the bullet went right through me, so you see, I was lucky, but what has pulled me down is that I was captured wounded by them dirty Germans and they took all my food. After three days without food and drink, and going through pain all the while, oh! I prayed to God to finish my sufferings, but they left me after three days, and God sent help ... It is a treat to get away from that terrible battle.[35]

The charge across the Cerny-en-Laonnois Plateau in defiance of the German guns to capture the Sugar Factory was an extraordinary feat of arms, but the heavy losses and the retirement from the position meant that this episode was an abysmal, tragic failure. The 1st Loyal North Lancashire Regiment was decimated. As well as losing Lieutenant-Colonel Walter Lloyd, its commanding officer, and Captain Richard Howard-Vyse, its Adjutant, the battalion lost Captain Grant Body, Captain R. Watson, Captain Harold Helme, Lieutenant George Goldie, Lieutenant Herbert Loomes and Lieutenant Edgar Robinson, all killed. Lieutenant

The 2nd Royal Sussex dug into positions and held on under heavy bombardment until relieved on 19 September. The Sugar Factory did not survive; the building and its tall chimney were reduced to a pile of rubble during the Battle of the Aisne.

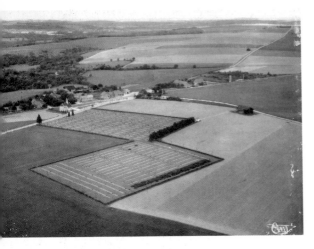

An aerial view of the French National Cemetery at Cerny-en-Laonnois. The Sugar Factory was situated to the right, with the Chemin des Dames Road and Cerny–Vendresse Road running either side of it. (Author)

THE 1ST LOYAL NORTH LANCASHIRE REGIMENT MEMORIAL, CERNY-EN-LAONNOIS

The 1st Loyal North Lancashire Memorial at Cerny-en-Laonnois consisting of a single column was erected a few hundred yards from the site of the Sugar Factory. It was unveiled by General Sir James Willcocks DSO on 22 September 1923 in the presence of local French dignitaries and members of the families of the men from the regiment who fell on 14 September. Captain Collins, Captain Hyndson and Company Quartermaster Sergeant Durkin who had taken part in the battle for the Sugar Factory were also in attendance. The memorial is dedicated to the 71 officers and 1533 men from the 1st Battalion who perished during the First World War. The inscription on the memorial reads:

<div align="center">

IN MEMORY OF
THE OFFICERS WARRANT
AND NON-COMMISSIONED
OFFICERS AND MEN
OF THE 1ST BATTALION
LOYAL NORTH LANCASHIRE
REGIMENT WHO LAID
DOWN THEIR LIVES
ON ACTIVE SERVICE
1914–1919

</div>

Rowland Mason was wounded and brought home to a hospital in Britain near his home in Edgbaston where he died from his wounds on 30 September. Five other officers from the battalion were wounded and approximately 500 other ranks were listed as casualties. Many of the casualties came from B Company, 3 out of 5 officers, 175 out of 200 ranks. The relative scale of such losses would be repeated during the Ypres campaigns in 1914/15, at Gallipoli and Loos in 1915, and would continue throughout the war.

The 2nd King's Royal Rifle Corps suffered 306 casualties from the ranks, 7 officers wounded and the following 8 officers killed: Major Hubert Foljambe, Captain Augustus Cathcart, Lieutenant John Forster, Lieutenant George Thompson, Lieutenant S. Davison, Lieutenant R.H.M. Barclay and Lieutenant M.F. Blake. The battalion was able to bury only two of these men during that day.

The 1st Northamptonshire Regiment lost Captain Edward White and Lieutenant George Paget who were killed in the advance with B Company. Lieutenant Mylne, a reinforcement who had recently joined the battalion during the previous week, was wounded. Three other officers were wounded together with 102 other ranks.

The 2nd Royal Sussex Regiment lost Lieutenant-Colonel Ernest Montresor, Major Mostyn Cookson, Captain Leonard Slater, Lieutenant Honourable Herbert Pelham, Lieutenant Edward Daun, Lieutenant William Hughes and 11 other ranks killed, 3 officers and 79 other ranks wounded, 114 missing.

General Willcocks, Colonel of the Regiment, gave a speech:

> The victory at Troyon has been described as one of the most brilliant achievements of the war. Starting in reserve at Vendresse, the Battalion was later brought up and ordered to attack the Sugar Factory, which was strongly held with machine-guns and flanked by two batteries of artillery, strengthened by trenches on either side by two 11-inch guns, which had successfully resisted the attacks of the leading battalions. With a cold rain in their faces and an uphill approach across clay fields deep in beet plants, for a quarter of a mile over open ground under fire from front and flanks, they advanced unflinchingly. The casualties were terrible. The commanding officer, Lieutenant-Colonel Lloyd, and six other Officers were killed during the great rush, and 50 per cent of the men fell in crossing this fire-swept zone. But the remainder drove on and captured the factory at the point of the bayonet.[36]

Below: The unveiling of the 1st Loyal North Lancashire Memorial at Cerny on 22 September 1923. (*The Lancashire Lad*)

Right: The 1st Loyal North Lancashire Regiment Memorial at Cerny en Laonnois today. (Author)

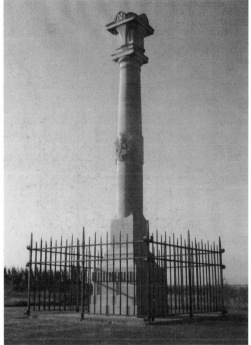

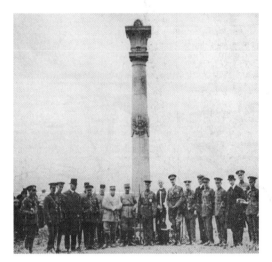

General Willcocks spoke of victory, but the battalion lost heavily and although the Sugar Factory at Cerny had been fiercely contested and captured, such was the ferociousness of German artillery fire, they were unable to hold on to the position and were forced to retire to Troyon.

NOTES

1. WO 95/1272: 2nd King's Royal Rifle Corps War Diary
2. Bolwell, F.A., *With a Reservist in France* (E.P. Dutton & Co., 1917)
3. WO 95/1272
4. Ibid
5. Ibid
6. Van Emden, Richard, *The Soldier's War* (Bloomsbury Publishing, 2008)
7. WO 95/1272
8. Ibid
9. *Northampton Mercury*, 2 October 1914
10. *Brighton Herald*, 26 September 1914
11. WO 95/1269: 2nd Royal Sussex Regiment War Diary
12. WO 95/1270: 1st Loyal North Lancashire Regiment War Diary
13. Bolwell
14. WO 95/1270
15. Ibid
16. Ibid
17. Ibid
18. Ibid
19. *Preston Guardian*, 10 October 1914
20. Bolwell
21. Ibid
22. WO 95/1272
23. WO95/1270
24. Lieutenant-Colonel John Ponsonby Diary, Regimental Headquarters Coldstream Guards Archive
25. WO95/1270
26. Hamilton, Lord Ernest, *The First Seven Divisions* (Hurst & Blackett Ltd, 1916)
27. IWM 79/33/1: Corporal John Stennett, 1st Northamptonshire Regiment
28. WO 95/1269
29. IWM 77/179/1: Captain Hubert Rees, 2nd Welsh Regiment
30. WO 95/1270
31. Ibid
32. Bolwell
33. Ibid
34. WO 95/1272
35. *Preston Herald*, 7 October 1914
36. *The Lancashire Lad*

THEY FOUGHT FOR THE SUGAR FACTORY AT CERNY

LIEUTENANT-COLONEL WALTER LLOYD
COMMANDING OFFICER, 1ST BATTALION LOYAL NORTH LANCASHIRE REGIMENT

Walter Reginald Lloyd was born in 1868 at the Farm, Sparbrook, Birmingham. He was the son of Sampson Lloyd who was Chairman of Lloyd's Bank and was MP for Plymouth. Walter Lloyd was educated at Eton and rowed for the school. He then went to the Royal Military College at Sandhurst and joined the 2nd Loyal North Lancashire Regiment in 1888. By 1896 he had attained the rank of Captain. In 1897 he was appointed the Battalion Adjutant and served in this role until 1901. Lloyd served in South Africa during the last eighteen months of the Boer War. He received the Queen's Medal with four clasps for his conduct there. Lloyd was promoted to Major in 1906. He went with the 1st Loyal North Lancashire Regiment to France and on 11 September while advancing to the river Aisne, Lieutenant-Colonel Guy Knight was killed by shell fire and Major Walter Lloyd assumed command of the battalion. He was promoted to Lieutenant-Colonel and two days later he led his battalion across the Aisne. Lloyd personally led his men in the attack upon the Sugar Factory at Cerny. Despite a head wound he continued to fight on until was shot through the heart later that day. He has no known grave and his name is commemorated on the La Ferté-sous-Jouarre Memorial.

Lieutenant-Colonel Walter Lloyd, 1st Loyal North Lancashire Regiment. (*Bonds of Sacrifice*)

CAPTAIN HAROLD HELME
1ST BATTALION LOYAL NORTH LANCASHIRE REGIMENT

Harold Lutwyche Helme was born in 1878 at Trewyn, Herefordshire. He was educated at Haileybury College and later joined the Worcestershire Militia. By 1899 he was serving as a 2nd Lieutenant with the Loyal North Lancashire Regiment. By February 1901 he was promoted to Lieutenant and served in the Boer War. He took part in operations in the Orange Free State and Cape Colonies and was wounded. He received the Queen's Medal with three clasps. Captain Harold Helme was killed when the 1st Loyal North Lancashire Regiment attacked the Sugar Factory at Cerny on 14 September. He has no known grave and his name is commemorated on the La Ferté-sous-Jouarre Memorial.

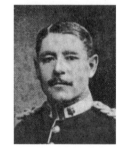

Captain Harold Helme, 1st Loyal North Lancashire Regiment. (*Bonds of Sacrifice*)

LIEUTENANT HERBERT LOOMES
1ST BATTALION LOYAL NORTH LANCASHIRE REGIMENT

Herbert Loomes was born in London in 1889. His family lived in Tufnell Park and he was educated at Highgate School. He joined the Loyal North Lancashire Regiment in May 1909 and reached the rank of Lieutenant in April 1912. For two years prior to the outbreak of war Loomes served as the Battalion Adjutant. He was an accurate marksman and won several awards in shooting competitions. He also enjoyed hunting and polo.

Loomes was sent to France with the 1st Loyal North Lancashire Regiment in August 1914. During the retreat

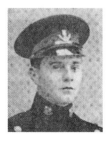

Lieutenant Herbert Loomes, 1st Loyal North Lancashire Regiment. (*Bonds of Sacrifice*)

from Mons Loomes had been taken ill as the battalion passed through Soissons on 1 September and had to fall out. He had been ordered to return to England to recover but refused and made an effort to reach his battalion. He did so at Troyon on 14 September, moments before they were about to attack the Sugar Factory at Cerny. His return would cost him his life. An anonymous 2nd Lieutenant from the battalion wrote:

Lieut. Loomes turned up and rejoined; we were all glad to see him. He was delighted at being back. When he had reached the base he was told to go to England, but not liking the idea he had got on a train and, by changing trains and living from hand to mouth, had succeeded in joining up just before going into action.[1]

Eye witnesses reported that Lieutenant Loomes led his men in a charge across open ground towards the Sugar Factory. He sustained a gunshot wound to his neck, but carried on regardless under heavy German machine-gun fire. He called out ranges for his men to fire and as his neck wound was being bandaged, both he and the man tending his wounds were killed by gunfire. He has no known grave and his name is commemorated on the La Ferté-sous-Jouarre Memorial.

2ND LIEUTENANT WILLIAM CALROW
1ST BATTALION LOYAL NORTH LANCASHIRE REGIMENT
William Robert Launcelot Calrow was born in San Antonio, Texas, USA, in 1895. His parents were English and when he was eighteen months old his mother died. Calrow was brought up by his father and grandmother. He was educated at Seascale, Cumberland, at Rugby and the Royal Military College at Sandhurst. He joined the 1st Loyal North Lancashire as a 2nd Lieutenant in November 1913. He went to France with the battalion on 12 August 1914 and took part in the retreat from Mons, the Battle of the Marne and fought at the Battle of the Aisne. The battalion war diary recorded that he died from shell fire while sitting in the mess on 29 September 1914; however, the Commonwealth War Graves Commission recorded his date of death as

7 October 1914. In a letter of condolence to his aunt, his commanding officer wrote: 'Young Mr Calrow is a hero, if ever there was one. Calrow behaved perfectly splendidly; he was wonderfully cool and collected.'[2] Another officer described Calrow as 'A thoroughly efficient young officer, as brave as you can make them and a great loss to us.'[3] 2nd Lieutenant William Calrow has no known grave and his name is commemorated on the memorial at La Ferté-Sous-Jouarre.

MAJOR HUBERT FOLJAMBE
2ND BATTALION KING'S ROYAL RIFLE CORPS
Hubert Francis Fitzwilliam Brabazon Foljambe was born in 1872. Educated at Eton he joined the King's Royal Rifle Corps during March 1895. He served in the Boer War and took part in operations in Natal, Transvaal. Foljambe was killed during the Battle of the Aisne on 14 September while leading his company at Troyon. He has no known grave and his name is commemorated on the La Ferté-sous-Jouarre Memorial.

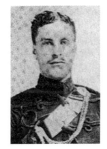

Major Hubert Foljambe, 2nd King's Royal Rifle Corps. (*Bonds of Sacrifice*)

CAPTAIN AUGUSTUS CATHCART
2ND BATTALION KING'S ROYAL RIFLE CORPS
Augustus Ernest Cathcart was born in 1875. Cathcart had served with the King's Royal Rifle Corps since January 1897 and had served in the Boer War, taking part in the operations in Transvaal and the Orange River Colony. Captain Cathcart was killed in the assault upon the Sugar Factory on 14 September and was buried in Paissy Churchyard. His epitaph reads:

LIFE'S RACE WELL RUN
LIFE'S WORK WELL DONE
LIFE'S CROWN WELL WON

2nd Lieutenant William Calrow, 1st Loyal North Lancashire Regiment. (*Bonds of Sacrifice*)

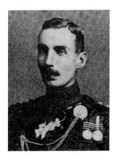

Captain Augustus Cathcart, 2nd King's Royal Rifle Corps. (*Bonds of Sacrifice*)

CAPTAIN THE HONOURABLE ERIC UPTON
2ND BATTALION KING'S ROYAL RIFLE CORPS

The Honourable Eric Edward Montague John Upton was born in Steventon, Hampshire on 8 March 1885. Educated at Eton and the Royal Military College at Sandhurst he was gazetted as a 2nd Lieutenant to the 2nd Battalion King's Royal Rifle Corps on 16 August 1905. He joined the battalion in India and he was promoted to Lieutenant during the following year. The battalion returned to Britain in 1910 and for the next three years he served as the Battalion Assistant Adjutant. He was appointed Adjutant on 1 January 1914. During the first months of the war Upton saw action during the retreat from Mons, the Battle of the Marne, the Battle of the Aisne and the Battle of Ypres. He was wounded and twice mentioned in dispatches. On 15 November 1914 he was promoted to Temporary Captain. He was killed on 9 May 1915 in action close to Rue de Bois.

Captain The Honourable Eric Upton, 2nd King's Royal Rifle Corps. (De Ruvigny's Roll of Honour, 1914–1918)

2ND LIEUTENANT GEORGE THOMPSON
2ND BATTALION KING'S ROYAL RIFLE CORPS

George Samuel Rodie Thompson was born in 1893. He was educated at Harrow. After graduating from the Royal Military College, Sandhurst, George Thompson was commissioned into the King's Royal Rifle Corps as a 2nd Lieutenant in September 1912. He took part in the bloody assault upon the Sugar Factory at Cerny. As he fell mortally wounded he cried 'Go on boys, never mind me!' He has no known grave and his name is commemorated on the La Ferté-sous-Jouarre Memorial.

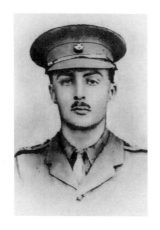

2nd Lieutenant George Thompson, 2nd King's Royal Rifle Corps. (Harrow Memorial Book)

RIFLEMAN JOHN ILES 11345
2ND BATTALION KING'S ROYAL RIFLE CORPS

John Thomas Iles was an 'old contemptible' who survived the war despite being involved in many campaigns from 1914 to 1916. He was born in 1895 and raised in Maidstone, Kent with his four brothers and three sisters. When he was aged 18, he joined the 2nd King's Royal Rifle Corps during 1913 as a Rifleman. Iles was sent to France with the battalion on 12 August 1914 and took

part in the retreat from Mons, the Battle of the Marne and the Battle of the Aisne at Troyon on 14 September. He ended the year serving in Flanders during the first battle of Ypres. On

Rifleman John Iles, 2nd King's Royal Rifle Corps. (Courtesy Keith Iles)

'Old Contemptible' Rifleman John Iles in later life, attending a Remembrance Day ceremony. (Courtesy Keith Iles)

29 January 1915 Iles was present when the battalion came under attack on the La Bassée sector. He took part in the Battle of Aubers Ridge on 9 May 1915 and at Loos on 25 September 1915. Rifleman John Iles took part in the Somme campaign at High Wood during July and September 1916.

It was on the Somme that Iles sustained a wound that would render him unfit for front line duties. His grandson Keith Iles wrote 'My father recalls that Grandad had told him he received "a clout around the ear", (probably his left as he wore a hearing aid on that side) from a German rifle butt.'

Rifleman John Iles as a pensioner in Chelsea.
(Courtesy Keith Iles)

Rifleman Iles was repatriated where he recovered from wounds sustained on the Somme. In December 1916 he married Emily Burridge and they lived in Maidstone where they raised a family of four girls and one son. After recovering from his wounds in England, being declared medically unfit for active service he was transferred to the Labour Corps in the summer of 1917. In 1919 Iles was transferred to the 3rd King's Royal Rifle Corps, based in England, and served with them until the battalion was disbanded on 1 June 1923.

After leaving the Army, John Iles worked as a chimney sweep and later as a Boiler attendant/Stoker at Sharps Toffee Factory in Maidstone. He would serve his country a second time with the Home Guard during the Second World War. He was on guard duty at the Fighter Command Centre at Detling, the RAF base in Kent.

On 12 August 1968 John Iles became an in-pensioner at the Royal Hospital Chelsea. He resided there until he passed away on 20 February 1976.

LIEUTENANT-COLONEL ERNEST MONTRESOR
COMMANDING OFFICER, 2ND BATTALION ROYAL SUSSEX REGIMENT
Ernest Henry Montresor was born in 1863 at Burdwan, Bengal, India. He was educated at Haileybury College and the Royal Military College at Sandhurst. Montresor joined the Royal Sussex Regiment as Lieutenant in February 1884. He served in the Sudan Expedition during 1884–85 and received the Khedive's bronze star. In 1888 he took part in the Hazara Expedition. During the period December 1895 until 1900 he served as Adjutant to the 1st Volunteer Battalion, Royal Sussex Regiment. Montresor served in the Boer War taking part in operations in the Orange River and Cape Colonies from March 1901 until January 1902. He also served in the Transvaal from March to May 1902. Montresor was mentioned in dispatches in the *London Gazette* on 29 July 1902 and received the Queen's Medal with five clasps for his role in the Boer War. In August 1902 he was promoted to Brevet Major. He was appointed commander of the 2nd Royal Sussex Regiment in February 1911 and promoted to Lieutenant-Colonel. His recreational activities included amateur dramatics and he was regarded as an amateur actor of great ability. Montresor was killed during the Battle of the Aisne at Troyon on 14 September. Private Yeates from B Company saw Montresor give the tactical command '"A" Stack Right' before he fell.[4] He has no known grave and his name is commemorated on the La Ferté-sous-Jouarre Memorial. An obituary in the *Sussex Daily News* recorded 'He knew practically every man in the 2nd Battalion, including most of the reservists who had been recalled for the war, and was recognised as a skilled leader of men and absolutely fearless in action.'[5]

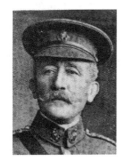

Lieutenant-Colonel
Ernest Montresor, 2nd
Royal Sussex Regiment.
(*Bonds of Sacrifice*)

MAJOR MOSTYN COOKSON
2ND BATTALION ROYAL SUSSEX REGIMENT
Mostyn Eden Cookson was born in Skipton-in-Craven, Yorkshire on 1 January 1868. He had served with the Royal Sussex Regiment since 1887. He was killed during the attack on the Sugar Factory at Cerny. He has no known grave and his name is commemorated on the La Ferté-sous-Jouarre Memorial.

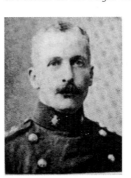

Major Mostyn
Cookson, 2nd Royal
Sussex Regiment.
(*Bonds of Sacrifice*)

CAPTAIN REGINALD ALDRIDGE

2ND BATTALION ROYAL SUSSEX REGIMENT

Reginald Aldridge was born in Poole, Dorset, in 1877. He was educated by a private tutor and then went on to study at Worcester College, Oxford. At Oxford he excelled at athletics, hockey and football. In 1900 he was commissioned into the Royal Sussex Regiment.

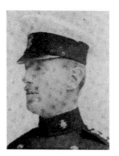

He took part in the Battle of the Aisne and was killed on 7 October 1914 by a shell. He was buried in Vendresse British Cemetery.

Captain Reginald Aldridge, 2nd Royal Sussex Regiment. (*Bonds of Sacrifice*)

CAPTAIN LEONARD SLATER

2ND BATTALION ROYAL SUSSEX REGIMENT

Leonard Slater was born in 1875 at Instow, North Devon. After completing his education at Marlborough College he went to the Royal Military College at Sandhurst. In October 1895 he joined the Indian Staff Corps as a 2nd Lieutenant. While serving with the Indian Army he was promoted to Lieutenant in 1897 and Captain in August 1904. Slater served with the 22nd Cavalry, Punjab Frontier Force, for eight years. During December 1904 he returned to England and transferred to the 2nd Royal Sussex Regiment. He would return to India and take part in the Waziristan Campaign in north west India and was awarded a medal with clasp for his role. Captain Slater was highly respected by his commanding officers and the men he

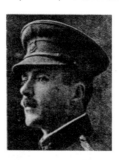

commanded. He was killed during the Battle of the Aisne on 14 September and was buried at Vendresse British Cemetery.

Captain Leonard Slater, 2nd Royal Sussex Regiment. (*Bonds of Sacrifice*)

LIEUTENANT THE HONOURABLE HERBERT PELHAM

ADJUTANT, 2ND BATTALION ROYAL SUSSEX REGIMENT

The Honourable Herbert Lyttleton Pelham was born on 3 April 1884 at Lambeth Rectory, London. He was the fourth son of the Reverend Francis Pelham, who would later inherit the title of the 5th Earl of Chichester. His family ancestry can be traced back to Oliver Cromwell,

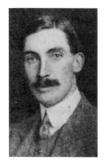

Lieutenant Herbert Pelham, 2nd Royal Sussex Regiment. (*Bonds of Sacrifice*)

the Duke of Marlborough and Sir John Pelham who was a knight of King Edward III, a Constable of Pevensey Castle in 1415 and who would later serve as Chamberlain of the Household of King Henry V. The family coat of arms features sword belt and buckles, given by King John II of France to Sir John Pelham when the French King was captured during the Battles of Poitiers.

Herbert Pelham was educated at Charterhouse and then served as a commissioned officer in the Duke of Connaught's Own Hampshire and Isle of Wight Garrison Artillery from April 1902. In June 1904 he transferred to the 2nd Royal Sussex Regiment. He joined the battalion in Malta, then served in Crete. After returning to England Pelham passed through the School of Musketry at Hythe and passed the Maxim-gun course with distinction. In 1908 Pelham was promoted to Lieutenant and was involved in the quelling of the Belfast Riots. In 1911 he was appointed Adjutant of the 2nd Royal Sussex Regiment. Pelham was trained as an aviator and gained a pilot's certificate from the Royal Aero Club in November 1913.

In August 1914, Pelham took part in rearguard actions during the retreat from Mons and during the Battle of the Marne. Major-General E.H. Bulfin wrote: 'I ordered the Sussex to pass on and seize the ridges north of Priez ... 10 Sept., for the good work done that day I sent Pelham's name for recognition.'[6]

Pelham was awarded the Croix de Chevalier of the Legion of Honour for 'conspicuous gallantry' for the period 21–30 August 1914 by the French President.

On 14 September Pelham managed to reach a farmhouse between Vendresse and Cerny where he established a machine-gun position. Here he worked the machine gun to good effect until a German artillery shell hit the building and killed him instantly. Major E.V.B. Green, his commanding officer wrote to his parents:

> Your son died a soldier's death in the forefront of the fighting on 14th ... We have lost a much loved comrade who we all felt had a promising career before him, in fact, perhaps I cannot do better than quote to you the words in which his name has gone forward for mention in dispatches. 'Lieut. and Adjutant the Hon. H.L. Pelham. I saw this officer two or three times under heavy fire conveying orders and encouraging troops. He was killed in an advanced position, assisting with the machine guns, several of

the detachment having been knocked out. In him the army has lost a most promising officer. His work during mobilisation and during the campaign has been deserving of the highest praise.' ... I wish I could give you further details regarding your son, but the circumstances of the battle on the 14th, the first day of the Aisne, were such that we were not able to hold to the foremost ground to which we got that day, and indeed although we have been here a month today, we have never got back on the actual ground on which your son was killed. I am being perfectly honest with you, as you wish me to be. We know where your son fell, in the forefront of the battle, but we do not know as yet where he lies. The Germans doubtless have buried him, and when we move forward we shall, I hope, be able to give you fuller particulars.[7]

It was likely that Pelham was buried by the Germans and it was not until after the war that his remains were recovered and he was buried at Vendresse British Cemetery. His epitaph reads:

THE PEOPLE
THAT KNOW THEIR GOD
SHALL BE STRONG
AND DO EXPLOITS

The Legion of Honour was conferred upon Pelham after his death.

LIEUTENANT EDWARD DAUN
2ND BATTALION ROYAL SUSSEX REGIMENT

Edward Charles Daun was born in Streatham, Surrey, in 1885. Daun was educated at Sunningdale School and Harrow. He joined the 3rd Royal Sussex Regiment in 1904 and transferred to the 2nd Battalion the following year. He was promoted to Lieutenant in 1909. He served in the Mediterranean and in Ireland and was part of the force that confronted the Belfast rioters during 1908. He served as the battalion's Instructor of Signalling, Musketry and of Machine Gunnery. He would later serve as the Assistant Adjutant. Daun was an accurate marksman and won the Officer's Cup at the Aldershot Command Rifle Meeting in 1912 and 1913. He left for France with the 2nd Battalion Royal Sussex Regiment in August 1914 and took part in the retreat from Mons. Lieutenant Edward Daun was amongst those men from the 2nd Royal Sussex Regiment who went forward to accept the surrender of German soldiers when they came under a torrent of German fire from the rear lines close to Troyon. He had accepted the sword of a German officer when he fell. The following report appeared in the *Sussex Daily News* on 14 January 1915 describing the circumstances of his death:

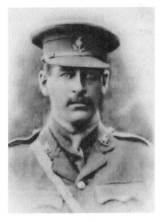

Lieutenant Edward Daun, 2nd Royal Sussex Regiment. (*Harrow Memorial Book*)

On reaching the top of the ridge 'A' Company came under rifle fire from the trenches near the Chemin des Dames. 'B' Company and the machine gun came up, and a strong firing line was built up. Soon a white flag was seen displayed by the Germans, and large numbers of them came forward to surrender. Shortly a heavy rifle and artillery fire was opened by the Germans upon the assembled mass of friend and foe. Under this fire 'A' Company suffered heavily, and it was during this time that Lieutenant Daun was killed.[8]

A fellow officer paid this tribute to him. 'He was a splendid officer, and worked night and day for the good of his regiment and his company, and had a great future before him. He was to have been our next Adjutant, and will be a great loss to the regiment.'[9] Lieutenant Edward Daun has no known grave and his name is commemorated on the La Ferté-sous-Jouarre Memorial.

2ND LIEUTENANT WILLIAM HUGHES
2ND BATTALION ROYAL SUSSEX REGIMENT

William Sladen Hughes was born at Blackrock, County Dublin, in 1889. He was a keen sportsman and played for Wanderers' Football Club, Dublin and also played golf and cricket. He was killed at Vendresse on 14 September 1914. He has no known grave and his name is commemorated on the La Ferté-sous-Jouarre Memorial.

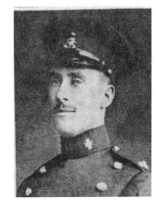

2nd Lieutenant William Hughes, 2nd Royal Sussex Regiment. (*Bonds of Sacrifice*)

LANCE CORPORAL ALFRED ALDRIDGE 9765
2ND BATTALION ROYAL SUSSEX REGIMENT

Alfred George Aldridge was born in Brighton in 1894. He worked as a laundry porter before enlisting to join the Royal Sussex Regiment on 10 October 1911. He declared that his age was 18 for the benefit of the recruiting sergeant. Alfred was in fact aged 17 years and 5 months. He enlisted for a period of 7 years service. He initially served with the 3rd Battalion and then transferred to the 2nd Battalion based at Curragh Camp in Ireland. In early 1912 the 2nd Battalion were sent back to their barracks in Woking and remained there until the outbreak of war. He took part in a demonstration battle with the 2nd Battalion before King George V and Henry Asquith, Prime Minister, in May 1914. Aldridge, who was a qualified machine gunner, took part in the Battle of the Aisne on 14 September. Six days later, while at Paissy he was promoted to Lance Corporal. Aldridge later took part in the First Battle of Ypres and was wounded close to Polygon Wood on 30 October 1914. He survived the war and settled with his wife, whom he married in 1923, in Headcorn, Kent. They raised four children. He lost his son Sydney during the Second World War when he was killed on 10 July 1944 in Normandy close to Hill 112 while serving with the Somerset Light Infantry during Operation Epsom. Alfred Aldridge died at home on 26 May 1973.

Left: Lance Corporal Alfred Aldridge, 2nd Royal Sussex Regiment. (Courtesy Neil Aldridge)

Below: Lance Corporal Alfred Aldridge, second from left in front of a field cooker. (Courtesy Neil Aldridge)

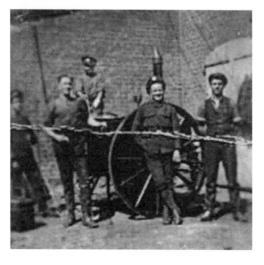

PRIVATE JAMES BALLARD L/8245
2ND ROYAL SUSSEX REGIMENT

James Ballard was born in 1886 in Hastings. He belonged to the 1st Cinque Port Rifle Volunteer Corps. He enlisted to join the Royal Sussex Regiment as a private on 12 July 1905 aged 19. Ballard saw service in England, Malta and Crete. On 18 October 1907 he was transferred to the 1st Battalion which was serving in India. He served in India for five years and acted as cook to the garrison staff at Rawalpindi. He was transferred to the reserve on 21 March 1913 in Gosport. His conduct and character was described as exemplary. He became a painter's labourer when he left the army, but was recalled to serve with the 2nd Royal Sussex Regiment when war broke out. Ballard was killed

during the Battle of the Aisne at Troyon on 14 September. He has no known grave and his name is commemorated on the memorial at La Ferté-sous-Jouarre.

Private James Ballard, 2nd Royal Sussex Regiment. (Courtesy Paul Ballard)

DRIVER SYDNEY CHAPPELL L/8314
2ND BATTALION ROYAL SUSSEX REGIMENT

Sydney Chappell was born on 28 May 1887 in Brighton. He joined the 1st Battalion Royal Sussex Regiment in 1905 and served in Malta, Crete and India. In 1908 he was on the streets of Belfast trying to restore order during the riots in the city. Chappell was killed at Vendresse during the Battle of the Aisne on 14 September. He was buried at Chauny Communal Cemetery, British Extension. He was initially listed as missing and his death was not confirmed until 22 August 1915. His obituary stated that Sydney Chappell was 'a staunch teetotaller, he was the proud possessor of thirteen Army Temperance Association Medals'.[10]

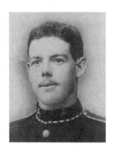

Driver Sydney Chappell, 2nd Royal Sussex Regiment. (Courtesy Chappell Family)

PRIVATE DAVID PURKIS 10021
2ND ROYAL SUSSEX REGIMENT

David George Purkis was born in Walton-on-the-Hill, Surrey, in 1893. By 1911 the family had moved to Eastbourne and David was working as a tobacconist's

porter. He went to France with the 2nd Royal Sussex Regiment and he was captured during the Battle of the Aisne. He spent the remainder of the war until early 1918 as a POW in Germany. He was repatriated on 23 February 1918 to King George Hospital in London.

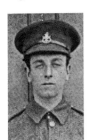

Private David Purkis, 2nd Royal Sussex Regiment.
(Carol Purkis)

CAPTAIN EDWARD WHITE
1ST BATTALION NORTHAMPTONSHIRE REGIMENT
Edward Erskine White was born in 1877. Educated at Stonyhurst, White served with the Imperial Yeomanry during the Boer War and took part in operations in the Transvaal and participated in the relief of Mafeking. He was severely wounded during the war and was awarded the Queen's medal with five clasps. White received promotion to Lieutenant in January 1904. He transferred to the Bedfordshire Regiment in July 1907 and in January 1908 transferred to the Northamptonshire Regiment. He was promoted to Captain in April 1913. Captain Edward White went to France with the 1st Northamptonshire Regiment in August 1914. He was killed while leading B Company in an assault near Troyon on 14 September. A report in the *Stonyhurst Magazine* reported that '"he was shot through the head, and died immediately" is all that could be gleaned from a soldier of his regiment lying wounded in hospital, who spoke very highly of him.'[11]

White's commanding officer wrote in a letter of condolence to his family, 'We have lost a very capable and gallant officer.'[12] Captain Edward White was 37 when he died. He has no known grave and his name is commemorated on the memorial at La Ferté-sous-Jouarre.

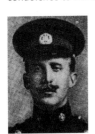

Captain Edward White, 1st Northamptonshire Regiment.
(Bonds of Sacrifice)

LIEUTENANT GEORGE PAGET
1ST BATTALION NORTHAMPTONSHIRE REGIMENT
George Godfrey Brandreth Paget was born in 1891 at North Bentcliffe, Eccles. Known as Godfrey he was raised at Great Horton House, near Northampton. After completing his education at Charterhouse in 1908 he joined the Northamptonshire Militia as a 2nd Lieutenant during April that year. In 1913 he passed the

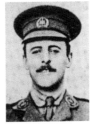

Lieutenant George Paget, 1st Northamptonshire Regiment.
(Bonds of Sacrifice)

Army Qualifying Examination and joined the regular 1st Battalion Northamptonshire Regiment as a 2nd Lieutenant in August 1914. He fought at Mons, took part in the retreat from Mons and at the Battle of the Marne. He was killed at Troyon on 14 September. He was hit by enemy bullets on two occasions during his final battle, but carried on. He and his men fought a hand-to-hand battle with their German opponents. Lieutenant Farrer recalled:

> Poor Godfrey was killed in action on 14th September. His company were attacking under a very heavy shell fire and rifle fire also. They had just halted in a bit of a dip, where they were out of rifle fire. He moved forward to see if they could go on when he was hit. The men of his platoon say he didn't seem to mind the lead that was flying round, and was urging them on all the time.[13]

Captain Lloyd, the adjutant from the 1st Northamptonshire Regiment wrote a letter of condolence to Ethel Paget, Godfrey's mother.

> There are some consolations for you. You know he died doing his duty, and that his name will be handed down to posterity, amongst the others of the regiment, as being one who assisted to uphold the glorious traditions of our regiment, and who emulated the deeds of times gone by.[14]

I doubt that these words brought much consolation for the loss of her only child. Paget's parents' grief was heightened by the fact that their son was listed as missing. He was confirmed killed in action, but there was no knowledge of the location of his remains. The commanding officer of the 1st Northamptonshire Regiment wrote to his father Charles:

> On the 14th September he was detached with his company 'B' from the rest of the battalion to occupy a certain position. The company was under the command of Captain White. There was a lot of very hard fighting that day and 'B' Company joined with the Queen's Regiment in a flanking attack on the enemy's position. In this both the Queen's and our company had many casualties. It was in this flank attack that Godfrey was hit. I heard that night that he was missing, and from the evidence of men in his company we knew that he was wounded. His Captain

(White) was also missing (we have reason to believe he was also killed), and most of the N.C.O.s were killed or wounded. Two or three days later – I think on the 17th – when we had more hard fighting, an officer of the Coldstream Guards brought in letters addressed to your son, which he said had been taken from the pocket of an officer in the Northamptonshires, who was some distance in front of our trenches, and who was dead. These letters were put aside by an officer to be sent to you, but I fear in the confusion due to the fighting they have been mislaid. [This officer was wounded later, but subsequently sent the letters, which fully established the identity of G.G.B. Paget.] The fact of these letters being brought in forced us reluctantly to come to the conclusion that your boy was killed. His body has not been found, nor his identity disc been brought in. The position where White and Godfrey got with their company is some distance ahead of the trenches we now occupy, and midway between ourselves and the Germans, so that it is impossible to get out to search the ground for those who are missing – the German fire will not allow us to do so. Unfortunately the Northamptons were moved from their trenches along the Chemin des Dames, some four or five miles north of Paissy, on 16th October 1914, to go to Northern France. The French forces took their place. It is pretty certain that the German trench where G.G.B. Paget was killed has not yet been taken [7 June 1915.] There is no knowledge of his having even been buried. You should have had notice from the War Office saying that 'Lieutenant Paget previously reported missing and wounded. This we followed up with a second report to War Office saying that 'Lieutenant Paget, previously reported missing, was killed' ... May I offer you and your wife my deepest sympathy. I know what a blow the loss of your son will be to both of you. He was a most gallant chap, and when we were doing some of our long marches he stuck to it so well, even when he was not feeling very fit. We were all very fond of him.[15]

Lieutenant George Godfrey Paget's remains were never found and his name is commemorated on the memorial at La Ferté-sous-Jouarre.

PRIVATE THOMAS BARRINGER 9403
1ST NORTHAMPTONSHIRE REGIMENT
Private Thomas Barringer served three years with the Northamptonshire Regiment. He took part in the Battle of Mons and when he was lying in trenches during the Battle of the Aisne a shell fragment wounded him in the foot. He was taken to hospital in St Nazaire before being transferred to hospital in England.

Private Thomas Barringer (left) and Private Frank Barringer (right), 1st Northamptonshire Regiment. (*Northampton Independent*, 17 October 1914)

PRIVATE FRANK BARRINGER 7763
1ST NORTHAMPTONSHIRE REGIMENT
Private Frank Barringer served with the Northamptonshire Regiment for nine years. He was wounded during the Battle of the Aisne; the day after his brother Thomas was wounded. Frank was shot through the wrist and taken to hospital in Brighton to recover from his wound.

PRIVATE WILLIAM BOSWORTH 9430
1ST NORTHAMPTONSHIRE REGIMENT
Private William Bosworth was born in 1894 and lived in Kettering, Northamptonshire. He worked at the factory of Messrs Thomas Bard and Sons before enlisting in the Northamptonshire Regiment in 1911. He belonged to B Company, 1st Battalion and fought at the Battle of the Aisne. He was killed on 24 September 1914 and was buried at Fere-en-Tardenois-Communal Cemetery.

Private William Bosworth, 1st Northamptonshire Regiment. (*Northampton Independent*, 17 October 1914)

PRIVATE WILLIAM BOYES 7318
1ST BATTALION NORTHAMPTONSHIRE REGIMENT
Private William Boyes fought in three engagements including the Battle of the Aisne. He was wounded in the left hand during the fighting on 16 September 1914. After being wounded he crawled into a trench for cover and eventually reached an ambulance wagon, which evacuated him from the battlefield.

Private William Boyes, 1st Northamptonshire Regiment. (*Northampton Independent*, 17 October 1914)

PRIVATE REGINALD FIELD 9708
1ST NORTHAMPTONSHIRE REGIMENT
Reginald Field was the second son of Charles Field, the landlord of the Woolpack Inn at Islip, Northamptonshire. Reginald served with the 1st Northamptonshire Regiment at Mons. He belonged to A Company and three weeks later took part in the Battle of the Aisne. On 14 September Field was wounded in the back by shrapnel during the advance on Troyon. He lay conscious where he fell until the order to retire was given. With limited mobility he was assisted by Captain Ward Hunt and Lieutenant Broughton. Field was taken to a cave on a stretcher close to the firing line. The wounded had to remain in these caves for the German shellfire was so severe it was impossible to evacuate them from the north side of the river. He remained in this cave for five days until it was safe for his removal. During that time one wounded man lying next to him died from his wounds. Reginald Field was suffering from considerable pain from the shrapnel wound. He

was transferred to hospital in St Nazaire and then to St Thomas's Hospital in London where he recovered.

Private Reginald Field, 1st Northamptonshire Regiment. (*Kettering Leader*, 6 November 1914)

PRIVATE FREDERICK LARKMAN 9691
1ST BATTALION NORTHAMPTONSHIRE REGIMENT
Private Frederick Larkman was eighteen when he was wounded during the Battle of the Aisne. He had served

with the 1st Northamptonshire Regiment for two years and on 29 September he was hit twice in the thigh.

Private Frank Larkman, 1st Northamptonshire Regiment. (*Northampton Independent*, 17 October 1914)

PRIVATE PERCY LOVELL 6830
1ST NORTHAMPTONSHIRE REGIMENT
Private Percy Lovell had served three years with the Colours prior to the war and nine years as a reservist. He worked for Northamptonshire Post Office before being called up at the outbreak of war in August 1914. Lovell fought during the Battle of the Aisne with the 1st Northamptonshire Regiment. Lovell was carrying a clasp knife in his left breast pocket. This knife saved Lovell's life when a German bullet hit it and was deflected away. Later during the battle Lovell was wounded when a

piece of shell struck his right wrist and he sustained a bullet wound in the left thigh.[16]

Private Percy Lovell, 1st Northamptonshire Regiment. (*Northampton Independent*, 17 October 1914)

CAPTAIN RIVERSDALE GRENFELL
9TH (QUEEN'S ROYAL) LANCERS
Riversdale Nonus Grenfell was born in 1880. He was raised at Wilton Park, Beaconsfield in Buckinghamshire. Educated at Eton, he joined the Royal Bucks Hussars during September 1908. By 1914 he had attained the rank of Captain and was attached to the 9th Hussars. Grenfall was killed during the Battle of the Aisne on 14 September 1914 when the 9th (Queen's Royal) Lancers charged along the Vendresse–Cerny Road. He was buried in Vendresse Churchyard and his epitaph reads:

TWIN BROTHER TO
CAPT. FRANCIS
GRENFALL VC
KILLED AT HOOGE 1915
LOYAL DEVOIR

Lieutenant Riversdale Grenfall, 9th (Queen's Royal) Lancers. (*Bonds of Sacrifice*)

CAPTAIN DOUGLAS LUCAS-TOOTH DSO
9TH (QUEEN'S ROYAL) LANCERS
Douglas Keith Lucas-Tooth was born in Sydney, Australia, in 1880. Educated at Eton he was given a Colonial Cadetship. In March 1899 he received a commission into the New South Wales Mounted Infantry. He served in South Africa that year and received minor wounds during the Boer War. On 8 August 1900 he received a commission with the 9th

Captain Douglas Lucas-Tooth, 9th (Queen's Royal) Lancers. (Courtesy Yves Fohlen)

(Queen's Royal) Lancers. During the three years that Lucas-Tooth spent in South Africa he fought in many campaigns. He participated in the relief of Kimberley and in operations in the Orange Free State and at Paardeberg. He fought at Johannesberg, Pretoria and Diamond Hill and in engagements at Bethlehem and Wittebergen. He later took part in operations in the Orange River Colony and in Caper Colony. Lucas-Tooth was mentioned in dispatches on 16 April 1901 and he received the Queen's medal with six clasps for his role in the Boer War.

He was promoted to Captain during 1908. Lucas-Tooth took part in the retreat from Mons. On 24 August at Andregnies he led a charge on German infantry and then extracted his men after the assault. Lucas-Tooth was awarded the Distinguished Service Order. His citation stated: 'For gallantry in action against unbroken infantry at Andregnies, Belgium, on 24th August.'[17]

Captain Francis Grenfell, who lost his brother Riversdale during the Battle of the Aisne on 14 September, held Captain Lucas-Tooth in high esteem:

Douglas' death will be a very great loss to my regiment. I am bound to say I admired him more than any other. He was so quiet and so cool, and yet had some magnetic influence which filled others with confidence and admiration. I was very fond of him. The last ride I had with the regiment was with him. We rode together and consulted each other for some time after we had got ourselves out of that confusion on the 24th. All my life I shall picture his calm figure. He was very kind to me and persuaded me to go to the Ambulance. I always thought he resembled Stonewall Jackson: he said very little, but in any emergency he was the one man to do a great deal. Of his military qualities we may safely say, 'We have never seen their limits.'[18]

Lucas-Tooth was killed at Vendresse by shrapnel on 14 September. His commanding officer Colonel Campbell wrote in more detail about the circumstances of his death:

I have just had a letter from Beale-Brown, who says: 'Poor Lucas was killed outside the village of Bourg on the Aisne. The village had been taken by the 4th Dragoon Guards, and was ordered to occupy a steep hill commanding the village ... the whole Brigade assembled on the top and de Lisle opened fire with his battery. The result was an avalanche of shells, one of which killed poor Lucas. He was buried in the churchyard at Moulins by Parry Evans, the chaplain who was with us at Potchefstroom.' The regiment is having a terribly hard time and they are now doing the work of infantry and holding trenches alongside the Guards. No one can compute what Douglas' loss will mean to the regiment – he was my most trusted leader and a model to us all.[19]

General de Lisle commanding the 2nd Cavalry Brigade also expressed similar sentiments of how the loss would affect the 9th Lancers in a letter of condolence to his parents:

I cannot ably express how greatly I feel the loss of your son, who was killed on 14th Sept. while leading his squadron of the 9th Lancers. I heard from Colonel Campbell tonight from England who writes: 'He was by far my best squadron leader – in fact, it would be very hard to find a better one for service.' Very high praise, but not higher than your son deserved.[20]

He was mentioned in Field Marshal French's dispatches on 14 October 1914 in the *London Gazette* for gallant and distinguished conduct in the field. Captain Wood, a fellow officer of the 9th Lancers, wrote of the personal loss to him as a comrade and to the squadron:

As you may know, I have been acting as 2nd in command to him out here, and there is no officer in the regiment we could have spared less. I was not with him when he was hit, having been sent down to get stores from the base, but am told he was killed instantly, being hit in the head by shrapnel. It is a loss that is absolutely irreparable to us as a regiment, and more so as a squadron. After our charge in Belgium, where he undoubtedly was responsible for getting, at any rate, our squadron away, if not the whole regiment, he was so highly recommended that he would have had a VC or DSO. I cannot say more than that all his squadron sympathise most deeply with you, feeling, as we do, that, apart from a personal friend of the best, we have lost a leader, in whom we had the greatest confidence and belief.[21]

Captain Lucas-Tooth was probably the second Australian-born officer serving with the BEF who was

killed in action in France. He rests in Moulins New Communal Cemetery. His epitaph reads:

SLEEP ON AND TAKE THY REST
ONLY GOODNIGHT BELOVED
NOT FAREWELL

PRIVATE H. LEONARD
9TH (QUEEN'S ROYAL) LANCERS

Private H. Leonard took part in the Battle of the Aisne. He was wounded on 29 September and was lucky to survive. He later wrote of how he was wounded in a letter home:

We were just going to have dinner and we stood talking together when a shell burst in the centre of us. It killed 13 and wounded 12, and I was one of the latter. I was hit in four places, including my right arm, but I can still write. I hope that they will not send me home as they have done a lot of the fellows.[22]

Private H. Leonard, 9th (Queen's Royal) Lancers. (*Northampton Independent*, 17 October 1914)

NOTES

1. WO 95/1270: 1st Loyal North Lancashire Regiment War Diary
2. Clutterbuck, L.A., *Bonds of Sacrifice: August to December 1914* (1915, republished by Naval & Military Press, 2002)
3. Ibid
4. *Sussex Daily News*, 28 September 1914
5. Ibid, 19 September 1914
6. De Ruvigny, Marquis, *De Ruvigny's Roll of Honour, 1914–1918* (1922, republished by Naval & Military Press, 2007)
7. Ibid
8. *Sussex Daily News*, 14 January 1915
9. *Harrow Memorials of the Great War* Volume 1 (1918)
10. *Brighton & Hove & South Sussex Graphic*, September 1915
11. *Stonyhurst Magazine*, December 1914
12. Clutterbuck
13. Ibid
14. Lieutenant George Paget Papers
15. Ibid
16. *Northampton Independent*, 17 October 1914
17. *London Gazette* 29001, 9 December 1914
18. De Ruvigny
19. Ibid
20. Ibid
21. Ibid
22. *Northampton Independent*, 17 October 1914

THE 1ST GUARDS BRIGADE THRUST UPON THE CHEMIN DES DAMES AT CERNY

After crossing the river Aisne, the 1st Guards Brigade bivouacked in a wood close to Vendresse during the night of 13/14 September. The following morning they reached Vendresse at 7.00am. The brigade was comprised of the 1st Coldstream Guards, 1st Scot Guards, 1st Black Watch (Royal Highlanders) and the 1st Queen's Own Cameron Highlanders. German artillery began to fire with vigour as the 1st Guards Brigade overwhelmed German forces occupying Moulins at 7.30am. The remainder of the 1st Division joined them. Two brigades from the Royal Field Artillery and 26th Heavy Battery were deployed on Paissy Spur.

The 1st Coldstream Guards led the brigade into Vendresse. As they entered the village, No.4 Company commanded by Captain Paget was cheered at the sight of German prisoners captured during the battle for the Sugar Factory at Cerny being led away to captivity. Captain Axel Krook from B Company the 1st Black Watch recalled:

Awakened on 14th by artillery fire, and ordered to move – we went slowly down through Moulins, and Vendresse – saw a lot of prisoners – one particularly beastly looking German Officer – it was very wet and misty as we marched up a hill by Troyon – and we were ordered to take off our waterproof sheets, as they made us look like Germans – we advanced in artillery formation and were soon under heavy fire.[1]

The 2nd Infantry Brigade was already engaged in the fight for the Sugar Factory at Cerny. Once the 1st Coldstream Guards reached Vendresse, Brigadier-General Ivor Maxse commanding the 1st Guards Brigade made the decision to extend the line of the 2nd Infantry Brigade on their right flank and orders for the 1st Guards Brigade to attack were issued on arrival at Vendresse. The 1st Guards Brigade was moving west of the 2nd Infantry Brigade. The 1st Coldstream Guards,

The Cerny-en-Laonois Plateau on the northern side of Cerny. (Author)

commanded by Lieutenant-Colonel John Ponsonby advanced from Vendresse up along the road that led to the Sugar Factory and before reaching the crest of the ridge they turned north through the wood.

Here they struggled through the dense undergrowth and over the chalky rocks as they climbed the wooded hill, which was extremely steep. As they laboured up the hillside, known as the Vendresse Ridge or Troyon Spur, in driving rain, they moved in single file. Once they reached the top, along the southern perimeter of the Cerny-en-Laonnois Plateau, they extended their lines on the southern slope, where they could see the chimney of the Sugar Factory 500 yards away to the north.

Lieutenant-Colonel John Ponsonby, commanding the 1st Coldstream Guards recalled:

> We passed through the Second Brigade and Maxse then gave me orders to push up the hill and get on the left of the Sussex Regiment, who at that time were on the right with the 60th Rifles [2nd King's Royal Rifle Corps] on their right.
>
> The hill was very steep and the wood very thick; When we eventually got to the top we found ourselves in line with the Cameron Highlanders on our left and the Black Watch on their left, both Battalions being deployed for attack.[2]

The 2nd Royal Sussex Regiment were on the right flank of the 1st Coldstream Guards and the 1st Cameron Highlanders on their left; 1st Black Watch farther to the left of the Camerons had found an easier path along a cart track on the southern tip of the Vendresse Ridge to reach the plateau and had already secured positions south west of this ridge by the time Ponsonby arrived at 8.00am. These two battalions came under heavy rifle and artillery fire. The Camerons and the Black Watch moved north. The Camerons supported by D Company, Black Watch, advanced westwards in order to meet a German counter assault which was being driven down the Beaulne spur on their left flank. The Cameron Highlanders came under a torrent of German rifle and machine-gun fire from the right flank and a storm of German shells were falling in their path. The company advancing on the right flank was decimated as a result; the remaining companies advanced despite this overwhelming fire.

Meanwhile A and C Companies commanded by Captain Green and Fortune from the 1st Black Watch were moving along the right flank across the line of advance of the 2nd Infantry Brigade assaulting the Sugar Factory. The mist caused great confusion and the formations were intermingling with other battalions. These two companies from the Black Watch found themselves east of the Sugar Factory at Cerny with elements from the Coldstream Guards and from the 2nd Infantry Brigade battalions, including the 1st

THE QUEEN'S OWN, CAMERON HIGHLANDERS.

A charge up the hill.

The Queen's Own Cameron Highlanders charging at an enemy position in a scene reminiscent of their advance on 14 September. (Author)

Northamptonshire Regiment and the 2nd King's Royal Rifle Corps.

The starting point of the 1st Black Watch was on the left flank of the 1st Loyal North Lancashires, but later during that morning some elements of the 1st Black Watch had advanced north east and found themselves on the right flank of the 1st Loyal North Lancashires. Private Frederick Bolwell, 1st Loyal North Lancashire Regiment, could observe the devastating affect that the German artillery had upon the advancing waves of the 1st Black Watch:

> On our right was the 1st Brigade, and connected up with us was the Black Watch. One large shell of the Germans which pitched amongst a platoon of theirs standing between two haystacks completely wiped them out with the exception of two men.[3]

A and C Companies from the Black Watch got to a position north of the Sugar Factory at Cerny. As the battle was being fought they could see the 2nd Infantry Brigade advancing up Troyon Valley on their right, while 3rd Infantry Brigade was driving forward on their flank to counter the German attack down Beaulne Spur. The Germans were being driven back towards the Chemin des Dames. D Company supported by artillery fire from the 116th Battery advanced upon the Sugar Factory from the track that led from Vendresse. B Company, which was initially held in reserve, acted as escort for the 116th Battery. B Company would endure heavy rifle and long range shell fire from guns on the Ailette Ridge to the north until 11.00am that morning.

Such was the confusion and disorder on the Cerny-en-Laonnois Plateau that morning that some soldiers from B Company the Black Watch nearly opened fire upon the Cameron Highlanders from the rear while acting as escort for the guns of the 116th Battery. Captain Axel Krook later testified:

> I sent Rennie's platoon to the left of the guns, Blair and Sgt. Baldwin in front of the guns, and Holt with reserve. While speaking to Holt I suddenly heard a burst of fire from the direction of Sgt. Baldwin's platoon. I ran up to his line and found that he was firing almost into the Camerons' line, and I stopped the fire – a staff officer came up and said that the firing was dangerous, and asked who was in charge? I said I was – then Colonel Grant Duff, who had come up into the firing line, said 'He was in charge, but he is not responsible – he has only just come up, and has stopped the firing' – I thought it so splendid of him to back me up like that.[4]

The 1st Black Watch were advancing on the right flank of the 1st Cameron Highlanders and adjacent to them

on the left flank were two companies from the 1st Scots Guards. The 1st Coldstream Guards positioned themselves between them and the left flank of the 2nd Royal Sussex Regiment. From this position the 1st Coldstream Guards and the 1st Camerons advanced north under heavy German fire until they reached the Chemin des Dames road. The 1st Coldstream Guards were disposed as follows: No.4 Company led by Captain Paget advanced on the right flank, while No.1 Company commanded by Captain Hargreaves-Brown and No.2 Company led by Major Brown attacked on the left. Lieutenant-Colonel John Ponsonby recalled:

> I ordered two leading companies to extend No 1 under Brown, No 4 with their left directed on a chimney by a large factory. No 1 Company in keeping touch with the Camerons swerved off to the left a bit. We came under sharp rifle fire and soon the guns opened on us. I sent Geoffrey Campbell to bring up No 2, as there was a bit of a gap.[5]

The Coldstreams, the Camerons, the Scots Guards and Black Watch advanced together towards the Chemin des Dames ridge. Some of them fought their way into the German trenches at the top of the plateau, but they could not hold on to the ground. A German counter attack rushed them and forced many of the British battalions to fall back to their starting positions at the bottom of the ridge.

Private W. Mackintosh was working as a postman in Avoch in Scotland a few weeks prior to the outbreak of the war and was in the firing line as his battalion, the 1st Cameron Highlanders, advanced in skirmishing order up the slope. From his hospital bed he wrote to his grandfather:

> We started to advance on their position, but before we got far, their artillery started again, and it was something awful. The air seemed to be on fire with bursting shells, and the ground was so soft that our artillery could not get into position to answer them, so there was nothing else for it but for the infantry to advance. Well we got to about 900 yards of them, but their fire was so hot we had to retire.[6]

Those that were wounded sought cover behind the many haystacks on the plateau. Hay does not make good armour.

The 1st Scots Guards suffered heavily as they advanced up the ridge. Private Hugh M'Cabe from the battalion was struck in the head by a bullet. Unlike many of his comrades who fell dead on that battlefield, he was fortunate to have survived. In a letter home to his wife he wrote: 'I was lucky to get off with a small bullet wound on the side of my head,

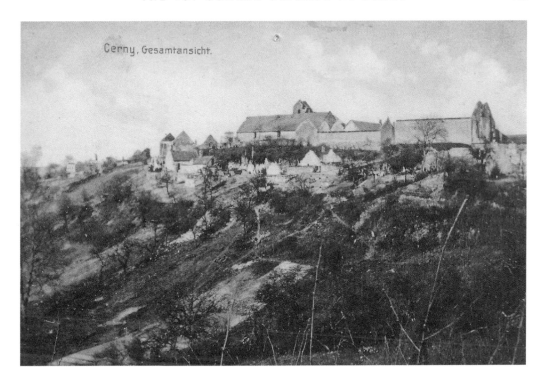

Two views of Cerny. (Author)

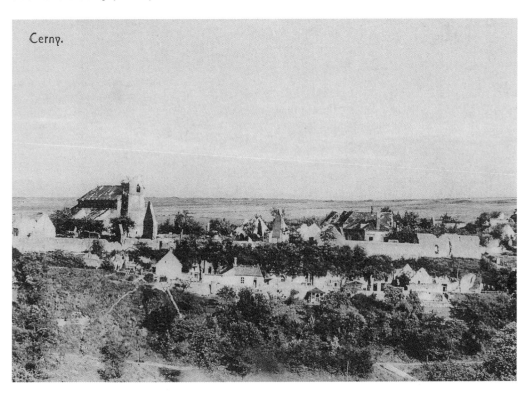

as there were hundreds lying killed by my side. I shall never forget the sight ...'[7]

An anonymous Corporal from the 1st Cameron Highlanders gave a graphic account of how he was wounded, which gives an idea of the intensity of the German fire:

I was struck above the left eye by a piece of shrapnel, and I really thought my number was up. However, one of our sergeants took my field dressing and bandaged it up. Then I continued the snapping. We were along with the Black Watch, and the Germans were fairly giving us it hot. Our firing line was lying in a field where there were a lot of stacks of wheat, and the hail of bullets was cutting the heads of them wholesale. We got close up to the enemy, and some even got in touch with the bayonet, but we could not advance an inch further owing to the perfect shower of bullets and the thousands of the enemy. After lying battering away for a long time the order was given to retire. I fell into a ditch where a lot more of our wounded were lying, and had to remain there. There were nearly twenty of us belonging to the First Brigade, and we were all placed hors-de-combat. A few of them were already dead. One bullet went through my leg: a few inches from that another grazed it and one also grazed my right leg. My kilt was riddled, and there were two other holes through my pack. I was busy having an inspection when one stray bullet came in and went through my equipment shoulder strap, which was lying by my side, and narrowly missed going into my stomach. Pieces of shrapnel were coming in now and again, but by this time I was past bothering about such trifles. I remained there all day and night amongst the dead and dying until a visiting patrol of the South Wales Borderers got us out at dawn the following morning.[8]

Private W. Mackintosh, 1st Cameron Highlanders:

Then the order came to advance again, and about half of my company got down in a big hole in the ground quite close to them. I am sure we stayed there for hours – in fact it felt like days – and every now and then some poor soul would groan. Then we got the order to advance again. I don't profess to be a Christian, but I think I prayed there. The bullets were like a shower of hail, and men were dropping in all directions. The loss of life was dreadful but still we did not crib as the Germans were losing twice as many as we were.[9]

The 1st Cameron Highlanders were overwhelmed and could not reach the German positions. They were met by a German counter attack descending from the top of the ridge. Mackintosh reported:

Well, my company got within 20 yards of the crest of the hill and lay there, waiting for reinforcement. But we did not get to stay long, as hundreds of Germans came over the ridge on top of us. We managed to hold them for a few minutes but it was useless, as there was always more and more of them coming, so we got the order to retire again. It was then, I think, we lost the most. I was seeing fellows fall on either side of me, and I was just counting myself lucky at not being hit when my rifle went spinning out of my hand. At first I didn't know what had happened. It seemed as if a hammer had struck me in the arm. Then I had a look at it and the first thing I saw was a piece blown off the sleeve of my jacket, and in my arm there are two holes about four inches apart – one just below my shoulder and the other down at my elbow.[10]

As they advanced across the open, the 1st Cameron Highlanders took what little cover they could, behind hay stacks and in ditches. Private Andrew Ramage, a reservist serving with the 1st Cameron Highlanders, dived into a shallow hollow. It was here that he heard someone groaning in agony. He recognised this man as Lance Corporal Milne from his home town of Dunfermline, who now lay mortally wounded. Ramage went to Milne's aid, but sustained shrapnel wounds to his neck, rendering him unconscious. He lay there with the dying Milne in the pouring rain through the night because it was too dangerous for stretcher bearers to get to their position.[11]

Driving rain, the mist and the smoke from the shells limited the vision of the 1st Coldstream Guards as they advanced. However, they could still see the distinctive chimney of the Sugar Factory, which acted as a point of reference. Private John Cowe, a Coldstream Guard, recalled: 'In the morning we got on top of the plateau. There was a Sugar Factory and a chimney of course; it rained in torrents that day. Visibility was bad. There was confusion but it was the same for the Germans.'[12]

Lieutenant-Colonel John Ponsonby was twice knocked down by exploding Lyddite shells:

The shells now burst all around us and I saw many men fall, some hit by shrapnel bullets, others by rifle bullets. It was difficult to see much in front of one; it began to rain hard and the early morning mist had not cleared away; the smoke from the Lyddite shells also stopped one seeing much. All I could see was the steady advance of the Cameron Highlanders on our left and the big factory chimney in the near

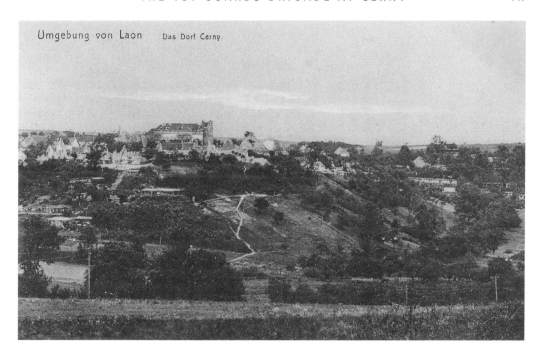

Umgebung von Laon Das Dorf Cerny.

This view of Cerny shows the steep incline that Lieutenant-Colonel John Ponsonby and his party had to climb during the night of 14/15 September in their bid to escape from German-held territory. (Author)

distance. The noise of the Lyddite shells bursting was terrific; the men advanced splendidly, no man hesitated, although many were falling on all sides.[13]

Lieutenant Allen Campbell, 1st Coldstream Guards had been wounded by shell fire in the advance. He saw Captain Tollemache fall and despite being wounded carried him for over a mile to safety. Campbell suffered severe shrapnel wounds and would die six days later, on 20 September.

Ponsonby reached a brick wall that formed part of the compound of the Sugar Factory. Here he found fellow officers Major Charlie Grant and John Wynn Finch. He also found Granville Smith, wounded. German artillery was targeting their position. During that morning Ponsonby saw the chimney come crashing down:

The wall however appeared to be a target for the enemy's guns, so Grant dashed forward to the road beyond. The others extended to the right of the factory, the shells seemed to be coming thicker and thicker and I could only see what the actual men round me were doing. Soon afterwards down came the big factory chimney with a crash.[14]

Realising that it was not safe to remain by this wall Ponsonby gathered the remnants of his party and

dashed towards the Chemin des Dames road. Ponsonby got the 1st Coldstream Guards to the Chemin des Dames but lost many casualties as they approached the road. Here he found the officers Major Charlie Grant, Captain Paget, Captain Warde-Aldham and Hall using the bank of the road as cover. The bank provided minimal cover so Captain Warde-Aldham pushed forward and found a part of the road that was sunken. He sent a message to Ponsonby recommending that they come to this part, which was two feet below the surface. Ponsonby sent his party in small rushes to Warde-Aldham's position.

Major-General Samuel Lomax commanding the 1st Division realised that the ferocity of the German guns indicated that a German counter attack upon the lines held by the 2nd Infantry Brigade would be launched. He therefore ordered the Cavalry Division at Paissy to protect his right flank.

By 9.00am the 2nd Infantry Brigade were entrenching along the line of the Chemin des Dames road with the 1st Coldstream Guards commanded by Lieutenant-Colonel John Ponsonby holding the left flank. Ponsonby assembled a party of approximately 100–150 men, barely the size of a company, comprised of men from the Coldstream Guards, Black Watch, Loyal North Lancashire Regiment and the Cameron Highlanders. Ponsonby recalled:

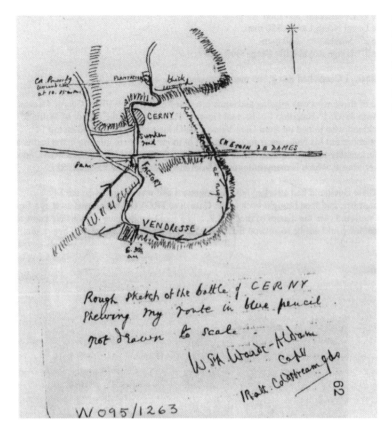

The route of Lieutenant-Colonel John Ponsonby's party behind enemy lines. (National Archives WO95/1263, Coldstream Guards War Diary)

We made rushes by sections and got to the sunken road and pressed on forward to a village, Cerny by name. At this time I suppose we were about 100 to 150 strong, but under the circumstances it was impossible to estimate numbers, we could only hope the remainder of the Battalion would come on.[15]

They would not; Ponsonby and his party would soon find themselves alone. By 11.00am the 1st Guards Brigade assault upon the Chemin des Dames had faltered. With their battalions severely mauled, those parties that did fight their way onto the Chemin des Dames were unable to consolidate their positions, they were without reinforcements or further supplies of ammunition. The shattered battalions began to retire south from the Chemin des Dames towards the Troyon Valley. The Cerny-en-Laonnois Plateau was no longer occupied by forces of the BEF by the end of that morning.

Battalion commanders immediately began the task of reorganising the remnants of their units in a desperate effort to lead them into another assault to capture the Chemin des Dames. Lieutenant-Colonel Adrian Grant Duff, commanding the 1st Black Watch, had used all his battalion reserves and had to summon every available man in the line, including himself. He set about collecting

men, reorganising their ranks, distributing ammunition. Successfully rallying and reorganising the remnants of his brigade under tremendously trying circumstances under heavy shell fire, he personally led an attack upon German positions, during which he was killed.

At 1.00pm a German counter attack was launched upon the 2nd Infantry Brigade lines at the Sugar Factory and the 1st Guards Brigade on their left flank. This German initiative overwhelmed the 2nd Infantry Brigade holding the Sugar Factory and they were forced to withdraw towards Troyon and Vendresse. The 1st Guards Brigade right flank was exposed and the German assault drove south west through their lines. The 1st Cameron Highlanders were cut down by German machine-gun fire and suffered many casualties.

By 1.00pm only 150 men from B Company, 1st Black Watch and a few men from A and C Companies were collected and ordered to occupy a position north west of the Vendresse ridge where the Vendresse–Troyon track reaches the plateau. Captain Axel Krook led B Company in a fresh assault upon the Chemin des Dames, but they only got 100 yards before they were forced to halt and take cover. For several hours they were pinned down by German fire and were unable to respond. Captain Axel Krook from B Company wrote:

Shell fire then became heavier, and I ran along and asked the CO if I could advance. He said 'Yes' – so I advanced in two rushes, about 100 yards and then could go no further without leaving the guns; there we lay for four or five hours without firing a shot, and being shelled and fired on all the time: the enemy came round our right flank and we had to change front – in carrying out this move we lost a few men, but finally got collected behind a bank from where we could defend any attack on the guns; we went forward again twice but the shell fire was too heavy, and we could see no threat to the guns, so we stayed where we were till dark.[16]

They held this position until nightfall when remnants from D Company came from the direction of Chivy Valley. D Company had been sent on the left flank to assist the Cameron Highlanders, however, since all their officers were annihilated, there was no one left to file a report of the company's actions that day. One eye witness observed them advancing up the Chivy Valley with the Cameron Highlanders to launch a counter attack. They were met by an overwhelming German attack with superior numbers. The observer saw them being slaughtered from a distance and was unable to send help. Such was the chaos of intermingled companies that Major Lord George Murray, commanding A Company, had lost contact with his company and found himself fighting alongside D Company when he was killed in the Chivy Valley.

Later that day, A and C Companies approached from the top of the Troyon Valley. Captain Green, Lieutenant Fortune and Lieutenant R.C. Anderson had reached the Chemin des Dames and held their captured position all day until they were able to fall back under the cover of darkness. The remnants of the 1st Guard's Brigade were holding the southern slopes of the Cerny-en-Laonnois Plateau. Their desperate advances to penetrate the German lines holding the Chemin des Dames during 14 September had failed.

By the end of the morning the 1st Division was holding onto positions south of the Chemin des Dames, but there was no sign of the 2nd Division, which was meant to have been on their left flank. German trenches along the Chemin des Dames ridge were being protected by machine-gun fire from positions north and east of the Sugar Factory at Troyon. German infantry launched counter attacks but they were repelled by the depleted and mixed battalions of the 1st Division. Private John Cowe of the Coldstream Guards recalled that there were no trenches at that point: 'It was all open country. You had to dig in the best you could.'[17] Cowe received a bullet wound. Exposed to German fire, he was there for days before anyone got to him. 'A gun shot wound through the shoulder. I had to lie out because we didn't

know the country and it was dark … I had to wait days before it got attended to.'[18] When Cowe was found he was taken back to England to recover; three weeks later he was sent back to France to join his battalion.

At 1.00pm a German counter attack was launched upon the 1st Guards Brigade and 2nd Infantry Brigade. The Royal Sussex were forced back to the Sugar Factory, which made the position held by the Camerons vulnerable as German machine guns fired upon their flank and they in turn retreated to Chivy valley after sustaining heavy casualties. A small party of 50 Cameron Highlanders led by Major the Honourable Alfred Maitland had managed to capture a section of German trench on the Chemin des Dames earlier that morning. As this German assault descended upon their position Maitland's courageous men repelled them with a stubborn defence. Their supplies of ammunition were exhausted, Maitland's party pulled back to a position 50 yards behind the crest of the Chemin des Dames.

They held their position as wave after wave of German infantry descended upon their position. The enemy massed upon their position five to six men deep. Their resistance was broken and Major Maitland was killed. They fought until they had expended all their ammunition. Two companies from the 1st Gloucestershire Regiment were brought from 3rd Infantry Brigade Reserve to provide covering fire for remnants of the 1st Cameron Highlanders and the 1st Black Watch who were retreating. By 3.00pm the German assaults had subsided and by the late afternoon the 1st Guard's Brigade was holding the line at the bottom of Vendresse Ridge.

The Battle of the Aisne raged on during that afternoon. The remainder of the 1st Coldstream Guards ventured east below the ridge top and had secured positions on the 2nd King's Royal Rifle Corps left flank. The 1st Queen's in the east had pressed forward and passed the Chemin des Dames. Encountering little German opposition they were able to reach the northern slope of La Bovelle Farm, half a mile north east of Cerny. From there they fired with rifle and machine gun upon German positions north of the Ailette.

A detachment from the 1st Queen's (Royal West Surrey) Regiment had penetrated German lines as far as Bovelle Farm, half a mile north east of Cerny and launched successive attacks on any German patrols that came their way. Sergeant C.S.A. Avis:

It was here that we received our introduction to the enemy's heavy artillery shells, which were nicknamed 'Black Marias' and 'Jack Johnsons'. They were of large calibre, and made deep, wide circumference craters. The noise of the explosion was very nerve wracking and the blast very powerful and dangerous.[19]

They had expected reinforcements but none came. The 1st Queen's position became untenable during the afternoon due to the French line collapsing on their right flank. By 4.30pm the 1st Queen's commander ordered a withdrawal to a line right of the Chemin des Dames.

Despite their being detached from their battalion, Lieutenant-Colonel John Ponsonby led his party forward through to Cerny earlier that day. He was hoping that reinforcements from the 1st Coldstream Guards would follow but was not aware that the 1st Guards Brigade had withdrawn. They had reached Cerny before 10.00am earlier that day. Ponsonby wrote in his diary: 'We could only hope the remainder of the battalion would come. Already we were a mixed lot, Coldstream, Cameron Highlanders, Black Watch and Loyal North Lancs. Charlie Grant took 50 men down one side of the village, Aldham, Paget and myself keeping down the centre of the village with the remainder.'[20]

On entering Cerny they stumbled across a significant force of German soldiers eating in the street. Ponsonby recounted the events that occurred when he was in hospital to Captain C.J. Balfour, Scots Guards, after the battle. Balfour noted Ponsonby's experience in his own diary: 'On going forward they found two Battalions of Germans having dinner in the middle of the street, so they wiped them out and took about five machine guns.'[21]

After taking this German party by surprise Ponsonby and his men encountered a large German ambulance corps, a concerned German colonel adorned with decorations and, wearing a Red Cross armband was accompanied by 20 medical officers who were busy tending to the wounded. The anxious German colonel came from out one of the houses, concerned for their fate and requested that the house that they were using as a dressing station be spared so that they could continue with caring for the wounded. The colonel explained to Ponsonby that his wife was English and that his medics were willing to provide medical care to the British wounded. Ponsonby reassured him that no harm would come to him or his medical team.

Ponsonby led his party farther into the village. Visibility was severely restricted by the mist that had descended, but they saw infantry advancing towards them. Initially they thought they were French troops, but as they drew nearer and after closer inspection of their uniforms they realised that they were German. They soon realised that they were encircled by German infantry. The German infantry surrounding Ponsonby thought that the Coldstream Guards were Germans. The 1st Coldstream Guards were the first to realise the truth: they opened fire and the Germans disappeared into the mist. Although isolated from the battalion and the entire 1st Guard's Brigade, Ponsonby's men had inflicted heavy casualties upon the enemy by rifle fire.

At first I thought they were French. [Lieutenant] McNaughton of the Black Watch pronounced them to be without doubt Germans. We opened rapid fire on them and they disappeared very quickly. Then two Maxim limber wagons galloped past us and we soon knocked these out, killing or disabling most of the horses and drivers.[22]

Farther on at the bottom of the hill they found a wood where they took cover. On hearing fire from two machine guns they all fell to the ground. They were not fired directly at them. Ponsonby was unaware who was firing. He sent a sergeant and a soldier from the Black Watch to crawl into the wood and investigate the position of the machine guns and to identify whether they were British or German. Ponsonby was hoping that they were British but to his dismay the patrol reported that they were German machine guns. They were firing randomly for they could not see who they were firing at through the fog.

Ponsonby had lost many men while behind enemy lines and the remnants amounted to 25 Coldstream Guards, 10 Black Watch and 6 Cameron Highlanders. He made the decision to withdraw to Cerny, at that point realising that he was surrounded. Ponsonby's party was spotted by German infantry who immediately opened fire:

In attempting to cross a bit of open ground, the Germans opened fire on us and I was hit in the ankle. I managed to crawl to the hedge, where I found 14 of our men in a ditch. The German infantry then opened fire on us from front, rear and on both flanks, but we lay in the ditch and did not move. I could not move myself and told the men it was best not to fire back, as it would give our positions away. Shells kept dropping round us and the Germans kept firing at intervals into the hedge and wood, but we had no other casualties, but the slightest movement on our part always drew fire.[23]

Ponsonby and remnants of his party were trapped in a ditch while Warde-Aldham, Paget and McNaughton were concealed a few yards away in a wood. All they could do was hold their nerve and wait for nightfall when they could make a dash for their own lines. They still clung on to the hope that reinforcements would join them, but none arrived. They remained in their position from 10.00am throughout the day.

During that time Warde-Aldham's 'unit' had dug a shallow trench to provide some cover. Everyone from the party retained 10 rounds for themselves, but they gave the remainder of their ammunition to one man in the group, who was a marksman. He fired at German patrols from a tree. Several attempts were made by German patrols to enter the wood, but Warde-

Colonel Steele's 1st Coldstream Guards headquarters at Vendresse. (*Mons to Ypres with General French*)

Company Quartermaster-Sergeant G.H. Blake, 1st Scots Guards, bringing up ammunition to the firing line on 14 September. He was awarded the DCM for his courage. (*Deeds that Thrill the Empire*)

Aldham's party held them back. Ponsonby was suffering considerable pain from his ankle wound.

> Whilst lying in the hedge I must mention that two privates, Jones and Vinicombe, were most kind and attentive, one of them cutting my boot off and dressing my wound, whilst the other lay across the ground to hide any movement I might make. They remained with me nine hours, making me comfortable and shouting to Aldham what was going on.[24]

Ponsonby sent messages requesting reinforcements but none got through. At 7.00pm a complete silence fell. Ponsonby accepted the reality that no British reinforcements were heading for their position and they had to fend for themselves.

Ponsonby could see the arrival of a German battalion in the village. This battalion established sentry posts close to where Ponsonby and his party were sheltering. They were not discovered by these German reinforcements.

Aldham, Paget, McNaughton had agreed that the only chance we had that night was to lie 'perdu' in the wood and hedge. We discussed what we should do. I was in favour myself of trying to get behind the Germans, to make a long detour to the right in the hope of striking a French force. Aldham thought our only chance was to try and get through the outposts by the way we had come and strike into the big wood. We eventually agreed to this plan and agreed that it would be no use to make an attempt till past midnight, when everything might be quiet.[25]

Although the battle had quietened on other areas of the Aisne sector, there was a lot of activity at Cerny close to where Ponsonby and his party were hiding. They came under sporadic German fire throughout that evening until 10.00pm but suffered no further casualties. Around 10.00pm two German patrols came close to the wood but were unaware of their presence. Another party arrived with horse and carts to collect their dead and wounded. Ponsonby recorded in his diary: 'We remained crouching down in dead silence and hoped they would move. We didn't dare move a finger, or whisper a word, as they were only a few yards from us.'[26]

A German brigade had bivouacked on the other side of the hedge where Ponsonby and his men were holding their breath in a ditch. Their chance to make an attempt to get back to British lines came around midnight, when it began to rain heavily and strong winds began to rattle the tree branches. After a brief deliberation with the other officers, Ponsonby decided that they should go for it. Owing to his wound, Ponsonby transferred command to Paget and Warde-Aldham. Captain Warde-Aldham and Lieutenant McNaughton led them south though the dark woods using a compass. Ponsonby was in terrible pain and had to be carried by four men. They agreed that they would move silently with fixed bayonets. It continued to rain and there was a cold wind – for once the elements were an advantage. Captain Paget and the rest of the party brought up the rear. They knew that they had to avoid Cerny and any German positions. They had to climb up the steep northern slope of the Chemin des Dames ridge covered with trees and thick undergrowth. The slow progress was made even slower as Ponsonby had to be carried.

We passed German troops within 50 yards, but keeping as quiet as possible and could only go at the rate of about one mile an hour, as I could not be carried any faster. Aldham led the way avoiding all roads, we climbed up a hill right away to the left of where we had originally come from and entered a thick wood. All the men took it in turns to carry me and it was a stiffish job as the hill was steep

and the wood very thick with undergrowth. We got up to the top after about an hour and passed some German outposts and so we went on slowly through the night, resting about 3am to give my leg a chance.[27]

They arrived at Vendresse at 5.00am, before the break of day on 15 September. The 1st Coldstream Guards had withdrawn to Vendresse for the night. Ponsonby was immediately taken to a dressing station at Vendresse. The escape from behind enemy lines was an amazing feat for Ponsonby and his party. It was a strenuous task for the men carrying Ponsonby without a stretcher, up the ridge from Cerny across rough terrain towards the crest. Warde-Aldham had led the party from deep inside enemy-occupied territory through the woods in complete darkness, without losing a single man.

The first day of the Battle of the Aisne was indeed a costly affair for the 1st Guards Brigade. Of the commanding officers, three were wounded and one was killed. The 1st Cameron Highlanders suffered the most casualties during the battle on 14 September: Major the Honourable Alfred Maitland, Captain Alastair Mackintosh, Captain Alexander Horne, Lieutenant Arthur Nicholson, 2nd Lieutenant Alastair Murray, 2nd Lieutenant Hector Cameron, 2nd Lieutenant Alexander Mackinnon, 2nd Lieutenant John Dickson and 2nd Lieutenant Archibald Smith-Silgo killed, 8 officers wounded. 151 other ranks killed or wounded. During the ensuing battle Lieutenant Napier Charles Gordon Cameron was also wounded. He pretended to be dead as the enemy cut his revolver and field glasses from his body for souvenirs.

Captain Matheson was wounded during the battle. Private Ross Tollerton from the 1st Cameron Highlanders saw him fall, put him in a place of safety and when the battalion retreated he returned to the wounded officer to wait for help. For his courage Tollerton was awarded the Victoria Cross.

Private Charles Mackenzie was amongst the wounded from the 1st Cameron Highlanders who were left lying on the slope of the Chemin des Dames. He was eventually recovered and transported to a hospital in Cambridge on 22 September. In a letter to his father he wrote.

I am sorry to say that I have been wounded in both legs, but I am getting on alright. It is a terrible place out yonder – nothing but heaps of bodies and plenty of blood. We lost a lot of men at a fight a week last Monday; there are only 300 left out of 1400. The Black Watch is the same. I am afraid it will take some time before it is finished. After being wounded I had to crawl a long way back to the back of a stack, where there were some more men. There I got my

wounds kind of sorted out and we had to stay there for three days before we got out. The Germans came round us at night and took everything off us that was useful – all the bread and meat – but did not touch us, as they do not touch the wounded.[28]

The fact that German soldiers were searching the dead and wounded for food indicated that they were also short of supplies.

The 1st Coldstream Guards suffered a total 388 casualties from all ranks. 77 were killed in the action of 14 September or subsequently died from their wounds. Lieutenant the Honourable Gerard Freeman-Thomas, the son of the 1st Viscount Willingdon, was amongst those killed. There were 224 wounded, including the officers Lieutenant-Colonel John Ponsonby, Major Charles Grant, Captain G. Hargreaves-Brown and Captain G.J. Edwards, Lieutenants Granville K.F. Smith, J.B.S. Bourne-May and D.M.B. Hall, and 2nd Lieutenants G.R.Lane, the Honourable M.H.D. Browne and C.E. Tufnell. 87 men from the 1st Coldstream Guards were captured on 14 September.

The 1st Scots Guards came into action just west of Vendresse under heavy fire to positions near Chivy. The leading company withdrew later and joined the rest of the battalion on Vendresse Ridge. Major John Carpenter-Garnier was mortally wounded and died on 15 September. Lieutenant Henry Inigo-Jones, 2nd Lieutenant Richard Compton-Thornhill and 16 other ranks were killed, 2 officers and 86 other ranks wounded, 12 missing.

Of the 1st Black Watch, Lieutenant-Colonel Adrian Grant Duff was killed. Major Lord George Stewart-Murray, Lieutenant Lewis Cumming, 2nd Lieutenant Reginald Don were also killed. 2nd Lieutenant Nigel Boyd was mortally wounded and died of his wounds four weeks later on 12 October. Six officers were wounded, 40 other ranks killed, 112 wounded, 35 missing. During that night the 1st Black Watch concentrated upon fortifying their position by digging trenches and collecting the dead and wounded.

The 1st Guards Brigade had suffered a tremendous ordeal on 14 September and would spend that night assessing their losses, reorganising their battalions, searching for their dead and wounded and entrenching their fragile positions at the bottom of the Cerny-en-Laonnois Plateau. Captain Axel Krook recorded the actions of the 1st Black Watch during that terrible night: 'We spent the night of the 14th digging and collecting dead and wounded – the collecting had to be abandoned owing to the fire kept up on the stretcher parties.'[29]

NOTES

1. Krook, Captain Axel, *1st Black Watch Memoirs* (Black Watch Museum)
2. Lieutenant-Colonel John Ponsonby Diary, Coldstream Guards Regimental Headquarters Archives.
3. Bolwell, F.A., *With a Reservist in France* (E.P. Dutton & Co., 1917)
4. Krook
5. Lieutenant-Colonel John Ponsonby Diary
6. *Highland News*, 3 October 1914
7. *Ayr Advertiser*, 1 October 1914
8. *Highland Times*, 8 October 1914
9. *Highland News*, 3 October 1914
10. Ibid
11. *The Scotsman*, 17 October 1914
12. Liddle Collection: tape 165: Private John Cowe, Coldstream Guards
13. Lieutenant-Colonel John Ponsonby Diary
14. Ibid
15. Ibid
16. Krook
17. Liddle Collection: tape 165
18. Ibid
19. IWM 84/58/1: Sergeant C.S.A. Avis, 1st The Queen's (Royal West Surrey) Regiment
20. Lieutenant-Colonel John Ponsonby Diary
21. WO 95/1263: 1st Battalion Coldstream Guards War Diary
22. Lieutenant-Colonel John Ponsonby Diary
23. Ibid
24. Ibid
25. Ibid
26. Ibid
27. Ibid
28. *Highland News*, 3 October 1914
29. Krook

SOLDIERS OF THE 1st GUARDS BRIGADE WHO FOUGHT ALONG THE CHEMIN DES DAMES AT CERNY

MAJOR THE HONOURABLE ALFRED MAITLAND

1ST BATTALION THE QUEEN'S OWN CAMERON HIGHLANDERS

Alfred Henry Maitland was born in 1872, the third son of the Earl of Lauderdale. Maitland joined the Cameron Highlanders in June 1894 and received promotion to Lieutenant in April 1898. He experienced active service in 1898 during the Nile Expedition and took part in the actions at Atbara and Khartoum and was awarded the British Medal and Egyptian medal with two clasps. He saw further action during the South African Campaign 1899. By that time Maitland had received promotion to Captain and fought in operations conducted in the Orange Free State, the Transvaal, the Orange River Colony and Cape Colony including actions at Zand Rivers, close to Johannesburg, at Pretoria, Diamond Hill, Wittebergen and Ladybrand. Maitland was awarded the Queen's Medal with five clasps for his role in the Boer War. Maitland continued to serve with the Cameron Highlanders through to the beginning of the First World War when he had reached the rank of Major and was in command of the 1st Battalion, The Queen's Own (Cameron Highlanders). Major Maitland led his battalion in an assault upon German positions on the Chemin des Dames close to Cerny. Maitland was killed during this battle. He has no known grave and his name is commemorated on the La-Ferté-Sous-Jourre Memorial.

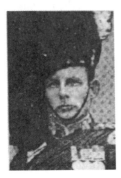

Major, the Honourable Alfred Maitland, 1st Cameron Highlanders. (Bonds of Sacrifice)

CAPTAIN NAPIER CAMERON

1ST BATTALION THE QUEEN'S OWN CAMERON HIGHLANDERS

Napier Charles Gordon Cameron was born in 1876 in Gibraltar. His father was General Sir William Cameron who fought during the Crimean War. Napier served with the Strathcona's Horse during 1900 and was commissioned in 1901 with the Scottish Horse. He served during the South African Campaign where he was wounded. He was mentioned in dispatches and was awarded the Queen's medal with four clasps. In June 1902 he transferred to the Northumberland Fusiliers until his battalion was disbanded in 1908. During that same year Cameron received a commission as a Lieutenant with the 1st Cameron Highlanders. He was promoted to Captain in September 1914. During the assault upon the Chemin des Dames on 14 September he was listed as wounded and missing. For two days Captain Cameron was behind German lines. On one occasion he evaded capture by pretending to be dead. A souvenir-hunting German soldier cut off his belt and removed his revolver. He waited until darkness before he made an attempt to get back to British lines. On 16 September he reached his battalion. He went back out towards the German lines when a wounded 2nd Lieutenant Nigel Boyd from the 1st Black Watch was calling for help. Under German fire Captain Cameron and a private from the Cameron Highlanders brought this officer to a place of safety. Captain Cameron was killed during the later stages of the Battle of the Aisne, on 26 September. He was buried at Bourg-et-Comin Communal Cemetery.

Captain Napier Cameron, 1st Cameron Highlanders. (Bonds of Sacrifice)

CAPTAIN ALEXANDER HORNE

1ST BATTALION THE QUEEN'S OWN CAMERON HIGHLANDERS

Alexander Horne was born in 1875. After completing his education at Charterhouse he initially served with the Seaforth Highlanders (Militia) before receiving a commission with the 1st Cameron Highlanders in 1897. Horne took part in the Egyptian campaign during 1898 and the actions at Atbara and Omdurman. Horne's company provided an escort for Lord Kitchener as they proceeded to Fashoda. He was awarded the Egyptian medal with two clasps and the Khedive's medal for his role in the campaign. Horne served with his battalion during the South African Campaign 1901–02 and participated in the actions at Transvaal, Orange River Colony, Cape Colony and on the Zululand frontier of Natal. Horne received the Queen's medal with three clasps and the King's medal with two clasps. Horne went to France with the 1st Queen's Own Cameron Highlanders. He was severely wounded when his battalion advanced upon German positions along the Chemin des Dames. Horne lay wounded and exposed to German machine-gun fire and shells. Private William Finnie attended to the wounded Captain Horne with utmost devotion until both men were shot dead at close range. Both men have no known grave and their names are commemorated on the La-Ferté-Sous-Jouarre Memorial.

Captain Alexander Horne, 1st Cameron Highlanders. (*Bonds of Sacrifice*)

LIEUTENANT RONALD MACDONALD

1ST BATTALION QUEEN'S OWN CAMERON HIGHLANDERS

Ronald Mosse Macdonald was born in Bombay in 1890. His family originated from the Isles of Skye. He enjoyed playing cricket and was a member of the Aldershot Cricket XI and he was an accomplished violinist. On completing his education at Winchester College he attended the Royal Military College at Sandhurst where he was commissioned to

Lieutenant Ronald Macdonald, 1st Cameron Highlanders. (*Bonds of Sacrifice*)

serve with the 1st Cameron Highlanders in November 1910. In 1913 he was appointed the Battalion's Signalling Officer.

In August 1914 he was promoted to Lieutenant. He was wounded in the fight for the Sugar Factory at Troyon on 14 September. He was taken to Angers to recover from his wounds. On recovering he rejoined his battalion on 8 October. He was killed in action at Veldhock, close to Ypres in Belgium on 3 November. When the 1st Queen's Own Cameron Highlanders marched out of Edinburgh Castle on 12 August to fight the war on the European continent, Lieutenant Macdonald was one of 25 officers in the battalion. He was the last remaining officer of all those who marched out three months before when he was killed. Macdonald has no known grave and his name is commemorated on the Ypres (Menin Gate) Memorial.

SERGEANT JAMES CARR 8633

1ST BATTALION QUEEN'S OWN CAMERON HIGHLANDERS

Sergeant James Carr was wounded during the Battle of the Aisne. No further details have been discovered.

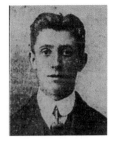

Sergeant James Carr, 1st Cameron Highlanders. (*People's Journal*, 3 October 1914)

QUARTERMASTER SERGEANT RODERICK MCLENNAN 3770

1ST BATTALION QUEEN'S OWN CAMERON HIGHLANDERS

McLennan from Inverness was killed during the Battle of the Aisne on 14 September. His remains were buried at midnight on 15 September. During the course of the war his grave was lost and his name is commemorated on the memorial at La Ferté-Sous-Jouarre.

Quartermaster Sergeant Roderick McLennan, 1st Cameron Highlanders. (*Highland Times*)

PRIVATE MICHAEL LEE 6826

1ST BATTALION QUEEN'S OWN CAMERON HIGHLANDERS

Michael Lee was born in 1885 in Dunfermline, Fifeshire. He was the eldest of seven children born to John and Susan Lee. He was brought up in Lochgelly. The 1901

census listed his occupation as a coal miner. Michael Lee married Helen in 1912 and they had a daughter Susan. When war broke out he went to France as a reservist with the 1st Cameron Highlanders. He was killed at the Battle of the Aisne on 14 September. He has no known grave and his name is commemorated on the memorial at La Ferté-sous-Jouarre.

Private Michael Lee, 1st Cameron Highlanders. (Courtesy Maureen McAuley)

PRIVATE HENRY MACKENZIE 5831
1ST BATTALION QUEEN'S OWN CAMERON HIGHLANDERS

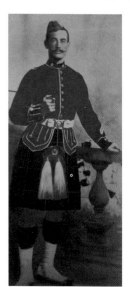

Henry Mackenzie was born in 1883 and lived in Leith, Edinburgh. He was killed during the Battle of the Aisne on 14 September. Aged 31, he left a widow, Euphenia. Private Henry Mackenzie has no known grave and his name is commemorated on the memorial at La Ferté-Sous-Jourre.

Private Henry Mackenzie, 1st Cameron Highlanders. (Courtesy Stuart Kilminster)

PRIVATE M. MACKENZIE
1ST BATTALION QUEEN'S OWN CAMERON HIGHLANDERS

Mackenzie, who resided in Dingwall, Scotland, was recalled to rejoin his regiment when war broke out. Within weeks he experienced the battle of Mons and the retreat to the Marne. Mackenzie belonged to D Company, 1st Cameron Highlanders, which was commanded by Captain Mackintosh. He recalled his experiences during the Battle of the Aisne on 14 September:

Private M. Mackenzie. (*People's Journal*, 10 October 1914)

We did a lot of hard marching by night and day with intermittent fighting and at the Aisne the fighting was exceedingly fierce. On 13th (Sunday) we were under fire ... On the Monday, after fierce fighting we got the command to retire after forcing back the Germans with fixed bayonet charges. We had got across the Aisne river when an officer of the Gloucesters called upon a number of them to come up and take a good position to get at the enemy, who were in close proximity. I did so with other Camerons, Black Watch, and Gloucesters, and opened fire on the enemy, and it was when fighting here that I received both wounds. The Germans were being knocked over wholesale by a deadly fire and I saw several of my comrades drop around me. We kept peppering away, when I received a bullet in the leg. I kept firing away and shortly afterwards a piece of shrapnel struck me in the arm. As best I could, I got back to hospital. When I left the ridge the officers were directing the men as cool as on parade with bullets and shells flying all around.[1]

PRIVATE ROBERT MILLAR 9447
1ST BATTALION QUEEN'S OWN CAMERON HIGHLANDERS

Robert Millar was born in 1894 and was the son of Robert and Mary Millar from Waterside, Peebles. He went to France with D Company, 1st Cameron Highlanders on 14 August. He served alongside his brother James. A month later, Robert fought at the Battle of the Aisne and was listed as missing on 14 September. He died in captivity on 26 March 1915 in Germany. He was buried at Niederzwehren Cemetery, Germany. His epitaph reads: 'Deeply mourned by his parents and James'.

Private Robert Millar, 1st Cameron Highlanders. (Courtesy Scott Millar)

PRIVATE ROSS TOLLERTON 7281 VC
1ST BATTALION QUEEN'S OWN CAMERON HIGHLANDERS

Ross Tollerton was born in Hurlford, Scotland, in 1890. During his childhood his family relocated to Irvine where he attended Laurieknowe Primary School. Tollerton served with the 1st Cameron Highlanders for seven years from 1905 to 1912. He left the army in 1912 and was placed on the reserve list. He worked for Irvine

Private Ross Tollerton VC, 1st Cameron Highlanders. (Author)

Shipyard until he was called up at the outbreak of war.

On 14 September the 1st Cameron Highlanders began the day by having breakfast at 4.00am at Paissy. They then moved through Moulins and into the village of Vendresse from where they moved towards the Chemin des Dames. Tollerton belonged to B Company, the reserve company and when they were ordered to join the line and support the other companies; they got alongside the company commanded by Major the Honourable Alfred Maitland south of the village of Troyon. When the mist lifted the 1st Cameron Highlanders and the 1st Scots Guards were ordered to advance in a north-westerly direction to support the 2nd Infantry Brigade. As they advanced up the Vendresse Ridge they attracted heavy German machine-gun fire. Tollerton saw Captain Matheson fall to the ground severely wounded. Matheson was lying face down in the mud and was in danger of drowning. Matheson gesticulated to Tollerton to get him on his back, but Tollerton was unable to do this on his own. Tollerton asked Lance Sergeant George Geddes to assist. Tollerton got to Matheson and Geddes helped to get the wounded officer on Tollerton's back, but in the process of doing so, Geddes was shot in the head and killed outright.

Under German machine-gun fire, Tollerton, who was six feet tall, carried the wounded officer on his back into an adjacent cornfield where he sheltered him by a haystack. He left the officer there and rejoined his company in the fight. During the battle Tollerton sustained wounds to the right hand and on the crown of his head. The 1st Cameron Highlanders were ordered to retire, but Tollerton did not forget Captain Matheson. Instead of withdrawing to British lines and despite his own wounds,

Grave of Private Ross Tollerton VC, Knadgerhill Cemetery. (Courtesy Scott Millar)

he went back to Matheson and lay by his side waiting for a suitable opportunity to evacuate him. They soon became surrounded by German infantry. Tollerton did not dare raise his head for fear of being targeted by snipers who were operating close by. During that night Tollerton realised that it would be impossible to carry the wounded Matheson through German lines undetected. It was a cold and wet night; both men were exhausted and severely weakened by their wounds. They were both very hungry. Tollerton did have a full bottle of water which he shared with Matheson during that night.

At daybreak, Tollerton could see large formations of German infantry who were preparing to launch a counter attack. They were in an adjacent field; had they entered their field Tollerton and Matheson's position would surely have been discovered. Fortunately, these German units headed down a nearby road. Owing to the continual German bombardment and numerous German counter attacks both men were unable to make any attempt to get to their own lines. They spent another cold and wet night in the cornfield. By 9.00am on 16 September Tollerton had lost a lot of blood and was suffering from hunger and exposure, which meant that he could not carry Matheson or even get himself to British lines. During the afternoon on 16 September German forces withdrew from the vicinity. Around 4.00pm Tollerton observed a party of British troops digging a trench in the distance. Severely weakened he was unable to get on his feet and walk to them. Instead he crawled to their position. A stretcher was called for Matheson and both men were sent to the nearest dressing station.

Private Ross Tollerton was sent home to Irvine in Scotland to recover from his wounds and was awarded the Victoria Cross for rescuing Captain Matheson. His citation in the London Gazette on 16 April 1915 stated:

> For most conspicuous bravery and devotion to duty on 14th September 1914 at the Battle of the Aisne. He carried a wounded officer under heavy fire as far as he was able into a place of greater safety; then, although himself wounded in the head and hand, he struggled back to the firing line, where he remained until his battalion retired, when he returned to the wounded officer and lay beside him for three days until they were both rescued.[2]

A month later Tollerton was presented with the Victoria Cross by King George V in a ceremony on Glasgow Green on 18 May 1915 in front of 50,000 people. Tollerton returned to the 1st Cameron Highlanders and served with them for the duration of the war, reaching the rank of Sergeant. After demobilisation Tollerton returned to Irvine where he found employment as caretaker at Bank Street School. He also served in the Irvine Company

of the Royal Scots Fusiliers, a territorial unit, with the rank of Company Sergeant Major. Tollerton died aged 41 on 7 May 1931. He received a military funeral with full honours on 9 May and was buried at Knadgerhill Cemetery. Amongst the wreaths was one sent by Major J.S.M. Matheson, the man he rescued on 14 September 1914 during the Battle of the Aisne. A street in Irvine was named Tollerton Drive in his honour.

LIEUTENANT-COLONEL JOHN PONSONBY DSO
COMMANDING OFFICER, 1ST BATTALION COLDSTREAM GUARDS

John Ponsonby was born in 1866. He was gazetted to the Royal Irish Rifles on 16 November 1887 and within a year later was transferred to the Coldstream Guards on 15 August 1888. He saw active service in Matabeleland and in Uganda. He had attained the rank of Captain by 1899 when the Boer War broke out and for the next three years he fought in South Africa. He took part in the actions at Transvaal from July to November 1900 and again during the period February to June 1901. He also took part in operations in Cape Colony, February to May 1902. Ponsonby was mentioned in dispatches, received the Queen's Medal with four clasps and was awarded the DSO for his service in South Africa. By October 1913 he had attained the rank of Lieutenant-Colonel and was appointed commander of the 1st Coldstream Guards. He valiantly led his battalion at the Battle of the Aisne on 14 September and would find himself with the remnants of other battalions behind enemy lines at Cerny. They spent several hours surrounded by German forces and despite being wounded, sustaining a bullet wound to his ankle, he and his men managed to reach the safety of British lines during the early hours of the following day. After recovering from his wounds, Ponsonby was appointed commander of the 2nd Infantry Brigade in August 1915. He was created a CMG in 1915. He remained the commander of 2nd Infantry Brigade until 19 November 1916. He commanded several brigades during the following months until 22 August 1917, when he was appointed commander of 40th Division. On 4 July 1918 he was appointed commander of 5th Divison, a position he held until the war ended. In 1918 he was created a Companion Order of the Bath. He retired from the British Army on 1927. Ponsonby died on 26 March 1952, aged 86.

Lieutenant-Colonel John Ponsonby DSO, 1st Coldstream Guards. (*The War Illustrated*, 3 October 1914)

MAJOR CHARLES GRANT
1ST BATTALION COLDSTREAM GUARDS

Charles John Cecil Grant was born in St James, London, in 1877. The 1891 Census records his place of residence as Hayling Island in Hampshire. He joined the Coldstream Guards on 20 February 1897 and was promoted to Lieutenant on 18 May 1898. He served throughout the Boer War from 1899 to 1902. He took part in the advance on Kimberley and was wounded during the action at Belmont. He fought in the actions in the Transvaal, east of Pretoria. He later served in the Orange River Colony and Cape Colony. Grant was wounded and was awarded the Queen's Medal with three clasps, and the King's Medal with two clasps. Grant served as Adjutant to the 1st Coldstream Guards from 1902 until 1905. He was promoted Captain on 3 October 1903 and had passed Staff College during that same year. Grant was promoted to Major on 28 October 1913 and when war broke out he went to France with 1st Coldstream Guards. On 14 September 1914, Major Grant advanced with the battalion towards

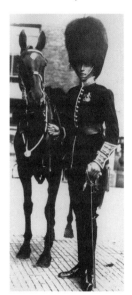

Major Charles Grant, 1st Coldstream Guards. (Coldstream Guards Regimental HQ Archives)

the Chemin des Dames. He charged across the Cerny-en-Laonnois Plateau and reached the perimeter wall of the Sugar Factory at Cerny where he and his party came under heavy German artillery fire. He advanced with Lieutenant-Colonel Ponsonby's party as they broke through German lines at Cerny and found themselves cut off from the main force. Grant led a party of 50 men down one side of Cerny while Ponsonby led the remainder of the group down the centre of the village. On realising that they were behind German lines Major Grant and his party had to lie low for the rest of the day and at night made their move back to British Lines. During this ordeal, Grant was wounded. Grant was awarded the Distinguished Service Order on 18 February 1915 for 'services in connection with operations in the field'. Grant also received the Legion of Honour in 1916. He served in various staff appointments until 21 October 1917 when he was appointed commander of 1st Infantry Brigade with the rank of temporary Brigadier-

General and served in this role until 30 March 1918. The following day he was appointed Brigadier-General, General Staff, attached to General Headquarters, French Army, where he acted as Liaison Officer between Marshal Ferdinand Foch and General Sir Henry Wilson, Chief of the Imperial General Staff. After the war he was given the Brevet of Colonel on 1 January 1919. Grant continued to serve with the British Army after the war and by 1937 he had reached the rank of General. During that year he was appointed General Officer Commanding in Chief, Scottish Command and Governor of Edinburgh Castle and served in this role until he retired in 1940. He lived at Pitchford Manor, Shropshire, during his retirement. He became a Knight Commander of the Order of the Bath and Knight Commander of the Royal Victorian Order. General Sir Charles Grant died on 9 November 1950.

CAPTAIN WILLIAM WARDE-ALDHAM
1ST BATTALION COLDSTREAM GUARDS

William St Andrew Warde-Aldham was born in 1882 in Kensington, London. He was educated at Eton and Trinity College, Cambridge. After passing out from the Royal Military College at Sandhurst he was gazetted as a 2nd Lieutenant with the Coldstream Guards on 4 June 1904. He married Clara Macavoy in 1912. By the time war broke out he had attained the rank of Captain. During the Battle of the Aisne he belonged to the party led by Lieutenant-Colonel John Ponsonby who advanced through German lines into Cerny and found themselves cut off from the main force. After Ponsonby was wounded command of this small party went to Warde-Aldham and Paget. It was Warde-Aldham who led the party to British lines in the darkness with his compass. Ponsonby recalled in his diary:

> Aldham leading with a compass and going due south. We passed German troops within 50 yards, but keeping as quiet as possible and with the aid of the storm of wind and rain, we passed through them unobserved. We could only go at the rate of about one mile an hour, as I could not be carried any faster.[3]

Warde-Aldham successfully led Ponsonby's party through the German lines to the safety of British lines the following morning. Warde-Aldham continued to serve throughout the war. He was mentioned in dispatches on four occasions and received the

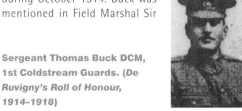

Captain Warde-Aldham, 1st Coldstream Guards. (Coldstream Guards Regimental HQ Archives)

Legion of Honour. He was severely wounded during 1914, but on recovery returned to active service. On 4 June 1917 his award of the Distinguished Service Order was gazetted 'for distinguished service in the field'. After the war he was promoted to Major. He was promoted to Colonel in 1923 and commanded the 149th (Northumberland) Infantry Brigade TA from 1927 until 1931. He was appointed President, Royal English Forestry Society in 1934 and served in this role until 1936. Warde-Aldham died aged 76 in 1958 in the Don Valley, West Riding, Yorkshire.

LIEUTENANT GRANVILLE SMITH
1ST BATTALION COLDSTREAM GUARDS

Granville Keith-Falconer Smith was born in 1886. Educated at Eton he joined the Coldstream Guards in August 1907. He was promoted to the rank of Lieutenant in December 1909. Lieutenant Granville Smith was wounded during the Battle of the Aisne on 14 September. He promptly returned to duty after recovering from his wounds and was sent with his battalion to the British front in Flanders. He took part in the First Battle of Ypres. He was leading a machine-gun section in an attack on German trenches close to Gheluvelt on 29 October 1914 when he received a bullet to the head, which killed him instantly. Lieutenant Granville Smith has no known grave and his name is commemorated on the Ypres (Menin Gate) Memorial.

Lieutenant Granville Smith, 1st Coldstream Guards. (Bonds of Sacrifice)

SERGEANT THOMAS BUCK 7584 DCM
1ST BATTALION COLDSTREAM GUARDS

Thomas Cyril Buck was born in Frettenham, Norfolk, in 1891. He enlisted to serve with the Coldstream Guards on 27 December 1907. By September 1912 he had attained the rank of Sergeant. Buck went to France with the BEF and fought at the Battle of the Aisne. He fought at Givenchy and Gheluvelt during October 1914. Buck was mentioned in Field Marshal Sir

Sergeant Thomas Buck DCM, 1st Coldstream Guards. (De Ruvigny's Roll of Honour, 1914–1918)

John French's dispatch on 20 November 1914. He was awarded the Distinguished Conduct Medal for his role at Givenchy. His citation recorded:

> For conspicuous gallantry and ability at Givenchy, 21 to 23 Oct. 1914 in going forward under heavy fire to select positions for machine guns, and subsequently for rescuing a wounded man who was lying out under fire. He also behaved gallantly on 29 Oct., near Gheluvelt, when in charge of machine guns.[4]

On 9 May 1915 Sergeant Thomas Buck was killed at Richebourg by shrapnel. Lieutenant T.A. Tapp wrote:

> As officer in charge of the machine-gun section I feel I must write to you and tell you how dreadfully cut up we all are at losing Sergt. Buck who had made a name for himself, not only for his machine-gun section, which was the best in the Army, but also for his own great personal bravery and devotion to duty. I feel I shall never have any chance of getting another Sergt. even half so good as Sergt. Buck was.[5]

Colonel J.A.G.R. Drummond Hay commanding the Coldstream Guards wrote:

> I will quote Colonel Ponsonby's own words as they evidently convey the feeling in the battn. as to the conspicuously gallant manner in which Sergt. Buck has conducted himself throughout the war. 'Sergt. T. Buck who got the D.C.M. a little time ago and was my machine-gun Sergt was killed (this was in a big fight that took place on Sunday 9, May). He will be a great loss. He has been right through the war, and was one of the bravest and coolest men under fire I have ever seen. I already mentioned him twice before for that reason and was so glad when he was given D.C.M. which he had so well earned.[6]

Sergeant Thomas Buck was buried at Rue-des-Berceaux Military Cemetery, Richebourg-L'Avoué.

LANCE SERGEANT WILLIAM PEARSON 7366
1ST BATTALION COLDSTREAM GUARDS

William Ransome Pearson was born in 1892 in St George's Barracks, Trafalgar Square. His father William was a former Colour Sergeant in the 1st Coldstream Guards and took part in the Nile Expedition to relieve General Gordon during 1884–85 and was wounded at the Battle of Abu-Klea, for which he was awarded a Distinguished Conduct Medal. William attended the Sandringham Road (Forest Gate) and Monega Schools. After leaving school he followed his father by serving in the 1st Coldstream Guards. He enlisted as a Drummer Boy on 27 July 1907. Pearson joined the ranks on 6

June 1912 and was appointed Lance Corporal because of his previous military experience. He was promoted to Corporal on 24 May 1914 and on 7 August 1914 he was promoted to Lance Sergeant. He was wounded during the Battle of the Aisne on 14 September. His commanding officer Captain William Warde-Aldham wrote the following letter to his parents detailing the last known actions relating to their only son:

> On 14 Sept we had a hard fight. The First Brigade (in which we are) attacked between two villages called Vendresse and Cerny near the Aisne; we captured a good deal of ground but were not able to hold all we had taken, and consequently a large number of casualties were left on ground afterwards re-occupied by the Germans. I am afraid your son was one of them. I knew your son well, having trained with him at Aldershot, but I cannot remember him definitely seeing him myself on the 14th. He was a very promising young sergt. and was a great loss to the Company ... whatever has happened to your son, I am quite confident he did his duty and upheld our old Coldstream traditions.[7]

Lance Sergeant William Pearson was possibly part of Ponsonby's party that penetrated deep into German-occupied territory beyond the Chemin des Dames Road on 14 September. He was wounded and lay where he fell for a week before he was found by German stretcher bearers. He was captured and taken to Germany. On 30 November 1914 Pearson wrote a letter to his parents from the *FestungLazarett* in Wessel, Germany:

> I was shot in the right thigh and lay where I fell for a whole week. I don't know how I lived it through, but I did. On the morning of the 21st some German stretcher bearers picked me up and took me to hospital where they dressed the leg, which, of course was broken. I have been shifted from one show to another till I have landed here, and here I shall be for two or three months.[8]

Pearson died on 24 December 1914 and he was buried at Cologne Southern Cemetery in Germany.

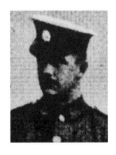

Lance Sergeant William Pearson, 1st Coldstream Guards. (De Ruvigny's Roll of Honour, 1914–1918)

LANCE CORPORAL BERTRAM GARWOOD 10042

1ST BATTALION COLDSTREAM GUARDS

Bertram Garwood was born in Bedford in 1892. He was educated at St Augustine's Grade School, Kilburn. He spent several years serving in various British Army regiments prior to the First World War. He served with the Grenadier Guards from 18 September 1909 until 2 November 1909. Garwood rejoined the Coldstream Guards on 26 March 1913 and in January 1914 he was promoted to Lance Corporal. Garwood went to France with the BEF on 13 August 1914 and took part in the Battle of the Aisne. He was killed in action on 22 December 1914 at Givenchy. He was buried half a mile south west from Givenchy Church but his grave was lost and his name is commemorated on the Le Touret Memorial.

Lance Corporal Bertram Garwood, 1st Coldstream Guards. (*De Ruvigny's Roll of Honour, 1914–1918*)

LANCE CORPORAL STEPHEN DOWDEN 9604

1ST BATTALION COLDSTREAM GUARDS

Stephen Willam Dowden was born in Peckham, London on 13 April 1885. He was educated in Wimbledon and Leatherhead prior to enlisting in May 1912. He went to France with the BEF in August 1914. Dowden took part in the retreat from Mons, the Battle of the Marne and was wounded in action during the Battle of the Aisne. He was sent home to England to recover from his wounds. He returned to the front on 16 December 1914. On 24 December he received further wounds. Dowden was transferred to No.13 General Hospital in Boulogne, where he died four days later. He was buried in the Eastern Cemetery Boulogne.

Lance Corporal Stephen Dowden, 1st Coldstream Guards. (*De Ruvigny's Roll of Honour, 1914–1918*)

LANCE CORPORAL SIDNEY WHATLEY 8919

1ST BATTALION COLDSTREAM GUARDS

Sidney John Whatley was born in Postwick, Norwich on 6 November 1892. He was educated at Thorpe, St Andrew's School in Norwich and enlisted on 13 June 1910. He received a gun shot wound to the head, which killed him on 14 September during the Cerny battle. He was buried in Vendresse British Cemetery.

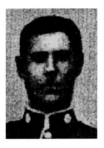

Lance Corporal Sidney Whatley, 1st Coldstream Guards. (*De Ruvigny's Roll of Honour, 1914–1918*)

PRIVATE HERBERT BARKS 7281

1ST BATTALION COLDSTREAM GUARDS

Herbert Barks was born in Clowne, Derbyshire, in 1888. He was the only child of Abraham and Emily Barks. He was educated at Wales School, Wales Bar in Yorkshire. Herbert Barks was a bricklayer by trade. He enlisted on 3 June 1907. On 27 September 1913 Herbert married Elizabeth Florence Rumble in Hampstead. Barks took part in the Battle of the Aisne and was killed on 14 September. He has no known grave and his name is commemorated on the memorial at La Ferté-Sous-Jouarre. His widow Elizabeth gave birth to their daughter Kathleen on 24 September, ten days after Herbert was killed in action.

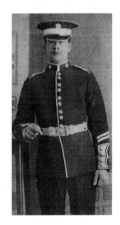

Private Herbert Barks, 1st Coldstream Guards. (Courtesy Trudie Barks)

PRIVATE WILLIAM BUCKLAND 6875

1ST BATTALION COLDSTREAM GUARDS

William Robert Buckland was born in 1883 at Gay House, close to the Outward Post Windmill at Bletchingley, Surrey. His father George was an agricultural labourer and worked at various farms in the area having to support a large family of ten children. By 1901 George was working as a foreman in a timber yard

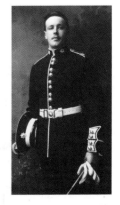

Private William Buckland, 1st Coldstream Guards. (Courtesy Dick Monk)

in East Grinstead. In 1906 William worked as a butcher. Later that year William enlisted as a Private with the 1st Coldstream Guards on 10 August in Guildford. After serving a year, he decided to extend his service to 7 years. On 26 December 1907 he received promotion to Lance Corporal. William developed a relationship with Stella Fearns and on 31 January 1909 their first child named William was born in South Farnborough. Within a month they legitimised their union and got married on 17 February 1909 at St Mark's Church, South Farnborough.

William lost his Lance Corporal's stripe on 12 April 1911 when he was held in civil custody for forging a signature on a payment order. On 10 August 1913 he had completed his service and was discharged from the army. By that time William and Stella had three children. On leaving the army he found employment with the Corporation of London and he brought his family to live at Peabody Buildings, Ebury Bridge, south west London. William Buckland remained a civilian for one year. He was mobilised from the Reserve on 13 August 1914. Private William Buckland joined the 1st Coldstream Guards on the third day of the retreat from Mons, close to Maroilles, on 26 August. He would march with the BEF to the Marne and take part in the rearguard actions that stalled the German advance at Guise on 27 August and held the bridges at La Ferté-sous-Jouarre.

William took part in the Battle of the Marne on 6 September and in the pursuit of the German army to the river Aisne. He was wounded during the 1st Coldstream Guards assault upon the Chemin des Dames on 14 September. He was evacuated from the battlefield and taken to the church at Troyon, which was being used as a dressing station. Two days later Buckland died from his wounds. He was buried in the Churchyard at Troyon. By the end of the First World War the village of Troyon had been reduced to rubble. Subsequently Buckland's grave was lost. All those soldiers buried at Troyon Churchyard, including William Buckland, were commemorated with a headstone in Vendresse British Cemetery.

His wife Stella received a telegram informing her of her husband's death on 3 October. She was left to look after their three children. Refusing to accept the heartbreaking truth, she kicked the telegram around the lobby at Peabody buildings. Stella found out the circumstances behind her husband's death when a window cleaner knocked on her

Private William Buckland, 1st Coldstream Guards. (Courtesy Dick Monk)

door and confirmed that he knew William Buckland and that he was with him when he died. He said that the wounded William was laid by a church wall and a shell exploded close by, destroying the wall, which fell upon him. There was no official reference to any wounded soldiers being killed by a falling wall at Troyon. However, Lieutenant-Colonel John Ponsonby's account referred to a company of Coldstream Guards 'who were lining a wall near a factory chimney, some German shells then brought the factory chimney down on them,'[9] so it is probable that Buckland was one of those men. Buckland was then probably brought to the dressing station at Troyon, where he died on 16 September 1914.

PRIVATE JAMES POULTON 6493
1ST BATTALION COLDSTREAM GUARDS

James Poulton was born in Ladywood, Birmingham, on 10 July 1888. He enlisted on 9 December 1905 and served for three years with the Coldstream Guards. He then signed on for a further nine years as a reservist. When war broke out he was mobilised as a reservist. He was killed during the Battle of the Aisne on 14 September. His widow Florence was left to raise her two children, Irene aged 2 and Thomas who was aged 4 months. He has no known grave and his name is commemorated on the memorial at La Ferté-Sous-Jouarre.

Private James Poulton, 1st Coldstream Guards. (De Ruvigny's Roll of Honour, 1914–1918)

PRIVATE FREDERICK WARNER 8649
1ST BATTALION COLDSTREAM GUARDS

Frederick Warner was born in Bethnal Green, London, in 1891. After completing his education at the London Council School he became a cycle fitter. On 17 March 1910 he joined the Coldstream Guards. He served through the retreat from Mons, the Battle of the Marne and the Battle of the Aisne. He was killed in action on 25 October 1914 during the Ypres campaign in Belgium. He has no known grave and his name is commemorated on the Ypres (Menin Gate) Memorial.

Private Frederick Warner, 1st Coldstream Guards. (De Ruvigny's Roll of Honour, 1914–1918)

PRIVATE WALTER WEAVER 8655
1ST BATTALION COLDSTREAM GUARDS

Walter Weaver was born in 1890 at Crudgington, Salop. He was educated at Lilleshall Public School in Newport, Salop. He worked as a porter at Rowton House, Newington Butts in London. Weaver enlisted as a Private to serve with the Coldstream Guards in March 1910. He was reported missing during the Battle of the Aisne on 14 September. He has no known grave and his name is listed on the memorial at La Ferté-Sous-Jouarre.

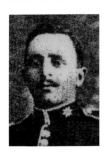

Private Walter Weaver, 1st Coldstream Guards. (De Ruvigny's Roll of Honour, 1914–1918)

LIEUTENANT-COLONEL ADRIAN GRANT DUFF
1ST BATTALION THE BLACK WATCH (ROYAL HIGHLANDERS)

Adrian Grant Duff was born in 1869. After completing his education at Wellington College he went to the Royal Military Academy at Sandhurst. Grant Duff joined the Black Watch in March 1889 and was promoted to the rank of Lieutenant during the following year. During the period 1897–98 he was in command of the Base Depot of the Tirah Expedition in Peshawar. In January 1902 he was sent to South Africa where he took part in the Boer War operations in the Transvaal and Orange River Colony. After returning to England he graduated from the Staff College in 1904 and served in several staff roles. He also qualified as an interpreter in French. During the period 1910–1913 Grant Duff served as Assistant Military Secretary to the Committee of Imperial Defence. In May 1914 he was appointed Lieutenant-Colonel of the 1st Black Watch (Royal Highlanders). When the war started he led the battalion to France. Grant Duff was always in the thick of the fighting and was well respected by the men that he commanded. As the battalion withdrew south and were close to Soissons, they came into contact with 3000 German soldiers who opened fire upon them. Private Alexander Miller later testified:

Lieutenant-Colonel Adrian Grant Duff, 1st Black Watch. (Bonds of Sacrifice)

Colonel A. Grant Duff escaped death by a miracle a hundred times. Bullets hummed round about him as he gave his orders. His concern was all for the men and he went up and down the line looking after wounded men. All our officers played their parts like men.[10]

On 8 September he was in command of the advanced guard of the 1st Division during the Battle of the Marne. On 14 September during the Battle of the Aisne Lieutenant-Colonel Grant Duff realised when there were no battalion reserves left that every man was needed on the front line, including him. Despite protestations from his subalterns who appealed for him to return to the rear, he remained with his men. Private Joe Cassells from the 1st Black Watch recalled.

Our commander, Colonel Grant Duff, was in the thickest of the fighting. I saw him distributing bandoliers of ammunition along the firing line. His men tried to make him go to the rear, but we were having a tough time to keep fire superiority, and we needed every man in the line.[11]

Lieutenant-Colonel Grant Duff led his men forward to assault German positions on the Chemin des Dames, but very soon he was shot and killed. Cassells recalled Grant Duff's last moments.

Suddenly Colonel Duff staggered and slouched forward on his hands and knees. The bandoliers he was carrying scattered. Several men rushed to him but he got to his feet himself and ordered them back to their posts. An ugly red stain was spreading over his tartan riding breeches and leggings, but he staggered onward with the ammunition. He had not gone a dozen steps when both his arms flew up into the air and he fell backward. This time he did not move. He had been shot straight through the heart.[12]

Lieutenant Adrian Grant Duff's remains were recovered and buried at Moulins New Communal Cemetery. His epitaph reads: 'Perfect Love Casteth Out Fear.'

LIEUTENANT CHARLES BOWES LYON
1ST BATTALION THE BLACK WATCH

Charles Lindsay Claude Bowes Lyon was born in 1885. Educated at Eton he then studied electrical engineering at the Royal College of Science in Newcastle. On graduation he became a member of the Institute of Civil Engineering. In April 1906 he joined the Forfarshire and Kincardine Militia Artillery and in 1910 he joined the 3rd Battalion (Special Reserve) Black Watch. When

war broke out he was mobilised and attached to the 1st Black Watch. Lieutenant Charles Bowes Lyon was sent to France in early September and was present during the battles of the Marne and Aisne. He participated in the Battle of Ypres. He was twice wounded but continued to fight. In an attempt to capture German trenches near Pilkem he was killed on 23 October. He was buried in Boesinghe Churchyard.

Lieutenant Charles Bowes-Lyon, 1st Black Watch. (*De Ruvigny's Roll of Honour, 1914–1918*)

LIEUTENANT GEOFFREY POLSEN

1ST BATTALION BLACK WATCH

Geoffrey Polsen was born in Paisley in 1890. He was educated at Charterhouse and New College, Oxford. He was very studious and a keen golfer while at New College. After graduating with second class honours in history he joined the army. He was gazetted to the 1st Black Watch as a 2nd Lieutenant on 19 August 1913. He received promotion to Lieutenant in June 1914. He took part in the Battle of the Aisne and was killed on September 15 while leading his company. He was buried at Moulins New Communal Cemetery. His epitaph states:

THY MOTHER
LAYS A LOWLY TRIBUTE
OF LOVE AND GRATITUDE
AT THY FEET

Dr W.A. Spooner, the Warden of New College, Oxford paid the following tribute:

Geoffrey Polsen was one of the best, if not the best, undergraduate I can remember at this college. Understanding that he came to Oxford to learn he stuck always manfully to his work, and succeeded in taking a fore place in the Honour History School for which he finally entered. But study formed a small part of

Lieutenant Geoffrey Polsen, 1st Black Watch. (*De Ruvigny's Roll of Honour, 1914–1918*)

his college activities; in games, in particularly in all games bearing on military life, he was an expert and a natural leader; in social life he had the art of attracting and winning friends and was deservedly one of the most popular and most influential men in college. When he left us we all expected him to make a first-rate officer; and our expectations were filled during the short period of his military career. His friends and the whole college heard with profound regret of his death, but they felt that he had died as he had lived, and that his death was the worthy crown of his life.[13]

2ND LIEUTENANT NIGEL BOYD

1ST BATTALION THE BLACK WATCH (ROYAL HIGHLANDERS)

Nigel John Lawson Boyd was born in Edinburgh in 1894. He was educated at Cargilfield School, in Midlothian and Winchester College. He excelled at sports including cricket and golf. He was a good horseman and enjoyed fishing. Being a good marksman he represented Winchester College at rifle shooting tournament for the Cadet Trophy at Bisley in 1911. Boyd then went to the Royal Military College at Sandhurst. It was his childhood ambition to serve with the Black Watch and that aspiration was achieved in February 1914. 2nd Lieutenant Nigel Boyd accompanied the battalion to France in August 1914 and took part in the retreat from Mons and the Battle of the Marne.

On 14 September during the Battle of the Aisne, on his twentieth birthday, he was wounded. He recounted the circumstances of his wound to his father in a letter which he wrote from his hospital bed in a military hospital in Rouen. During the morning he had been ordered to take up a position with his platoon and defend it from German counter attacks at all costs. German infantry charged at his position in overwhelming numbers. They could only be seen when they got to within 100 yards because of the mist. Boyd fired ten rounds from his rifle, then used up all the rounds in his revolver. The shell, shrapnel, machine-gun and rifle fire was intense. Boyd stood up to give an order to the remaining survivors from his platoon, and as he drew his claymore and turned to give the order, a German bullet struck the scabbard and deflected into his left hip, penetrating his bladder. German infantry swarmed over their position. Boyd tried to seek help from

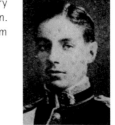

2nd Lieutenant Nigel Boyd, 1st Black Watch. (*Bonds of Sacrifice*)

one German soldier who threatened to shoot him. From then on he pretended to be dead. As he lay wounded, he was robbed by German soldiers who took his revolver, field glasses and money.

Captain Napier Cameron from the Cameron Highlanders reached him and carried him to safety in a sunken road to the rear where he remained, exposed to the falling rain, for 16 hours until he was found by stretcher bearers and carried to a Field Hospital. Boyd told his father that he owed his life to Captain Cameron; the place where he fell wounded was swept by cross fire from both sides. Boyd was transferred to a hospital in Rouen where he underwent surgery and it was hoped that he would make a complete recovery. On 12 October Boyd suffered a blood clot and died. His remains were returned to his family and he was buried with full military honours in Dean Cemetery, Edinburgh, on 19 October. One senior officer wrote to his family that 'he was very popular with all ranks.'

PRIVATE ROBERT BEVERIDGE 401

1ST BATTALION BLACK WATCH (ROYAL HIGHLANDERS)
Robert McAuslan Beveridge was born in 1887 in Cherrybank, Perth. He was educated in Perth and joined the Black Watch on 30 October 1905. He was initially based at Fort George during his first year with the regiment. In 1906 he was posted to India, where he would serve for six years. He left the Army, but when the First World War broke out he was recalled to serve on 6 August 1914. He was severely wounded during the Battle of the Aisne on 14 September. He was transferred to No. 3 Hospital at St Nazaire where he died from his wounds on 28 September 1914. He was buried at St Nazaire (Touts-Aides) Cemetery.

Private Robert Beveridge, 1st Black Watch. (*De Ruvigny's Roll of Honour, 1914–1918*)

PRIVATE JOE CASSELLS 338

1ST BATTALION THE BLACK WATCH (ROYAL HIGHLANDERS)
Joe Cassells was born in London in 1887. At 18 he joined the 1st Black Watch, in September 1905. Two years later he was transferred to the 2nd Black Watch and served at their base at Peshawar, close to the Khyber Pass in Afghanistan. His transfer papers to the 2nd Battalion describe him as 'exemplary, a thoroughly sober man' and state that he was a first class shot in musketry. He left the army in January 1913 and was placed on the reserve list. Cassells was mobilised the day after war broke out

Private Joe Cassells, 1st Black Watch. (*The Black Watch: A Record in Action*)

on 5 August. Within three hours of arriving at the 1st Battalion Black Watch depot in Perth, he was one of a thousand reservists mobilised for war and was sent by train to Aldershot. After a week's intensive training he and the Black Watch were sent to Le Havre in France on 13 August. He was a scout for the battalion. During the approach to the river Aisne a shell exploded close to his position. Cassel recalled:

Toward evening of 13th of September, I was scouting on our left flank. The German heavy guns had been keeping up a steady searching fire all day, but little damage had been done. I got so accustomed to the roar of the explosions that they did not bother me very much. After a while a man gets so used to the sound of a shrieking shell in the air that he can tell by instinct when one is coming his way in time to throw himself flat on the ground. I had not yet reached that stage of proficiency. A shell did come my way. How close it came I will never know, because all of a sudden I felt as though my head were bursting. I seemed to be tumbling end over end and being torn to pieces. My ear drums rang and pained excruciatingly. I thought to myself 'I am dying,' and wondered how I kept feeling a sort of consciousness, although I must be already torn to bits. Then I found myself sitting up on the ground with a man from my patrol supporting my head. Now, this is the strange thing. I was instantly and absolutely oblivious when the shell exploded. All the sensations I have described came when I was recovering consciousness. Surgeons have told me since then that they were exactly what the shell caused when it exploded, but that my brain did not register them until my senses returned. My clothes were scorched and my even my hair was singed. I do not know why I was not killed, but in a few hours I was ready for duty once more. The man who picked me up said that the shell had burst some little distance overhead. If it had struck the ground close to me, it would doubtless have sent me 'west'.[14]

During the next day, 14 September, Cassells advanced through the thick woods and undergrowth of the Vendresse valley towards the Chemin des Dames:

We were advancing in skirmishing order through a wood. A pal of my old athletic days, Ned McD_____, fighting a few yards from me in our scattered line, fell with a bullet through both thighs. I made him as comfortable as I could in a nook about twenty paces back from where our men, lying on their stomachs, were keeping up a steady rifle fire through the underbrush. I had hardly returned to the line when the whistle of our platoon commander sounded shrilly, and we were ordered to retire to the farther edge of the plateau, where our men could have better protection from the enemy fire. I hurriedly placed McD_____ under the edge of a bank, where, at least, he would not be trampled on by men or horses. 'Don't attempt to leave the spot Ned', I said. 'I'll get back to you tonight if there is an opportunity'. The chance did come, but when I reached the spot he had disappeared.[15]

When Cassells left his wounded comrade, he got back into the battle:

Soon after leaving the spot where McD_____ lay, I joined in a charge on a line of hidden trenches. We were upon them, and it was steel and teeth again. I saw an officer run in under a bayonet thrust, and jab his thumbs into a German's eyes. The Boche rolled upon the ground, screaming. How long we fought I do not know. When it was over we began to pick up the wounded. It was night.[16]

Many wounded were lying out in the woods and fields, vulnerable to German shell fire:

The Prussian guns were still hammering at us, and some of the shells set fire to a number of haystacks in the field we had crossed in the open. It was Hell. In the red glare of the fire the stretcher bearers hurried here and there with the dying, while others who had been placed by haystacks for shelter burned to death when stalks caught fire. The few who could, crawled away from the fire. Those of us who were able to do so, pulled others to safety, and many a man had his hands and face badly burned rescuing a helpless comrade.[17]

Cassells was wounded when he took part in another assault on German trenches close to the Sugar Factory on 15 September:

The next morning we went at them again. In the first rush, I felt a sudden slap against my thigh. It did not feel like anything more than a blow from an open palm. I thought nothing more of it until after the fight, when someone told me I was bleeding. A

bullet had struck the flesh of my thigh. The slight wound was dressed at the regimental station, and I was ready for duty again.[18]

Cassells was on outpost duty between the British and German lines during the night of 15/16 September. German artillery shells targeting roads leading to the Chemin des Dames prevented the flow of supplies of ammunition and, in some ways even worse, food. Cassells had to take matters into his own hands and searched for scraps of food amongst the dead that lay close by:

I was almost starved. My stomach ached incessantly from sheer hunger and I was weak from the bleeding of my wound. It seems terrible looking back at it, but during the night, while my partner watched, I crawled out and searched the dead for rations. I found none. Fifty paces from our post lay a dead artillery horse. We had to eat – or drop. What could we do? Wriggling on my belly like a snake I drew myself toward the smelling carcass, cut off enough with my jackknife to do the section, brought it back and we ate it.[19]

On 25 September, after being withdrawn from the front line, Cassells and the 1st Black Watch were recalled to the quarry where they had been holding the line. A shell had exploded by the quarry trapping many of the officers and men from the 1st Cameron Highlanders who had just relieved them. After trying to reach those buried alive, Cassells and the 1st Black Watch were involved in a bitter skirmish:

We were called from this scene of carnage to defend a trench line against the Prussian Guards who were threatening to break through. The machine-gun and shrapnel fire was terrific, and for a time we were glad to squeeze ourselves close against the parapet. Then suddenly everything seemed uncomfortably quiet. Wounded were screaming and groaning all about us; men who had not been struck, were muttering to themselves – driven half mad by the bombardment, but the instant the roar of the guns and shell explosions ceased, all seemed still. The Prussians were undoubtedly preparing to charge us, but they must have been slow in getting started. We got hurried orders to get ready to go over the top and surprise them. I thought of but one thing as I ran forward; that was – 'Blighty'. On going to billets it had been my intention to write to the folks at home the next day after getting a rest, but our stay had been so short that to do so had been impossible. And now my thought was: 'Perhaps I shan't return'.

The Prussians seemed surprised by our quick attack, and the offensive was wrested from them.

We became the assaulters. How I got through the entanglement I cannot tell. All I know is that I left part of my kilt dangling amid the wires. However, before we reached their trench line, the Prussians had scrambled over their parapet to meet us. In the general mix-up I found myself locked in the arms of a bear-like Prussian Guardsman who evidently had lost his rifle and bayonet. His knee was at my knee – his chest pressed against my chest. Our faces touched.

I slid my hands up along the barrel of my rifle until they were almost under the hilt of the bayonet. Very slowly I shoved the bayonet. Very slowly I shoved the butt back of me and to the side. Lower and lower I dropped it. The keen blade was between us. All the Hun seemed to know about wrestling was to hug. He dared not let go. Had he known a few tricks of the game, I should not be writing this today. Instinctively I felt that the point of my bayonet was in line with his throat. With every ounce of strength in my body, I wrenched my shoulders upward and straightened my knees. The action broke his hold, and my bayonet was driven into his greasy throat. His arms relaxed; I was drenched with blood, but it was not my own. I staggered away from him, wrenching my rifle free as he fell.[20]

Cassells was fighting in one of the first hand-to-hand encounters of trench warfare; struggles that would be played out on a daily basis for the next four years on the Western Front:

It was an awful melee. There were men swinging rifles overhead; others kicking and punching, and tearing at their adversaries; while others again, wrestling, had fallen to the ground, struggling one to master the other. One Highlander who had been struck by a bullet just before reaching the enemy parapet, grasped his rifle and crawled as best he could the intervening distance, waiting his chance to get his man. At last it came. His bayonet found its mark, before the bulky Hun could ward off the unexpected stroke from the wounded lad. In a moment they were both lying prone on the earth. The Highlander, I am sure, died content – content that he had got his quota at least.

It was the wildest confusion, but its impressions were absolutely photographic. I can see it all, again, this moment.

The Prussians were finally obliged to vacate it because it was subject to an enfilading fire from the enemy. As we retreated in company squads, we kept up a steady fire. While making for our trenches, I shouted to one of the fellows on my left to keep down as we were drawing the enemy's fire. The

sentence was hardly completed, when something hot struck me on the left jaw. It seemed as if I had been hit with a sledge hammer. I spun round, stumbled, and fell to the ground. I realised that it was a bullet and tried to swear at the boches, but all I could do was to spit and cough, for the blood was almost choking me. The bullet, entering my cheek and shattering some of my teeth in passing, made its exit by way of my mouth.[21]

Within days Private Joe Cassells was patched up and returned to duty. He survived the Battle of the Aisne and fought during the first Battle of Ypres during October 1914. He was wounded in the trenches by shell fire in January 1915 and after recovering was deemed medically unfit to serve and was discharged on 5 August 1915. In February 1916 he emigrated to the US. Just before leaving Edinburgh he met the man he referred to in his testimony as Ned, the man whom he sheltered during the Battle of the Aisne. Cassells had thought he was dead. He had been wounded, captured and because of the nature of his wounds he was sent back to England from Germany on a prisoner exchange.

In 1918 Cassells wrote: 'My fighting days are over, but ever my blood will quicken with the thought that I have played my part and done my service and shed my blood in the ranks of the Black Watch fighting for right and for the freedom of mankind.'[22]

PRIVATE JOSEPH M'LEOD
1ST BATTALION THE BLACK WATCH (ROYAL HIGHLANDERS)

Joseph M'Leod was working for the Arbroath Postal Service when he was recalled as a reservist to serve with the 1st Black Watch. He was wounded on 14 September as the battalion advanced up along Vendresse Ridge towards the Chemin des Dames:

... we passed through Moulin, and advanced in extended order. It was at this stage that I was wounded. A furious sound of firing told us we were at last getting into touch with the enemy. We advanced across fields in short spurts, dropping at every twenty yards, and after a short pause dashing on again. This was a terrible battle. I was lying in a turnip field when I was wounded. The bullet which struck me must

With apologies for the poor state of the photograph, Private Joseph M'Leod, 1st Black Watch. (*Weekly News* (Dundee), 10 October 1914)

have ricocheted off a stone or something for it struck me in the head side on. Had it hit me direct from the rifle I would have assuredly been killed.

I lay for an hour where I was until a couple of Camerons came along and assisted me to shelter. Just then a R.A.M.C. officer passed, and he dressed my wound. I was taken back to Moulin, but the German artillery made the place too hot for us, and we were forced to shift. At the next place we boarded motor cars and were driven to St Nazaire, where we embarked for Sheffield. From other wounded men I have learned that our commanding officer Lieutenant A. Grant Duff, was killed just about the same time as I received my wound.[23]

NOTES

1. *People's Journal*, 10 October 1914
2. *London Gazette* 29135, 16 April 1915
3. Lieutenant-Colonel John Ponsonby Diary, Coldstream Guards Regimental Headqaurters Archive
4. De Ruvigny, Marquis, *De Ruvigny's Roll of Honour, 1914–1918* (1922, republished by Naval & Military Press, 2007)
5. Ibid
6. Ibid
7. Ibid
8. Ibid
9. WO 95/1263: 1st Battalion Coldstream Guards War Diary
10. *The Weekly News* (Dundee) 10 October 1914
11. Cassells, Scout Joe, *The Black Watch: A Record in Action* (1918, republished by BiblioBazaar, 2009)
12. Ibid
13. De Ruvigny
14. Cassells
15. Ibid
16. Ibid
17. Ibid
18. Ibid
19. Ibid
20. Ibid
21. Ibid
22. Ibid
23. *The Weekly News* (Dundee), 10 October 1914

THE WELSH BATTALIONS' ASSAULT ON CHIVY

The original plan for 1st Division operations on 14 September was for the 2nd Infantry Brigade to advance towards the Chemin des Dames and secure positions west of Cerny. The 1st Guards Brigade was designated advanced guard and ordered forward by Moulins and Cerny towards Chamouille. Their objective was to push forward the 1st Division's left flank. The 3rd Infantry Brigade, comprised of the 1st Queen's (Royal West Surrey Regiment), 1st South Wales Borderers, 1st Gloucestershire Regiment and the 2nd Welsh Regiment, were ordered to follow behind the 1st Guards Brigade.

The 1st South Wales Borderers were scheduled to move off from their billets close to Bourg-et-Comin at 7.30am enabling them time to eat breakfast and issue rations. When they started to move off northwards the single road was congested with British troops.

Captain Charles Paterson, the Adjutant for the 1st South Wales Borderers, wrote on 16 September of the terrible ordeal the battalion had suffered in the previous two days: 'I have never spent and imagine that I can spend a more ghastly and heart-tearing 48 hours than the last. Not a moment in which to write a word in my diary. We have been fighting hard ever since 8.00am on the 14th, and have suffered much.'[1]

At 8.00am they headed north from Moulins. The 1st Queen's (Royal West Surrey Regiment) were heading north east and the 1st South Wales Borderers led the brigade. The 1st Queen's (Royal West Surrey Regiment) advanced through Moulins towards Paissy and then across the Chemin des Dames and into the wood north of the road. Here the battalion observed enemy trenches on the slopes ahead. They fired at a distance between 700 and 800 yards inflicting many casualties.

With the 1st Queen's acting as right flank guard for the 3rd Infantry Brigade, the 1st South Wales Borderers were in effect leading the brigade. When they reached

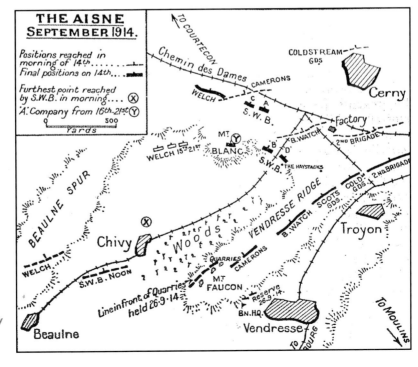

The Chivy Valley and Vendresse Ridge showing positions of the 1st Guards Brigade, 2nd Infantry Brigade and 3rd Infantry Brigade on 14 September. (*History of the South Wales Borderers*)

a crossroads half a mile south from Vendresse their advance was blocked by the congestion and they had to remain there for some time. As they waited, the battalions from the 3rd Infantry Brigade could hear the 2nd Infantry Brigade already engaged at the Sugar Factory on their right flank. The 1st South Wales Borderers were ordered to take the high ground on their left flank on the Vendresse Ridge in order to assist them. Shrapnel was flying around them, but miraculously they did not sustain any casualties at that point. They were out of range of most of the German artillery and the majority of the shells were falling 50 yards from their position. Captain Hubert Rees from the 2nd Welsh Regiment wrote:

> We moved slowly up the road to Vendresse, reaching a point about a mile south of that village at 10am on the 14th. It was obvious that a great battle was in progress. The Vendresse ridge was covered with bursting shells, where some of the 2nd Brigade had obtained a precarious footing. Colonel Fanshawe rode down the column saying that we had captured twelve guns and a number of prisoners. The 1st and 2nd Brigades were heavily engaged along the Vendresse Reidge and about the Troyon Sugar Factory, when the 3rd Brigade were ordered to prolong the line to their left.[2]

Major-General Samuel Lomax, commanding the 1st Division, sent the 3rd Infantry Brigade forward at 10.00am to reinforce the left flank of the 1st Guards Brigade, to ensure that the Chemin des Dames road above Chivy was captured and to establish contact with the 2nd Division on their left. The 1st South Wales Borderers and the 2nd Welsh Regiment were the only battalions available, together with two companies from the 1st Gloucestershire Regiment. The 1st South Wales Borderers received Lomax's orders to advance at 10.30am. They advanced west of Vendresse towards Chivy and they had to pass a wooded ridge which ran south west from Troyon and was sandwiched between the Vendresse and Chivy Valley. This ridge was known as the Vendresse Spur, or the Troyon Spur. The south-western tip of this spur was known as Mount Faucon. The 1st South Wales Borderers skirted round the western perimeter of Vendresse in order to reach the bottom of the Vendresse Spur and then proceeded to climb it. By 11.00am they reached the crest and they used the cover of the woods to form up in preparation to advance. They came under German shell fire, but the explosions were high above their heads and did not cause many casualties.

From Vendresse Spur they could observe the Chivy Valley and to their right they could see the Chemin des Dames Ridge. Across the Chivy Valley they could see the Beaulne Spur, which ran south west and south from the Chemin des Dames Ridge. The 1st and 2nd Infantry Brigades were already engaged in bitter fighting to their right. The 3rd Infantry Brigade was meant to be linking up with the 2nd Division on their left flank, but they could not be seen. The 2nd Division was ordered to advance up along the Beaulne Spur but a German counter attack along that ridge had prevented them from doing so. Captain Charles Paterson, adjutant 1st South Wales Borderers wrote:

> Later we moved a little to the left into a wood on the side of the hill, the position being just about south east of Chivy. From the top of the hill just inside the wood we get a fine view. A deep valley with the village of Chivy and then a ridge about 200 yards away. On the ridge we saw about 50 Germans moving from right to left, with British troops moving up towards them. They were just getting to close quarters when some of our guns opened on them. On that the Germans turn and make for home as fast as they can. Our guns got in amongst them and they left quite a few behind them. We get quite a number of shells over our wood but they are not effective.[3]

The 1st South Wales Borderers were sheltered by high ground, which rose steeply. On passing over the crest of this ridge they descended into the wood on the other side and remained there to await further orders. The horse belonging to Captain Charles Paterson of the 1st South Wales Borderers became the first casualty, receiving a bullet wound to the head. The horse was able to carry the Adjutant's belongings but he did not ride her. As they waited in the wood, ricochet shells and bullets became a terrible hazard for the 1st South Wales Borderers, wounding several men. Captain John Jenkinson, Brigade Major for the 3rd Infantry Brigade, was killed.

By 11.00am the mist lifted and guns from the 116th Battery were positioned on the front line west of Troyon supporting the 1st Guards Brigade and were able to provide supporting fire. However, they were no match for the German 8-inch howitzers.

At midday the 1st South Wales Borderers received orders to advance in a north-westerly direction across the Chivy Valley towards the Chemin des Dames. A Company was left on Vendresse Ridge to provide covering fire with the machine guns as C Company led B and D Companies across the valley. Artillery of the 39th Brigade who were close by also provided some covering fire.

As the 1st South Wales Borderers and the 2nd Welsh Regiment were moving through the Chivy Valley the Borderers found the dense woods difficult to pass through. The 2nd Welsh Regiment on their left flank covered easier terrain and made more rapid progress.

As the Welsh Battalions advanced west across the Chivy Valley, three battalions and two machine-gun companies from the German 25th Reserve Infantry Regiment were advancing south west on the right flank of Chivy along the Beaulne Spur, with the intention of launching a decisive strike upon Vendresse to destabilise the 1st Division's bridgehead. (The Official History states they advanced at 10.30am). If they captured Vendresse then the BEF's position north of the river would be seriously undermined. The 1st South Wales Borderers and the 2nd Welsh Regiment opposed their assault and prevented a collapse in the line.

The 2nd Welsh Regiment sustained heavy casualties as the battalion advanced from a sunken road across the Chivy Valley. The officers of the battalion led the advance 5 yards ahead of their men, with drawn swords. 2nd Lieutenant C.A.B. Young recalled:

Our objective at the Aisne was the ridge of the Chemin des Dames. The approach to it was up about 600 yards. A grassy slope with no cover, even a hillock, absolutely open. There was no possible chance of taking the position because it was too far and there was no cover. We had no artillery worth having and the Germans apparently just got a Corps up in time to hold it, otherwise we might have got it.[4]

C Company commanded by Captain Hubert Rees from the 2nd Welsh Regiment led the advance across the Chivy Valley. Advancing across exposed ground the 2nd Welsh became easy targets for German riflemen and machine gunners on the wooded spur. The German positions were concealed by the trees. Captain Hubert Rees was six feet four inches tall and affectionately known as 'Long 'un' by his peers:

We advanced in a north-westerly direction, covered by the steep slope of the Vendresse ridge on our right, and attacked and captured a portion of the Beaulne ridge, leaving the village of that name on our left, as we advanced. We were rushed into action rather hurriedly, and shook out into attack formation as we advanced. We crossed the Chivy valley almost

at right angles and were then exposed to long range rifle and machine-gun fire, which caused a fair number of casualties.[5]

Lieutenant Melville commanding the machine-gun section of the 2nd Welsh Regiment reported:

I, with my machine-gun section in extended order, followed closely behind the leading Company in the attack. The machine-gun section of the S.W.B. and the Brigade machine-gun officer (Lyttleton) were with the supporting Company. The advance was a most unhealthy one, as owing to the nature of the ground, we were fired at, not only from the front, but also from the right flank, and, to make it even more unpleasant, some shorts from our covering artillery fell on our own troops. Halfway across the valley, my section sergeant, next to me, was shot through the leg, and I saw him no more that day.[6]

Captain Mark Haggard and his company were held up by a German machine-gun position. The company was pinned down by this Maxim machine-gun fire and could not advance. Haggard knew that something had to be done. According to Private Derby, Haggard gave the order to fix bayonets.[7] Haggard led three men in an assault upon this obstinate German position. Charging 30 yards ahead of his men he shot the three German soldiers who were manning one machine gun. His rifle was empty and he laid out other German soldiers with the butt end of his rifle before he fell mortally wounded. This episode was worthy of a Victoria Cross, but Haggard, like many other soldiers who demonstrated great courage on that day, never received such recognition.

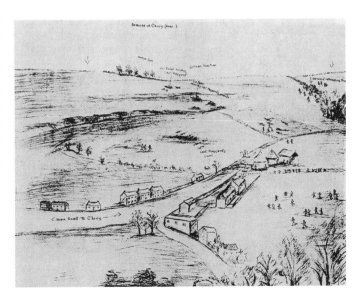

Drawing showing the advance of the 2nd Welsh Regiment and where Captain Mark Haggard fell mortally wounded. (*Deeds that Thrill the Empire*)

Private Sidney Payne, D Company, 2nd Welsh Regiment, had supported Haggard's assault upon the German Maxims:

> Our position was made more insecure by the presence of two Maxims which were brought to bear upon us. These we were ordered to charge. We were met with a heavy fusillade which swept our ranks and as we reached the guns our gallant captain fell, riddled with bullets.[8]

Lance Corporal William Fuller served as orderly to Haggard and saw him fall. At great risk to himself, and under heavy fire, Fuller reached the mortally wounded Haggard and brought him to a place of shelter where he dressed his wounds. Fuller was awarded the Victoria Cross for his bravery. 2nd Lieutenant Young also witnessed Captain Mark Haggard fall wounded and Private William Fuller rescue him under a hail of German fire. Young recalled:

> Mark Haggard of course, was one of the famous characters of that time. He was hit and couldn't move and he kept shouting out 'stick it Welsh' but he died poor chap. A fellow went out and picked him up and got a Victoria Cross for it ... He was fallen wounded and this chap went out and picked him up and brought him back. Not very far ... they hadn't gone more than about 40 yards before we all came to a halt.[9]

With their ranks falling to the ground dead and wounded, the Welsh could not make any headway. 2nd Lieutenant C.A.B. Young remembered:

> I should think it was not more than about a quarter of a hour before everybody realised it was an impossible job ... You have got to go back to the sunken lane where [you] started from. It was common sense. We all saw that it was impossible and started to come back.[10]

Captain Hubert Rees briefly left C Company to attempt to establish contact with the 2nd Highland Light Infantry who were advancing with 5th Infantry Brigade along the west side of the Beaulne spur. Rees could see that if the Highlanders line broke and the enemy captured this ridge then the position of the 2nd Welsh Regiment and the 1st South Wales Borderers would be appalling. It was essential for him to link up with them. Rees recalled:

> As we started up the Beaulne ridge, I saw a number of Highlanders running back along the top of the ridge above Beaulne on our left. I came to the

conclusion that it was necessary for somebody to intercept them and tell them to hold on, because if the Germans got on to the ridge on our left, as well as being in front and on our right, our situation could hardly be satisfactory. I obtained permission from Major Kerrich to go and talk to them. I ran through the village of Beaulne and up the slope where I found the remnants of a company of R.L.I. with a 2nd Lieut. in command. He said his company commander and all the other officers had been killed and that the Germans were counter attacking along the ridge. He promised to hold on where he was to cover our left flank.[11]

When he returned to C Company, who were fighting on the east side of Beaulne spur, Rees found the 2nd Welsh Regiment engaged in a vicious struggle. He recalled the scene of carnage.

> When I got back to the Battalion I found a very hot action in progress. We were holding a steep bank on the near crest of the ridge with the Germans amongst some corn stooks, only 150 yards away. In cautiously putting my head over the bank, I drew the immediate attention of a machine gun at point blank range. Eventually we rushed the Huns, and the remnants fled. The ground was littered with their dead. We continued to advance with most of C Company, and about half some other Company, across the top of the ridge, until we passed a line of apple trees on the farther side. As soon as we passed the apple trees, a perfect storm of shells struck round us. Luckily, few, if any, burst; I fancy we must have nearly surprised a field gun battery. Anyhow, two shells struck the ground on either side of me, and I flew myself flat in the long grass for the storm to pass.[12]

Private M. Slee of the 2nd Welsh Regiment was wounded in the advance and was left lying on the battlefield:

> I was lying five hours in the big battle that started last Monday week. It was a battle. If they had been any shots they ought to have shot us all down. Nearly all their shots hit the ground. They wounded a lot of British, but they lost terribly themselves. They were in the best position in France where they beat the French years ago, but we shifted them. They had every advantage over us; we had nothing to hide behind for cover. I lay five hours, bullets dropping all around me. I never expected to get up again. I don't know how I should have got on if two fellows had not carried me to a barn out of the way.[13]

Captain Hubert Rees had been pinned down by machine-gun fire for some time and at an opportune moment crawled towards a fellow officer to decide the next course of action:

When things had quieted down, I crawled over to talk to Moore and we agreed that our present position was hopeless. We were facing at right angles to our proper direction and were liable to be wiped out by shell fire as soon as the Huns had accurately located us. We therefore decided to retire the 250 yards across the ridge, to the bank we started from. We started back in small groups from the right. Unfortunately the German gunners, who were doubtless about to shell us, saw the movement and opened fire with every form of projectile. It seemed to me that every yard of that plateau top was blowing up. I hurled myself down the bank head first, when I got there, closely followed by a Lance Corporal, who had had his arm practically blown off. The Huns deluged the bank with shells. I saw Moore and ran over to him. We both threw ourselves flat as we heard the scream of a shell, and it burst a few yards below us, killing Fitzgerald and four or five men. Fitzgerald was a special reserve officer who had lately joined us. Moore's first comment was 'Well, I thought they would hit you anyhow' [which] was hardly satisfactory.[14]

A and C Companies from 1st South Wales Borderers went ahead through the wood, but lost touch with D Company. Patrols from B and D Companies went back into the valley to look for them, where they encountered German parties and exchanged rifle fire for a brief moment until the Germans withdrew. There was a great risk of accidently firing upon comrades during night skirmishes. Captain Charles Paterson from the 1st South Wales Borderers:

I have a horror of night firing. One is very likely to kill one's own men, and from wounds I have seen since I am sure some of them were hit like that on this very occasion. The Brigadier and his staff came along and rode right past us, and in a few moments they were fired on.[15]

Lieutenant Mervyn Johnson 1st South Wales Borderers (from A Company) was mortally wounded by a bullet as he led C Company in an attack. Several men from Brigadier-General Herman Landon's staff went missing. Apparently the missing men had been wounded, and were found two days later. They had been fed and looked after by the Germans.

The assault launched by the 2nd Welsh was paralysed by the overwhelming German machine-gun fire. Losing so many officers seriously undermined the attack. The officer casualties amongst the 2nd Welsh Regiment included Major John Kerrich, 2nd Lieutenant Gabriel Fitzpatrick and 2nd Lieutenant George Owen Birch, all killed during the advance.

D Company, 2nd Welsh Regiment managed to reach the Beaulne Spur but with only 60 men. They found that they were short of ammunition. They had reached their objective, but did not have the munitions to defend it. Three men were sent to get more ammunition but they were killed. The situation became so fraught that CSM Hunter crawled amongst the dead and wounded to search for ammunition and distribute it amongst the remnants of his company.

With the mist lifted, artillery of the 46th and 113th Battery supporting the two Welsh battalions positioned near Moussy on the road south of Chivy opened fire upon the 25th Reserve Infantry Regiment. The 25th suffered heavy casualties as a consequence and were prevented from advancing farther. Lieutenant Melville from the 2nd Welsh Regiment saw the devastating effect of the British artillery upon the ranks of the German infantry:

I then saw a most beautiful exhibition of shooting by the 113th Field Battery, which was supporting us in the valley below. As soon as the enemy broke from their trenches, the guns opened on them with

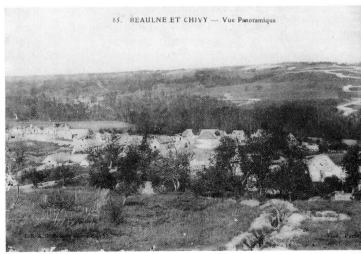

85. BEAULNE ET CHIVY — Vue Panoramique

Beaulne Spur and the village of Chivy. It was here that the 1st South Wales Borderers and the 2nd Welsh Regiment advanced. The photograph shows trenches in the bottom right and top right hand corners. (Author)

shrapnel. The slaughter was terrific. Later on in the day the drama was repeated, the Boche being forced back into their trenches, only to break once again and retire over the hill. They never returned after that, and the hillside was thick with their dead and wounded.[16]

The 1st South Wales Borderers war diary recorded: 'Swarms of Germans on the ridge rather massed. Our guns open on them at 1800 yards and one can see a nasty sight through one's glasses. Bunches of Germans blown to pieces.'[17]

The resistance offered by the two Welsh battalions supported by artillery had a devastating effect upon the waves of advancing German infantry; their brigade commander was mortally wounded. They were unaware that they had inflicted such heavy casualties. One battalion from the 25th Reserve Infantry Regiment was so decimated that it had to retire. They found cover behind a steep slope south of Courtecon, where they tried to recover and reassemble. The two other battalions became disorganised to the point where they could no longer carry on with the advance and were forced to withdraw to the reverse slope between Courtecon and point a mile west of Malval Farm.

By 1.00pm the 2nd Welsh Regiment had secured positions on the south-eastern slopes of the Beaulne Spur and the 1st South Wales Borderers in the rear formed a line along the Chivy–Beaulne road facing north west. At the same time German artillery was targeting their positions with heavy shell fire. Such was the intensity of the German fire the 2nd Welsh had to resort to crawling in order to move. Lieutenant Melville commanding the Machine Gun Section of the 2nd Welsh Regiment recalled:

I made my way up to the front line, but quickly realised that machine guns were of no use there, for it was impossible to put one's head up for any length of time, let alone bring two guns into action. At this time I also observed a German officer leading a platoon towards our right flank, obviously with the intention of attacking it. So I crawled down to the ridge a little way, and moved to the extreme right to engage him. I believe that a platoon under Carleton was despatched also, on the same mission. I got my guns into action and told my men to open fire as soon as I gave the word, watching the German officer, meanwhile, carefully through my glasses. Presently I saw him kneel, give a signal to his men, and then jump up. As he did so my gunners opened fire and the poor fellow pitched forward dead, the spike of his helmet burying itself in the ground. Later in the day when we advanced over this ground, one of my men handed me his sword and belt as a trophy.[18]

The 2nd Welsh Regiment was further ahead than the 1st South Wales Borderers who were charging towards German trenches on their right flank. Having neutralised a German assault on his own flank, Melville and his machine gunners were able to provide supporting fire for the South Wales Borderers:

Having wiped out this little counter attack, I suddenly, to my intense excitement, observed the German trenches on my right filled with troops prepared to repulse the attack of the S.W.B. Ranging very carefully with my Barr and Stroud, I started vertically searching from both my guns. As the range was only about 700 to 800 yards, the execution was terrible. Eventually the Germans could stand it no longer, and breaking from their trenches ran back over the crest of the hill like a football mob, both my guns pumping into them as hard as they could fire.[19]

During that afternoon Captain Hubert Rees and the remnants of C Company found an opportunity to eat and to tally the wounded and the dead:

Melville's machine guns had done great execution on our right, from their position in a quarry, catching a mass of Germans in the open. There did not appear to be any chance of a decision. The men decided that it was quite time for food and discussed their bully beef and the battle with gusto. Moore and I came to the conclusion that they were right, so we followed suit, before being joined by Ferrar. He told us that Kerrich had been killed and that Mark Haggard had been badly wounded. Poor Mark died next day. He was a grievous loss.

Fitzroy Somerset had had his shoulder smashed by a bullet and Ford had had both legs broken by a shell. C. Sergt. Major Porter had a piece of iron in his thigh, whilst at least 50 of the rank and file of 'C' company had been knocked out, chiefly by the shell fire on the ridge, though a good number had been hit by rifle fire during the charge. We came to the conclusion that we had had a pretty rough time.[20]

Two companies from the 1st Gloucestershire Regiment, 3rd Infantry Brigade, were sent to plug the gap, stabilising the line until 3.00pm. German forces tried to push back the 1st Division line south towards the river with little success. As the day progressed the German attacks became weaker. They had subsided by 4.30pm, at which point Haig ordered the 1st Division to advance. Daylight was fading. The 3rd Infantry Brigade reached a position 300 yards from the Chemin des Dames.

German infantry launched a counter attack on positions held by the 1st Queen's (Royal West Surrey) Regiment and at 4.00pm the battalion withdrew to the

Chemin des Dames. The battalion was positioned just 30 yards in front of the British guns. Lieutenant Ronald Henriques was killed. Lieutenant-Colonel Henry Pilleau DSO and Lieutenant Robert Pringle were mortally wounded; 8 officers were wounded, 13 other ranks killed, 88 wounded and 39 listed as missing. Pilleau died of his wounds on 21 September.

The South Wales Borderers suffered casualties too and were forced to withdraw to Vendresse Ridge. Here they held the position. The superior German numbers could not be pushed back. Many of the wounded lay unattended in Chivy Valley. It was difficult to get stretcher bearers into the valley. Private Stan Whitelock who advanced with D Company 2nd Welsh Regiment was wounded and lay exposed for several hours:

I received a very nasty wound on the second day of the big battle (Sept. 14th). I got hit in the left leg just below the knee, through the bone, leaving a nasty gash where the bullet came out. I lay there in the firing line for about eight hours. Nobody could pick me up as firing was too heavy; but I didn't grumble.[21]

At sunset the 1st South Wales Borderers received the order to proceed up the valley towards the northern extremity of Chivy Valley. There was enough daylight for Brigadier-General Herman Landon, commanding the 3rd Infantry Brigade, to identify a barn on the far ridge as a reference point for Captain Ward from A Company to head for. A Company carefully descended from woods on the slope of Vendresse Ridge followed by the other companies of the battalion. As they proceeded down into the Chivy Valley, German artillery poured high explosive and shrapnel shells onto their position. A melanite shell exploded in the middle of No 1 platoon, D Company, wounding many, including Lieutenant Vernon, who was severely wounded. Despite the artillery fire they continued.

The village of Chivy was on their left flank as they headed north west. They had advanced uphill through a dense wood with thick undergrowth. The battalion continued to advance as the sun was setting and the sound of gunfire began to subside. There was little risk of being fired at in the dark. It was difficult to maintain direction and contact with each other. There was not much infantry opposition to their advance. As they went forward the 2nd Welsh captured between 150 and 200 German prisoners, many of whom were unarmed.

During this advance, Captain Robins, commanding A Company 2nd Welsh Regiment, was wounded and captured. Lieutenant-Colonel Charles Morland had an opportunity to reorganise the remnants of his battalion and for his men to get some much needed rest. Their rifles with fixed bayonets were nevertheless ready at their sides. Captain Hubert Rees, commanding C Company:

The night was very dark and it started to rain. We lay out with our bayonets fixed awaiting events, by no means clear as to the situation. There were said to be two battalions on our left, but they retired during the night and as we were not in touch on our right, the situation at dawn was precarious.[22]

Captain Ward and A Company from the 1st South Wales Borderers reached a bank close to the barn highlighted by Brigadier-General Herman Landon below the crest of the ridge leading to the Chemin des Dames. They were south west of Cerny. Earlier that day the 1st Black Watch had advanced on their right. It was an ideal position for them to wait for the other companies. C Company soon joined them. B and D Companies did not arrive and had gone in another direction. They had lost contact with C Company but had secured a position on the right rear flank of A Company along a track that led from Chivy to Cerny. Heavy rain was falling and everyone was tired. When the 2nd Welsh Regiment arrived on their left flank, their commanding officer, Lieutenant-Colonel Morland, made the decision to hold the bank that Captain Ward and A Company had taken.

Once the 1st South Wales Borderers and the 2nd Welsh Regiment had occupied positions below the ridge, German forces launched a counter attack, which was quickly rebuffed. Brigadier-General Herman Landon and his Staff Captain rode along the Chivy to Cerny track prior to the German counter attack, past the lines held by the 1st South Wales Borderers, and ran into a German party. Their horses were shot from under them and they escaped back to Welsh lines on foot. With 2 Companies from the 1st Gloucestershire Regiment standing by in reserve close to Chivy, the two Welsh regiments were left to improve their defences and dig in for the night. The road was held during the night of 14/15 September. D and C Companies held the line in front of the road, while A and B Companies were held in support. A German counter attack was repelled at 1.00pm on 15 September. The 1st South Wales Borderers and the 2nd Welsh Regiment held on throughout the 15th.

During that night the battalion medical officer Captain Elliott and his stretcher bearers from the South Wales Borderers made strenuous efforts, taking advantage of the darkness, to recover the wounded lying in No Man's Land. Most of the British recovered during the following two nights on this sector were Cameron Highlanders wounded during the morning of 14 September. There were many others who could not be recovered because of their proximity to German trenches.

The 1st South Wales Borderers lost heavily. Lieutenant Mervyn Johnson was wounded on 14 September and died later that day in Vendresse. Captain Marwood Yeatman was killed on 15 September; 18 men were killed with 1 officer and 76 other ranks wounded; 54 men were listed as missing. The 2nd Welsh Regiment lost 5 officers and 50 ranks killed and 6 officers and 132 men wounded, with 28 men missing during the period 14 September to 5 October.

The German 25th Reserve Infantry Brigade sustained many casualties in the battle for Chivy on 14 September. The battalion that advanced on the left flank lost 18 officers and 420 men. Most of these casualties were caused by Lieutenant Melville's machine-gun section. The other two German battalions had reached the Beaulne spur, but were stopped by the 1st South Wales Borderers and 2nd Welsh Regiment, who had inflicted casualties amounting to 35 officers and approximately 1000 men. The German Brigade was forced to withdraw.

NOTES

1. WO 95/1280: 1st South Wales Borderers War Diary
2. IWM 77/179/1: Captain Hubert Rees, 2nd Welsh Regiment
3. Captain Paterson's Diary, Adjutant 1st South Wales Borderers: Regimental Museum of the Royal Welsh.
4. Liddle Collection: interview tapes 599 and 600: 2nd Lieutenant C.A.B. Young, 2nd Welsh Regiment
5. IWM 77/179/1
6. Marden, Major-General Sir Thomas, *History of the Welch Regiment 1914–1918* (1931, republished by Naval & Military Press, 2002)
7. *South Wales Daily Post*, 12 October 1914
8. Ibid, 22 October 1914
9. Liddle Collection: tapes 599 and 600
10. Ibid
11. IWM 77/179/1
12. Ibid
13. *South Wales Daily Post*, 24 September 1914
14. IWM 77/179/1
15. WO 95/1280
16. Marden
17. WO 95/1280
18. Marden
19. Marden
20. IWM 77/179/1
21. *South Wales Daily Post*, 7 October 1914
22. IWM 77/179/1

THEY FOUGHT IN THE CHIVY VALLEY

LIEUTENANT-COLONEL CHARLES MORLAND
2ND BATTALION THE WELSH REGIMENT

Charles Bernard Morland was born in 1867. He was gazetted to the Welsh Regiment in February 1887. He attained the rank of Captain in April 1898 and was appointed Adjutant of his battalion in March 1900. He saw active service during the Boer War being present at the relief of Kimberley and taking part in actions in the Orange Free State, at Paardeberg, in the Transvaal, Cape Colony, and Orange River Colony. He fought at Poplar Grove, Driefontein, Vet and Zand Rivers, close to Johannesburg, at Pretoria, Diamond Hill, Belfast and Colebrook. Morland was recognised for his bravery, being twice mentioned in dispatches and awarded the Queen's Medal with six clasps and the King's medal with two clasps. Morland was promoted to Lieutenant-Colonel in March 1914 and was appointed commanding officer of the 2nd Welsh Regiment. He was mentioned in Sir John French's dispatches of 8 October 1914 and 14 January 1915. Morland led the battalion during the Battle of the Aisne in September 1914 and a month later he was wounded during the First Battle of Ypres on 30 October 1914. He died from his wounds the following day and was buried in Ypres Town Cemetery.

Major John Kerrich,
2nd Welsh Regiment.
(*Bonds of Sacrifice*)

Lieutenant-Colonel
Charles Morland,
2nd Welsh Regiment.
(*The Welsh Regiment,
1914–1918*)

MAJOR JOHN KERRICH
2ND BATTALION THE WELSH REGIMENT

John Herbert Kerrich was born in 1874 in Cheltenham. After completing his education at St Paul's School he attended the Royal Military College at Sandhurst.

Joining the Welsh Regiment in 1894 he was promoted to Lieutenant in 1896. He served in the Boer War from 1899 to 1902. During April to May 1901 he acted as an Intelligence Officer. He saw action at Belfast, Diamond Hill and Johannesburg. He later took part in operations at Vet River and Zand River in the Orange Free State and in Cape Colony. Kerrich was awarded the Queen's medal with five clasps and the King's medal with two clasps.

Kerrich married Gwendolen Katherine in 1908 and would raise two children. He was promoted to Captain the following year. In March 1914 he was promoted to Major and went to France with the 2nd The Welsh Regiment in August. During the Battle of the Aisne Kerrich led his men while exposed to enemy fire. Kerrich was killed during the assault at Chivy. Brigadier-General Herman Landon commanding the 3rd Infantry Brigade wrote the following tribute to Kerrich in a letter of condolence to his widow. 'He was loved and honoured by all who knew him. His loss is one which will be felt by the whole Army, as well as by his regiment and all those who knew and loved him.'[1]

Private Stan Whitelock, D Company, 2nd Welsh Regiment saw the moment when Kerrich was killed. Whitelock lay wounded with many others in the Chivy Valley and it was difficult to raise one's head due to the perpetual rifle and machine-gun fire. 'Once when I rose my head ... I saw our major raise a little. He said something to the men and got a bullet in the mouth.

Poor old Major, that was our last time to hear from him. He was not a bad sort to his men.'[2]

Kerrich was aged 40 when he died. He was buried at Vendresse British Cemetery where his epitaph reads:

FAITHFUL UNTO DEATH
THE LORD BLESS AND KEEP YOU
AND GIVE YOU PEACE

CAPTAIN GABRIEL FITZPATRICK
2ND BATTALION THE WELSH REGIMENT

Gabriel Roy Fitzpatrick was born in Chelsea, London, in 1883. He was educated at Jesuit College, Stamford Hill and Ratcliffe College. Fitzpatrick served with the City Imperial Yeomanry from 1901 to 1902. He later served with the 3rd Essex Regiment from 1905 to 1909. In 1909 he transferred to the 3rd Battalion, Welsh Regiment and was promoted to Lieutenant. Fitzpatrick served three years with the British East African Police 1909–12. By the time the First World War began Fitzpatrick was a Captain serving with the 2nd Welsh Regiment. He went to France in August 1914 and was a participant in the retreat from Mons and the Battle of the Marne. Captain Gabriel Fitzpatrick was killed at Beaulne during the Battle of the Aisne on 14 September. He has no known grave and his name is commemorated on the memorial at La Ferté-Sous-Jouarre.

Captain Gabriel Fitzpatrick, 2nd Welsh Regiment. (*Bonds of Sacrifice*)

CAPTAIN MARK HAGGARD
2ND BATTALION THE WELSH REGIMENT

Mark Haggard was born in 1876 in London. Haggard was educated at Cambridge University prior to joining the Army. When the Boer War broke out in 1899 he joined the City of London Imperial Volunteers and served in South Africa. In 1900 he received a commission with the Welsh Regiment. A career soldier, he attained the rank of Captain in 1911. He was very popular with the men under his command. One private wrote, 'We are prepared to follow him anywhere.'[3]

Captain Mark Haggard, 2nd Welsh Regiment. (*Bonds of Sacrifice*)

On 14 September, during the Battle of the Aisne, Captain Haggard was in command of B Company. As he charged to the crest of the ridge above the village of Chivy, he was well ahead of his men and ordered them to lie down while he reconnoitred the German positions. On reaching the crest he could see the German machine-gun position that had caused so many casualties amongst the battalion. He gave the order to his men from the 2nd Welsh Regiment, 'Fix bayonets boys!' and they advanced into a hail of German machine-gun fire. Haggard killed three of the German machine-gun crew. He was seen to be using the butt end of his rifle upon surviving German soldiers. Just as he was getting close to the German machine-gun position Haggard was hit by several bullets. One of those bullets entered his abdomen and exited through his right side. One soldier from the 2nd Welsh Regiment was hit and was lying close to Haggard. He later recalled: 'Near me was lying our brave Captain, mortally wounded. As the shells burst over us, he would occasionally open his eyes, between the spasms of pain, and call out weakly: "Stick it, Welsh!"'[4] Corporal Abbott also witnessed Haggard's bravery. 'We would undoubtedly have been mown down. I witnessed the whole incident, and am proud to have had such a thoughtful officer: sooner than the Company should suffer, he took on himself this daring work.'[5]

Haggard's courage on 14 September in the Chivy Valley was worthy of a Victoria Cross, however it was his orderly, Private William Fuller who would receive this prestigious award for reaching Haggard and evacuating him to a place of safety (see below). Haggard died of his wounds at 4.40pm on 15 September. Private Derby had seen Haggard's heroic action in the Chivy valley and commented: 'He died as he had lived – an officer and a gentleman.'[6]

Haggard was buried at night in Vendresse with Lieutenant-Colonel Charles Morland, commanding officer of the 2nd Welsh Regiment conducting the service. Haggard was recommended for a posthumous Victoria Cross, but the award was not sanctioned. Haggard lies in Vendresse British Cemetery. On his headstone reads the epitaph 'Stick it the Welch'.

LANCE CORPORAL WILLIAM FULLER 7753 VC

2ND BATTALION THE WELSH REGIMENT

William Fuller was born in 1884 at Newbridge, Carmarthenshire, in West Wales. When he was four his family moved to Swansea where he was educated at Rutland Street School. Fuller tended to abscond and so attended the Truant School in Swansea. Fuller enlisted to serve in the Welsh Regiment on 31 December 1902 and served in South Africa and India. After completing his service Fuller was discharged from the Army and placed on the reserve list. He married Mary Philips and they would raise two children. Fuller worked as a timber handler and then caretaker of the Elysium Cinema in Swansea. At the outbreak of the First World War Fuller was recalled to serve and went to France with the 2nd Welsh Regiment on 11 August 1914.

During the Battle of the Aisne on 14 September, Private William Fuller was orderly to Captain Mark Haggard, commander of B Company. Fuller followed some distance behind Haggard as they charged the ridge above Chivy. He saw Haggard wounded and under withering German machine-gun and shell fire. Being the only uninjured man in the party, he went at great personal risk to Haggard's aid. He dashed to his commanding officer and carried him 100 yards, then dressed his wounds but was unable to evacuate him from the battlefield because of the shell fire and bullets. Fuller recalled the events of 14 September in an interview he gave to the *South Wales Daily Post*:

We were supposed to be the advance party for the South Wales Borderers, but instead formed a bit to the left and made an advance ourselves. We marched from a wood in the direction of a ridge, and on the way we came across a wire fence. Instead of waiting to use our wire cutters, Captain Haggard pulled one of the posts out, and we continued our advance to the top of the ridge. On reaching that point we saw the enemy and Captain Haggard and myself and two other men who were in the front started firing. On proceeding a little further we were faced by a Maxim gun. There was a little wood on the top and a hedge about 50 yards long. It was not long before the men on Captain Haggard's left were both shot, and the man on the right was wounded. About the same time Captain Haggard was struck in the stomach, and he fell doubled, the shot coming out through his right side. Thus I was the only one uninjured. Our company was met with such an enfilading fire that the right part of the platoon had to retire back and make an attack towards the right. That left Captain Haggard, myself, and the wounded man below the ridge, and it became necessary for me to carry Captain Haggard back to cover. This was done by him putting his arm around my neck, while I had my right arm under his legs and the left under his neck. I was only from 10 to 20 yards behind him when he was shot, and as he fell he cried 'Stick it, Welch!' With the shots

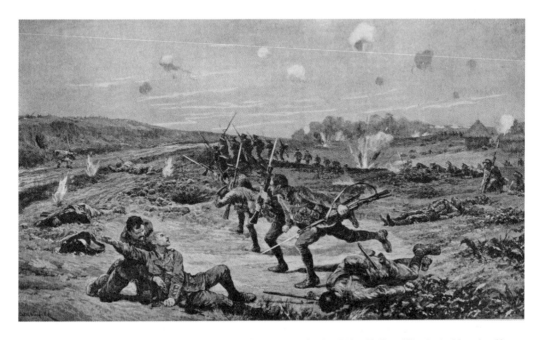

Lance Corporal Fuller going to the aid of Captain Haggard in the Chivy Valley. *(Illustrated London News, 1914)*

Lance Corporal
William Fuller,
Victoria Cross, 2nd
Welsh Regiment.
(Author)

of the Aisne, but was wounded on 29 October 1914 at the Battle of Gheluvelt, near Ypres in Belgium. As the 2nd Welsh Regiment was advancing against German positions they came under a torrent of German shrapnel. Fuller saw a comrade named Tagge fall wounded, so he stopped to apply dressings to the man's wounded leg. Fuller sustained a bullet wound. The bullet went through his body into his neck. He was sent back to England, initially to a hospital in Manchester and then home to Swansea. While recovering from his wounds in a Swansea Hospital the bullet lodged in his neck was discovered and removed. Fuller kept this bullet as a memento.

buzzing around us I bandaged him, all the while our fellows were mowing down the Germans, and Captain Haggard asked me to lift up his head so that he could see our big guns firing at the Germans as they were retiring from the wood.[7]

Fuller received notification that he had been awarded the Victoria Cross for tending to Captain Haggard, when it was gazetted on 23 November 1914. His citation records:

Fuller had to wait an hour before the firing subsided when he could make an attempt to get Haggard away. During that time Fuller removed Haggard's kit and dressed his wounds the best he could. Fuller carried his officer a distance of three quarters of a mile and at some point he met Lieutenant Melville, the battalion machine-gun officer and Private Snooks who helped him to carry Haggard. They got him to a farmhouse in Vendresse which was being used as a dressing station, where he died the following day.

> For conspicuous gallantry on 14th September, near Chivy on the Aisne, by advancing about 100 yards to pick up Captain Haggard, who was mortally wounded, and carrying him back to cover under very heavy rifle and machine-gun fire.[8]

Fuller would become the first Welshman to be awarded the VC during the First World War. He was modestly

Fuller received an immediate promotion to Lance Corporal on 14 September. Fuller survived the Battle

Lance Corporal Fuller's VC action in the Chivy Valley. Fuller was the first Welshman to be awarded the Victoria Cross during the First World War. (*Deeds that Thrill the Empire*)

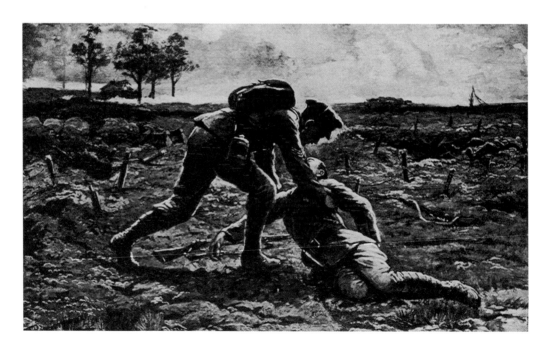

nonchalant when he told a Swansea reporter: 'What I did anyone else would have done in my place, I know I risked my life, but others would have done the same under the circumstances.'[9]

Fuller became a recruiting Sergeant when he had recovered from his wounds and on 31 December 1915 the Army deemed him medically unfit to serve. In June 1938 when aged 54 Fuller received the Royal Humane Society Medal for Lifesaving for rescuing two boys who fell into the sea. During the Second World War Fuller served his country once again as an Air Raid Warden in Swansea. William Fuller died on 29 December 1974, aged 90. He was buried at Oystermouth Cemetery, The Mumbles, Swansea, and was granted a military funeral with full honours. His coffin draped with the Union Jack was carried by soldiers from the 3rd and 4th Battalions, Royal Regiment of Wales.

CAPTAIN HUBERT REES DSO
2ND BATTALION THE WELSH REGIMENT

Hubert Conway Rees was born in 1882 in Conway (Conwy), North Wales. He was the son of the Reverend Canon Henry Rees, Honorary Canon and Precentor at Bangor Cathedral. After completing his education at Charterhouse, he was commissioned in the 3rd Militia Battalion, East Surrey Regiment, in December 1900. Rees was six feet four inches in height and affectionately known as 'Long 'un' by his contemporaries. He served in the Boer War 1901–02 and took part in the operations at Cape Colony and Orange River Colony in July 1901. He returned to fight in the operation in Cape Colony from July 1901 to May 1902. Rees was awarded the Queen's Medal with four clasps. Rees was gazetted as a 2nd Lieutenant with the Welsh regiment on 28 January 1903. By the time the war began Rees had attained the rank of Captain serving with the 2nd Welsh Regiment. He was sent to France on 12 August and participated in the retreat from Mons. He took part in the struggle for Chivy Valley during the Battle of the Aisne. Weeks later, on 21 October 1914, Rees saw action again at Langemarck in Flanders during the First Battle of Ypres, when the 2nd Welsh Regiment fought off several

Captain Hubert Rees, 2nd Welsh Regiment. *(The Distinguished Service Order 1886–1915)*

German assaults. Rees was awarded the Distinguished Service Order for his role in this engagement. His citation reported: 'In the course of the action on 21 Oct, by his particularly skilful reconnaissances and by gallant leadership, successfully supported the advanced line with a company under a heavy fire, relieving the pressure on the South Wales Borderers.'[10]

Ten days later on 31 October 1914 Rees and the remnants of the 2nd Welsh Regiment held the fragile line at Gheluvelt. Many of the battalions who fought weeks earlier at the Battle of the Aisne would end the 1914 campaign defending the village at Gheluvelt against waves of German infantry advancing towards Ypres and the Channel ports. German infantry captured the village but the 2nd Welsh and other battalions defended a fragile line along the perimeter of the Gheluvelt Chateau. It was a decisive battle; if the German Army had succeeded, arguably the war could have been lost. With the same determination and courage that they demonstrated during the Aisne battle, they held the line losing many casualties. The 2nd Welsh Regiment entered the Battle of Gheluvelt with 100 men. Rees was one of two officers and 25 men from the 2nd Welsh Regiment who survived. Rees wrote that 'on the 31st October, the 2nd Battalion of the Welsh Regiment was annihilated. No other term can describe the casualties.'[11] At the end of October, Rees was in command of the remnants of the 2nd Welsh Regiment and 1st Queen's (Royal West Surrey Regiment). Rees served in various staff roles and in the week before the Somme campaign began he was promoted to Brigadier-General and commanded the 94th Infantry Brigade while Brigadier-General Carter Campbell was on sick leave. Carter Campbell returned to duty on 1 July 1916, the first day of the campaign, when the brigade suffered heavy casualties at Serre. Rees was appointed commander of the 11th Infantry Brigade on 4 July 1916. On 27 February 1918 he was given command of 150th Infantry Brigade, which would be involved in trying to stop the German advances during the Michael offensive in March 1918 and the Georgette operation in April 1918. After his brigade suffered heavy losses it was transferred to the Chemin des Dames, which was considered a quiet sector of the Western Front. On 27 May 1918, the Blücher-Yorck operation was launched on the Chemin des Dames and the British Army suffered many casualties. Brigadier-General Hubert Rees was captured on this day. Rees was an 'old contemptible' who had fought on the Chemin des Dames during the First Battle of the Aisne in 1914. It is ironic that he survived the war and would end it captured in the same region. He would meet Kaiser Wilhelm II on 28 May 1918, the man who, back in 1914, had so little regard for the BEF he reportedly called them 'a contemptible little army'. This meeting

took place at Le Plateau de Californie, located along the Chemin des Dames a couple of miles east of where the fighting took place in September 1914:

> About 11am we three were ordered to get into a car and drove to Craonne. Here, we were ordered to get out and walk up the plateau. I was furious as I imagined that we were being taken to see some corps commander and thought it was deliberately humiliating. I made a remark to Laverack to this effect. The German staff officer with us overheard it and said, 'When you reach the top, you will see H.I.M. The Kaiser, who wishes to speak with you.' When we approached, the Kaiser who was apparently having lunch stepped forward on to a bank and told me to come and speak to him. He asked me numerous questions with regard to my personal history and having discovered I was a Welshman said 'Then you are a kinsman of Lloyd George.' He asked no questions which I could not answer without giving away information and made no indirect attempts to secure information of this character either. Presently, he said, 'Your country and mine ought not to be fighting against each other; we ought to be fighting together against a third. I had no idea that you would fight me. I was very friendly with your royal family, to whom I am related. That, of course, has now all changed and this war drags on with its terrible misery and bloodshed, for which I am not responsible.' He added some further comments on the intense hatred of Germany shown by the French and then asked, 'Does England wish for peace?'. 'Everyone wishes for peace,' I replied, He then after a pause said, 'My troops made a successful attack yesterday. I saw some of your men, who have been taken prisoner; they looked as if they had been through a bad hour. Many of them were very young.' I then said that I hoped my troops had fought well against him. He said, 'The English always fight well' and bowed to intimate that the interview was at an end. I withdrew. He talked English with practically no accent.[12]

Rees was incarcerated in several camps until the end of the war. He was repatriated in December 1918. Rees retired from the British Army in 1922 and passed away on 3 January 1948.

PRIVATE JOHN MORSE 6963
2ND BATTALION THE WELSH REGIMENT

John Morse from Swansea took part in the Battle of the Aisne and was killed on 25 September 1914. He has no known grave and his name is commemorated on the memorial at La Ferté-Sous-Jouarre.

Private John Morse, 2nd Welsh Regiment. (*South Wales Daily Post*, 29 October 1914)

CAPTAIN MARWOOD YEATMAN
1ST BATTALION SOUTH WALES BORDERERS

Marwood Edwards Yeatman was born at Holwell Manor, near Sherborne, Dorset, in 1883. Educated at a private school in Winchester, he then went to the Royal Military Academy at Sandhurst. After passing out he joined the South Wales Borderers as a 2nd Lieutenant in October 1903 and was immediately dispatched to serve in India. Promoted to Lieutenant in 1907, two years later he was sent to the battalion's depot. Yeatman spent some time in Russia where he developed his linguistic skills and qualified as a 1st Class Interpreter in the language. By the time he was sent with the 1st South Wales Borderers to France he was a Captain. He participated in the retreat from Mons and played an active role in the Battle of the Aisne on 14 September. Yeatman was a crack shot and was reported to have shot four German soldiers who were 60 yards away with his revolver. Captain Marwood Yeatman was killed by a German sniper on 15 September, shot through the heart. Yeatman has no known grave and his name is commemorated on the memorial at La Ferté-sous-Jouarre.

Captain Marwood Yeatman, 1st South Wales Borderers. (*Bonds of Sacrifice*)

2ND LIEUTENANT NORMAN SILK
1ST BATTALION SOUTH WALES BORDERERS

Norman Galbraith Silk was born in Rusbrook, Cork, in 1895. He was educated at Eastman's, Southsea, and Cheltenham College and from January 1913 to February 1914 attended Sandhurst. He was gazetted as a 2nd Lieutenant with the 1st South Wales Borderers on 24 February 1914. He took part in the retreat from Mons, and the Battles of the Marne and the Aisne. He was promoted to Lieutenant on 15 November 1914 and later that month he was wounded at Ypres. Silk was

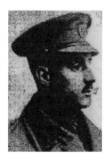

Lieutenant Norman Silk, 1st South Wales Borderers. (*De Ruvigny's Roll of Honour, 1914–1918*)

invalided home and on recovering from his wounds he was transferred to the 2nd Battalion in February 1915. He landed at Sedd-ul-Bahr at Gallipoli I on 25 April 1915 and took part in operations on the Turkish peninsula until his death on 9 June 1915. His commanding officer wrote:

> He is a very great loss. He had proved himself to be a most gallant and capable officer and as devoted to his men as they were to him. He was always bright and cheerful, and always only too keen to be ever right at the front, and I know that had he had lived he must have made a name for himself.[13]

Lieutenant Norman Silk was buried in Twelve Tree Copse Cemetery.

LANCE CORPORAL FRANCIS EVANS 11061
1ST BATTALION SOUTH WALES BORDERERS

Francis Evans was from Foxhole, Swansea. He worked at Hufod Copper Works prior to joining the army. Well liked by his peers he played football for his regiment. Known as Frank, his parting words to his parents when he left home for the war were 'I am going to make a name for myself.'[14] He was struck during the Battle of the Aisne while trying to carry a wounded comrade. A German soldier bayoneted him in the back. Francis Evans was transferred to No.1 Stationary Hospital in Le Mans where he died from his wounds on 22 September

1914. His parents heard nothing from their son Frank for three weeks until his mother received the following letter from Chaplain Hedley Burrows:

> Dear Madam, I am venturing to send you a short letter to tell you of the passing of your son. He was brought to the hospital from the front, and he was in good hands. Doctors and nurses did all they could for him. He was, when I saw him, just well enough to give me your address. It was a relief to him to feel that I could send word about him. You will be proud to hear that at the time when he received his wound in the back he was trying to carry a wounded pal of his into safety. His friend was brought in at the same time to the same hospital, and is going on fairly well. All here at the hospital were much moved by the story of your son's heroism. We send you our deepest sympathy. May God bless you and comfort and strengthen you.[15]

The 19-year-old was buried at Le Mans West Cemetery.

LIEUTENANT RONALD HENRIQUES
1ST BATTALION THE QUEEN'S (ROYAL WEST SURREY REGIMENT)

Ronald Lucas Quixno Henriques was born in 1884. He was educated at Harrow from 1898 to 1901. He received a commission to join the Queen's (Royal West Surrey Regiment) in 1903 and was promoted to Lieutenant in December 1907. Henriques served with the 2nd Battalion the Queen's in Gibraltar, Bermuda and South Africa. When war broke out Henriques was in England. Anxious to play a role in the war he requested

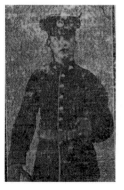

Private Francis Evans, 1st South Wales Borderers. (*South Wales Daily Post*, 30th October 1914)

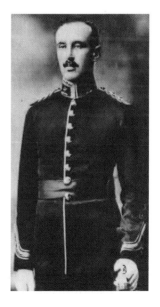

Lieutenant Ronald Henriques, 1st Queen's (Royal West Surrey) Regiment. (*Harrow Memorial Book*)

to be transferred to the 1st Battalion in order to get to Europe immediately. Henriques took part in the retreat from Mons. On 14 September Henriques was advancing through the village of Paissy towards German trenches when he was killed. A private who was with Henriques at that moment recalled:

> We had just come through – I think it was the village of Paissy – on to some very high ground. We halted, and we were told that the enemy were entrenched on the hills in front of us, and we were to drive them out. We started the advance, my platoon about thirty yards behind, Mr. Henriques in support. We had just come out of a valley when the Germans opened fire on us. However, we kept on advancing until we were about thirty yards from the enemy. We were all up in line, and I was the third man from Mr. Henriques. He just raised his head and shoulders and said. 'Advance!' when he was shot through the centre of the forehead, killing him instantly.[16]

An anonymous fellow officer paid this tribute to Henriques:

> The men worshipped him ... he commanded my Company in Bermuda and trained them there, and I am quite certain that no man ever took so much trouble to make his men efficient. He worked night and day for them, and was well repaid by their success and their devotion to him ... D Company will give a great account of themselves, and it will be greatly due to the magnificent example set them by him whose gallant conduct was just what they expected.[17]

Henriques' Platoon Sergeant wrote: 'I must tell you he was sincerely loved by every N.C.O. and man of his Company, also the Regiment ... How we would have loved to have him lead us at the Front.'[18] Henriques was buried at Vendresse British Cemetery. His headstone bears the Star of David and the epitaph reads:

<div align="center">

IF OUR TIME BE COME
LET US DIE MANFULLY
FOR OUR BRETHREN

</div>

LIEUTENANT ROBERT PRINGLE

1ST THE QUEEN'S (ROYAL WEST SURREY REGIMENT)
Robert Scott Pringle was born in 1885. He served with the Royal West Surrey Regiment from March 1907. Pringle was wounded during the battle for Chivy on 14 September and died from his wounds during the following day. Pringle was buried at Moulins New Communal Cemetery.

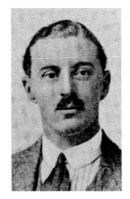

Lieutenant Robert Pringle, 1st Queen's (Royal West Surrey) Regiment. (*Bonds of Sacrifice*)

CAPTAIN JOHN JENKINSON

RIFLE BRIGADE, BRIGADE MAJOR 3RD INFANTRY BRIGADE
John Banks Jenkinson was born in 1881 in London. After completing his education at Harrow, he was commissioned into the Rifle Brigade in 1900. He served with the mounted infantry during the Boer War and received the Queen's medal with five clasps. By 1912 he was on the General Staff, Eastern Command, as a Brigade Major. During the following year he was appointed Brigade Major for the 3rd Infantry Brigade. He was killed during the Battle of the Aisne on 14 September. Jenkinson was mentioned in despatches on 19 October 1914. A friend paid the following tribute: 'I knew him well, as he and I went to Harrow the same day and shared the same room at the Head Master's House. He was just as brave as a lion; he did not know what fear meant.'[19] Jenkinson was buried in Vendresse British Cemetery. His epitaph reads:

<div align="center">

BLESSED ARE
THE PURE IN HEART
FOR THEY SHALL SEE GOD

</div>

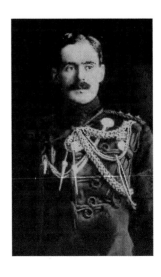

Captain J. Jenkinson, Rifle Brigade. (*Harrow Memorial Book*)

NOTES

1. Clutterbuck, L.A., *Bonds of Sacrifice: August to December 1914* (1915, republished by Naval & Military Press, 2002)
2. *South Wales Daily Post,* 7 October 1914
3. Anon, *Deeds that Thrill the Empire* (Standard Art Book Company Ltd, 1918)
4. Anon, *Wonderful Stories: Winning the V.C. in the Great War* (Hutchinson, 1920)
5. Marden, Major-General Sir Thomas, *History of the Welch Regiment 1914–1918* (1931, republished by Naval & Military Press, 2002)
6. *South Wales Daily Post,* 12 October 1917
7. Ibid, 24 November 1914
8. *London Gazette,* 28983, 20 November 1914
9. *South Wales Daily Post,* 1914
10. *London Gazette* 28968, 6 November 1914
11. IWM 77/179/1: Captain Hubert Rees, 2nd Welsh Regiment
12. Ibid
13. De Ruvigny, Marquis, *De Ruvigny's Roll of Honour, 1914–1918* (1922, republished by Naval & Military Press, 2007)
14. *South Wales Daily Post,* 30 September 1914
15. Ibid
16. *Harrovian War Supplement,* November 1914
17. Anon, *Harrow Memorials of the Great War* Volume 1 (1918)
18. Ibid
19. Ibid

VERNEUIL

The 6th Infantry Brigade comprised of the 1st King's (Liverpool Regiment), 2nd Staffordshire Regiment, 1st Royal Berkshire Regiment and 1st King's Rifle Corps, together with the 37th Brigade Royal Field Artillery led the 2nd Division across the Aisne by pontoon bridge at Pont Arcy at 5.00am on 14 September. The Berkshire's acted as vanguard, followed by the King's Royal Rifle Corps, then the King's Liverpool Regiment and the South Staffordshire's brought up the rear. The 1st King's Liverpool Regiment left Dhuizel at 4.30am, but after marching 2 miles they encountered congestion on the road leading to the southern banks of the river. Troops, artillery guns, horses and equipment were slowed as they approached the bridge at Pont Arcy. The narrow width of the bridge meant that the 6th Infantry Brigade did not complete the crossing to the north bank until 8.00am.

The battalions of the 6th Infantry Brigade assembled south of the village of Verneuil. They were ordered to advance up the Braye en Laonnois Valley. The valley was a mile in width and was sandwiched between Beaulne Spur on the right flank and Soupir spur on the left flank. Both spurs were wooded. The wood on the Beaulne Spur was known as the Bois des Grelines. In between the Bois des Grelines and Moussy was exposed ground with no adequate cover.

The village at Braye was positioned at the head of the valley on the ridge that sloped upwards towards the Chemin des Dames. The Canal de l'Oise à l'Aisne ran through the Braye valley in a north-westerly direction to Braye, where the canal turned left close to the village and entered a tunnel.

The 1st Royal Berkshires led the 6th Infantry Brigade north west towards Braye with two troops from the 15th Hussars. The 1st King's Royal Rifle Corps was split into two once they had reached the north bank. Captain Willan took B and C Companies and ventured right towards Tilleul in an effort to link up with 5th Infantry Brigade. Major Armitage led A and D Companies towards La Bovette Wood with the intention of establishing contact with the 4th Guards Brigade on the left flank. They were advancing in the same direction as the 1st Royal Berkshires. Moving along the adjacent ridges, these two companies from the 1st Kings Royal Rifle Corps protected their flanks along the slopes as the 1st Royal Berkshires moved through the valley.

The 1st King's Royal Rifle Corps had to pass over open ground as they left the canal bank and some men were hit by shrapnel before they reached the cover of some nearby woods. They also came under heavy machine-gun fire from German positions concealed in La Bovette Wood and Tilleul Wood. As they got closer to Braye they came under increasing artillery fire.

The 1st Royal Berkshire's passed through the village of Moussy, then headed to Moulin Brûlé (Ecluse) via Ferme de Metz. At this point their advance was thwarted by heavy German artillery fire and they were pinned down. Here they held a line running east and west through Moulin Brûlé (Ecluse).

On reaching Maison Brûlée at 9.00am, located mid-way between Moussy and Braye, the 1st Royal Berkshires encountered German artillery and rifle fire from the ridge north of Braye and from the woods on the side of the valley. British guns of the 34th Brigade Royal Artillery positioned on the southern slopes of the Beaulne Spur began a supporting barrage at 10.00am. At 10.30am the 1st King's Royal Rifle Corp and the 1st Royal Berkshires began their attack. The King's drove east of the canal while the Berkshires advanced north. At times the Berkshires were ahead of the King's on the other side of the canal. Later in the assault, the King's overtook the Berkshires.

The 1st King's Liverpool Regiment was two miles away at Verneuil and was brought forward to support the 1st Royal Berkshire Regiment. They had orders to advance up the Braye valley and to capture Malval. A German garrison had fortified Malval Farm positioned north of the Chemin des Dames, which afforded good observation over the Aisne valley. Captain P. Hudson, Adjutant of the 1st King's Liverpool Regiment:

[The] Berkshires were sent up the valley with 'A' and 'B' Companies [of the King's] on their right. I took 'C' Company farther to the right whilst the Colonel [Colonel Bannatyne] came along with 'D' Company in support. Half a company of 60th Rifles [1st King's Royal Rifle Corps] was sent on our right [Beaulne Ridge] and half a company on left of Berkshires [the Soupir side]. The line of attack followed both sides of the road from Moussy to the canal and along it. Berkshires got in first – our companies worked along well till they got to the end of the

wood below the Beaulne Ridge. Here 'A' and 'B' crossed to their right. I took 'C' Company along to the wood and then went back to report to the C.O. Returning to the bottom of the wood under the spur I found Major S. [Major Steavenson] with 'B' Company and part of 'C'; they were being fired into from behind. I went back to try and find out what it was, found our infantry were firing on the Germans who had not been cleared off the ridge above and behind our advance. 'A' Company had pushed on on the right, in the open. All through the advance the companies had been under very heavy rifle and artillery fire from the field guns and big howitzers. 'C' Company had got badly handled on the right and Major Steavenson had managed to pull them back to 'B' Company. Tanner [Capt. R.E.] was hit twice, once in the advance and again when being brought back. Two platoons of 'D' Company were sent up to reinforce and were put in with 'C' to try and clear the Germans who were entrenched; they came under a fearful shell and rifle fire and could [not] clear them out. Two platoons of the Worcesters (5th Brigade), who had got lost, were sent in but could not hold the Germans. It was then found that it was impossible to get on till the high ground on our right had been cleared, and Major Steavenson then pulled the whole of the companies engaged back, as the fire from behind made it nearly impossible to get forward. Later we received orders to hold a line from the Beaulne Spur to the canal, with the 5th Brigade holding a line on the high ground on our right and the Berkshires on our left. Capts. R. E. Tanner and F. E. Feneran wounded. We took five Germans prisoner. Our losses were two officers killed, ninety other ranks killed and wounded. Machine guns were of no assistance to us in this day's work and were away with the Berkshires on the left.[1]

Major Steavenson recalled: 'We [1st King's Liverpool] had had a nasty time in the wood, where all direction was lost as well as being fired at from three sides, and were glad to get out as we did'.[2]

The power of the German barrages was felt by the 6th Infantry Brigade while on the western slope of the Beaulne Spur. Captain Sheppard wrote of the first time he encountered the German 8-inch howitzer shells, known as Black Marias:

I became vaguely aware in the middle of the continual screech of shells from our own and the enemy's guns that some unusually large shells were being used by the enemy and were bursting on impact with a terrific roar. It was about this time I first became aware of the effect of the impact of an 8-inch howitzer shell filled with high explosive. I was

smoking a pipe in anything but a tranquil frame of mind ... when old Percy [Captain Hudson] rolled up from one of his excursions, told the C.O. something or other, and went bundling off again shouting some directions to an orderly, the end of which I caught – 'Turn to the left by the uprooted tree.' 'By the uprooted tree,' thought I, 'what does he mean by that?' So I followed the orderly a little way along the edge of the wood and came to where there had been (for I saw it) a fine Scotch fir. It had gone out by the roots as cleanly as if a flash of lightning had blasted it into a thousand pieces. Of course it may sound absurd now that 'Black Marias' have for so many weary months become as common as currants on a bush, but I stood and gaped at the chasm like Robinson Crusoe when he saw the footprint.[3]

The 47th Battery, 44th Brigade Royal Field Artillery reached Verneuil later that morning. Captain L.A. Kenny from 47th Battery described the German bombardment:

We crossed the river Aisne in the early morning at Bourg-et-Comin and moved up to a position near Verneuil to await orders. We were under very heavy shell fire. They were shelling us with everything they had, including their heavy high explosive shells, 6 and 8 inch from a position the other side of the Aisne Valley, which they must have had already prepared for a very long time, and well camouflaged. The object of their very heavy shelling was to prevent us from crossing the river before they had got to their prepared positions the other side of the Valley of the Aisne.[4]

Captain Kenny was not in action for long:

In the early afternoon, after having crossed the river fairly successfully, we were halted and awaiting orders, still under heavy fire. Orders soon came: that we were to advance and come into action on top of

The ruins of Verneuil. (Author)

a rise, north of and close to the village of Verneuil, close to Tilleul south of Beaulne. This hill or rise, where we were to come into action, was being very heavily shelled, and suffered many casualties, as had all the other units of the 2nd Division, both here and in crossing the river.

Just previous to going into action I heard a remark from someone – 'We are in for it now' – and we no doubt were. The exact spot where we had come into action was being very heavily shelled of course to prevent us doing so. You could see the shells bursting and churning the ground up. However, we dropped into action, facing the German artillery across the valley. I was just pointing out the aiming point to the gun layer, when, as I learnt much later, a 6 inch high explosive shell burst right on the gun itself, killing the whole of the gun detachment, six men and a sergeant, and very seriously wounding myself.[5]

By midday the Berkshires had captured the small spur north east of Braye. The King's Royal Rifle Corps reached the foot of the main ridge where they were met by German fire from trenches in their front, right and rear. A counter attack forced two companies from the 1st King's Royal Rifle Corps back to the Beaulne Spur. The 2nd Worcestershire Regiment from the 5th Infantry Brigade who had held positions on the Tilleul Spur since 10.00pm the previous night were called upon to assist but failed to clear the German positions that were threatening the 1st King's. The 1st Royal Berkshires and the 1st King's were forced to withdraw to a line north of the Ferme de Metz at 2.00pm. The detachment from the King's holding the right flank was bolstered by the 2nd Worcestershire Regiment and the 2nd Highland Light Infantry from the 5th Infantry Brigade. These battalions were supported by the 3rd Infantry Brigade on their right flank and were able to resist a German assault.

The companies led by Major Armitage reached the 4th Guards Brigade by using the road that ran north from Soupir under German sniper fire. On the left flank B and C companies from the 1st King's occupying La Bovette Spur moved into the woods and reached the right flank of the 4th Guards Brigade at 2.00pm. They were supported by artillery fire from 46th and 113th Batteries. While B and C Companies were fighting in this sector, A and D Companies from the 1st King's Royal Rifle Corps were supporting the 2nd Connaught Rangers at La Cour de Soupir.

Brigadier-General Richard Haking commanding 5th Infantry Brigade led the 2nd Worcestershires and 2nd Highland Light Infantry together with two companies from the 1st King's advanced towards the Beaulne Spur at 4.30pm. The Beaulne Spur was within half a mile of Moussy-Verneuil. Here these three battalions held on against German counter attacks.

At one point two companies from the 1st King's Royal Rifle Corps were compelled to fall back. Arriving reinforcements from the 2nd Highland Light Infantry and 2nd Worcester's tried to advance through a wood close to Moussy and Verneuil. German machine gunners had established a position in the wood. They opened fire and caused casualties amongst both battalions.

Sergeant Thomas Painting of the 1st King's Royal Rifle Corps was responsible for the company range finder and therefore did not have a rifle:

> On the morning of the Aisne at 5.30 it was a scotch mist morning. We got over the river Aisne and we got above on the high ground over a mile in front of the Aisne. Got up there and we bumped into a very strong force of Jerries who were waiting for us. There were only seven platoons of us and there was a brigade of Jerries ... A German machine gunner opened fire on me and put a burst of bullets a yard past my head and a yard in front of me. I was down flat to mother earth quick.[6]

Painting realised that being responsible for the company range finder he could not fight, so he passed it to a wounded man. '"You take this back to the dressing station and give me your bundook [slang for a rifle from Hindi]. That is more use to me." I had got 250 rounds and my bayonet, so I took his rifle.'[7]

As further waves went forward, more casualties were caused from the concealed firing positions. Surviving parties took cover behind hay stacks and in ditches. Private George Wilson of the 2nd Highland Light Infantry detected some movement in the wood and eventually saw two German soldiers. He immediately reported the sighting to 2nd Lieutenant Rhys Powell. Powell raised his field glasses to get a closer look at the enemy position and was shot in the head and killed. Wilson fired two shots bringing both men down. He charged into the wood in an effort to take the machine gun. On reaching the position he stumbled upon a group of eight German soldiers who were holding two British soldiers as prisoners. He was alone, but he pretended that he was leading an attack by shouting 'Come on, men, charge!' The deception worked and the Germans swiftly held up their hands. He released the two prisoners from the Middlesex Regiment and summoned help from his battalion to come quickly to contain his prisoners before they realised that they had been duped. German machine-gun fire was still pouring from inside the wood and further casualties were falling. Once his comrades had reached him and secured the prisoners, Wilson and a rifleman from the King's Royal Rifle Corps went deeper into the wood to look for this troublesome machine-gun position. The German machine gunners found them and a burst of

machine-gun fire brought down the rifleman killing him. Wilson was alone. He dodged the bullets and took cover. Crawling in the undergrowth he tried to get to a position where he could take out this machine-gun nest. When he got close enough, and in a suitable firing position, he brought the machine gunner down. Another man from the machine-gun crew rose to take his place but Wilson killed him. Four other men followed in succession and they were all killed. Wilson broke his cover and charged at the position. As he drew closer he was confronted by a German officer who fired his revolver point blank. The officer missed and Wilson charged at him and killed him with his bayonet. Wilson turned the gun around and fired in the direction of the German lines. Enemy shell fire was falling around him and he had to retire. Exhausted on arrival, Wilson passed out and lost consciousness. When he awoke he discovered that no one from his battalion had gone back and retrieved the German machine gun. He took it upon himself to return to the position on several occasions to bring the back the gun and the remaining ammunition. On the final trip Wilson went back to retrieve the body of the rifleman killed in the assault. Wilson reported that this brave fellow had received 17 bullet wounds.

Private James Duncan belonged to the 2nd Highland Light Infantry witnessed Wilson's act of bravery. His testimony was reported in *The Scotsman* in an article entitled 'The Edinburgh VC – Brave Deed Witnessed by Dundee Soldier':

Corporal James Duncan, of the Highland Light Infantry, who was wounded at the Aisne, has returned to his home in Dundee. He was a witness of the gallant deed which gained the VC for Private George Wilson, the Edinburgh news boy. He described Wilson as 'a very nice chap', and stated that the men in the regiment were about to dig trenches when Wilson and another man set off, presumably for the enemy's trenches two hundred yards away. They crept along the ground for a considerable distance, and then took cover behind a haystack. From this point Wilson picked off the men behind the machine gun one by one. 'It was a great sight' said Duncan 'to see Wilson coolly marching back to the British lines with the machine gun on his shoulder. The Colonel complimented him on his bravery, and said the regiment was proud of such a man'.[8]

Sergeant Thomas Painting from the 1st King's Royal Rifle Corps was close to Wilson when he earned the Victoria Cross:

During the fight there we got pushed back about 300 yards. We had to leave our wounded and dead.

The HLI's and Worcester's came up. Private Wilson of the HLI and one of our men went to get this machine gun and our man got killed. Private Wilson of the HLI killed the machine gunner and captured the machine gun. He got a VC. Our man got a wooden cross. That's the difference. Our man was killed and one got away with it.[9]

While Wilson was silencing this machine-gun crew, his commanding officer Lieutenant Sir Archibald Gibson-Craig personally led a section from D Company in an attempt to capture another machine-gun position, but was killed. Gibson-Craig's men continued the assault and knocked out the German machine-gun crew in the wood. They lost two killed and three wounded. They brought the wounded back to their own lines two miles away under continuous shell fire. One of those wounded privates considered that 'if the Germans had kept cool and used their gun they must have wiped out the whole of the little band of Britishers'.[10]

The advance continued until nightfall when they reached the Chemin des Dames. Patrols were sent out and they found a strong enemy presence. Deciding it was imprudent to remain in this position while unsupported, a withdrawal to a position south of the Beaulne Spur was ordered.

The 1st King's Royal Rifle Corps lost 168 casualties during the Battle of the Aisne. Amongst the casualties were Captain A.F.C. Maclachlan DSO, Captain G. Makins, Lieutenant J.S.Alston and 2nd Lieutenant H.C. Lloyd.

1st King's Royal Rifle Corps and the 2nd Highland Light Infantry reached the Chemin des Dames at midnight and established positions along the ridge overlooking Courtecon. Captain Stacke recalled that the advance was over ground covered with dead and wounded. There was no support on both flanks, therefore they withdrew to the southern section of the Tilleul Spur and retired to bivouacs at Moussy. Sergeant Thomas Painting:

During that night my platoon was sent up to collecting the wounded. That night I collected and buried as many of the dead as I could. I come across my own Company Sergeant Major. He was badly wounded. We had no stretchers, only a waterproof sheet. He was cold, with loss of blood. I put my overcoat over him. We carried on with the work. I came across a German who was wearing one of our officer's field glasses.[11]

Sergeant Painting recovered the field glasses and buried the German soldier.

During that night, frantic efforts were made to entrench as German shells descended on Moussy

Spur. The 1st Royal Berkshires had lost 2nd Lieutenant Reginald Perkins and 40 others on 14 September. They had established battalion headquarters at Metz farm and dug into positions along the Moussy Spur. Here they endured German shell fire and fought off several German counter attacks during the following week.

From 15 to 21 September they sustained casualties amounting to 116 killed or wounded.

The 2nd Highland Light Infantry lost 6 officers killed and 2 wounded, together with 20 men killed and 70 wounded, with 25 listed as missing during the period 14–21 September.

NOTES

1. Wyrall, Everard, *The History of the King's Regiment (Liverpool) 1914–1919* (1928, republished by Naval & Military Press, 2002)
2. Ibid
3. Ibid
4. IWM 77/97/1: Captain L.A. Kenny, 47th Battery, 44th Brigade, Royal Field Artillery
5. Ibid
6. IWM Sound Archive: Reference 212: Interview Thomas Painting, 1st King's Royal Rifles Corps.
7. Ibid
8. *The Scotsman*, 11 December 1914.
9. IWM Sound Archive Reference 212
10. Clutterbuck, L.A., *Bonds of Sacrifice: August to December 1914* (1915, republished by Naval & Military Press, 2002)
11. IWM Sound Archive Reference 212

THEY FOUGHT AT VERNEUIL

LIEUTENANT CHARLES CORNISH
2ND HIGHLAND LIGHT INFANTRY

Charles Lawson Cornish was born in 1887 in Brighton. He was educated at Charterhouse and Trinity College, Cambridge. In 1910 he was gazetted to the 2nd Highland Light Infantry as a 2nd Lieutenant. A year later he was promoted to Lieutenant. He resigned his commission in early 1914 and joined the Reserve of Officers. He rejoined his battalion when war broke out. Cornish took part in the retreat from Mons, the Battle of the Marne and the Battle of the Aisne. He was killed by a shell on 13 November 1914 during the Battle of Ypres. His body was buried along

the Passchendaele–Becelaere Road, but the grave was lost and his name is listed on the Ypres (Menin Gate) Memorial.

Lieutenant Charles Cornish, 2nd Highland Light Infantry. (De Ruvigny's Roll of Honour, 1914–1918)

LIEUTENANT SIR ARCHIBALD GIBSON-CRAIG
2ND BATTALION HIGHLAND LIGHT INFANTRY

Sir Archibald Charles Gibson-Craig was born in 1883. He was educated at Harrow and Trinity College, Cambridge where he graduated in 1905. Gibson-Craig joined the 2nd Highland Light Infantry in July 1906. In 1908 he succeeded his father as the 4th Baronet of Riccarton, Midlothian. Gibson-Craig was promoted to Lieutenant in 1909. In March 1913 he was serving with the Nigeria regiment, West African Frontier Force. When war broke out he rejoined the 2nd Highland Light Infantry. On 14 September 1914, while leading his platoon in an assault on a machine-gun position in a wood close to Verneuil, Gibson-Craig was killed. A fellow officer recalled the circumstances of his death:

> Gibson-Craig was shot while leading his men to an attack on a German machine gun which was hidden in a wood. He located the gun and asked our second-in-command whether he might take his platoon (about 20 men) and try to capture the gun, which was doing a lot of damage to our troops at the time. The major gave his consent, and Gibson-

Lieutenant Sir Adrian Gibson-Craig, 2nd Highland Light Infantry. (Bonds of Sacrifice)

> Craig went off to get the gun … He and his men crawled to the top of the hill and found themselves unexpectedly face to face with a large body of Germans. Our men fired a volley, and then the Lieutenant drew his sword and rushed forward in front of the troops, calling 'Charge men! At them.' He got to within ten yards of the enemy, then fell. The Germans held up their hands, but our men were so mad at their officer being killed (and also suspected treachery, as the Germans had not thrown down their arms) that about fifty Germans were killed on the spot. By his gallant action Gibson-Craig did a great deal to assist the general advance of the regiment and, indeed the whole of the troops concerned.[1]

Lieutenant Sir Archibald Gibson-Craig has no known grave and his name is commemorated on the memorial at La Ferté-sous-Jouarre.

2ND LIEUTENANT RHYS POWELL
2ND BATTALION HIGHLAND LIGHT INFANTRY

Rhys Campbell Folliott Powell was born at Dhamsala, Punjab, India, in 1892. His father, Major C.H. Powell, was an officer serving in the Indian Army. Rhys Powell was educated at Winchester College and at Trinity College, Cambridge. He joined the Army as a University candidate on 23 September 1913. A year later he went to France with the 2nd Highland Light Infantry. He was leading his platoon into a wood close to Verneuil on 14 September. Private George Wilson reported a position in the wood where he had seen two German

2nd Lieutenant Rhys Powell, 2nd Highland Light Infantry. (De Ruvigny's Roll of Honour, 1914–1918)

soldiers. When Powell looked through his field glasses to confirm the sighting he was shot and killed. A special memorial was dedicated to 2nd Lieutenant Rhys Powell in Vendresse British Cemetery. His epitaph reads: 'Lost to Men of Man but not to the Almighty'.

PRIVATE GEORGE WILSON 9553 VC
2ND BATTALION HIGHLAND LIGHT INFANTRY

George Wilson was born in 1886 in Edinburgh. As a boy he sold newspapers on the streets of the city. He had served in the British Army for three years and spent seven years in reserve. He was recalled at the outbreak of war. He served with the 2nd Highland Light Infantry and distinguished himself during the Battle of the Aisne when he captured a German machine-gun position that was inflicting heavy casualties. His citation states:

> For most conspicuous gallantry on 14th of September near Verneuil in attacking a hostile machine gun, accompanied by only one man. When the latter was killed, he went on alone, shot

the officer and six men working the gun, which he captured.[2]

Wilson continued to serve with the 2nd Highland Light Infantry until he was wounded and gassed at the Battle of Loos in September 1915. Wilson was discharged in 1916 and returned to selling newspapers in Edinburgh. He was known with affection as the 'Newsboy VC'. The war affected his health and he developed a dependency on alcohol. At one point he was so impoverished that he pawned his Victoria Cross. Wilson died from tuberculosis on 22 April 1926, days before his 40th birthday. He was buried at Piershill Cemetery, Edinburgh.

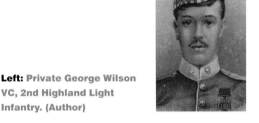

Left: Private George Wilson VC, 2nd Highland Light Infantry. (Author)

Left and below: Artist's depiction of Private George Wilson's VC action at Verneuil. (*Deeds that Thrill the Empire*)

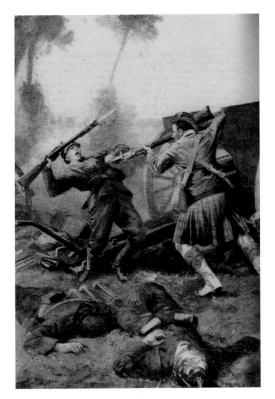

Right: Private George Wilson bayoneting a German soldier at Verneuil. (*The War Illustrated*, 2 January 1915)

LIEUTENANT HIS HIGHNESS PRINCE MAURICE BATTENBERG

1ST BATTALION KING'S ROYAL RIFLE CORPS

Prince Maurice Victor Donald Battenberg was a grandson of Queen Victoria. He was born in 1891 at Balmoral. He was educated at Wellington College where he served as a Lance Corporal in the Officer Training Corps and was renowned as the best marksman in the college. He attended the Royal Military College

HRH Lieutenant Prince Maurice Battenberg, 1st King's Royal Rifle Corps. (*De Ruvigny's Roll of Honour, 1914–1918*)

at Sandhurst and was gazetted as a 2nd Lieutenant with the 1st King's Royal Rifle Corps on 4 March 1911. Promoted to Lieutenant in February 1914, he went to France with the battalion at the outbreak of war. He was twice mentioned in Field Marshal French's Dispatches. An anonymous sergeant from his battalion wrote:

> [A]t every opportunity he makes his men go at the double after the enemy. In our very first engagement Prince Maurice lost his hat. A shot from a German rifle went through the front of the peak and the wind did the rest. The narrow shave just amused the Prince and he had to stop running for laughing.[3]

He distinguished himself during the Battle of the Marne. Corporal J. Jolley wrote of his action close to Charly-sur-Marne:

> On the morning of the 7th the King's Royal Rifles were the advance guard. We traversed a wood and found that the enemy had camped on the other side. We could see the Germans making blockages on the bridge, preparing to blow it up, but on seeing us they made off and as we had no artillery with us they got off free. The order then came that the bridge must be taken at once. When we got there we found that the bridge had three blockages, comprised of carts, furniture, glass, wire, etc. Prince Maurice of Battenburg was the first man over, searching the house beyond, all by himself. This was a brave act for an officer alone. The blockage was removed, and the batt. got across without a shot being fired.[4]

At the crossing of the river Aisne Prince Maurice was the first from the battalion to cross and led the advance to Verneuil under hostile fire. Prince Maurice continued to fight with the battalion during the Battle of the Aisne and in Flanders. On 27 October 1914 he was mortally wounded at Ypres. An eye witness recalled the circumstances:

> He met his death leading his men against a German position. On the advance, they came to a wood which was too thick for them to get through conveniently. Prince Maurice was leading his men across the open space when a shell fell and burst right by him. He knew that his injuries were mortal. He was carried to a field dressing station, but died before he reached it.[5]

Prince Maurice was buried at Ypres Town Cemetery at 3.30pm on 30 October. The burial took place under the sound of artillery fire. Captain Dyer wrote:

Prince Maurice Battenburg's grave at Ypres Town cemetery. (Author)

... not far away the German guns were firing on our trenches, and our men were doing their best to put them out of action. The guns were making such a noise that you could not hear the Chaplain's voice.[6]

General Monro, commanding the 2nd Division wrote that 'His Highness had throughout the campaign displayed a rare example of courage and fortitude to the men of his batt.'[7]

Rifleman William Coleman, 1st King's Royal Rifle Corps. (*De Ruvigny's Roll of Honour, 1914–1918*)

RIFLEMAN WILLIAM COLEMAN 7512
1ST BATTALION KING'S ROYAL RIFLE CORPS
William Albert Coleman was born on 4 May 1886 in Ipswich. He served with the King's Royal Rifle Corps from 10 May 1906. He went to France on 20 August 1914 with the 1st Battalion and took part in the Battle of the Aisne. He was captured on 4 November 1914 at Ypres and died from fever at a Prisoner of War Camp at Gustrow, Mecklenburg, on 24 January 1915. He was buried at Hamburg Cemetery.

RIFLEMAN IDRIS DAVIES 7096
1ST BATTALION KING'S ROYAL RIFLE CORPS
Rifleman Idris Davies died of wounds sustained during the Battle of the Aisne on 14 September He has no known grave and his name is commemorated on the memorial at La Ferté-sous-Jouarre.

Rifleman Idris Davies, 1st King's Royal Rifle Corps. (*South Wales Daily Post*, 8 October 1914)

NOTES

1. Anon, *Harrow Memorials of the Great War* Volume 1 (1918)
2. *London Gazette*, 4 December 1914
3. *People's Journal* (Aberdeen City Edition), 3 October 1914
4. De Ruvigny, Marquis, *De Ruvigny's Roll of Honour, 1914–1918* (1922, republished by Naval & Military Press, 2007)
5. *Anon, Wellington Year Book of 1914* (1914)
6. De Ruvigny
7. Clutterbuck, L.A., *Bonds of Sacrifice: August to December 1914* (1915, republished by Naval & Military Press, 2002)

THE BATTLE FOR COUR DE SOUPIR FARM

The 4th Guards Brigade was ordered to cross the Aisne at Pont Arcy at 7.00am, but due to the 6th Infantry Brigade's delay in their crossing they had to wait their turn in the pouring rain. The 4th Guards Brigade consisted of the 2nd Grenadier Guards, 2nd Coldstream Guards, 3rd Coldstream Guards and the 1st Irish Guards.

The 2nd Coldstream Guards left their billets at 6.00am that morning. Captain Lancelot Gibbs, battalion transport officer, had to destroy one lame horse before they set off. Many of the horses with the battalion had lost their shoes and must have been suffering considerable discomfort as they made their way to the pontoon bridge at Pont Arcy. Gibbs recalled:

Got off about 6am, raining as hard as ever. One horse had to be chucked out, and most of them lost shoes. However we got off somehow. We then trekked down one side of the canal to a pontoon bridge the RE had made, and we then got the battalion over, also the SA and water carts.[1]

At 8.30am the 2nd Grenadier Guards led the 4th Guards Brigade across the pontoon bridge hastily constructed by the Royal Engineers. The 1st Irish Guards brought up the rear and did not complete the crossing until 10.00am. The 4th Guards Brigade was ordered to head north west from Pont Arcy to Soupir, then proceed another

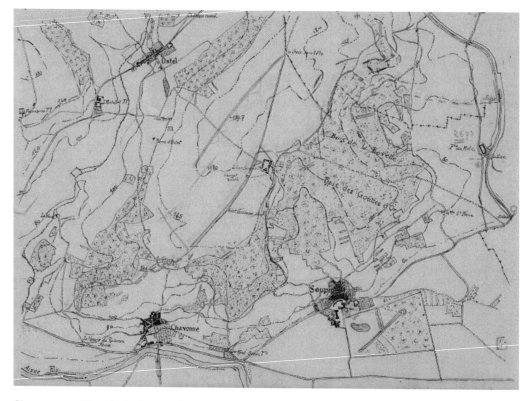

Chavonne and Soupir; La Cour de Soupir farm was positioned on the edge of Soupir Spur. The 4th Guards Brigade advanced up the steep ridge towards the farm and were vulnerable to ambush from German patrols and snipers. (www.memoiredeshommes.sga.defense.gouv.fr)

mile up a steep wooded hill to a farm called La Ferme de Cour Soupir. The farm was positioned close to the edge of the Soupir Spur that overlooked the Aisne valley. Surrounded by thick, high walls, Cour de Soupir Farm could be fortified into a strong defensive compound and its capture was necessary for the 4th Guards Brigade to establish a foothold on this ridge, enabling them to use it as a springboard to capture Soupir Spur and its summit, Point 197, known as La Croix sans Tête.

They were then to push on another mile at the crossroads at Ostel. Major George Jeffreys leading the 2nd Grenadier Guards was without detailed or adequate intelligence of the terrain, nor did he have knowledge of enemy- or British-held positions north of the Aisne. Jeffries commented in his diary. 'I was given no information, either about our own troops or the enemy, and no one seemed to anticipate severe fighting.'[2]

The 2nd Grenadier Guards crossed the pontoon bridge at Pont Arcy unopposed. Was this an oversight by the Germans? Had they made an error in not positioning guards at Pont Arcy? If German forces were determined to oppose the BEF's crossing, it seemed hard to believe that they would allow an entire battalion to cross the river without offering some resistance.

Major G. Hamilton commanding No.1 Company and No. 1 Platoon commanded by 2nd Lieutenant John Pickersgill-Cunliffe led the 2nd Grenadier Guards and

moved two miles westward from Pont Arcy along the northern bank. It was a dangerous situation as they entered Soupir for they did not know whether German forces were in possession of the village, waiting to ambush them. After carefully searching Soupir, they found no enemy presence. However, the column was shelled by German artillery forcing the Grenadier Guards to take shelter under the wall of Soupir Chateau. They then moved along the road from Soupir that ascended to the steep ridge to Cour de Soupir Farm on the Soupir Spur. There was a very steep hill to climb with the ground rising sharply on the west side of the road leading to the plateau above Chavonne. These Guards had spent the past three weeks on the move, retreating from Mons and then pursuing the German Army from the Marne to the Aisne. They had been pushed to the limits of physical endurance and to climb Soupir Ridge was an additional challenge. The Grenadier Guards were unable to see ahead or to the right and left of them because of the thick woods on either side of the road. It was foggy and there was a great risk of an enemy ambush en masse, or of coming under fire from snipers hidden in the trees. At 9.15am Jeffreys moved battalion headquarters and main guard companies west of Soupir and ordered units to push patrols on either side of the road that led to the top of the plateau.

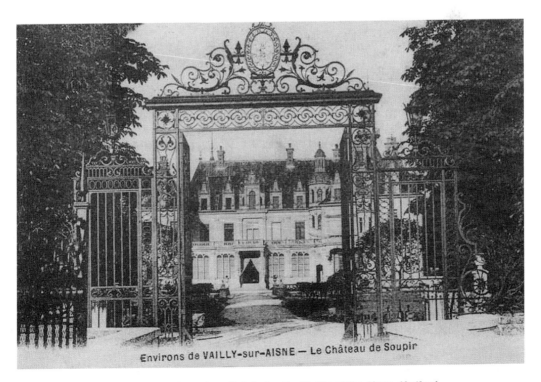

Environs de VAILLY-sur-AISNE — Le Château de Soupir

Soupir Chateau, which was used as a hospital during the Battle of the Aisne. (Author)

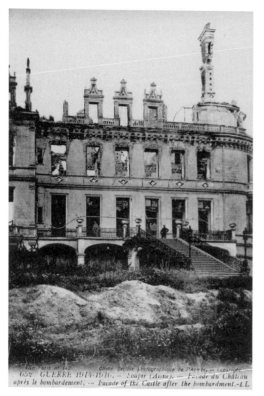

Hamilton had sent half of No.2 Company led by Captain Symes-Thompson through the woods to the edge, west of the La Cour de Soupir Road, to act as flank guard on their left. Symes-Thompson reported the presence of substantial numbers of German soldiers west of the road on the high ground towards Chavonne. As they proceeded half way up the hill they came into contact with German outposts. At this point stray parties from the 5th Infantry Brigade appeared, having gone too far on the left flank. If they had continued any farther they would have been captured. Major G. Hamilton sent a message to Jeffreys raising concerns about the left flank. Jeffreys responded quickly and sent the remaining units from No.2 Company up the Cour de Soupir Road to reinforce the flank held by Captain Symes-Thompson. No.1 Platoon commanded by 2nd Lieutenant John Pickersgill-Cunliffe and No.2 Platoon commanded by Prince Alexander Battenberg formed defensive positions along the western flank in the woods overlooking Chavonne to protect the main body of the battalion as it marched along the road.

At 10.00am Major Jeffreys and the 2nd Grenadier Guards had gone half a mile from Cour de Soupir where they suddenly heard heavy gunfire ahead of their position. Jeffreys was unaware of what was occurring in front of him. He was certainly unaware that Major William Sarsfield commanding the 2nd Connaught

Facade remains of Soupir Chateau. (Author)

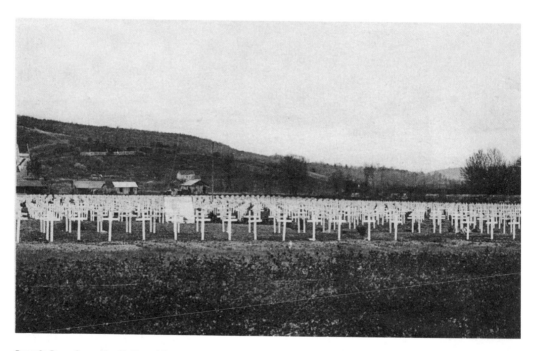

Soupir Spur from the National French Cemetery at Soupir. On 14 September the ridge would have been covered with trees, but four years of war destroyed the woodland, as this post-war photograph shows. (Author)

Rangers, who had been holding the line on the 5th Infantry Brigade's left flank on the outskirts of Soupir since the previous night, had decided to establish a position at Cour de Soupir Farm.

The situation highlights the poor or non-existent communication amongst British battalions on the north bank of the Aisne. The 2nd Grenadier Guards were not aware that at 1.00am on 14 September Major Sarsfield heard that the 4th Guards Brigade was on its way and without orders he had led his battalion forward to occupy high ground near to Cour de Soupir. At 5.30am on 14 September he ordered outposts to be established at Croix Sans Tête. They encountered no enemy and the battalion was able to establish themselves at Cour de Soupir. He established outposts around the farm and sent patrols to search for German positions. They confirmed that there was no enemy presence as far as Point 197. Sarsfield reported the situation at Cour de Soupir Farm to 5th Infantry Brigade Headquarters, but did not receive a response until 9.45am, advising him that that it would take some time for the 4th Guards Brigade to reach them and to hold the farm until they arrived. Sarsfield was ordered not to attempt to secure Point 197 until the 4th Guards Brigade had arrived.

Sarsfield received this message just as the 2nd Grenadiers were approaching their position. They did not know what was ahead of them. There was a great risk of entering into cross fire, being ambushed by the enemy or being fired upon by the 2nd Connaught Rangers. The situation was volatile and uncertain.

At 9.45am, leading units from the 2nd Grenadier Guards arrived at Cour de Soupir Farm. They were completely unaware that the 2nd Connaught Rangers had occupied it. The weather conditions were atrocious, the rain soaking the exhausted troops.

2nd Lieutenant John Pickersgill-Cunliffe with the leading platoon was 100 yards away from Cour de Soupir Farm and heading in the direction of Point 197 when they encountered and engaged with a German force assaulting the farm, supported by German heavy artillery. Pickersgill-Cunliffe's party joined the Connaught Rangers who were defending outpost positions. They were overwhelmed by superior German infantry numbers and were captured. Pickersgill-Cunliffe was severely wounded and was left where he fell.

No.3 Company from the 2nd Grenadier Guards, led by Captain Alwyn Gosselin, was ordered to clear the woods to the east of the Cour de Soupir Road and defend the right flank. They very soon became engaged with German forces in the woods. German snipers had climbed trees and were targeting them from their concealed positions. The situation became desperate. Gosselin requested reinforcements, which were hastily dispatched. Despite heavy German resistance they fought their way through the edge of the wood east of

Soupir Spur from the National French Cemetery at Soupir today. (Author)

Interior of La Cour de Soupir Farm. This compound was transformed into a fortress during the Battle of the Aisne and served as a hospital. (Dick Monk)

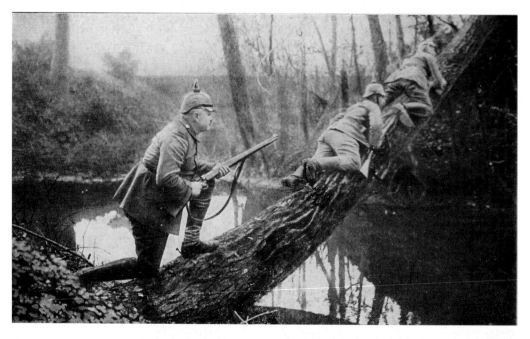

German soldiers pose on the Aisne in 1914. Snipers hiding in trees posed a deadly threat to the soldiers from the 4th Guards Brigade who advanced up to La Cour de Soupir Farm. (Author)

the farm on their left. They could not make any progress on their right flank as large numbers of German soldiers were firing upon them once they left the cover of the wood. It was here that Lieutenant des Voeux was killed when a bullet went through both his lungs. There was the threat of being fired upon from German detachments still in the wood itself. Major Jefferys was still on the Cour de Soupir Road and with his Adjutant, Captain Ebenezer Pike, he ventured farther up the plateau to investigate the situation. When he reached the farm he found that his entire battalion and the 2nd Connaught Rangers were committed to the battle and were spread out over a large area.

Sarsfield immediately sent three companies from the 2nd Connaught Rangers from the enclosure of the farm's compound to protect the east and west flanks and the front of the farm. It was very fortunate that the leading companies of the 2nd Grenadier Guards led by Major George Jeffreys had reached the farm when they did, for they were immediately ordered to support the left flank of the Connaught Rangers. Three German battalions covered by substantial artillery fire were advancing across open ground upon the farm. Some German infantry entered the wood at La Bovette in an effort to outflank the Connaught Rangers. After an hour's fighting German infantry had battled their way through the wood and penetrated the Connaught line to within 100 yards of the farm. If the Germans took the farm, they would then get clear line of sight over Soupir and the river Aisne and its southern approaches. A fierce action ensued as the 2nd Grenadier Guards and the 2nd Connaught Rangers repelled the German assault. Heavy casualties were sustained on the left flank. Some German infantry units managed to get into the wood on the right flank, where further actions would be fought to clear them.

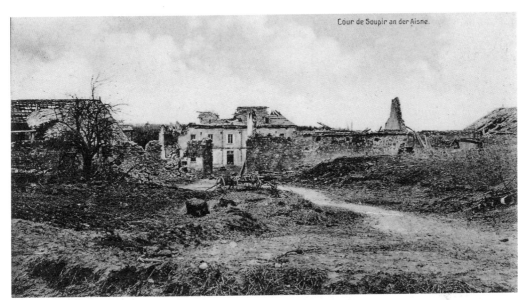

Cour de Soupir an der Aisne.

Two views of the north-west entrance of La Cour de Soupir Farm, one taken during the war and the other taken today. The terrain itself has changed very little.

At 10.20am the 3rd Coldstream Guards commanded by Major T.G. Matheson had arrived to bolster the defences of the farm. They were supported by the 1st Irish Guards following close behind. Jeffreys was unaware that they were to follow behind his battalion, and it was a surprise when the Adjutant of the 3rd Coldstream Guards, Lieutenant Arthur Smith, reported that the battalion was heading for the farm. The battalion had suffered from German barrages on the way up and was forced to deviate from the Cour de Soupir Road and to approach the farm from La Bovette Wood. No.1 Company commanded by Captain E. Longueville and No.3 Company led by Captain Vaughan were dispatched to the right flank to support the defensive position held by the Connaught Rangers; they swung the battle in their favour. No. 2 Company commanded by Captain Brocklehurst and No.4 Company commanded by Captain Banbury supported the 2nd Grenadier Guards on the left flank. They arrived just in time to oppose the German onslaught west and north west of the farm.

The firing line comprising men from the Connaught Rangers, Grenadier and Coldstream Guards was behind the bank of the sunken road north and east of the farm, which afforded them some limited cover. Wave after wave of German infantry charged. Ammunition supplies were fast becoming depleted, but they made every shot count. Accurate marksmanship countered superior numbers. Lieutenant Walker, Lieutenant Harcourt Vernon and Lieutenant MacKenzie were wounded while defending the farm.

Unable to penetrate the British line the assault faltered and the Germans were forced to withdraw. As the force withdrew, a German officer was seen to pull out his revolver and shoot dead 2nd Lieutenant John Pickersgill-Cunliffe, who was lying wounded on the ground. Captured Grenadier Guards from Pickersgill-Cunliffe's company also saw this terrible incident. These prisoners were abandoned by their German captors and could corroborate the execution of this 19-year-old officer. Some eyewitnesses stated that they recognised the officer responsible for the murder amongst a group of POWs captured later that day; others testified that vengeance was swift, for this German officer was killed by advancing soldiers of the 3rd Coldstream Guards led by Captain Bentinck, who bayoneted him.

Another two companies from the 3rd Coldstream Guards and 1st Irish Guards attempted to subdue German forces in the woods to the right of the farm. As they got to within 200 yards of the wood they were met by heavy enemy fire. Captain Hamilton Berners was killed. Captain J.N. Guthrie was wounded. Lieutenant Watson from the Royal Army Medical Corps was attending a wounded Irish Guardsmen when he was shot and wounded.

One isolated party from the 2nd Coldstream Guards – Lieutenant Redvers Bewicke-Copley and 2nd Lieutenant Richard Lockwood with a sergeant – had captured a party of 25 German prisoners on the edge of the wood. They were found by Lieutenant Greer from the Irish Guards who was leading a machine-gun section. Soon after Greer had reached this party of three Coldstreamers, a sniper killed Lockwood outright and caused other casualties. With few men, Greer and Bewicke-Copley withdrew. Bewicke-Copley did not want the prisoners to get away so he called for a volunteer to go back and collect them. An Irish Guardsman named Harrington stepped forward and

La Cour de Soupir Farm today. (Author)

together with three other stragglers who appeared from the Coldstream Guards, they returned to secure the prisoners and brought them to the farm.

The mixed units of the 2nd Connaught Rangers, 2nd Grenadier Guards, 1st Irish Guards and the 3rd Coldstream Guards stopped the German advance and prevented them from capturing Cour de Soupir Farm. This victory resulted from good fortune – in the unplanned convergence of these three battalions in the vicinity at the same time – and guts. They had repelled a substantial German attack, without any planned strategy for defence.

With the enemy held at bay, Major Matheson, Major Jeffreys and Major the Lord Gordon-Lennox had a brief respite in which to hastily organise a counter attack to secure Point 197. Rain fell incessantly as these officers discussed the situation on the road adjacent to the farm at around 11.00am. They had no communication with Brigade Headquarters. Artillery officers were not available and therefore there was no artillery support during the defence of the farm. Steep slopes and dense woods would have made it impossible for artillery crews to identify targets anyway. German artillery fire had subsided and they were targeting their guns to the south of Cour de Soupir. The small parties at the farm were holding a firing line that stretched from the northern edge of the wood through to the east of the farm, into the sunken road along the northern perimeter, which then turned in a south-westerly direction beyond the farm. The majority of the Connaught Rangers were inside the farm's compound.

At that moment rifle shots were heard close by and an NCO ran into the courtyard and reported that German infantry was advancing on their position in large numbers. As they were discussing their next move Major Herbert Stepney and the main contingent from the 1st Irish Guards arrived to provide support to Captain Alwyn Gosselin and No.3 Company, 2nd Grenadier Guards, in clearing the enemy from La Bovette Wood on the right flank. They had lost many men to sniper fire as they climbed up the hill. Irish Guards were defending the Cour de Soupir–Chavonne Road and holding high ground overlooking Chavonne.

Private Kilcoin described the movements of the 1st Irish Guards after they had crossed the river Aisne at Pont Arcy. 'Arrived at Soupir town (Madame Gailleux Château) from here we started our advance to the attack – up a steep hill then through the woods.'[3]

Matheson, Jeffreys and Gordon-Lennox were aware that many German soldiers were lying low in the field to the north of the farm. They were fearful of accurate British rifle fire and had decided either to wait until night, when they could withdraw under the cover of darkness or to stick it out until a further German counter attack. The three British officers, without orders

from their brigade commander, decided that there was no time to lose and that they should counter attack.

Matheson would use his reserve company and together with the company defending the western flank would make an effort to capture Point 197, while Jeffreys would advance on the right flank. Both the 2nd and 3rd Grenadier Guards launched an attack at midday, which was interrupted when German soldiers who were lying in the field north of the farm got to their feet and started to run towards them with their hands up. There were about 200 of them and they left the counter attack in disarray. A white flag was seen as the surrendering German troops approached. Soldiers from the Connaught Rangers, Grenadier, Coldstream and Irish Guards left their own positions and rushed forward in haste to seize and secure the prisoners, much to the consternation of Major Jeffreys and Major Matheson, who ordered them to stand fast. Lieutenant J.S. Fitzgerald from the Irish Guards and Lieutenant Cotterel-Dormer were confronted with 150 German soldiers sitting close to haystacks waving white handkerchiefs. British soldiers intermingled with surrendering German troops all came under fire from advancing German waves moving to attack the farm half a mile away. They opened fire causing many British casualties and shot many of their own men as well. Irish Guards who heard cheering as the surrendering Germans came out of La Bovette Wood got caught in the cross fire. The surrendering Germans and the Grenadier Guards lay flat as German shell fire and rifle shots exploded around them. The momentum of the attack of the Grenadier Guards was completely lost during this chaotic episode. Some British soldiers dragged their captives into the sunken road to the north of the farm. Major George Jeffreys wrote:

I don't believe there was any intentional treachery on the part of the Germans. Their leading line had had enough and meant to surrender. Incidentally they had hardly any ammunition left. Their supports in rear, however, had no intention of surrendering and opened fire when they got a good target. I had no idea what good cover a root field could give to men lying down: they were as invisible in it as partridges.[4]

German fire increased in intensity, a lot of it from the ridge at Point 197, 500 yards north east of the farm. Overwhelmed by German forces, the British were compelled to retire. Private William Hazell of the 3rd Coldstream Guards was amongst those who withdrew. He was wounded in the right arm, the bullet exiting through the elbow and shattering the bone. Despite the wound he continued to withdraw and sustained another bullet wound in his left hip cutting away his

haversack. He continued to limp back, but a third bullet hit him in the left leg above the knee and went through his leg. He then crawled under heavy fire 150 yards to the rear, where he received medical attention and was evacuated to a barn used as a field dressing station, where he remained for four days.

Amidst the chaos Jeffreys and Matheson decided that Matheson would take an intact platoon from Jeffrey's 2nd Grenadier Guards and push eastwards into La Bovette Wood in an attempt to find and link up with the Irish Guards and organise an attack upon Point 197.

Matheson left Jeffreys in charge of the mixed remnants of the Guards Brigade. The Connaught Rangers consolidated their position within the high walls of the farm compound and removed captured German prisoners to a quarry on the edge of the wood east of the farm. Jeffreys began to restore some sort of order amongst the battalions, using the cover of the wood and the sunken road to place most of the Grenadiers on the right flank and the Coldstream Guards on the left. Farther along the line the units remained mixed. The remnants of the Guards Brigade provided covering fire as Matheson ventured off into La Bovette Wood at 1.00pm.

Matheson eventually found Major Stepney and the Irish Guards still trying to clear the Germans from La Bovette Wood. Despite already being engaged in a battle for the wood, Major Stepney agreed to launch an assault with Major Matheson upon Point 197, which was pouring fire upon the farm. At an opportune moment the remnants of the Guards Brigade commanded by Major Jeffreys at the farm would support the Irish Guards.

The 1st Irish Guards launched an attack at 2.00pm on the right of the farm, but as soon as they emerged from the cover of the woods they were cut down. Lieutenant E.B. Greer, machine-gun officer of the 1st Irish Guards, brought two machine-gun teams forward to assist. One gun team was totally wiped out, while the other gun was lost. The lost gun was later recovered under the cover of darkness when Corporal Sheridan, Private Carney and Private Harrington volunteered to search for it. Private Kilcoin from the 1st Irish Guards took part in this assault and later wrote:

Fought desperate engagement here with the Germans. I was one of a party of 20 who lost touch with our company in the melee. We had a very exciting and anxious time. Did not manage to get in touch with any troops till about 4:00pm, then fell in with the Coldstreamers and Connaught Rangers. Did bayonet charge on plateau to the right of farm Cour de Soupir. Captured many prisoners – our losses very heavy especially amongst officers, those killed being Captain Berners and Captain Lord

Arthur Hay and several wounded. Cannot remember names of all killed. Rather confusing, fancy Lord Guernsey killed in this engagement. The sights of the killed and wounded too terrible to describe.[5]

The 1st Kings Royal Rifle Corps was brought up to enter the line on the extreme right flank. German infantry also poured from La Bovette, running from the Irish Guards, and providing targets for Jeffreys' men at the farm. The Germans holding Point 197 withdrew. Sergeant John McIlwain belonged to Lieutenant Lentaigne's platoon from the 2nd Connaught Rangers:

In the afternoon we doubled in skirmishing order through the farm buildings at the summit of the hill under a brisk rifle and machine-gun fire which played quite musically on the leaves and branches of the tall trees in the wood that masked the German position. At the edge of this wood my platoon officer, Lieut. Letaigne, halted us, and ordering me to take command, fixed his sword in the ground to mark the point of the advance, went forward alone and was not seen again. Latterly, being in doubt, and having neither information nor instructions, I led the platoon forward and was met by our company commander, Major Alexander, who reported our position as on the right flank of the attack; further, that the guards were falling back as the flank was in danger. We retreated to the wood again with a mixed party of Grenadiers and Coldstreamers. 'We'll show them how the Irish can fight', someone said earlier. A small party of us took up position at the end of an avenue where from a hundred yards range we directed a heavy fire on advancing and passing German infantrymen, holding up their advance at that point.[6]

The battle at Cour de Soupir Farm was anarchic because of the mix-up of units, lack of clear direction from brigade headquarters and because so many officers were casualties. If it were not for the efforts of battalion commanders such as Jeffreys, Sarsfield, Stepney and Matheson making decisions in the heat of battle, then the situation would have been a complete disaster with a lot more casualties suffered.

By 4.00pm a line had been secured by the 2nd Division that ran from La Bovette, passing in front of Cour de Soupir Farm and skirting the edge of the spur towards the village at Chavonne. Matheson returned to the farm at 4.00pm and discussed the situation. It was decided that since the Guards Brigade was scattered, no further attempts to drive the line forward would be attempted. They had no artillery support and no orders. Major the Honourable W. Ruthven from Brigade Headquarters arrived at the farm at this time to assess the situation. He brought no orders, which meant the

battalion commanders of the 4th Guards Brigade had no communication with brigade headquarters that day. Messages were sent but no responses were received. It was impossible to signal with flags across the woodland. Ruthven did inform Jeffreys that the 2nd Coldstream Guards was to split into two. Two companies were sent to Chavonne where they linked up with elements from the 1st Cavalry Brigade in an effort to plug the gap in the line between the 2nd and 3rd Division at Vailly, while the other two companies were sent to support the 1st Irish Guards on the right flank.

As dusk was approaching German snipers were still operating on the front held by the 1st Irish Guards. Captain Lord Guernsey, Acting Quartermaster for the battalion, reported to his commanding officer to assist where required. He was immediately posted to No.2 Platoon as a replacement officer for the wounded Captain Guthrie. Captain Lord Arthur Hay was in overall command. As Lord Guernsey liaised with Lord Arthur, both men were shot dead by a single German sniper.

At 6.00pm men from all battalions of the 4th Guards Brigade cautiously went into the fields north of the farm to search for pockets of German soldiers who wanted to surrender. What they considered to be the white flag deception carried out earlier that afternoon made the guardsmen very wary. Private Kilcoin:

Above: Soldiers from the 4th Guards Brigade capture a machine-gun position in La Bovette Wood, close to La Cour de Soupir Farm on 14 September. (*The War Illustrated*, 24 October 1914)

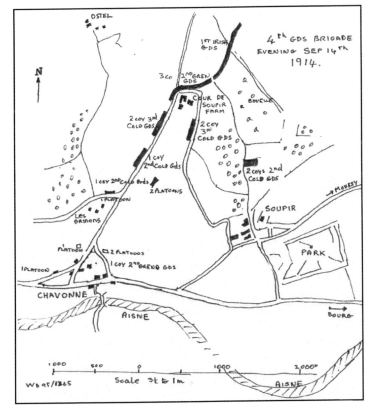

Left: The positions of battalions from the 4th Guards Brigade during the evening of 14 September. (National Archives WO 95/1365)

... about 6.00pm went out with a party of 80 all of various regiments to bring in Germans who wished to surrender, found about 300 waiting to come in. Brought this party in very carefully and kept sharp look out for treachery. Earlier in the afternoon we had been fired on by a white flag party of the enemy. Our losses on this occasion appalling – these prisoners were all lodged in Soupir farm temporarily but were removed to safer quarters about 9.00pm. The stragglers of the Irish Guards moved out to the left of farm – lay down on edge of the road and formed a firing line – all very very quiet, not a German within miles of us by the look of things.[7]

Major Jeffreys and Matheson decided to wait until dusk before they made a serious attempt to organise their ranks into their battalions and dig in. As night fell trenches were dug. Despite exhaustion and hunger they summoned enough strength to dig. Little did they know that the trenches dug that night were the muddy beginnings of the entire Western Front. The Grenadiers held the track in the wood 200 yards east of the farm up to the Chavonne–Point 197 road. The 3rd Coldstream Guards held a line south west of Cour de Soupir Farm along the Chavonne Road and linked with the 2nd Coldstream Guards. The Irish Guards were positioned on the right flank. Two platoons of Grenadiers were deployed to Chavonne and the 1st Cavalry Brigade extended the line in the direction of Vailly. At nightfall the Connaught Rangers withdrew from the farm.

The 2nd Grenadier Guards dug trenches 100 yards north of the sunken road in front of the farm. As trenches were being dug stretcher bearers ventured out. Substantial numbers of British and German dead and wounded were lying in the fields and woods surrounding the farm. There was a long line of dead German soldiers lying west of the farm building and many were lying in the fields. There were also many German soldiers, some alone, others in isolated parties, who were not dead or wounded, but waiting for an opportune moment either to surrender or escape under the cover of darkness.

One stretcher bearer reported to Major Jeffreys that he had met a German officer with a party of men who questioned him about their strength and said that he would only surrender if outnumbered – and then only to a British officer. The stretcher bearer told him there were 1000 British soldiers in the vicinity. This German lieutenant did find a British officer to surrender to and was brought to Major Jeffreys.

There was insufficient space to accommodate the wounded within the confines of the farm and not enough medical personnel. The farm became overcrowded and many wounded were placed in outbuildings. There were only four or five horse ambulance wagons available, and the poor horses had the arduous task of going up and down the steep hill time after time through the night. Only a small number of wounded could be transported at one time on these wagons; and once they reached the pontoon bridge at

2nd Grenadiers front line position at Chavonne, photographed during the later phase of the Battle of the Aisne. Left to right: Earl Percy (Staff), Lieutenant D. Miller, Major Lord Bernard Gordon-Lennox and Captain G. Powell. (Grenadier Guards Regimental Headquarters Archives)

La Cour de Soupir Farm taken from German lines from a position between Ostel and the farm. La Bovette Wood, which was captured by the 1st Irish Guards, can be seen on the left. The farm was positioned on the edge of Soupir Spur and commanded a good observation point across the Aisne valley, its river crossings and southern approaches. (Author)

Pont Arcy, they would come under heavy targeted shell fire. Major Jeffreys:

> There was great difficulty in dealing with the wounded. The large farmhouse was full of them and so were the big cattle byres, barn, cart sheds, etc., and a number were lying on straw in the farmyard, and just outside the gate were a number of German wounded, who groaned and cried out continuously through the night. Our wounded on the contrary were very quiet ... There were not enough Medical Officers, orderlies etc., at the farm to deal with the wounded, and the farm was not cleared of them until 16th September.[8]

Some elements of the 2nd Coldstream Guards were held in reserve in the village of Soupir in the Aisne valley, where they were shelled. French inhabitants of the

The iron gate of Soupir Chateau, all that remains of the building that housed many of the wounded after the Battle of the Aisne. (Courtesy Yves Fohlen)

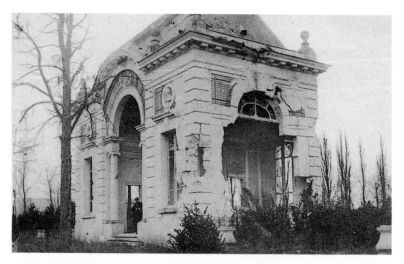

The eastern gatehouse of Soupir Chateau during the First World War. (Author)

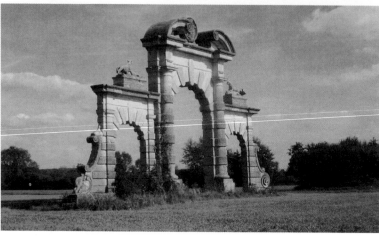

The ruins of the eastern gatehouse of Soupir Chateau, September 2010. (Author)

village remained there. Captain Lancelot Gibbs recorded in his diary:

> Came to a village Soupir where we got heavily shelled ... The battalion was in reserve most of the day and so no ammunition required. Got little news. The Germans seem to have been holding the hill with a large force (9 Battalions). Shell after shell of shrapnel kept bursting just about us in the village of Soupir.
>
> It was an awful day. Men being brought in all day and night to the church, school and anywhere else. All the villagers terrified, but very kind to us about giving food.[9]

The cost of the battle at Soupir was high for both sides. The 2nd Connaught Rangers had captured approximately 250 German prisoners, but had lost heavily. The casualties included Lieutenant John Fraser, Lieutenant Rhys Thomas, 2nd Lieutenant Ralph Spreckley MC killed and 5 officers wounded, 250 other ranks were casualties. Spreckley and Thomas were awarded the Military Cross for their work at Soupir. Sergeant Major Bruen was awarded the Legion of Honour.

The 2nd Grenadier Guards had captured 300 to 400 prisoners. They lost 2nd Lieutenant Pickersgill-Cunliffe and Lieutenant Des Voeux. Amongst the officers wounded were Stewart, Welby, Walker, Mackenzie and Harcout-Vernon. The battalion also lost 120 NCOs and men. There was an acute shortage of officers. Captain Alwyn Gosselin sustained a wound to his hand and Lieutenant Richard Welby who was wounded in the shoulder remained on duty despite his wounds while others who were severely wounded were evacuated. Welby was killed two days later by shell fire. Captain Alwyn Gosselin was awarded the Distinguished Service Order for his role at Cour de Soupir Farm. His citation in the London Gazette stated: 'Although wounded and

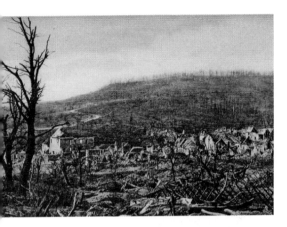

Ruins of the village of Soupir in April 1917. (Author)

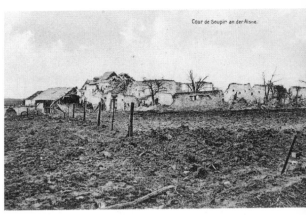

Cour de Soupir an der Aisne.

La Cour de Soupir Farm after the Battle of the Aisne. (Author)

in considerable pain, commanded his company against the advice of the Medical Officer and until he could be relieved by another officer.'[10] Gosselin would lose his life near Bethune on 7 February 1915.

The 2nd Coldstream Guards lost 2nd Lieutenant Richard Lockwood and another man killed and 63 other ranks wounded. Amongst the wounded were Captain J.S. Egerton and Sir W.B. Barttelot Bart.

The 3rd Coldstream Guards sustained 178 casualties at Cour de Soupir Farm. Lieutenant David Bingham and Lieutenant Percy Wyndham was both killed together with 21 other ranks. 153 men were wounded including Captain G.E. Vaughan and Lieutenant H.N. Fane. Lieutenant Victor Gordon-Ives died from his wounds on 16 September. Captain Charles Banbury died the same day.

Those soldiers at Cour de Soupir Farm who were not required to hold the line were able to seek some rest and shelter in a deep quarry containing several caves situated behind the farm. The only danger was from German howitzers. The German prisoners were kept in the caves until they could be escorted back to the river and British lines the next day.

Through the night of 14 September, many soldiers remained in shallow trenches defending their fragile line, their clothes soaked by persistent rain. Sergeant Arthur Lane of the 2nd Coldstream Guards:

Recalled by signal I rejoined my Company at the top of a big hill governing the village in which we had been on outpost. There we were subjected to a very heavy shell fire which again did very little damage. We fired on small parties of the enemy whom we saw retiring. The majority of the Battalion moved off to our right flank, but we were ordered to remain. We dug shallow trenches and stayed in them all night. Had nothing warm since our tea this morning. Raining heavily. Wet through and very cold. About midnight a very heavy bombardment took place on our left, but no part of our line was attacked.[11]

NOTes ⋯⋯⋯

1. Captain Lancelot Gibbs Diary, Coldstream Guards Regimental Headquarters Archive
2. Major George Jeffreys Diary, Grenadier Guards Regimental Headquarters Archive
3. Private L.L. Kilcoin Diary, Irish Guards Regimental Headquarters Archive
4. Major George Jeffreys Diary
5. Private L.L. Kilcoin Diary

6. IWM 553796/29/1: Sergeant John McIlwain, 2nd Connaught Rangers
7. Private L.L. Kilcoin Diary
8. Major George Jeffreys Diary
9. Captain Lancelot Gibbs Diary
10. *London Gazette*: 9 November 1914
11. IWM 81/14/1: Sergeant Arthur Lane, 2nd Coldstream Guards

THEY FOUGHT AT COUR DE SOUPIR FARM

MAJOR WILLIAM SARSFIELD
2ND BATTALION CONNAUGHT RANGERS

William Stoppford Sarsfield was born in 1868 at Doughcloyne, County Cork. Educated at Cheltenham College, he joined 1st Connaught Rangers in September 1888. In February 1890 he was promoted to Lieutenant and in May 1897 he attained the rank of Captain. He continued to serve with the 1st Connaught Rangers through the Boer War taking part in the battles at Colenso on 15 December 1899, Spion Kop 20–24 January 1900 and Vaal Krans 5–7 February 1900. Sarsfield also took part in the action on the Tugela Heights in Natal 14–27 February 1900 and was present at the relief of Ladysmith on 1 March 1900. He was awarded the Queen's medal with three clasps and the King's medal with two clasps. He continued to serve with the British Army after the Boer War and throughout the next decade. When war broke out he went to France with the 2nd Battalion Connaught Rangers. He played an active role in the Battle of the Aisne and took command of the battalion when the commanding officer was wounded. Sarsfield acted without orders when he captured Cour de Soupir Farm and held this position until battalions from the 4th Guards Brigade arrived on 14 September. Sarsfield was killed on the Aisne while repelling a German counter attack on 20 September. He left a widow, Beatrice, and a five-year-old son, Patrick. Sarsfield was buried in Vailly British Cemetery. His epitaph reads: 'Quis Separabit'.

Major William Sarsfield, 2nd Connaught Rangers. (Bonds of Sacrifice)

LIEUTENANT NEVILLE LANCELOT AVELING
2ND BATTALION CONNAUGHT RANGERS

Neville Lancelot Aveling was born in Rochester in 1892. He was educated at Gresham's Holt School and served with the Officer Training Corps for four years. He represented the school in shooting competitions at Bisley. He served with the 2nd Connaught Rangers in France with the BEF. He received two bullet wounds during the Battle of the Aisne on 14 September. He transferred to the 1st Battalion and was wounded at Ypres on 7 November 1914. Aveling was mentioned in dispatches in February 1915. He was wounded again on the Ypres front on 26 April 1915. He died from his wounds three days later at a hospital in Hazebrouck. He was buried in Hazebrouck Communal Cemetery. His colonel wrote: 'He was such a splendid officer and so charming a fellow. He is, indeed a most irreparable loss to my battalion.'[1]

Lieutenant Neville Aveling, 2nd Connaught Rangers. (*De Ruvigny's Roll of Honour, 1914–1918*)

LIEUTENANT GEOFFREY FENTON
2ND BATTALION CONNAUGHT RANGERS

Geoffrey Fenton was born at Sligo in 1889. He studied at Cheltenham College and the Royal Military College at Sandhurst. In September 1909 he joined the Connaught Rangers. He was an enthusiastic sportsman, rifleman and enjoyed fishing. Fenton took part in the retreat from Mons and the Battle of the Aisne, including the defence of Cour de Soupir Farm. On 20 September he was occupying trenches close to the farm and was within 300 yards of German trenches. An observation officer in his platoon was shot by a sniper. Fenton immediately took his place and shortly afterwards he also was killed by a sniper, who shot him in the head. In 1912 he had married Millicent Montresor, the eldest daughter

Lieutenant Geoffrey Fenton, 2nd Connaught Rangers. (*Bonds of Sacrifice*)

of Lieutenant-Colonel Ernest Montresor, commanding officer of the 2nd Battalion Royal Sussex Regiment. Montresor was also killed during the Battle of the Aisne, on 14 September. The Battle of the Aisne was a double tragedy for Milicent Fenton. Lieutenant Fenton has no known grave and his name is commemorated on the memorial at La Ferté-Sous-Jouarre.

LIEUTENANT JOHN FRASER
2ND BATTALION CONNAUGHT RANGERS

Although of Irish descent John Irwin Fraser was born in Tientsin, China, in 1884. His father came from Riversdale, Boyle, in Ireland. After completing his education at Mr Bookey's School, Bray, County Wicklow, he attended the Royal Military College at Sandhurst. He was commissioned into the Connaught Rangers in 1905 and received promotion to Lieutenant in 1906. After serving three years in India he worked with the King's African Rifles in Somaliland 1908–10. Lieutenant John Fraser went to France with the 2nd Connaught Rangers when war broke out. During the battle for Cour de Soupir Farm on 14 September Fraser was badly wounded while attempting to rescue a fellow officer, Captain Charles Joseph O'Sullivan from Cork, who was his brother-in-law. John's sister, Eva Maria Fraser, met O'Sullivan when he was Adjutant with the 4th Connaught Rangers in Boyle, County Roscommon. The men fought together at Cour de Soupir Farm. Captain O'Sullivan sustained a severe wound to his arm. Fraser dragged O'Sullivan into the farm. O'Sullivan survived the Battle of the Aisne but never returned to active service. Fraser died from his wounds in the kitchen of Cour de Soupir Farm later that day. Major William Sarsfield, his commanding officer, wrote of Fraser in his notebook, mentioning 'his coolness under fire and his efficient leading of his men at all times, especially at the action of La Cour de [Soupir] on 14 September, where he behaved with conspicuous gallantry, and was very dangerously wounded'.[2] Lieutenant John Fraser was buried at Vailly British Cemetery. His epitaph reads:

GREATER LOVE HATH
NO MAN THAN THIS.

Lieutenant John Fraser, 2nd Connaught Rangers. (*Bonds of Sacrifice*)

2ND LIEUTENANT RALPH SPRECKLEY MC
2ND BATTALION CONNAUGHT RANGERS

Ralph Lesingham Spreckley was born in Worcester in 1893. Spreckley was educated at Bromsgrove School,

Lieutenant Ralph Spreckley, 2nd Connaught Rangers. (*Bonds of Sacrifice*)

where he developed his leadership skills as colour sergeant in the Officers Training Corps. He also excelled at cricket and football while at the school. After attending the Royal Military College at Sandhurst he joined the Connaught Rangers as a 2nd Lieutenant in February 1913. Spreckley was killed during the battle for Cour de Soupir Farm on 14 September. A staff officer wrote:

> One fellow – Spreckley – who comes from north of Worcester, earned the VC twice over before he was killed. He was hit in the leg at a critical moment, went back and got dressed, and hobbled up to the firing line in the woods, cheering his men on. He was hit again and did ditto, getting back just as his fellows were breaking. He rallied them and drove the Germans on, only to be shot when the situation was saved.[3]

Spreckley was awarded the Military Cross and was mentioned in Sir John French's dispatch on 8 October 1914. Spreckley was buried at Vailly British Cemetery.

MAJOR LORD BERNARD GORDON-LENNOX
2ND BATTALION GRENADIER GUARDS

Lord Bernard Charles Gordon-Lennox was born in London in 1878 and was the third son of the 7th Duke of Richmond and Gordon. He was educated at Eton and after completing his training at Sandhurst, in February 1898 he joined the Grenadier Guards. He saw active service during the Boer War and was awarded the Queen's medal with two clasps. He later served in China from 1904 to 1906 with the Chinese Regiment at Wei-hai-Wei. He went to France as a Major with the 2nd Grenadier Guards in August 1914 and took part in the Battle of the Aisne. Major Lord Gordon-Lennox was killed in action at Zillebeke on 10 November 1914. He was buried at Zillebeke Churchyard.

Major Lord Bernard Gordon-Lennox, 2nd Grenadier Guards. (*Bonds of Sacrifice*)

LIEUTENANT FREDERICK DES VOEUX
2ND BATTALION GRENADIER GUARDS

Frederick William Des Voeux was born in 1889 at Government House in Hong Kong. His father, Sir George Des Voeux, was Governor of Hong Kong. He joined the Royal Navy in 1905 as a cadet at HMS *Britannia* but his constitution was not suited to life at sea and he was compelled to leave the service through ill health in 1909. Des Voeux joined the 3rd Battalion Grenadier Guards as a 2nd Lieutenant on 28 May 1910. He received promotion to Lieutenant the following year. Des Voeux went to France with the 2nd Grenadier Guards when war broke out. He took part in the retreat from Mons and the Battle of the Marne. De Voeux fought at Cour de Soupir Farm on 14 September, where he was killed. He was described as 'a smart young officer with charming manners, which endeared him to everyone who knew him.[4] He was buried at Soupir Communal Cemetery. His epitaph reads:

ONLY GOOD NIGHT
BELOVED. NOT
FAREWELL.

Lieutenant Frederick Des
Voeux, 2nd Grenadier
Guards. (*Bonds of Sacrifice*)

LIEUTENANT RICHARD WELBY
2ND BATTALION GRENADIER GUARDS

Richard William Gregory Welby was born at Denton Manor, Grantham, Lincolnshire in 1888. After completing his education at Eton he studied at Christ Church College, Oxford. He attended the Royal Military College at Sandhurst and he was commissioned into the Grenadier Guards as a 2nd Lieutenant on 23 February 1910. The following year he was promoted to Lieutenant. When war broke out he went with the 2nd Grenadier Guards to France and was present in the Mons area. He took part in the retirement through France, seeing action at Landrecies, Villers-Cotterets and the Marne. He was wounded during the battle for Cour de Soupir Farm by a bullet to his shoulder. There was a shortage of officers since all those of No.3 Company were killed or wounded during the battle. Welby could have gone to hospital to get his wound tended but he courageously

Lieutenant Richard Welby,
2nd Grenadier Guards.
(*Bonds of Sacrifice*)

remained in the line. The bullet was removed from his shoulder on 15 September and Welby returned to duty. Lieutenant Welby was killed by a shell at Soupir on 16 September. A fellow officer recalled Welby's courageous and self sacrificing exploits during the Battle of the Aisne:

> We had a very severe action on Tuesday when Dick Welby was wounded in the shoulder ... We were very short of officers, owing to our heavy casualties. He very pluckily insisted on remaining at duty (instead of going into hospital) to help us through the difficulty, and remained at duty during the day. On the third day we got a terrible shelling, and poor Dick was killed. His death was absolutely instantaneous – he was hit in the head by a shrapnel bullet – so that he had no pain or suffering, and he was cheerful and happy up to the minute before his death ... I can't tell you how we all deplore Dick's loss, nor how gallantly he did his duty to the end, and I hope his people will accept the most deep and hearty sympathy of all his brother officers.[5]

It was the view of some of those he led that he should have won the Victoria Cross. Sergeant W. Baker wrote the following letter to Lady Maria Welby, his bereaved mother:

> I am so very sorry I have been so slow in writing, but I have been so uncomfortable lately. I have lately found out about your son (Lieut. Welby) and he was very brave. If anyone was entitled to the Victoria Cross, Mr Welby was. He was wounded first, and the commanding officer told Welby to go back, but he stuck with his Company and cheered his men on, besides bringing back a wounded officer when he was wounded himself. All the men that knew Mr Welby honoured him, he was a fine officer, and took care of his men.[6]

Lieutenant Welby lies in Soupir Churchyard. His epitaph reads:

QUI ANTE DIEM PERIIT SED
MILES SED PRO PATRIA.

'Who died before his time, yet a soldier for his country'. Welby was mentioned in Field Marshal Sir John French's dispatch on 8 October 1914.

2ND LIEUTENANT JOHN PICKERSGILL-CUNLIFFE
2ND BATTALION GRENADIER GUARDS

John Reynolds Pickersgill-Cunliffe was born in Saffron Walden, Essex in 1895. He was wounded at Cour de

2nd Lieutenant Pickersgill-Cunliffe, 2nd Grenadier Guards. (*Bonds of Sacrifice*)

Soupir Farm. He was left where he fell and was captured by the enemy. When the Germans were routed, a German officer shot Cunliffe, who was lying helpless and wounded on the ground, and killed him. The German officer who killed the nineteen-year-old was soon himself killed, it is believed. Pickersgill-Cunliffe was buried at Soupir Communal Cemetery.

2ND LIEUTENANT ALFRED CUNNINGHAME
2ND BATTALION GRENADIER GUARDS

Alfred Keith Cunninghame was born in Windsor in April 1891. He was the son of Lieutenant-Colonel William Wallace Cunninghame. He was commissioned into the Grenadier Guards from Special Reserve during 1913. When war broke out he was a 2nd Lieutenant and was sent to France with the 2nd Battalion. He fought continuously with this battalion from August 1914 until his death during the Battle of the Somme in 1916. Major George Jeffreys recalled that 'the other boys call him "Flash Alf", but he was very much all there and has got the transport in good order.'[7]

Cunninghame took part in the retreat from Mons and the rearguard action at Landrecies. He advanced across the Aisne with the 2nd Grenadier Guards and took part in the battle for Cour de Soupir Farm on 14 September. By 19 November 1914, after the battalion had fought in the First Battle of Ypres in Flanders, Cunninghame and Jeffreys were the only surviving officers from the 2nd Battalion of those who left Wellington Barracks at the outbreak of war. Jeffreys was aware of this: 'Barring Cunninghame (Transport Officer) I am now the only Combatant Officer left who started the war with the Battalion.'[8]

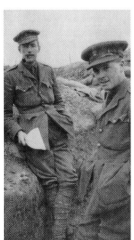

Lieutenant the Honorouble Wilfred Bailey (left) and Captain Alfred Cunninghame (right). (Grenadier Guards Regimental Archives)

Cunninghame was promoted to Captain in May 1916 and was killed in action on 25 September when the 2nd Grenadier Guards assaulted German trenches at Lesboeufs during the Battle of the Somme. On the night of 24 September, the 2nd Battalion Grenadier Guards moved from Bernafay Wood to relieve the 2nd Coldstream Guards in their trenches to the right of the Ginchy-Lesboeufs Road. They were given orders that they were to attack German trenches at 12.35pm the next day. The trenches that they occupied were so narrow that the Guardsmen from the 2nd Grenadier Guards could not sit or lie down and were forced to stand throughout the morning, shoulder to shoulder in the trench. A creeping barrage was established by British artillery for the 2nd Grenadiers to follow 200 yards behind. Although they were supported by this barrage, the barbed wire entanglements in No Man's Land had not been cut by the exploding shells, which meant that the Guards became entangled in the wire and were mown down by German machine guns. Captain Alfred Cunninghame and three fellow officers could see that the wire was left standing undamaged and was concealed by crops. They realised that it would mean almost certain death for anyone to attempt to go into No Man's Land to cut the wire. Instead of ordering their men to go forward and cut the wire, Cunninghame and his fellow officers ordered their men to lie down while they went to cut gaps with wire cutters. They succeeded in making enough breaches in the wire for the battalion to go forward and assault the German trenches, but Cunninghame and two of the other officers were killed, one wounded. Cunninghame had been exposed to danger at Cour de Soupir Farm and in defending trenches during the Battle of the Aisne so he was fully aware of the dangers. Aged 25 Cunninghame paid the ultimate sacrifice. He was buried at Citadel New Military Cemetery, Fricourt. His entry in the Commonwealth War Graves Commission registry recorded that he 'served continuously with the 2nd Battalion from 14th August 1914, and was the last survivor of the original battalion.'[9] The epitaph on his headstone reads: 'Younger son of Liet. Colonel Cunninghame of Caprington, Ayrshire'.

LANCE CORPORAL BERT CLEMENTS 14488
2ND BATTALION GRENADIER GUARDS

Bert Richard Clements was born in Barry Dock, Cardiff, in 1892. He was educated at Council Schools at Barry Dock and worked for two years as a telegraph boy at the Barry Dock Post Office. He later enlisted to serve with the Royal Garrison Artillery, but being an only son, his mother was able to get him out of the service. Clements returned to a military career when he joined the Grenadier Guards on 2 January 1909.

On completing three years with the Guards Clements joined the Cardiff City Police Force. He was mobilised in August 1914. He went to France with the 2nd Grenadier Guards and saw action during the retreat from Mons, the Marne and during the Battle of the Aisne. Lance Corporal Bert Clements was killed by shrapnel on 7 November 1914 at Zillebeke near Ypres. He has no known grave and his name is listed on the Ypres (Menin Gate) Memorial.

Lance Corporal Bert Clements, 2nd Grenadier Guards. (De Ruvigny's Roll of Honour, 1914–1918)

PRIVATE WILLIAM CHAPMAN 16431
2ND BATTALION GRENADIER GUARDS

William Alfred Chapman was born in Weston, Hertfordshire, in 1894. He worked in the engineering works of the Dacre Motor Car Co. at Letchworth and later at Heatley Gresham Works. On 24 April 1913 he enlisted to serve with the Grenadier Guards. When war broke out he went with the 2nd Battalion to France. He took part in the retreat from Mons, the Battle of the Marne and on the Aisne. He was captured in November 1914 but escaped. Chapman was recommended in Field Marshal Sir John French's Dispatch on 14 January 1915 for gallant and distinguished conduct in the field. Private William Chapman was killed on 7 February 1915. A comrade reported that the bullet hit him, he smiled, and then he fell dead. He was buried at Cuinchy Communal Cemetery.

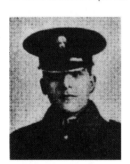

Private William Chapman, 2nd Grenadier Guards. (De Ruvigny's Roll of Honour, 1914–1918)

PRIVATE WALLACE CLISSOLD 16370
2ND BATTALION GRENADIER GUARDS

Wallace Christopher Clissold was born in Bussage, Gloucestershire, in 1895. He served with the 2nd Grenadier Guards and is believed to have been killed during the battle for Cour de Soupir Farm 14–16

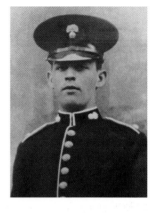

Private Wallace Clissold, 2nd Grenadier Guards. (Courtesy Martin Clissold)

September 1914. His body was taken to Vailly for temporary burial. In 1918 he was one of sixteen guardsmen who were removed for reburial in Soupir Communal Cemetery. His epitaph reads 'Gone but not forgotten'. After the war Lieutenant Stewart visited Wallace's parents. He told them how he had been wounded during the Battle of the Aisne and it was Clissold who volunteered to go and fetch him. Clissold successfully brought Lieutenant Stewart back to the British trenches but was killed during this brave act. Stewart gave Clissold's parents some money that was used to purchase a memorial to Wallace at Bussage Church Yard.

Private Wallace Clissold with his comrades of the 2nd Grenadier Guards, in barracks. We think he is second from right. (Courtesy Martin Clissold)

PRIVATE SYDNEY SMITH 12331
2ND BATTALION GRENADIER GUARDS

Sydney Joseph Smith was born in 1888 at Newport, Monmouthshire. He served with the Grenadier Guards from 1 September 1905. When war broke out he went to France with the 2nd Battalion and saw action during the retreat from Mons, the Marne and on the Aisne. Private Sydney Smith was killed in action on 7 November 1914. He has no known grave and his name is listed on the Ypres (Menin Gate) Memorial. Captain Alwyn Gosselin DSO wrote in a letter of condolence to his parents: 'Your son was always cheerful under the

very trying conditions of the campaign, and he is a great loss to his comrades.'[10]

Private Sidney Smith, 2nd Grenadier Guards. (*De Ruvigny's Roll of Honour, 1914–1918*)

LANCE SERGEANT FRANK HOLDING 9025
1ST BATTALION COLDSTREAM GUARDS

Frank Holding was born in St Edmonds, Exeter in 1891. On completion of his education in Exeter he enlisted on 7 March 1911. He married Ethel on 3 August 1914 in Dumbleton, near Evesham. On 7 August 1914, three days after the outbreak of war, Holding was promoted to Lance Sergeant. According to De Ruvigny's Roll of Honour, Holding took part in the fight for Cour de Soupir Farm with No.4 Company, 1st Coldstream Guards, on 14 September 1914 and was reported wounded and missing after this battle. The 1st Battalion advanced farther east at Cerny, so it is difficult to explain why a guardsman from the 1st Battalion was at Cour de Soupir on that day. A likely explanation is administrative error; he may have served with the 1st Battalion before the war, but at the Battle of the Aisne he may have been serving with either the 2nd or 3rd Battalion Coldstream Guards. He has no known grave and his name is commemorated on the memorial at La Ferté-Sous-Jouarre.

Lance Sergeant Frank Holding. (*De Ruvigny's Roll of Honour, 1914–1918*)

LANCE CORPORAL OLIVER MUDDIMAN 4868
1ST BATTALION COLDSTREAM GUARDS

Although the 1st Coldstream Guards did not fight in the Battle for Cour de Soupir Farm, Lance Corporal Muddiman was reported missing after taking part in the fighting there. He may have been detached from his battalion and joined the 2nd and 3rd Coldstream Guards in their fight for the position. Oliver Muddiman was born in 1883 in Winchester. He attended the Winchester Council School and on completing his education enlisted on 22 October 1902 to join the Coldstream Guards. On

9 August 1914 he was promoted to Lance Corporal and went with the battalion to France on 21 August. According to De Ruvigny's Roll of Honour, he took part in the fight for Cour de Soupir Farm on 14 September. As with Frank Holding above, his fighting at the farm is understandable if there was an administrative error. His widow May was left to raise two sons, Oliver aged 6 and Eric aged 8 months. Lance Corporal Oliver Muddiman has no known grave and his name is commemorated on the memorial at La Ferté-sous-Jourre.

Lance Corporal Oliver Muddiman. (*De Ruvigny's Roll of Honour, 1914–1918*)

CAPTAIN ARTHUR LEIGH-BENNETT MC DSO
2ND BATTALION COLDSTREAM GUARDS

Arthur Leigh-Bennett was born in 1885 at Thorpe Place. He was educated at Winchester and the Royal Military College at Sandhurst. He was gazetted to serve with the Coldstream Guards on 28 January 1905. He was promoted to Lieutenant on 22 January 1907. When war broke out he went to France with the 2nd Battalion Coldstream Guards. He was awarded the Military Cross for the role he played during the Battle of the Aisne. He was wounded in November 1914 and promoted to Captain during that month. He was awarded the Distinguished Service Order for 'conspicuous gallantry' at Cuinchy on 1 February 1915. His citation reported him 'leading his men with great ability against the enemy, he stopped their advance, and eventually captured their position.'[11] During the morning of 3 October 1915 he was killed while inspecting trenches with his battalion commander. He was buried at Vermelles British Cemetery.

Captain Arthur Leigh-Bennett MC DSO, 2nd Coldstream Guards. (*De Ruvigny's Roll of Honour, 1914–1918*)

LIEUTENANT NIGEL LEGGE-BOURKE
2ND BATTALION COLDSTREAM GUARDS

Nigel Legge-Bourke was born in Grosvenor Square, London, in 1889. He was educated at Eton from September 1902 until December 1907 and then

Lieutenant Nigel
Legge-Bourke, 2nd
Coldstream Guards.
(*Bonds of Sacrifice*)

Sergeant Arthur Lane,
2nd Coldstream Guards.
(Courtesy Arthur & Brian
Lane)

proceeded to the Royal Military College at Sandhurst. He was commissioned into the Coldstream Guards in February 1909. When war broke out he was sent to France on 12 August with the 2nd Battalion. He distinguished himself throughout the engagements of August and September 1914, including the battle for Cour de Soupir Farm. He was recommended 'for his very excellent work and exceptionally good leading of his platoon on all occasions up to the Battle of the Aisne'.[12] Legge-Bourke was killed in action at Rental Wood near Ypres on 30 October 1914. He has no known grave and his name is commemorated on the Ypres (Menin Gate) Memorial.

2ND LIEUTENANT RICHARD LOCKWOOD
2ND BATTALION COLDSTREAM GUARDS
Richard Lockwood was born in London in 1891. Educated at Eton he joined the 2nd Coldstream Guards on probation during 1910. He was gazetted 2nd Lieutenant on 1 February 1913. 2nd Lieutenant Richard Lockwood was killed on 14 September 1914 after carrying his wounded captain out of danger at Soupir. He was buried at Soupir Communal Cemetery. His epitaph reads:

IN LOVING MEMORY
ENTER MY REST
YOUR CROWN OF LIFE
IS WON

2nd Lieutenant Richard
Lockwood, 2nd Coldstream
Guards. (*Bonds of Sacrifice*)

SERGEANT ARTHUR LANE 7291
2ND BATTALION COLDSTREAM GUARDS
Arthur Lane was born in Birmingham in 1887. He joined the army and served for three years with the colours and five with the reserves. He had joined the City of London Police in 1914 and when war broke out in August he posted mobilisation notices on London Bridge before answering the call to rejoin the 2nd Coldstream Guards

as a Sergeant. He fought in the Battle of the Aisne and towards the end of 1914 he was admitted to hospital suffering from enteric fever and rheumatism. In 1915 Lane was transferred to the 2nd Welsh Regiment where he was commissioned with the rank of 2nd Lieutenant. He was awarded the Military Cross. He continued to serve with the Army after the First World War. He went to China and later served as Adjutant of the 5th Welsh Regiment. During the Second World War he was a recruitment officer based in Manchester. He had attained the rank of Lieutenant-Colonel by the time he retired from the Army in 1948. Arthur Lane died in 1956.

Lieutenant-Colonel Arthur Lane serving as Chief Recruiting Officer in Manchester during the Second World War. (Courtesy Arthur and Brian Lane)

SERGEANT THOMAS MCMULLAN 7360
2ND BATTALION COLDSTREAM GUARDS
Thomas McMullan was born in Sunderland in 1889. He was educated at St Joseph's School in Sunderland and later at Albert Road School in Darlington. He worked as a shipyard labourer prior to enlisting on 28 July 1908. Within five years of service he had reached the rank of Sergeant. He took part in the Battle of Mons, the Marne and the Aisne. He was killed in action on 1 February 1915 at Cuinchy. He has no known grave and his name is commemorated on the Le Touret Memorial. He was mentioned in Field Marshal French's dispatch of 31 May 1915.

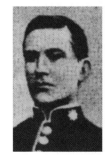

Sergeant Thomas
McMullen, 2nd Coldstream
Guards. (*De Ruvigny's Roll
of Honour, 1914–1918*)

LANCE CORPORAL JOHN IVINS 7794
2ND BATTALION COLDSTREAM GUARDS

John Ivins was born in Yardley, Birmingham, in 1892. He attended the Yardley School and St John's Sparkhill, Birmingham. On completing his education he enlisted on 13 April 1908. Ivins went to France in August 1914 and took part in the retreat from Mons, the Battles of the Marne and Aisne. Known as Jack to his comrades, he received his Lance Corporal stripe at the front. He served on the Ypres sector and he was killed in action on 29 December 1914 in action at Eppinette. His sergeant wrote: 'We were being relieved when Jack, who was getting out of the trench, was hit in the head by a stray bullet, and before we got to him he was dead.'[13] Ivins was buried in Le Touret Military Cemetery, Richebourg-L'Avoué.

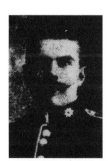

Lance Corporal John Ivins, 2nd Coldstream Guards. (*De Ruvigny's Roll of Honour, 1914–1918*)

LANCE CORPORAL FREDERICK JUDGE 8439
2ND BATTALION COLDSTREAM GUARDS

Frederick David Judge was born in 1888 in Sarratt, Hertfordshire. He worked as a printer, then enlisted on 12 August 1909 and served three years in the army. He resumed his trade as a printer until he was mobilised in August 1914. He was assigned to the 2nd Coldstream Guards and took part in the retreat from Mons, the Battle of the Marne and the Battle of the Aisne. He was killed during a bayonet charge at Cuinchy, near La Bassée, on 1 February 1915. Frederick Judge was buried at Cuinchy Communal Cemetery.

Lance Corporal Frederick Judge, 2nd Coldstream Guards. (*De Ruvigny's Roll of Honour, 1914–1918*)

PRIVATE ERNEST BUCKLAND 8895
2ND BATTALION COLDSTREAM GUARDS

Ernest Albert Buckland was born in East Grinstead, Sussex, in 1893. Ernest followed his older brother William into the British Army. He attested on 24 October 1910 and joined the 2nd Coldstream Guards on 28 October 1910 at Caterham. When war broke out he left for France with the battalion on 11 August 1914. Private Ernest Buckland participated in the retreat from Mons, the Battle of the Marne and during the Battle of the Aisne fought in the action at Cour de Soupir Farm. His elder brother William was killed on 16 September 1914 while serving with the 1st Coldstream Guards in the action at Troyon. Ernest would see further action at the First Battle of the Aisne through October 1914. For the remainder of the war he served with the 4th Guards Brigade Headquarters. Ernest married Alice Slater at St Anne's Church, Lambeth, on 16 September 1915 while on leave. The marriage took place on the first anniversary of William's death. The sad expressions on the faces of the bride and groom and their guests in this wedding photograph perhaps show they were thinking of William. Ernest would continue to serve in France throughout the First World War until 26 February 1919. He was one of the few Old Comtemptibles who served through and survived the war.

The marriage of Private Ernest Buckland and Alice Slater at St Anne's Church, Lambeth, on 16 September 1915. The wedding took place on the first anniversary of his elder brother William's death. (Courtesy Dick Monk)

LANCE CORPORAL ROBERT COLES 7043
2ND BATTALION COLDSTREAM GUARDS

Robert Coles was born in Crediton, Devon, in 1887. He had served with the Coldstream Guards since 1907. Coles was renowned as a crack shot with a rifle and won numerous competitions at Bisley. He was killed during the Battle of the Aisne on 14 September and was initially buried at Soupir Cemetery. After the war his remains were moved for reburial at Vailly British Cemetery.

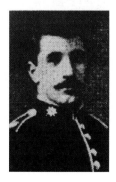

Private Robert Coles, 2nd Coldstream Guards. (*De Ruvigny's Roll of Honour, 1914–1918*)

PRIVATE JAMES HAYMAN 7574
2ND BATTALION COLDSTREAM GUARDS

James George Hayman was born in Longford, Oxfordshire, in 1889. On completing his education at the Tunbridge Wells National School he enlisted on 16 December 1907. He served for three years, then transferred onto the reserve list. He worked as a gardener before being mobilised on 5 August 1914. He served with the 2nd Coldstream Guards during the retreat from Mons, at

Landrecies, the Marne, the Battle of the Aisne and at Ypres. He was sitting in a trench at the Rue du Bois, near Fleurbaix, talking to a pal, when he was killed by a shell on 20 May 1915.

Private James Hayman, 2nd Coldstream Guards. (De Ruvigny's Roll of Honour, 1914–1918)

PRIVATE LEONARD HENSON 7290
2ND BATTALION COLDSTREAM GUARDS

Leonard Henson was born in Loughborough in 1890. After completing his education at the Emmanuel Boys' School in Loughborough he enlisted on 11 June 1907. He served for seven years and in 1914 he joined the Leicestershire Constabulary. He was stationed at New Swannington when he was mobilised as a reservist. He took part in the Battle of the Aisne and was wounded by shell fire on 23 September 1914. He was evacuated and that night was taken to Claridge's Hotel in Paris. Two days later he died from his wounds. The doctor tending to Private Leonard Henson wrote: 'a very brave patient, he passed away quietly at half past four on Friday 25th.'[14]

He was buried at the City of Paris Cemetery, Pantin. He was given a military funeral with full honours. A company of French soldiers accompanied his cortege and fired a volley of shots over his coffin.

Private Leonard Henson, 2nd Coldstream Guards. (De Ruvigny's Roll of Honour, 1914–1918)

PRIVATE ARTHUR NICHOLLS 8777
2ND BATTALION COLDSTREAM GUARDS

Arthur Henry Nicholls was born in 1895 in Birmingham. He attended Highfield Road School and after completing his education enlisted on 30 June 1910. He served for three years and then worked as a carman for Great Western Railways. He was mobilised as a reservist

on 5 August 1914 and went to France with the 2nd Coldstream Guards. He was involved in the retreat from Mons; the Battle of the Marne and of the Aisne. He was wounded at La Bassée on 31 January 1915 and died on that same day. He was buried at Bethune Town Cemetery. He left a widow, Helen, with an eight-month-old daughter, Phyllis.

Private Arthur Nicholls, 2nd Coldstream Guards. (De Ruvigny's Roll of Honour, 1914–1918)

PRIVATE HARRY LANCASTER 9753
2ND BATTALION COLDSTREAM GUARDS

Harry Lancaster was born in 1893 in Clayton, Manchester. He was mortally wounded at Cour de Soupir Farm. He fell behind enemy lines and despite being badly wounded he remained silent to ensure that he did not attract the attention of enemy soldiers to himself or his comrades. He lay in agony for six hours until stretcher bearers from the RAMC evacuated him. Private Lancaster was taken to hospital in Versailles but died from his wounds on 17th September 1914. He was buried at Les Gonards Cemetery, Versailles. In this book, we honour Private Lancaster as our own Unknown Soldier, in one sense; there is no picture of Harry, not even one as poor as some of those reproduced here, not a visual trace of his 21-year-old life.

PRIVATE ALFRED WOOTTEN 6995
2ND BATTALION COLDSTREAM GUARDS

Alfred Wootten was born in Somersham, Cambridgeshire, in 1885. He enlisted in Lincoln on 23 October 1906. After serving seven years he was transferred to the reserve on 23 October 1913. He was mobilised as a reservist on 6 August 1914 and was sent to France with the 2nd Coldstream Guards. He was wounded at Troyon on 29 September. Private Wootten was taken to No.4 Casualty Clearing Station at Braine where he died on 1 October 1914. He was buried at Braine Communal Cemetery. Brigadier-General H.W. Studd, Coldstream Guards, paid this tribute to Private Wootten. 'No more

faithful true and gallant soldier gave his life for his country. He did his duty as a guardsman and died a Coldstreamer.'[15]

Private Alfred Wootten, 2nd Coldstream Guards. (De Ruvigny's Roll of Honour, 1914–1918)

DRUMMER CHARLES WATKINS 8495

2ND BATTALION COLDSTREAM GUARDS

Charles Henry Watkins was born in 1893 in Caterham, Surrey. He was educated in Winslow and Aylesbury. Watkins enlisted in the Coldstream Guards in December 1910. He went to France with the BEF on 15 August 1914. He was present at the Battle of the Aisne in September. During the Battle of Ypres he was shot in the head by a German sniper and killed while crossing from one trench into another on 10 November 1914. He lies in Sanctuary Wood Cemetery.

Drummer Charles Watkins, 2nd Coldstream Guards. (De Ruvigny's Roll of Honour, 1914–1918)

CAPTAIN CHARLES BANBURY

3RD BATTALION COLDSTREAM GUARDS

Charles William Banbury was born in London in 1877. He was the son of Frederick Banbury MP. Banbury was educated at Eton and University College, Oxford. He was a keen rower and he rowed in the Eton Eight in 1891 and in the University College boat in 1896. After Oxford he attended the Royal Military College at Sandhurst and joined the Grenadier Guards in August 1899. Banbury served during the Boer War taking part in operations in Cape Colony and in the Transvaal and the Orange River towards the end of 1900. He received the Queen's medal with three clasps and the King's medal with two clasps for his role in the South African campaign. While in South Africa he was promoted to Lieutenant in 1901. He was promoted to Captain in 1909 and during that year he was appointed ADC to the General Commanding in Chief, Eastern Command and in 1912 he was appointed ADC to Lieutenant General Sir James Grierson. Banbury held this position when war broke out and was with Grierson when he died suddenly in France in August 1914. Banbury accompanied Grierson's body to Britain and attended the military funeral in Glasgow. Banbury returned to France on 23 August where he joined the 3rd Grenadier Guards. Within weeks of arriving in France he was wounded twice. He received his second wound at the battle for Cour de Soupir Farm when he was

Captain Charles Banbury, 3rd Coldstream Guards. (Bonds of Sacrifice)

in command of the 2nd Company. Banbury died on 16 September 1914. Known as 'Cakes' by his fellow officers, the 36-year-old Charles Banbury was buried in Soupir Communal Cemetery. His epitaph reads: 'Their name liveth forever more'.

He left a widow Josephine and a daughter Mary, who was 6 months old. Josephine gave birth to their son Charles on 18 May 1915.

LIEUTENANT DAVID BINGHAM

3RD BATTALION COLDSTREAM GUARDS

David Cecil Bingham was born in 1887. He was educated at Eton and the Royal Military College at Sandhurst. He received a commission with the Coldstream Guards in August 1906 and was promoted to Lieutenant during the following year. After being promoted to Captain in July 1911 he was appointed Adjutant of the 3rd Battalion. Bingham was killed during the battle for Cour de Soupir Farm on 14 September 1914. He has no known grave and his name is commemorated on the La-Ferté-Sous-Jouarre Memorial to the missing.

Lieutenant David Bingham, 3rd Coldstream Guards. (Bonds of Sacrifice)

LIEUTENANT PERCY WYNDHAM

3RD BATTALION COLDSTREAM GUARDS

Percy Lyulph Wyndham was born at Saighton Grange, Chester in 1887. He was the son of the Right Honourable George Wyndham MP, who held the appointment of Chief Secretary to the Lord Lieutenant of Ireland. Wyndham joined the Coldstream Guards in February 1909. He was killed at Cour de Soupir Farm on 14 September 1914. He has no known grave and his name is commemorated on the La-Ferté-Sous-Jourre Memorial to the missing.

Lieutenant Percy Wyndham, 3rd Coldstream Guards. (Bonds of Sacrifice)

SERGEANT ARTHUR BURCHETT 7882

3RD BATTALION COLDSTREAM GUARDS

Arthur Burchett was born in 1890. His father William was a labourer and his mother Eliza was a farmer's daughter from Elstead, Godalming, Surrey. After

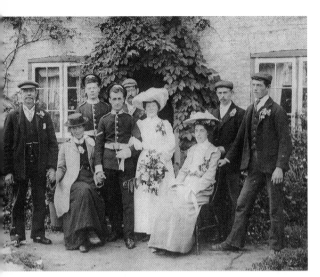

Sergeant Arthur Burchett, 3rd Coldstream Guards (Courtesy Denise Jackson and Keith Burchett)

completing his education in the National School there he enlisted to serve in the British Army on 10 June 1908. He served in Egypt 1909–11 and after leaving the army Burchett returned to Elstead where he became a postman. He was on the reserve list so when the war began in 1914 he was recalled to serve with the 3rd Coldstream Guards. He was killed during the Battle of the Aisne in the fight for Cour de Soupir Farm on 14 September 1914. Sergeant Arthur Burchett was initially buried at Soupir. His remains were transferred to Vailly British Cemetery after the war.

His brother Colin served with the 17th Middlesex Regiment and was killed on the Bapaume sector on 11 December 1917. Arthur's elder brother Edwin was aged 40 when he was killed on 1 November 1918 while serving with the 1st/4th Wiltshire Regiment in Israel. Another brother Thomas was reported missing on 30 August 1914, but was discovered to have been held as a prisoner of war in Germany in 1916.

The photograph shows the wedding of Sergeant Arthur Burchett, taken during the period 1908 to 1911. He is wearing a Lance Corporal's stripe.

SERGEANT ALFRED LANCHBURY 5402
3RD BATTALION COLDSTREAM GUARDS
Alfred Lanchbury was born in Coventry in 1883. He was educated at Foxford Council School and enlisted on 19 February 1904. By the time that war broke out he was a Sergeant. He went to France with the 3rd Coldstream Guards and took part in the Battle of the Aisne. He was killed at Vermelles, during the Battle of Loos, on 27

September 1915. Lanchbury has no known grave and his name is commemorated on the Loos Memorial. His widow was left to raise three young daughters.

Sergeant Alfred Lanchbury, 3rd Coldstream Guards. (*De Ruvigny's Roll of Honour, 1914–1918*)

LANCE SERGEANT FRANK YARDE 3197
3RD BATTALION COLDSTREAM GUARDS
Frank Yarde was born in Staple Hill, Buckland St Mary, Somerset, in 1880. He enlisted on 8 June 1900 and served during the Boer War and was awarded the Queen's Medal with three clasps. When the war began he went to France with the 3rd Coldstream Guards. He participated in all actions in which the battalion was engaged including the Battle of the Aisne. He was killed on 28 September 1915 at Vermelles during the Battle of Loos. He was buried at the bottom of Hill 70 close to the village of Hulluch. His grave was lost and his name is commemorated on the Loos Memorial.

Lance Sergeant Frank Yarde, 3rd Coldstream Guards. (*De Ruvigny's Roll of Honour, 1914–1918*)

PRIVATE JOSEPH BILTON 6030
3RD BATTALION COLDSTREAM GUARDS
Joseph Bilton was born in Hull in 1887. He joined the army in 1903 and served for eleven years. He became the Labour Master at York Workhouse and worked there until he was called up to serve with the 1st Coldstream Guards. He took part in the Battle of the Aisne and was killed in action at Soupir on 16 September 1914. Private Joseph Bilton was buried at Vailly British Cemetery.

Private Joseph Bilton, 3rd Coldstream Guards. (*De Ruvigny's Roll of Honour, 1914–1918*)

PRIVATE HARRY DUNCOMBE 6570
3RD BATTALION COLDSTREAM GUARDS

Harry Duncombe was born in Lincoln in 1887. During the period 1906 to 1910 Harry served with the 3rd Battalion Coldstream Guards and was deployed to Egypt and Khartoum, in Sudan. He left the army in 1910 and married Florence during that year. He found employment as an asylum attendant. Harry was placed on the reserve list when he left the army, so when war broke out in 1914 he was recalled to serve with his old battalion. He took part in the Battle of the Aisne and in the bitter struggle for Cour de Soupir Farm on 14 September 1914. Harry, who was 27, was killed in action on 15 September. He was initially buried in the Guards Cemetery east of Cour de Soupir Farm but his remains were transferred to Vailly British Cemetery after the war.

Private Harry Duncombe, 3rd Coldstream Guards. (Cynthia Bone and Derek Duncombe)

PRIVATE JAMES FORTUNE 6844
3RD BATTALION COLDSTREAM GUARDS

James Fortune was born in 1887 in Foxham. Fortune served for several years with the British Army, then lived in Farnborough where he worked for the Gospel Mission and as a committed Sunday School Teacher. He was mobilised when the war broke out in August 1914 and fought with the 3rd Coldstream Guards during the retreat from Mons, the Battle of the Marne and the Aisne. He was killed while on sentry duty at Rentel on 27 October 1914. He has no known grave and his name is commemorated on the Ypres (Menin Gate) Memorial.

Private James Fortune, 3rd Coldstream Guards. (De Ruvigny's Roll of Honour, 1914–1918)

PRIVATE JOHN KENNEL 6802
3RD BATTALION COLDSTREAM GUARDS

John Henry Kennel was born in 1888 in Ripley, Derbyshire. He enlisted on 12 June 1906. He fought at Cour de Soupir Farm on 14 September 1914 where he was killed. He has no known grave and his name is commemorated on the memorial at La Ferté-Sous-Jouarre.

Private John Kennel, 3rd Coldstream Guards. (De Ruvigny's Roll of Honour, 1914–1918)

PRIVATE THOMAS LEIGH 5624
3RD BATTALION COLDSTREAM GUARDS

Thomas Horatio Alfred Leigh was born in Armitage, Stafford, in 1886. He was educated at the Elementary School in Armitage and enlisted on 21 July 1904. Leigh served with the Camel Corps in Egypt from 16 January 1908 until 23 March 1911. He was involved in an operation along the River Nile to suppress a native uprising. He left the army on 20 July 1912 and was transferred to the reserve list. He was mobilised on 5 August 1914 and went to France with the 1st Coldstream Guards. He was killed during the fighting at Cour de Soupir Farm. Leigh was buried at Vailly British Cemetery.

Private Thomas Leigh, 3rd Coldstream Guards. (De Ruvigny's Roll of Honour, 1914–1918)

PRIVATE JOHN LYON 4011
3RD BATTALION COLDSTREAM GUARDS

John Adams Lyon was born in Chorley, Lancashire, in 1881. He enlisted on 22 January 1901. He served with the 3rd Coldstream Guards in France and Flanders from 26 August 1914 until 8 October 1915. He took part in the Battle of the Aisne during September 1914 and was wounded at the Battle of Loos in September 1915. He was evacuated to No.5 General Hospital, Rouen, where he died from his wounds on 16 October 1915. He was buried at St Sever Cemetery, Rouen.

Private John Lyon, 3rd Coldstream Guards. (De Ruvigny's Roll of Honour, 1914–1918)

PRIVATE JOSEPH MORAN 7776
3RD BATTALION COLDSTREAM GUARDS

Joseph Moran was born at Sharleston, near Wakefield in Yorkshire. He was educated at the local Colliery School. He enlisted in 1908 and took part in the retreat from Mons and the Battle of the Marne. He took part in the Battle of the Aisne and was wounded on 17 September 1914 at Cour de Soupir. He died on 24 September at a hospital in Versailles.

Private Joseph Moran, 3rd Coldstream Guards. (*De Ruvigny's Roll of Honour, 1914–1918*)

PRIVATE REGINALD SHEPPARD 6124
3RD BATTALION COLDSTREAM GUARDS

Reginald Sheppard was born in Salisbury, Wiltshire, in 1886. He enlisted in the Coldstream Guards on 27 February 1905 and served for three years. He rejoined the 3rd Battalion Coldstream Guards at the outbreak of war and was involved with the retreat from Mons, the Battle of the Marne and the Battle of the Aisne. He was killed in action at Zillebeke on 20 November 1914. He has no known grave and his name is commemorated on the Ypres (Menin Gate) Memorial.

Private Reginald Sheppard, 3rd Coldstream Guards. (*De Ruvigny's Roll of Honour, 1914–1918*)

CAPTAIN LORD ARTHUR HAY
1ST BATTALION IRISH GUARDS

Lord Arthur Vincent Hay was born in 1886. He was the second son of the 10th Marquess of Tweedale. Educated at Eton and the Royal Military College at Sandhurst he joined the Cameron Highlanders as a 2nd Lieutenant in June 1905. Six months later he transferred

Captain Lord Arthur Hay, 1st Irish Guards. (*Bonds of Sacrifice*).

to the Irish Guards. He retired from the regiment with the rank of Captain, but at the outbreak of war he rejoined them on 15 August 1914. He was serving with the 1st Irish Guards as Acting Quartermaster when he was killed by a German sniper hidden in a tree close to Soupir Farm during the Battle of the Aisne on 14 September. He was buried at Soupir Communal Cemetery. His epitaph reads:

> IN SUCH A DEATH THERE IS NO STING
> IN SUCH A GRAVE EVERLASTING
> VICTORY. MOTHER

CAPTAIN LORD HEANAGE GUERNSEY
1ST BATTALION IRISH GUARDS

Lord Heanage Greville Guernsey was born the eldest son of the Earl of Aylesford in 1883 in London. He went to Eton in 1893 and on completing his schooling to the Royal Military College at Sandhurst. After passing out he joined the 3rd Battalion Wiltshire Regiment in August 1901. He served in the Boer War and received the South African medal. He briefly served with the 7th Hussars before transferring to the Irish Guards in June 1902. In 1905 he served as Aide-de-Comp to the Governor of Gibraltar. He later served in the Warwickshire Yeomanry and on 17 August he was promoted to Captain. He left the Army on 14 April 1914 and was put on the reserve list. Within months war had broken out and he was recalled to serve with the 1st Irish Guards. Captain Lord Guernsey was killed by a sniper while in action at Cour de Soupir Farm. The same sniper also killed Lieutenant Hay. Lord Guernsey was buried next to Lord Hay at Soupir Communal Cemetery. On the headstone of Lord Guernsey is the epitaph:

Captain Lord Guernsey, 1st Irish Guards. (*Bonds of Sacrifice*)

The graves of Lord Hay and Lord Guernsey at Soupir Communal Cemetery. (Author)

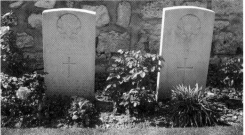

WE KNOW THAT HE WENT
AS HIS SOUL BADE HIM TO GO.
WE KNOW THAT HE DIED
AS HE CHOSE TO DIE
ON THE SOIL OF FRANCE
AND IN SIGHT OF THE FOE.
GLORY POINTS WHERE
BUT GOD WHISPERS WHY?

CAPTAIN HAMILTON BERNERS

1ST BATTALION IRISH GUARDS

Hamilton Hugh Berners was born at Longcross, Surrey in 1881. Educated at Eton he went on to serve with the Irish Guards from November 1905. By December 1912 he had reached the rank of Captain. When the 1st Irish Guards sustained heavy casualties after the action at Villers Cotteret on 1 September 1914, Berners was appointed second in command of the battalion. Captain Berners was well respected by the men that he commanded. An anonymous corporal wrote:

> Captain Berners, of the Irish Guards, as at the depot, was the life and soul of our lot. When shells were bursting over our heads he would back us up with his humour about Brock's displays at the Palace [Brock's fireworks]. But when we got into close quarters it was he who was in the thick of of it, and didn't he fight! He was one of the best officers, and there is not a Tommy who would not have gone under for him.[16]

During the action at Soupir on 14 September he went to the aid of one of his men who had fallen badly wounded by a shell explosion. Under heavy German fire he reached the wounded man and carried him to a place of safety. Five minutes later as he raised his field glasses to try and ascertain where the enemy fire was coming from he sustained fatal wounds through his chest and body. According to Gerald Madden he was killed by the sniper perched in a tree that killed Lord Hay and Lord Guernsey. Within minutes he died. Berner was buried at Soupir Communal Cemetery. His epitaph reads:

PROFICISCERE
ANIMA CHRISTIANA
DE HOC MUNDO

'Go upon your journey, Christian soul, from this world.'

Captain Hamilton Berners, 1st Irish Guards. (*Bonds of Sacrifice*)

LIEUTENANT THE HONOURABLE HAROLD ALEXANDER MC DSO

1ST BATTALION IRISH GUARDS

The Honourable Harold Alexander was born in London in 1891. He was the third son of the Earl of Caledon. He was educated at Harrow and entered the Royal Military College at Sandhurst in 1910. By the time that war broke out, Alexander was a Lieutenant serving with the 1st Irish Guards. He took part in the Battle of the Aisne at Cour de Soupir Farm. He continued to serve throughout the First World War and was wounded twice. Alexander was promoted to Captain in February 1915 and Major in 1917. For three months during 1917 he served as Acting Lieutenant-Colonel and commanded a battalion during the last year of the war. He was decorated with the Military Cross in January 1916 and the Distinguished Service Order in October 1916 for leading an attack during the Somme campaign. During the opening months of the Second World War Alexander commanded the 1st Infantry Division in France and supervised their withdrawal from Dunkirk in May 1940. While he was organising the evacuation from the Dunkirk beaches, Alexander was appointed commander of I Corps and was amongst the last to leave the beaches on 3 June 1940. He was promoted to Lieutenant General in the following month and on 1 January 1942 he was knighted. On 8 August 1942 he was appointed Commander-in-Chief, Middle East Command. He was responsible for overseeing the campaign against Rommel's Africa Corps in the deserts of North Africa. General Bernard Montgomery, Commander of the Eighth Army (another veteran of the Battle of the Aisne in 1914) was one of his subordinates. He presided over the defeat of Rommel in the desert and would command the 15th Army Group in Italy during 1943. Although he was the first choice of Eisenhower to command the land forces for the D-Day Landings on 6 June 1944 and was popular with both American and British generals, he was kept in Italy for the duration. In March 1952 he was elevated to a peerage as Earl Alexander of Tunis. He died in hospital on 16 June 1969 in Slough. After a funeral service conducted at St George's Chapel, Windsor, he was buried in the churchyard at Ridge, Hertfordshire near his home.

Lieutenant the Honourable Harold Alexander, 1st Irish Guards. (*The War Illustrated*, 12 December 1914)

NOTES

1. De Ruvigny, Marquis, *De Ruvigny's Roll of Honour, 1914–1918* (1922, republished by Naval & Military Press, 2007)
2. Clutterbuck, L.A., *Bonds of Sacrifice: August to December 1914* (1915, republished by Naval & Military Press, 2002)
3. Ibid
4. *Northampton Independent*, 26 September 1914
5. Clutterbuck
6. Sergeant W. Baker's Letter, courtesy Sir Bruno Welby
7. Major George Jeffreys Diary, Grenadier Guards Regimental Headquarters Archives
8. Ibid
9. Commonwealth War Graves Commission website
10. De Ruvigny
11. *London Gazette* 29095, 15 March 1915
12. Clutterbuck
13. De Ruvigny
14. Ibid
15. Ibid
16. Clutterbuck

THE BATTLE FOR ROUGE MAISON FARM, JOUY SPUR AND LA FOSSE MARGUET

During the morning of 14 September there existed a significant breach in the line of two miles between the left flank of I Corps in the eastern sector of the BEF front and the right flank of the II Corps in the west. The 3rd Division had already established positions north of the Aisne and was ordered to continue the advance. On the 9th Infantry Brigade front, the 1st Lincolnshire's and the 4th Royal Fusiliers at Rouge Maison Farm were attacked by German infantry, strongly supported by artillery and machine-gun fire, at 7.00am. Wave after wave of German infantry attacked the 1st Lincolnshire Regiment at Rouge Maison. During the fight Private Macnamara heard a German soldier shout from the ranks of a German company, 'Wait till we catch you in our barber's shop in London.' As the fusiliers wiped out this German company with the bayonet, a fusilier replied 'You won't get to London again.'[1]

It was foggy and wet. Mud had clogged the rifle mechanisms. B and D Companies launched a counter attack in conjunction with the 4th Royal Fusiliers. The 4th Royal Fusiliers were unaware due to the fog that German trenches were only 600 yards from their own position. Captain Arthur Byng's outpost was so close to the enemy lines that they could hear German being spoken. The Germans were unaware of their presence. X and Z Companies made an effort to extend their line on their left flank and Companies W and Y were ordered forward to support them. When W Company advanced to provide support to X Company they discovered through the fog that there was a German trench on their right flank, approximately 300 yards from their line of advance. German forces appearing from a wood were on their right flank and were causing difficulties. W Company immediately changed direction and turned right to launch a direct assault upon this German trench.

The 1st Northumberland Fusiliers were summoned and were brought up to hold the left flank in support of the 4th Royal Fusiliers. All three battalions then launched their own counter attack. After emerging from the cover of the woods they came under heavy fire. German forces attacked the 1st Northumberland Fusiliers forcing C Company to retire. A and B Companies holding the

woods were driven back on the left flank to a sunken road south of Rouge Maison. Captain Harry Toppin and Captain Richard Gatehouse were killed, 4 officers were wounded, 7 other ranks killed and 80 were wounded. Private P. Cunningham of the 1st Northumberland Fusiliers was amongst the wounded. He suffered an extraordinary twelve bullet wounds during this action and when he was brought to hospital in his home town of Ayr in Scotland he was covered in bandages. The *Ayr Advertiser* reported that when he was interviewed from his hospital bed 'only a few inches of his face could be seen, but despite a harrowing experience his eyes glittered merrily enough out of the mass of bandages.'[2] Cunningham recounted the circumstances on how he was wounded at Rouge Maison:

> We were in the valley of the Aisne, and in the thick of it. The German fire was coming down on us like mad, but I got five shots into me before I had to give up. The first one got me in the leg, but it wasn't bad; the second went through my mouth and out at the cheek; the third fractured my jaw, and the fourth I also got on the face. An inch one way or the other, and any of them would have finished me, but I managed to keep my gun going until the fifth and sixth shots, and as they got me in both arms that put me out of action. I had just to lie down and take what came. I got another six shots in various places in the legs, but none of them was deadly.[3]

The 1st Lincolnshire Regiment holding the line on the right flank adjacent to the 4th Royal Fusiliers advance was also being fired upon. German machine guns entrenched in Rouge Maison Farm cut down A and C Companies. Captain F.W. Greatwood commanding A Company was amongst the wounded. A message was sent to Brigade Headquarters requesting reinforcements. Two companies from the Royal Scots Fusiliers were dispatched. As they got close to Rouge Maison Farm they came under heavy fire and were forced to retire after suffering many casualties. A signal was sent to the 1st Lincolnshire Regiment ordering

A German machine-gun team is seen establishing a position in the roof of a cottage. (*The Great War, I Was There*)

them to retire systematically by platoons from the right flank. A German machine-gun position was rushed forward to establish a firing position within a wheat stack 50 yards away and shot at the 1st Lincolnshire's as they retired south towards Vailly and back across the Aisne to the south bank. Lieutenant-Colonel Smith and elements from the Royal Scots Fusiliers were waiting in a ravine close to Vailly. Due to heavy German artillery barrages upon the village, Vailly did not offer a viable defensive position so Smith decided to withdraw his battalion across the Aisne to a railway cutting.

The remnants of the battalion came under a heavy German artillery bombardment at the railway cutting. Lieutenant-Colonel Smith and his adjutant Lieutenant Hutchinson from the 2nd Royal Scots Fusiliers were hit. Despite their wounds they went back across the river to Vailly with the battalion three hours later. On reaching the north bank, they took shelter in a wood 200 yards away. During that night the German bombardment subsided and it was safe for the 1st Lincolnshire's to go into Vailly where they could sleep in billets. Captain Herbert Dawson (Commanding B Company) and Lieutenant Alexander Peddie were amongst the 8 officers killed on 14 September; 4 officers were wounded together with 180 casualties amongst the other ranks. Medical Officer Captain Kemp and one other officer were listed as wounded and missing.

The 4th Royal Fusiliers also faltered. The 1st Lincolnshire Regiment had already retreated on their right, which left their own flank exposed to enfilade German machine-gun and rifle fire. Captain Mowbray Cole and 2nd Lieutenant Frank Hobbs fell dead.

Captain Ashburner led the remnants of the 4th Royal Fusiliers in a retirement to a sunken road 200 yards south

of Rouge Maison Farm where the 1st Northumberland Fusiliers had withdrawn. The battalion consolidated and entrenched their position and came under heavy German shell fire. Two platoons from X Company were still in possession of Rouge Maison Farm and held on throughout that night. German infantry launched a further attack in strength upon their lines during the night and the battalion repelled them with rifle and bayonet. Captain Arthur Byng, Captain Mowbray Cole, Captain Algernon Attwood and 2nd Lieutenant Frank Hobbs were killed, Lieutenant Orred was wounded and 200 other ranks from the 4th Royal Fusiliers were either killed or wounded.

At dawn on 14 September the 8th Infantry Brigade comprising the 2nd Royal Scots (Lothian Regiment), 2nd Royal Irish Regiment, 4th Duke of Cambridge's Own (Middlesex Regiment) and the 1st Gordon Highlanders established positions on the Jouy spur. The 2nd Royal Scots came under heavy fire as they reached the crest of this ridge. The 4th Middlesex Regiment were brought up on their left flank while the 2nd Royal Irish Regiment was on their right flank to secure the line. The Brigade numbered only 1500 men and although the 40th Brigade Royal Field Artillery had crossed the river, they were unable to find a suitable position to set up their guns and provide support. German commanders launched a counter attack at 9.00am and within an hour they had forced these battalions to withdraw to a position south of the Jouy Spur.

As the 8th Infantry Brigade was engaged with the enemy on Jouy Spur that morning, the 7th Infantry Brigade was approaching the river Aisne from the south. The 7th Infantry Brigade, consisting of the 3rd Worcestershire Regiment, 2nd Prince of Wales Volunteers (South Lancashire Regiment), 1st Duke of Edinburgh's (Wiltshire Regiment) and the 2nd Royal Irish Rifles, was ordered to cross the Aisne and support the 8th Infantry Brigade. Corporal John Lucy recalled his emotions as the 2nd Royal Irish Rifles descended from the ridge at Chassemy into the Aisne valley towards the river:

> It was a fine fresh morning, and we moved on exhilarated by a feeling of the unexpected, down a wet leafy lane, until we came to an open space between the woods and the southern bank of the river, where we made our first deployment. We gripped our rifles hard. We felt on the edge of a fresh battlefield, with the curtain about to go up, and looked all about our front for the direction of the first threat of danger.[4]

The 2nd Royal Irish Rifles came under heavy shell fire from the north side of the river. They were exposed and they had no indication of what they were heading in to. Corporal John Lucy:

Our shells swished close overhead, on their way to the dominating heights on the far bank, and presently enemy shrapnel whipped and cracked above us. A curse or two expressed the nausea which every man with a stomach experiences when he feels helpless under a rain of slivers of steel and bullets hurled at him by an enemy two miles or so out of rifle shot.[5]

A torrent of German shell fire prevented the battalions from the 7th Infantry Brigade from crossing the Aisne at Vailly. Diverting east towards a railway bridge close to Ecluse they were able to cross the river across a single plank that breached the gap in the bridge. This diversion meant that 8th Infantry Brigade was not supported. Aggressive German artillery focused their attention upon the pontoon bridge at Vailly throughout that morning and destroyed it completely by 1.00pm.

As the 2nd Royal Irish Rifles headed eastwards in single file along the southern bank of the river towards Ecluse, German shells were exploding around them but they continued regardless of the danger to the railway bridge. Corporal John Lucy confirmed in his testimony that the bridge was destroyed.

As we approached the bridge we saw that it was completely wrecked; a tangled mass of ironwork, most of which was submerged, with a dead horse held against it by the current, and only a line of single planks was hastily and precariously rigged against what was left of the iron supports of the railway bridge. A nasty proposition.[6]

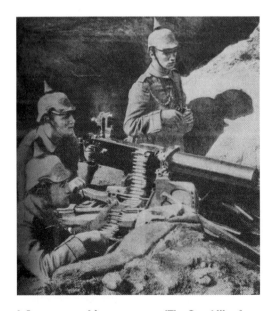

A German machine-gun crew. (*The Great War, I Was There*)

As they approached the railway bridge the 1st Lincolnshire Regiment were withdrawing from the north bank. Overwhelmed by German resistance they fell back to positions south of the river. Lieutenant-Colonel Wilkinson Dent Bird commanding the 2nd Irish Rifles liased with Lieutenant-Colonel W.E.B. Smith commanding the 1st Lincolnshire Regiment, who appraised him of the situation. Bird wrote:

As we were advancing the Lincolnshire regt. fell back over the river and the C.O. Lieutenant-Colonel Smith, who had been slightly wounded, told me he had been driven off the hills on the north bank and that the Royal Fusiliers who were with them had also retired.[7]

Bird was ordered to lead the 2nd Royal Irish Rifles across the Aisne at Vailly.

... the Royal Irish Rifles moved under cover along the railway embankment and then over a bridge made of a barge and planks, the railway bridge over the Aisne having been broken. The enemy shelled us during the movement. As the men had to move in single file this took some time.[8]

Bird stood courageously on the south bank as he oversaw the crossing. Corporal John Lucy carefully crossed over the makeshift bridge but many men fell into the river as they lost their balance. Fountains of water were propelled into the sky as shells hit the water:

A fresh English regiment crossed over as we drew nearer, and we 'blondinied' across it, section by section, close under the bursting shells. No casualties occurred near me but shouts of alarm from behind showed that the following company had caught it. We did not turn to see. We heard some of those hit had fallen into the river.[9]

The right flank of the 9th Infantry Brigade lines was vulnerable, since there was a breach in the line of 1.5 miles between their position and the line being held by the 2nd Division on the Chavonne Spur. The mist that descended during that morning had made it impossible to initiate supporting barrages. The only British units between the 2nd and 3rd Divisions were the 2nd Dragoons (Royal Scots Greys) and the 12th (Prince of Wales Royal) Lancers from the 5th Cavalry Brigade, which had exploited the cover of the mist and crossed the bridge at Vailly that morning. German forces lost the opportunity to separate I and II Corps and failed to advance towards Vailly. General Haig received reports that the 3rd Division advance had been repulsed at 2.00pm, which meant that the left flank of the 2nd Division was at risk.

The 1st Wiltshires and 1st Lincolnshires followed the 2nd Royal Irish Rifles. The 1st Wiltshire Regiment from the 7th Infantry Brigade had crossed the bridge at Vailly at 1.00pm and advanced towards St Precord Spur, where they entrenched on the right flank of the 9th Infantry Brigade. The 2nd Royal Irish Rifles joined them at 3.30pm. The line was secured. The 5th Cavalry Brigade was ordered south of the Aisne.

The 1st Wiltshires were ordered to occupy the ridge left of La Fosse Marqueil. The 2nd Royal Irish Rifles were deployed to the left of the Wiltshires. As soon as they reached the north bank they advanced uphill through the trees and undergrowth in attack formation. They came under German rifle and machine-gun fire. They were unable to see the enemy. German machine-gun crews and snipers had carefully concealed their positions. They were in command of the situation. Corporal John Lucy:

A shrapnel bullet penetrated my haversack and tore into the middle of a folded towel inside it. I felt startled and angry at the tug it gave and at my narrow escape and pushed on with the others. The Germans had seen us cross over, and were now firing salvoes at us. Our company commander was hit in the arm.

Two or three other officers of the following companies were also hit and a good many men were knocked out, but we did not miss them in the excitement. We went on steadily uphill, seeing nothing of the enemy. We had hardly cleared the shelled area near the bridge when bullets began whistling about us. We must have been within a couple of hundred yards of enemy riflemen, but though we looked hard through the undergrowth we could not see them. We cursed them, and relying on the luck of soldiers we bowed our heads a little, shut our jaws and went stubbornly on. Quicker we went, onto our toes and crouching lower. In for a penny, in for a pound, quicker and quicker to get over. Their rifles cracked sharply now, and the whistle and whine of bullets passing wide changed to the startling bangs of bullets just missing one. The near rattle of machine guns sent our hearts thumping.[10]

Corporal John Lucy and the survivors of the 2nd Royal Irish Rifles defied the German guns to reach the edge of a plateau where they were provided with some cover by a continuous chalk cliff. It was here that they became aware of the casualties that they had sustained. Lucy's company was the advance company and was ordered in reserve. They had sheltered in a cave which was being used as a dressing station.

During that afternoon the wounded were lying on the battlefield close to Rouge Maison. Private P. Cunningham of the 1st Northumberland Fusiliers, the man who had received 12 bullet wounds, was picked up by two soldiers from the 2nd Royal Irish Fusiliers who took him to a farm where three other wounded men were sheltering:

That night we heard someone prowling round the farm, and thinking they might be the enemy, the Irish Fusiliers hid in a large cupboard, where they would be able to make a good attack. We hadn't long to wait, and a small party of German infantry came in – on a looting expedition, likely. The men in the cupboard accounted for three, and the others yelled and ran. The farmer and his wife got scared, and they disappeared, and we didn't see them again till Wednesday. But we were to have a still worse experience, for on Tuesday morning the German shells began to get near us now and then, as the farm was in the line of fire for the British position. After a lot of painful shifting we all got into the cellar, and all that day we heard the rumble of falling stones as the shells hit the farm. Although we knew we were safer down below, we had the feeling that we would rather have been in the open. No one came near the house, and when the firing quietened

VAILLY-sur-AISNE - Route de Rouge Maison Lib. A. Berthe, Vailly Cliché II.

Route de Rouge Maison from Vailly. (Author)

down we came up again, but the farm was battered ... I suppose I've got my share of German lead, but I don't mind going back if I am needed.[11]

By 5.30pm on 14 September, the 3rd Division had consolidated their fragile bridgehead north of the Aisne. The 7th and 8th Infantry Brigades each lost approximately 150 men.

The 9th Infantry Brigade lost 700 men. The 1st Lincolnshire Regiment lost 2 officers and 4 men killed. Its commanding officer, Lieutenant-Colonel W.E.B. Smith, together with 3 officers and 102 men, were wounded. The medical officer, Captain G.A. Kempthorne, together with 2nd Lieutenant Wyatt and 72 men, were listed as missing.

The 1st Lincolnshire's, the 1st Northumberland Fusiliers and the 4th Royal Fusiliers were unable to consolidate and entrench their positions and were forced to withdraw to the edge of the spur. The 1st Royal Scots Fusiliers were brought forward from reserve to bolster the line. They took part in the battle for Rouge Maison. Captain George Briggs was killed, 2 officers wounded, 8 other ranks killed, 67 wounded and 90 missing.

With the line secured the 5th Cavalry Brigade and three batteries from XL Brigade Royal Field Artillery were withdrawn from the north bank. The 5th Cavalry Brigade crossed the pontoon bridge built by the 57th Field Company with strict discipline, a troop at a time. Most of the cavalry got to the southern bank but 40 men and 6 horses were wounded. The sappers were led by Captain Theodore Wright, VC. Wright was killed while assisting the cavalry to evacuate to the southern bank. XL Brigade could not get their guns across the pontoon at Vailly and had to travel east along the northern bank to the crossing at Pont Arcy.

NOTES

1. *The Scotsman*, 5 October 1914
2. *Ayr Advertiser*, 1 October 1914
3. Ibid
4. Hammerton, Sir John (ed) *The Great War, I Was There* (The Almalgamated Press, 1938)
5. Ibid
6. Ibid
7. WO 95/1415: 2nd Royal Irish Rifles War Diary
8. Ibid
9. Hammerton
10. Ibid
11. *Ayr Advertiser*, 1 October 1914

THEY FOUGHT AT ROUGE MAISON FARM AND LA FOSSE MARGUET

CAPTAIN ALGERNON ATTWOOD
4TH BATTALION ROYAL FUSILIERS

Algernon Foulkes Attwood was born in Wandsworth, London, in 1880. He was educated at Haileybury and Christ Church College, Oxford. He was gazetted as a 2nd Lieutenant in the 4th Royal Fusiliers as a university candidate on 4 May 1901. He had attained the rank of Captain by spring 1914. During this time he attended a course in aviation at Upavon and was recommended for an appointment to the Royal Flying Corps, but Attwood rejoined the 4th Royal Fusiliers when the battalion was mobilised for war. He took part in the Battle of Mons and in the retreat to the River Marne. On 14 September, Captain Attwood was hit twice in rapid succession by German fire and mortally wounded as he was withdrawing his men from an advanced position at Vailly. He has no known grave and his name is commemorated on the memorial at La Ferté-Sous-Jouarre.

Captain Algernon Attwood, 4th Royal Fusiliers. (De Ruvigny's Roll of Honour, 1914–1918)

CAPTAIN ARTHUR BYNG
4TH BATTALION ROYAL FUSILIERS

Arthur Byng was born in Southsea, Portsmouth in 1872. He was educated by an Army tutor in Caen. He joined the West Indian Regiment in 1895. In June 1900 he was promoted to Captain and during the following year he was transferred to the Royal Fusiliers.

Captain Arthur Byng, 4th Royal Fusiliers. (Bonds of Sacrifice)

He saw active service during the Boer War at Transvaal, Orange River Colony and Cape Colony. Byng was a keen cricketer and footballer and represented Hampshire on many occasions. He went to France with the 4th Royal Fusiliers in August 1914 and was at the Battle of Mons. He was killed at Vailly on 14 September while looking through his field binoculars. A fellow officer wrote: 'He has done very well with his company; no man could have done more … He was our great interpreter, being very good at French … He was always taking risks and leaving the trenches with a rifle to walk about in front.'[1] Byng has no known grave and his name is commemorated on the memorial at La Ferté-Sous-Jouarre.

2ND LIEUTENANT FRANK HOBBS
4TH BATTALION ROYAL FUSILIERS

Frank Matthew Hobbs was born in Tunbridge Wells in 1895. He attended Ardingly College where he became a member of the Officer Training Corps. He was gazetted to the 4th Royal Fusiliers as a 2nd Lieutenant on 11 December 1913. He took part in the Battle of Mons, the retreat from Mons, the Battle of the Marne and was killed during the Battle of the Aisne on 14 September at Vailly after sustaining shrapnel wounds to his head. He has no known grave and his name is commemorated on the memorial at La Ferté-sous-Jouarre.

2nd Lieutenant Frank Hobbs, 4th Royal Fusiliers. (De Ruvigny's Roll of Honour, 1914–1918)

LIEUTENANT FREDERICK RUSHTON MC
2ND BATTALION ROYAL IRISH REGIMENT

Frederick Hornby Lever Rushton was born in Gresford, Denbighshire, in 1888. He was educated at Charterhouse where he excelled at football and other

Lieutenant Frederick Rushton MC, 2nd Royal Irish Regiment. (*Bonds of Sacrifice*)

Corporal Christopher Whelan and his brother Thomas Whelan, 2nd Royal Irish Regiment. (Courtesy Paul Whelan)

sports. He initially served with the Liverpool Regiment from 1907. In December 1909 he received a commission to serve with the Royal Irish Regiment and two years later he was promoted to Lieutenant. Rushton when to France with the 2nd Royal Irish Regiment in August 1914. During the Battle of Mons Rushton distinguished himself when he saved the lives of his commanding officer, Lieutenant-Colonel Cox, and the Adjutant, Richard Philips, when he brought them out of the firing line to safety. Cox wrote to Rushton's sister: 'You have every reason to be very proud, very proud, of your brother. I was wounded in the leg, and could not get along ... so he and others carried me out of action under an extremely heavy fire.'[2]

Lieutenant Frederick Rushton led a party to knock out a machine gun causing considerable casualties amongst the 2nd Royal Irish Regiment close to Vailly. Rushton received a bullet through the shoulder. Despite being advised to stop and seek medical attention he chose to go forward with the assault. Rushton was subsequently killed in this action. A fellow officer wrote:

> He was absolutely splendid in the field, and in addition to other deeds of gallantry he undoubtedly saved Dick Philips' [the Adjutant] life at Mons. Rushton was killed in an advance action in which he had been previously wounded and dressed by Laing, who implored him not to advance any more, as he was wounded right through the shoulder; but he insisted on going on, and he was killed shortly afterwards.[3]

Major E.H.E. Daniell respected the young officer and wrote of the 'loss of a new valuable young Subaltern named Rushton'.[4] Rushton has no known grave and his name is commemorated on the memorial at La Ferté-sous-Jouarre.

PRIVATE CHRISTOPHER WHELAN 6817
2ND ROYAL IRISH REGIMENT

Christopher Whelan was born in 1880 in Dublin. He initially joined the Royal Dublin Fusiliers, then on 23 January 1900 he transferred to the Royal Irish Regiment. His brother Thomas also served in the same battalion and they were both sent to South Africa in 1900. While serving in South Africa Christopher was court

martialled for falling asleep while on sentry duty and for striking an officer. He went into the reserves in 1908. Christopher and Thomas were recalled to serve with the 2nd Royal Irish Regiment in August 1914 and both brothers fought at Mons on the eastern outskirts of the town, where the battalion suffered 308 casualties. Both would cross the Aisne using a plank under heavy enemy fire on 13 September at Vailly and would take part in the fighting north of the village. At some point during the campaign Christopher was mentioned in dispatches and on 10 October 1914 he was promoted to Corporal. Christopher was wounded at Le Pilly on 25 October 1914. He lost fingers and sustained shrapnel wounds to his lower back. The fate of Thomas is unknown, but Christopher was sent back home Dublin. After recovering from his wounds he returned to duty on 12 February 1916 and was sent to India where he worked as a cook to the end of the war. Christopher was the father of eight children and became a widower when they were young.

CAPTAIN GEORGE BRIGGS
1ST BATTALION ROYAL SCOTS FUSILIERS

George Clark Briggs was born in 1878 in Edinburgh. He was educated at the Edinburgh Academy, Malvern College and Clare College, Cambridge. On 3 May 1899 he was gazetted as a 2nd Lieutenant to the 1st Royal Scots Fusiliers. He served

Captain George Briggs, 1st Royal Scots Fusiliers. (*De Ruvigny's Roll of Honour, 1914–1918*)

during the Boer War from 1899 and took part in the relief of Ladysmith. Briggs was promoted to Lieutenant on 24 February 1900. He was captured at Colenso, but was released when Lord Roberts entered Pretoria. He escorted Boer prisoners to Ceylon and on his return to South Africa he took part in the Frederickstad operation, 17–25 October 1900. He was awarded the Queen's medal with four clasps and the King's medal with two clasps. By the time that the war broke out, Clark had reached the rank of Captain. He was dispatched to France with the 1st Royal Scots Guards and led the men with distinction during the engagement at Jemappes during the retreat from Mons. Corporal T. Gibson and Private Cox from his battalion were both wounded and later recounted Captain Briggs' role to a journalist from *The Scotsman*.

> In the retreat from Jemappes the Germans were pressing the Fusiliers closely, and towards evening the Coy. reached the village dead beat after a long march. Capt. Briggs got the men together and gave the order to fix bayonets. At the same time he spoke a few patriotic words with regard to the regt. and its illustrious history, pointing out that it had never been known to surrender. The Capt. said that he was prepared to make a last stand and with bayonets fixed the men waited on the enemy coming through. The last stand was not needed, however, as the Germans did not press home their advantages.[5]

Captain George Briggs was killed in the battle for Rouge Maison near Vailly on 14 September. He was mentioned in Field Marshal French's dispatch of 8 October 1914. His parents had lost their only son. Briggs was buried at Vailly Cemetery. His epitaph reads: 'Thou hast made him most blessed forever.'

2ND LIEUTENANT CHARLES ANDERSON
1ST BATTALION ROYAL SCOTS FUSILIERS
Charles Alexander Kenneth Anderson was born in 1893 in Nottingham. He was educated at Harrow from 1907 to 1911 and then at Pembroke College, Cambridge. Anderson received his commission as a university candidate with the 1st Royal Scots Fusiliers on the day that war broke out. He joined his battalion at Gosport a

2nd Lieutenant Charles Anderson, 1st Royal Scots Fusiliers. (De Ruvigny's Roll of Honour, 1914–1918)

week later and sailed for France on 13 August 1914. He was transferred to the 1st King's Royal Rifle Corps on 14 August, but because he had already left for France with the 1st Royal Scots Fusiliers, he remained with this battalion until his death later that year. He took part in the retreat from Mons and the battles of Le Cateau and the Marne. He also participated in the action around Rouge Maison Farm during the Battle of the Aisne. At 3.00am on 12 November 1914, during the Battle of Ypres he was killed while leading half of C Company, 1st Royal Scots Fusiliers in an assault upon trenches at Chateau Haerentage situated on the Ypres–Menin Road. Andreson has no known grave and his name is commemorated on the Ypres (Menin Gate) Memorial. Lieutenant-Colonel Douglas Smith, his commanding officer, described him as 'a capital boy in every sense of the word. Always cheerful and ready to work, and thoroughly reliable. He did not know what fear meant, and was so eager to undertake anything that was going.'[6]

Captain Alexander Seaton, his tutor and history lecturer at Pembroke College paid this tribute to his former student. 'We felt it all the more because Mr. M_____ told us he had run up against Anderson in the road on the retreat from Mons. He said he was very mud-stained and dirty, but smiling as serenely as ever.'[7]

COMPANY SERGEANT MAJOR CHARLES WILKINSON 4170
1ST BATTALION NORTHUMBERLAND FUSILIERS
Charles Wilkinson was born in 1877 at Stonebridge Park, Middlesex. He enlisted on 13 April 1894. He served in Gibraltar from 3 October 1896 to 16 January 1898. He then took part in the Sudan Expedition until 2 October 1898, where he was awarded the Queen's medal and the Khedeval medal. He was deployed to Crete from October to April 1899. Wilkinson was promoted to Lance Corporal in March 1899. Wilkinson served during the Boer War from September 1999 until 6 April 1903. He took part in the operations at Belmont, the Modder River, Orange Free State and Transvaal. He was awarded the Queen's medal with two clasps and the King's medal with two clasps. By April 1902 he had attained the rank of Sergeant. Wilkinson served in Mauritius for three years until 1906. He served on two occasions in India, from February 1906 until March 1907 and then in operations

Company Sergeant Major Charles Wilkinson, 1st Northumberland Fusiliers. (De Ruvigny's Roll of Honour, 1914–1918)

in the Mohmand Country, North West Frontier, from September 1908 to November 1913.He served as the Officer's mess sergeant for nearly five years while in India. When he returned to Britain he had attained the rank of Company Sergeant Major. Wilkinson had enjoyed a distinguished career with the British Army. In August 1914 he was sent to France with the 1st Northumberland Fusiliers. He took part in the retreat from Mons and crossed the Aisne on 14 September 1914. Sergeant Major Wilkinson was killed at Vailly on 16 September. He was aged 37 when he died. Major H.R. Sandilands wrote:

> Sergt.-Major Wilkinson belonged to the finest type of British non-commissioned officers, keen, smart and straight as a die, he was loved and trusted equally by the officers and men in the ranks of the regt. in whose welfare he was so keenly interested, and in whose service he died. 'Wilkie' will ever be held in affectionate remembrance by all who had the privilege of serving with him.[8]

Wilkinson has no known grave and his name is commemorated on the memorial at La Ferté-sous-Jouarre. His wife Maud was expecting their third child when he died. His third son was born on 2 November 1914 and named Charles Frank St George Wilkinson.

LANCE CORPORAL HARRY MCGREVY 553
1ST BATTALION NORTHUMBERLAND FUSILIERS

Harry McGrevy was born in 1884 and was raised in Gateshead, County Durham. Harry served as a career soldiers until 15 March 1907 when he transferred to the Army Reserve list. Returning to civilian life he worked as a shipyard labourer. Harry married Ruth Golightly on 6 August 1911. During the following year, Harry and Ruth celebrated the arrival of their new-born daughter Margaret, known as Betsy, on 9 July 1912. When war broke out he was recalled as a reservist to serve with the 1st Northumberland Fusiliers. It appears from the following letter that events moved swiftly and he did not get much time to spend with his family before he left with the battalion. Harry wrote from Cambridge Barracks, Portsmouth on 12 August.

Lance Corporal Harry McGrevy, 1st Northumberland Fusiliers. (Courtesy Teresa Newbegin)

Dear Ruth,

We have just arrived here, well about 9.30 this morning and we have had a bad time since. Well dear, Ruth, you know I haven't much time to talk to you all before we came away, but that was hardly my fault. After we arrived we had a speech from the Commanding Officer, he said unfortunately we were confined to barracks but that we were just waiting orders for the front but couldn't say when but he hoped it would be soon and I hope so too. I was sorry not to see our Maggie and Jimmy but give them my love, also yourself my best love. I feel sorry for all my friends, Aunt Ann, Lottie and our _____. I hope Aunt Ann didn't break down. But the thing that touched me was our 'little Betsy' shouting 'Daddy man' although I knew you would be brave. The rumour is here that we have to march out tomorrow at 12 noon for active service but really we do not know what time we go aboard ship. Ruth I would like you or Lizzie to let our Arthur know how this war goes and to send him the papers daily if possible. I expect you will receive some money in a day or two but I don't know really how much, perhaps 10 or 15 shillings. I expect you will be alright as far as that is concerned. But if by chance you are not, you must go to barracks and explain to C and they will see you get something. Well dear Ruth I am writing in a hurry and if you don't hear from me for a day or two, don't put yourself about, but read the newspapers and my number is 553 but I think I will be alright. And dear Ruth give my best love to all my friends who saw me away and those who couldn't see me off and also to _____ and our little Betsy.

I am Ruth, your loving husband,
Harry[9]

Harry embarked aboard SS *Norman* at Southampton on 13 August and arrived at Le Havre at 5.00am the following day. On 23 August Harry took part in the Battle of Mons and in the retreat from Mons to the Marne and in the subsequent advance to the river Aisne. Lance Corporal Harry McGrevy was killed at Rouge Maison on 14 September. Private Bill Gilchrist, a friend of Harry's who had been wounded the day before Harry's death, wrote to Ruth McGrevy on 6 October:

> Just a few lines to tell you the day I got wounded was on the river Aisne and Harry and me we were together on the __Sep_____[censored] safe getting plenty to eat and the next morning while crossing the Bridge _____[censored] we got out of that one safely_____[censored] had to attack the enemy there was a lot killed and I got hit in the

legs and Harry was alright, then I inquired the next morning he was dead from a lot of his company, while I was in hospital I got wounded 13th Sep. <u>Harry Killed</u> 14th September.

I hear there was a lot escaped out of that Big Battle on the 14th by some chaps that came wounded last night and I hope he is one who got away.

I expect to be home shortly.[10]

After recovering from his wounds Private Gilchrist returned to the 1st Northumberland Fusiliers, but was killed on 16 June 1915 near Ypres. Harry McGrevy, who was 30 years old, has no known grave and his name is commemorated on the memorial at La Ferté-sous-Jouarre. His parents would lose two other sons in the war. Lance Sergeant Arthur McGrevy, 2nd East Yorkshire Regiment, was killed at the Battle of Loos on 4 October 1915. He has no known grave and his name is listed on the Loos Memorial. Corporal James McGrevy, 25th Northumberland Fusiliers (2nd Tyneside Irish), was killed during the Battle of Arras on 28 April 1917. He too has no known grave and his name is commemorated on the Arras Memorial at Faubourg-d'Amiens Cemetery.

The fact that the three McGrevy brothers had no known grave denied the family even the opportunity to grieve formally. 84 years later, in 1998, Harry's

Lance Corporal Harry McGrevy's daughter Betsy visiting Chemin des Dames in 1998, to see the area where her father was killed in 1914. Here she is seen at the grave of an unknown soldier in Vailly British Cemetery where she laid a message to her father. (Courtesy Teresa Newbegin)

granddaughter Theresa Newbegin researched the circumstances surrounding Harry's death and was able to take his beloved Betsy to visit the Chemin des Dames where he fought and died for his country. There is a possibility that Harry lies in a grave of an unknown soldier, bearing a headstone with the inscription 'Known Unto God' at Vailly British Cemetery, where he is thought to have been buried. Betsy left the message you see here (left) at the graveside.

RIFLEMAN ALFRED BARAHM 8724
2ND BATTALION ROYAL IRISH FUSILIERS
Alfred Barahm lived in Belfast, he was wounded during the Battle of the Aisne.

Rifleman Alfred Barahm, 2nd Royal Irish Rifles. (*Larne Times*, 7 November 1914)

To the unknown soldier of the Northumberland Fusiliers lying in this grave. If you are Lance Corporal Harry Mc Grevy, killed in action on September 14th 1914, then I am your daughter, Margaret Theresa Smith, nee McGrevy. (You used to call me little Betsy). I have missed you all my life. It has taken 84 years for me to find you, and I know we'll meet again.

20 October 1998

Rest in Peace Dad

Your little Betsy

A message to Lance Corporal Harry McGrevy, 1st Northumberland Fusiliers, from his daughter Betsy. (Courtesy Teresa Newbegin)

RIFLEMAN DAN LORIMER 8066
2ND BATTALION ROYAL IRISH RIFLES
Lorimer was a reservist who was called up for service when war broke out. He fought during the Battle of Mons three weeks later. Lorimer recalled his experiences at Mons and during the retreat:

We were busily engaged in firing on the enemy when we got the order to fix swords in order to make a bayonet charge. Just then, the word came down from the aeroplanes scouting over the German lines that the enemy had also fixed swords ready to charge and that they outnumbered us by almost ten to one. We then got the order to remain where we were and when the enemy attacked, Cpl. Heggarty, who has since been killed, gave us the order for three rounds of rapid firing which we did with good effect and the Germans were checked here and lost heavily.

We subsequently retired on the right flank till we came to a little village on the 26th of the month. We opened out and the word came that the German lancers were in the village. Our artillery opened fire on the village and cleared it as far as possible and then our infantry advanced and unfortunately some considerable damage was done to them by a couple of shells fired by a British gun in the rear.[11]

Rifleman Dan Lorimer would see action at La Fosse Marquet on 14 September, where he sustained a bullet wound in the left shoulder. He lay where he fell until it was safe for him to get back to his battalion's lines:

After the turning movement which led up to the Battle of the Aisne on 14th September we saw some very severe fighting. Across the river a bridge was blown up by the Germans and there was a single plank left across the river resting on a small pontoon boat on which we had to jump to get to the bank. As soon as 'A' coy of the Rifles got across, rifle fire was opened on us and we had to run for a plantation and later on we got cover of an embankment.

Captain Soutry gave us orders to advance but had not gone 100 yards till he was wounded and we had to retire. Captain Durant, who was next in command, took charge and we were within 300 yards of the Germans when he was wounded on the thigh and Private Clarke who went to bind his wounds was also wounded.

Captain Durant then gave orders for Colour Sgt. Lynas to take charge and when I was passing along this word I was wounded. The bullet passed through my left shoulder and

grazed my lung. I was wounded between three and four o'clock in the morning and lay there till between five and six o'clock at night. Captain Durant was also lying wounded and I crawled over to get a drink out of his water bottle. I told Private Clarke that I was going to make a dash for it, but he said I was wrong, to remain where I was.

However, I made the attempt and I had only gone about fifty yards when I fell as the result of weakness and loss of blood. I had to lie there for a considerable time as the bullets both from our side and the Germans were passing close. All I was able to do was shout out 'Royal Irish Rifles' and I saw an officer in the British lines who had a Maxim gun, waving on me to come on. I got up again and the officer, whom I do not know, but belonged to one of the Irish Regiments, and who was a very plucky man, kept the Maxim going till I reached safety.

All I had by this time was my shirt and my trousers and I was in a bad state, but I was soon removed to a hospital on the outskirts of Paris. Private Abernethy of Harryville who was wounded in the leg and Private T. McCluggage (formerly of Thomas Street, Ballymena) who had one of his fingers shot off, were with me and looked after me in the train.

The French people were very good to us all along the line and my comrades gave me my share of the good things which were offered to us. I also saw Private Joe Richardson of Harryville in the battle and Private Jack Martin of Ballymena too. I am sorry to say that Private Martin was killed and I fear Pte McClintock met the same fate.[12]

Lorimer returned home to Ballymena, where he recovered from his wounds and continued to serve for the duration. He was later awarded the Distinguished Conduct Medal.

RIFLEMAN WILLIAM MAGILL
2ND BATTALION ROYAL IRISH RIFLES
William Magill was wounded during the Battle of the Aisne.

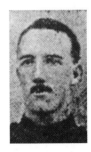

Rifleman William Magill, 2nd Royal Irish Rifles. (*Larne Times*, 31 October 1914)

RIFLEMAN JOHN MARTIN 8490
2ND BATTALION ROYAL IRISH RIFLES
John Martin was born in 1883. He lived in Londonderry before the war. Known as Jack, he fought in the Battle of the Aisne and was killed on 18 September 1914. He has

Private Dan Lorimer, 2nd Royal Irish Rifles. (*Ballymena Observer*, 14 November 1914)

no known grave and his name is commemorated on the memorial at La Ferté-sous-Jouarre.

Lance Corporal Jack Martin, 2nd Royal Irish Rifles. (*Ballymena Observer*, 14 November 1914)

24 October 1914 at Neuve Chapelle. He has no known grave and his name is commemorated on the memorial at Le Touret.

RIFLEMAN JOE RICHARDSON 8068
2ND BATTALION ROYAL IRISH RIFLES

Joe Richardson was born in 1884. He joined the army in 1906 and his eight years service was in India. In March 1914 he worked in Belfast. Within six months he was recalled to serve with the 2nd Royal Irish Rifles and took part in the Battle of the Aisne. He was killed on

Private Joe Richardson, 2nd Royal Irish Rifles. (*Ballymena Observer*, 14 November 1914)

NOTES

1. Clutterbuck, L.A., *Bonds of Sacrifice: August to December 1914* (1915, republished by Naval & Military Press, 2002)
2. Ibid
3. Ibid
4. IWM 87/8/1: Major E.H.E. Daniell, 2nd Royal Irish Regiment
5. *The Scotsman*, 17 October 1914
6. Anon, *Harrow Memorials of the Great War* Volume 1 (1918)
7. Ibid
8. De Ruvigny, Marquis, *De Ruvigny's Roll of Honour, 1914–1918* (1922, republished by Naval & Military Press, 2007)
9. Lance Corporal Harry McGrevy Papers, courtesy Teresa Newbegin
10. Ibid
11. *Ballymena Observer*, 6 November 1914
12. Ibid

LA MONTAGNE FARM

The 4th Division had received orders to advance north over the plateau between Crouy and Vregny in order to assist the 5th Division on the right flank and the French 45th Division on the left flank, which had failed to make headway. Brigadier-General Henry Wilson, commanding 4th Division, was reluctant to initiate an attack upon German positions which were strongly entrenched until these divisions had made an advance. Wilson was hesitant to launch an assault with no artillery support available, so the 4th Division held its position but came under heavy Germany artillery fire that caused 100 casualties amongst the 10th Infantry Brigade.

The 10th Infantry Brigade, commanded by Brigadier-General J. Haldane, was comprised of the 1st Royal Warwickshire Regiment, 2nd Seaforth Highlanders (Ross-Shire Buffs, The Duke of Albany's), 1st Princess Victoria's (Royal Irish Fusiliers) and 2nd The Royal Dublin Fusiliers.

The 2nd Seaforth Highlanders crossed the Aisne at Venizel during the early hours of 14 September. They headed for La Montagne Farm, north of Bucy-le-Long. They were positioned in between the 1st Rifle Brigade on their right flank and the 1st Hampshire Regiment on their left. The soldiers of the 2nd Seaforth Highlanders had crossed the river Aisne with empty stomachs because ferocious German artillery barrages prevented food from reaching their position. When they arrived at their position close to La Montagne Farm at 4.00am they resorted to taking potatoes from a nearby field. Before it was light the 2nd Seaforth Highlanders were able to carry out a swift reconnaissance. A and B Companies were sent out to form a firing line while the other two companies in support dug trenches.

At daybreak the enemy denied them the opportunity to consolidate. German artillery bombarded their position incessantly for 13 hours that day. An attempt to light fires to cook potatoes alerted German artillery observers to their position. Shells were bursting above them bringing trenches down upon them.

At 9.00am Lieutenant-Colonel Sir Evelyn Bradford (Bart), commander of the 2nd Seaforth Highlanders, was killed by a shrapnel shell. Captain C. Stockwell assumed command of the battalion and at 11.30am German artillery intensified their fire upon their trenches. There was apprehension that the increased rate of the German barrages might mean that an infantry attack was imminent. As a precaution the front line of the 2nd Seaforth's line was reinforced with the reserve companies. The battalion war diary recorded that the 'German trenches appeared to be 1500 yards away and no attack was attempted by their infantry. We kept up a certain amount of fire on their advanced line. Their artillery appeared to be firing at about a range of 2000 to 2500 yards.'[1]

Artillery supporting the 4th Division began to cross the Aisne before dawn on 14 September. The 37th howitzer Brigade comprised of the 31st and 35th howitzer Batteries had crossed the river before daybreak and set up their guns in the valley west of La Montagne Farm. Although observation north of their position was restricted, they had good line of sight in the direction of Crouy. They targeted German batteries on the heights beyond Crouy and ensured that those guns remained silent during the morning. After midday a German reconnaissance aeroplane flew over La Montagne Farm. The aviators observed the guns of the 31st Battery and fired a Very light over their position. German shells began to fall upon this battery and continued to do so throughout the afternoon. Despite 35 artillerymen and 35 horses being killed, no guns were destroyed. A company from the 2nd Royal Dublin Fusiliers was deployed to the front line in acticipation of an enemy infantry assault. After advancing half a mile they encountered German infantry and overwhelmed them.

The 68th Battery from the 14th Brigade, Royal Field Artillery, was bombarded throughout the day and had to be withdrawn to positions south of the river. Major C.L. Brereton, commanding the 68th Battery:

An effort at breakfast at 5.00am and then as it was getting light we went to our guns. For the first time, I remained with my section, while Loch took on the shooting of the Battery. We had just got the order to advance again to support the infantry attack, and had sent for our wagons, when the first shell came along. In about 5 minutes the Hun had completely got the range, and we were fairly 'for it'. A direct on one of Loch's guns finished most of that detachment. Sergt. Reid was wounded, and

there were about 29 casualties in a very short time. A direct hit on one of my guns then finished me and most of my detachment, and also poor Wallinger who was observing for his Howitzer Battery from behind my limber.[2]

No. 10 Field Ambulance had established a dressing station in the village of Bucy-Le-Long. German shells did not discriminate between hospitals and legitimate military targets and No. 10 Field Ambulance had to continue tending to the wounded under fire. Sergeant David Lloyd-Burch recalled: 'The next day was a trial for them, they were crowded with wounded and the Germans commenced to shell the village. The dressing station was hit, several of our men wounded.'[3]

The 2nd Seaforth Highlanders continued to hold their position. As well as losing their commanding officer, Lieutenant-Colonel Sir Evelyn Bradford (Bart), the 2nd Seaforth Highlanders lost Captain William Edward Murray who was seconded from the 1st Gordon Highlanders and 2nd Lieutenant Alexander Williamson; they also sustained casualties in the ranks of 14 killed and 81 wounded. The battalion war diary recorded: 'Our casualties would have been much smaller had we had time to entrench our position, as it was, the trenches we managed to dig were very poor protection against shrapnel and the reinforcements in many cases had no cover at all.'[4]

Persistent German shelling prevented the battalion from burying the dead. They had to wait until dark when the artillery stopped. They also laboured under the cover of darkness to strengthen their trenches and dig deeper in anticipation of further bombardments.

The 2nd Seaforth Highlanders held onto their trenches over the following weeks. Private Archie Murray from B Company, 2nd Seaforth Highlanders, wrote in a letter to his parents of his experience in a bayonet charge:

We were all busy digging trenches, when a fusillade of bullets came over our heads. We got the order to stand to arms. We advanced through a hedge at the side of a field until we got near the German trenches, when our Colonel sounded the charge and 'fix bayonets'. We charged right up to their muzzles, and shot and bayoneted them all roads. You should have seen them dropping their guns and up with their hands like a lot of sheep ... Their trenches were full of their dead and wounded, others crawling out like the cowards they are. You should have heard the shout from our throats 'Caber-feidh'. [Stag's head or antler, the ancient banner of Lord Seaforth.] When word was sent to the General, he could say nothing less than 'Brave Seaforths'. It was a brave charge considering the field of fire.[5]

LIEUTENANT-COLONEL SIR EVELYN BRADFORD
2ND BATTALION SEAFORTH HIGHLANDERS

Evelyn Ridley Bradford was born in 1869. Educated at Eton and the Royal Military College at Sandhurst he was gazetted to the Seaforth Highlanders in August 1888. By July 1895 he had attained the rank of Captain. He served in the Nile Expedition in 1898 and took part in the Battles of Atbara and Khartoum. In May 1899 he was appointed aide-de-camp to the Governor and Commander-in-Chief, Malta. In January 1900 he was sent to serve in the Boer War. He took part in various operations during this war and received the Queen's Medal with four clasps and the King's medal with two clasps and was twice mentioned in dispatches. Bradford was a fine cricketer and represented the county of Hampshire and played for the Army.

Upon his father's death in 1911 he assumed the title of 2nd Baronet and was known as Sir Evelyn Bradford. In May 1913 he was promoted to Lieutenant-Colonel and appointed commanding officer of the 2nd Battalion Seaforth Highlanders. Lieutenant-Colonel Sir Evelyn Bradford was killed by a shell during the Battle of the Aisne on 14 September 1914. An article was published in *The Scotsman* on 21 October, based on the testimony of Private Macdonald, which detailed the circumstances surrounding the death of Lieutenant-Colonel Bradford:

It was in the Battle of the Aisne, when they had taken up a position near a wood, that the Germans began a heavy fire. The Colonel was standing with two other officers surveying the field of operations, when he was struck and instantly killed. A lieutenant of the Gordon Highlanders, who was attached to the battalion, was killed, and a number of the men were also hit. In all about thirty men were wounded on that occasion. They attempted to bury the Colonel that night, but were prevented from doing so on account of the continuous and heavy shell fire from the enemy. Private Macdonald was one of the burial party who set out about nine o'clock in the evening to lay their officer to rest on the face of a hill near a big farm, which was the headquarters for the time being. 'They buried him darkly at the dead of night.' It was nearly two in the morning before their melancholy task was done. The chaplain of the regiment recited a short service, after which the mourners returned to the trenches.[6]

Lieutenant-Colonel Bradford was buried in Crouy-Vauxrot French National Cemetery, Crouy.

Lieutenant-Colonel Sir Evelyn Bradford, 2nd Seaforth Highlanders. (*Bonds of Sacrifice*)

2ND LIEUTENANT ALEXANDER WILLIAMSON
2ND BATTALION SEAFORTH HIGHLANDERS

Alexander John Neeve Williamson was born in Calcutta, India, in 1887. Educated at Highgate School he held the record for running the half mile in a competition amongst various public schools, and held the cup for three years. He served in the school cadet corps from 1903 and when he left in 1907 he had attained the rank of Colour Sergeant. He maintained his links with the military when studying at Pembroke College, Cambridge, where he joined the Officer Training Corps. Here he developed skills in musketry, signalling and map reading. After graduating he became a school master at Blundell's School in Tiverton, Devon. Here he served with the School Corps, which was a similar organisation to the modern-day Army Cadets or CCF. In July 1911 he served with the Special Reserve. In 1912 he returned to his old school, Highgate, as a schoolmaster and became second in command of School Corps. One day after war was declared Williamson reported for duty at Shorncliffe Barracks. He was sent to France and joined the 2nd Seaforth Highlanders during the retreat from Mons. 2nd Lieutenant Alexander Williamson was killed in action during the Battle of the Aisne near Bucy-Le-Long on 14 September by a shell. The battalion adjutant wrote a letter of condolence to his mother on 15 September:

> I regret very much to have to inform you that your son, A.J.N. Williamson, was killed in action yesterday, 14th September 1914, He was in charge of his platoon of the regiment in the trenches, and was exposed to a very heavy shell fire, and unfortunately lost his life.
>
> There were no officers in the immediate vicinity at the time, but, from the account of the men, he behaved with the greatest gallantry and coolness in very trying circumstances. The fire brought to bear on us was extremely heavy and well sustained, and too much credit can not be given to him for the manner in which he conducted himself' Captain H.F. Baillie, who commands the company to which your son was attached, speaks very highly of his soldierly capabilities.
>
> He was buried in a separate grave last night. At a later date I hope to be able to inform you of the exact locality, but at present the censorship does not admit of this.

2nd Lieutenant Alexander Williamson, 2nd Seaforth Highlanders. (Bonds of Sacrifice)

On behalf of the officers of the regiment, I beg to tender you our deepest sympathy in your loss, a loss in which we all share. I hope, one day, to be able to let you have a few little things we found on his body.[7]

2nd Lieutenant G.W. Mackenzie was a fellow officer from the 2nd Seaforth Highlanders. He wrote a letter of condolence to his mother on 19 September:

> At the time we had just taken up a position on high ground on the North of the river Aisne, near Soissons. It was at a critical moment and your son went up with his platoon in support of the two companies in the firing line. Apparently he was hit and killed instantaneously by a shell ... I write to express my personal sincere sympathy, as your son was a great friend of mine, having been up to Pembroke together ... He was extremely popular in the Battalion and a great loss to his company and to us all. He was recognised as being a most efficient officer.[8]

Captain E. Campion wrote a letter of condolence to his brother and described the circumstances surrounding Williamson's death:

> We got up this hill very early on Sept: 14th, and had but little time to entrench at all before the enemy opened on us with artillery fire, which continued all day for 13 hours, and our men suffered severely. Our Colonel was killed early and your brother and Lieutenant Murray of the Gordons (attached to us) later in the day. Your brother was not in my company but was on my left at the time. He was hit in the head and could not have suffered at all ... I can only describe him as a magnificent officer, he knew his work as well and better than most regular officers, and was always cheery and got any work he liked out of his men, who loved him. He is a very great loss to us and to his country.
>
> He was killed, poor chap, commanding his men in the front line of battle (a line we hold now, for we cannot go forward and of course we won't go back) and so died the true soldier's death, and leaves behind him a record of gallantry and a life clean and well-lived.
>
> We buried our Colonel, Murray and your brother in a beautiful spot overlooking the valley of the Aisne, just north of the village called Bucy-Le-Long ... The spot will in the future be very easily found, and it is, in fact, the site of a new cemetery. Our Colonel was buried on the right, then Murray, then your brother.
>
> I assure you I feel very deeply for you and your Mother! You may most certainly be proud for,

poor fellow, his record is a fine one, and he died a splendid death.[9]

2nd Lieutenant Alexander Williamson – the first school master to be killed in the First World War – was buried in Crouy-Vauxrot French National Cemetery, Crouy. His epitaph reads:

> MASTER AT HIGHGATE SCHOOL
> HE THAT LOSETH HIS LIFE
> SHALL FIND IT

CAPTAIN WILLIAM MURRAY
3RD BATTALION GORDON HIGHLANDERS ATTACHED TO THE 2ND BATTALION SEAFORTH HIGHLANDERS

William Edward Murray was born in 1880 in Hong Kong. He was educated at Wellington College and at the Royal Military College at Sandhurst. He joined the 1st Gordon Highlanders in March 1900 and served during the Boer War and was awarded the Queen's medal with four clasps. By the time the First World War started he had reached the rank of Captain. He remained in Aberdeen guarding the Wireless Station while the rest of the battalion went to France. At Mons the battalion was so badly decimated that he was sent with a draft of 100 men to be attached to the 2nd Battalion Seaforth Highlanders when they were pursuing the German Army from the Marne to the Aisne during September 1914. Captain Murray led an assault on a stretch of German trench near Bucy-Le-Long on 14 September. He rallied his men with the words 'Come on, Gordons! There is only a handful of us, but we will do it!' After capturing the German trench Murray was mortally wounded when shrapnel hit him in the head. His last words before he died on 14 September were 'You must hold on here at all costs.'[10]

Only seven men from Murray's party of 100 were fit to fight after this battle. One private who survived paid this tribute to Captain Murray: 'Our Captain was as brave an officer as I ever saw in the firing line ... We would have done anything for him.'[11] Sergeant A.H. Fraser from the 2nd Seaforth Highlanders wrote:

They were a splendid lot of fellows. We had some very trying marches, following up the retiring Germans until we came to the crossing

Captain William Murray, 2nd Seaforth Highlanders. (Bonds of Sacrifice)

of the Aisne. We crossed the river on the night of the 13 Sept. under cover of darkness and took up a position on the north bank of the river near Soissons. The following morning when dawn broke, we found ourselves within a thousand yards of the German position. They were not long before they made their presence felt, and we had to dig ourselves into the face of the bank under a heavy shell fire. Capt. Murray was beside me and dug himself in with my entrenching tool, but he did not occupy it very much for I saw him out on the road giving his men advice about how to entrench themselves, and this whilst shrapnel was whistling about his ears, at which he only laughed. Later on, after our Colonel was killed, Capt. Murray was ordered to reinforce a part of our line, and with these words 'Come on Gordon's' he went up with about half of his party, and in less than ten minutes I was informed that he was killed. Every man of his party expressed deepest sympathy for his death; they felt it very keenly. Personally I have never seen a man so cool under fire before or since. His name I am sure will be remembered in my regt., when all our battles are fought over again.[12]

Brigadier-General Haldane commanding the 10th Infantry Brigade recalled the circumstances of his burial.

He was buried in a rough coffin that night about 12.30am within a quarter of a mile from where he fell. On one side of him we buried Col. Sir E. Bradford and on the other Captain Williamson of my regt. They all had rough crosses placed over their graves, and several others were buried there. In fact I think it has been railed off now as a small cemetery. It is a very pretty spot on the slope of a hill overlooking the Aisne valley towards Soissons, quite close to a farm called La Montagne Ferme, just above Bucy-le-Long.[13]

Captain Murray was buried in Crouy-Vauxrot French National Cemetery, Crouy. His epitaph reads: 'The Master is Come and Calleth for Thee.'

PRIVATE JAMES ROSS 7129
2ND BATTALION SEAFORTH HIGHLANDERS

Private James Ross from Rosemarkie was a veteran of the Boer War and saw active service on the Indian Frontier for which he was decorated. He was killed during the Battle of the Aisne on 14 September and was buried in Crouy-Vauxrot French National Cemetery, Crouy. A correspondent in Rosemarkie wrote the following obituary:

Private James Ross, 2nd Seaforth Highlanders. (*Highland Times*, 15 October 1914)

The grim reality of the Great War was brought home to our doors on Wednesday morning, when intimation was received by Mr and Mrs Thos. Ross, High Street, that their youngest son, Private James Ross, of the Seaforths was killed in action in France on Monday 14th September. Private Ross left Cromarty encampment for the front on Friday morning, August 21st, and the previous evening paid a flying visit to the old home and said the farewells. He was then in the full vigour of his young manhood, every inch a soldier, and physically fit to endure the hardships of a long and trying campaign, and it is hard to realise that the place which knew him once will know him no more. 'Tommy' as he was affectionally called by his comrades in arms was the living incarnation of that spirit of altruism and chivalry upon which according to military text books the character of the soldier is based and built. Sincere in his friendships, honest in his convictions and entirely free from any trace of contentious parade or vainglorious display, he was in every sense of the term a soldier and a man. And as he lived so we feel sure he died, looking the enemy in the face, and holding his head erect in the sight of God and man, a noble example of that high resolve and singleness of aim, which we trust shall never die with his race. To his aged parents and other relatives whose homes have been darkened by the shadow of death, his loss is an irreparable one, but as with heavy hearts and faltering footsteps they walk along the mysterious path of human destiny, perhaps they may be comforted by the assurance that greater love hath no man than this – that he laid down his life for his friends.[14]

NOTES

1. WO 95/1483: 2nd Seaforth Highlanders War Diary
2. IWM 86/30/1: Major C.L. Brereton, 68th Battery, 14th Brigade, Royal Field Artillery
3. IWM 87/26/1: Sergeant David Lloyd-Burch, No.10 Field Ambulance
4. WO 95/1483
5. *The Scotsman*, 7 October 1914
6. Ibid, 21 October 1914
7. IWM 89/21/1: 2nd Lieutenant Alexander Williamson, 2nd Seaforth Highlanders
8. Ibid
9. Ibid
10. Clutterbuck, L.A., *Bonds of Sacrifice: August to December 1914* (1915, republished by Naval & Military Press, 2002)
11. Ibid
12. De Ruvigny, Marquis, *De Ruvigny's Roll of Honour, 1914–1918* (1922, republished by Naval & Military Press, 2007)
13. Ibid
14. *The Highland Times*, 15 October 1914

THE BATTLE FOR THE CHIVRES HEIGHTS

The 5th Division had continued to cross the Aisne during the night of 13/14 September and were ordered to extend their bridgehead and proceed 15 miles north towards Laon. They could not fulfil their orders because the Chivres Spur was still occupied by the enemy. German forces were securely entrenched on this ridge overlooking Missy and Condé. They had utilised the old fort at Condé built on the summit of Chivres Spur. The village of Chivres was positioned on the south-western slope of the spur and German forces could command the front approach and both the flanks. Woods covered both flanks of the spur, which provided cover for the German forces.

It was obvious from early morning that the 5th Division would be unable to carry out their orders and reach Laon. A contingency plan was hastily formulated to capture Chivres Spur. The 14th Infantry Brigade – the 2nd Suffolk Regiment, 1st East Surrey Regiment, 1st Duke of Cornwall's Light Infantry and the 2nd Manchester Regiment – was ordered to advance east from St Marguerite and capture Missy and then assault Chivres Spur from the south.

The 1st East Surrey Regiment would launch an assault upon St Marguerite from Missy. They advanced across open country fully exposed to enemy guns. By midday B, C and D Companies had captured Missy, while A Company was engaged in fighting east of the village.

The 14th Infantry Brigade was hindered by enfilade German machine-gun and rifle fire from trenches on the western slopes of the Missy heights and from the village at Chivres. The 2nd Manchester Regiment carried the left flank of the 14th Infantry Brigade, but their

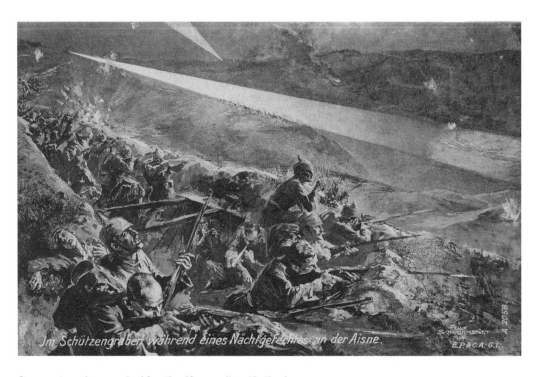

Im Schützengraben während eines Nachtgefechtes an der Aisne.

German trenches overlooking the Aisne valley. (Author)

advance was stopped by machine-gun fire from Missy and German artillery shells that were directed from the Chivres ridge into the valley close to Missy. They got to within 300 yards of the German trenches and could go no further. The 1st Duke of Cornwall's Light Infantry advancing in the centre, with three companies from the 1st East Surrey Regiment carrying the right flank, had orders to attack the village north of Missy along the western wooded slopes of the Chivres Spur. Their advance was hindered by German artillery and machine-gun fire targeting the road from St Marguerite. The 1st East Surrey Regiment reached the northern perimeter of Missy by midday. Infantry from the 1st Duke of Cornwall's Light Infantry were caught in the crossfire. Captain R.H. Oliver and Captain C.B. Woodham led C and D Companies from the 1st Duke of Cornwall's Light Infantry. A and B Companies were forced to seek cover in nearby woods. German machine gunners dominated the valley and the Duke of Cornwall's were unable to make any headway. A and B Companies were ordered to tackle the obstinate defenders of Chivres by deviating to Missy, then assaulting the western slope from the south. This revised strategy proved fruitless and the advancing waves of the Duke of Cornwall's were thwarted by overwhelming heavy machine-gun fire. They had no artillery cover, because visibility was poor and British artillery batteries in the area were coming under fire from German howitzers. Captain Arthur Nugent Acland, Adjutant of the 1st Duke of Cornwall's Light Infantry recorded in his diary:

Early next day we got orders to move back in a south-easterly direction and then make an attack on the village of Missy, the high ground north of it and the valley on the west of this high ground; and we were told to push the attack hard, so as to allow another brigade to pass across in rear of us and to attack on our right. This was September 14th (Monday) – so it was not really our day for a fight! However, we attacked and tried to push it home, but the valley was a death trap, cross fire from machine guns, infantry and artillery, and no troops could have got farther than ours did, unsupported as we were by our artillery. Also it was impossible to get up the valley until the heights above Missy had been cleared.[1]

The 1st Duke of Cornwall's lost heavily. Captain R. H. Oliver was hit by a bullet in the head and was mortally wounded. Before he died he stretched out his hand and shook hands with his Company Sergeant Major who was lying wounded beside him. He was buried in the grounds of St Marguerite Farm. His grave was lost during the course of the war and his name is commemorated on the memorial at La Ferté-sous-Jouarre. The battalion had 4 officers wounded and 145 casualties amongst the ranks.

The 15th Infantry Brigade consisting of the 1st Norfolk Regiment, 1st Bedfordshire Regiment, 1st Cheshire Regiment and 1st Dorsetshire Regiment could hear the 14th Infantry Brigade's attempts to dislodge the Germans on Chivres Spur from their position at St Marguerite. Although not directly involved in the battle, they were vulnerable. Captain John Macready, adjutant to the 1st Bedfordshire Regiment:

Here a battle was in progress and we remained under fire for a considerable time, without any orders to move. Eventually, about 11.00 hours, we got orders to move to Missy, about a mile to our right. Having lain for so long under machine gun and artillery fire we were glad to move.[2]

The 15th Infantry Brigade left the 1st Dorsetshire Regiment in reserve in a sunken road north of St Marguerite while they headed for Missy. Captain John Macready recalled the journey:

It was no easy job to get to Missy, as the road between St Marguerite and Missy was swept by bullets. By taking cover carefully and running, we got to the light railway running between these villages and then over the light railway bank, which was about two feet high in some places but in others non-existent. We finally got to Missy.[3]

The leading units from this brigade arrived at Missy at 2.30pm, however persistent artillery fire impeded their advance and the battalions were not ready to attack until 4.30pm.

At 4.30pm the 15th Infantry Brigade and the East Surrey's launched a bayonet charge and nearly succeeded in clearing the ridge, which would have enabled the 1st Duke of Cornwall's Light Infantry to advance up the valley. Ten companies from the 1st Norfolks and the 1st Bedfordshires from the 15th Infantry Brigade and the 1st East Surreys from the 14th Infantry Brigade drove round the rear of the Duke of Cornwall's' attack against the southern end of the spur north of Missy and assaulted Chivres Spur from the south east. The attack was supported by the 8th Howitzer and 15th Brigade Royal Field Artillery from their positions at Bucy-le-Long. The 1st Royal West Kent's and the 2nd King's Own Scottish Borderers from the 13th Infantry Brigade assisted them on the right flank.

The 1st Bedfordshires and the 1st East Surreys pushed forward on the left flank and accurate marksmanship shot down many German soldiers. The battalions advancing on the right flank did not have

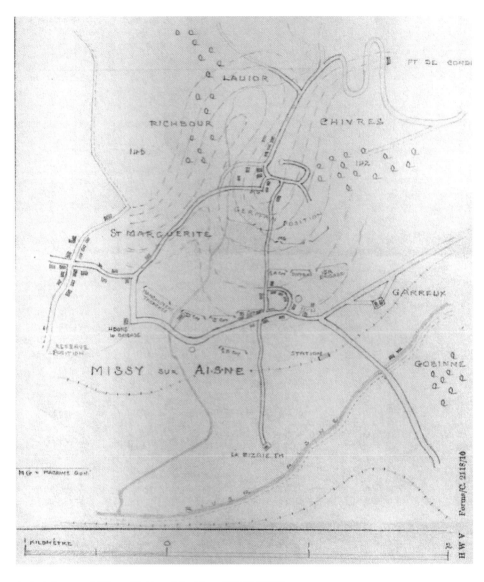

A sketch map of Missy. (National Archives WO 95/1564)

sufficient time to assemble and their drive through the woods was stopped by barbed wire defences, strongly defended German trenches and shell fire from German and British guns. Some parties lost direction and confusion amongst the attacking British force gave the Germans time to reorganise themselves and offer an impenetrable resistance. The British were driven back down the valley. They withdrew to a position south of Missy under the cover of the railway embankment.

The 1st East Surrey Regiment and 1st Bedfordshire Regiment were within 70 yards of the German trenches and held the positions that they captured on

a spur north of Missy until withdrawn at 6.30pm to St Marguerite. Captain John Macready was aware of the significance of the action:

> The dominating feature over the Aisne valley was Chivres Ridge which stood up over the village of Missy. We waited for some time in Missy village, heavily shelled by 5.9s. C Company, under Allason, pushed on up the hill and eventually got onto Chivres Ridge, with a company of the East Surrey Regiment. The OC Company of the East Surrey Regiment got a message from his Brigadier (Holt) that he must go back to St Marguerite. Allason explained to him

that if he left, both his flanks would be uncovered, for there was no one on Allason's right. The OC East Surrey Company promised to stay and sent a message to his Brigadier, but said that if he got another order to retire to St Marguerite he would have to do so. This actually happened in the evening and C Company was withdrawn by order of the Brigadier, so our hold on the Chemin des Dames was lost. What a difference to the War it might have made if it had been allowed to stay on the Chemin des Dames.[4]

The 15th Infantry Brigade regrouped south of Missy and established a line east of St Marguerite that stretched to Missy.

The 1st Duke of Cornwall's Light Infantry managed to capture and secure Missy. A and B Companies from the 1st Duke of Cornwall's Light Infantry were holding the western perimeter of the village while C and D Companies were secure in outpost positions in woods outside Missy. During that night C and D Companies joined A and B Companies and rested in Missy. The 14th Infantry Brigade had set up a defensive line from St Marguerite to Missy and the 1st Royal West Kent's held the line to Missy Bridge.

On 14 September the 1st East Surrey Regiment lost 2nd Lieutenant Gerald Relton and 15 other ranks killed; 2 officers and 81 other ranks wounded. 1st The Queen's Own (Royal West Kent Regiment) suffered 31 casualties killed and 96 wounded while defending the trenches at Missy.

2ND LIEUTENANT CHARLES CRANE
1ST BATTALION DUKE OF CORNWALL'S LIGHT INFANTRY
Charles Crane was born in Birlingham, Worcestershire on 18 February 1892. He was educated at Oakfield, Cheltenham College and Sandhurst. He was gazetted to serve with the 1st Duke of Cornwall's Light Infantry on 4 September 1912. He served with the regiment in Belfast to quell the civil unrest during the spring of 1914. At the outbreak of war he went with the battalion to France. Crane took part in the retreat from Mons and displayed compassion for the men that he commanded. Lance Corporal J. Horan wrote:

I had the pleasure of serving with your gallant son. All through the famous retreat from Mons it will always live in my memory his kindness to me; that was when we started the advance. He picked me up where I was lying by the road one night and put me in an ambulance wagon, and also another private; we both owe our lives to him. He was most kind and considerate in all his orders and would never ask his men to go any place he would not go himself. We had trying times, especially on the 26 Aug., he took

us out of the village of Le Cateau. I don't remember him losing any of his platoons. It was a dreadful ordeal, for they were firing on us in all directions. His conduct was brilliant in the extreme; it was his coolness that got us out of it. I cannot express his kindness for on the retreat I have seen him carrying the men's rifles. He would give us chocolates and cigarettes, or whatever he had he would give to anyone. I cannot speak too highly of him.[5]

He was mortally wounded during the Battle of the Aisne at Mont de Soissons Farm and subsequently died from his wounds four days later on 18 September. He was buried at Vailly British Cemetery. Lieutenant-Colonel M.N. Turner wrote the following letter of sympathy to his father: 'Your boy was absolutely brave and good. We were all so very fond of him, and he was such an excellent officer. He was absolutely fearless and one of the best.'[6]

A fellow officer paid this tribute: 'He was hit on 14 Sept. when doing real good, brave work. Another good soldier and leader, and another gallant officer! We miss him very much; we all liked him so tremendously.'[7]

CORPORAL F. SMITH 7167
1ST BATTALION DUKE OF CORNWALL'S LIGHT INFANTRY
Corporal F. Smith had served in the army for seven years and then worked at the Gold Street Conservative Club in Northampton. When war broke out he was called up as a reservist and went to France with the 1st Duke of Cornwall's Light Infantry Regiment. Smith first saw action at Mons on 23 August 1914. The battalion had set up defensive positions along the Mons-Condé Canal close to Le Petit Crepin. Rifle shots were fired at 6.00am. By 4.45pm waves of German infantry advanced in great numbers from the direction of Ville Pommeroeuil. Corporal F. Smith recalled:

Left to right: Private Leaking, Corporal F. Smith and Sergeant John Pettam. (*The Northampton Independent*, 24 October 1914)

numbers were vastly inferior to the massed German Army heading in their direction. The retirement was covered by the 2nd Manchester Regiment to the River Haine in the direction of Dour. Corporal Smith recalled that 'Dour was the next halt, but after two hours rest we were fighting again, and the German guns quickly getting the range we retired again, my section being tolled off as ammunition escort.'[9]

On 25 August the 1st Duke of Corwall's Regiment was back in action at Le Cateau:

> At Le Cateau later on we were told to fall out, but almost as soon as we did so the German shells found us, and we were ordered to take cover on some high ground. Again we retired farther back, and were digging trenches when we were told that Major Petaval lay wounded 250 yards in front. I and two men volunteered to fetch him, but when we reached him he said 'Leave me; there's a private worse than me behind'. We went to the private, but he, poor chap, was too far gone, and we returned to the officer who still refused to let us help him so we came back alone. When we rejoined the fighting we found that the enemy had pushed its right flank right past our left and had we tried to move we should have been enfiladed.[10]

Corporal F. Smith retreated with the battalion and during early September took part in the Battle of the Marne, a turning point for the BEF, for now they were advancing and pursuing the enemy. This came as a welcome relief for Smith and his comrades, who saw it as an opportunity to avenge the deaths of fallen comrades:

> They held us back for two hours and then retreated to the Marne, where they took up a strongly fortified position. At nine in the morning we came into action with the enemy's trenches 700 yards away. We were ordered to take the position and advanced by short rushes over a shot-swept space. When we were 200 yards distance we were ordered to fix bayonets and charge. Every man was anxious to avenge fallen comrades and we drove them from the trenches where their dead and wounded lay in heaps. We had taken the position but suffered heavily.[11]

Smith fought throughout the Battle of the Marne and in the advance to the Aisne. During the Battle of the Aisne he took part in the assault on Chivres on 14 September and on 15 September he sustained several bullet wounds:

> We next advanced on Soissons and tried to cross the Aisne on pontoons, but the first pontoon was blown to pieces and we had to wait for night when

> Our first sight of the Germans was at Mons, where we arrived on August 23rd and were promptly ordered out to outpost duty. Soon afterwards we were recalled to dinner, in the middle of which we received an order to dig trenches at once. We had hardly been at the job five minutes before the place was absolutely raining lead, but we kept steadily on with the work. We were entrenched on the banks of a canal, with another branch of the canal running parallel 500 yards in front, a wood farther behind, cottages on the left. The bridges over the canal had been destroyed. Suddenly the Germans came out of the wood and attempted to cross the canal on a barge. Our fellows could not miss such a good target, and we mowed them down very fast. The town behind the Germans and the cottages on their left were in flames. Just then we received the order to retire, leaving two companies behind to cover our retirement.[8]

The 1st Duke of Cornwall's Light infantry inflicted heavy casualties upon the German infantry but they could not hold on to their position indefinitely. Their

we crossed. The horrors of the first four days of the Battle of the Aisne are indescribable. We repulsed two night attacks with bayonets and on the fourth day, a Northampton man, Sergt. Pittam, was struck by my side and died of his wounds ... Shortly afterwards I was hit in the leg, through the left lung, and on the finger, and that was the last I saw of the fighting.[12]

NOTES

1. Captain Arthur Nugent Acland's Diary, courtesy Cornwall's Regimental Museum
2. Captain John Macready Account, Bedfordshire & Luton Archives
3. Ibid
4. Ibid
5. De Ruvigny, Marquis, *De Ruvigny's Roll of Honour, 1914–1918* (1922, republished by Naval & Military Press, 2007)
6. Ibid
7. Ibid
8. *The Northampton Independent,* 24 October 1914
9. Ibid
10. Ibid
11. Ibid
12. Ibid

THE POSITION AT THE END OF 14 SEPTEMBER

At 11.00am on 14 September; as the Battle of the Aisne was being fought north of the river, Field Marshal Sir John French convened a meeting with his Corps Commanders at his headquarters at Fère en Tardenois. He told Haig and Smith-Dorrien to order their troops to entrench the positions captured.

German forces had become entrenched along the heights that overlooked the Aisne valley. The allies had lost momentum. The German XVIII Corps arrived to support the VII, XV and XII Corps, which were holding the line along the Aisne. They held the high ground and were supported by heavy artillery, which meant that they held the two key advantages. The day saw many skirmishes but the attacks were uncoordinated and did not make any significant breakthroughs.

The BEF had lost many casualties in order to establish their positions north of the Aisne. The I Corps had achieved some significant success on the right flank and had reached the heights of the Chemin des Dames, four miles north of the river Aisne. The 4th Cavalry Brigade held the eastern extremity of the BEF's line, at Paissy, adjacent to the French front. Battalions from the 1st Division held positions on the Chemin des Dames north east of Troyon. The line extended east of the Sugar Factory at Troyon where it linked with the French Moroccan Division and ran south west across the Vendresse Spur towards into Chivy Valley to a position south of Chivy.

The 2nd Division continued the British line south of the Beaulne spur towards La Bovette and La Cour de Soupir to Pont 166. There was a gap of 3.5 miles between I Corps and II Corps with small parties of 1st and 2nd Cavalry Brigades holding outpost positions between their lines. I Corps and II Corps front was separated by the Chivres Spur, occupied by German infantry and artillery. The 3rd Division held a mill a mile west of Chavonne and occupied Rouge Maison, Vauxcelles and a chateau. The 5th Division held the line west of Missy west towards St Marguerite. Two battalions from the 13th Brigade were positioned south of the river Aisne at Sermoise, which was south east of Missy. 4th Division from III Corps were at St Marguerite, La Montagne and a position west of Crouy.

The gains made by I Corps on 14 September cost them approximately 3500 men. The casualty rates were similar to those sustained on the first day of the Somme on 1 July 1916. The 1st Cameron Highlanders lost 600 men. The 1st Coldstream Guards, 1st Loyal North Lancashire Regiment, 2nd Royal Sussex Regiment, 2nd Grenadier Guards and 3rd Coldstream Guards suffered approximately 350 casualties each. Many officers were lost, including commanding officers such as Lieutenant-Colonel Adrian Grant-Duff commanding the 1st Black Watch. Brigadier-General Bulfin lost three out of four battalion commanders of the 2nd Infantry Brigade. The BEF was a limited resource stretched across an extensive frontline which it could not defend. Haig's I Corps had to confront the majority of the German 7th Reserve Corps and a division from the III Corps. Haig had no choice but to commit all his battalions in the front line and was left with no reserves.

Having sent the BEF across the Aisne using pontoons, French risked his force being trapped on the north bank. Incessant rain caused the river to swell and threaten to wash these temporary bridges away. Persistent German artillery bombardment of the British crossings across the Aisne was another hazard.

General Von Bülow had positioned the First, Second and Seventh German Armies north of the Aisne to block the British and French advance. The BEF was numerically inferior to the German armies defending their impregnable position on Chemin des Dames, but Von Bülow was unaware that he held that advantage. If he had known that a small British force had crossed the Aisne, he had the strength and resources to push them back across the river – but he feared that the BEF had reinforcements following behind them. The allies' attempt to secure the Chemin des Dames on 14 September had in part pre-empted Von Bülow's intention to push the BEF and the French 18th Corps to the south bank. Von Bülow did not have all his units in position to execute such a drive, and those that were already positioned along the Chemin des Dames probably did not have the energy to launch an offensive. One German account confirmed this:

Nothing was to be seen of the XV Corps, in whose attack the VII Reserve was to cooperate; far from troops coming on, part of Von Marwitz's cavalry

corps (which was to cover its advance) sent its baggage back in the direction of Bruyères (south of Laon). It was very exhausted. Strong bodies of cavalry followed and took cover behind Fort Montbérault (4 miles north of Troyon, and Von Zwehl's headquarters). It was reported and confirmed that forces considerably stronger than our own, as it was supposed, had crossed the Aisne, moving northwards. The VII Reserve Corps and also the III Corps felt they must confine themselves to the defensive.[1]

Both British and German forces were ignorant of the real situation. One wonders whether Field Marshal French would have sent the BEF across the Aisne at all, had he known that the Germans were entrenched along the Chemin des Dames and by the end of the day would have reinforcements joining their lines along the high ground they controlled.

On the evening of 14 September Kaiser Wilhelm II replaced General Helmuth von Moltke as Chief of Staff with Lieutenant General von Falkenhayn, then minister of war. Before the war had begun, Moltke had promised to defeat the French within 39 days of mobilisation and transfer his forces to assist on the Russian Front. 9 September was the day scheduled for the defeat of France, but Moltke could not deliver. The following day he would suffer a disastrous defeat on the Marne and would begin the retreat to the Aisne. It was inevitable that without a victory over the French and the consequential retreat to the Aisne, Kaiser Wilhelm II would dismiss his Chief of Staff. Moltke was ordered to remain at his headquarters in an effort to conceal the fact that he was dismissed and that the assault on France had failed. Falkenhayn immediately ordered the preparation of German counter attacks upon the British and French lines held along the north banks of the Aisne.

The French had crossed the river Aisne at Soissons. However, with the arrival of German reinforcements there was little prospect of British and French divisions advancing. The only way of making any headway

was to attempt to outflank the German Army in the west. Major-General A.G. Wauchop, the chronicler of the Black Watch history, eloquently summed up the significance of that day as he described the 1st Battalion's actions on the night of 14 September: 'In pouring rain the Battalion began to entrench, and threw up some of the first spadefuls of that long line which was soon to stretch from Switzerland across France to the sea.'[2]

The BEF had failed to push beyond the Chemin des Dames in accordance with the orders of Field Marshal Sir John French. It is apparent that during the afternoon of 14 September French did not know what to do, he had not formulated the next move, for in Operation Order No.25 he issued a vague order for the following day: 'The Army will operate tomorrow according to instructions issued personally by the Commander-in-Chief to G.O.C. Corps and Cavalry Divisions.'[3]

In previous orders since the advance from the Marne, French had issued vague orders for the BEF to advance. In Operation Order No.25 he continued in the same vein. He received a telegram from General Joffre at 1.15am on 15 September affirming the notion that the German Army intended to hold the ground along the Chemin des Dames:

> It seems as if the enemy is once more going to accept battle in prepared positions north of the Aisne. In consequence, it is no longer a question of pursuit, but of a methodical attack, using every means at our disposal and consolidating each position in turn as it is gained.[4]

By the end of 14 September and during the early hours of the following morning, both Field Marshal French and General Joffre would come to the conclusion that the pursuit from the Marne was over and that they had now to overwhelm the German defences. The German Army was far better prepared for the siege warfare that was to take place. On 14 September the first train carrying engineer stores for the construction of BEF trenches arrived on the Aisne sector.

NOTES

1. Edmonds, Brigadier-General J.E., *The Official History of the War: Military Operations: France & Belgium 1914* (Macmillan & Co, 1933)
2. Wauchop, Major-General A.G., (ed) *A History of the Black Watch (Royal Highlanders) in the Great War 1914–1918* (The Medici Society, 1925)
3. Edmonds
4. Ibid

PART THREE

DESCENT INTO STALEMATE AND TRENCH WARFARE

General Joffre had accepted the reality that pursuit of the enemy was not feasible on 15 September. He realised that the war of movement had been brought to an abrupt end along the Aisne valley. A new strategy would be required. German forces had hastily brought reinforcements to the Chemin des Dames and were able to deploy troops in the gap between the German First and Second Army lines. It was too late for Field Marshal French and the BEF to exploit this breach in the line. Von Bülow gave orders to push the BEF back across the Aisne on 15 September. The BEF were denied the opportunity to consolidate and fortify by German counter attacks and bombardments during 15 September.

That was the day when the stalemate began. The BEF was ordered to entrench their positions along the Aisne valley and heavy artillery batteries were to bombard the German lines.

The Germans had fortified the Chivres Spur and holding this commanding ground, they could force the BEF in the sector to keep their heads down. German artillery on the spur pounded the village at Missy. German snipers could fire down into the British line and prevent them from entrenching. Any British initiative to advance from Missy was stopped. There was no time to dig in; all they could do was to confront each determined German counter attack and cause significant losses.

Light showers fell over the Aisne Valley during 15 September and the reconnaissance aeroplanes of the RFC were able to get into the air and take photographs of German artillery positions, providing great assistance to the British artillery.

The heavy German artillery at the Chemin des Dames were the largest calibre guns ever seen by the BEF. They were hidden in the wooded spurs and quarries and the 11-inch 'Black Marias' outranged the British guns. Apart from the bombardment, lack of adequate entrenching tools further hindered consolidation of the British lines. Soldiers scavenged for any tools from farms and houses that would help them to dig for their lives.

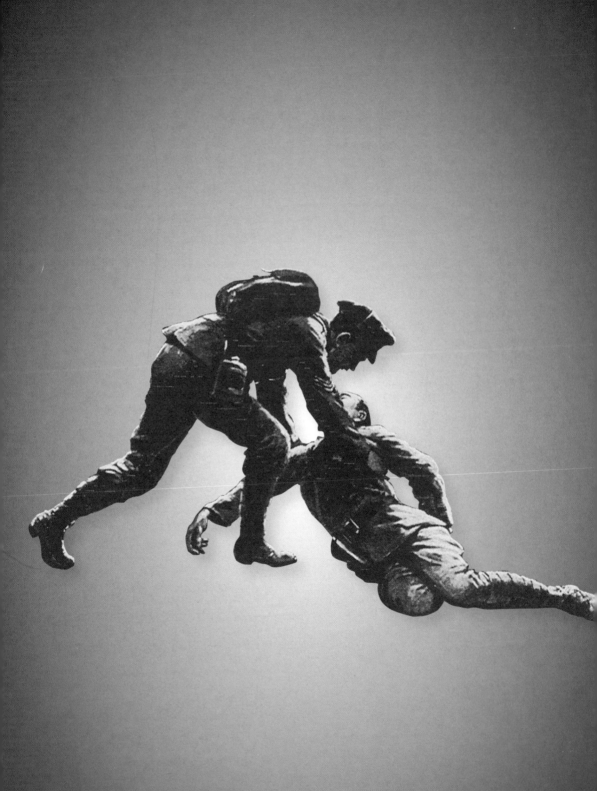

LA FOSSE MARGUET AND ROUGE MAISON

At dawn on 15 September, German forces began to dig trenches and consolidate a position close to the sector held by the British 3rd Division between La Fosse Marguet, 1 mile north east of Vailly and Rouge Maison. They were 200 yards north of a wooded area. Two companies from the 2nd Royal Irish Rifles were sent to capture their trenches, but they were met with strong opposition and incurred heavy casualties.

Major Charles Spedding of the 2nd Royal Irish Rifles was aware that German infantry were holding trenches 700 yards from their position at La Foss Marguet. He sent D Company commanded by Lieutenant Dawes to the edge of the wood to a position 300 yards from these German trenches. Spedding had given strict orders to the commander of D Company not to proceed beyond the wood. D Company had been gone for 20 minutes and no firing was heard. By that time Lieutenant-Colonel Wilkinson Bird commanding 2nd Royal Irish Rifles arrived at Major Spedding's position to assess the situation. Bird did not trust Lieutenant Dawes; he 'had no confidence in his judgement and feared he might make a rash attack'.[1]

There some uncertainty as to whether the enemy still occupied the trenches identified by Spedding: 'As the distance to the edge of the wood was not more than a quarter of a mile and as no firing had been heard, I concluded that probably the Germans had retired and ordered A Company to move forward east of the wood in support of D Company.'[2]

A Company commanded by Captain Durrant had fought the previous day. Corporal John Lucy from the 2nd Royal Irish Rifles wrote that he and the remnants of A Company volunteered to attack a German position close to La Fosse Marguet during the morning of 15 September. As they advanced German soldiers were seen running from their trenches. This was definite proof that the trenches were occupied and that A Company was advancing into the path of their machine guns. Bird wrote: 'I now saw what took to be a few Germans running away and as this seemed to show that their trenches were still held, signalled to A Company to halt.'[3]

Corporal John Lucy fought alongside his brother Denis, who was serving as a Lance Corporal in another

platoon in the battalion. John Lucy wrote of the moment they advanced towards those German trenches:

We fixed our bayonets, as the enemy were close, and sorted ourselves by sections along the plateau edge, searching for easy places to surmount so as to get on to the level of the plateau.

It cannot be said that the operation was very well organised. It was all too rapid, and we got no definite objective, our task being to engage any enemy on our front by advancing to find him and attack him. My brother's platoon suddenly got the order, unheard by me, and up went the men on the open grassland, led by their officer. Denis went ahead, abreast with this officer, too far in front of his section, I thought. He carried his rifle with the bayonet fixed threateningly at the high port, and presented a good picture of the young leader going into battle.

Not quite necessary for a Lance-Corporal. He was exposing himself unnecessarily and would be one of the first to be shot at. I raised myself high over the parapet of our cliff, and shouted to him: 'Take care of yourself.' And I blushed at such a display of anxiety in the presence of my comrades. My brother steadied a moment in a stride which was beginning to break into a steady run forward, and looking back over his shoulder winked reassuringly at me. The beggar would wink.

Forward he went, and out of my sight for ever. I had to forget him then because Lieutenant Waters drew his sword and signalled us. We rose from cover and doubled forward over the grass to the right of my brother's platoon. There was an uncanny silence. We could see fairly level wooded country and some cottages to our immediate front, backed by more broken landscape. With a sinking heart I realised that our extended line made an excellent target as we topped a slight rise and went on fully exposed across flat country without the slightest cover. The Germans were waiting for us, holding fire.[4]

John Lucy at that moment did not know of course if his brother Denis had survived this assault – but he carried

on with his job. Corporal John Lucy was correct, German forces were indeed holding their fire until 2nd Royal Irish Rifles were horribly exposed. Lieutenant-Colonel Bird sent his adjutant to Captain Durrant to relay the order to advance 'but to proceed with the greatest possible caution'.[5]

Major Charles Spedding brought up the battalion's machine-gun section to support A Company, but on its arrival German machine gunners unleashed their firepower upon the 2nd Royal Irish Rifles. Corporal John Lucy:

> As we cleared the crest a murderous hail of missiles raked us from an invisible enemy. The line staggered under this smash of machine-gun, rifle and shell fire, and I would say that fully half our men fell over forward on to their faces, either killed or wounded. Some turned over onto their backs, and others churned about convulsively. With hot throats the remainder of us went on, as there is no halt in the attack without an order.[6]

Corporal John Lucy chronicles an assault where there was poor communication, inadequate leadership, lack of orders:

> The wood on our left, through which the other company was advancing, seemed on fire, as it sparkled with bursting enemy shells, and then became almost hidden under a pall of rolling smoke. The wood was a shell-trap, and the company had 'bought it', as the troops curtly say. More men fell, but my section still went strong. Two men of the nearest section to our left fell, and both immediately sat up and began to tear open their first field dressings. They had been hit low, in the legs. A bullet ripped through the sole of my right boot as I ran on and jerked my own leg aside. For the next few paces I kept stamping my right foot on the ground, testing it and half expecting to see blood spurt from the lace holes. This low fire was a bloody business and most efficient – the kind of stuff we were taught ourselves. I believe I was now beginning to get really afraid of these Germans.[7]

A and D Company were in the wood and pinned down by German machine-gun fire. Lieutenant-Colonel Bird realised that the assault had failed and sent his adjutant to bring forward B Company to cover the retirement of the two other companies. His adjutant lost his way as the battle ensued. Bird had to find B Company and lead them from their reserve position. Bird wrote:

> Meanwhile D Company had succeeded in rushing a trench and taking a few prisoners, but being met

with heavy artillery fire and counter attacked was driven into the wood where A Company and the machine guns had also been forced to take shelter.[8]

With no officers, there were no orders and the battalion was in a state of confusion. Corporal John Lucy kept going forward amidst the chaos:

> The high rate of concentrated fire continued, and the men were now advancing in a very thin line, with most of their number scattered on the grass behind. No officer remained. A sergeant on the left shouted and the men nearest him got down into the prone position. We followed suit and hastily threw ourselves flat on the grass. Hardly had we done so when a machine gun raked the whole line, a weak and feeble line now, and shot accurately home into it.
>
> Some of the lying men flapped about; others, shot through the head, jerked their faces forward rapidly and lay still. I trembled with fear and horror. This was a holocaust. The relentless spray of the deadly machine gun traversed back along the line from the left towards us. The Catholic soldiers blessed themselves in a final act of resignation. But the curve of the traverse came luckily short as it swept across my section, and it traced the ground in front. Little spurts of earth showed the strike of each group of bullets, a few yards before our faces.[9]

At this stage Lucy could not identify the position of the machine guns. As he went forward he discovered an enemy machine-gun nest:

> By lucky chance or instinct I saw the enemy machine gun. There it was mounted daringly on the roof of a cottage, close to the left side of the chimney, about six hundred yards away and directly to my front. With all my strength I shrieked the range, described the target, and ordered five rounds rapid fire. There was a heartening response as we opened fire at the first and only target we had seen in this terrible attack.
>
> In about four seconds some thirty bullets were whistling about that dark spot near the chimney as we slammed in our rapid fire, glad to have to have work to do, and gloriously, insanely, and incredibly the German gun stopped firing, and then it disappeared as it was quickly withdrawn behind the roof.[10]

The 2nd Royal Irish Rifles withdrew. It was madness for these men to advance into positions where there was little intelligence to identify location and strength of

the enemy. The assault on German positions at La Fosse Marguet was a disaster. The 2nd Royal Irish Rifles lost 10 officers and approximately 150 other ranks. 2nd Lieutenant Henry Swaine and 2nd Lieutenant Richard Magenis were killed. Lieutenant-Colonel Bird estimated that a German regiment, a machine-gun company, two field and one or more heavy batteries were opposite the line held by the 2nd Royal Irish Rifles and Wiltshires. Bird gives the impression that he did not want an attack to take place and questions the officers commanding A and D Companies:

> I understand that the O.C. D Company who was wounded, subsequently stated that he was under the impression that he had been sent forward to attack the Germans. I asked the O.C.A Company, who was also wounded, when I met him at home, why he had attacked, and he said that he had a faint recollection of having been told to advance with caution, but seeing the other company attacking he did so too.[11]

At 5.00pm on 15 September German infantry launched a counter attack. Despite sustaining heavy casualties earlier that day the battalion fought off the enemy attack until 9.15pm, when the German assault subsided.

The 4th Royal Fusiliers had entrenched in a sunken road 200 yards south of Rouge Maison Farm and held this position despite heavy German shelling, which wounded two men. The shell fire exploding in and around Rouge Maison Farm during the day on 15 September made the position untenable and the two platoons holding the farm had no choice but to retire to the edge of Rouge Maison Spur. At dusk a platoon from X Company repossessed Rouge Maison Farm. During that night this platoon fought off a German infantry assault upon the farm with rifle and bayonet.

The 1st Northumberland Fusiliers climbed up along the wooded road between Maison Rouge Spur and Ostel Spur but after suffering heavy casualties were forced to withdraw. The Battalion was shelled throughout the day. The Germans attacked during the night but the battalion held their ground. Captain John Matthews was killed, Lieutenant Geddes and three men were wounded. German forces were attacking the 1st Lincolnshire's defending Ostel Spur. They were overwhelmed by the assault and by 1.00pm they were forced to retire to the south bank of the river.

Despite German efforts to fracture the line held by the British 3rd Division, the line held at Vailly remained static. Accurate marksmanship repelled the advancing German waves. As the battle raged, Royal Engineers continued the work of repairing the bridge at Vailly.

2ND LIEUTENANT HENRY SWAINE
2ND BATTALION ROYAL IRISH RIFLES

Henry Poyntz Swaine was born in 1890. He joined the Royal Irish Rifles as a 2nd Lieutenant on 5 October 1910. He was killed during the Battle of the Aisne on 15 September 1914. He has no known grave and his name is commemorated on the memorial at La Ferté-Sous-Jouarre.

2nd Lieutenant Henry Swaine, 2nd Royal Irish Rifles. (*Bonds of Sacrifice*)

CORPORAL JOHN LUCY
2ND BATTALION ROYAL IRISH FUSILIERS

John Lucy was born in Cork in 1894. He joined the Royal Irish Rifles with his brother Denis on 3 January 1912, his eighteenth birthday. Denis was a year younger, but he altered his birth date and because he was bigger than John he convinced the recruiting sergeant that he was old enough to serve. Within two years John had reached the rank of Corporal and Denis was promoted to Lance Corporal. They served together and sailed for France with the 2nd Royal Irish Rifles when war broke out. They fought at Mons and took part in the retreat to the River Marne.

John and Denis took part in the Battle of the Aisne in an action between La Fosse Marguet and Rouge Maison on 14 September 1914. During the following day Lance Corporal Denis Lucy was killed in action. His brother John recalled:

> Actually my brother was lying dead out in front, about three hundred yards away, all this time, and I did not get to know this for days. Only one man of his section had come back alive. That I did not know either. After some days this survivor told me that my brother was killed with the rest of the section by shell fire. He also confirmed that he had been wounded first.[12]

Denis Lucy has no known grave and his name is commemorated on the memorial at La Ferté-sous-Jouarre.

Corporal John Lucy carried on the fight despite the tragic loss of his brother. He fought at Ypres

Corporal John Lucy, 2nd Royal Irish Rifles. (*The Great War, I Was There*)

in November 1914 and by the end of the year was promoted to Sergeant. In December 1917 he sustained several severe wounds caused by a German grenade, to his knee, abdomen, thigh, arms and buttock. By the time that he had recovered the war was over. John Lucy continued to serve with the regiment when it became the Royal Ulster Constabulary in 1921. During the Second World War he was recalled as a reservist and went to France in 1940. He escaped to England via St Nazaire. He became a training officer and in January 1942 he was appointed Lieutenant-Colonel of the 70th Young Soldiers' Battalion, Royal Ulster Rifles. John Lucy died in Cork on 1 March 1962.

NOTES

1. WO 95/1415: 2nd Royal Irish Rifles War Diary.
2. Ibid
3. Ibid
4. Hammerton, Sir John (ed) *The Great War, I Was There* (The Almalgamated Press, 1938)
5. WO 95/1415
6. Hammerton
7. Ibid
8. WO 95/1415
9. Hammerton
10. Ibid
11. WO 95/1415
12. Hammerton

CHIVRES SPUR

The 5th Division were ordered to assault the Chivres Spur and positions east of Missy for a second time on 15 September. The 14th and 15th Brigades were ordered to repeat the attacks they made on the previous day across the same ground. The assault was scheduled to take place at 7.30am that morning but Brigadier-General Stuart Rolt, 14th Infantry Brigade Commander, insisted that artillery fired a preparatory barrage to soften the German defences, which had been greatly strengthened during the previous night in anticipation of another attack. As they waited for the artillery to bombard the German positions a German reconnaissance aeroplane flew over Missy at 8.30am and observed the village crowded with soldiers from the 1st Duke of Cornwall's Light Infantry. Captain Arthur Nugent Acland stated that the aeroplane flew over their position at 9.25am and wrote in his diary:

> By 9am they were still waiting for the artillery to shell the hill before they attacked. At 9.25am a German aeroplane flew right over and of course saw our village packed with these troops waiting to attack the heights. Mr Hammans and I had a bet as to whether the Germans would shell the village within the hour or not, for of course the aeroplane would go straight back and report what he had seen in Missy.[1]

Acland and the 1st Duke of Cornwall's did not have to wait too long. Very soon German artillery opened fire upon the village. Acland – who was in the village – narrowly escaped death as heavy calibre high explosive shells rained down upon Missy:

> At 9.55 it came. One shell dropped short first, then some thirty or forty right into the buildings on either side of the street the troops were massed in. The effect was somewhat startling, if one had had the time to be startled. One shell struck the Church, and at once a huge gaping hole appeared about ten yards in diameter, and great blocks of stone fell into the street and churchyard. Capt. Wetherley happened to be up with us at the time and I was just walking up the street with him. I think some guardian angel must have been watching over us, for three of these huge projectiles struck houses

just in front and behind us as we walked along. The powdered masonry fell on us until we both assumed the appearance of millers, and great lumps of stone fell all around us. I don't think that I was touched tho' perhaps I got a brick on my left foot, and he was only hit on the back of the hand by a splinter of stone. It is not possible to describe the scene properly; the roar of the explosion and rumble of the falling houses. It is a sight to see once (if possible from a distance!) and then no more. Remember all the time we were being sniped at by the Germans on the heights above and you can imagine that it was not a pleasant spot to be in.[2]

The German shells and the constant sniping made the position of the 1st Duke of Cornwall's in Missy untenable. They had to withdraw in a disciplined, organised manner. Acland wrote:

> We could not leave our men in there, and we could not abandon the village altogether. So we left B Company on the Western outskirts of the village in a house which had not been touched; (B Coy had held it all the time) and then we filed the remainder of the battalion out to the left rear of the village. The men were splendid – it takes a bit of doing to wait your turn to <u>walk</u> out of an inferno – yet they did it![3]

Three companies from the 1st Duke of Cornwall's evacuated the village. B Company remained in a house on the western perimeter. At midday B Company withdrew from the village and the entire battalion moved towards 14th Brigade Headquarters at St Marguerite. The route they took was along the railway line, which was protected by a bank that provided them with them some cover. At St Marguerite the Duke of Cornwall's were placed in reserve to support the Suffolks. By midday the German artillery bombardment had subsided and the 1st East Surrey Regiment occupied Missy.

The 13th Infantry Brigade was to advance towards the Chivres Spur from the south east. The 2nd Duke of Wellington Regiment crossed the river at Missy using rafts. As they approached the southern banks they suffered casualties from German high explosive shells.

The 2nd King's Own Yorkshire Light Infantry were unable to cross the Aisne because rafts were not ready, but they too were coming under attack and sustaining casualties on the southern bank.

The 13th Infantry Brigade was overwhelmed by German artillery and machine-gun fire and could not move down the Condé Road to the assembly position prior to the assault. The 15th Infantry Brigade came under heavy fire during the morning of 15 September. Lieutenant Jimmy Davenport from the 1st Bedfordshire Regiment:

> I went up and joined HQ which was on the road leading to Missy and we lay down by a dung heap and under cover. They shelled and sniped us all the time and the General stuck up his red hat on a stick and got it peppered. Shells were bursting all round us and spattered us with dirt and one went into the ground only a few feet from me but did not explode. There was a terrific attack going on and shrapnel, which was really very pretty to watch, was bursting in white clouds over our heads.[4]

The 15th Infantry Brigade was unable to force its way through the wood in an effort to seize Chivres Spur. The 1st Norfolk Regiment led the vanguard supported by the 1st Bedfordshire Regiment and tried to advance over territory that had been passed across the previous day. These British battalions slowly made their way through the dense undergrowth to encounter wire net fences six foot high. They attempted to cut their way through the wire.

German snipers concealed amongst the undergrowth and in the trees were able to shoot at the positions held by the 1st Bedfordshire Regiment along the line of the light railway on the edge of the village. The enemy snipers showed great ingenuity in placing the corpses of dead comrades in positions to act as decoys. Soldiers from the Bedfordshires would shoot at these corpses and would expose their position to the snipers. The British soldiers were exhausted after the retreat from Mons and then the advance to the Aisne. Some of them inevitably let their guard slip and came under the sights of the enemy snipers. Captain Ker was one exhausted officer who was killed by a German sniper. Lieutenant Jimmy Davenport from the 1st Bedfordshire Regiment:

> I went up to the front to see what was doing in an interval and was quite close to Johnnie Ker who was sitting on a bank. He got up and stretched himself and yawned saying that he was tired of it all and wanted a good sleep when a sniper shot him through the head and he died at once. Almost at the same time, if not with the same bullet, H. Courtenay

was hit in the eye but not killed. It was an awful blow losing poor little Johnnie. Major Onslow, Mayne and Edwards were also wounded and I helped Onslow back and saw him into an ambulance. Sniping was getting pretty bad and the Germans very wily about it all, putting up their dead in a position for us to shoot at and to act as decoys.[5]

Direct machine-gun fire from Chivres Spur poured from above upon the 1st Duke of Cornwall Light Infantry and the 2nd Manchester Regiment, which stopped their advance. As these battalions faltered, supporting battalions from the 14th and 15th Infantry Brigades became congested as they tried to pass through Missy.

The decision was made at 11.00am to appoint Brigadier-General Stuart Rolt, commander of the 14th Infantry Brigade, to command all British forces holding positions north of this sector of the river Aisne. Unable to dislodge the enemy from the Chivres Spur it was decided to consolidate the line between Missy and St Marguerite. The 15th Infantry Brigade was withdrawn south across the Aisne river and placed in reserve.

The British withdrew to a line which ran from St Marguerite to the banks of the Aisne between Condé and Sermoise. The 5th Division dug trenches along this line and held this position throughout the Aisne battle. This was a perilous position – the Germans were just 400 yards away on the Chivres heights and could see them clearly. This was the farthest extent northwards of the Allied advance.

Rain fell heavily during the evening of 15 September. The 5th Division made a spirited attempt to dislodge German occupiers from Chivres spur, but this only resulted in further losses. If they had captured the plateau at Chivres then the German position at Condé would have been compromised and the village would have been evacuated. Condé was not taken in 1914 and would remain in German hands causing problems to Allied commanders until it was taken by French forces during the spring of 1917.

Confusion reigned during that day. One man reported to Lieutenant Davenport that the Lieutenant was one of the fatalities. Davenport was very much alive and during that night he and his battalion, the 1st Bedfordshires, settled down in their positions close to Missy. They hoped it would be a quiet night but they were startled by their first experience of German forces using flares:

> While we were forming up a tremendous attack started and the Germans fired star shells for the first time. These lit up the whole place and as we had never seen them before and did not know what

they were, we all got the wind up badly. Here we were in Column of Route in full view of the enemy who answered us with bullets and there was a bit of panic to get down under cover for a minute of two. I was pushed into a ditch and had about 50 fellows on top of me.[6]

NOTES

1. Captain Arthur Nugent Acland: Courtesy Cornwall's Regimental Museum
2. Ibid
3. Ibid
4. Lieutenant Jimmy Davenport's Account: Bedfordshire & Luton Archives
5. Ibid
6. Ibid

CHIVY VALLEY

During the morning of 15 September the 1st South Wales Borderers and 2nd Welsh Regiment were entrenched in positions south west of Cerny. At sunrise, 5.30am, a party of German soldiers was seen approaching the trenches held by the 2nd Welsh Regiment. This assault was repelled and another more substantial attack from the north east was launched on the 2nd Welsh Regiment and 1st South Wales Borderers positions at 7.00am.

A and C Companies were severely enfiladed from the right flank and were forced to withdraw to a new position on the edge of a wood north of Chivy. They brought with them German prisoners taken the previous night. Lieutenant-Colonel Harry Leach commanding the 1st South Wales Borderers established battalion headquarters along a road less than a mile north east of Chivy. The new line was formed on the northern perimeter of a wood. A and C Companies were sent to battalion reserve. B and D Companies had held their positions there throughout that morning. As well as enduring German shell fire and fire from infantrymen they also came under fire from their own British artillery when shells fell short. It was a terrible situation.

When a German officer called out to speak to a British officer, the commanding officer was apprehensive knowing of other units' past experiences with German soldiers who offered to surrender and then opened fire. Captain C.J. Paterson:

> One of the officers called out to us that he wished to speak to an officer, but after the episode at Landrecies with the Guards, we weren't having any of that. I have no doubt that they really did wish to surrender but they must do it properly as one man did this morning and march up with his hands above his head and no arms upon him. So we opened fire, and although we lost some men we wiped them out at 200 yards, and there they lie in front of us. Poor devils.[1]

German artillery enfiladed the positions held by B and D Companies of the 1st South Wales Borderers soon after this incident. Captain Paterson recalled that they were ordered to hold their ground: 'We were told we were to hang on at all costs and at all costs it had to be. We lost severely and it was a very bad business.'[2]

These two companies valiantly held on and were even able to strengthen their positions. German snipers were also operating from within woods close to their lines. Captain Marwood Yeatman and his batman crept into the wood, crawling through the undergrowth they stalked their prey and Yeatman was able to shoot one sniper with his revolver. Yeatman was shot and killed as he was returning to his company.

C Company from the 1st South Wales Borderers was left in reserve while A Company was sent to Mont Blanc in an effort to link up with the 2nd Welsh Regiment At midday the battalion received a message from Field Marshal French praising the 1st Division for holding onto their positions and allowing the remainder of the BEF to cross the Aisne.

Hungry and exhausted German soldiers who had had enough were coming towards their lines with their hands up. 'We have had a good few German prisoners and many Germans wounded have come through our hands, poor fellows, absolutely done and half-starved.'[3]

Many wounded British soldiers were crying out in front of their position. Captain Paterson: 'The sights were ghastly. Wounded crying all night for help and no one to help them. The doctors have done all they can, but the casualties are heavier than they can easily cope with.'[4]

The 1st South Wales Borderers held on to their position at all costs as ordered, but they had paid a heavy price. Since they entered the battle on 14 September Captain Marwood Yeatman and 18 other men were killed. Lieutenant Mervyn Johnson died of his wounds. 2 officers and 76 other ranks were wounded and 122 were classified as missing. However, 68 of those men listed as missing had become detached from the 1st South Wales Borderers during the night and had linked up with the 5th Infantry Brigade in the west. Therefore the estimated overall casualties for the battalion on 14/15 September amounted to approximately 150 men. On 16 September Captain Paterson wrote in his diary of the carnage in the Chivy Valley:

> Here I sit outside our Headquarters' trench in the sun. The rain which we have had without a break for the past two days had now stopped and the world should look glorious. The battle has stopped here for a bit although in the distance we can hear the 2nd English Army Corps guns and their battle generally.

As I say all should be nice and peaceful and pretty. What it actually is is beyond description. Trenches, bits of equipment, clothing (probably blood-stained); ammunition, tools, caps, etc, etc, everywhere. Poor fellows shot dead are lying in all directions. Some of ours, some of the 1st Guard Brigade who passed over this ground before us and many Germans. All the hedges torn and trampled, all the grass trodden in the mud, holes where shells have struck, branches torn off trees by the explosion. Everywhere the same hard, grim, pitiless sign of battle and war. I have had a bellyful of it. Those who were in South Africa say that that was a picnic to this and the strain is terrific. No wonder if after a hundred shells have burst over us some of the men want to get back into the wood for rest. Ghastly, absolutely ghastly, and whoever was in the wrong in this matter which brought this war to be, is deserving of more than he can ever get in this world.[5]

The 1st South Wales Borderers would spend the next five days holding trenches in this sector. The men learnt very quickly the requirement to dig as deeply as possible in order to afford some cover from the German shelling. Such was the ferocity of German artillery that on 19 September the battalion was compelled to evacuate its headquarters in the village at Chivy and relocate behind Vendresse Ridge. They also came under sniper fire during the day and at night both sides were apprehensive of further attacks, so that rifle fire was continual. German infantry did try get into the South Wales Borderers' positions under the cover of darkness during those five days but failed. On 19 September a mass of German infantry up to 500 men in strength advanced upon A, D and C Companies' positions but was repelled. Another attempt by 150 German infantry was made on the night of 20 September but was fought off. The South Wales Borderers were locked in the misery of trench warfare, where no side could advance.

NOTES

1. WO 95/1280: 1st South Wales Borderers War Diary
2. Ibid
3. Ibid
4. Ibid
5. Ibid

SUGAR FACTORY, CERNY

By the morning of 15 September the 1st Loyal North Lancashires had deepened their trenches at Troyon south of the Sugar Factory. German infantry units were holding trenches just south of the factory. The Loyal North Lancashires had spent a cold night in their trenches as heavy rain fell. During that night several stragglers from previous attempts to take the Sugar Factory rejoined the battalion and some of the wounded managed to crawl to their lines.

The 2nd King's Royal Rifle Corps were roused at 3.00am that morning and it was intended that they were to launch an advance, but this action was abandoned. Instead they held onto their trenches and fought off numerous counter attacks through the day.

German artillery began bombarding trenches held by the 1st Loyal North Lancashires from 5.30am until 11.00am. Once reinforcements had arrived, German forces launched a counter attack at 2.00pm and tried to come round on the 1st Loyal North Lancashires' right flank. An anonymous 2nd Lieutenant reported that 'they were driven back at the point of the bayonet with heavy loss and some prisoners'.[1]

At one point during this engagement both British and German soldiers ceased fire. The 2nd Lieutenant from the 1st Loyal North Lancashire Regiment recalled this unusual incident:

> Another curious thing happened during the action. Both sides ceased fire and stood up, each thinking the other wished to surrender. Captain Watson, Queen's Regiment, who was acting Brigade Major, galloped out to them to accept their surrender, but on getting up to the officer in command was informed that they thought he wanted to. He turned round and came away, being fired at but not hurt, and the fight was resumed.[2]

On 15 September, Major J.T.C. Murray assumed command of the 1st Black Watch because its commanding officer, Lieutenant-Colonel Adrian Grant Duff, had been killed the previous day. At daybreak he ordered C Company supported by D Company to move forward on a reconnaissance operation to ascertain if German forces still occupied the Vendresse Plateau.

They immediately engaged the enemy with rifle fire as soon as they ascended the ridge, then a barrage of German artillery shells poured upon their position. At one point German infantry tried to trick the 1st Black Watch into thinking that they wanted to surrender. Captain Axel Krook:

> Early on the morning of the 15th 'C' company was heavily shelled, and reported the advance of hostile infantry – fire was opened, and they raised the white flag, but we knew that dodge and took no notice; eventually 'C' company were shelled out of their position, and they retired.[3]

D Company went forward to support C Company but they had sustained casualties including 2nd Lieutenant Geoffrey Polson killed and Captain Green wounded. Such was the ferocity of the German artillery fire that both companies were compelled to withdraw.

With persistent shelling it was imperative that they dig trenches. It was of course difficult to consolidate the ground occupied and dig trenches while the enemy was bombarding their position. 'We were shelled all day while digging.'[4]

Sappers from the 26th Field Company, Royal Engineers, were sent forward to support the battalions from the 1st Guards Brigade. Their war diary recorded: 'Ordered to assist 1st Guards Bde in trenches on southern edge of hill N.W. of VENDRESSE. Arrived there under very heavy shell fire, assisted Black Watch and Camerons to dig themselves in, bivouacked in trenches.'[5]

The 1st Black Watch was suffering in the atrocious weather, and it was difficult to bring much needed hot food and drink to the front line under the shell fire. Owing to the heavy casualties, reserves were scarce and the men from the Battalion were ordered to hold. Private John Laing from the 1st Black Watch recorded in his diary:

> ... shelling us continually, lost our platoon officer, the first to go this morning and a lot of men wounded. Only 1 officer left in our company out of 4 ... 5pm still as thick as ever and raining heavy. 10pm got a drop of tea not very warm but very

thankful of it all the same, still raining very hard. Got warned that the enemy were going to attack our position and that we were not to retire at any cost, every man to die at his post as we were holding the main position. It was only a light attack, nothing occurred.[6]

The 1st Northamptonshire Regiment was also engaged with the enemy on 15 September. Captain Gordon was in command of a detachment comprising 2 officers and 160 men from the 1st Northamptonshires entrenched in positions ahead of the main British line close to Troyon. A party of 250 German soldiers were holding trenches 250 yards away. The 1st Northamptonshires' trenches were knee high in water. Captain Gordon who momentarily got out of his trench was shot and killed. Soon a senior lieutenant took command of the party, but he was also killed. 2nd Lieutenant Burlton, who had served less than a year in the Army, assumed command. Corporal John Stennett wrote:

> The battle still in full force, we were now waiting for the French Army to help us. At 12 noon we had orders to prepare to advance. The Germans were only 70 yards from us so we knew it would mean a charge, as at 1pm we went in and we captured their trenches but I am sorry to say with the loss of Captains White and Gordon, both killed and we forfeit the position we gained later in the afternoon. In this retirement one of my friends is now a prisoner of war. Private P. Bradley was wounded. During the evening we were told that the enemy had retired having a strong rearguard to hold the position while the main body made their new line strongly fortified. Being in the same position as we were at the beginning of the day we thought of making ourselves comfortable for the night but we were kept busy by the enemy attacking, without result.[7]

French infantry took up positions on the right flank of the Queen's Regiment and were able to provide enfilade fire upon the German assault. The German attack faltered and as they withdrew their artillery fire ceased.

During the evening the alarm was raised at 9.30pm on the 2nd King's Royal Rifle Corps front close to Troyon and the Battalion was stood to arms. When nothing happened they were stood down. Men who were wounded on the 14th managed to crawl back to their lines during the night of the 15th. The 2nd King's Royal Rifle Corps war diary recorded:

> During the night some wounded men came in. They were all shot in the legs or in such a way

as to prevent them walking. They had been hit during the morning of the 14th and had lain out between the two fighting lines all that day and the following night and day. At last in desperation they determined to try and get in. A German officer appears to have treated them kindly during the fighting, pulling them in under cover of a haystack. All the men who could walk had been taken prisoner and had been marched off after we had withdrawn to the trenches on the afternoon of the 14th. The others who had been left started after nightfall, dragging themselves along with their hands as best they could through the turnips in the pouring rain. Some had one, some both legs broken, but they helped each other along towards our trenches. They were shot at as they came in; one man continued to crawl forward and fell fainting into the trench, and the remainder, about 15 in number, then got in, including Sergeant Hinge amongst them.[8]

CAPTAIN ROBERT GORDON
1ST BATTALION NORTHAMPTONSHIRE REGIMENT

Robert Eddington Gordon was born in 1877 at Ellerslie, Toorak, Melbourne in Australia. He was educated at Toorak College in Melbourne and then by private tutors in Edinburgh in Scotland. After completing his education he returned to Australia where he joined the Military Forces, Victoria, as a 2nd Lieutenant. In December 1897 he joined the 1st Northamptonshire Regiment in Peshawar. He was promoted to Lieutenant in 1900 and five years later was promoted to Captain. During 1905 he left India to join the 2nd Northamptonshire Regiment based in England. He was seconded to the West African Frontier Force from November 1907 to December 1911 when he rejoined the 2nd Northamptonshire Regiment. At the outbreak of war he went to France with the 1st Northamptonshire Regiment, fighting at Mons and the various rearguard actions to the Marne. On 15 September he was leading his men to German trenches on the Chemin des Dames when he was killed by a shot to the head. He has no known grave and his name is commemorated on the memorial at La Ferté-sous-Jouarre. Gordon was likely to have been the third Australian-born officer to be killed in action in France.

Captain Robert Gordon, 1st Northamptonshire Regiment. (Bonds of Sacrifice)

PRIVATE F. TIMSON

1ST BATTALION NORTHAMPTONSHIRE REGIMENT

Private F. Timson was wounded during the Battle of the Aisne. In a letter home to his parents he wrote:

> I never expected to come out alive. The bullets flew around like rain, but I had the good luck to only get shot in the foot. I crawled about half a mile to get out of the firing line and then stretcher bearers picked me up. The worst day was September 15th. We lay in the trenches and were being shelled all the while, but the worst was when the enemy were firing on us with rifles and we had the order to advance.[9]

Private F. Timson, 1st Northamptonshire Regiment. (*Northampton Independent*, 3 October 1914)

BOMBARDIER ERNEST HORLOCK 42617 VC

113TH BATTERY, 25TH BRIGADE, ROYAL FIELD ARTILLERY

Ernest George Horlock was born in 1885 at Beech Farm, Alton, Hampshire. It is thought that Horlock

Royal Field Artillery Bombardier Ernest Horlock VC. (Author)

joined 113th Battery in 1907 and by 1914 he had reached the rank of Bombardier. On 15 September 1914 Bombardier Ernest Horlock was a member of a gun crew from the 113th Battery firing shells upon German counter attacks. During that day the battery came under heavy German artillery fire. 'Jack Johnsons' were falling around their position close to Vendresse. One shell exploded beneath Horlock's gun, killing one of his crew members. Horlock received splinters in his right thigh. He went to a dressing station where a doctor dressed his wounds and ordered him to go in an ambulance to hospital. Despite the doctor's advice he returned to his battery where he continued to work his gun. Five minutes later he received wounds to his back and returned back to the dressing station. The same doctor asked him why he did not go to hospital. Horlock replied that he could not find an ambulance.

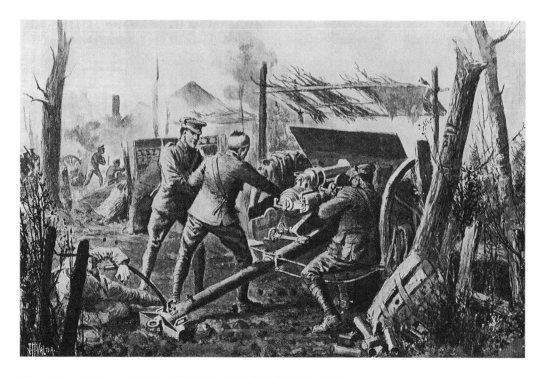

The actions of Sergeant Horlock VC. (*Deeds that Thrill the Empire*)

When the doctor dressed his wound he placed Horlock under the supervision of an orderly and exclaimed, 'If he can walk to the battery he can walk to hospital.' While being escorted to hospital he pointed out to the orderly casualties that needed his attention and said that he could get to the hospital by himself. The orderly agreed, and Horlock once again returned to 113th Battery. Horlock was soon wounded a third time, getting splinters in his arm. He was afraid to return to the dressing station because he could not face the doctor and remained at his post. When Horlock's officer notified the doctor of what had happened, Horlock was reprimanded. Horlock was awarded the Victoria Cross for his conduct at Vendresse. His award was gazetted on 25 November 1914. King George V decorated Horlock at General Headquarters in France on 3 December 1914. Horlock also received a promotion to Sergeant.

Horlock continued to serve with 113th Battery until February 1916 when he was promoted to Sergeant Major and transferred to D Battery, 119th Brigade, Royal Field Artillery. In September 1916 he was sent to Salonika with 301 Brigade SAA Column, 60th (London) Division. In July 1917 he was transferred to the Base Depot in Egypt. He married Ethel Hasted the following month in Littlehampton, England, on 13 October. Towards the end of November he left England to return to Egypt. He travelled across France to Marseille where he boarded the RMS *Aragon* which was bound for Alexandria. On 30 December, RMS *Aragon* was within ten miles of reaching her destination when a German submarine fired two torpedoes into her hull. The vessel capsized and sank within 30 minutes. Horlock was amongst the 610 lost. His remains were recovered from the Mediterranean Sea and buried in the British Military Cemetery at Hadra.

NOTES

1. WO 95/1270: 1st Loyal North Lancashire Regiment War Diary

2. Ibid

3. Krook, Captain Axel, *1st Black Watch Memoirs* (Black Watch Museum)

4. Ibid

5. WO 95/1252: 26th Field Company, Royal Engineers War Diary

6. Private John Laing, 1st Black Watch, Diary, The Black Watch Museum

7. IWM 79/33/1: Corporal John Stennett, 1st Northamptonshire Regiment

8. WO 95/1272: 2nd Battalion King's Royal Rifle Corps War Diary

9. *Northampton Independent*, 3 October 1914

LA COUR DE SOUPIR FARM

The 4th Guards Brigade was still holding La Cour de Soupir Farm on 15 September. Stretcher parties were sent out after daylight searching for wounded from the previous day lying in the thick undergrowth in the woods nearby. The parties were soon observed by German soldiers, who opened fire. The stretcher bearers were promptly withdrawn. Many of the wounded were concealed by the foliage in the wood and some bled to death because they were not found and evacuated in time.

German artillery began their merciless bombardment of La Cour de Soupir Farm from 4.30am and then throughout the day. It was here that the battalions from the 4th Guards Brigade would learn the importance of the spade in modern warfare. However the entrenching tools issued by the British Army proved to be inadequate for the digging of deep defensive trenches. The unit history of the Coldstream Guards recorded:

> Our whole line was now subjected to the fire of very powerful artillery, which was not to be silenced by our guns, and rained large high-explosive shells upon our troops. The main difficulty was to get cover from this fire. The tools the men carried in the field were sufficient to make shallow trenches, but not to excavate earthworks which would afford adequate protection against this superior armament. Better tools were being collected, but until they were distributed our tenure of the ground we were occupying was not too secure.[1]

British artillery could not respond effectively and some British shells fell upon their own lines. One man was killed and eight men from the 2nd Coldstream Guards injured by a British shell falling short. Sergeant Arthur Lane with No 1 Company, 2nd Coldstream wrote in his diary:

> Still in trenches; very wet and cold. At 4 o'clock am the Artillery opened their fire. At 8.30 we heard we might get some tea. It is now 9.40 o'clock and still no sign. Shell firing is pouring down. We remained in trenches until 8 o'clock when No.4 Company relieved us.[2]

Sergeant W.J. Cook from the 2nd Coldstream Guards wrote: 'The enemy commenced bombarding at 3.30am

and kept up a terrific shelling which made one feel as though one would sooner have one's feet under the table at home.'[3]

Major George Jeffrey commanding the 2nd Grenadiers Guards was concerned for the well-being of Prince Alexander Battenberg, as he led a flanking party west of the La Cour de Soupir–Chavonne Road and had been missing since the previous day. Prince Alexander was found in Chavonne in the morning of 15 September. At midday German artillery increased the intensity of their bombardment. The Battalion was able to evacuate some of the wounded from the farm. They were unable to bury the dead until dark when they were safe from artillery. No chaplain was available so Major George Jeffrey stepped in to carry out the services with his Adjutant Pike shining an electric torch on the pages of the Bible. Two large graves were dug for the British and German soldiers while the fallen officers were taken to Soupir Churchyard where they were buried.

German infantry launched an attack at La Cour de Soupir Farm but was stopped by two companies from the 2nd Coldstream Guards. Approximately 250 German prisoners were captured. The 2nd Connaught Rangers were relieved and escorted these German prisoners to Soupir. Sergeant John McIlwain wrote:

> We settle in billets in Soupir village under the hill. With the help of the Germans we make great fires in the churchyard. Cigarettes are swapped with our prisoners and those who can speak English appear to be pleased with their situation. They are said to be mostly Bavarians, mostly small men.[4]

Private L. Kilcoin from the 1st Irish Guards described his experience at La Cour de Soupir Farm:

> About 1.00am ordered to dig in – we did this but only made shelter pits for rifle fire – when day broke all quiet – about 10.00am our artillery observing officer galloped out about a quarter of a mile in front of us to a ridge. Here he pulled up and stayed for quite a while looking for the German positions. He would only just return when the shrapnel started to burst all around that ridge. The officer got back safely, but the shelling continued rigorously – our artillery very weak in comparison. About 11.30am

one of our guns destroyed the German Jack Johnson (almost the first we had seen). Learned after that practically all our gun team horses killed – Jack Johnsons kept shelling our artillery positions regularly now, our guns answering very feebly. No large guns with us a very few 18-pounders. Put in an awful day. No water and no food. About 5.30pm a German Taube flew over and along our lines very low, evidently not having seen us. We opened fire on it, but without effect, she promptly altered course and before many moments we were showered with Jack Johnsons, our trenches being blown to bits – obliged to evacuate them and retire across open ground. The Germans seeing us retreat sent shrapnel over galore but we all got through to a new position safely. Took up position in natural caves. In morning

with 3 more men of my own company succeeded in finding our company and joined them in Quarry (near where we had made the bayonet charge the previous afternoon).[5]

During that evening Field Marshal French issued Operation Order No.26: 'The Commander-in-Chief wished the line now held by the Army to be strongly entrenched, and it is his intention to assume a general offensive at the first opportunity.'[6]

There was no talk of pursuit of the enemy, this was the first recognition by the commander of the BEF that although it was his intention to launch an offensive, he did not know when he would be in a position to do so. The construction of the Western Front had begun.

NOTES

1. Bladensburg, Lieutenant-Colonel Sir John Ross of, *The Coldstream Guards 1914–1918* (Oxford University Press, 1928)
2. IWM 81/14/1: Sergeant Arthur Lane, 2nd Coldstream Guards
3. IWM P278: Sergeant W.J. Cook, 2nd Coldstream Guards
4. IWM 553796/29/1: Sergeant John McIlwain, 2nd Connaught Rangers
5. Private L. Kilcoin's Diary, Irish Guards Regimental Headquarters Archives
6. Edmonds, Brigadier-General J.E., *The Official History of the War: Military Operations: France & Belgium 1914* (Macmillan & Co, 1933)

16 SEPTEMBER

The day began with mist and heavy rain. It saw both British and German forces digging and fortifying their trenches. The war had been transformed from one of mobile offensives into a static, defensive conflict. The German III Corps (on the Soupir front) and the VII Reserve Corps at Cerny were ordered to renew their attacks in an effort to break through the British lines north of the river Aisne. Commanders from the III Corps insisted that they could not proceed with their attack until VII Reserve Corps attacked Haig's I Corps at Vendresse. The two divisions from VII Reserve Corps were unable to penetrate the British lines and the intended assault became a stationary fire fight.

The rain and mist cleared by 8.00am and as soon as the weather changed for the better, German artillery let loose. With shells raining down upon the Aisne valley the priority for the British soldiers was to dig deeper trenches. The deeper they dug, the safer they would be. The Germans occupied their time by strengthening their defences, digging deeper and erecting barbed wire entanglements in front of their trenches. They had received a train load of tools and equipment to build trenches on 14 September. The soldiers of the BEF only had limited amounts of barbed wire and sand bags. They could only dig for cover with the basic trench spades that they carried. They found it difficult to dig trenches close to the river because of the rocks and hard soil. The shallow trenches that they had managed to dig were very narrow measuring two feet in width. Some collapsed under the high explosive shells, burying the occupants alive in many cases.

As both sides laboured, British and German sharpshooters found positions to harass their opponents. The 26th Field Company, Royal Engineers were setting up barbed wire fences along the 1st Guards Brigade's sector north west of Vendresse and their war diary emphasises the close proximity of the enemy: 'Put up about 300 yards of single stretch of barbed wire on posts ... Germans entrenched about 350 yards away from place where we were working.'[1]

The 1st Loyal North Lancashire Regiment strengthened their trenches during the early hours of the morning. German artillery began to shell the vicinity of Troyon from 9.00am and snipers were operating throughout the day. The battalion began the gruesome task of burying their dead. At 5.00pm British guns opened fire on German positions and 45 minutes later heavy German guns retaliated wounding two men of the battalion.

The 4th Royal Fusiliers, holding the 3rd Division front close to Rouge Maison Farm, could also almost look the enemy in the eye:

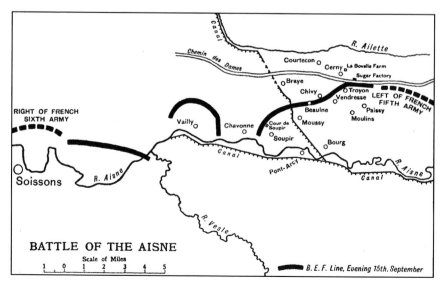

BATTLE OF THE AISNE

Position on the Aisne on 15 September. (*The Annals of the King's Royal Rifle Corps*)

Still holding on to position. All ranks doing splendidly. Still improving on entrenchments. The enemy can be seen between 2 and 300 yards from our position, also entrenched. A good deal of sniping in this place, but we have very few casualties.[2]

Corporal John Stennett, 1st Northamptonshire Regiment, led 14 men across open ground to bolster the strength of B Company. As they dashed in front of the enemy across open ground, Stennett lost all his men:

The battle was still in full force, the French Army having come up to assist us taking up position on our extreme left. 'B' Company had during the night advanced about 20 or 30 yards and entrenched over the ridge which I may mention was not a very pleasant spot, if you showed your head it was all up as the Germans had some very keen shots on the look out. At 2pm we received notice that 'B' Coy had suffered heavily and that 1 section of 'C' Coy would have to reinforce them. I was detailed to take No.2 section. Before going we were told that as soon as we got to the top of the ridge we should come under heavy fire so we should be exposed to the enemy and must run like H___ rabbits. So before starting I told each man to look after himself and away we went. I thank the Lord I went first as I was practically in the trenches before they saw what was happening. They sent a shower of bullets across the piece of ground we came over and of course I lost all my men. I was the only one to get to 'B' Coy safe. When it was dark I went back over the same ground only to find 12 killed and on arrival at my own Company they told me the other two were wounded. I reported the same to my Company officers. Captain R.B. Parker who already knew. I said I should never get killed after that.[3]

H.J. Milton from the 2nd Highland Light Infantry recalled the shelling: 'Up at 4.30 soaked to the skin still raining and I am very cold, shelling started at once. We moved from our place but got into worse, shells dropping all around us, had to run for cover and lay under shrapnel all the time.'[4]

At La Cour de Soupir stretcher parties were sent out on 16 September at dawn. Many wounded were found, but at daylight German artillery thwarted the attempts to look for more with shell fire.

The 4th Guards Brigade holding Cour de Soupir Farm came under severe German artillery fire at midday. The commanding officer of the Guards Brigade was so concerned by the accuracy of the German guns that he ordered a temporary withdrawal to the shelter of a sunken road. 2nd Grenadier Guards Battalion Headquarters was removed from the farm and relocated with the horses into the quarry.

This violent artillery barrage was the precursor to a counter attack. The trenches held by the men from the battalions of the 4th Guards Brigade skirted the perimeter wall of the farm at Cour de Soupir. A shell landed in the trench occupied by Lieutenant Welby killing him and two other men. Welby had been wounded in the shoulder two days previously during the defence of the farm and despite his wounds, insisted that he remained on duty.

The perpetual bombardment meant that it was difficult to bring rations to the front and when they did arrive, the supplies were consumed swiftly and many soldiers were left with nothing. Private Kilcoin of the 1st Irish Guards:

Though pleased to be back with the company and very much relieved, still without a bite to eat. Rations had been issued just before and we found nothing left for us – after a time some of our pals scramble together a few bits of biscuit and bully and some water, which we only too gladly accepted – shelled here rather furiously during the day, but got off very lightly. Only one of our men killed – a man of my Coy. – killed by shrapnel.[5]

Shells continued to fall throughout the morning. Captain Ridley and two men of the 2nd Grenadier Guards remained in a position on top of a large corn rick east of the farm on the right flank, where they sniped at a German fire observation post, which was 1100 yards away and directing artillery fire upon the farm. Undeterred by the horrendous shells that exploded around them they remained at their post until 11.00am, when the rick was set on fire. Dazed, he and the two snipers who were with him, both wounded, had to abandon their sniper's nest. With the rick on fire German artillery observers could more easily pinpoint the farm and poured shrapnel and high explosive shells onto it. Had they had known that many German wounded were occupants receiving medical attention within the farm, they might not have shelled the position so enthusiastically. Soon the farm at Cour de Soupir was ablaze. One of the farm's barns was on fire and it was being used as a hospital; 50 wounded German soldiers were still inside. Major Matheson, commanding the 3rd Coldstream Guards, called for volunteers to go back into the barn and evacuate the German wounded. Major Steele and Doctors Huggan and Shields stepped forward with men from No.1 Company commanded by Lord Fielding. There began a desperate effort to get the wounded, both British and German, out of the burning building. The rescuers did not distinguish between British or German, armed with a sense of humanity and unquestionable courage they evacuated the wounded men. These brave volunteers dodged the German

shells in order to reach their foes and take them to the safety of a quarry. Every wounded German soldier was evacuated from the burning barn.

Major George Jeffreys, commanding the 2nd Grenadier Guards, ensured that the evacuation was carried out in an orderly manner, making all walk to safety instead of running to avoid a stampede. Jeffreys, who had relocated his Battalion headquarters to the quarry, thought that German infantry was about to launch an assault on the burning farm and the quarry. He ordered No.2 Company from 2nd Grenadier Guards to leave their position in the quarry and to man its northern ridge where they could provide support to comrades holding the front trenches. Within fifteen minutes of their deployment an 8-inch high explosive shell missed the farm but exploded on their position. The explosion killed and wounded 59 men of No.2 Company. Only 44 men from the company remained unharmed. The entire quarry was filled with a dense yellow-black smoke and as it lifted it revealed a terrible scene of death and carnage. Major Jeffreys:

> Early in the afternoon the shelling became very intense both on the trenches and on the woods in the rear. All kinds of guns were firing, from field guns to very heavy howitzers. We got all the troops closed up close under the steep north bank of the quarry: the bank was not too steep to climb and had little ledges on it, on which a certain number of men sat. As the shelling seemed to portend an attack, I moved No.2 Coy up to just below the top edge, so as to be handy for counter-attack. I sat with Pike (Adjutant), Bernard Gordon-Lennox, and George Powell near the top of the bank, so that we could look over occasionally. We sat there for over an hour quite unscathed, while the shells roared and screamed overhead and crashed into the wood farther down the slope. The trenches were mostly shelled with light stuff, the heavy shells going farther over. The noise was so continuous that one couldn't hear any single shell, and we were smoking our pipes and getting quite used to it when the unluckiest thing possible happened – a heavy howitzer shell just cleared the edge of the quarry and burst amongst the troops at the bottom of the slope, killing and wounding a great number, both of those at the bottom, and of those sitting up the slope, Neither I nor the three officers with me (Bernard Lennox-Gordon, Pike, G. Powell) were touched, though we were right in the blast of the shell. It was an awful sight – dead and wounded men lying all round.[6]

Lieutenant Reginald Worthington, Lieutenant Hugh Mockler-Ferryman and 2nd Lieutenant Paul Girardot and 28 men from C Company of the Oxford & Buckinghamshires who were attached to the 4th Guards Brigade were also killed by this shell. Captain C.G. Higgins, Captain R.C. Evelegh, 2nd Lieutenant Tylden-Patterson and eight other ranks were wounded. The company was billeted in a large cave near Cour de Soupir Farm and were hit just as they were leaving to form up outside. Evelegh and Tylden-Patterson were able to return to duty two days after they were wounded. Lieutenant Huggan from the Royal Army Medical Corps was also killed. Huggan was a Scottish International Football player prior to the war and had distinguished himself at Landrecies and Villers-Cotterets. Huggan was buried in the grounds of the farm, but his grave was lost during the course of the war and his name is commemorated on the La Ferté-sous-Jouarre Memorial.

Some of those wounded British and German soldiers who had been evacuated from the burning barn to the safety of the caves in the quarry were either killed or sustained further wounds. With Lieutenant Huggan amongst the dead, there was no doctor to tend to the wounded. Jeffrey wrote:

> ... and I shouted for the doctor – Huggan, R.A.M.C., attached 3rd Coldstream – whom I had just seen previously. There was no answer, and I shouted again, 'Where's the Doctor?' Someone said, 'Here Sir', and I saw he was dead. There was no other doctor and the stretcher bearers tied up wounds as best they could with the 1st Field dressings, and we moved some of the wounded into some small caves in the quarry bank.[7]

German snipers were operating close to the farm. Captain the Honourable W.A. Cecil was killed on this day when he was shot in the throat. The regimental history paid the following tribute:

> One of the Battalion's much-regretted losses of this day was Captain the Hon. W.A. Cecil. He had been in the thick of every engagement since the start, and had gained a great reputation in the past three weeks for the effective way in which he handled the machine guns. On more than one occasion his keenness had led him into very dangerous corners, and it was while he was reconnoitring for a good position for his machine guns that he was killed.[8]

The 2nd Oxford & Buckinghamshire Light Infantry were held in reserve at Soupir. During the afternoon of 16 September, C and D Companies were brought forward to support the 4th Guards Brigade at the farm.

The 4th Guards Brigade had to wait until nightfall before it was safe to bury the fallen. Private W.

Merryweather from the 2nd Oxford & Buckinghamshire Light Infantry recalled the burial service that took place that night at Soupir Churchyard:

> I shall never forget it as long as I live. We had been in the trenches for many hours and our losses were very heavy. At dusk the German fire grew less and less, and as night came it ceased altogether save for an occasional shell. We brought our dead to a little village churchyard where the peasants had dug a great grave. We stood around in the dark, with just the moon and stars for light and the priest said the services. It was in French, so we didn't understand much about it. At the end we saluted and then filled up the grave. The villagers promised to plant flowers and take care of it for us.[9]

Sergeant Arthur Lane of the 2nd Coldstream Guards recorded the events on the 2nd Division sector and at Soupir in his diary:

> Reveille 4 o'clock. Breakfast 5.30 o'clock which we had on the field in trenches that we had dug as protection from shell fire. An awful night, no rest

The burial of soldiers from the 2nd Oxfordshire & Buckinghamshire Regiment in Soupir Churchyard. This had to take place during the night of 16 September owing to the shelling during daylight. (*The Graphic*, 17 October 1914)

and wet through. Just finished breakfast when we were swept (or the field was) by the enemy's guns. A few men were hit but their wounds were very slight. Retired to the village and were billeted in the Hothouse of Monsieur Caillaux. The best place that I have seen. There are hundreds of wounded lying in the stables waiting for wagons to take them away. Returned to trenches at dusk, 7.30pm.[10]

The 1st Lincolnshire Regiment on the 3rd Division sector north of Vailly also suffered under the torrent of artillery shells. Battalion headquarters, which was set up in a cottage close to a road, was obliterated forcing its officers and men to live in holes in the ground. Within sight of German observers, the soldiers from the 1st Lincolnshire Regiment were not allowed to light fires to keep warm or cook food. Smoke emitted from fires would reveal their position to the enemy who would target their position.

The 2nd Royal Irish Rifles at La Fosse Marguet came under attack from advancing German forces. Lieutenant-Colonel Wilkinson Bird wrote:

> This was a rainy and foggy day. The enemy's field artillery fired intermittently, ours not at all. Whenever the fog lifted we could see men in widely extended order 30–40 paces apart being dribbled down the hill into the German trenches. We opened fire when the Germans were coming down in what we thought too large numbers and caused some casualties, but at considerable expenditure of ammunition as the ranges were from 1,000 yards to 1,500 yards; visibility was poor.[11]

Two days into the battle, the 2nd Royal Irish Rifles received adequate supplies of spades to begin the process of digging deeper trenches. Lieutenant-Colonel Bird wrote: 'During that day I obtained the entrenching tools from our 1st line transport and the men improved their cover as far as they could.'[12] They had established contact with the 4th Royal Fusiliers and wounded comrades were continually being brought in.

At La Montagne Farm, the 1st Hampshire Regiment continued to hold their trenches north of Bucy-le-Long. One officer from the Battalion wrote home on 16 September:

> You propose sending me shirts and socks; don't do this, as no parcels ever seem to reach us. I am at present in a trench under fairly heavy shrapnel fire and an occasional stray rifle bullet. We cannot reply, as we can see nothing. We have been in here all night, and will remain all day. We have been on the go for the last ten days, sleeping in the open, with no other washing than an occasional scrub in a

bucket; no change of clothing at all, and only twice had my boots off. We have been continually under fire for the last three days, but have suffered little. The last three days, it has rained continuously, and yet we have laid down on the wet ground soaked to the skin and gone to sleep without ill effects ... The French peasants are kindness itself to us. I am absolutely fit, except for stiffness in most of my limbs, due to the damp.[13]

There was no respite from the ear splitting sounds of the heavy calibre missiles of the German howitzers. The soldiers of the BEF had to adapt to a whole new kind of warfare. They were unable to work freely on strengthening their trenches because of the risk from German snipers. They were unable to sleep at night because of the flares that were continually thrown up.

The 6th Division arrived at the rear of the British III Corps lines and its brigades were split in order to act as relief for the exhausted five divisions that had retreated from Mons, advanced from the Marne and for the past three days had been fighting a savage battle for the Aisne sector.

LIEUTENANT JAMES HUGGAN

ROYAL ARMY MEDICAL CORPS, ATTENDING 3RD BATTALION COLDSTREAM GUARDS

James Laidlaw Huggan was born in 1888. He was educated at Darlington College where he excelled at football and was the captain of the school team. He was a keen rugby player and played for the Jed Forest Rugby Club. He studied medicine at Edinburgh University where he graduated with first class honours in surgery. Huggan joined the Royal Army Medical Corps in July 1912. He was able to pursue his passion for rugby by representing the Army in two occasions in Army v Navy tournaments. Huggan played rugby for the London Scottish RFC and took part in the last rugby international before the outbreak of war, in March 1914. In the match at Inverleith, Edinburgh, he scored three tries in the match for the Calcutta Cup despite losing to England 15 to 16.

Six months after representing his country in a rugby international he would be serving his country on active service in France. Lieutenant Huggan was attached to the 3rd Coldstream Guards and during the retreat from Mons he would distinguish himself when

Lieutenant James Huggan.
(Courtesy Pauline Huggan)

tending to the wounded. Lieutenant-Colonel G.P.T. Feilding, the commanding officer of the 3rd Coldstream Guards, wrote:

> If I ever met a brave man, he was. At Landrecies, when we were under a heavy fire for some hours during the night, he remained up in the front the whole night, helping and dressing the wounded as coolly as if he were in a hospital in time of peace. At Villers Cotterets he was conspicuous for his bravery. This was a rearguard action, and the line was being pushed back; but he was always in the rear, and sometimes even nearer to the enemy, dressing the wounded and helping them back.[14]

When a barn in the compound of Cour de Soupir Farm was ablaze on 16 September it was Huggan who risked his life to rescue wounded British and German soldiers inside. Shortly after this extraordinary display of courage, Huggan was killed. Feilding described this act to Huggan's brother in a letter of condolence:

> At the Battle of the Aisne he was most conspicuous everywhere. On the day in which he was killed he again did a very brave action. There were in a barn about sixty wounded Germans. They were all cases that could not move without help. The Germans shelled this barn and set it on fire. Your brother, in spite of shot and shell raining about him, called for volunteers to him to save these wounded men from the burning building, and I am glad to say that it was greatly in consequence of his bravery that they were all saved. After he had run this great danger successfully he moved many of his wounded men to a quarry in rear when a big shell came into it and killed him and many others. He was buried, near where he fell, in the garden of La Cour de Soupir Farm. The whole battalion regretted his loss, as we had all got very fond of him, and admired him as a really brave man, always ready to sacrifice himself for the good of those who should happen to come under him for treatment.[15]

Lieutenant-Colonel G.P.T. Feilding, the commanding officer of the 3rd Battalion Coldstream Guards, who between 5–17 September 1914 was temporary commander of the 4th Guards Brigade, recommended Lieutenant James Huggan to receive the Victoria Cross but the recommendation was not approved. As Feilding mentions, Huggan was buried in the garden but the grave was lost during the course of the war, therefore he has no known grave and his name is listed on the memorial at La Ferté-sous-Jouarre. His name was also commemorated in Jedburgh on a memorial stone outside Jedburgh Abbey.

James Huggan (left) played for Jed Forest Rugby Team. (Courtesy Pauline Huggan)

Lieutenant Reginald Simson, his friend and fellow London Scottish rugby player was killed the day before while serving with the 16th Battery, Royal Field Artillery. Simson was the first known rugby international of any nation to die during the war.

LIEUTENANT HUGH MOCKLER-FERRYMAN
2ND BATTALION OXFORD & BUCKINGHAMSHIRE LIGHT INFANTRY

Hugh Mockler-Ferryman was born in Maidstone in 1892. He was educated at Wellington College where he excelled at cricket. He was a proficient bowler who would later represent Berkshire County and Aldershot Command. After passing out at the Royal Military College Sandhurst he was gazetted as a 2nd Lieutenant to the 2nd Oxfordshire & Buckinghamshire Light Infantry. In April 1914 he was promoted to Lieutenant and in August he went with the battalion to France. He took part in the retreat from Mons and the Battle of the Marne. He was amongst the officers killed by a shell at a quarry close to Cour de Soupir Farm on 16 September. A senior officer wrote the following tribute to his family: 'The whole regt. mourns the loss of one of its best and most popular officers. You would be proud if you could hear the way in which the N.C.O.s and men speak of him.'[16] He was buried at Soupir Churchyard. His epitaph reads: 'Thou will keep him in perfect Peace.'

Lieutenant Hugh Mockler-Ferryman 2nd Oxfordshire & Buckinghamshire Regiment. (*Bonds of Sacrifice*)

LIEUTENANT REGINALD WORTHINGTON
2ND BATTALION OXFORD & BUCKINGHAMSHIRE LIGHT INFANTRY

Reginald George Worthington was born in 1886 and his family originated from Reading. He was educated at Branksome, Godalming and Charterhouse. After graduating from the Royal Military College at Sandhurst, Worthington was gazetted 2nd Lieutenant with the 3rd Oxfordshire Light Infantry in February 1904. He was transferred to the 2nd Oxfordshire and Buckinghamshire Light Infantry in May 1908, appointed Assistant Adjutant and Scout Officer. Worthington was promoted to Lieutenant in April 1911. He was a recipient of the Croix de Chevalier of the Legion of Honour. On 16 September, Lieutenant Reginald Worthington was killed when a shell exploded close to the quarry he was occupying. He was buried at Soupir Churchyard.

Lieutenant Reginald Worthington, 2nd Oxfordshire & Buckinghamshire Regiment. (*Bonds of Sacrifice*)

2ND LIEUTENANT PAUL GIRARDOT
2ND BATTALION OXFORD & BUCKINGHAMSHIRE LIGHT INFANTRY

Paul Chancourt Girardot was born in 1895 in Southampton and was raised at Colston Hall, Nottinghamshire. He was educated at Ashampstead School, Eastbourne and Cheltenham College. Joining the Army in February 1914, Girardot proved to be an all-round sportsman and a good marksman. While resting in a quarry close to La Cour de Soupir Farm he was killed by a shell on 16 September. He was buried at Soupir Churchyard. His epitaph reads:

IN MOST LOVING
MEMORY OF MY
BELOVED CHILD.
MOTHER.

2nd Lieutenant Paul Girardot, 2nd Oxfordshire & Buckinghamshire Regiment. (*Bonds of Sacrifice*)

2ND LIEUTENANT FRANCIS PEPYS DSO
2ND BATTALION OXFORDSHIRE & BUCKINGHAMSHIRE LIGHT INFANTRY

Francis Pepys was born in 1891 at Budleigh Salterton, Devon. He studied at Charterhouse where he was in the

2nd Lieutenant Francis Pepys, 2nd Oxfordshire & Buckinghamshire Regiment. (*The Distinguished Service Order 1886–1915*)

cricket eleven. He joined the Special Reserve attached to the Devonshire Regiment. In May 1913 he was gazetted as a 2nd Lieutenant to the 2nd Oxfordshire & Buckinghamshire Light Infantry. Pepys enjoyed sports including golf, steeple chasing and fishing, He went to France with the 2nd Oxfordshire & Buckinghamshire Light Infantry when war broke out, taking part in the retreat from Mons, the Battle of the Marne and the Battle of the Aisne. On 3 November he took part in an action at Ypres that would earn him the Distinguished Service Order. His citation noted 'conspicuous good work in advancing from his trench and assisting in driving away a party of the enemy who were commencing to dig a new trench within 30 yards of his own. 30 of the enemy were shot down on the occasion.'[17] His commanding officer wrote: 'He most thoroughly earned it for the splendid way he, with three others, turned 30 or 40 Germans out of a trench and for his splendid leading on other occasions.'[18]

On 11 November 1914 Pepys repelled a counter attack launched by the Prussian Guards. He was mentioned in Field Marshal French's Dispatch on 14 January 1915. 2nd Lieutenant Francis Pepys would not live to know that he was awarded the Distinguished Service Order or that he was mentioned in French's Dispatch. He was killed when a shell exploded close to his trench. He was buried at Zonnebeke, but his grave was lost and his name is listed on the Ypres (Menin Gate) Memorial.

PRIVATE HARRY POWELL 9630
1ST BATTALION NORTHAMPTONSHIRE REGIMENT

Harry Powell was born in 1896 and lived in Far Cotton, Northamptonshire. He had served with the 1st Northamptonshire Regiment for two years before war broke out. He fought with B Company during the Battle of the Aisne and was killed on 16 September 1914. He was aged 18 when he died. He has no known grave and his name is commemorated on the memorial at La Ferté-sous-Jouarre Memorial.

Private H. Powell, 1st Northamptonshire Regiment. (*Northampton Independent,* 17 October 1914)

NOTES

1. WO 95/1252: 26th Field Company, Royal Engineers War Diary
2. WO 95/1431: 4th Royal Fusiliers War Diary
3. IWM 79/33/1: Corporal John Stennett, 1st Northamptonshire Regiment
4. IWM 81/1/1: H.J. Milton, 2nd Battalion Highland Light Infantry
5. Private L. Kilcoin's Diary, Irish Guards Regimental Headquarters Archives
6. Major George Jeffreys Diary, Grenadier Guards Regimental Headquarters Archives
7. Ibid
8. Ponsonby, Lieutenant-Colonel Sir Frederick, *The Grenadier Guards in the Great War* (Macmillan & Co, 1920)
9. *The Graphic,* 17 October 1914
10. IWM 81/14/1: Sergeant Arthur Lane, 2nd Coldstream Guards
11. WO 95/1415: 2nd Royal Irish Rifles War Diary
12. Ibid
13. *Hampshire Regimental Journal*
14. Clutterbuck, L.A., *Bonds of Sacrifice: August to December 1914* (1915, republished by Naval & Military Press, 2002)
15. Ibid
16. De Ruvigny, Marquis, *De Ruvigny's Roll of Honour, 1914–1918* (1922, republished by Naval & Military Press, 2007)
17. *London Gazette* 28992, 1 December 1914
18. Creagh, Sir O'Moore and E.M. Humphris, *The Distinguished Service Order 1886–1915* (1924, republished by Savannah Publications, 1978)

17 SEPTEMBER

The 17th saw further supplies of entrenching tools delivered to II Corps. It was noticed that after this date the number of casualties was reduced because the British were able to dig deeper trenches.

During that day snipers were operating along all fronts held by the BEF. The 1st South Wales Borderers remained in their trenches, but they were vulnerable to German marksmen. Captain C.J. Paterson wrote in his diary 'We sit all day in the trenches being sniped at and worse still being enfiladed by the German guns.'[1] Sergeant C.S.A. Avis wrote:

> September 17 was another bad day for the Battalion. The enemy attacked in great force. The Moroccan troops on our right flank retired and left the flank unprotected. The French artillery 75-mm shells commenced to drop on our position. The Moroccan troops returned later reinforced by French troops. The Commanding Officer, Lieut. Colonel D. Warren, met his death by a sniper's bullet, and the Adjutant, Captain C.R. Wilson, was killed by shrapnel at Regimental Headquarters near a haystack.[2]

The BEF had their own snipers. Private Kilcoin from the 1st Irish Rifles was one such who accounted for several of the enemy during that day. 'Entrenched under good bank on outskirts of wood – artillery pounding us all the time – ours replied with some effect. Did some sniping today, accounted for a few (from a tree); continued burying the dead – a gruesome task.'[3]

The 2nd Connaught Rangers were deployed into the support line on 17 September where the 2nd Highland Light Infantry had fought on 14 September near Verneuil. It was here that they were confronted with a scene of horrendous carnage as the early morning mist cleared to reveal the many dead that lay on the battlefield. They set about clearing the dead from the field and consolidating the trenches. They could only carry out this ghastly task when the German guns were silent. As soon as German artillery opened fire men from the 2nd Connaught Rangers could not hold the trenches and were compelled to seek cover in nearby caves. Sergeant John McIlwaine:

> Daylight, with a hot sun in our tired eyes clearing away the mist from the hill, showed us our first

sight of the horrors. It must have been a desperate fight. Germans, in full kit, helmeted and with their chin-straps still worn, had fallen in rows where they had charged the H.L.I. trenches. Major Alexander told us to remove the British dead first, occupy the trenches if possible, but at the first sign of German shell fire to retire to some caves behind. He has obviously had his instructions as to the untenability of the trenches. I drag a body by the leg and pull the leg off. I recorded that I was 'sick with the sight and scent of mangled human flesh'. This may be rhetorical but it is accurate. I got a bit sick as the hot sun raised the smells. Later we got to know these caves very well. We christened the position 'Coal Box Hill'. It was our first experience of really heavy shells, the weight of which suggested one of the heaviest things we could think of; a barrack room coal-box.[4]

The 2nd Connaught Rangers held positions at Verneuil from 17–21 September. Sergeant John McIlwaine:

> From this date until 21st September we change position almost daily with the other battalions in the brigade. The Worcesters, H.L.I. and Oxfords. We shelter in the caves when bombardments are heavy ... for their entrances all face away from the enemy from our front line. When relieved from that line we lie about in trenches or isolated holes lower down the hill towards Verneuil. There is little attempt at making really strong trenches. We are far behind the French and Germans at that business.
>
> The caves, which the German gunners have the range of to a foot, though formed of powerful stone, are precarious enough. In the largest a company of 200 men can shelter, cook and sleep: the roof, in places, is twenty feet high. During the five days we were in and out of this cave the shelter became less secure. On our last day, I think it was, the continual bombardment had so loosened the rock about the entrance that when a particularly good hit by a German gunner broke off a huge boulder, the sudden darkening of the light within indicated to us the unpleasant possibility of being buried alive. This happened a week or two after, when, in that same cave, a company of Cameron

Highlanders was buried here. I do not know if their bodies were ever taken out. One curious incident was the sudden appearance amongst us of three French soldiers who popped up from the depths one day. They had hidden there a week or so before, when the place was in German occupation. They had spied upon us for days, and having no knowledge of English or German were uncertain about us. They had argued amongst themselves before deciding to hand themselves over. When I saw them they were eating ravenously of the bully beef and bread our fellows had provided. I never knew nor bothered to ascertain how far that front line was from the Germans. I should say it was at least 200 yards, as I did not see any live Germans. No Man's Land was covered with bodies, from amongst which, wounded and still alive, some were brought in at night. Our procedure on that position was to occupy the caves when bombardments began; have a half-platoon or so on duty near the exit to rush out when the shelling ceased, occupy the entrenchments and stone breastworks, and await an enemy attack.[5]

At Cour de Soupir Farm, the 2nd Coldstream Guards fought off several determined attacks by the enemy inflicting heavy casualties upon them. Sergeant Arthur Lane, 2nd Coldstream Guards, was adapting to life in the trenches and the daily bombardments from howitzers:

Rifle shot just hit ground in front of me, but I caught a German with my second shot. Repetition of previous day. Shell fire extraordinarily accurate, but we are so used to it by now that no one was injured. At about 2.30 in the afternoon during a heavy downpour of rain, we were subjected to a heavy bombardment, and a line of skirmishers attacked at the same time. They were mown down by our machine gun which took them on the flank. Out of about 60, four got away.[6]

2nd Grenadier Guards were holding positions north of Chavonne and came under fire from snipers in a nearby barn. There was no artillery available at that time to call in a bombardment to take them out. Corporal Thomas and two comrades from the 2nd Grenadiers decided to take action. They left their trench and took sheaves from a cart close to their trench, then dashed towards the barn where the snipers were positioned. Piling the sheaves against some wood on the side of the barn they set it alight and then ran back to their trenches amidst a hail of bullets. All three men got back without being harmed. The enemy had no choice but to withdraw as the barn burnt furiously. Private Ward and his party had resolved the sniper problem. Ward was promoted

to Sergeant and on 6 November he was awarded the Distinguished Conduct Medal for another act of bravery.

At 4.30am the 2nd Oxford & Buckinghamshire Light Infantry relieved the 2nd Grenadier Guards at Cour de Soupir Farm. B, C and D Companies entered the trenches. A Company was left behind to secure positions at Chavonne. The trenches were dug immediately in front of the farm and heavy rain had made the trenches very wet. The caves close to these trenches provided additional cover from German artillery fire. All companies came under attack throughout the day.

The 2nd Grenadier Guards were relieved to get a brief respite from the trenches at the farm. Officers and men withdrew to billets where they slept throughout the day. Many reported sick, including Prince Alexander Battenberg. Major George Jeffreys:

Alexander of Battenberg is in hospital with a chill. He stuck the retreat much better than I expected, but he's not a heaven born soldier and is rather a responsibility to have on one's hands, so I asked our Doctor, Howell R.A.M.C., if we could get him sent home. He said they had more cases than they could deal with and very little accommodation, and that they would be glad to get him away.[7]

The 4th Royal Fusiliers on the 3rd Division sector still held on at Rouge Maison Farm during 17 September. German artillery fired shells into the valley south of their position throughout the day, but caused little damage. With no cover over their trenches the soldiers were soaked to the skin. An expected German attack during the night of 17/18 September meant that the Battalion was standing to all night. Their nerves were shattered by shell fire and they were on edge as they stood in their wet trenches in anticipation of a German attack that never came.

Also on the 3rd Division sector there was a doubt that German forces were still occupying the opposite trenches. Lieutenant-Colonel Bird, commanding the 2nd Royal Irish Rifles, sent his adjutant accompanied by a private to go forward and ascertain whether there was any movement within the enemy lines during the morning. Bird wrote: 'He went to and actually fell into a German trench and found everyone asleep.'[8]

It was a deadly challenge to run the gauntlet of shell fire to bring up supplies. Major Charles Spedding was sent to Vailly with the ration party to collect a draft of reinforcements consisting of one officer and six men when he was killed by shell fire.[9]

Later that day on the front being held by the 2nd Royal Irish Regiment there was no movement in the German trenches. Lieutenant-Colonel Bird ordered his adjutant to go on a reconnaissance operation to see if anyone was home. Bird recalled:

He returned and said he could see none and stood in the open 300 yards from the trench without being fired at. I accordingly ordered D Company to occupy the edge of the wood and patrol from it. The company commander took his company forward and then sent word that he would like me to come and see the situation as the German trench appeared to be full of men. I went to the edge of the wood and after crawling with him ordered him to fall back as the company would have been much exposed and the roots of the trees would have made entrenching difficult. No sooner had the order been given then the enemy who seems to have discovered our presence began to shell the wood heavily and we had some casualties as we fell back.[10]

NOTES

1. WO 95/1280: 1st South Wales Borderers War Diary
2. IWM 84/58/1: Sergeant C.S.A. Avis, 1st The Queen's (Royal West Surrey) Regiment
3. Private L. Kilcoin's Diary: Irish Guards Regimental Headquarters Archives
4. IWM 553796/29/1: Sergeant John McIlwain, 2nd Connaught Rangers
5. Ibid
6. IWM 81/14/1: Sergeant Arthur Lane, 2nd Coldstream Guards
7. Major George Jeffreys Diary, Grenadier Guards Regimental Headquarters Archives
8. WO 95/1415: 2nd Royal Irish Rifles War Diary
9. Ibid
10. Ibid

GERMAN DECEPTION AT TROYON

Torrential rain continued to fall on the 17th. The 1st Loyal North Lancashire Regiment and the 1st Northamptonshire Regiment were holding trenches near Troyon. Their trenches were waterlogged. They were living off bully beef and drinking water brought up to them by fatigue parties that crawled to their position at night. It was perilous for anyone to raise their head or show themselves for German forces were entrenched on high ground 250 yards away. All that separated the combatants was a turnip field.

German artillery shelled Troyon and the surrounding trenches from 10.00am until midday. When British artillery responded, some shells fell short upon their own trenches killing one man and wounding another. Every moment spent in the trenches was fraught with the danger of shells, snipers or of being overwhelmed by German assaults. Private B. Lloyd belonging to D Company, 1st Northamptonshire Regiment, was wounded in the trenches. When he arrived at the Royal Herbert Hospital in Woolwich, London, he wrote a graphic account of what life was like in the Aisne region in a letter to his sister:

I dare say you will be surprised to hear from me, especially as I happen to be in England ... I arrived in England wounded but not seriously, so do not worry about me. I am all right. I have been very lucky I can tell you. In fact I got quite used to the shots and 'coalboxes' flying all round, under and over the top, so close to us and only just missing us dozens of times. We used to say that our luck was in, and begin to think that we could not be hit. We were drenched through with rain, wet through to the skin, and nothing to change into for days and days, being in trenches with about three or four inches of water in them all night. All this we went through with a good heart and tried our best to cheer each other up with a song. When we saw a shell coming we would say 'Look out!' and 'Bob down!' and 'Here's another coalbox coming'. But it is not war – it is murder. But still we have been winning and shall do. I was wounded at the same battle that is raging now – the Battle of the Aisne.[1]

The 1st Northamptonshire Regiment who were holding trenches in face of the Sugar Factory and east of Troyon received orders to prepare for an attack on German lines. A, B and D Companies from the 1st Northamptonshire Regiment were holding front line trenches during that morning while C Company was held in reserve. The battalion unit history records that a very strong German force were attacking in force on the right flank of the 1st Division at 1.30pm. C Company was brought forward to support the right flank held by French Zouaves, which was faltering under the German assault launched by the 28th Brigade of the German VII Reserve Corps. These French troops from North Africa had lost most of their officers and their line broke momentarily.

C Company, commanded by Captain Robert Parker, was ordered to launch an immediate counter attack. Torrential rain was pouring down upon the soldiers of the 1st Northamptonshire Regiment who had been standing by in the flooded trenches ready to make an attack since the morning. The order to advance was given at 1.55pm according to Corporal John Stennett from C Company, 1st Northamptonshire Regiment:

During the night the French army had moved from our left to the right. With the enemy only 70 yards away one had to be careful how one moved. We were ordered to get ready as we were going to make an attack at 11am. We started the artillery putting a few in the right place and the troops were sending the bullets to them in good order. This continued until 1.55pm. When the order came down the line to advance we had previously fixed our bayonets for dirty work. We advanced about 20 yards and then opened a rapid fire.[2]

Lieutenant Needham of C Company:

We fell in quickly and doubled along the terrace to a point between us and the front line levelled off, just opposite the right flank of 'A' Company, the flank company of the battalion. Here we turned to the left and advanced, still at the double, in extended order. We reached the road (Chemin des Dames) and lay down there for a few minutes to get our breath. Then Parker (O.C. Coy) gave the order to fix bayonets and a few minutes later to charge. Over the low bank we went. Parker shouting 'Come on.

The Cobblers!' and the men cheering like hell. I ran as hard and as best I could over the roots, with my drawn sword in one hand and my revolver in the other, stumbling over and cursing the roots and expecting every moment to be tripped up by my sword and scabbard!. We charged through heavy fire and machine-gun fire and men were dropping in every direction.[3]

The 1st Northamptonshire Regiment had tried to capture these trenches on 14 September, but now the Germans had fortified them. Needham had difficulty in making his commands heard over the sounds of machine-gun fire and shells. It was still misty and they had no artillery support. German shell fire was pouring upon their positions and shrapnel was flying everywhere. C Company made a gallant charge towards the German trenches but the fire was so overwhelming that they were forced to go to ground. The assault lost momentum. Lieutenant Needham:

We lay where we were for some considerable time, keeping up a steady fire at the trench ahead of us. We were being well sprinkled with shrapnel all this time, and again, owing to the rain and misty conditions, were getting practically no artillery support from our guns ... The line was now at a standstill, and looked like remaining so; the only thing to do appeared to be to keep up our fire and take what cover we could in the roots. After what seemed hours, I saw young Gordon [2nd Lieutenant Cosmo Gordon] crawling along in his tummy towards me from the right flank of the company; he eventually reached me and told me that poor, dear old Parker had been killed leading the charge and that I was in command of the company and also of the 60th Rifles [2nd King's Royal Rifle Corps] on our right, all of whose officers had been either killed or wounded![4]

C and D Companies from the 2nd King's Royal Rifle Corps were sent to assist the 1st Northamptonshire Regiment. They managed to secure the right flank of the 1st Northants line and recaptured one of the trenches at the cost of heavy casualties. Captain George Priaulx who led C Company was shot through the chest at a range of 20 yards. Priaulx survived the Battle of the Aisne, but was killed on 24 March 1918. Reinforcements arrived to support the King's Royal Rifle Corps and they were able to push their line forward 200–300 yards north of the Chemin des Dames east of Cerny. The 2nd King's Royal Rifle Corps war diary reported:

The fight had now assumed more considerable dimensions and the other two companies of

the battalion were sent forward to reinforce. A Company of the Coldstream Guards came up to the Chemin des Dames on our left and a battalion of the Queen's arrived in the support of our right.[5]

Needham was in an unenviable position; he was pinned down, unable to carry on the attack, his senior officers and his friends had become casualties and he was now in command of C Company:

I was horrified to hear of Parker's death and also at my position. Gordon and I lay down together for some time debating as to what on earth we should do. We decided to try to get the line on and rush to the trench. We passed messages down to each flank to tell everyone to be prepared to renew the charge when we blew our whistles and started. But when we did blow them as loud and long as we could, and started forward with the men next to us who had got the message correctly, the hostile fire broke out again stronger than ever; and as the rest of the line had not budged an inch, down we had to go again.[6]

Lieutenant Needham and 2nd Lieutenant Gordon held their positions under enemy fire for some time until the firing stopped – white handkerchiefs were being waved by the occupants of the trenches held by the German 28th Brigade and many of them had raised their hands. The 2nd King's Royal Rifle Corps reported that this took place at 4.30pm. Lieutenant Needham:

Then suddenly I heard the men shouting, 'They're surrendering!' and, looking up, I saw a line of white flags (or rather white handkerchiefs or something of the kind tied to the muzzles of rifles) held up all along the German trench from in front of us right away to the left. I shouted out to the men to cease fire and stop where they were.[7]

German soldiers, with their hands up came across the turnip fields towards the trenches held by A Company, who were delighted to see it. A Company had lost most of its officers. 2nd Lieutenant Burlton, a young subaltern who had served less than a year in the Army, was now OC. Needham wrote:

After a few minutes I saw a large number of Germans, two or three hundred at least, moving forward from their trench towards 'A' Company on the road, some with their rifles, but many with white flags tied to them, and many with their hands up. They got down to 'A' Company's trench and stood there for some time apparently conversing. All this time the white flags in front were standing with their hands up.[8]

Lieutenant Wauchope witnessed hordes of German soldiers coming forward to surrender:

> On 17th we had quite a proper battle, but it was marked by some treachery of the Germans. We had got fairly close, or rather they had, as we were entrenched, and waiting for them to come over the crest-line. We were only about 200 yards apart, and from a flank (their right) I had been able to get one of my guns into action, and had been pumping it into them most of the afternoon. All of a sudden, a man stood up in their trenches with his hands up, and another showed a white flag. Then they all began coming forward and beckoning to us to come out. It was a genuine surrender. I went up to see what was going on and they were throwing down their arms, which, however, they would not let us collect, they were so nervous and distrustful. Others kept coming in and a good many of them threw down their arms.[9]

2nd Lieutenant Burlton had witnessed Lieutenant Needham and C Company's advance as German soldiers approached with their hands up. Burlton later recalled the episode:

> We saw a line of our troops deployed and advancing. And hardly had we spotted them, when, to our unbounded joy, we saw the enemy in front of us making signs of surrender by putting their hands up. Their fire stopped, and I ordered mine to do likewise. I stood upon the parapet and called for an officer to meet me. An individual – I think a private – who spoke English, responded to the call, and I went out some forty yards ahead of my trench to make the necessary arrangements. On my finding out he was not an officer, I ordered him to return and to tell his officer to replace him. A sergeant or under officer next turned up, but was also returned as 'not wanted', after which an officer did materialise. He appeared to find great difficulty in understanding me. I agreed to accept surrender, but, as a preliminary thereto, naturally ordered him to make his men lay down their arms.[10]

Burlton went forward into No Man's Land to continue the surrender negotiations; many German soldiers were moving forward with the hands up, while others were still holding rifles. Burlton:

> Our conversation took place halfway between the opposing trenches, and to my annoyance I saw a large number of the enemy debouch from their trenches before my arrangements were completed. Most of them had their rifles, but many had not,

and many had their hands up. I tried to make the Boche officer understand that I would order my men to fire if his men continued to advance with their arms. All this time the enemy continued to advance, and the officer appeared quite willing to surrender, but unable to grasp my idea about his men putting their rifles down as a preliminary. I found myself being surrounded by the advancing Germans, and, as there was no officer in our own trench (Second-Lieutenant Jarvis was in a state of concussion and non effective), I could not afford to remain out in No Man's Land, which was rapidly being overwhelmed by the advancing Huns. I was, at this time, quite sure of their bona fides as to surrender, and did not want to open fire for two reasons (I do not know how far I calculated these reasons at the time, but their validity was certainly in my mind).[11]

Burlton was in a dangerous ethical dilemma. Either do nothing and risk being fired upon or captured, or open fire and kill German soldiers who wanted to surrender:

> Firstly I thought it was a bona fide surrender, as many of the enemy came without arms and with hands up; and, to make the illusion complete, some of those who were armed delivered their rifles over to some

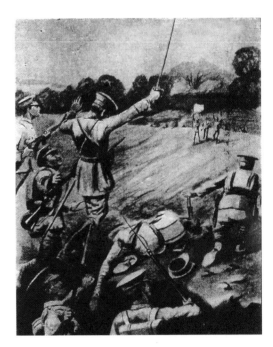

Soldiers from 1st Northamptonshire Regiment during the white flag treachery incident at Troyon on 17 September. (*Northampton Independent***, 31 October 1914)**

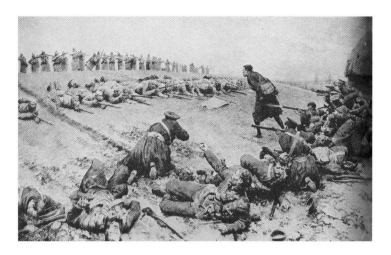

The 1st Northamptonshire Regiment suffered many casualties during the white flag deception. (Amalgamated Press)

of our Tommies, who had come out on their own to meet them. It would have been a dirty business to have opened fire on men who were advancing with their arms because they did not understand English. Secondly, I had a message delivered verbally to me by one of my men. 'From the General, do not fire' – I remember that message most distinctly; its incongruity did not strike me at the moment, and I thought it a genuine one. It came down from the right of our line from a quarter in front of which the enemy had also put up their hands. By this time I was back on the top of my own trench with the Boche officer and the under officer, the Huns, about 400 strong, already amongst us, and in many cases surrendering their arms to Tommy Aitkins and being warmly shaken by the hand.[12]

When the German officer who stepped forward to negotiate the surrender realised the small British force that opposed them, he changed his mind – he ordered his men to charge. Burlton:

This situation passed very quickly, however, for a German quite close to me shot one of my men dead, and the officer, on my saying that if he did not order an immediate cessation of his fire I would order mine to open, informed me that I was his prisoner. We then all set to in earnest, so to speak, and at point-blank range, of course; no accuracy of shooting was necessary – the men used their butts and bayonets lustily. We were, however, far outnumbered, being but some seventy odd, I believe against 400.[13]

Lieutenant Wauchope:

Suddenly a rifle went off and immediately they began firing into us. Our fellows replied at once,

and my sergeant, who happened to be at the gun, turned it at them, killing many, and other machine guns also were turned on and mowed them down. Then they disappeared over the crest, and that was the end of it, though not before many of our fellows had got it. There must have been 400 to 500 of the enemy coming into surrender, and we did not get more than a couple of dozen prisoners.[14]

The Northamptonshires were outnumbered. A party from the 1st Coldstream Guards arrived on the scene to support the Northamptonshires as they fought a fierce close quarter fight in the turnip field. It has been reported that 2nd Lieutenant Burlton shot the German officer with his revolver. Burlton had received a gunshot wound to his shoulder, fired by a German sergeant who was two yards away. Although wounded, Burlton was able to continue to fight his corner and with his revolver shot the German sergeant and a private. When Burlton's revolver was destroyed by a bullet, he was just about to be bayoneted by another German soldier when Private Ward stepped in and killed the man, saving Burlton's life.

Lieutenant Needham could see the unfolding drama erupt into a savage close-quarter confrontation from C Company's position:

All of a sudden a burst of heavy firing broke out by 'A' Company's trench and we saw the Germans and our men engaged in a hand-to-hand fight. Still the white flags in front of us remained up. Just as Gordon and myself had decided to reopen fire and to chance whether we were right or wrong, I saw Captain J.A. Savage of 'D' Company, and Lieutenant J.H.S. Dimmer of the 60th (2nd King's Royal Rifle Corps), walk through the left of 'C' Company and on up to the German trench in front of us. Apparently they could talk German.[15]

Sergeant Cooke from the 1st Northamptonshire Regiment recalled the action from his hospital bed in Brighton:

> We had been in the trenches for four days and the Germans would never have moved us – as a matter of fact we were getting the better of it – when they held up their hands to surrender. We called them into our lines. There were at least 400 of them and about 60 of us and when they saw how many we were they wanted to say that we were their prisoners. Of course we were not having that and they started to fire into us.[16]

Lance Corporal Saull from the 1st Northamptonshire Regiment had sustained a fractured arm and received a gunshot wound which took all the flesh from his wrist during the white flag deception. He was evacuated from the Aisne and was taken to a hospital in Woolwich. It took him a long time before he fully recovered. Doctors were unable to set his broken arm until his wrist wound had healed. While recuperating in Woolwich, Saull wrote the following account:

> I only got to hospital just in time to stop bleeding to death and I shall not be able to use my arm for a long time. I had a good run for my money, and hardly know how I got away at all. They hit my cap and shot the heel of my boot clean off. They are perfect devils. They put up the white flag to us and gave in as we thought, so I was sent out of our trenches to bring them in and collect the rifles. There were about 20 in front of us, but hundreds on our right and left.
>
> Well, out I went without my own rifle and another chap as well. The officer in charge of them went to our trenches on his own and gave himself up decently. We had him. The others dropped their rifles and stood still. I was bringing one chap in, when all of a sudden someone behind me fired a round at one of the Germans. I turned to see who it was and as soon as my head turned this 'Jerry' caught hold of my throat. I didn't half have a shock, I can tell you.
>
> Anyhow, I got away from him and had to do a run to get to our own trenches, because they all started to pick up their rifles and began to get ready to fire. This chap picked up his rifle and fired at me while I was within two yards of him, and only hit my wrist. He was a bad shot, or else it was because I hit him in the face while we were struggling. The bullets sang before I got away. Then they took me to hospital. How I got away I'm sure I do not know. But I saw a chap of my company who got hit the same night and he says they all expected me to go under.

They dare not fire because I was in the way. But they shot all of them later. Not one got away. They (the Germans) were proper cowards. We had five of them in a house one night. They were hiding in some straw and we were looking for something to eat. There were seven of us. I felt a bit sorry for them after our chaps had done with them, but I only wish they had given them some more now. We did not take any of them prisoners, so you can guess what became of them. We served them the same as they would have served us.[17]

Captain John Savage from D Company, 1st Northamptonshire Regiment, was sent to take command of A Company currently being led by 2nd Lieutenant Burlton. While Burlton and his company were engaged in the vicious close quarter battle, Savage and Lieutenant John Dimmer from the 2nd King's Royal Rifle Corps, who could both speak fluent German, approached the German soldiers opposing Needham and C Company. Savage ventured into this sector of No Man's Land to accept the surrender. Leaving his sword and revolver behind he walked across to a German officer to discuss surrender terms, accompanied by Lieutenant Dimmer. Both Savage and Dimmer approached and saluted the German officer; they spoke for five minutes in fluent German. When the conversation ended they saluted, the German officer made his way back to his trench while Savage and Dimmer turned their back and returned to their trench. As they were doing so, Dimmer heard the sound of the bolt of a rifle and immediately suspected that German infantry were about to open fire and as he hit the ground he tried to warn Savage. Savage was shot in the back and killed instantly. Machine gunners from the Northamptonshire Regiment opened fire and dispersed the Germans. The 2nd King's Royal Rifle Corps war diary reported:

> About 4.30pm a party of Germans came forward towards C Company with two officers advancing at a distance of about 20 to 30 yards in front of their men. The whole party, officers and men, advanced with their hands raised about their heads, seemingly as a token of surrender, but with their rifles slung over their shoulders. Lieutenant Dimmer of the King's Royal Rifle Corps and Captain Savage of the Northants Regiment went forward to meet them. On nearing them however, Dimmer heard the bolt of a rifle being opened and closed and suspected treachery. He called out to Captain Savage, and himself dropped down in the turnips. The Germans immediately opened fire from their hips and Savage, checked by his sword as he was, in the act of dropping down was instantly killed, while many

of the Riflemen who had been standing up in their trenches beckoning to the Germans to come in, fell victims to the same ruse.[18]

Lieutenant Needham:

They stayed there talking for about five minutes and then started to walk back to us, the white flags still being up. To our horror, after they had got about half way to us, the Germans opened fire on them, and we saw Savage pitch forward dead, shot in the back. Dimmer threw himself down and started to crawl back to us, eventually reaching our line all right.[19]

2nd Lieutenant Cosmo Gordon, who was very close to Needham was soon killed. Needham:

During all this white flag episode Gordon and I had been kneeling up, trying to make out what was going on, and were still doing so when the Huns opened fire on Savage and Dimmer. Gordon, who was not a foot away from me, suddenly pitched forward on his face and yelled out, 'Oh, my God, I'm hit!' He writhed about on the ground in agony, and I tried to keep him quiet, while at the same time watching Dimmer and what was going on down the line. He assured me again and again that he was shot through the stomach and that he was going to die.

 Poor devil; it was hell, being able to do nothing for him and to see him in such agony. I could only try to reassure him. The scrap down by 'A' Company was still going on, and by now we also were firing at the Germans opposite as hard as we could, having reopened fire as soon as Dimmer got back safely to us.[20]

2nd Lieutenant Burlton valiantly continued to fight despite being wounded in the shoulder. He was bayoneted in the foot and he survived two close shaves with death when two bullets went through his cap. Corporal John Stennett was amongst those who advanced towards the German party:

At this stage the Germans hoisted 5 white flags. We laid still waiting orders. Brigadier-General Bulfin was communicated with and sent orders that B & C Companies were to fetch them in. 'D' Company would afterwards occupy the trenches under the command of Captain R.B. Parkes & Lieut Mibue. Off we went until we were within 15 to 20 yards of them everything was A1. Then suddenly the front line of Germans fell flat and a second line opened a rapid fire with machine guns and rifles cutting us down like mowing corn. Of 187 which started, 8 of us came out, 6 being wounded and 2 without

a scratch and if it had not been for the Queen's Royal West Surreys we should have been prisoners or perhaps done in, but they took them in hand and cut them up in all directions, then they had the sauce to show the white flag again but the Queen's ignored it.[21]

Soldiers from the 1st Queen's could see the precarious situation that the Northamptonshires were in and provided machine-gun cover from the flank. This awesome firepower mowed down and dispersed the numerically superior German infantry. Burlton:

The Queen's on our right, seeing we were in trouble and seeing that the Boches were, for the most part, standing on our parapet and firing down into us in the road, turned on their machine gun and the spectacle was one never to be forgotten. They fairly enfiladed the Huns on our parapet, and the execution can only be compared to that of a harvesting machine as it mows down wheat. A regular lane was cut – those Boches on their side of the lane (perhaps some hundred strong) made their best pace back to their trenches; those on our side of the lane threw down their arms and surrendered; but we declined their offer and, in fact, I think only kept one prisoner – a souvenir, no doubt.[22]

Lieutenant Needham too was elated to see what he later thought were the machine guns of the 1st Queen's Royal West Surrey Regiment open fire:

Then, to our joy, we heard the tap-tap of a machine gun behind us, and saw a machine-gun detachment (that of the 1st Queen's, as we afterwards learned) fairly lacing into the Germans in front of 'A' Company, who started to look back into their own trench. Very few got back, however; those who were not mown down by the machine-gun fire (firing at about 150 yards range) being finished off by the infuriated remnants (about seventy men) of 'A' Company.[23]

Lieutenant R.H. Purcell from the 2nd King's Royal Rifle Corps was in command of a machine-gun position and ordered his men to upon fire. The 2nd King's Royal Rifle Corps war diary recorded that the machine-gun fire was from their guns, not those of the 1st Queen's Royal West Surrey Regiment:

The Northants, taken by surprise, fell back 40 or 50 yards, but our machine guns at once opened fire on the Germans, who turned tail and fled, being mowed down as they ran across the flat. They were also exposed to rifle fire from our trenches to the

north of the road, and very few, if any, of them, escaped.

The action of our machine guns on this occasion has been attributed to those of the Queen's, but Lieutenant Henderson, their machine-gun officer, saw Colonel Serocold shortly afterwards and disclaimed the honour, as his guns were not there at the time.[24]

German adversaries opposing A Company tried to play the same ruse and were waving white handkerchiefs indicating the desire to surrender. Lieutenant Needham was not going to be caught out. 'We redoubled our own fire, and about a quarter of an hour later up went the white flag again in front of us, to which we paid no attention whatever!'[25]

In another part of the line on the 2nd King's Royal Rifle Corps front another party of German soldiers tried to carry out the same trick. The 2nd King's Royal Rifle Corps war diary reported:

> Whilst this was going on, on another part of the line, twenty or thirty Germans surrendered, some wounded, some unwounded. One of the unwounded prisoners was approached by Major Warre with a view to his going over to ascertain if others wanted to surrender, but he said he would have his throat cut if he went back, and that there was no intention of surrendering amongst the enemy as a whole.[26]

The fighting continued throughout that afternoon and into the evening in torrential rain. A German counter attack was launched upon trenches held by the Queen's. The Northamptonshires, Rifles and a machine gun from the 1st Loyal North Lancashires assisted in repelling this assault, which resulted in the capture of 40 or 50 prisoners. It was reported that 400 German soldiers from the 28th Brigade were involved in this action and 300 were killed.[27] A German artillery barrage began at 5.45pm and lasted for half an hour.

Later during that day Lieutenant Dimmer was appointed CO of his company of the 2nd King's Royal Rifle Corps. Together with the 1st Northamptonshires they advanced during the night to take the German trenches. They found the trenches full of dead and wounded German soldiers. Four badly wounded soldiers raised their hands to surrender. Lieutenant Needham was embittered by the treacherous white flag incidents earlier that day, but sent them back to rear lines as prisoners of war. Both battalions buried the enemy dead.

Stretcher bearers made efforts to collect the wounded from the plateau and evacuate them to a dressing station below the ridge in the village of Troyon.

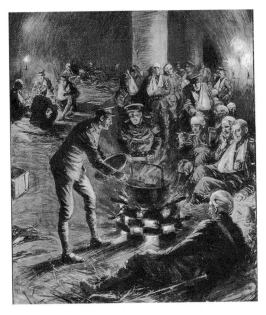

Soldiers od the 1st Northamptonshire Regiment sheltering in the Aisne Caves. (*The Graphic*, 7 November 1914)

The bearers from the 2nd King's Royal Rifle Corps found soldiers who had been wounded on 14 September. After lying for three days in the pouring rain, they were close to death. The battalion war diary reported:

> Our stretcher bearers meanwhile brought in a Rifleman who had been lying out wounded since the early hours of the 14th. He looked more like a mummy than a man; the skin of his face was drawn and yellow, his limbs limp and powerless. His equipment was still buckled up, and from a wound in his side the blood had stained the webbing of his belt and his clothing. One amongst many others who must have been in similar agony, slowly dying from loss of blood and starvation in this so-called civilised warfare. A sip of brandy and water however, received acknowledgement from his eyes, and he was sent down to the hospital at Troyon.[28]

It was a tragic day for the 1st Northamptonshire Regiment. It had lost 161 men in the deception.

CAPTAIN JOHN SAVAGE
1ST BATTALION NORTHAMPTONSHIRE REGIMENT
John Ardkeen Savage was born in Chatham in 1883. Educated at Kelly College, Tavistock, in October 1900 he joined the 3rd West Riding Regiment. He served

during the Boer War and took part in operations on Cape Colony December 1900–June 1901. Savage was awarded the Queen's medal with four clasps for his role in South Africa. In March 1912 he was promoted to Captain and joined the 1st Northamptonshire Regiment in India. Savage and the battalion went to France in August 1914 and took part in actions from Mons through to the Battle of the Aisne. He was in command of B Company and was one of the few remaining officers to have survived the action on the Aisne by 14 September. On 17 September he was being sent to take command of D Company that was being led by a junior officer, Lieutenant Burlton. German soldiers were waving white handkerchiefs indicating their surrender. Savage could speak fluent German and made an attempt to negotiate their surrender. He was shot in the back by the enemy. The following eye witness account gives details of Savage's last moments.

On Monday, the 15th September, the English advance trench on the Aisne was occupied by one hundred and sixty men of 'B' Company, 1st Northamptonshire Regiment, who had fought their way back from Mons. On Tuesday, all the officers except a Subaltern having been killed, Captain Savage was sent from his own 'D' Company to take command. At about 2.30 on the following day (Wednesday) word came down the line that the Germans were showing the white flag. This was unconfirmed, but about an hour later it was reported that they were laying down their arms, and had actually hoisted the white flag over the trench. On this Captain Savage got out of the trench, and laying down his sword and revolver advanced unarmed towards the German position, which was about eight yards distant. He was followed by his Subaltern – Lieutenant Dimmer, K.R.R.C. – who afterwards received the Victoria Cross. The German officer in command met Captain Savage in the middle of the intervening ground, and both officers were seen to salute. After about five minutes' conversation they again saluted and each turned to return to his trench. Just as Captain Savage reached his own, Mr Dimmer, who looked round, saw that the Germans were in the act of firing, and called out to warn Captain Savage, at the same time throwing himself on the ground. As Captain

Savage did so the scabbard of his sword caught in the ground, causing a moment's delay, and he fell dead riddled by the bullets of the treacherous enemy. Captain Savage was buried on the same day. Of him it was written that he was an officer dearly loved by his men, and a man who seemed utterly without a knowledge of fear. It is said that when 'B' Company came out of their trench on Friday their strength was eight sound men and four wounded.[29]

Captain John Savage's grave was lost during the course of the war and his name is commemorated on the memorial at La Ferté-sous-Jouarre.

CAPTAIN ROBERT PARKER
1ST BATTALION NORTHAMPTONSHIRE REGIMENT

Robert Burton Parker was born in Cressington, Liverpool, in 1879. He was educated at St Edward's School, Oxford and Wellington College. He served in the Boer War with the Montgomeryshire Yeomanry as a trooper from 1900 to 1902 and was awarded the Queen's medal with three clasps and the King's medal with two clasps. He was mentioned in dispatches and was initially given a commission with the Army Service Corps prior to being transferred to the 2nd Northamptonshire Regiment in July 1901. By August 1914 Parker had attained the rank of Captain and was on leave. Since his battalion was serving in Egypt, Parker was transferred to the 1st Northamptonshire Regiment and dispatched to France. He took part in the retreat from Mons and was killed leading an assault on 17 September. His commanding officer Colonel E.O. Smith wrote: 'He was the most gallant man I ever met. He did not know what fear was. He was greatly loved by all ranks and a most able and energetic officer, always thinking of the comfort of others.'[30]

A comrade serving in his battalion paid this tribute to Parker to a reporter from a local Northamptonshire newspaper. 'The Battalion admired and esteemed him. He was a brave British soldier; not a man of many words, but of much military ability, strong in will and determination.'[31]

His remains were buried close to Bourg-et-Comin, but were lost. He therefore has no known grave and his name is commemorated on the memorial at La Ferté-sous-Jouarre.

Captain John Savage, 1st Northamptonshire Regiment. (*Northampton Independent, 26 September 1914*)

Captain Robert Parker, 1st Northamptonshire Regiment. (*Bonds of Sacrifice*)

LIEUTENANT NEEDHAM

1ST BATTALION NORTHAMPRONSHIRE REGIMENT

Needham was deeply traumatised by the experience of 17 September. He had seen his comrades fall in treacherous circumstances, he was in the thick of a bitter battle and during this awful ordeal he would become the senior officer and commander of A Company. He was conscious of his responsibilities to his men and superior officers and anxious to make the right decision under such appalling circumstances. Needham recalled:

Lieutenant Needham, 1st Northamptonshire Regiment. (*The Great War, I Was There*)

I was feeling just about all in, being wet through to the skin, chilled to the bone and nerve racked after having one of my very best friends in Parker killed, in having poor young Gordon practically killed beside me, and in seeing poor old Savage butchered in that foul style; also the whole show had been such an awful muddle and I was terrified of having done the wrong thing. I shall never forget that afternoon till my dying day, nor the horror or uncertainty of it.[32]

Needham would forever be haunted by those events of 17 September. He would be transfixed by the question – did the Germans genuinely intend to surrender, or was it a trick to lull the 1st Northamptonshire Regiment into a false sense of security, to flush them out? Needham wrote 20 years later:

To this day it is a mystery to me. Did the Germans really mean to surrender, but on getting down to 'A' Company to do so and finding so few men there, change their minds and try to reverse the proceedings and take them prisoner! Or was the whole thing a put up job! We shall never know.[33]

2ND LIEUTENANT COSMO GORDON

1ST BATTALION NORTHAMPTONSHIRE REGIMENT

Cosmo George Gordon was born at the Royal Marine barracks at Deal, Kent, in 1894. Educated at Warden House, Deal, he later attended Cheltenham College. He then went to the Royal Military College at Sandhurst where he excelled at football and hockey. After passing officer training at Sandhurst he joined the 1st Northamptonshire Regiment in March 1914. Before leaving with the BEF for France he passed examinations for promotion to Lieutenant. On 17 September he was

holding trenches near Troyon when he was mortally wounded and died later that day. Lieutenant Needham paid this tribute to Gordon:

Young Gordon's batman had volunteered to go back and get some stretcher bearers up, and presently these arrived and we got poor Gordon on to the stretcher. He made me promise to see that his sword was sent back to his family and his batman took it. They carried him off and I never saw him again. Poor boy; he died at a casualty clearing station the next day, as he said he was going to, having suffered terribly, and was buried there. A typical cheery, plucky boy straight from Sandhurst, gazetted only that January, to whom everybody had taken a great fancy and whom I particularly liked.[34]

2nd Lieutenant Cosmo Gordon was buried at Vailly British Cemetery.

2nd Lieutenant Cosmo Gordon, 1st Northamptonshire Regiment. (*Bonds of Sacrifice*)

CORPORAL JOHN STENNETT 8873

1ST BATTALION NORTHAMPTONSHIRE REGIMENT

John Stennett was born in 1891 in Peterborough. He enlisted at a young age and was a career soldier. He went to France with the 1st Northamptonshire Regiment as a Corporal. He was wounded on 17 September 1914 during the German white flag deception incident. Stennett recalled:

During this I received 14 wounds commencing at the spine, shattering my right shoulder. The sensation was a shell had burst very close and I thought a piece of brick had hit me in the back of the neck. Of course I was knocked down. The fire was too heavy for me to try and get to the dressing station. I lay still for about 20 minutes then thought I would try and get back. I just managed to get up

Sergeant John Stennett, 1st Northamptonshire Regiment, in a photograph taken whilst he was serving in Mesopotamia. (Courtesy Pete Statham)

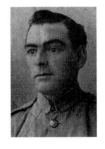

Sergeant John Stennett, 1st Northamptonshire Regiment, in hospital recovering from wounds received during the Battle of the Aisne. He is the seated figure second closest to the camera in a black suit. (Courtesy Pete Statham)

Private W. Barker, 1st Northamptonshire Regiment. (*Rushden Echo*, 9 October 1914)

... we got about 200 of them to fall in on the road ready to march them away as prisoners. While we were doing this another party came up from about 200 yards behind them and opened fire on us. Our prisoners at once tried to 'bunk' and a hand-to-hand fight at once commenced. Finally we collared about 50 prisoners who had remained with their hands up, the others getting away or being killed ... I myself got wounded at the same time, receiving a bullet wound in two fingers of my right hand and a shrapnel wound in my right ankle. Using my rifle as a crutch I managed to reach the field hospital, which was about half a mile away, under heavy fire. I remained in the field hospital for two days and was moved in an ambulance wagon and subsequently entrained for the coast. After two days in the camp hospital I embarked to England, arriving at Southampton on September 27th, after two days on the water. I was taken to Manchester Hospital and after four days there I was given a fortnight's leave and allowed to proceed home.[36]

but was promptly sent down again with another in my back. This put me out for the count. The next I remember was being dressing by the M.O. in a cave just behind the firing line. I remained in this cave until dark and was then moved to a village a few miles away.[35]

Stennett was sent to Britain to recover from his wounds. In 1915 Stennett was promoted to Sergeant.

On 1 February 1915, he married with his arm in a sling. He and his wife raised two boys and two girls. Stennett continued to serve in the British Army despite limited movement in his right arm as a result of his wounds.

He was transferred to the Army Service Corps and would serve in Mesopotamia until the early 1920s. He worked as an undertaker's driver after leaving the Army and would later drive buses for Northamptonshire Corporation. He was remembered by his granddaughter as 'a warm and loving grandfather with a good sense of humour'. He died on 3 March 1965.

John Stennett is photographed above while recovering from wounds. He is the seated figure, centre, in a black suit. His right arm is stuck out at an unusual angle as it was set in this position.

PRIVATE W. BARKER 9687
1ST BATTALION NORTHAMPTONSHIRE REGIMENT
W. Barker resided in Higham Ferrers prior to the war. He took part in the fighting on 17 September and the subsequent German white flag incident and was wounded. Barker recalled, of the surrendering Germans

PRIVATE HERBERT BILLINGTON 7477
1ST BATTALION NORTHAMPTONSHIRE REGIMENT
Herbert Billington from Long Buckby worked as a mail cart driver prior to the war. He was one of the soldiers from the 1st Northamptonshire Regiment who was wounded on 17 September when German soldiers

indicated their wish to surrender then opened fire at point blank range. In the photo he seen with sister, wearing the same clothes that he had worn when he received a bullet wound in his left thigh. The bullet hole could be seen when he had returned home weeks later and he could show his family and friends back home the dangers of war.

Private Herbert Billington, 1st Northamptonshire Regiment. (*Northampton Independent*, 24 October 1914)

PRIVATE FREDERICK FOLWELL 9684

1ST BATTALION NORTHAMPTONSHIRE REGIMENT

Frederick George Folwell was born in St Giles, Northampton, in 1896. He had served with the Northamptonshire Regiment two years before the outbreak of war. Before he left for France in August 1914 he wrote this prophetic and emotive letter to his mother in which he refers to himself and his brother who was serving in the Loyal North Lancashire Regiment.

> We may never see you again, me and poor Will, but I hope God will spare us to come back home again. I do not care. I am longing to go. I enlisted as a soldier for my King and country, and I will be a true soldier, to the dear old flag, if I have to fight to the last drop of blood. Do not worry I am as happy as I can be. If I have got to die, I will die with a good heart.[37]

This young man who was eager to get to the front line was only 18 years old. However, there is an indication that he knew he was not going to survive the war. Private W. Barker recalled Folwell's grim premonition of his death: 'On September 14th I accompanied Private Folwell, of Northampton to a village near by to get the water bottles filled, and he said to me, "Give me a cigarette paper, have got a bit of bacca and would like to have a smoke as I might get shot tomorrow".'[38] (Though no doubt such comments were made by many men.) Folwell was shot in the forehead and killed instantly on the Aisne, during the German white flag incident on 17 September. Private Frederick Folwell has no known grave and his name is commemorated on the memorial at La Ferté-sous-Jouarre.

Private Frederick G. Folwell, 1st Northamptonshire Regiment. (*Northampton Independent*, 17th October 1914)

PRIVATE FRANK GARDNER 7252

1ST BATTALION NORTHAMPTONSHIRE REGIMENT

Frank Gardner was born in 1886 and lived in Creaton. He was a member of the Brixworth Miniature Rifle Club and served with the Northamptonshire Regiment. On completing his service he became a conductor on the Northampton Corporation Tramways. He was called up as a reservist when the First World War broke out. He was killed during the German white flag treachery incident

on 17 September. Private Frank Gardner had no known grave and his name is commemorated on the memorial at La Ferté-Sous-Jouarre.

Private Frank Gardiner, 1st Northamptonshire Regiment. (*Northampton Independent*, 31 October 1914)

PRIVATE HARRY HILL 9483

1ST BATTALION NORTHAMPTONSHIRE REGIMENT

Private Harry Hill narrowly escaped death during the Battle of the Aisne when a German rifle bullet struck the regimental cap badge on his cap. Instead of shattering his skull, the bullet was deflected by the badge, but left a gash to his forehead, knocking him to the ground senseless. He lay in the wheatfield where he fell for a long time before he was found by stretcher bearers and evacuated from the Aisne battlefield to hospital.

Private Harry Hill, 1st Northamptonshire Regiment. (*Northampton Independent*, 7 November 1914)

PRIVATE EDMUND KING 7219

1ST BATTALION NORTHAMPTONSHIRE REGIMENT

Edmund King had previously served in the army for eight years and was posted to India. He returned to civilian life, but was called up as a reservist when war broke out. He was killed on 17 September 1914. He has no known grave and his name is commemorated on the memorial at la Ferté-sous-Jouarre.

Private Edmund King, 1st Northamptonshire Regiment. (*Kettering Leader*, 30 October 1914)

PRIVATE PERCY SHAWLEY 9774

1ST BATTALION NORTHAMPTONSHIRE REGIMENT

Percy Shawley was born in All Saints, Wellingborough in 1893. He was killed during the Battle of the Aisne on 17 September 1914 and was buried in Vendresse British Cemetery.

Private Percy Shawley, 1st Northamptonshire Regiment. (*Kettering Leader*, 30 October 1914)

LIEUTENANT JOHN DIMMER VC, MC

2ND BATTALION KING'S ROYAL RIFLE CORPS

John Henry Stephen Dimmer was born in south Lambeth, London in 1883. In 1902 he joined the King's Royal Rifle Corps. He was promoted to Lance Corporal later that year and joined the 4th Battalion, which was serving in South Africa. By August 1914 he was a Lieutenant serving with the 2nd King's Royal Rifle Corps. He took part in the battle for the Sugar Factory at Cerny on 14 September. Three days later he and Captain Savage from the 1st Northamptonshire Regiment met German officers with white flags and discussed terms of surrender, as described earlier. Dimmer had spent time in Germany and was able to speak the language fluently. Savage was unable to take cover and was killed. Dimmer managed to crawl back to British lines and survived the Battle of the Aisne.

Lieutenant Dimmer saw action again when the battalion was sent to Flanders in October and took part in the battle for Gheluvelt at the end of that month. On 12 November at Klein Zillebeke Dimmer was in command of four machine guns. German artillery shelled their position and Prussian infantrymen were firing their rifles 100 yards from their position. A German shell killed three of his men and Dimmer received three shrapnel wounds and was shot twice. Despite his wounds Dimmer struggled to reach one of the machine guns and fired over 900 rounds holding off the German attack. He continued to fire his machine gun until he fell unconscious. He sustained bullet wounds to his face and four small wounds

Lieutenant John Henry Stephen Dimmer VC, 2nd King's Royal Rifle Corps. (Author)

to his right shoulder. He was sent to Bellevue Hospital at Wimereux, north of Boulogne where he learned that he was to be awarded the Victoria Cross. His citation stated: 'This Officer served his machine gun during the attack on 12 November at Klein Zillebeke until he had been shot five times – three times by shrapnel and twice by bullets, and continued at his post until his gun was destroyed.'[39]

Dimmer recovered from his wounds and on 13 January 1915 he received the Victoria Cross at Buckingham Palace from King George V. He was also awarded the Military Cross for devotion to duty for the period 29–31 October. He returned to duty and served with the 6th King's Royal Rifle Corps at Sheerness. He later joined the 3rd Battalion as Brigade Machine-Gun Officer and was sent to Salonika. He contacted malaria but resisted moves to send him home to England. He gained his Observer's Certificate while training with the local Flying Corps, but when he became ill again, he was transferred to England to recover. He returned to the 2nd King's Royal Rifle Corps in February 1917 but after suffering from blood poisoning he was once more hospitalised. Appointed commander of the 2nd/4th Royal Berkshire Regiment, he took part in the Battle of Cambrai in November 1917. Lieutenant-Colonel John Dimmer was on horseback leading his battalion while retreating from the Kaiser's offensive when he was killed on 21 March 1918 at Marteville, close to St Quentin. He was buried at Vadencourt British Cemetery.

LIEUTENANT-COLONEL HENRY PILLEAU DSO

1ST BATTALION THE QUEEN'S (ROYAL WEST SURREY REGIMENT)

Henry Charles Pilleau was born in 1866 In Bermuda. He was educated at Wellington College and then went on to the Royal Military College at Sandhurst where he passed out with honours. Pilleau was commissioned into the Royal West Surrey Regiment in February 1887. He was promoted to Lieutenant in July 1889 and to Captain in March 1896. He served during the Boer War and was present at the relief of Ladysmith and took part in the actions at Colenso, Spion Kop, Vaal Krans, Pieter's Hill. He later took part in operations at Tugela Heights and Natal. He was mentioned twice in dispatches and was awarded the Distinguished Service Order for his service

Lieutenant-Colonel Henry Pilleau, 1st Queen's Royal West Surrey Regiment. (*The Distinguished Service Order 1886–1915*)

in South Africa. When Lieutenant-Colonel Warren was killed by a sniper on 17 September 1914 during the Battle of the Aisne, Pilleau was appointed commanding officer of the 1st Queen's (Royal West Surrey regiment). The appointment was short-lived because Pilleau was mortally wounded while leading his battalion in an attack. He continued to direct the men under his command for four hours. He died of his wounds a week later at Neuilly on 21 September. He was buried at Neuilly-sur-Seine New Communal Cemetery.

NOTES

1. *Kettering Leader*, 2 October 1914
2. IWM 79/33/1: Corporal John Stennett, 1st Northamptonshire Regiment
3. Hammerton, Sir John (ed) *The Great War, I Was There* (The Almalgamated Press, 1938)
4. Ibid
5. WO 95/1272: 2nd Battalion King's Royal Rifle Corps War Diary
6. Hammerton
7. Ibid
8. Ibid
9. *The Scotsman*, 19 October 1914
10. Anon, *Northamptonshire Regiment 1914–1918* (1932, republished by Naval & Military Press, 2005)
11. Ibid
12. Ibid
13. Ibid
14. *The Scotsman*
15. Hammerton
16. *Northampton Mercury*, 2 October 1914
17. Ibid
18. WO 95/1272
19. Hammerton
20. Ibid
21. IWM 79/33/1
22. Anon, *Northamptonshire Regiment*
23. Hammerton
24. WO 95/1272
25. Hammerton
26. WO 95/1272
27. *Northampton Independent*, 31 October 1914
28. WO 95/1272
29. Clutterbuck, L.A., *Bonds of Sacrifice: August to December 1914* (1915, republished by Naval & Military Press, 2002)
30. De Ruvigny, Marquis, *De Ruvigny's Roll of Honour, 1914–1918* (1922, republished by Naval & Military Press, 2007)
31. *Northampton Independent*, 3 October 1914
32. Hammerton
33. Ibid
34. Ibid
35. IWM 79/33/1
36. *Rushden Echo*, 9 October 1914
37. Ibid
38. Ibid
39. *London Gazette*, 19 November 1914

18 SEPTEMBER

Wirelesses were fitted in aeroplanes on 18 September to make communication easier between aerial reconnaissance planes with artillery batteries on the ground. The initiative was the brainchild of Captain Douglas Swain Lewis, who set up the new method of 'pinpointing' for the artillery with Major Geoff Salmond, Commander of No. 3 Squadron. (For the full story of aerial reconnaissance, see the magisterial *Shooting the Front* by Colonel Terrence Finnegan.) Since 13 September when the mist lifted, aeroplanes from the Royal Flying Corps had been providing intelligence to the artillery. Each British division had a reconnaissance aeroplane allocated to them and early each day an artillery observer would fly with the pilot identifying and noting German positions on a squared map – also devised by Lewis and Salmond – which would be sent to divisional army commanders to set more accurate ranges against German targets.

For the soldiers of the BEF on the ground, the day was just like the previous ones, rain continued to fall as German artillery continued to fire their heavy shells. The British were becoming familiar with the persistent shelling, the wet, the hunger and the squalor. The 1st Black Watch had been holding onto their trenches for five days and nights. Private John Laing wrote in his diary on 18 September:

> Daybreak, the usual, shelling us for all they are worth. I don't know what to make of it, whether we are trying to starve or shell them out as this is our 5th day and night in this trench ... Awful rain through to the skin ... Tried to get a few winks but no use, trenches full of water and still raining.[1]

The ground of the Chemin des Dames consisted of between 2 to 3 metres of soil and under this were layers of chalk. It took several days for the rainwater to go through the chalk, which meant that the trenches were flooded.

The 2nd Connaught Rangers were holding the main road north of Verneuil when they came under heavy German bombardment leaving their commander Major William Sarsfield mortally wounded and 4 other ranks killed.

H.J. Milton of the 2nd Highland Light Infantry had a narrow escape from death prior to moving up to the trenches at Verneuil during the night of 18 September. He had just finished eating a meal of bully stew when a piece of Lyddite shell scratched his cheek. 'Moved again at night to trenches in a pouring rain, all soaked to the skin and to dig fresh and deeper trenches to hold out against the shell fire as the old trenches were in the line of fire and shelled out. Tried to sleep at 2am standing in water.'[2]

Captain Hubert Rees was holding positions on Chivy valley with the 2nd Welsh Regiment. He and fellow officers speculated how long the Battle of the Aisne would last: 'We wondered how long the battle would last ... We were informed that the Germans would soon be forced to retire and that the advance to the Rhine would continue.'[3] In reality, the 2nd Welsh Regiment were in a stand-off with the Germans entrenched a few hundred yards ahead:

> We were at the edge of the woods, laboured with entrenching tools. We appeared to be almost escort to a battery of German field guns, which were only just over the ridge 400 yards away. The German observer established

Primitive barbed wire defences in front of German trenches on the Aisne front. (Author)

Captain Douglas Swain Lewis, an innovator in the use of aerial reconnaissance, wireless and mapping for artillery targeting.

himself on a haystack 300 yards away, and our guns, with which there was no telephone connection, failed to hit him. We tried to dislodge him with rifle fire; as he usually gave us a dose of shrapnel in reply, it was not very popular. A popular amusement was a daily duel at 700 yards with some Germans at another haystack more to our right. The S.W.B.s tried to attack there one day but did not have any success, whilst another day, the Germans attacked in their turn and got a very bad mauling, running back with sheaves of corn on their shoulders to escape detection. The observer at the haystack in front became such a public nuisance that a Sergt. crawled out to the haystack one night, bayoneted the German guard, put a match to it and made good his escape. A very fine performance. The smoking heap next morning was a very gratifying sight.[4]

German commanders were sending out skirmishing patrols, as were the British. Lieutenant-Colonel Bird of the 2nd Royal Irish Rifles wrote: 'We lost a few men from artillery fire and some of our patrols met German patrols in the wood.'[5]

An observation post positioned at the corner of the wood 300 yards on the left of the line of trenches held by the 1st Northumberland Fusiliers was attacked by German forces at 4.00pm. German soldiers got into their trenches but were repulsed. The Northumberland Fusiliers lost two killed and one wounded.

The 1st Queen's (Royal West Surrey Regiment) also resisted German efforts to enter their trenches. The battalion was relieved and was held in reserve at Vendresse. During that night the battalion received 197 reinforcements led by Lieutenants J.M. Rose-Troup and M.S. Pound.

Captain Charles Paterson, Adjutant of the 1st South Wales Borderers, had spent less than a week in the trenches and the experience had taken its toll. He was unaware at that time that this would become day-to-day existence for thousands over the next four years:

At dawn the firing starts again, and this time we have to stay in our trenches the whole day long. I wonder how many thousands of shrapnel bullets must have been fired at us during the last twenty four hours. It is a wearing, trying job and gets on one's nerves fearfully. We manage at daybreak to send out a search party to bring in any wounded that there may be in front and we find some have been there three days, wounded with no water, no food and no shelter. And when found, a large number say they are not half as bad as someone else close to them and will we look at the others first. Magnificent spirit, and people who say England is going to the dogs and that the men of England

are inferior to those of the past do not know what they are talking about. The rain comes down about 9.00am and falls all day long in sheets. All the trenches are full of water. No draining any good. A cold S.W. wind on top of the hill does not improve matters, but again everyone tries to be as cheery as possible and so night comes on. The battle stops for a bit and again we have some rest, but little sleep, it is too cold really for that. At dawn, firing starts again. How long can it go on, I wonder, and how long can one's nerves stand it. Of course, one is safe enough as far as things go in trenches with cover, etc, but it is the noise and shock that tires one. A whistle and a bang, and a noise that sounds like a shower of hail as the shrapnel comes through the branches of the trees, and then all is over for a minute and then at it again.[6]

Captain Charles Paterson would not endure four years of trench warfare; he was killed on 1 November 1914 at Ypres.

There was little activity on the front held by the 1st Loyal North Lancashire Regiment at Troyon during the day. German artillery began bombarding their trenches during the afternoon and British artillery responded. Later that afternoon the 1st Loyal North Lancashires began preparing for an anticipated German night attack. There was no German advance but they fired their rifles just the same. The battalion war diary recorded:

The enemy did not advance, but appeared to open fire all along the line from their trenches. The attack was kept up for 3 hours off and on. We lost no one during the attack. The weather was most disagreeable. It rained hard during the whole night making the lines almost inhabitable, the men have stood it wonderfully well and so far we have had only 2 sick from exposure. Most of the trenches were flooded.[7]

The 1st Loyal North Lancashire Regiment fortified their trenches and erected barbed wire defences to the front. The barbed wire entanglements would further paralyse movement along the entire Western Front. Private Frederick Bolwell was one of the soldiers who were given the unenviable task of going into No Man's Land to wrap barbed wire around the stakes. This was a very dangerous undertaking. Inevitably, knocking the stakes in the ground, as well as winding the coils of barbed wire, was a noisy business. Bolwell recalled:

On the fourth night I was allotted a nice job. My Section Sergeant, coming to me just after dark, said: 'I've a nice little job for you.'

'Oh yes,' says I – thinking it was a nice little berth behind the transport – 'What is it?'

'Do you know anything about barbed wire?' says he 'Just twisting it around stakes?'

'I don't know,' says I. 'I may be able to do it; anyhow I could have a try.'

'Well, out in front about forty yards,' says this Sergeant, 'you will find a lot of stakes and two reels of barbed wire. Now you go out and I'll send another fellow to knock in the stakes while you can twist the wire round them and make some entanglements.'

I can't say I liked the job, because I didn't! The enemy lay only a few hundred yards away, and I had to go out there attracting attention by knocking in stakes and twisting barbed wire around them, a thing the enemy would be sure to try their best to prevent. But it had to be done, so off we started, creeping over the top. We were looking for nearly an hour for this wire and, after twice nearly walking into the enemy's lines, we at length found it, and managed, after several volleys from the enemy, to accomplish our task, and rig up some sort of defence. Every night after that, whenever we occupied the front line, I was one of the men erecting the barbed wire entanglements, and many were the narrow squeaks I had at the hands of the Germans.[8]

The 2nd Grenadier Guards returned from relief at Soupir to the front line at Cour de Soupir Farm to relieve the Coldstream Guards on 18 September. They took up positions to the left of the one they defended two days previously. Major Jeffreys deployed No.1 and No.2 Companies in the firing line and held No.3 and No.4 Companies in reserve. Anticipating another day of heavy German shelling they immediately started to dig their trenches deeper. They could also see their German counterparts fortifying their trenches 700 yards away. Not long after they relieved the Coldstream Guards the shelling began. They made little progress in deepening their trenches. Shells were exploding all around them. Craters were made by German howitzers that could accommodate three or four horses. An average of 50 shells per minute fell during a six-hour bombardment of the

2nd Grenadier Guards. The unit history of the Grenadier Guards describes the nature of the first trenches that were dug and occupied by the British on the Aisne:

> The trenches during the first few months of the war consisted not of continuous lines of trench, but of a series of deep holes holding three to four men apiece, and separated from the next by some 10 feet of undug earth, which formed a natural traverse. There was hardly any parapet, and the earth was scattered to the front. The advantage of this type of trench was that it was difficult to locate and destroy by artillery, but if the enemy was near at hand, vigilant communication either laterally or to the rear was practically impossible.[9]

The 2nd Grenadier Guards utilised the caves as shelter and accommodation for their companies in reserve:

> The supports and reserves were all hidden in caves very like those they had occupied in the quarry behind their first position. They were all rationed, with plenty of fresh meat, vegetables, and jam. They were indeed, very much better off than the men in the trenches, for it turned very cold again at night, and rain fell heavily.[10]

The heavy bombardment of the line held by the 4th Guards Brigade was to prepare for a German infantry assault to break through their line and force them back across the Aisne.

The 2nd Oxfordshire & Buckinghamshire Regiment relieved some of the Guards holding trenches at Cour de Soupir Farm on the 18th. Captain Harry Dillon, a company commander of the Battalion, observed that 'Hundreds of German dead and wounded lie in thick clusters within a few yards; but we cannot come out and collect them.'[11]

The wounded still lay on the battlefield, but there was no way of reaching them because of the risk of death from machine-gun, sniper and shell fire. The horrible consequences of trench warfare were becoming apparent.

NOTES

1. Private John Laing, 1st Black Watch, Diary, The Black Watch Museum
2. IWM 81/1/1: H.J. Milton, 2nd Battalion Highland Light Infantry
3. IWM 77/179/1: Captain Hubert Rees, 2nd Welsh Regiment
4. Ibid
5. WO 95/1415: 2nd Royal Irish Rifles War Diary
6. WO 95/1280: 1st South Wales Borderers War Diary
7. WO 95/1270: 1st Loyal North Lancashire Regiment War Diary
8. Bolwell, F.A., *With a Reservist in France* (E.P. Dutton & Co., 1917)
9. Ponsonby, Lieutenant-Colonel Sir Frederick, *The Grenadier Guards in the Great War* (Macmillan & Co, 1920)
10. Ibid
11. IWM 82/25/1: Captain Harry Dillon, 2nd Oxfordshire and Buckinghamshire Regiment

19 SEPTEMBER

The only German infantry assault carried out on the BEF sector on 19 September was focused upon Vailly but was stoutly resisted. German infantry poured rifle and machine-gun fire into St Marguerite. German artillery continued to bombard British positions on the BEF's left flank around Vailly, Missy, and Bucy-le-Long. At Missy, D Company, 1st Royal West Kent's, came under heavy fire and a single shell killed three valued NCOs. Sergeant Fitzgerald, Sergeant Zebulum Barden and Lance Sergeant W. Warnett were vapourised. 18-pounder guns arrived on the British sector to replace the guns lost at Le Cateau. Reinforcements began to arrive to bolster the depleted ranks of the British battalions.

German soldiers laboured to erect barbed wire defences along the extreme left sector towards Soissons, held by the 4th Division, which was a positive indication that the German Army had no intention of withdrawing from the Chemin des Dames. The 4th Division was able to provide artillery support to the French on their left flank but had orders not to launch any infantry attacks.

Field Marshal French still held out hope for a German withdrawal but this was wishful thinking. He advised his divisional commanders to be prepared to advance if the Germans retreated; at the same time he made provision for the trenches to be dug and fortified on the ridges south of the river Aisne as a contingency in the event that the BEF were driven from the Chemin des Dames and forced back across the Aisne. The 19th Infantry Brigade, assisted by locals from the neighbouring villages, was involved in the construction of these defences.

During the day German infantry launched attacks upon the 2nd Division front and a massive assault at dusk upon the 3rd Division line, which was repulsed causing many casualties amongst the Germans.

The BEF was now in a position to observe German positions and direct artillery fire accordingly. A German report of 19 September recorded: 'There was no progress worth mentioning as the enemy was in possession of good observation posts on the Chemin des Dames and could direct his field and heavy artillery where he desired.'[1]

The 2nd Oxford & Buckinghamshire Light Infantry came under attack at Cour de Soupir Farm. The German attack was held back. As German shells poured upon Soupir during the evening of 19 September, Captain Rosslyn Evelegh from the 2nd Oxford & Buckinghamshire Light Infantry left the shelter of his trench to save – something at once astonishing and moving – a wounded pig. Evelegh was killed by a shell during this rescue attempt. Evelegh had been wounded on 16 September and after two days had returned to duty. Lieutenant Aubrey Barrington-Kennet was mortally wounded and died of his wounds the following day. Eight other ranks were killed and 26 were wounded by shell fire.

Brigadier-General the Earl of Cavan arrived on 19 September to take command of the 4th Guards Brigade and Lieutenant-Colonel Wilfred Smith took over command of the 2nd Grenadier Guards. The Battalion would remain in the trenches for a further three days. They came under heavy German artillery fire; however, German infantry units were reluctant to engage in close quarter combat.

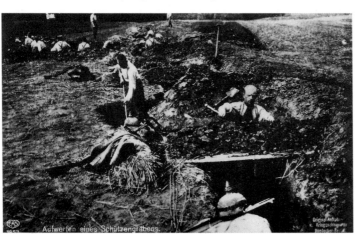

German soldiers digging some of the very first trenches on the Western Front in 1914.

Lord Congleton was summoned from his dugout to report to Battalion Headquarters. When he returned he found that his shelter had been completely destroyed by a shell. Lord Bernard Lennox-Gordon had a close encounter with death when he took off his coat and placed it at the rear of his trench. He had moved off a couple of paces when a shell exploded. Turning around he saw that the right arm of his coat had gone and the remainder of the coat was torn to shreds.

The 2nd Grenadier Guards were kept on alert through the night when German snipers were sent out to fire upon their trenches to do just that. Sleep deprivation was a great problem for these Grenadiers, as well as the trenches becoming waterlogged.

The 1st Irish Guards had occupied trenches close to Cour de Soupir Farm during the day. Private Kilcoin, 1st Irish Guards, was relieved when they were taken off the line later in the day becuase they had been waiting for a German infantry attack that never materialised. Later that day he wrote in his diary while in the village at Soupir.

> Relieved by 3rd Coldstreams and very nice too – as things are bad with us. Raining badly, everything sodden – went back to town of Soupir for a rest, billeted in farm, very comfy, had an alarm or two during the time – nothing much doing. Though we lay in wait behind our front line trenches (at the time we did not know what for) to do a bayonet charge which never came off THANK GOD! – Germans did not attack – on our way back passed long string of ambulance wagons which had been brought up for the affair. What a hope![2]

On 19 September, German artillery bombarded the trenches of the 1st Loyal North Lancashire Regiment at Troyon from 6.00am for 20 minutes. Private Charles Stringer was killed as he was running to the trenches during this bombardment. He has no known grave and his name is listed on the memorial at La Ferté Sous Jouarre Memorial. Another private from the battalion had a lucky escape when a dud British shell passed him at knee height and landed in a nearby bank without exploding.

The 2nd Highland Light Infantry came under heavy shell fire as they continued to hold the line at Verneuil. H.J. Milton recorded the ordeal:

> Still raining, covered in clay, most pitiable object, halted at 5am, no food. I tried to dig a trench for self but as a shell fell 50 yards off I had to run, shells were falling all along the trench line. This has been the most terrible shell fire we have had. My trench was blown up. It must have been the Grace of God that saved us all as every man was

a-tremble, our nerves are almost shattered by this continual shell fire that we have been subjected to all this time. How we escaped this morning is a miracle. We had to run to some caves in the line of fire, we were safer and got calmed down. We stayed here all day. Move off tonight to trenches again. Found the body of Lt. Powell, been dead 5 days, shot in head and side, buried in morning. A rumour that the G big gun has been silenced, not sure but still very heavy fire, lyddite and shrapnel. We dried our clothes on us, we are in a bad state, badly in need of rest. On outpost all night, very cold and wet. Fighting all the time.[3]

The 4th Royal Fusiliers war diary reported the weather on 19 September to be fine. From 2.30pm the enemy began 'a very severe shelling' of their positions at Rouge Maison causing several casualties. British artillery was unable to respond because the German guns were out of range. The German guns were firing until 6.00pm. As soon as the shelling stopped a determined German infantry assault was unleashed. The German waves became disorganised and some parts of the line got lost in the darkness and smoke. The Germans suffered many casualties as a consequence. Many dead German soldiers were counted in front of X Company. The 4th Royal Fusiliers fought them off, but themselves suffered approximately 50 casualties.

The 2nd Royal Irish Rifles holding trenches at La Fosse Marguet endured the German bombardments. Lieutenant-Colonel Wikinson Bird commanding 2nd Royal Irish Rifles wrote:

> Early on the 19th the Germans began to shell our position with shrapnel and continued with pauses to do so all morning. In the afternoon the shelling was more rigorous, the battery attacking us firing progressively at 1,500 metres, the usual procedure being two salvos shot, one on our trenches, one over. Probably the fact that trees were 50–60 yards behind us made it difficult for them exactly to locate our position, but the fire was accurate, some shells bursting on our parapets. The casualties were nonetheless comparatively few.[4]

Lieutenant-Colonel Wilkinson Bird was amongst those wounded by the German shell fire that day. He was evacuated from the battlefield and his leg was amputated. During the period 14–22 September the 2nd Royal Irish Rifles lost 2 officers killed, 12 wounded, 270 other ranks killed or wounded. Many of the 2nd Royal Irish casualties were caused by the German artillery.

It was important to establish telephone lines between 3rd Division Headquarters on the south bank

with the 9th Infantry Brigade located on the north bank. During the evening of 19 September there was no way across the river, which was swollen by the rain to 60 yards in width. There were no boats available to take a telephone line across. A private from the Royal Engineers volunteered to swim across with a cable. Lieutenant George Hutton, also from the Royal Engineers, was aware that this man was married and felt he had too much to lose, so he volunteered to swim across the swollen river himself. He bravely entered the cold waters and nearly made it, but was overwhelmed by the strong currents. Hutton never surfaced.

The 1st East Surrey Regiment was defending Missy on the 5th Division's sector. Captain Andrew de Vere Maclean was killed and 20 other ranks wounded on 19 September. Captain Maclean had joined the battalion just three days earlier with 7 officer reinforcements.

During that night the right flank of the BEF was relieved with fresh troops from the 6th Division. Although the 3rd Infantry Brigade remained on this sector, the 1st Guards and 2nd Infantry Brigades, who had been holding the line near to Vendresse and Troyon and were in desperate need of respite, were relieved by the 18th Infantry Brigade in the evening. The 18th Infantry Brigade was strong and was able to hold the ground occupied by the two brigades along the Cerny-en-Laonnois Plateau. The 2nd Sherwood Foresters (Nottinghamshire & Derbyshire Regiment) had arrived at Vendresse and relieved 1st Black Watch. The 2nd The Royal Sussex Regiment was relieved by the 1st East Yorkshire Regiment and withdrew to caves at Paissy.

NOTES

1. Edmonds, Brigadier-General J.E., *The Official History of the War Military Operations: France & Belgium 1914* Volume 1 (Macmillan & Co, 1933)
2. Private L. Kilcoin's Diary: Irish Guards Regimental Headquarters Archives
3. IWM 81/1/1: H.J. Milton, 2nd Battalion Highland Light Infantry
4. WO 95/1415: 2nd Royal Irish Rifles War Diary

HOLDING THE LINE AT TROYON

General Josias von Heeringen commanding the German Seventh Army ordered the entire VII Reserve Corps to launch an attack upon the British and French positions along the Cerny-en-Laonnois Plateau on 20 September 1914. The 18th Brigade from the 6th Division was brought forward to bolster the line on the right flank of the 2nd Brigade during the previous evening. They held the eastern extremity of the BEF line beneath the Chemin des Dames ridge. The 18th Brigade established their position at Paissy in between the 2nd Infantry Brigade on their left flank and the French Zouaves on their right flank.

The 18th Brigade was made up of the 1st Prince of Wales's Own (West Yorkshire Regiment), 1st East Yorkshire Regiment, 2nd The Sherwood Foresters (Nottinghamshire and Derbyshire Regiment) and the 2nd Durham Light Infantry. They took over trenches north of Troyon on the Cerny-en-Laonnois Plateau during the night of 19 September. Private J. Warwick entered the trenches with the 2nd Durham Light Infantry. He described in a letter the state of the trenches and their close proximity to the enemy: 'Rain was coming down in torrents and our trenches were practically up to the thighs in water. The Germans were entrenched not 80 yards away on the other side of a hill, their trenches being far more formidable than ours.'[1]

The 1st Prince of Wales's Own (West Yorkshire Regiment) commanded by Lieutenant-Colonel F.W. Towsey, relieved the Coldstream Guards in the front line trenches during the same night and were holding the

far eastern extremity of the BEF's sector above Troyon. Zouaves from the French territories in North Africa occupied trenches on their right flank.

The 1st West Yorkshires were attacked by German infantry at 9.00pm soon after they entered the line but repelled this attack. Throughout the night the 1st West Yorkshire Regiment strengthed their trenches and constructed overhead covers to provide shelter from flying shrapnel.

On 20 September battalions from the 18th Brigade were entrenched in a line north of Troyon. The 1st East Yorkshire Regiment held the left flank, the 2nd Durham Light Infantry were in the centre and the 1st West Yorkshire Regiment on the right flank. The 2nd Sherwood Foresters were kept in reserve in Troyon.

During the early hours of 20 September from 3.30am until 4.30am German artillery began firing upon their lines and the French North African troops on their right flank came under German infantry attack, which forced them to retire rapidly over the Paissy Hills. Towsey sent a patrol commanded by Lieutenant Thomas Meauty to the right flank. This patrol was fired upon. Towsey was concerned that his right flank was in danger of collapsing and ordered Captain Lowe and D Company to advance to cover the exposed flank left by the French Morrocans. As D Company dashed across open ground the French North African troops rallied and returned to their original position and fired upon the West Yorkshires by mistake. D Company sustained casualties as a consequence and withdrew to their trenches. One

The French Zouaves were holding the line east of the 1st West Yorkshire Regiment's position at Troyon on 20 September. This photograph shows them passing through the Laigue Forest during the Battle of Vic-sur-Aisne. (Author)

was killed and 26 were wounded. Lieutenant Naylor-Leyland from the Royal Horse Guards who was attached to the battalion died from his wounds the following day.

With the French line in a state of disarray and the 1st West Yorkshires' line exposed, the trenches occupied by the 2nd Durham Light Infantry on their left flank also became vulnerable. The 1st East Yorkshire Regiment on their adjacent left flank was ordered east to support the West Yorkshires' line but was beaten back by German fire.

At 8.00am the firing line trenches held by the 1st West Yorkshires came under fire. Lieutenant-Colonel Towsey accompanied by Lieutenant Thomas Meauty went forward to assess the situation. Meauty was mortally wounded and Towsey returned and ordered D Company forward. The French Moroccans retired once again and one company from the 2nd Royal Sussex Regiment was brought up together with a squadron from the 18th Hussars to reinforce the right flank. Fighting ensued throughout the morning. The 1st West Yorkshires fought off a second German infantry assault between 10 and 11.00am that morning.

Between noon and 1.00pm another German assault was launched upon trenches held by the 1st West Yorkshire Regiment along the Chemin des Dames in a torrential rainstorm. At 1.30pm a soldier arrived at the 1st West Yorkshires' headquarters to report that German infantry during this attack had advanced bearing a white flag. They were also carrying stretchers on which were hidden machine guns ready for use. When the 1st West Yorkshires went forward to accept their surrender they came under heavy fire and found themselves surrounded. Many were killed or wounded. Only a few men escaped. German infantry on the right flank exploited the breach in the line made by the withdrawal of the French Zouaves and moved forward to provide enfilade fire. The line of 1st West Yorkshires had broken

and waves of German infantry were advancing across the Cerny-en-Laonnois Plateau.

Private J. Warwick of the 2nd Durham Light Infantry who were positioned west of the 1st West Yorkshires witnessed the deception:

> When we first began to fight there were at least 600 Germans on our right, and I might say that their artillery fire was remarkable. A party of the West Yorkshires went out to meet them, as the Germans were apparently walking along with their rifles up in the air, our men thought that they were giving themselves up as prisoners. As soon as the West Yorkshires got to about 30 yards from us, the Germans opened a heavy fire and wiped out a big number of our soldiers. There can be no getting away from the fact that the Germans are abusing the white flag, and after this we received strict orders that we must on no account take any notice of this flag in future.[2]

Private Charles Osborne was with the 2nd Sherwood Foresters held in reserve in caves below the Cerny-en-Laonnois Plateau. He later wrote of the German deception of the West Yorkshires:

> We were not left in peace long, for on the morning of the 20th Sept, the Germans, by the white flag trick, took the trenches which had been held by the West Yorks. This is how it happened as told to me by a Pte of the W Ys. About noon on the 20th, a large body of Germans (about 200) appeared in front of the trenches showing the white flag. Upon seeing this, our men were tolled off as escort and got out of the trench, some, or most of the officers also got out, but no sooner had they done so, when a deadly fire was poured into them by two machine

French Zouaves crossing the Aisne after the attack on the German trenches. (Author)

The Cerny-en-Laonnois Plateau north of Troyon where the 1st West Yorkshire Regiment held trenches along the Chemin des Dames. The Sherwood Foresters charged across this open ground on 20 September in an effort to restore the 1st West Yorkshires' line. (Author)

guns which had been carried on stretchers. Several of the officers were hit and a good many men and so suddenly was it carried out, that our men were unable to stand against a greater body of the enemy, who had advanced.[3]

At 2.00pm C Company of the 1st West Yorkshires who were held in reserve at Troyon were sent forward by Towsey to the frontline trenches along the Chemin des Dames in an effort to try and save the forward companies from capture. With bayonets fixed they charged at the double across the Cerny-en-Laonnois Plateau, but they encounted heavy German machine-gun and rifle fire from the front and the right flank. Overwhelmed, they retired. Towsey ordered his men to fall back to Paissy Hill in the hope that they would connect with 2nd Cavalry Brigade that was expected to arrive from Paissy. Once it was confirmed to Towsey that the cavalry was on its way he stopped the withdrawal and ordered another attempt to occupy the trenches that had been abandoned. He sent Major Lang forward to reconnoitre before headquarters and C Company advanced to the trenches once occupied by A and B Companies, where they linked up with parties of the 1st East Yorkshire Regiment and the 2nd Durham Light Infantry.

The 2nd Durham Light Infantry also confronted the Germans. Private J. Warwick of this battalion gave a compelling account of the situation after the battle. Warwick saw many of his comrades fall and in an interview to a journalist while he was recovering in hospital in Newcastle he recalled:

> The Germans were entrenched not 80 yards away on the other side of a hill, their trenches being far more formidable than ours. We had not very long

to wait before shells and bullets began to fly about us in all directions. Our men tried to rush up the hill, but first one and then the other fell under the hail of fire. Although the Germans were at least twelve to one, our men held their own, fighting as I have never seen men fight before. We had a great leader in Major Robb. He led the men splendidly.

> Lieutenant Twist, one of our number, tried to advance with the company up the hill, but was quickly shot down. I saw him shot, and although the shrapnel was flying and bullets were coming like rain I made a dash and brought him back to the trenches.

> Then I saw Private Howson, a Darlington chap, and I succeeded in bringing him within the firing line. The poor chap was shot through the neck and the shoulders, though I believe he is still living. I then went back again and succeeded in bringing in Private Vaughan.[4]

Warwick's actions on that day made him a worthy recipient of the Victoria Cross. Although recommended for this prestigious decoration for rescuing two wounded officers and two injured privates, he was never given the award. After three trips into No Man's Land to recover wounded comrades he made a final excursion, dodging German bullets to go out and bring back the wounded Major Alexander Robb to safety. Robb had led an assault upon German trenches and despite being wounded he continued the attack until he fell. Warwick:

> My last journey was the most difficult of all. I had to travel over the hill to within thirty yards of the German trenches, and how I escaped being killed I really do not know. I crawled on my stomach and

got along as best I could, and I am glad to say that I succeeded in bringing Major Robb back, right, as it were, from under the very noses of the Germans. It was a hard job to get him, and in my effort I was shot through the back and fell.[5]

Warwick had brought Robb close to lines held by the 2nd Durham Light Infantry, but his wounds were mortal and Robb died later that day.

The 2nd Sherwood Foresters (Nottinghamshire & Derbyshire Regiment) were being held in reserve at the foot of the Cerny-en-Laonnois Plateau north of Troyon. A and C Company from this Battalion were positioned close to the French sector and had been ordered to stand to earlier that morning. At 2.00pm they could hear the sounds of gunfire getting heavier from the direction of the West Yorkshires' trenches. It was at that time that they received the alarm that German forces had penetrated into the West Yorkshires' lines and had captured their trenches. A and C Companies immediately sprang to arms and led by their officers rushed across the plateau towards the West Yorkshire trenches in an effort to secure the line. Major Leveson-

Gower moved along the side of the hill on the plateau north of Troyon trying to organise a counter attack. He ordered Captain Parkinson and A Company to advance on the right flank towards a small copse and Captain Popham with C Company to drive along the left flank towards a specific haystack. The situation was so desperate that they were not in formation and they dashed in the direction indicated despite being exposed to German machine guns positioned on the high ground. The machine guns caused many casualties amongst the two leading companies.

They also cut through the two support companies. B Company, commanded by Captain Way and D Company, led by Major Taylor, were advancing close behind. They were easy targets for the German machine gunners. Though the emergence of B and D Companies brought further rifle fire upon the German positions, which forced the German machine gunners to keep their heads down and bought sufficient time to press forward the advance up the slopes.

Despite lack of British artillery support the 2nd Sherwood Foresters managed to regain the trenches lost by the West Yorkshires. Captain Popham sustained several bullet wounds and C Company was severely mauled. However, the remnants of this company managed to get close to the German trenches. Captain Parkinson got A Company to a hedge on the right flank, where he fell wounded. Private Charles Osborne of the 2nd Sherwood Foresters:

The advance of the Sherwood Foresters across the Cerny-en-Loannois Plateau on 20 September. (1st and 2nd Battalions the Sherwood Foresters ((Nottinghamshire and Derbyshire Regiment)) in the Great War)

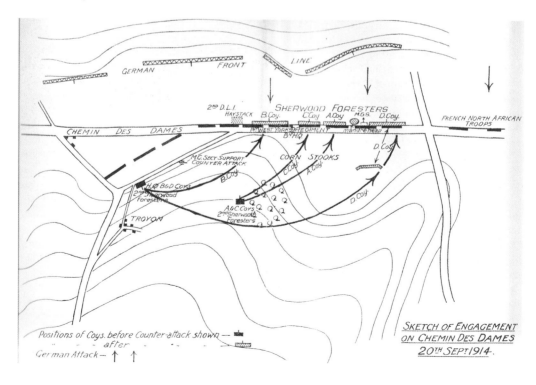

Cutting beneath the Cerny-en-Laonnois Plateau north of Troyon; the 2nd King's Royal Rifle Corps launched their attack upon the Sugar Factory from this position on 14 September. A week later, on 20 September, the 2nd Sherwood Foresters charged from this position across the plateau to recapture trenches along the Chemin des Dames. (Author)

It was on this day we had our first issue of rum and tobacco and were enjoying a quiet smoke while our dinner was cooking, when we got the order to fall in. Most of us did not know what we were falling in for, but we soon knew, when we doubled down the valley towards the trenches and heard the bullets zipping overhead. At the end of this valley we came out into the open and here we had our first casualties, a good many of 'C' Coy going down in front of a fierce machine-gun fire. Capt Popham, DSO seemed to have got very near to these guns, as he came back wounded in the head and arm (on one side). Capt Luther, Capt Parkinson, Lieut Needham, were wounded here, Lieut Milner being killed while running with a message; and other officers were also hit in the attack.[6]

20 September was a significant day in the Sherwood Foresters' regimental history. It was known as Alma Day: 60 years to the day soldiers from the battalion known as the 95th Regiment stormed the heights of Alma during the Crimean War in 1854. Despite enfilading German fire from the right flank and ahead of them they charged up hill and evicted the Germans from the West Yorkshires' trenches.

German forces launched a counter attack upon trenches held by the 1st East Yorkshire Regiment and broke through on the right flank overlooking Vendresse

and Troyon. A and B Companies were sent forward in a counter attack but were overwhelmed by German shrapnel and machine-gun fire.

The 2nd Durham Light Infantry launched a further attack at 4.00pm. A reporter from *The Scotsman* interviewed a wounded sergeant from the battalion and detailed his experience in the following article, entitled 'Shot by a dead German':

A sergeant of the 2nd Durham Light Infantry told a graphic story of the fighting on the Aisne. He was eight days in the trenches there, and they were attacked very strongly by Germans who were thrown back with very heavy losses. On Sunday 20th September, there was a terrific artillery battle for some hours and then an attack by German infantry who were again driven back, the Durhams delivering a counter attack. Then they made another attack on the Germans, who suffered severely. The Germans were in four lines of trenches, and about

Private Charles Bell took part in the action to secure the line at Troyon on 20 September. While most of his company from the 1st West Yorkshire Regiment were wiped out, Private Bell saw his sergeant fall wounded and went to his aid, then 'started for home'. At times he had to crawl along the ground with the wounded sergeant on his back. Under heavy fire they reached the safety of their lines after two hours. (Amalgamated Press, 1914)

four on the Sunday afternoon, one platoon charged the front line of trenches, the Sergeant being one of the men employed. There were numbers of the Germans lying dead in and around the trench. In the trench were nine Germans with three Maxim guns, the trench being what is called a machine-gun trench. The sergeant bayoneted two men and turned to bayonet a third. He lunged forward, dropping on one knee as he did so, and his bayonet entered the stomach of the German, coming out at his shoulder. The German fell forward on top of the Sergeant, and as he did so his trigger was pressed somehow and the bullet inflicted a severe wound in the Sergeant's arm. So close was it, that his tunic was burned by the powder.

The nine Germans in the trench were all killed, and the Durhams turned to get to their own trenches again. The sergeant dropped into a gulley, where he remained, as he was in satisfactory cover, but he could hear some of the men saying 'The sergeant is dead.' He remained there for a little lying beside the body of a German whose head had been blown off, and after crawling for some distance, rose and ran for the trenches, which he reached successfully. He was fired at but not struck. The Germans were armed with rifles and had bayonets fixed, but evidently they could not use these well. When the Durhams rushed the trench the Germans seemed panic-stricken, and ran in all directions. The last one to be killed was in a corner. All the Germans were killed. At that point the infantry trenches were within eighty yards of one another, with a slight rise of ground between.[7]

2nd Lieutenant Eric Wilson was killed as he led his men of the 1st West Yorkshire Regiment in a desperate attempt to capture trenches lost to the enemy. He is seen falling in front of his men. (Amalgamated Press, 1914)

The battle ended at 4.30pm and the line was secured. The 1st West Yorkshire Regiment having linked up with the 1st East Yorkshire Regiment on their left flank, they held these trenches until 8.00pm, when they were relieved by the Sherwood Foresters.

The 1st West Yorkshires lost heavily on 20 September. Out of 1150 men who entered the line on 19 September, only 206 answered roll call after the engagement. Amongst the officers killed were Major Alexander Ingles, Captain Mortimer Fisher, Captain J.F. I'Anson, Captain William Elliot, Lieutenant Thomas Meautys, Lieutenant Offley Thompson and 2nd Lieutenant Eric Wilson. Lieutenant-Colonel F.W. Towsey the CO was wounded and 8 officers missing. 71 other ranks were killed, 110 wounded and 436 missing.

The 1st East Yorkshire Regiment lost Captain Eric Edwards and Lieutenant Basil Hutchinson killed. Lieutenant-Colonel Richard Benson, commanding the battalion was mortally wounded and died of his wounds on 29 September 1914. 4 other officers were wounded, 73 other ranks killed or wounded.

The 2nd Durham Light Infantry sustained heavy casualities on that day too. Major D'Arcy Mander, Captain Harry Hare, 2nd Lieutenant Charles Stanuell and 36 other ranks killed. Major Alexander Robb, 2nd Lieutenant Roger Marshall mortally wounded, 5 officers, 92 other ranks wounded.

The 2nd Sherwood Foresters lost Lieutenant Laurence Bernard, Lieutenant Basil Ash, Lieutenant Patrick Murray and 2nd Lieutenant Roy Milner all killed. 8 other officers were wounded, 44 other ranks killed and 165 wounded. The 2nd Sherwood Foresters would spend the next two days in the trenches under the inevitable heavy artillery fire. Private Charles Osborne:

For us, the firing line trench was not very safe as a German Battery had an enfilade fire on one part and the few days we were in, we lost somewhere about 75 men in wounded and killed. I was very fortunate in not being in these trenches, as there were not room for all, so some of us strengthened the DLI's line. It was while here that I saw some awful sights, one of which was really terrible to

witness. The German Battery would send over two Lyddite shells, which knocked in the trench, then two shrapnel, which caught anyone who was silly to leave his trench. One poor chap was crawling away (and through the glasses, we could see he was hit in the left arm which hung loose, and the right leg which trailed behind him) but he had not got far when a shell caught him and cast him in the air like an old coat. We were able to visit the spot later in the evening but could find nothing of the poor chap.[8]

MAJOR ALEXANDER INGLES
1ST BATTALION PRINCE OF WALES'S OWN (WEST YORKSHIRE REGIMENT)

Alexander Wighton Ingles was born in 1869. Educated at Haileybury, in March 1892 he joined the West Yorkshire Regiment after serving with the Louth Rifles Militia. He saw service in South Africa and saw action in the Transvaal. He went to France with the 1st West Yorkshire Regiment in August 1914. During the Battle of the Aisne Major Ingles went forward to accept German soldiers who were advancing under a white flag. These German soldiers opened fire and surrounded the British who had come forward. On realising their hopeless situation, Ingles cried out 'All who will not surrender follow me!' Major Ingles has no known grave and his name is commemorated on the memorial at La Ferté-Sous-Jouarre.

Major Alexander Ingles, 1st West Yorkshire Regiment.
(Bonds of Sacrifice)

CAPTAIN J.F. I'ANSON
1ST BATTALION PRINCE OF WALES'S OWN (WEST YORKSHIRE REGIMENT)

I'Anson was born in 1883 in Howe, near Thirsk, Yorkshire. Educated at Ripon Grammar School, he joined the 3rd Battalion West Yorkshire Regiment. He became a Captain in the Special Reserve in 1907. He volunteered for active service on 5 August 1914. He was one of many men killed during the German

Captain J.F. I'Anson, 1st West Yorkshire Regiment.
(Bonds of Sacrifice)

white flag deception incident on 20 September 1914. A private recounted the circumstances surrounding his death that day.

> The battalion had taken up a position in the trenches, relieving the Coldstream Guards, on the evening of the 19th September, and held it till dawn. Then an order was given for a section to advance across a field to draw the enemy's fire. As a result only three out of a section of a sergeant and thirteen men got back to their trenches. Soon after 1pm on the 20th the Germans got through on the right flank, and came up with a white flag. Thinking that the men had surrendered, a young officer gave the order to 'Cease fire!' When the enemy were about twenty yards from the British position they opened fire with Maxim guns, and mowed the West Yorks down, when fortunately the Sherwood Foresters came to their aid, and as all the West Yorks had lost all their officers one of the Sherwood officers took command, and they fought until the position had been made secure.[9]

Captain I'Anson has no known grave and his name is commemorated on the memorial at La Ferté-Sous-Jouarre.

CAPTAIN MORTIMER FISHER
1ST BATTALION PRINCE OF WALES'S OWN (WEST YORKSHIRE REGIMENT)

Mortimer Fisher was born in King's Langley, Hertfordshire in 1883. He was educated at Aldenham School, Elstree. He joined the militia, the 3rd Battalion West Yorkshire Regiment in April 1900. In October 1901 he was serving with the 2nd Battalion in South Africa where he remained for two years. He took part in three battles in the Transvaal November 1901–May 1902 and was awarded the Queen's Medal with three clasps. By August 1914 he had attained the rank of Captain and was serving with the 1st Battalion when they were sent to France. Captain Mortimer Fisher was killed while defending trenches north of Troyon on 20 September 1914. He has no known grave and his name is commemorated on the memorial at La Ferté-Sous-Jouarre.

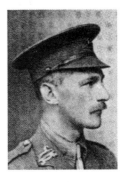

Captain Mortimer Fisher, 1st West Yorkshire Regiment.
(Bonds of Sacrifice)

LIEUTENANT THOMAS MEAUTYS

1ST BATTALION PRINCE OF WALES'S OWN (WEST YORKSHIRE REGIMENT)

Thomas Gilliat Meautys was born in Wimbledon in 1889. Educated at Marlborough and the Royal Military College at Sandhurst he joined the West Yorkshire Regiment. He played a prominent role in the Battle of the Aisne on 20 September 1914. He was mortally wounded while looking for a good position for his guns. He died from his wounds on 22 September. Lieutenant Meautys was buried in Vendresse British Cemetery where his epitaph reads:

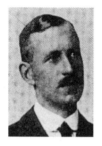

HE GAVE HIS LIFE FOR KING AND COUNTRY.

Lieutenant Thomas Meautys, 1st West Yorkshire Regiment. (Bonds of Sacrifice)

2ND LIEUTENANT ERIC WILSON

1ST BATTALION PRINCE OF WALES'S OWN (WEST YORKSHIRE REGIMENT)

Eric Western Wilson was born at Thornton-le-Moor, Yorkshire in 1893. He was educated at Leeds University and passing out from the Officer Training Corps he was gazetted 2nd Lieutenant in the Special Reserve, West Yorkshire Regiment, in July 1913. He joined the 1st Battalion when the war began. Wilson was killed while leading his platoon in an assault to recapture trenches on 20 September 1914. He has no known grave and his name is commemorated on the memorial at La Ferté-Sous-Jouarre.

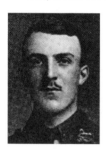

2nd Lieutenant Eric Wilson, 1st West Yorkshire Regiment. (Bonds of Sacrifice)

LIEUTENANT PATRICK MURRAY

2ND BATTALION SHERWOOD FORESTERS (NOTTINGHAM & DERBYSHIRE REGIMENT)

Patrick Maxwell Murray was born in London in 1890. Educated at Repton School and the Royal Military Academy, Woolwich, he joined the 2nd Sherwood Foresters in 1909. He went to France with this battalion in August 1914. During the Battle of the Aisne he led his men in a successful attempt to capture trenches lost by

the West Yorkshires on 20 September. He was killed in those trenches. An eyewitness later reported:

> A small number of men, headed by Lieutenants Murray and Whicher, made their way into the trenches, the latter having the satisfaction of bayoneting a German. Of poor Murray I cannot speak too highly; he gallantly led his men, taking every advantage of dead ground, and was eventually shot as he was standing up in the trenches shouting to the men behind which way to come up [1st and 2nd Battalion The Sherwood Foresters].[10]

Private Charles Osborne observed that 'Lieutenant Murray was shot by a sniper, while looking through his glasses.'[11] Murray has no known grave and his name is commemorated on the memorial at La Ferté-Sous-Jouarre.

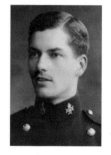

Lieutenant Patrick Murray, 2nd Sherwood Foresters. (Author)

LIEUTENANT LAURENCE BERNARD

2ND BATTALION SHERWOOD FORESTERS (NOTTINGHAM & DERBYSHIRE REGIMENT)

Laurence Arthur Bernard was born in 1886 at Copdock, Ipswich, Suffolk. He was educated at Bradfield College, Berkshire and at the Royal Military College, Sandhurst. He excelled at cricket and football and while at Sandhurst earned the Marksmanship Badge. He joined the Sherwood Foresters in 1906. Bernard was killed on 20 September 1914 while leading a counter attack to capture trenches lost by the 1st West Yorkshires north of Troyon. An eye witness recalled:

> A further advance up the valley was attempted by another platoon of 'D' commanded by Lieutenant Bernard, who although wounded in the arm soon after leaving the bivouac, insisted on carrying on; but again the enemy fire was too heavy, and the platoon was unable to get

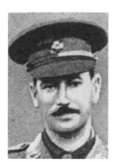

Lieutenant Laurence Bernard, 2nd Sherwood Foresters. (Bonds of Sacrifice)

very far. Thirty-six men of this platoon were killed and wounded, including their commander; he was a great loss to us, had only been with the Battalion a short time, but had endeared himself to everybody and shown what an exceptionally good officer he was.[12]

He was buried at Chauny Communal Cemetery, British Extension.

2ND LIEUTENANT ROY MILNER
2ND BATTALION SHERWOOD FORESTERS (NOTTINGHAM & DERBYSHIRE REGIMENT)

Roy Milner was born at Totley Hall in 1892. He was educated at Repton and the Royal Military College at Sandhurst. He was commissioned into the Sherwood Foresters in 1913. A year later he went to France with the 1st Battalion. Milner was killed during the battle for the trenches lost by the 1st West Yorkshire Regiment along the Chemin des Dames on 20 September 1914. An eye witness recalled: 'Ash and Milner also admirably led their men up the valley, but were killed, with most of their fellows, by the deadly machine guns.'[13]

Lieutenant-Colonel Crofton-Atkins, commanding the 2nd Sherwood Foresters wrote to his parents a letter of condolence providing details of his death:

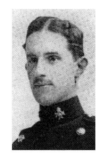

2nd Lieutenant Roy Milner, 2nd Sherwood Foresters. (Bonds of Sacrifice)

It will be some consolation to you to know that his end was worthy of the brave young soldier he was. He died when leading his little command in the most dashing manner during our first fight on the 20th, a notable regimental anniversary – Alma Day. His action, together with that of others, secured the successful issue of a fight which was of vital importance to the safety of the whole line. It is hardly necessary for me to tell you how much we all loved and appreciated him. He was one of my most promising young officers, and his loss is a personal grief to me.[14]

Milner was buried in Chauny Communal Cemetery British Extension. The inscription on his tombstone reads: 'Faithful Unto Death'.

PRIVATE GUS TERR
2ND BATTALION SHERWOOD FORESTERS (NOTTINGHAM & DERBYSHIRE REGIMENT)

Gus Terr was raised in Bulwell, Nottingham and after completing his schooling he enlisted in the British Army. He served in India and had returned home in 1913 and to civilian life. Terr worked at the Broxtowe Colliery until the outbreak of war whe he was recalled as a reservist to serve with the 2nd Sherwood Foresters (Nottingham & Derbyshire Regiment). Private Gus Terr fought at the Battles of the Marne and the Aisne. He was wounded during October or November 1914 in Flanders and was taken to No.4 Hospital, Versailles, to recover. In a letter home to his mother he describes his ordeal in the front line, he refers to the savage battles fought in Flanders weeks after he took part in the Battle of the Aisne and gives a startling impression of the losses suffered by the 2nd Sherwood Foresters:

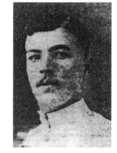

Private Gus Terr, 2nd Sherwood Foresters. (*Notts Local News*, 28 November 1914)

I have been sent here with a slight injury to my knees and hope to be back with my company in the trenches again before long. But mother, it is murder out here in the war. It is like being in hell! Our regiment – gallant Notts. and Derbyshire – has just been cut up. My company was advance guard to our brigade, and we had been chasing the Germans for about two weeks. At last we got up to their main position, where we had to entrench ourselves about 500 yards from their trenches. They let us have shot and shell for about two days. There were men falling all round us, but you can take that as an everyday occurrence and we have got used to it. Don't forget that we are letting them have it at the same time. We were like that for about 24 hours, when we noticed they were coming round our flanks and getting behind us. We let them have as much as they wanted, and there were dead Germans lying about in heaps just to remind them that the contemptible little army's artillery and rifles are in very good hands and always ready for them when they are ready for a set-to.

When the Germans catch sight of the bayonet they just look like a runaway motor coming to a standstill after it has run into a 12-foot brick wall. They don't like the steel. I can answer for my bayonet

being sharp. But it is cruel work when you come to think of it afterwards. When you are in the thick of it you take no more notice than picking up a can of ale and drinking it. It was a proper hand-to-hand fight in the streets of a village. I lost my regiment in the fight, and got mixed with the Durhams, who had been up to support our regiment. At last I found out where the remains of my regiment were. Then we went up on a ridge to defend it, while they got our guns away. I think there would be about 50 of us on this ridge and I bet we held 2,000 Germans at bay while our men saved the guns.

The Germans kept shouting 'Cease fire!' but it was no use. We have got used to these games, and we let them have it all the more till we got the order to retire. It was a sight at daybreak to see us mustering. We only numbered 150 out of 1,100, and we were all smothered with mud through crawling along ploughed fields. I have been through the battles of the Marne and the Aisne – but they were not a patch of the one we are now engaged in – the battle of Flanders at Yser. I hope to have the luck to return home safely and see good old Bulwell once again.[15]

MAJOR ALEXANDER ROBB
2ND BATTALION DURHAM LIGHT INFANTRY

Alexander Kirkland Robb was born at Poona, India in 1872. He was educated at the Aberdeen Grammar School and later at Aberdeen University. After graduating from the Royal Military College, Sandhurst, he joined the 2nd Durham Light Infantry during May 1893. He fought in the Tirah Campaign during 1897 and 1898 where he distinguished himself by volunteering with a non-commissioned officer and a private to defend a peak, preventing the enemy from capturing the position. They protected the British force's flank. Armed with only a revolver, Robb and his comrades held the position and Robb used up all his ammunition. Major Robb was killed as he charged German positions along the Chemin des Dames on 20 September 1914. He was buried in Vendresse British Cemetery where his epitaph reads: 'Faithful Unto Death'.

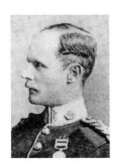

**Major Alexander Robb,
2nd Durham Light Infantry.
(*Bonds of Sacrifice*)**

MAJOR D'ARCY MANDER
2ND BATTALION DURHAM LIGHT INFANTRY

D'Arcy Wentworth Mander was born in London in 1870. He was educated at Charterhouse and Trinity College, Cambridge. Major Mander was killed on 20 September 1914, when the 1st West Yorkshires were deceived by German soldiers pretending to surrender. A fellow officer from the 2nd Durham Light Infantry recalled:

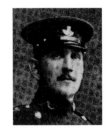

**Major D'Arcy Mander, 2nd
Durham Light Infantry.
(*Bonds of Sacrifice*)**

I was with Major Mander just before he was killed. We went up and relieved a regiment in the trenches just after dark on Saturday the 19th. As soon as it was daylight the enemy's snipers started bothering us. At about 10am on Sunday, the 20th, the Germans started an attack, chiefly against the West Yorks, on our right. We could not do anything to help, as the enemy were hidden from us by the ground, and we were expecting all the time to be attacked ourselves. At lunch time I walked along the trenches and joined Major Mander and another officer. Whilst we were eating a party of perhaps one hundred Germans walked in towards the West Yorks trenches, holding their hands above their heads, but still in possession of their rifles. We stood up to watch them, and saw that when they got in amongst the West Yorks they appeared to bayonet some of them. This was all happening about four hundred yards to our right. We all three jumped up and shouted to the company to stand to, and went to our places in the trenches. The Germans almost immediately faced down our line and opened fire. I was looking along the trenches and saw Major Mander standing about fifty yards in front of me, also in the trenches. We were all shouting to some men from our trenches (not D.L.I.), who were running back, telling them to stop. This they did, and opened fire on the Germans. Just at that moment I was hit, and did not see any more. It was a very low trick the Germans played on us.[16]

Manders left a widow Esme and a five-year-old son and a three-year-old daughter. He was buried in Vendresse British Cemetery. On his tombstone is written the inscription:

HAPPY AND LOVED IN LIFE
HE DIED GLORIOUSLY
AND IS NOT FORGOTTEN 1926

CAPTAIN HARRY HARE
2ND BATTALION DURHAM LIGHT INFANTRY
Harry Vivian Hare was born in Folkestone in 1881. He was the son of Admiral the Honourable Richard Hare and grandson of the Earl of Listowel. Harry was educated at Harrow and the Royal Military College at Sandhurst. On passing out he was commissioned in the Durham Light Infantry. He was killed on 20 September 1914 while leading his men in an assault upon German lines north of Troyon. He has no known grave and his name is commemorated on the memorial at La Ferté-Sous-Jouarre.

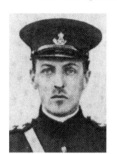

Captain Harry Hare, 2nd Durham Light Infantry. (Bonds of Sacrifice)

2ND LIEUTENANT ROGER MARSHALL
2ND BATTALION DURHAM LIGHT INFANTRY
As he fought off German counter attacks on 20 September, Marshall's last words before his death were 'Surrender be hanged! Stand up and fight!' He has no known grave and his name is commemorated on the memorial at La Ferté-Sous-Jouarre.

2nd Lieutenant Roger Marshall, 2nd Durham Light Infantry. (Bonds of Sacrifice)

LIEUTENANT-COLONEL RICHARD BENSON
1ST BATTALION EAST YORKSHIRE REGIMENT
Richard Erle Benson was born in 1862 in London. He was educated at Eton and served during the Boer War. He led the 1st East Yorkshire Regiment to

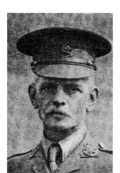

Lieutenant-Colonel Richard Benson, 1st East Yorkshire Regiment. (South Wales Daily Post, 8 October 1914)

France at the outbreak of war. They arrived at the Aisne on 19 September where they relieved the Royal Sussex Regiment holding trenches that were being persistently shelled. There was no chance to get familiar with life in the trenches, they were thrown in at the deep end. On 20 September they were ordered to attack. Benson got to within 50 yards of the German trench before he was shot down. A fellow officer paid this tribute to Benson:

> He was so magnificent, so full of energy and courage – always in the front – and the men would have followed him anywhere. Even after he was wounded he would not be brought in till he knew the other wounded were safe, and his one thought was for the safety and welfare of his regiment.[17]

He died from his wounds on 29 September at St Nazaire Base Hospital. His remains were brought to the family vault for burial at Reynoldston, Gower.

LIEUTENANT THOMAS BOTTOMLEY
1ST BATTALION EAST YORKSHIRE REGIMENT
Thomas Reginald Bottomley was born in Ripponden, West Yorkshire, in 1887. He was educated at Rishworth Grammar School and at St John's Training College, Battersea. In 1909 the Croydon Educational Committee appointed him as a teacher. He taught at Oval Road Boy's School. During the period 1908 to 1911 Bottomley served as a cadet and later sergeant in the 10th (Territorial) Battalion, Duke of Cambridge's Own (Middlesex Regiment). He also studied at Birkbeck College, University of London, where he graduated with a Bachelor of Arts and the Teachers' Diploma of the Board of Education in 1913. Bottomley had planned to take the Honours exam in 1915 and become a teacher but this aspiration was curtailed by the outbreak of war. While he was at the University of London he served with the Officer Training Corps for three years. He passed military exams for promotion and became a qualified physical instructor. In April 1914 he accepted a commission as a 2nd Lieutenant in the 1st East Yorkshire Regiment. He married Eveline Gibson on 29 August 1914 and a few days later he went to France with the battalion. He entered the line with his battalion at Vendresse on 20 September 1914. Three days later Bottomley was killed. His commanding officer wrote the following letter of condolence to his widow Eveline:

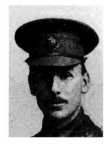

Lieutenant Thomas Bottomley, 1st East Yorkshire Regiment. (Bonds of Sacrifice)

The whole company, of officers and men, deeply sympathise with you in your loss: he was our loss too, as we all admired and respected him. He fell in the trenches, hit by the first shell of the day: he could not have suffered at all. The nearest village to the place is Vendresse, and the trenches were on the ridge north of the village. He was buried near Troyon, a cross marking his grave.[18]

Troyon was destroyed during four years of war and Bottomley's grave was lost. He therefore has no known grave and his name is commemorated on the memorial at La Ferté-Sous-Jouarre.

NOTES

1. *Peoples Journal* (Aberdeen City Edition), 3 October 1914
2. Ibid
3. Private Charles Osborne Account, The Sherwood Foresters Museum
4. *People's Journal*
5. Ibid
6. Osborne
7. *The Scotsman*, 9 October 1914
8. Osborne
9. Clutterbuck, L.A., *Bonds of Sacrifice: August to December 1914* (1915, republished by Naval & Military Press, 2002)
10. Wylly, Colonel H.C., *1st and 2nd Battalions the Sherwood Foresters (Nottinghamshire and Derbyshire Regiment) in the Great War* (Gale and Ponden, 1925)
11. Osborne
12. Wylly
13. Ibid
14. Clutterbuck
15. *Notts Local News*, 28 November 1914
16. Clutterbuck
17. Ibid
18. Ibid

ROUGE MAISON AND
TILLEUL SPUR

Before daybreak on 20 September, German artillery unleashed a devastating barrage on the trenches held by the 9th Infantry Brigade south west of Rouge Maison. They were a mile from the river crossing at Vailly and had crept to a position 500 yards away from the trenches held by the 4th Royal Fusiliers. They were armed with machine guns and had brought forward two field guns to outflank the 4th Royal Fusiliers' position. The Germans also brought forward a heavy howitzer to 800 yards from their position. The 9th Infantry Brigade's right flank was in serious jeopardy. As mentioned earlier, this was a significant day in the history of the regiment, for it was Alma Day commemorating the regiment's role at the Battle of Alma during the Crimean War.

At 9.00am two howitzers from the XXX Brigade, Royal Field Artillery, targeted the German forces threatening Rouge Maison forcing them to withdraw the howitzer. The 4th Royal Fusiliers offered a stubborn defence inflicting heavy casualties upon the enemy and forcing them to retire. Although the German infantry assault fizzled out, the 4th Royal Fusiliers still came under German fire. They held on until relieved by the 1st Lincolnshire Regiment at 5.00pm. The 4th Royal Fusiliers lost 20 casualties including 2nd Lieutenant Hughes. They had held onto their position close to Rouge Maison Farm for seven days and eight nights. During their period in the line they lost 5 officers and 300 men. It must have been a welcome relief to get off the line; though they were billeted in Vailly, which was not safe from German shelling. They were then moved to Courcelles during the morning of 21 September. Later that afternoon they were visited by Field Marshal Sir John French who commended their efforts and paid the following tribute: 'No troops in the world could have done better than you have. England is proud of you, and I am proud of you.'[1]

At dawn on the 20th the 1st King's Liverpool Regiment was attacked. Waves of German infantry managed to get within 80 yards of their trenches, which were positioned east of the Oise and Aisne Canal to the western slope of Tilleul Spur. They fought off the initial German wave, which withdrew; however, at 9.00am a second German assault began, covered by two machine guns which were firing into the King's Liverpool Regiment's right flank.

A and B Companies from the 2nd Worcestershire Regiment and two platoons from the 2nd Highland Light Infantry were ordered to support the 1st King's Liverpool Regiment. These two Battalions repelled the onslaught and pursued the retiring Germans through a wood and across the Beaulne Spur. Through dense undergrowth they charged and captured a section of German trench. Unwittingly they had been led into an ambush and were receiving German machine-gun fire on their left flank. Carrying their wounded with them the remnants of the 2nd Worcestershires and the 2nd Highland Light Infantry withdraw into the fire of the 1st King's Liverpool Regiment. The 2nd Connaught Rangers who were defending a ridge to the east close to Verneuil were forced to leave their trenches due to the German shell fire. The 2nd Highland Light Infantry suffered another traumatic day under shell fire on 20 September at Verneuil. This was their seventh consecutive day on the line. H.J. Milton wrote:

Fighting from _____ on all sides of us. First line of trenches shelled at and Connaught Rangers retired, we had to support them in another lot of trenches; shelled out of these. Shells falling within 10 yards of us, nerve racking and terrible, we move again to the first firing line. Almost all A Coy cut up trying to rush the G trenches, our men falling everywhere. Medical officer killed. We were trying to get relieved.[2]

This left the position held by the 1st King's Liverpool Regiment vulnerable, however, together with the remnants from the 2nd Worcestershire and 2nd Highland Regiment they reorganised their line, rallied and fought of the German attack.

The Germans were severely mauled; during the following day a patrol from the 1st King's Liverpool Regiment found in a single abandoned enemy trench 70 dead and many wounded German soldiers.

The 1st King's Liverpool Regiment sustained many casualties on 20 September losing many of their officers to enfilade machine-gun fire. Captain Arthur Kyrke-Smith, Captain Francis Marshall and Captain Ralph Tanner received mortal wounds during this

engagement. Lieutenant Murray Sweet-Escott and 21 men were killed. 2 officers and 38 men were wounded.

The 2nd Worcestershire Regiment lost Lieutenant Aubrey Hudson killed. Captain Reginald Pepys and Lieutenant Henry Lowe died from their wounds. Two officers were wounded, 6 other ranks killed, 5 wounded, 16 missing.

The 2nd Highland Light Infantry fought off a German attack on 20 September. 2 platoons from B Company made an unsuccessful counter attack. The medical officer Lieutenant J.F. O'Connell, 2nd Lieutenant James Fergusson, 2nd Lieutenant Colin Mackenzie and 2nd Lieutenant Evan MacDonald were killed, 2 other officers were wounded, 20 other ranks killed, 70 wounded, 25 missing.

The 4th Guards Brigade holding the ridge above Soupir did not face any German infantry assaults, but were continuously shelled. The 2nd Coldstream Guards were taken off the front line and sent to Chavonne for rest. Sergeant W.J. Cook recalled in his diary on 20 September:

> Heavy shelling during the day and relieved at night, when we moved back into billets at Chavonne. From the 21st of September until the 13th of October we worked on a system of two companies in the firing line and 2 companies in reserve billets at Chavonne. This gave the troops time to take a little rest and regain a little of the spirit they had lost during the retirement and advance. Chavonne was continuously heavily shelled, but there were not many casualties. During the whole of the time we were in this position the enemy were thoroughly acquainted with all our movements owing to spies.[3]

LIEUTENANT EVAN MACDONALD
2ND BATTALION HIGHLAND LIGHT INFANTRY

Evan Ronald Horatio Keith Macdonald was born on the Isle of Skye in 1893. Macdonald was educated at the Edinburgh Academy, Harrogate, Southport and at the Edinburgh Institution. He was a keen athlete and in 1911 won the cup for the mile race at the Edinburgh Institution. He joined the 3rd Highland Light Infantry on 3 July 1912 and was transferred to the 2nd Battalion on 10 June 1914. Macdonald took part in the engagement at Paturages on 24 August 1914. In the Battle of the

2nd Lieutenant Evan Macdonald, 2nd Highland Light Infantry. (Bonds of Sacrifice)

Aisne on 20 September he was shot in the right temple and killed. Colonel Wolfe Murray, his commanding officer wrote to his bereaved mother:

> I am thankful to say that it was quite instantaneous, while he was most pluckily directing the fire of his men. I feel his loss very much. He was an excellent young officer, keen, quick and reliable, and his company commander Capt. Mayne, who has seen a good deal of service, told me how cool he was under fire and that he showed great promise.[4]

Macdonald was buried close to where he fell, about a mile north of Verneuil. Despite a wooden cross erected over his grave and description of the location noted, his grave was lost and his name is therefore commemorated on the memorial at La Ferté-sous-Jouarre.

2ND LIEUTENANT COLIN MACKENZIE
2ND BATTALION HIGHLAND LIGHT INFANTRY

Colin Landseer Mackenzie was born in Malvern in 1892. He was the great nephew of the eminent artist Sir Edwin Landseer who sculpted the lions at the base of Nelson's Column in Trafalgar Square. He was educated at Haley Preparatory School in Bournemouth, Stubbington Naval School and Cheltenham College, where he served in the Officer Training Corps and learned to speak German. He then served with the 3rd Reserve Battalion Seaforth Highlanders as a 2nd Lieutenant on probation. After passing his 'Army Competition' he was confirmed as a 2nd Lieutenant and gazetted to the 2nd Highland Light Infantry on 24 May 1913. He went to France with the battalion on 13 August 1914 and was killed during the Battle of the Aisne on 20 September. Captain Chichester, his company commander wrote:

> He was in the trenches at the time, defending a position, and was watching a charge of our men on his left front, and had turned round to tell his men to cease fire, in case they hit any of their own side, when he was shot in the head, death being instantaneous. He was a gallant fellow and a good officer, his death is much deplored.[5]

2nd Lieutenant Colin Mackenzie was buried on the ridge above Verneuil. After the war his remains

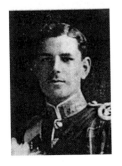

2nd Lieutenant Colin Mackenzie, 2nd Highland Light Infantry. (Bonds of Sacrifice)

were interred in Vendresse British Cemetery. His epitaph reads: 'Ferendum et Sperandum' ('we must endure and we must hope').

2ND LIEUTENANT JAMES FERGUSSON
2ND BATTALION HIGHLAND LIGHT INFANTRY

James Adam Hamilton Fergusson was born in London in 1892. He was educated at Winchester College and then went on to the Royal Military College at Sandhurst. He was gazetted to the 2nd Battalion Highland Light Infantry on 14 February 1912 and promoted to Lieutenant during the following year. Fergusson was a keen golfer and sportsman. He was killed during the Battle of the Aisne when he received a bullet through the forehead when he went to the aid of a wounded man. He has no known grave and his name is commemorated on the memorial at La Ferté-sous-Jouarre.

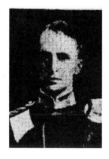

2nd Lieutenant James Fergusson, 2nd Highland Light Infantry. (*De Ruvigny's Roll of Honour, 1914–1918*)

SERGEANT CHARLES ELDER 7903
2ND BATTALION HIGHLAND LIGHT INFANTRY

Charles Elder was born in Glasgow in 1885. He was educated at the Albany Academy in Glasgow and enlisted in July 1902. By August 1914 Elder had attained the rank of Sergeant. On 20 September during the Battle of

Sergeant Charles Elder, 2nd Highland Light Infantry. (*De Ruvigny's Roll of Honour, 1914–1918*)

the Aisne he was wounded in the foot at Verneuil. He carried on despite his wound but was killed later that day. A comrade commented that 'he died as a true British soldier, gallantly leading his section.'[6] He was buried at Vendresse British Cemetery. His epitaph reads:

> IN THY PRESENCE IS FULLNESS
> OF JOY.

CAPTAIN REGINALD PEPYS
2ND BATTALION WORCESTERSHIRE REGIMENT

Reginald Whitmore Pepys was born in 1883. He was the youngest son of the Reverend H.G. Pepys, Honorable Canon of Worcester. Reginald was educated at Haileybury College and Sandhurst. He was appointed 2nd Lieutenant to the 4th Worcestershire Regiment on 18 January 1902. Two years later he was promoted to Lieutenant and during September 1908 he was seconded to the West African Regiment. After serving five years service in Africa he returned to the British Army, he was promoted to Captain and joined the 2nd Worcestershire Regiment in May 1913. Pepys married Maud Foster at St Mary's Church. Iffley, on 27 July 1914. A month later he was sent to France with the 2nd Worcestershire Regiment. Captain Pepys was wounded on the Tilleul Spur on 20 September. He was most likely taken for medical treatment at Verneuil Chateau where he died from his wounds on 21 September 1914. He was buried in the grounds of Verneuil Château and after the war his remains were reinterred in Vendresse British Cemetery. In 1918 a German soldier was captured in Belgium and was found to be in possession of the binoculars worn by Captain Pepys. These binoculars were obviously removed from his body in 1914. The binoculars are now displayed at the Worcester Regiment Museum.

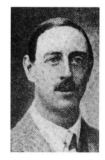

Captain Reginald Pepys, 2nd Worcestershire Regiment. (*Bonds of Sacrifice*)

NOTES ··

1. O'Neill, H.C., *The Royal Fusiliers in the Great War* (1922, republished by Naval & Military Press, 2002)
2. IWM 81/1/1: H.J. Milton, 2nd Battalion Highland Light Infantry
3. IWM P278: Sergeant W.J. Cook, 2nd Coldstream Guards
4. De Ruvigny, Marquis, *De Ruvigny's Roll of Honour, 1914–1918* (1922, republished by Naval & Military Press, 2007)
5. Ibid
6. Ibid

CHAVONNE AND VAILLY

The 7th Infantry Brigade defended positions along the eastern salient from Chavonne north-westwards towards Vailly. They became the focus of German artillery from 8.00am in the morning of 20 September. After a barrage lasting an hour German infantry from the 56th Regiment from the VII Reserve Corps and 64th Regiment from III Corps directed a thrust at the brigade's central line held by the 1st Wiltshire Regiment. Two hours later 200 German soldiers supported by two machine guns advanced through thick undergrowth to launch an assault upon the 1st Wiltshire regiment's right flank and positions held by 3rd Worcestershire Regiment. Aided by the cover of the trees these German infantry units broke through the lines and captured reserve units from the 1st Wiltshire Regiment. At the same time, advance parties from the 2nd South Lancashire Regiment were arriving to bolster the line held by the Wiltshires. Savage close quarter fighting ensued. The 2nd Irish Rifles holding the left flank adjacent to the 1st Wiltshires were unable to offer support, because they were overwhelmed by enemy artillery fire. The situation was so desperate that Brigadier-General F. McCracken requested assistance from the 4th Guards Brigade situated east at Chavonne.

The 1st Wiltshires continued to hold as the cry for assistance was being sent to the 4th Guards Brigade. The Queen's Bays at Chavonne were unable to assist because they could not leave their position at Chavonne. The request for help was then relayed to an artillery battery nearby to provide some support until infantry reserves could be sent in to help the Wiltshires. Eventually the 2nd South Staffordshires from the 6th Infantry Brigade were sent in to enter the line half-way between Vailly and Chavonne and then venture north up the valley in an attempt to threaten the German left flank. A gun from the XXIII Brigade Royal Field Artillery was brought to bear upon the German infantry that were confronting the Wiltshires. This artillery support was extremely effective because by 2.00pm the German infantry began to withdraw to two hills but the shrapnel that was flying around prevented them from staying there. At 4.00pm the 1st Wiltshires, 3rd Worcestershires and the 2nd South Lancashire Regiments launched a counter attack to drive back these German forces to their own lines.

The 56th Regiment from the VII Reserve Corps and 64th Regiment from III Corps lost heavily in this engagement. Reports from the VII Reserve Corps recorded that its troops were exhausted and just managed to hold the line. The III Corps reported that some local fighting had taken place without achieving any success. There was no acknowledgement that they had tried to break through the British lines and failed; but the dead and wounded lying on the battlefield testified to that failure.

The 7th Infantry Brigade's valiant and outnumbered attempt to hold the line near Vailly was a success, at the heavy price of 400 casualties. The 1st Wiltshire Regiment lost Captain Henry Reynolds killed, 2nd Lieutenant Harold Roseveare mortally wounded. 1 officer wounded, 80 other ranks killed, wounded or missing.

The 2nd South Lancashire Regiment lost 2nd Lieutenant Ernest Watson, 2nd Lieutenant David Wallace and 2nd Lieutenant Gordon Birdwood killed, 4 officers wounded, 141 other ranks killed, wounded or missing.

The 3rd Worcestershire Regiment lost Lieutenant Herbert Graham-Gilmour and Lieutenant Claude Henry on 19 September. On 20 September Lieutenant Cyril Harrison was killed with 78 other ranks killed, wounded or missing.

CAPTAIN HENRY REYNOLDS
1ST DUKE OF EDINBURGH'S (WILTSHIRE REGIMENT)
Henry Reynolds was born in London in 1883. He was educated at Bradford College and served in South Africa in 1901. When the war started he was a Captain attached to the 1st Battalion the Duke of Edinburgh's (Wiltshire Regiment). Reynolds took part in the retreat from Mons and the Battle of the Marne. He was killed north east of Vailly on 20 September 1914. He has no known grave and his name is commemorated on the memorial at La Ferté-sous-Jouarre.

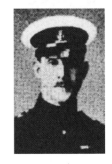

Captain Henry Reynolds, 1st Wiltshire Regiment. (De Ruvigny's Roll of Honour, 1914–1918)

2ND LIEUTENANT HAROLD ROSEVEARE

SPECIAL RESERVE, 1ST DUKE OF EDINBURGH'S (WILTSHIRE REGIMENT)

Harold William Roseveare was born in 1895. He was educated at Marlborough where he served as a Cadet Captain in the Officer Training Corps and was a member of the school rugby team. He studied at St John's College, Cambridge and was appointed to the Special Reserve on probation during April 1914. At the outbreak of war he left his studies in Cambridge and was attached to the 1st Duke of Edinburgh's (Wiltshire Regiment). During the Battle of the Aisne, 2nd Lieutenant Harold Roseveare was sent to lead a platoon to locate and capture a German machine gun that was causing havoc on the battalion's right flank. He fell as he led his men, sustaining bullet wounds to his head and lung. He

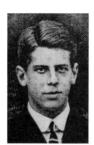

died from his wounds later the same day. He has no known grave and his name is commemorated on the memorial at La-Ferté-Sous-Jouarre.

2nd Lieutenant Harold Roseveare, 1st Wiltshire Regiment. (*Bonds of Sacrifice*)

LIEUTENANT HERBERT GRAHAM-GILMOUR

3RD BATTALION WORCESTERSHIRE REGIMENT

Herbert Gilmour was born in 1883 in Southport, Lancashire. He was educated at Hartford House and Radley College, Oxford. He served with the Worcestershire Militia during the Boer War and was awarded the Queen's medal with two clasps. When he returned to Britain he was gazetted as a 2nd Lieutenant to serve with the 3rd Worcestershire Regiment on 28 January 1903. He served in Tipperary, Dover, South Africa and India. He took part in the retreat from Mons and was killed at the Battle of the Aisne on 19 September. He was buried at Rouge Maison. His grave was lost and his name is commemorated on

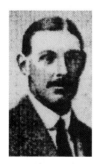

the memorial at La-Ferté-Sous-Joaurre.

Lieutenant Herbert Graham-Gilmour, 3rd Worcestershire Regiment. (*De Ruvigny's Roll of Honour, 1914–1918*)

2ND LIEUTENANT GORDON BIRDWOOD

2ND BATTALION SOUTH LANCASHIRE REGIMENT

Gordon Birdwood was born at Mhow, India, in 1895. He was educated at Tonbridge School and then went to the Royal Military College at Sandhurst. He was commissioned into the 2nd South Lancashire Regiment in August 1914. The Battalion arrived in France on 8 September and reached the Aisne on 17 September. The Battalion was in support on 20 September when German forces broke through the British line. Birdwood played a pivotal role in leading a bayonet charge in a desperate bid to reclaim a hill that had been lost and was killed during this action. One soldier from his company carried his body to a place of safety and later recalled the tragic events to Birdwood's grandfather:

> The extreme gallantry of your grandson seems to have been the cause of his early death ... he was almost too brave, and as a matter of fact it eventually got him knocked over ... Lieutenant Birdwood led a brilliant bayonet charge, and it was mainly due to him that this was successful and that this part of the position was captured.[1]

Birdwood and his party had captured some surrendering Germans. A German machine-gun crew poured machine-gun fire indiscriminately upon their comrades and soldiers from the 2nd South Lancashires, including Birdwood. A special memorial is dedicated to Birdwood in Vailly British Cemetery.

2nd Lieutenant Gordon Birdwood, 2nd South Lancashire Regiment. (*Bonds of Sacrifice*)

PRIVATE FREDERICK STOTTER 9993

2ND BATTALION SOUTH LANCASHIRE REGIMENT

Frederick Edward Stotter took part in the Battle of the Aisne while serving with the 2nd South Lancashire Regiment. Later during the war he transferred to the Machine Gun Corps.

Private Frederick Stotter, 1st South Lancashire Regiment. (Courtesy Michael Stotter)

NOTES

1. Clutterbuck, L.A., *Bonds of Sacrifice: August to December 1914* (1915, republished by Naval & Military Press, 2002)

ADAPTING TO TRENCH WARFARE

After successfully constructing pontoons and repairing damaged bridges, Sappers from the Royal Engineers were then deployed to the front line to assist in the digging of trenches and erecting barbed wire defences. The Royal Engineers were transferred from the river Aisne at the Pont Arcy and were deployed north to begin the construction of the Western Front defences. Sapper J. Woodhead wrote:

> On the morning of the 20th Sept we left Pont Arcy & went on to Bourg, here again we had some more shell fire. We stopped there until the 27th. On the night of the 27th we moved off and went on to Chavonne and Laupes, here again we had a big task before us working day and night constructing barb wire entanglements and trenches and loading, bridging etc, which also was carried out under heavy fire. We stopped in that position until 14 October.[1]

Lieutenant Bernard Montgomery, who would later become Field Marshal in the Second World War and lead the British Army to victories at Alamein in 1942 and Normandy in 1944, was a subaltern in the 1st Royal Warwickshire Regiment during the Aisne campaign. The 1st Royal Warwickshire Regiment held the line at Le Moncel. He wrote a letter to his mother on 20 September:

> I eat the peppermints with a dead man beside me in the trench. I have been awfully lucky so far as I have had some very narrow shaves; on two occasions the man standing up next to me has been shot dead. The weather is perfectly vile; they say September is a very wet month in France. It is getting cold too and they will have to send out warm things soon for our men if they are to keep well. Any warm things you like to send out for the men of my company would be very acceptable.[2]

He described his duties on the night of 19/20 September:

> I had an awful night in the trenches last night, it poured with rain all night and the trenches became full of water. I had to go forward visiting sentries etc all night to see they kept alert. Some were very far out to the front towards the German trenches and I crawled about on my stomach in mud and slush and nearly lost myself. The advanced German trenches are only 700 yards from us, so I might easily have been captured by one of their patrols. But good luck pursues me and I am quite safe. My clothes are in an awful state of mud and of course wet through. But it doesn't seem to matter much as I haven't even a cold after it. I came straight in my wet clothes, threw myself down and slept as I was, without taking off anything, I find that rum is a great standby; they give us some every day.[3]

The 1st Loyal North Lancashires were holding trenches south of the Sugar Factory at Troyon. A 2nd Lieutenant from the battalion wrote: 'We now settled down to trench warfare. Our trenches were deepened and improved daily. Night attacks by the enemy were frequent, but produced no results. On the night of the 20th an officer and 25 men of the Guards captured a small German advance work without loss, and killed all the occupants.'[4]

Many of the German soldiers who had worked in England prior to the war could understand English fluently. The 2nd Lieutenant recounted the following apocryphal incident: 'Stories began to go about. One wit called out "waiter!" and about _____ heads popped up from the German trenches. They were promptly shot.'[5]

At 5.00pm on 20 September the 1st Loyal North Lancashire Regiment received reinforcements comprised of 3 officers and 263 NCOs and men. The Battalion strength rose to 14 officers and 895 other ranks.

The 1st South Wales Borderers remained in their trenches as German artillery poured shells upon them. The Battalion lost 35 men killed and 131 wounded. It was frustrating to be forced to shelter in the trenches and to take substantial casualties without even seeing the enemy. They had to adapt to modern warfare and adapt quickly. Captain Charles Paterson wrote in his diary:

> We still sit in our trenches, being heavily shelled by enfilade fire from enemy's guns. Every now and then a man knocked out and nothing to shoot at.

One does not mind losing men when one is doing something, but to sit still and be knocked over one by one without seeing a soul is trying.[6]

The 2nd Connaught Rangers were positioned close to Verneuil on 20 September where they resisted a German assault. They lost Lieutenant Geoffrey Fenton, Lieutenant Raymond Henderson, 2nd Lieutenant Robert Benison and 2nd Lieutenant Robert de Stacpoole killed, 35 other ranks killed or wounded.

German snipers positioned along the northern perimeter of the wood claimed many casualties amongst the 1st Northumberland Fusiliers at Rouge Maison that day. Lieutenant Edward Boyd was killed. Captain Beauchamp Selby and Lieutenant Eric Tottie were mortally wounded. Tottie died of his wounds on 22 September.

The 1st Royal Scots Fusiliers were also positioned at Rouge Maison on 20 September when German forces got to within 600 yards of their trenches. They suffered 8 casualties killed and 15 wounded.

During the night of 20/21 September the 1st South Wales Borderers and 2nd Welsh Regiment were withdrawn from their positions north of the Chivy valley to a position south of Chivy. They had been holding the position for 7 days and nights. This withdrawal meant that German forces could gain access into the Chivy Valley; however, this would prove a death trap because British artillery could pour deadly fire into it.

2ND LIEUTENANT ROBERT BENISON
2ND BATTALION CONNAUGHT RANGERS

Robert Benison was born in 1891 and lived in Ballyconnell, County Cavan. He entered the Royal Military College at Sandhurst in August 1910 and joined the Connaught Rangers in September 1911. Benison was killed on 20 September 1914 and was buried at Vendresse British Cemetery.

2nd Lieutenant Robert Benison, 2nd Connaught Rangers. (Courtesy Oliver Fallon)

NOTES

1. IWM 80/25/1; Sapper J. Woodhead, Royal Engineers
2. IWM World War 1 Letters Album, Bernard Law Montgomery Ref: 1/18
3. Ibid
4. WO 95/1270: 1st Loyal North Lancashire Regiment War Diary
5. Ibid
6. WO 95/1280: 1st South Wales Borderers War Diary

STALEMATE, 21/25 SEPTEMBER

On 21 September D Company with B Company from the 1st South Wales Borderers were moved to positions at Mont Faucon at the tip of Vendresse Ridge. A and C Companies were in Brigade reserve located in Vendresse on the eastern side of the ridge. Here they were afforded some protection. Captain Charles Paterson wrote: 'Here we sit under a cliff with shells coming thick and fast over us, but they can't touch us, I am glad to say, as the slope is too steep.'[1]

The 2nd Highland Light Infantry spent an eighth consecutive day in the trenches at Verneuil. Their final day in these trenches on 21 September saw the same heavy shell fire. These men were utterly worn out, exhausted by weeks of marching and fighting. When these men were relieved they had to march 10 miles to billets in the rear and they barely had the strength to carry on. H.J. Milton:

> In trenches all day, firing all day, still the continual shell fire in trenches all night long, no sleep attacking the G, expect to be relieved soon. Delusions again last night, must be nerves affected a little. Manned trenches again at dusk but relieved at 7.30 by Black Watch, then marched 10 miles, got into a rest camp at 2am utterly worn out. At every halt men fell on the muddy road hardly able to waken, some left behind. However we have a good bed of hay. A great comfort.[2]

Sapper C.F.G. Staines belonged to the signalling staff of the Royal Engineers. Before the outbreak of war he was a member of the York Postal Telegraph Staff. On 21 September he was on the north bank of the river Aisne where he wrote of the ambiguous strategical situation at that time. 'We are still on the defensive-offensive owing to the fact that if we went for them our loss would be out of proportion to the advantage gained, and we can afford to wait.'[3]

Reinforcements were gradually arriving on the Chemin des Dames to allow the soldiers who had fought the battle since 13 September to get some relief. The 1st Prince of Wales's (North Staffordshire Regiment) had arrived on the 21st at Soupir and relieved the 2nd South Staffordshires during the following day. On that day, Lieutenant Gordon from the North Staffordshires went on a solo patrol into No Man's Land. As he returned to

British lines he was fired upon and forced to take cover and lay on the ground until nightfall on 22 September. As he approached the British line he whistled the Regimental March in order to signal to the sentries from the 1st North Staffordshires not to open fire and he was allowed to enter the trench.

The 2nd Prince of Wales's Leinster Regiment (Royal Canadians) relieved the 2nd Oxfordshire & Buckinghamshire Light Infantry during the night of 21 September in front line trenches at Cour de Soupir Farm where they found the ground littered with large numbers of dead soldiers from both sides.

The 2nd York & Lancaster Regiment entered the line near Vailly at Rouge Maison during the early hours of 21 September. A Company had to improve their section of trenches to give them more adequate cover. They took over the line before daybreak but once German observers could see the working parties strengthening the defences, guns opened up with shrapnel killing three men and wounding Lieutenant Lethbridge, together with 11 others. During their first period in the line at Rouge Maison the 2nd York and Lancasters were in such close proximity to the enemy trenches that hand grenades were within range. The war diary recorded: 'The enemy used many flare lights by night and also many small bombs thrown from their trenches. This however did no damage.'[4] This may well have been the first use of hand grenades against the BEF, a weapon that would become a common feature of the war.

The 1st Irish Guards went back into the line at Cour de Soupir Farm on the night of 21 September and were in for a rough time as German artillery continued to target the farm. With the farm ablaze, livestock was killed. Private Kincoin recorded in his diary on that day:

> Relieved Grenadiers at night – artillery very busy on both sides – farm La Cour de Soupir shelled very heavily and practically destroyed by fire. Dozens of oxen perished in the flames – all chained up in sheds – had salt pork cabbage, etc (also cider and wine on the quiet) – had usual attack during the evening – all well.[5]

On 23 September, Major Bayley led a patrol from the trenches to the farm at Rouge Maison at dawn and discovered that German patrols were entering the farm

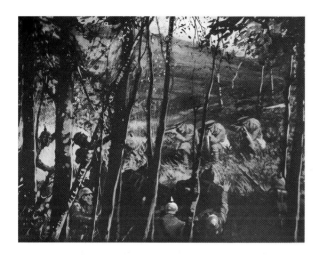

Lance Corporal McDonnell from the 1st Grenadier Guards, along with two comrades, was ambushed by a large party of German soldiers holding a trench while reconnoitring a wood in the Aisne valley on 23 September. The Germans had superior numbers and were confident that the three soldiers would surrender and walked out to secure them as prisoners. To their astonishment McDonnell gave the order to open fire, felling several Germans, and he and his comrades managed to escape. McDonnell was awarded the Distinguished Conduct Medal. (*Deeds that Thrill the Empire*)

compound to fetch water. Bayley also saw the remains of several German soldiers within the farm.

Ten days of heavy German bombardment had smashed the landscape of the Chemin des Dames and its surrounding villages. The 2nd Royal Inniskilling Fusiliers had been holding the line at St Marguerite. On 24 September the battalion war diary recorded: 'Several shells fell in village [St Marguerite], but owing to the configuration of the ground it is difficult to drop shells into the village, the neighbouring villages of MISSY-CHIVRES-BUCY-LE-LONG have been destroyed and are on fire.'[6] Sergeant Arthur Lane, 2nd Coldstream Guards, recorded in his diary on the 24th:

> Very quiet until about 5 o'clock when Germans shelled us with big guns. My shirt which was drying on side of trench had collar blown off, and a couple of holes were blown in my waterproof sheet. A hole was blown in ground a yard in front of my trench, the earth sent in all directions. One piece of boot hit, but did not penetrate.[7]

That day Field Marshal French on a visit to the front line had to shelter in a cave near Missy while German artillery bombarded the position:

> I can remember sitting for hours at the mouth of a great cave which lay high up the southern bank of the river within about four hundred yards of the village of Missy and to the eastern flank of it, from which point I saw some of the first effects of the six-inch siege howitzers which were sent to us at that time. Missy lay along the bed of the stream on both banks, and the Germans occupied a curiously shaped, high conical hill which was called 'Condé Fort'. This was situated about six hundred yards north of Missy and reached by a steep ascent from the banks of the river. The hill completely dominated the village.[8]

There was no sign of the Battle of the Aisne abating and the soldiers had no idea when it would come to an end. Lieutenant Wauchop, 1st Northamptonshire Regiment:

> This great battle is still going on. Those that are left of us (our battalion) are fit and well. We have lost 5 officers killed and 8 wounded. The last letter I wrote was from the trenches which we had occupied for a week in awful weather. Most of the trenches were half full of water, and we were in an awful state, but quite happy ... The bad weather has ceased, for the present at any rate, and today is glorious, but cold, and last night we had a lovely sunset, all red and blue, and cloudless. The village where we are is quite high up, so the view is grand. The only thing against it is that on the ground above this house, not 100 yards away, is a battery of our artillery, so the place gets shelled by the Germans mercilessly, every day and all day. However, as the place is under a cliff, it is hard for the shells to reach us; all the same, occasionally a howitzer shell does, as these weapons do high-angle fire for this very purpose; ours do the same. Of course, it does not go on at night, but ceases about 6.30pm and begins once more about 5.30am.[9]

On the evening of 24 September German soldiers holding trenches at Beaulne began to cheer. The 2nd Welsh Regiment could hear their celebration. The German troops had just received the news that the German Submarine U9 had sunk three Royal Navy armoured cruisers, HMS *Aboukir*, HMS *Hogue* and HMS *Cressy* off the Kent coast two days previously. Captain Hubert Rees wrote:

> A great roar of cheering swept the German trenches from end to end. A man sitting in the trench near me, sat up and listened, temporarily suspending his efforts to open a tin of bully beef and shouted

down the trench 'Those blokes must 'ave 'ad an issue of fresh meat.' This set me chuckling, but the real spice of the evening was yet to come. The Germans having finished cheering, sang with great patriotic fervour 'Deutschland, Deutschland uber alles' followed by the Austrian national anthem. It was really magnificent and very impressive, until the retort courteously came from the British lines in the shape of 'Come, come, come and have tea with me, down at the Old Bull & Bush.' The many English-speaking Germans must have been furious at this careless reduction of the sublime to the ridiculous.[10]

There was a brief respite in shelling during 25 September. The sector held by the 2nd Sherwood Foresters was reasonably quiet, which allowed reconnaissance parties to leave their trenches and scout towards the German lines. Private Charles Osborne:

CSM Royce and Corporal Robinson went out in front of our trench, but did not stay long, as the sights they saw were too gruesome. In front of our line were a few small dummy trenches, in one of which was a big Prussian Guardsman in the proper firing position, with his eye looking down the sights; he was quite dead as were also four of the West Yorks in another trench, all in the same firing position. They must have been overcome by lyddite fumes from our guns as they fired on our trenches while the Germans held them. It was in this way that our Adjutant was killed (but by one of our shrapnel shells) whilst talking to the Colonel just behind the trenches.[11]

On 25 September after spending 12 days in the squalid conditions of the trenches and losing 112 casualties, the 2nd Royal Irish Regiment was pulled out of the line for rest and refit at Courcelles. Major E.H.E. Daniell wrote to his mother on 26 September:

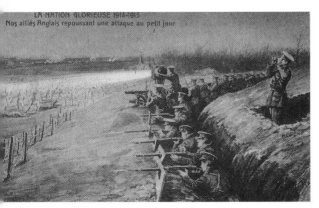

Any officer standing exposed like that during an attack would probably be hit in seconds. (Author)

At last we have arrived at the stage when we have been given a rest. After spending 12 days and nights in the trenches in a _____ battlefield we came back last night to a place about 8 miles in rear to get a few days' rest and to refit. We have not had a day's repose since we started the campaign; previous to this it has been march, fight, hell fire from shells continuously. A few days away from action will work wonders for us. I hardly knew myself last night sleeping under a roof and on a bed. I got to bed about 8am and slept until 8.30 although I did not rise until about 9.30am.[12]

Major Daniell continued to describe the horrendous conditions of living in the first constructed trenches of the First World War. There was a great risk of an outbreak of pneumonia, colds and flu, but surprisingly the men held out and because they were living on adrenalin and their bodies were constantly on alert, it seems they had developed high resistance levels to fight off such illnesses while they were fighting:

Five of our nights in the trenches we spent in pelting rain, most of the men had no great coats and as the cold was intense I do not know how they kept their health, but they have done so, as there has been next to no sickness. We have been sitting in the trenches exposed to shell fire, and when our own artillery has been unable to reply to give us any assistance, during the day we have kept very few men in position. The rest have been underground. Every man had to dig a hole in the bank and completely disappear like a rabbit. Some days they could not even come out for any food. Casualties have occurred daily except for one day. In spite of all this the men are well and in excellent spirits. Such a filthy dirty job as we in were you cannot imagine. For ten days I was unable to take off my clothes or get a complete wash, and I had to keep on the same wet boots for 5 days.[13]

Major Daniell had received a bullet wound:

My bullet wound in the leg has not quite healed up as it should have done. We had no doctor with us, and probably a little bit of dirt went into it with the bullet, it is now being taken in hand and will be well in a day or two. A doctor joined us about 10 days ago, but he was hit by shrapnel and now we have another.[14]

The 2nd Royal Irish Regiment was relieved by the 4th Royal Fusiliers who entered the front line on high ground north of Vailly. The battalion war diary noted the position as 'a curious one. Very wooded in places

with trenches facing in all directions and ... commanded by the enemy.'[15] There was no field of fire, but there was some advantage because it was difficult ground for the enemy to attack over.

German artillery later resumed bombardment on 25 September. The 2nd King's Royal Rifle Corps war diary recorded:

On 25th we relieved the 18th Brigade in the old line about Troyon. They had suffered very heavily in a German attack soon after they had relieved us. For the next three of four weeks we remained in the same position, carrying out reliefs as a rule every four days. The time was spent in improving the trenches and making better shelter for officers and men. We were constantly shelled and lost a good many officers and men both from this cause and from rifle fire in the trenches. There were frequent 'alarms' and warnings of German attacks but we were never seriously attacked and it is doubtful if the enemy ever left their trenches except for sniping.[16]

The 1st Bedfordshire Regiment continued to improve their trenches close to St Marguerite. The dead from both sides still littered the battlefield. Lieutenant Jimmy Davenport from the 1st Bedfordshires:

We improved the trenches as best as we could and put up shelters so that we could walk about without being seen so easily. We were also occupied in burying several men of the Manchester Regiment and some dead Germans whom we found lying about and some who were only half buried.[17]

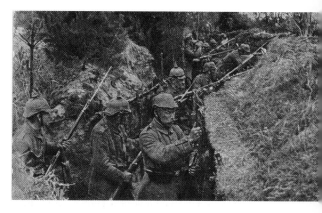

German trenches more fit for purpose than those of the BEF in the beginning. (Author)

Snipers were a great danger:

Stood to arms in the trenches at 4am and sniped and were sniped at all day long. While I was sitting on a biscuit box well under cover as I thought, talking to Drummer Chequer, a sniper plugged at us and hit Chequer, who was practically touching me, in the shin bone. It was a most extraordinary wound and took about 6 inches out of his leg. He didn't think much of it at the time and was splendid about it and although it must have been very painful, bore it awfully well. He was taken back to hospital and died after losing the leg a few days afterwards.[18]

Drummer Herbert Drummer, who had been mentioned in dispatches, died from this sniper wound in a hospital in Versailles on 28 September.

NOTES

1. WO 95/1280: 1st South Wales Borderers War Diary
2. IWM 81/1/1: H.J. Milton, 2nd Battalion Highland Light Infantry
3. *The Scotsman*, 6 October 1914
4. WO 95/1610: 2nd York & Lancaster Regiment War Diary
5. Private L.L. Kilcoin, 1st Irish Guards Diary, Irish Guards Regimental Headquarters Archive
6. WO 95/1505 2nd Inniskilling Fusiliers War Diary
7. IWM 81/14/1: Sergeant Arthur Lane, 2nd Coldstream Guards
8. French, Field Marshal Viscount, *1914* (Houghton Mifflin Company, 1919)
9. *The Scotsman*, 19 October 1914
10. IWM 77/179/1: Captain Hubert Rees, 2nd Welsh Regiment. It is interesting to note that the *Deutschlandlied* did not beomce the national anthem of Germany until 1922.
11. Private Charles Osborne Account: The Sherwood Foresters Museum
12. IWM 87/8/1: Major E.H.E. Daniell, 2nd Royal Irish Regiment
13. Ibid
14. Ibid
15. WO 95/1431: 4th Royal Fusiliers War Diary
16. WO 95/1272: 2nd King's Royal Rifle Corps War Diary
17. Lieutenant Jimmy Davenport Account, Bedfordshire & Luton Archives
18. Ibid

CAVE TRAGEDY FOR THE CAMERON HIGHLANDERS

2 00,000 German reinforcements from Brussels and from Verdun arrived on the Aisne sector on 25 September. They were transported on trains via Liège and Valenciennes. The troops from Verdun had been fighting over the previous weeks and were very weary.

By the time the 1st Queen's Own Cameron Highlanders returned to the line to relieve the 1st Black Watch in trenches close to Beaulne on 25 September they had lost 17 officers and 500 men. German artillery bombardment began at 7.15am on the morning of 25 September. Just behind the front line being held by the Battalion were several chalk caves used as 1st Queen's Own Cameron Highlanders Headquarters, a collecting base for the wounded and a place to rest. At 7.30am a shell exploded on the roof of the cave causing it to fall in upon all those inside. The cave was 300 yards behind the British trenches and no one was close by to observe the ensuing tragedy and realise the plight of the unfortunate souls inside. Most of the occupants inside had been crushed to death by the mass of earth and rock that fell upon them. Bandsman H. Rosher from the 1st Cameron Highlanders wrote:

> Several shells fell near us then, when all of a sudden a big shell must have fallen on top of the cave, as I never heard an explosion, but we were all buried. When I came to I found my head sticking out of the earth, but could not move. Two men came to help me and eventually about 10am I got out.[1]

There were some survivors at the back of the cave who were shouting for help. Bandsman Corporal Mitchell from the 1st Cameron Highlanders and three other soldiers were trapped under rocks but were conscious and were able to shout out. They had to wait another hour and a half before four comrades from the Cameron Highlanders who were walking close by heard their desperate cries. The four men immediately began to try and remove the earth and rock that had blocked the cave entrance. Three of the men inside were recovered but at the moment one man reached Mitchell, a shell exploded killing his rescuer and causing more earth and rocks to fall upon the unfortunate Mitchell. He was again trapped within the cave, now in a sitting position with

his knees doubled up and his head bent forward on his arms Enormous pressure from the rocks on top of him made it difficult for him to breathe. He was also bleeding from four splinters from the first shell, which had penetrated his leg. Mitchell was given up for lost when more shells fell close by, forcing the rescue operation to be abandoned. Mitchell held on but within two hours the pressure of the earth and rocks meant that he lost consciousness. At one o'clock an officer and four men from the Scots Guards who were told of the situation came forward to the cave with entrenching tools and resumed the rescue. After a further two hours digging with picks and shovels they reached Mitchell, who had been buried for eight hours.

Private Joe Cassells was one of the members from the 1st Black Watch who helped the men from the Scots Guards in the attempt to rescue those trapped inside the cave:

> I did not seem, however, as if I had had much more than the proverbial 'forty winks' when we were sent back to support the Cameron Highlanders. It was the Camerons who had just relieved us and their headquarters were in a quarry where ours had been. A few 'coal boxes' had landed in the quarry, and reduced it to a mass of debris. Only one officer and bugler survived. It was here that Sergeant Major Burt, of my native town, was killed. He was reputed to have the 'best word of command' in the British Army. We reached the scene in time to help the Scots Guards dig out some of them. It was a gruesome job. Some of the men had been pinned under heavy rocks for hours without losing consciousness. There was, in particular, one instance of an officer whose legs were crushed and pinned down. His head had been cut by a shell splinter. When we tried to dig him out, he ordered us to attend first to a private a few feet away, whose ribs had been smashed in and who was bleeding from the nose and mouth. In all, about thirty officers and men lost their lives here.[2]

Captain Douglas Miers, Captain Allan Cameron, Lieutenant Napier Charles Gordon Cameron, Lieutenant Kenneth Meiklejohn, Lieutenant John Crocket (from

the Royal Army Medical Corps) and 24 other ranks were killed. Regimental Sergeant Major George Burt was amongst the other ranks from the 1st Cameron Highlanders who was killed. Originating from Old Meldrum, Aberdeenshire, he had been a recipient of the Distinguished Conduct Medal. According to official documents there were only four survivors. They were unable to remove the bodies for a number of days.

CAPTAIN ALLAN CAMERON
1ST BATTALION QUEEN'S OWN CAMERON HIGHLANDERS
Allan George Cameron was born at Achnacarry in 1880. Educated at Eton and the Royal Military College at Sandhurst he was gazetted as a 2nd Lieutenant to serve with the Queen's Own Cameron Highlanders in October 1899. By August 1914 he attained the rank of Captain. He was killed during the Battle of the Aisne on 25 September 1914. During that morning Cameron became the commanding officer of the Battalion when Captain Meirs was wounded. He had braved horrendous shell fire to get to Battalion headquarters, which was in a cave, when a shell caused the roof of the cave to fall on top of the occupants, including Cameron. Captain E.J. Brodie, the Battalion Adjutant, recalled the details surrounding his death:

Just as Allan Cameron got to the trench – or rather cave – a huge high explosive shell burst on the top and blew it in. The cave contained headquarters, signallers, stretcher-bearers, etc. Death to all must have been instantaneous. It took us three nights to get the bodies out, 31 in all. We could only work in the dark, as the place was shelled by day. We buried the officers and the Sergt-Major at Bourg. Capt. Meirs, Alann Cameron, Meiklejohn, Napier Cameron, and Dr Crockett were the officers killed.[3]

Cameron left a widow, Hestor, and a nine-month-old son, Angus. Cameron was buried at Bourg-et-Comin Communal Cemetery where his epitaph reads: 'The utmost for the highest'.

LIEUTENANT KENNETH MEIKLEJOHN
1ST BATTALION QUEEN'S OWN CAMERON HIGHLANDERS
Kenneth Forbes Meiklejohn was born in 1885 in Woolwich. On completing his schooling at Rugby

he went to Sandhurst. He was gazetted with the 1st Cameron Highlanders as a 2nd Lieutenant on 27 February 1904. He was promoted to Lieutenant on 13 September 1909 and was appointed Battalion Adjutant in 1913. Meiklejohn was a good linguist and qualified as an interpreter in French and Russian. Meiklejohn went to France with the BEF in August 1914 and took part in the Battles of the Marne and the Aisne. He died in the cave collapse described above. Meiklejohn was buried in the grounds of the Chateau of Verneuil and after the war was reinterred in Vendresse Cemetery. His epitaph reads: 'He Pleased God and was Beloved of Him'. Meiklejohn's widow Sybill gave birth to their son Kenneth Matthew Meiklejohn on 14 January 1915.

Lieutenant Kenneth MeikleJohn, 1st Cameron Highlanders. (*Bonds of Sacrifice*)

CAPTAIN DOUGLAS MEIRS
1ST BATTALION QUEEN'S OWN CAMERON HIGHLANDERS
Douglas Meirs was born in Perth, Scotland, in 1875. He was educated at The Oratory School, Edgbaston and at Downside. Meirs was gazetted to the Cameron Highlanders from the 2nd (Militia) Battalion in September 1896. He saw active service during the Nile Expedition during 1898, being present at the Battle of Atbara. He was awarded the British Medal with clasp and the Egyptian Medal. He saw further action during the Boer War and was a participant of the actions at Vet River, Zand River, Wittebergen and Ladysmith. He was twice mentioned in dispatches and was awarded the Royal Humane Society's bronze medal for saving the life of a fellow officer in the Zand River. He was awarded the Queen's Medal with four clasps for his role in the Boer War.

Meirs went to France with the 1st Cameron Highlanders on 13 August and was sent to Landrecies with 250 men to act as bodyguard to Lieutenant General Sir James Grierson. Grierson died on a train en route to the front line, which meant that Meirs acted as bodyguard to his successor, General Sir Horace Dorrien-Smith. Meirs

Captain Douglas Meirs, 1st Cameron Highlanders. (*Bonds of Sacrifice*)

Captain Allan Cameron, 1st Cameron Highlanders. (*Bonds of Sacrifice*)

took part in the Battle of the Aisne on 14 September and brought out the remnants of the Battalion, which amounted to 4 officers and 80 men. Meirs was killed in the cave collapse on 25 September 1914. Captain Brodie, Adjutant, 1st Cameron Highlanders:

> He was with the headquarters in command of the battalion in support of two companies, holding somewhat advanced positions in a wood and on a ridge near Verneuill, on the river Aisne. With him were the Headquarters Staff and the Signallers. On the 24th September our men had been subjected to very heavy shell fire, and Captain Miers gave orders that one of those advanced trenches was not to be held on the 25th. On that day our troops were again very heavily shelled. At 7am Captain Miers received a flesh wound in the arm, and decided to go to Verneuil to have it dressed in hospital, saying he would return in the afternoon. Before he could get away the shelling recommenced, and he delayed going, having in the meantime sent a message to Captain Cameron, the next senior officer, to say he was going. Captain Cameron came up to headquarters, and just as he arrived a high-explosive shell burst on top of the trench and blew it in. Headquarters were in a cave, the trenches having been in some underground slate quarries. The shell burst on top of the cave, and another burst

at its mouth, bringing down tons of heavy stones, burying the inmates … The officers and sergeant-major were buried at Bourg. We as a regiment deeply deplore their loss, and I have lost a most kind and able Captain and commanding officer.[4]

Captain Meirs left a widow and three children. He was buried at Bourg-et-Comin Communal Cemetery where his epitaph reads:

ALWAYS HE LOVED HIMSELF LAST.

LIEUTENANT JOHN CROCKET
ROYAL ARMY MEDICAL CORPS
John Crocket was born in 1886 in Edinburgh. He studied medicine at Edinburgh University and joined the Royal Army Medical Corps. He was killed during the Battle of the Aisne when he was attending the wounded in the cave. He was buried at Bourg-et-Comin Communal Cemetery.

Lieutenant John Crocket.
(Bonds of Sacrifice)

NOTES

1. *South Wales Daily Post*, 21 October 1914
2. Cassells, Scout Joe, *The Black Watch: A Record in Action* (1918, republished by BiblioBazaar, 2009)
3. De Ruvigny, Marquis, *De Ruvigny's Roll of Honour,*
 1914–1918 (1922, republished by Naval & Military Press, 2007)
4. Clutterbuck, L.A., *Bonds of Sacrifice: August to December 1914* (1915, republished by Naval & Military Press, 2002)

DEFENCE OF MONT FAUCON RIDGE

At 4.00am on the morning of 26 September under the cover of darkness German forces attacked positions at the head of Moulins Valley held by the 3rd Infantry Brigade. The vanguard of the German advance was directed towards the sector held by the 1st Queen's (Royal West Surrey Regiment). British artillery shells fell short upon their own lines killing 3 and wounding 3 from C Company. British machine guns poured fire into the advancing waves of German infantry and the assault lost momentum. Lieutenant Thompson and 20 men were wounded together with 3 more killed.

The 1st Gloucestershire Regiment who were holding the line adjacent to the 1st Queen's on their left flank were untouched by the German advance, however the 1st South Wales Borderers on their left did bear the brunt of a significant German assault that morning. 4000 German soldiers from the 50th Brigade, German 25th Division and elements from the 21st Division, both from XVIII Corps, launched an attack at 4.15am upon the 1st South Wales Borderers holding quarries beneath the north-west face of Mont Faucon. Mont Faucon stood at the southern tip of the Vendresse Spur. German commanders were anxious to seize control of Mont Faucon because it would have seriously compromised the 1st Division who were holding Vendresse and Troyon on the other side of Vendresse Ridge.

B Company was in the process of relieving A Company when the German attack took place. The initial wave of 1200 men charged from the woods in platoon columns. They broke through the 1st South Wales Borderers lines on the Mont Faucon Ridge and reached a quarry in the middle of their line. Captain Ward and Lieutenant Steward formed their men behind a bank that provided good firing positions. It was at that point that the German advance was halted. However, D Company on the left flank was outwitted. At daybreak those in the outposts on front of the trenches moved back to the trench line. German infantry and machine guns were positioned in a wood close by and when the outpost occupants returned to their trench lines the Germans swarmed up behind them and overwhelmed them and the occupants of the trench. Bitter hand-to-hand fighting took place, soldiers picking up whatever weapon was within reach. One individual used a table

fork. Major Welby and 2nd Lieutenant Sills were killed during this savage close quarter action. Captain Charles Paterson remembered 'the whole place alive with bullets.'[1]

The German battalions tried to outflank on the left. Two companies from the 2nd Welsh Regiment were brought forward to bolster the line. Lieutenant Blackall-Simmonds led a platoon from C Company into the fight for the left-hand quarry. Blackall-Simmonds was killed but Major Lawrence brought up the other platoon from C Company. They worked their way round the perimeter of the quarry and cleared the German forces that were currently in the South Wales Borderers' trenches. Led by Captains Prichard and Gwynn, they forced the Germans to withdraw back into the woods they came from, assisted by machine-gun fire from a position established by Major Lawrence. Here the Germans reorganised themselves and held their ground. Captain Harold Davies, commanding A Company, was killed during this action. Captain Hubert Rees was sent forward to take command of A Company:

> We moved along the foot of the ridge and attacked the enemy in flank. It was a very mixed fight and the bullets were coming from every point of the compass. It lasted a very short time, however, the Huns standing no chance against this flank attack and they disappeared down the eastern slope leaving a large number of dead on the ridge top.[2]

The fight spread along the line of quarries held by A and B Companies, 1st South Wales Borderers. Despite determined efforts to reach the quarries the German assault was thwarted. The fighting had subsided by 7.15am that misty morning. When the mist lifted at 9.00am British observers could see further reserves of German infantry massing in the Chivy Valley and were able to identify ranges for their artillery. With shell, machine-gun and rifle fire the South Wales Borderers inflicted heavy casualties as the enemy advanced. By midday, the German assault had faltered and the remnants of the shattered ranks withdrew from the Chivy Valley. As the attackers withdrew north, soldiers from the 1st Cameron Highlanders were waiting for

them farther along the ridge. In addition, 33 guns and howitzers from the 1st and 2nd Divisions opened fire on them. For the retreating soldiers of the 21st and 25th Divisions it became a modern valley of death.

All that was left in front of the South Wales Borderers beneath Mont Faucon Ridge were dead and wounded German soldiers. The Battalion had the gruesome task of burying the German dead and their own dead comrades.

A communication trench which led from the quarry to the front line trench was utilised as a grave to bury 30 men from D Company, together with Major Welby and Lieutenant Charles Sills. It was decided to use the quarry as the front firing line so it was necessary to fill in the communication trenches to the front line trenches that led from the quarry.

When the Cameron Highlanders relieved the 1st South Wales Borderers during the evening of 27 September, one officer reported that there was a line of dead German soldiers lying shoulder to shoulder in a line stretching 40 yards from the quarry. The Cameron Highlanders had buried 300 German dead close to their lines but there were many more who were left unburied in the Chivy Valley.

The 1st South Wales Borderers had themselves paid a heavy price for the defence of their position. Major Glynne Welby, Lieutenant George Blackall-Simmonds and 2nd Lieutenant Charles Sills were killed, together with 86 men. Captain Prichard was amongst three officers wounded and he lost a leg. Lieutenant John Coker was mortally wounded. 87 other ranks were killed, 95 wounded, 12 missing. It was later discovered that these twelve men had surrendered.

The 1st South Wales Borderers was congratulated by Major-General S.H. Lomax. The Divisional Commander compared the defence of the quarries on the Mont Faucon Ridge to the Regiment's stand at Rorke's Drift

in 1879. Sir Douglas Haig also complimented the battalion:

> The conduct of the South Wales Borderers in driving back the strong attack on them made by troops massed in the Chivy valley is particularly deserving of praise. Please tell the Brigadier how proud I feel at having such splendid troops under my command.[3]

Major William Lawrence was awarded the Distinguished Service Order 'for gallantry and ability in repelling the enemy'. Sergeant Duffy was awarded the Distinguished Conduct Medal for confronting German snipers.

They had resisted a superior German force of 4000 and held their ground. If they had capitulated, the German 15th Brigade of the 25th Division would have seized Mount Faucon, which would have resulted in the 1st British Division's withdrawal back across the Aisne river. Captain Charles Paterson remembered it as 'the most ghastly day of my life and yet one of the proudest because my regiment did its job and held on against heavy odds.'[4]

As the Aisne campaign continued the British supplies of ammunition and armaments were fast becoming depleted. Sir Charles Haddib, Master-General of the Ordnance, arrived at Field Marshal Sir John French's headquarters to highlight the deficiency. French assured him that the matter was in hand.

Major William Lawrence DSO, 1st South Wales Borderers. Major Lawrence was killed in the battle for Gheluvelt on 31 October 1914. (*Bonds of Sacrifice*)

NOTES

1. WO 95/1280: 1st South Wales Borderers War Diary
2. IWM 77/179/1: Captain Hubert Rees, 2nd Welsh Regiment
3. Atkinson, C.T., *The History of the South Wales Borderers 1914–1918* (The Medici Society, 1931)
4. WO 95/1280: 1st South Wales Borderers War Diary

WINSTON CHURCHILL AND TWO VICTORIA CROSSES

The 27th saw the first instance of a German hand grenade thrown into a British trench held by the 1st Lincolnshire Regiment. The BEF did not have any supplies of hand grenades with them and had to call upon the Royal Engineers to devise a weapon to counter the German hand grenade using gun cotton until supplies of real grenades reached them.

After the failure of the assault on Chivy Valley the previous day, German commanders restricted their actions to artillery bombardments along the Aisne valley. Missy took a pounding as 300 shells fell upon the village but this did not have any impact upon British operations in the surrounding areas.

The 1st South Wales Borderers holding the quarry on the Mont Faucon Ridge were relieved by the Camerons. The 1st Cameron Highlanders had lost heavily. Their officer ranks had been decimated and the remnants of the battalion were commanded by officers who had recently passed out. Captain Charles Paterson, Adjutant of the 1st South Wales Borderers wrote:

> The Camerons arrive at 9.00pm to take over our bit of the line. Poor devils, they have had a worse time than we have from the officers losses point of view. They are left with a Captain commanding them and three companies commanded by Second-Lieutenants fresh from Sandhurst.[1]

Private Charles Tew of the 1st Northamptonshire Regiment wrote home to his wife Nellie in Rushden:

> It seems nice to get your letters. I shall always write as long as I get the chance. As long as you keep drawing your money you will know that I am about. I was pleased you got the other letter for we were in the trenches all that week, and it rained every day, so you can guess how we looked. Talk about clay pit men, and you may laugh when I tell you that I had a wash and a shave on the Saturday, and then didn't get either until the following Sunday week, so you can tell what I looked like, but we got relieved for a few days rest as we have had it a bit hot, I can tell you, though we are back in the same place again now, and the same battle is in progress. I don't know

> when things will clear up for its bang, clang, all day and night, and only an hour before I got your letter I had taken my kit off and as soon as I put it down a bullet went straight through my water bottle, so I lost my water and bottle as well, but thank God, things were no worse, and I hope they never will be.[2]

Tew would serve with the 2nd Northamptonshire Regiment for another three years. He attained the rank of Sergeant and he was killed on 5 March 1917 on the Somme.

Lieutenant Billy Congreve – who would later receive the Victoria Cross, Distinguished Service Cross and Military Cross – was appointed aide-de-camp to Major-General Hubert Hamilton, commander of the 3rd Division during the first months of the war. On 27 September Winston Churchill, First Lord of the Admiralty, visited 3rd Division Headquarters to see how the Battle of the Aisne was progressing. Hamilton placed Churchill in the care of Lieutenant Congreve and ordered him to take the distinguished visitor to an observation station on the Brenelle Plateau above Chassemy. Churchill was dressed as a Trinity Brother, wearing a blue coat with brass buttons. As he was being driven to Chassemy in a Rolls-Royce, Churchill was worried that German forces might be lurking in the surrounding woods. He asked Congreve, 'Are you quite sure there are no parties of Germans inside our lines?'[3] Congreve confirmed that the region that they were travelling through was cleared of German personnel. The Boer War correspondent and ex prisoner of war was not convinced. As they drove to Chassemy, Churchill kept this revolver firmly on his knee as a precaution. Churchill did not have to use it. They drove behind the Brenelle plateau where British Artillery was positioned. Congreve insisted that Churchill wait in the car while he went to the observation position on top of the plateau to ensure that it was safe. At the time German shelling had subsided and Congreve escorted Churchill to the top of the Brenelle Plateau where he could see the river Aisne and the imposing Chemin des Dames ridge. Churchill saw what the BEF were up against. He returned to his car and grandiloquently claimed: 'Now I have been under fire in five continents.'[4]

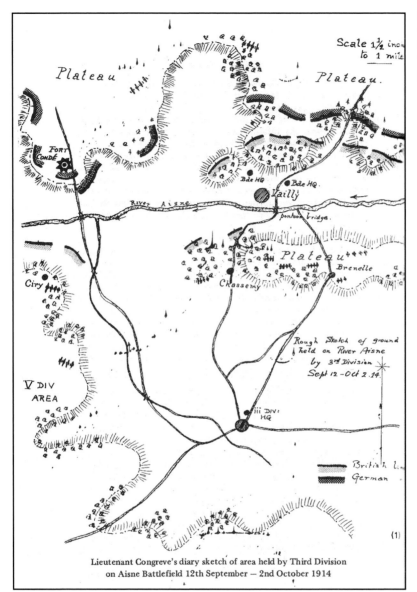

Lieutenant
Congreve's
Sketch map of
Third Division's
position at Aisne.
(Armageddon Road)

Lieutenant Congreve's diary sketch of area held by Third Division
on Aisne Battlefield 12th September — 2nd October 1914

Lieutenant Billy Congreve would reach the rank of Major and was awarded the Military Cross for bravery at Hooge in 1915, the Distinguished Service Order for his actions at St Eloi in Belgium in 1916 and the Victoria Cross posthumously for gallantry at Delville Wood, during which action on 20 July 1916 he was killed.

By 28 September, all British offensive actions on the Aisne front had stopped and the race to the sea had begun. Both sides made attempts to outflank each other's trenches on the Chemin des Dames to break the deadlock. Reinforcements on both sides were brought into the line to try, but the only outcome was the digging of more trenches northwards. The trenches begun on the Chemin des Dames eventually extended

across the Somme valley, then running east to Arras through to Ypres in Flanders, until they reached the Belgian coast; hence the phrase the 'race to the sea'.

On 28 September the 1st Irish Guards were ordered to construct barbed wire entanglements in front of their trenches at Cour De Soupir Farm. The men must have begun to appreciate the implications of such defensive preparations.

On the same day the 2nd Coldstream Guards were holding a position known as Tunnel Post to the left of the 4th Brigade's line. A thick mist had descended upon the Aisne Valley during the morning. Three men from Captain Follett's company were sent to patrol ahead of their lines. When the mist lifted the patrol was exposed

and came under German fire. Two were shot and the third managed to get back to battalion lines with only a graze. German machine-gun fire made any attempt to rescue the two wounded men look doomed. The logical solution would be to wait until nightfall – 14 hours hence. The nature of their wounds was undetermined and they might not survive that long. Private Frederick Dobson volunteered to leave the safety of the 2nd Coldstream trenches and reach them. Crawling from his trench across open ground, fully exposed to German infantry holding the trenches opposite, he successfully reached the two men. He found one of the men dead, while the other man was wounded in three places.

The Race to the Sea, September–October 1914. (Courtesy Department of History, US Military Academy, *West Point Atlas*)

Initially Dobson applied first-aid dressings to this man's wounds, then crawled back to his own line to summon help. He returned with Corporal Brown and a stretcher. They reached the casualty and brought him back. Captain Lancelot Gibbs observed this act of valour: 'Went up to trenches and watched Corporal Brown and Dobson bring in a wounded man from in front. Very fine act as under fire the whole time.'[5] Private Dobson was awarded the Victoria Cross and Corporal Brown was awarded the Distinguished Conduct Medal.

When the recommendation for Dobson to receive the Victoria Cross was brought before Sir Douglas Haig, he was reluctant to sanction the decoration: 'I am not in favour of this coveted award being created for bringing in wounded officers or men in European warfare.'[6] Haig recommended Dobson for the Distinguished Conduct Medal instead. When he heard of Dobson's courage, King George V overruled Haig's decision and Dobson was awarded the VC at a ceremony at Buckingham

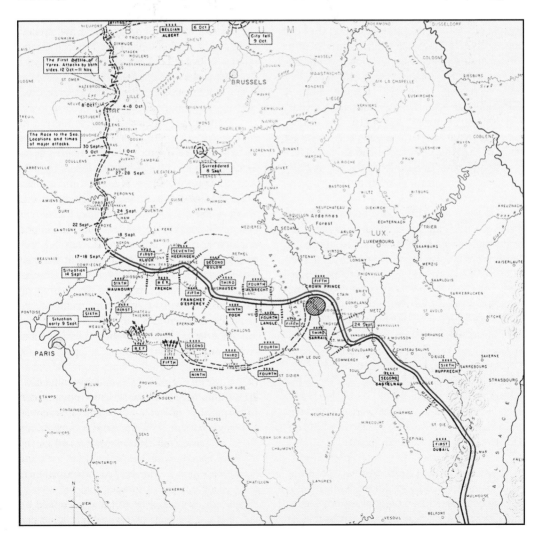

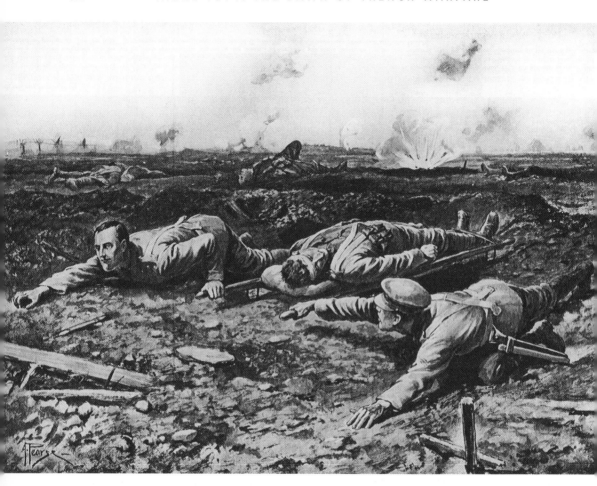

Private Frederick Dobson and Corporal Brown dragging a wounded soldier across open ground towards the British lines whilst under fire. (*Deeds that Thrill the Empire*)

Palace on 3 February 1915. Dobson was promoted to Lance Corporal and would continue to serve until July 1917 when he was discharged as medically unfit. He had sustained numerous shrapnel wounds. Dobson died aged 49 on 13 November 1935 and was buried at Ryton and Crawcrook Cemetery, County Durham.

NOTES ···

1. WO 95/1280: 1st South Wales Borderers War Diary
2. *Rushden Echo*, 9 October 1914
3. Congreve, Billy, *Armageddon Road* (William Kimber, 1982)
4. Ibid
5. Captain Lancelot Gibbs, Coldstream Guards Regimental Headquarters Archive
6. WO 32/4993: Recommendations for awards by Sir John French

THE FIRST TRENCH RAID

A 2nd Lieutenant of the 1st Loyal North Lancashire Regiment described the terrible scene on 29 September, when the Regiment took over the 1st West Yorkshire Regiment trenches:

> It was one continual round of trench warfare. The trenches of the West Yorkshire Regiment were still full of their dead, and it was almost impossible to dig in places without coming on dead bodies. We were subject to several attacks and continual heavy bombardment. We repulsed all attacks and in no case did the enemy set foot in our trench. The bombardment was the worst and we suffered several casualties. One day Major Burrows, Allason, Allen, Calrow, Reid (who only joined that day), and myself were all sitting in the mess talking when a shell just burst at the door. Allason and Calrow were killed. Reid was wounded and also Major Burrows. Allen and myself were not touched, although I was knocked over.[1]

Snipers were a deadly menace and in order to peer over the trenches to look into No Man's Land without raising one's head over the parapet, primitive periscopes were constructed by placing mirrors on the ends of sticks. The 2nd York & Lancaster Regiment war diary recorded on 30 September the first ever use of such 'periscopes' in trenches on the western front. 'The use of small mirrors on the end of a stick was found very useful for observing the enemy without being seen.'[2]

The 1st Rifle Brigade was holding the north of Bucy-le-Long and the days were spent consolidating defences and dealing with German snipers. During the three days 26–28 September the battalion war diary recorded: 'Improved trenches, constructed latrines etc. A good deal of sniping goes on.'[3] Sniping continued the following day: 'Sniping of patrols and sentries continues. We retaliate with snipers who meet with success.'[4]

The 2nd Welsh Regiment was entrenched along the Vendresse Ridge and Captain Hubert Rees gives a dramatic account of sniper activity along this sector:

> The distance between the enemy's lines on the Chemin des Dames and the Vendresse Ridge was at least a mile, so a considerable amount of sniping and fighting between scouts and patrols went on. Coy.

'BEF waist deep in flooded trenches – Aisne.' (*The War Illustrated*, 3 October 1914)

Q.M. Sgt. Cownie, who was a first rate shot, used to crawl out shooting Germans on every available occasion. He was a Scotchman, and a born scout. I met him coming back from one of these expeditions one evening and asked him how he had got on. 'I got six,' he replied, 'they put their heads too high above the heather.' He proposed to go and count them, but his Coy Commander told him he wouldn't let him take such absurd risks. A few days later, Cownie told me confidentially – 'There were six, but dinnae let on to the Captain I told ye, sir.' I heard afterwards that he had gone down the enemy's side of the wood to count them, so as to keep out of sight of his company commander. Brilliant shooting was not entirely the prerogative of the British Army, although the general standard of shooting by the British Army was far higher than that of the Germans. The German crack shot was good indeed, as I had cause to remember. One day, I went to examine the ground at the west end of Vendresse ridge and stood leaning against a tree with my hand between me and the tree trunk. I had been there no more that a minute, when a rifle bullet bulged the wood under my hand. It could not have been fired at a lesser range than 550 yards and the miss was probably caused by a miscalculation of the wind. On another occasion, I saw a bullet put through the sleeves of a man's coat, who had incautiously raised his arms above the trench whilst putting his coat on.[5]

As the improvement of trenches and defences was proceeding, the opposing sides were sleepwalking into the stalemate of trench warfare. Intense bombardments and infantry rushes were replaced by occasional patrols and sniper activity. The 1st Rifle Brigade war diary reported the situation north of Bucy-le-Long and confirmed that the front was becoming less active with regard to artillery fire.

> Same as previous days. Occasional alarms occur. No serious attack develops. Not many shells strike our position. Our front is now well covered with spiked sticks, barbed wire, entanglements, concealed holes etc. and trenches are well built and comfortable.[6]

2nd Lieutenant Neville Woodroffe of the 1st Irish Guards regarded the period entrenched on the Chemin des Dames in September as a period of rest and respite following the retreat from Mons. He had no notion that trench warfare would be how the war would be fought over the next four years:

> We continue to hold this position the other side of the Aisne and have been entrenched now for over sixteen days. One is beginning to feel the reaction after all our previous marching and we are longing to be on the march again. This is really the first time that we have been in the same position for more than one day. It is in some way a rest after our previous experience but we were shelled all day long and have occasional fusillades at night.[7]

Woodroffe writes of the Chateau at Soupir that had been transformed into a hospital and of the first instances of self inflicted wounds:

> There is a wonderful Chateau in the village, very large, new and vulgar. It has now been turned into a hospital. It has lovely gardens, but they have been practically destroyed by guns, and horses being allowed to wander and mess all the lawns and flower beds. But war is war and the owner must consider himself very lucky the whole thing is not in ruins. It seems odd to see the wounded lying in the most wonderful beds and sheets and others on the very finest carpets you could find. It seems a favourite and old trick to shoot one's finger off when one is cleaning one's rifle. Two men were admitted to hospital having blown off their fingers cleaning their rifles.[8]

Woodroffe's letter written on 30 September shows that he was fully aware of the perils and futility of going over the top:

> We seem to be going to hold this position indefinitely as it means sure massacre to advance over open ground in face of a most deadly fire from rifles and Maxims at such a short range. This is a terrible war and I don't suspect there is an idle British soldier in France. I wonder when it will end; one hears so much. There has been more fighting and more loss of life crowded into seven weeks than there was in the whole of South Africa. It is awful what the Brigade of Guards have lost and being like one big regiment one knows everyone and feels it all the more.[9]

By 28 September, a typical day for the British Tommy serving with the BEF on the Aisne would be confined to the construction of new trenches, the strengthening of existing trenches, erecting barbed wire fences, sentry duty, sniping and patrolling. On 3 October Corporal Sanson, accompanied by Privates Melvin and O'Neill of the 1st Coldstream Guards, volunteered to carry out a reconnaissance patrol north from their trenches at Troyon and Vendresse. They ventured beyond their lines in the early morning mist and discovered that the Germans were constructing a network of three trenches directly opposite their line. They also noted that they were digging a sap from the frontline German trench towards their lines. Sanson and his patrol immediately stood up and started shooting at the German engineers. They returned fire and the three Coldstream guardsmen had to rush back to the safety of their lines. During that night 2nd Lieutenant M. Beckwith-Smith from the 1st Coldstream Guards and Lieutenant Lucey from the 1st Loyal North Lancashire Regiment carried out their own inspection of the German trenches. It was decided that Beckwith-Smith would lead a raid to gather information about the trench system and to fill in the sap.

Germans in flooded trenches at the Battle of the Aisne. (Author)

This would almost certainly be the first trench raid to be carried out on the Western Front. The raid took place north of Troyon to the east of the road that led to the Sugar Factory. Beckwith-Smith led a platoon from No.2 Company, 1st Coldstream Guards 100 yards across No Man's Land at 8.00pm under the cover of darkness. They were armed with a rifle and each carried a shovel to fill in the sap. In silence they charged into the first German trench with fixed bayonets. This first trench was found to be unoccupied except for 15 dead German soldiers who were most likely killed by British shell fire or snipers earlier that day. After a momentary pause Beckwith-Smith led his platoon 70 yards towards the second trench. Half-way between the first and second trenches they were fired upon. Beckwith-Smith immediately gave the order to charge and the raiders made it to the trench where they overwhelmed the occupants with the bayonet and rifle. Twenty German soldiers were either bayoneted or shot by the platoon. Beckwith-Smith was the first man in the trench and was immediately set upon by two German occupants. During the struggle Beckwith-Smith was knocked to the ground and shot in the arm. Corporal Russell reached the trench just in the nick of time and killed the two German soldiers with his bayonet, saving Beckwith-Smith's life. Fire from a third German trench was brought down upon the raiders and strong reinforcements were seen approaching. Although Beckwith-Smith had fulfilled his orders to secure the first two trenches, the enemy fire coming from the third prevented him from filling in the sap. Seeing that it was impossible to carry out

A German soldier writing a letter in the trenches. (Author)

this objective he blew a whistle to signal withdrawal. The participants of this first raid returned to their trenches with the password COLDSTREAM. Beckwith-Smith was wounded with seven other men. Two other men were listed as missing presumed killed in the German trenches. Private R. Melvin, who had discovered the construction of the German trenches earlier, died from his wounds on 14 October at St Nazaire.

Together with Lance Corporal R. Russell, the post operation report recorded the names of four men that deserved special mention for their part in the raid:

> No.7983 Sergeant W. Brown & No. 5018 acting Sergeant G. Troke who behaved with great coolness and gave their officer every assistance. No.8725 Private R. Paxton who by his promptitude in the German trench was probably the means of saving Sergeant Brown's life.[10]

The report also provided good intelligence as to the condition and structure of the German trenches north of Vendresse.

> The first trench is reported to be a deep narrow trench giving cover standing and appears to be not yet completed. The second trench has a still deeper part ... there are recesses cut in under this trench for cover from shell fire held by props and boards.[11]

Lance Corporal R. Russell was awarded the Distinguished Conduct Medal for his bravery, while Beckwith-Smith was awarded the Distinguished Service Order. His citation read:

> On the night of the 4th October, near Vendresse, with a party of 50 men, he attacked and carried with the bayonet the advanced German trenches disabling 20 of the enemy and displayed great enterprise and coolness in this operation, in which he was wounded.[12]

This desperately dangerous work would form part of daily trench life for the next four years.

NOTES

1. WO 95/1270: 1st Loyal North Lancashire Regiment War Diary
2. WO 95/1610: 2nd York & Lancaster Regiment War Diary
3. WO 95/1496: 1st Rifle Brigade War Diary
4. Ibid
5. IWM 77/179/1: Captain Hubert Rees, 2nd Welsh Regiment
6. WO 95/1496: 1st Rifle Brigade War Diary
7. IWM 95/35/1: Lieutenant Neville Woodroffe, 1st Irish Guards
8. Ibid
9. Ibid
10. WO 95 1263: 1st Coldstream Guards War Diary
11. Ibid
12. *London Gazette*, 9 November 1914

DEALING WITH THE WOUNDED

Shrapnel wounds from heavy calibre artillery of a kind not seen in previous conflicts were a tremendous challenge for surgeons in the field, as were the large numbers of wounded men. Non combatants from the Royal Army Medical Corps would venture out under heavy fire in order to recover the wounded. Bandsmen from each regiment would work as stretcher bearers. The Royal Army Medical Corps suffered heavy casualties. Private J. M'Lennan of the 2nd Royal Scots Fusiliers was wounded by shrapnel and while recovering in Craigleith Military Hospital explained the RAMC losses to a reporter from *The Scotsman*:

> We all have pretty much the same story to tell, lying in the trenches with shells bursting round about and bullets spluttering into the earth. That's about all there is to say; with good luck you got clear, with bad luck you got hit. The stretcher bearers and Royal Army Medical Corps men do good work with the wounded and their part in the fight is as severe as any at times. When the line is advancing it isn't so bad, for they can keep behind the forces and pick up the wounded, but when we have to retreat the ambulance men have to undergo a severe test. They have then to get on the ground we have left, and they stick to their post carrying out the wounded under the heaviest fire. The casualties amongst the

R.A.M.C. were pretty heavy ... A good many were killed endeavouring to save the wounded after the order had been given to the fighting line to retire.[1]

On the night of 14 September No.1 Field Ambulance had to avoid the torrent of shells that fell around them when they crossed the river Aisne and then get to positions where they could best help the wounded. Without the aid of lights, which were forbidden because they could attract the attention of German artillery, they had to move around the north banks of the Aisne in the dark. The war diary reported:

> At 6pm received orders to march to VILLERS-OEUILLY over two pontoon bridges (other bridges being blown up) to MOULINS and await orders – A very dark night and difficult march – many shells overhead – no lights allowed – waited at Moulins from 8.45pm until 10pm when we were told to go forward to VENDRESSE and arrange with O.C. No 3 Field Ambulance, F– AMBC for area to collect wounded at daybreak – informed that these were very numerous and scattered in groups around the villages of Moulins – Vendresse and Paissy – arranged with O.C. No 3 to collect casualties in Moulins and Paissy where two sections of bearer Div of No 1. had been during the day.[2]

1st East Surrey Regiment: Lieutenant G.D. Eccles, the Battalion Medical Officer, with stretcher bearers. (*The Church in the Fighting Line*)

Wounded soldiers were evacuated to a regimental aid post. The majority of the wounded lay in 'No Man's Land'. Stretcher bearers were principally bandsmen in peacetime and it was their role to bring in the wounded and transfer them to regimental aid posts. During the opening days of the Aisne battle stretcher bearers learned from bitter experience that German machine-gun and artillery fire made it impossible for them to go and look for their wounded men during daylight, despite hearing their pitiful cries for help. As a consequence many of the soldiers wounded on 14 September were missed and either died of their wounds or their wounds became infected and made their condition worse. Some of the wounded found the strength to crawl to the British lines, while others had to wait several days before they were found.

German snipers showed no mercy towards stretcher bearers or personnel from the RAMC who ventured

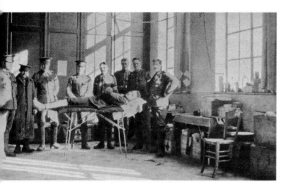

The 14th Field Ambulance in training. This photograph shows an operating theatre of a field ambulance, which could be erected inside any suitable building. (*The Church in the Fighting Line*)

into No Man's Land. Lieutenant Hugh John Haden Shields attending the 1st Irish Guards at La Cour de Soupir Farm had been captured while looking after the wounded but escaped when the enemy retreated. During the Battle of the Aisne Shields risked his life on numerous occasions in brave expeditions into No Man's Land to find wounded soldiers. In a letter to his father he writes of the dangers of German snipers who were not deterred by the Red Cross arm band. He describes the search for a British soldier who had been wounded by a German sniper:

As I did not know where our man was, I had to look about a bit, which I did by short runs and lying down. As it was, the sniper had ten or more shots at me, all very close, one covering me with earth as I was squatting down for a breather. When I found our man he was dead. It is a strange thing, and rather contrary to what one expects, that though I have been under fire of all sorts, shell and rifle, and have been many times missed by inches, I have never been actually frightened, but the immense excitement of it acts as a kind of stimulant. I can't say I wouldn't rather stay in the cave than go out to be shot at by a crack marksman 400 yards off, but the thrill of the excitement far outweighs the fear. My friend, the sniper, however, had killed this poor fellow pretty dead. I am afraid I have too many narrow shaves.[3]

Shields appears fearless, always putting the needs of others before his own personal safety:

I make a point of entirely disregarding fire when it comes to the point of seeing to a wounded man and

pay no attention. I don't believe precautions beyond the ordinary one of not exposing yourself more than can be helped do any good, and I am rather a fatalist. After all, I always think if one is killed doing one's duty we can't help it, and it is the best way of coming to an end, and so I mentally repeat that to myself when I am getting plugged at. Somehow, I don't feel that God means me to get killed yet, though before I came out I had a conviction I should not come back alive.[4]

A few weeks after the Battle of the Aisne, Shields' conviction was realised and he was killed on 25 or 26 October during the first Battle of Ypres.

The 1st Field Ambulance operated the crudest triage around Paissy and Vendresse The war diary recorded:

At 5.30am our bivouac was shelled – (artillery being in position S. of us) – and shells and 'Brown Bess' were tearing up the ground in our bivouac area – moved at once into village of Moulins which was rather less exposed. The hospital began to fill at once but as it was impossible owing to heavy fire to collect those from Vendresse those were collected by No 2 Field Ambulance (who, by the way, were under fire all day) Casualties from Paissy were brought in during intervals of fire, The inter [connecting] road being raked by fire most of the day.

We have been under shell and shrapnel fire all day – many narrow escapes – several ambulance wagons hit by shrapnel – Convoy of wounded sent, by A.D.M.S. orders, to Villers – all walking and sitting up cases list as it seemed during the morning we could not hold the position – Enemy pushed back later and less shell fire, but renewed a bit later – A late convoy at 7pm sent off, consisting chiefly of lying down cases – In all about 130 wounded removed – about 25 serious cases, unfit for removal remain here tonight – several buried during day when firing had eased off.[5]

The regimental aid post might consist of a dug out, a farm building, a sunken road or a house. Chaplain Owen Watkins of the 14th Field Ambulance recalled the scene at a regimental aid post established in a farm close to St Marguerite:

When I reached the farmhouse which the regimental doctors had made their headquarters, and into which they had gathered the wounded men belonging to the regiments to which they were attached, I found it could only be entered from the back, the road in front being swept by the enemy's rifle, machine and shrapnel fire so that no man could stand upon it and live. Inside I was met by a

scene I will not attempt to describe – a scene all too familiar to doctors and chaplains on service – the wounded fresh from the fight, grimed, unkempt, bloodstained, and many of them maimed for life. Fifty in all were gathered there; some were dying. Others were in the trenches, whom it would be impossible to reach until after dark.[6]

During the early stages of the Battle of the Aisne the field ambulances were not in a position to tend to the wounded. Many of the wounded from the first day of the battle were left where they fell for days. Those who were fortunate enough to have been evacuated from the field had no dressing stations to go to.

The church in Vailly together with three adjacent buildings was used as a makeshift hospital. Within a very short time this hospital was full of wounded men and it was almost impossible for the medical staff of the 8th Field Ambulance to give the necessary treatment. Lieutenant H. Robinson wrote:

We soon had large numbers of wounded on our hands; the whole floor of the church was speedily covered with mattresses which we commandeered from the houses in the town and the other three buildings were also fitted up for the reception of the wounded. At the school there were some five

or six young French women who had some First Aid training, and made themselves very useful. The influx of wounded was incessant, and we had to handle 500 of them in the first 48 hours.

The scene inside the church was one which defies all description. It was a large church for the size of the town, and the whole of the floor space was covered with mattresses: we even had to put them on the altar steps. Wounded men, covered in mud and blood, were everywhere; and space so precious that we could not even keep gang ways through the rows of mattresses: to get to our patients we had to step over others. Many of the wounds were very serious, and my bottle of morphia was in constant request: in fact it was soon empty and I had to get a fresh stack from a chemist in the town.

During the three nights that I spent in Vailly I slept altogether about five hours. Fresh batches of wounded kept coming in at all times of the day and night, and the work was absolutely incessant.[7]

Captain A.H. Habgood of the 9th Field Ambulance entered the village of Vailly and described the church:

Inside the church which was lit by candles, there were about two hundred men lying upon straw

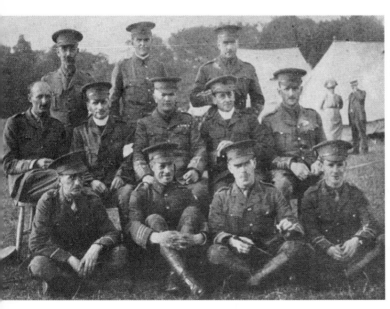

The officers of the 14th Field Ambulance. Top row: Lieutenant T. Grenfall, Lieutenant W. Danks, Captain Kelly. Middle row: Major Goldsmith, Reverend O.S. Watkins, Colonel G.S. Crawford, Reverend D.P. Winnifrith, Major F.G. Richards. Bottom row: Captain Bell, Major Fawcett, Lieutenant Clarke, Captain Crymble. (*With French in France & Flanders*)

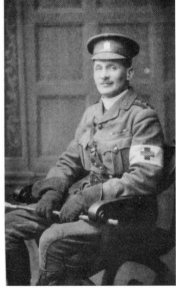

Chaplain Owen Watkins, 14th Field Ambulance. (*With French in France & Flanders*)

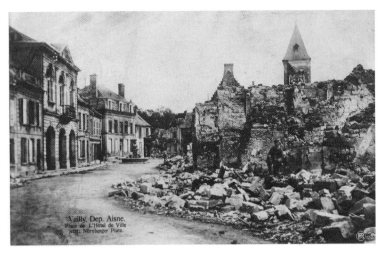

Left: Vailly and its church, which was used by the BEF as a hospital during the Battle of the Aisne, although it was vulnerable to German shell fire. (Author)

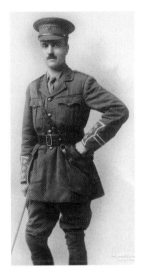

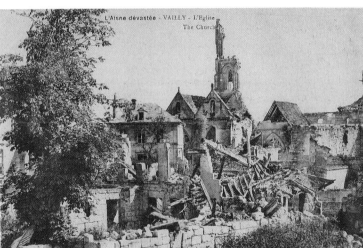

Above: Captain A. Habgood, 9th Field Ambulance. (Courtesy the Right Reverend Lord Habgood)

Left: The ruins of Vailly church. (Author)

and mattresses of all sorts, they lay in the aisles, the chancel, the Lady Chapel and the altar steps. Rifles and equipment were stacked in the porch, and the 'lightly' wounded sat in groups on church chairs, placidly eating, drinking and smoking, in tattered khaki with dirty faces and scrubby beards they looked like scarecrows.

Most of the wounds had been caused by shells and some of the men had been hit a day or two before they could be brought in; their wounds were already festering, and the air of the church was bitter with the sickening stench of gangrene. Many of the men were quiet, but some were shouting in delirium; others groaning, praying, cursing and crying monotously for water and morphia.[8]

There were not enough resources and medical supplies to provide the appropriate treatment. The staff of the field ambulances were overworked, understaffed and

exhausted. Some medical officers faced the awful dilemma of assessing who had the best chance of survival and who was a hopeless case. Lieutenant H. Robinson stationed at Vailly Church:

I can remember another case which raised a somewhat disputable point. A soldier was taken into Dr Lancry's house suffering from a horrible shell wound to his abdomen. A piece of his abdominal wall about as big as a pudding plate had been shot clean away, and one could see two or three broken ribs, a large piece of his liver, large intestine, small intestine. Although men have recovered many times in this war from wounds which apparently must have been fatal, in this case it was indisputable that recovery was totally out of the question. I advised that the man should be given a poisonous dose of morphia at once, but I was overruled, and the man lingered on for two or three days

occupying a bed which would have been better given to somebody less seriously wounded. It is of course a very large question whether any doctor is ever justified in deliberately killing a patient, but I think if ever there was a case where that course is humane and defensible, it was in this case. The man was unconscious from the shock of his injuries, so there was no question of his being able to send any messages to his relatives, to make a will, or anything of that sort; he was of course given small doses of morphia – enough to prevent his feeling pain – but if I had had charge of him I should have given him two grams straight off.[9]

Many men succumbed to their wounds and died in the dressing station at Vailly Church and the adjacent buildings. One of those houses belonged to Doctor Lancry who had fled his home as the war came close to Vailly. Graves were dug in Lancry's garden. Lieutenant H. Robinson from the 8th Field Ambulance recalled:

A good many of our wounded died in the dressing station and we generally had them buried in the garden of the Dr's house. One day when a grave was being dug for this purpose the diggers unearthed a collection of silver plate and other treasures, which the doctor had evidently hidden there before he fled from his house; we immediately had the hoard covered up and the graves were dug after that in another part of the garden.[10]

A Presbyterian Chaplain working with a field ambulance wrote:

I have been in the thick of hospital work for ten days now, and it is impressive and very satisfactory. What brave fellows our soldiers have been and are. The men I see have been hit some time between the Mons retreat and the beginning of the Aisne battle, and their stories are never to be forgotten. It isn't war; it is murder.[11]

It was difficult for field ambulances to feed themselves and the patients. The 1st Field Ambulance war diary reported:

Rations are our great difficulty for patients – At no time since we left B_____ have we failed to draw rations or half rations, etc for R.A.M.C. personnel, but in spite of urgent indents, we cannot get rations for patients – have urgently informed A.M.D.S. of this – I have tried to obtain rations from regiments and in a few cases have been successful, but often we are nowhere near units and this method fails us – I have a good surplus supply still of medical

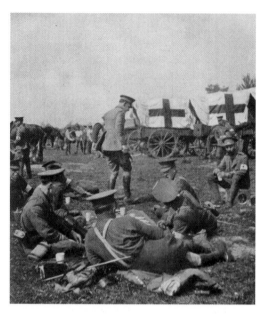

The 14th Field Ambulance in a rare moment of repose. (*With French in France& Flanders*)

comforts, but many of the patients require food as they have been away from their units, in barns etc, in some cases two or more days and on the 13th iron rations were to be used.[12]

The 1st Field Ambulance at Moulins resorted to searching nearby fields for vegetables to feed the wounded soldiers:

Late last evening a large convoy of wounded were sent in from my bearer Div – who are now at a small village (near Vendresse) at TROYON about one mile to N of us and 2 miles by road – these were sent back under cover of darkness after fire ceased as during the day it is under heavy fire – roughly 140 in all – lists not yet complete – These again have no rations but I am feeding them by means of vegetables and anything I can locally collect to supplement meat rations made into stews – Milk and other such supplies are impossible to obtain here as villages are cleared out – Under the circumstances we are doing well and all will get one good meal and biscuits are at present plentiful – I hear artillery units in action behind us have been without rations since yesterday – All tent sections hard at work in church and barns redressing wounds, many of which are already septic – only urgent operations being performed – majority of wounds are from rifle and shrapnel fire ... Lt Pringle died last night – Heavy fire over village this

morning – message at 6.30am from Major [Pairrie] I/C Bearer Div asking for every available ambulance wagon to be sent to <u>TROYON</u> as soon as situation permits or when dark to evacuate large number of further casualties – Heavy rain again last night, improving now – Sent off convoy of wounded (91 cases) at 1pm today to Villers where they were to be transferred to motor lorries for railhead ... Eighty cases received at 5pm from Bearer Division, expect remainder at dawn tomorrow ...[13]

First aid was administered here by the regimental doctor until the casualty was taken from the regimental aid post to a dressing station further behind the line. A medical officer accompanied by a squad of four to six stretcher bearers from a field ambulance would come to the regimental aid post to transfer the casualty.

Field ambulances were responsible for the establishment of dressing stations. A field ambulance was in effect a mobile hospital that would follow the army in the field. Each field ambulance could accommodate 150 patients. Each had, or should have had, nine medical officers, a quartermaster and 242 non commissioned officers and men. These men would be drawn from the Army Service Corps who drove the ambulance wagons and 'specialists' in the Royal Army Medical Corps who worked as stretcher bearers, nursing orderlies and trained theatre assistants. They were expected to establish hospital facilities where urgent operations could be carried out and wounds would be re-dressed. If no suitable house, farm building or church could be found to use as a hospital, they could set up in field tents. Field ambulances included 10 ambulance wagons, 3 water carts, 6 wagons and 2 carts for stores, 14 riding and 68 draught horses. The horse-drawn ambulances could get close to the trenches. Motorised ambulances were more useful in transporting the wounded from a dressing station to a hospital or railhead.

Field ambulances displayed the flag of the Red Cross, alongside a Union Jack. At night time when the Red Cross flag could not be seen, two lamps emitting a white light denoted that the position was a field ambulance.

The officers and men of the field ambulances were all committed to the task and devoted to the care of their

wounded comrades. Chaplain Douglas Winnifrith who belonged to the 14th Field Ambulance wrote:

Of the work done by the officers and men of the 14th Field Ambulance it is impossible to speak in too high terms of appreciation. They are heroes every one, and I count it a privilege to have been associated with them.

In this campaign, with its artillery duels between long-range guns, the Field Ambulance has been constantly under shell fire, and the journeys between the dressing station and the regimental aid posts have always been perilous. But, whether it was across the open plain on the north side of the Aisne, upon which shrapnel was constantly bursting, or along the cobbled roads of Belgium studded with 'Jack Johnson' holes, they always performed readily and cheerfully. Frequently in our mess at night when, in answer to the announcement 'The wagons and squads are ready, sir', the Colonel would ask, 'Whose turn is it to go out tonight?' have I heard several officers answer together, 'I should like to go out tonight, sir.' I often accompanied these expeditions, and have, therefore, first-hand knowledge of the difficulties and dangers they involved.[14]

A field ambulance also of course received men who had reported sick and had been sent by the regimental doctor. From August to November the 14th Field Ambulance treated 48 officers and 1773 men who were sick and 68 officers and 1640 men who were wounded. Motor ambulances would arrive at field ambulances twice a day to transport the sick and wounded deemed in need of evacuation to a clearing hospital.

Chaplain Douglas Winnifrith praised the ceaseless work of the medical officers:

During these days many men owed their lives to the surgical skill of Captain Lindsay, and Lieutenants Clark and Tasker. On one occasion they worked in the operating theatre, a room in a farm house from

The 14th Field Ambulance advanced dressing station positioned 500 yards south of Aisne. (*The Church in the Fighting Line*)

7pm until 2am incessantly. One night they were especially busy, the ambulance wagons bringing us in as many as a hundred and fifty wounded.[15]

Winnifrith also praised the way in which the wounded conducted themselves:

As they lay on straw in the rooms of the farmhouse, in barns and in outhouses. I went around and did what I could, taking a message from one, writing a card for another, giving drinks of Bovril, helping some to move into a more comfortable position, saying a word of cheer to all, and having prayers with the most serious cases.

The fortitude of these wounded was magnificent, not a word of complaint did one of them utter, though many were suffering from ghastly injuries. This has invariably been my experience, and one of our doctors bears the same testimony: 'Believe me', he says, 'the Victoria Cross is won over and over again in a single day. They are brave! What if you were to see how the wounded act after the excitement of battle! They suffer their wounds, great and small, without a murmur; they get their wounds dressed, take chloroform, give consent to have their limbs amputated, just as if they were going to have their hair cut. They are gloriously brave.'[16]

Having been reovered under cover of darkness, once the wounded were at a dressing station they could not be evacuated across the Aisne until night fell once more. They were not safe even then to cross the pontoon bridges because German searchlights were shone into the valley to identify river crossings and direct fire.

Such was the intensity of the shelling, it was not safe

on the south side of the river either. A wounded soldier from the 2nd Connaught Rangers recalled seeing in a field 'a man's hand on which was a gold ring with the initials "J.H." There was no sign near of whom the hand belonged to.'[17]

Sergeant David Lloyd-Burch arrived at No.10 Field Hospital at Bourg-Le-Long:

Ambulances of 5th Division from the 14th Field Ambulance in the Aisne valley. (*With French in France & Flanders*)

During our stay at Bourg-Le-Long the Germans sent a few shells over but they drop near our field hospital doing no damage to us. We stopped here for three weeks. I saw some terrible sights here. The wounded were brought from the trenches to our dressing station; our officers were most skilful doing marvellous operations. I saw a poor fellow with a fractured thigh, a terrible wound as well, our doctors took his leg off. During the night one of the Seaforth Highlanders was brought in. A bullet had hit him in the abdomen, his intestines were protruding, nothing could be done for him, he died during the night.[18]

Once the badly wounded made it to the southern banks of the river they were transported to western France to the port at St Nazaire, where they embarked for England. One wounded corporal of the 1st Cameron Highlanders recalled his experience of being evacuated:

I was put in an ambulance wagon and conveyed across the Aisne after dark, as the Germans always shelled the pontoon bridges during the day. The wounded were then transferred to motor wagons, and had another run for over 30 miles. It was not a very comfortable journey for men in our state, but such things have to be put up with on active service.[19]

Captain L.A. Kenny from 47th Battery, 44th Brigade, Royal Field Artillery, was wounded by German shell fire close to Verneuil. He wrote of the danger of crossing the river on 14 September:

The wounded, including me, were taken to a barn belonging to a large chateau close by. I was right out and did not come to till many hours later. We were on stretchers on the floor of the barn. Three

days later we were taken by horse ambulance to the foot of the pontoon bridge over which we had come previously, when crossing in our advance, and which was still being shelled heavily.

We had to wait our turn with the other ambulances, and during a lull in the shelling, and at a signal, the driver of the ambulance whose turn it was to cross would, with the aid of whip and spur, get his horses into a gallop as quickly as possible. You can imagine what it felt like to the wounded inside the ambulance, an old rickety springless vehicle, the pontoon bridge swaying and shells dropping. Words cannot describe it. It was hell. Some of us got over, many didn't. As soon as we got over the bridge and into the main road we proceeded to a town called La Ferté, where we were placed on a train for St Nazaire.[20]

The 14th Field Ambulance regimental aid post established in a farm north of the Aisne. (*The Church in the Fighting Line*)

Many wounded were in such a bad state that they were not transferred to hospitals in Britain but taken to military hospitals established in France. Lieutenant Wauchope, 1st Northamptonshire Regiment had been badly wounded by shell fire, his body torn by shrapnel on 21 September. He was sent to hospital in Rouen. In a letter home of 4 October he wrote:

There is nothing to worry about, but it will be some time before I am allowed to cross the Channel, say, some six weeks, and naturally, much longer before I get home ... I got hit last Sunday at about 6.30pm by a small sized melinite shell (not a 'Black Maria'). It hit the ground and burst at my feet, and a piece of the shell shaved off some of my chest on the right side, together with some pieces of ribs, one of which was broken and pierced the lung. However it did not hurt a great deal, and I managed to walk in, not far, but a big enough distance. I was sent off at once and dressed and sent down to Braisne, which is a railhead, as they call it ... The train was a huge one, about seventy casualties, filled only with wounded, of course. The officers were in 'wagon-lits', and I was fairly comfortable, but the journey lasted till Thursday morning, eight o'clock. We went all sorts of roundabout ways, picking up wounded, and the average pace would not have exceeded eight miles an hour, not because of the wounded, but because of the length of the train.[21]

Wauchope tells his family it 'did not hurt a great deal'. It takes little imagination to realise that for a man with a punctured lung to 'walk in' and then undertake that train journey, needing six weeks to recover even before being shipped back, this was a white lie.

Private Harland from the 2nd Royal Sussex Regiment was seriously wounded in the battle for the Sugar

Factory at Cerny on 14 September. He had lived in Brighton before the war and was relieved when after several days he was evacuated and transferred to the Brighton Military Hospital. In his diary he describes the ordeal of getting there:

They got me into a barn, where I should think there were about fifty other wounded men, and gave me just the rough field dressing – the best they could. Then the shells began to fall on the barn, and they had to get us all out. Some had to crawl out as best they could: some had to be carried out. I was helped out by an orderly. Then they got us all into a church. We put the Red Cross flag out. But, bless you, the Red Cross flag is just what those Germans like to aim at, and we weren't long in there before they got the range of the church and shelled that. We had to be got out again. Then they got us into a motor lorry and drove us for thirty miles or so. I can tell you it was a terrible ride. They had to put us in as best they could, men badly wounded, men with broken arms and legs – and drive us over rough ground anywhere they could to get us away. It was a trying experience, but we had to put up with it. Then they got us into some horse boxes and on to the railway, being taken across France to St Nazaire, which we were using as a base. It was a dreadful journey and no one touched my wound all that time. You hardly believe it, but my wound wasn't touched for seven days. However it couldn't be helped.[22]

In some instances the wounded were not tended until they reached hospital in Britain. Any delay at any stage along the route from battlefield to hospital could be fatal. Private Thomas Uwin, for example, was wounded in the shoulder on the 14th. He lay on the battlefield for two and a half days before he was found

and evacuated. The 23-year-old was brought to Netley Hospital in England where he died from his wounds on 29 September. If had been reached earlier and tended to, he must surely have survived a shoulder wound.

The wounded were taken to military hospitals across Britain. Many were sent to the military hospital in Edinburgh. The Earl of Rosebury made available Dalmeny House, his residence, as a hospital. The first batch of 80 wounded soldiers arrived during the night of 16 October and included many soldiers who had been wounded during the Battle of the Aisne. They were brought off a troopship that morning and had to endure a train journey of twelve hours. They arrived at Princes Street Station, Edinburgh, that evening. Thirty motor vehicles were requisitioned to transfer the wounded from Princes Street Station to Dalmeny House. A hundred volunteers from various charity organisations organised by the Red Cross Society were in attendance to help in this transfer. *The Scotsman* reported: 'There were a few really serious cases and not all of them were wounded, some being victims of rheumatism and pneumonia contracted through spells in the rain-sodden trenches of the valley of the Aisne. Shrapnel accounted for a large percentage of the serious wounds.'[23]

Repatriated, the wounded told their stories to journalists. One soldier from the Northamptonshire Regiment said 'We have had some terrible fighting in the trenches at 300 yards range. Thousands killed and wounded.'[24] Private J. Anderson from the Cameron Highlanders told a reporter:

> I am just getting the use of my hand and arm now. I have had a narrow escape. A bullet entered my shoulder from behind and came right through and entered my neck. If it had been a little further round – well, I would have been sleeping beside a lot more of my chums over in France.[25]

Many wounded British soldiers were recovered by German patrols. Lieutenant C.E. Wallis was wounded in the shoulder on 14 September and took shelter amongst the ruins of house, where he lay for the next 24 hours. Wallis was found by a German patrol the next day:

> About 9.00am on 15th September a party of Germans searched the ruined house in which I had been lying since the previous morning. The NCO in charge spoke a little English. He asked me if I could walk. My reply that I was too weak owing to loss of blood. He replied that he would return in half an hour with a stretcher party. He then left taking with him anyone who could walk. He appeared to treat them with consideration.[26]

Things would then take a turn for the worse:

About a quarter of an hour after he had left, another party of Germans entered and threatened us with bayonets and made signs to us that if we did not get out we should be bayoneted. I crawled out of the house on hands and knees, together with a few men who were also able to do this. The remainder – about ten – stayed in the house – being unable to move, and I do not know what happened to them. Outside two Germans lifted me to my feet, while one stood behind with a bayonet, with which he prodded me and shouted 'March.'

> I took two or three steps forward, but collapsed from weakness and in doing so the bandage and tourniquet round my arm became loose, and the blood commenced to flow very badly. Eventually a stretcher was found, and I was put on it and carried about a mile. There were also two men of the Cameron Highlanders walking beside me – one wounded through the throat, and the other through the shoulder. During this mile I was kicked by passing Germans several times and also struck in the face by a NCO. The man wounded in the throat was clubbed with a rifle butt, knocking him down, while the other one was struck several times.[27]

Lieutenant Wallis was taken to a German dressing station, which could offer limited care. His treatment improved when he reached a hospital in Laon three days later, where he was treated by French doctors and nurses for six weeks before being transferred to a prisoner of war camp in Germany.

Many of the soldiers on both sides were holding their trench positions waist deep in water. Pumps were brought in to drain the water but proved largely ineffective. The first cases of trench foot were inevitably recorded at the Aisne. Private D.W. Reed serving with the 3rd Coldstream Guards was one of the first

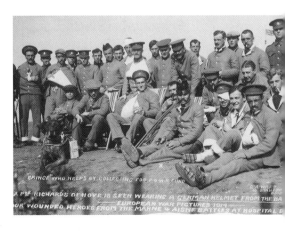

Aisne and Marne wounded at a hospital in Sussex, October 1914. (Author)

sufferers: 'I was sent home with frozen feet. My feet were all frozen. It was caused by wet clothes, frost and exposure. They turned bad.'[28] Some troops never took their boots for fear that their feet would swell so much they could not get them back on.

PRIVATE CHARLES AGER 7618

1ST BATTALION NORTHAMPTONSHIRE REGIMENT

Charles Ager served for several years before working for Messers Lilley and Co., Curriers in Irthlingborough He was called up as a reservist and attached to the 1st Northamptonshire Regiment. Private Charles Ager was badly wounded during the Battle of the Aisne. He was evacuated to No.4 General Hospital at Versailles, where he died from his wounds on 25 October 1914. He was buried at Les Gonards Cemetery, Versailles. His mother received a letter from Chaplain H.W. Fox, who tended to him at this hospital, dated 29 October 1914:

Private Charles Ager, 1st Northamptonshire Regiment. (*Rushden Echo*, 20 November 1914)

Dear Madam – I expect that you will have already heard of the death of your son, which took place in this hospital on the 25th of this month. He was admitted several days before, wounded badly in the head. At first the doctors had hopes of his recovery, but in spite of all their efforts, and the devoted care of the nursing sisters, he passed away on Sunday night.

I was with him frequently during his last days, and, although he was unconscious at the end, yet earlier, in his moments of consciousness, he was always glad to pray, and joined with me in saying the Lord's Prayer. The funeral took place yesterday in the special piece of ground reserved here for British soldiers. Many people were present and showed their sympathy by laying flowers upon his grave. A cross has been placed upon it bearing his name and regiment, and I hope before long to send you a photograph of it. Meanwhile I am enclosing a piece of heather which I picked from close beside it as a slight remembrance.

May I express my own sympathy with you in your sorrow, and I pray God that he may give you the comfort of his own presence, and that you may find him a very present help in this time of trouble.[29]

PRIVATE PATTISON

ROYAL ARMY MEDICAL CORPS ATTACHED TO THE KING'S OWN SCOTTISH BORDERERS

Private Pattison of the Royal Army Medical Corps was attached to the King's Own Scottish Borderes. He had been present at the battle of Mons and was badly wounded during the Battle of the Aisne, when a shell fragment took a piece from his scalp. A piece of shell was lodged in the joint of his knee and it was reported in a local newspaper that doctors were unable to remove it.

Private Pattison. (*Kettering Leader*, 16 October 1914)

NOTES

1. *The Scotsman*, 7 October 1914
2. WO 95/1257: 1st Field Ambulance War Diary
3. *The Cambridge Review*, 1914
4. Ibid
5. WO 95/1257
6. Watkins, Chaplain Owen, *With French in France & Flanders* (Charles Kelly, 1915)
7. WO 95/1407: 8th Field Ambulance War Diary
8. IWM Con Shelf: Captain A.H. Habgood, 9th Field Ambulance, 3rd Division
9. WO 95/1407
10. Ibid
11. *The Scotsman*
12. WO 95/1257
13. Ibid
14. Winnifrith, Reverend Douglas, *The Church in the Fighting* (Hodder & Stoughton, 1915)
15. Ibid
16. Ibid
17. *The Scotsman*, 9 October 1914
18. IWM 87/26/1: Sergeant David Lloyd-Burch, No.10 Field Ambulance
19. *Highland Times*, 8 October 1914
20. IWM 77/97/1: Captain L.A. Kenny, 47th Battery, 44th Brigade, Royal Field Artillery
21. *The Scotsman*, 19 October 1914
22. WO 95/1269: 2nd Royal Sussex Regiment War Diary
23. *The Scotsman*, 17 October 1914
24. *Northamptonshire Mercury*, 9 October 1914
25. *The Scotsman*, 9 October 1914
26. WO 161/95/61: Lieutenant C. Wallis Prisoner of War Report
27. Ibid
28. Liddle Collection: interview tape 124: Private D.W. Reed, 3rd Battalion, Coldstream Guards
29. *Kettering Leader*, 6 November 1914

ASSESSMENT

If staff officers at British General Headquarters had been appraised of the weakness of German forces from the night of 11 September to dawn on 13 September and had moved faster to take possession of the Chemin des Dames ridge, then the Battle of the Aisne might not have resulted in deadlock and the war might have followed a completely different course. Lieutenant N.H. Huttenbach of the Royal Field Artillery commented on the BEF's lack of expediency in reaching the river. 'The advance proceeded with insufficient momentum, which permitted the Germans to prepare a strong defensive position on the river Aisne from which we failed to dislodge them and the first sign of trench warfare was born.'[1]

If commanders had behaved in the same manner as Brigade General Hunter-Weston and had driven the men under their command apparently beyond endurance to capture high ground on the north banks of the Aisne then stalemate could have been averted. At night, Hunter-Weston's 11th Infantry Brigade had seized high ground without opposition, without losses. This probably could not have been accomplished if attempted the following day, in broad daylight with German forces perched on the ridge.

If the Connaught Rangers had pushed ahead and captured the summit at La Cour de Soupir on the night of 13/14 September the 2nd Division would have been better placed to secure the Chemin des Dames. If the 5th Infantry Brigade had secured a line along the Beaulne

and Soupir Spur and had the entire 2nd Division crossed to the north bank of the Aisne, they would have had four hours to reorganise and prepare for an advance through German positions.

If Field Marshal Sir John French had not sent the BEF in a broad front across the Aisne but had concentrated all his forces on one smaller front, they might have been able to break through the German lines.

That, of course, is a lot of ifs. It was a tough call for BEF commanders to make. The decisions made by these men would have major consequences for the outcome of the battle and the war as a whole. As described earlier, it must never be forgotten that the BEF had been fighting the war for three weeks, continually marching and fighting during that time with only two days rest. They had had to endure hot summer days at the beginning of the war, then at the Aisne weather fronts brought in cold temperatures and heavy rain. Many of the soldiers had dispensed with their winter coats due to the summer heat. Now that the weather had changed they were marching and fighting in summer clothes, which were wearing out quickly. Rations were inadequate. It is difficult to comprehend how these men endured those three weeks, but they kept on going, loyally carried out their orders.

A lack of detailed orders to express the Commander-in-Chief's strategic plan did little to help his officers and men. With no appreciation of what lay ahead, no awareness of the German forces fortified on the

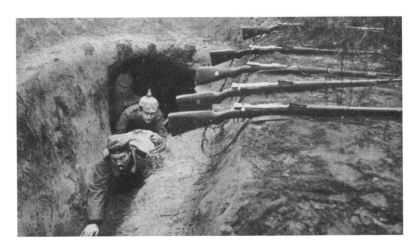

A German trench in 1914; primitive, in comparison with later constructions. (Author)

ridges and on the slopes of the Aisne valley, the BEF blundered their way into piecemeal actions. Lack of communication between staff officers and officers in the front line was evident.

Lieutenant Bernard Montgomery, 1st Royal Warwickshire Regiment, wrote in a letter to his father on 27 September 1914: 'Our object is I think to hold them here while the French get round behind them, or there may be some other reason, we are not told much of the strategic plans.'[2]

German High Command was aware that if they lost possession of the Chemin des Dames, then the town of Laon to the north and its railway hub – vital to the German supply lines – would become vulnerable. German High Command had to maintain and control the railway network at all costs.

The Germans had utilised the natural terrain of spurs, bluffs and ridges. Their trenches and strategically positioned machine-gun nests and artillery batteries made it virtually impossible to remove them from their entrenchments north of the river. They could see the BEF cross the Aisne and observe their every move while concealed themselves.

By the end of 15 September the BEF held a very fragile bridgehead north of the Aisne. If General Alexander von Kluck had ordered an intensive artillery bombardment upon the British positions and then ordered waves of infantry towards them, the BEF might have been compelled to withdraw. Fortunately for the BEF, General von Kluck did not have the military resources available in the region to force the BEF south. German forces therefore had to adopt a defensive strategy and hold their ground until reinforcements and supplies of munitions arrived.

16 September saw both British and German forces entrenching and fortifying their positions. By the end of the month, no side could advance. The trenches, the barbed wire, the artillery, the machine guns, all prevented it. British, French and German military leaders had been schooled in offensive strategy. They had been trained to advance and fight in the Victorian era. Very little had been learned by the British, even during the relatively recent Boer War, to overturn that offensive doctrine. Throwing infantry in large waves against modern weapons would only result in huge casualties with no breakthrough.

Lieutenant-Colonel Sir Frederick Ponsonby summarised the experience of the 2nd Grenadier Guards during the first months of trench warfare – but only after the war:

> For nearly three weeks the 2nd Battalion Grenadiers remained in the trenches, two companies at a time … the Germans had given the Allies time to entrench themselves, and found it equally impossible to

advance. Trench warfare had begun, and had come to stay. Months of comparative inaction were to follow, while the artillery pounded away at the infantry in the trenches.[3]

British commanders could not foresee the impact of modern weapons. In 1914 they had no conception of how to use the modern rifle, machine guns, artillery and aeroplanes to fight and win a war. Field Marshal Sir John French wrote in 1919:

> It is easy to be 'wise after the event'; but I cannot help wondering why none of us realised what the most modern rifle, the machine gun, motor traction, the aeroplane, and wireless telegraphy would bring about. It seems so simple when judged by actual results. The modern rifle and machine gun add tenfold to the relative power of the defence as against the attack. This precludes the use of old methods of attack, and has driven the attack to seek covered entrenchments after every forward rush of at most a few hundred yards … I feel sure in my own mind that had we realised the true extent of modern appliances of war in August 1914, there would have been no retreat from Mons, and that if, in September, the Germans had learnt their lesson, the Allies would never have driven them back to the Aisne. It was in the fighting on that river that the eyes of all of us began to be opened.[4]

A new place on earth, No Man's Land, was delineated for the first time. The Rifle Brigade chronicler recalled early experiences of excursions into No Man's Land at night:

> No Man's Land was in the neighbourhood of a thousand yards in depth, providing a capital arena for patrol skirmishes. By day all was quiet. After dark, activity began on both sides. We used to race the Boche opposite us for a haystack that was about halfway between the two lines and was the selected place for a standing patrol at night. As soon as dusk came on we used to send an N.C.O. up a high tree just inside our lines to let us know when the enemy patrol left their trench so that ours might start out too. One night the enemy started earlier. The N.C.O. on climbing the tree shouted down that the patrol was already nearly at the stack. 'Give them a shot to steady them,' said the officer on duty (Captain Morgan-Grenville). It chanced that the N.C.O. was Sergeant D. Muddle, the crack shot of the battalion. He sighted his rifle at five hundred yards, and firing out of the tree, brought down his man with his first shot. The war of movement was over for the time being.[5]

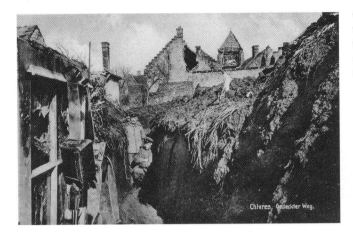

German trenches at Chivres in the last years of the war. These trenches were deeper and more strongly fortified in comparison to the early trenches. (Author)

Many of the soldiers who fought at the Aisne had also fought at Mons and the Marne. The Aisne was different. Corporal C. Warren from the 2nd King's Own Scottish Borderers wrote: 'I have been in three battles now; the first two were nothing to us. We had a company in our trench, and we never expected coming out alive.'[6]

Snipers and enemy machine gunners would prevent men from venturing from their trenches into No Man's Land to search for the wounded and recover the bodies of dead comrades and carcasses of horses and cattle for burial. This would affect the men emotionally and the smell of decaying flesh would contaminate the air. The smell of death would become a part of daily trench life in the weeks, months and years to come. Captain John Macready:

Had we but known it, this was the beginning of trench warfare. We never even so much as smelt the top of the Chivres Ridge again. There was, of course, no wire, and trenches were far apart, the intervening ground being covered with fire. Patrolling went on nightly, through the Boches' lines and back again.

We lost many men through sniping during the day. So much so that in one of Allason's forward platoons, no movement whatsoever could be made in daylight. The morale of this post was definitely down and something had to be done about it. One night a patrol returning to our line came through an orchard and found a ladder against an apple tree and dozens of empty cartridges below it. They took an exact line on this. Next day, some of our best shots gave their attention to this tree. Sniping on this post of C Company ceased after this, men could move more freely. The weather became hot and the smell of dead bodies in the woods was dreadful, both Germans and our own had fallen in odd places and not been discovered. Carcasses of horses and cattle were even worse. There was no hope of burying these during the day, for we were completely overlooked

by the enemy. Bit by bit we got them buried, but it takes some doing to bury a cow which has swollen to three times its normal size.[7]

Soldiers had to learn fast the code of conduct in order to survive. Those on the front line trenches would either be on sentry duty or digging further trenches while taking it in turns to rest. Those battalions who had come off the front line got no respite from the trenches, for they were detailed to build more, or were tasked with the transportation of ammunition, rations and supplies to the front. Private Frederick Bolwell serving with the 1st Loyal North Lancashire Regiment wrote of the routine:

There was plenty of work on the Aisne during those days, the men in the front line connecting each single trench up with another, so as to form one continual line; also the making of bunny holes. During the day we had the usual order: one man in three on sentry, now commonly termed in the trenches 'look-out'; and, at night, every other man – if a quiet night, one would be on sentry, one resting, and one taken for digging a communication trench, each man taking his turn an hour about. Those in the reserve lines would all turn out with picks and shovels the whole of the night, digging one main communication trench.[8]

The heavy German howitzers could fire shells of a calibre that never been seen before. It was the first time that the British Army was confronted with artillery firing shells of larger calibre than their own. Field Marshal Sir John French:

The first surprise came when the 'Jack Johnsons' began to fall. This was a nickname given by the men ('Black Marias' was another) to a high-explosive shell fired from eight-inch howitzers which had been brought down from the fortress of Maubeuge

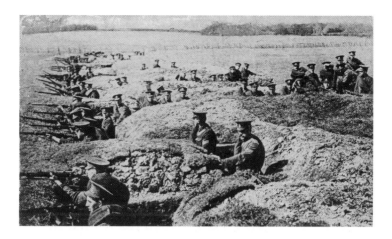

BEF troops in early trenches. (Author)

to support the German defensive position on the Aisne. They were our first experience of an artillery much heavier than our own. Although these guns caused considerable damage and many bad casualties, they never had any very demoralising effect upon the troops.[9]

In fact, men were badly shaken by the enormity of the German bombardments and throughout the four years of war many soldiers would succumb to shell shock. After the war those who survived would be mentally affected by the bombardments that shattered their minds and their senses. Arguably, John French's confidence on this point demonstrates how remote the commander-in-chief was from the true situation.

The British could only dispatch old pattern 6-inch howitzers. This inferior British response arrived on the Aisne on 23 September. Neither British nor French artillery could match the Germans' firepower.

The German artillery could fire various types of shell – high explosive shrapnel, small high velocity shells, known as 'whizz-bangs' – but it was the High Explosive shell fired by German 8-inch howitzers that would cause the most devastation, blowing craters 20 feet wide and 10 feet deep. Such explosions could vapourise a man and reduce villages and towns to rubble. An anonymous officer from Swansea wrote in a letter home:

> We have been in our present position ten days, holding a strong position. The Germans are about a thousand yards ahead of us, and from the numbers of prisoners we have taken and the stories they tell us they seem to be in a bad way. We are being shelled here every minute. It is very terrifying, especially in a wood, but we are getting used to it. The big shells do an awful amount of damage. I have seen a tree completely uprooted and hurled on top of others. If we hear a shell whistling towards us we immediately dive into our holes.[10]

It is most probable that this anonymous officer was referring to the battle in Chivy valley on 14 September:

> We took part in the _____ fight. It began before I could realise it. The hill I was on an absolute inferno, and how I came through it unhurt is still a marvel to me. We had to cross a valley and get up the crest of another hill. This crest was simply plastered with shrapnel; but when I went over the shrapnel more or less ceased and the German infantry came up and opened a heavy rifle fire instead.[11]

Field Marshal French:

> As day by day the trench fighting developed and I came to realise more and more the much greater relative power which modern weapons have given to the defence; as new methods were adopted in the defensive use of machine guns; and as unfamiliar weapons in the shape of 'trench mortars' and 'bombs', hand grenades, etc., began to appear on the battlefield, so, day by day, I began dimly to apprehend what the future might have in store for us.[12]

Shell holes began to appear at Aisne and would become a common moonscape feature along the entire Western Front. Private Frederick Bolwell wrote: 'That valley, when we left it, was like a pepper-box top – simply perforated every few yards. How we managed to remain alive on the Aisne the first week was simply a mystery.'[13]

Both sides learned that it was dangerous to peer over the parapets. Captain Harry Dillon from the 2nd Oxfordshire and Buckinghamshire Regiment wrote on 3 October:

> I went out the other night a little way and one could hear them talking quite close. I could not see them from my place as there is a slight rise in front but where I am tomorrow I am only 500 yards off and

amuse myself having pots at them if they put up their heads. If they pot back I can walk along the bottom of the trench a little farther on.[14]

New drafts, clean shaven and wearing pristine uniforms arriving on the Chemin des Dames were in marked contrast to the soldiers who had been fighting the battle since 14 September. Captain C.T. Atkinson, chronicler of the South Wales Borderers unit history in the First World War, wrote:

Trench warfare was in its absolute infancy, not yet accepted as a chronic condition of existence, and no one had as yet thought of the systematic mitigation of its hardships. There was no chance of getting a wash or a shave or a change of clothes: one officer who arrived on September 20th with a draft was deeply impressed by the flourishing beards with which the C.O. and Adjutant were adorned, while his company commander 'looked like a tramp' and the men were 'as white as millers' from the chalk mud.[15]

The BEF had difficulty in bringing in supplies of ammunition and evacuating the wounded due to German shelling. There was no logistical provision to ensure that the British soldiers holding the line in the first trenches were fed. Private Frederick Bolwell wrote of the measures that the British Tommy had to take in order to ensure that he ate:

Food was scarce; and once we had a single loaf issued out between a hundred men. We tossed for it, the winner to receive the lot, the others going without. After the first week we were much better supplied, having bread or biscuits, with a ration of cheese or bacon, but precious little of that; and oftentimes I tossed for the lot and lost all! Fortunately there were plenty of potatoes and carrots in the ground – these were dug up, boiling them, and after straining the water off, partook of them with a slice of cold corn beef. Some would boil the beef with the potatoes, thereby getting the salt from the beef into the potatoes: this we called 'bully stews'.[16]

Lieutenant Bernard Montgomery serving with the 1st Royal Warwickshire Regiment pointed out that some fortunate soldiers on the Chemin des Dames did receive adequate supplies of food (unless he was lying):

I keep extraordinarily fit & well, and really believe that if I washed I should get ill! ... The firing on both sides is generally heaviest in the early morning from 5–9am; we can't get the wounded men away in the early morning from the forward trenches

as stretcher bearers coming up would at once get knocked out. So they have to lie there till it is dark, with just a field dressing on the wound. We can see the Germans coming out of their trenches at dawn, stretching themselves and rubbing their eyes, we wait until a few collect together and then fire on them. They tried a night attack the other night but we beat them off alright. What we really want is some fine weather to dry up the trenches and get all our clothes thoroughly dry. It would be fine I think but for the guns; this morning it was beautiful but as soon as the guns began it started raining. Our men are all very cheery indeed, in spite of hardships and living as they are at high pressure. Of course they get very good food. They get biscuits, bully beef, bacon, jam, cheese, every day and of course we get the same.[17]

Progress reports on the Battle of the Aisne featured in national and local newspapers across Britain. Journalists did not foresee that the war would take many years to win. On 19 September a deluded *Times* correspondent wrote:

The great battle draws to a close. Exhaustion rather than shot and shell has wrought a terrible peace along the river banks, a peace which my experience of the last few days leads me to believe may prove the herald of victory. That, at least, is how I read the situation, and I have had opportunities of studying it, which I fancy few others have enjoyed. I have seen our troops and the French go into battle these last days, not as worn and weary men, but as conquerors. I have seen them return wounded from this valley of death with the conquering spirit fanned to fiercer flame.[18]

The experience of war was becoming more accessible to people at home as it was being fought. Letters from soldiers on the frontline were printed in national and regional newspapers. Reporters were able to interview the wounded. The war was being fought on the other side of the English Channel and regular news brought the war into the forefront of the minds of those at home as never before.

Many of those men who fought in the 1914 campaign thought that the war would be over soon. Private Danny Davies, 2nd Grenadier Guards, who was killed during the Aisne battle on 23 September, thought that after the Battle of the Marne and with the Germans in retreat they were fighting the final stages of the war – 'on the last lap of the struggle'.[19]

Field Marshal French was aware of the logistical problems of supply. Equipment, food and ammunition would have to be transported to Paris, then sent north-

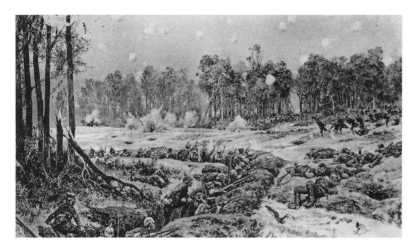

The BEF left the Aisne for Flanders in early October 1914 but French units took over their positions and continued to struggle for ground in the Aisne sector. These two images show trench warfare at Vailly on 30 October 1914 when French infantry tried to capture German trenches. (Author)

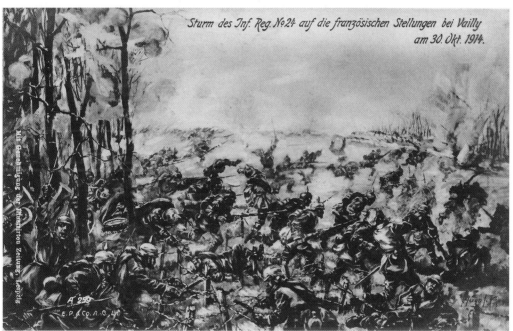

Sturm des Inf. Reg. №24 auf die französischen Stellungen bei Vailly am 30. Okt. 1914.

east to the Aisne. French approached General Joffre with the proposition of transferring the BEF to Belgium where they could defend the left flank of the western front. They would be closer to home, which would shorten the supply line. French was mindful of the fact that further divisions would be transported from Britain to reinforce the BEF. Operating closer to home would also therefore ease the burden on the French railway network. Sir John French was also concerned that if the BEF and French Armies were engaged in a stalemate on the Aisne, then German forces might sweep from Belgium into Northern France and seize the Channel ports at Dunkirk, Calais and Bolougne and cut off the BEF from Britain. If the BEF could have their own front along the Belgium/northern France sector they would

be able to work with the Royal Navy to ensure that the English Channel remained open to British and French fleets.

Joffre agreed to French's request. French territorials replaced the ranks of the BEF on the Aisne front line. Territorials in France were not like the territorial forces in Britain. The French territorials were men who were too old for regular active service. German commanders adopted the same policy by replacing their lines north of the river Aisne with the German Landwehr, which also contained men who were too old for regular service.

The operation to withdraw the BEF from the Aisne began on 3 October when General Gough's 2nd Cavalry Division marched from Compiègne and headed for their new front line in Flanders. The French General Staff

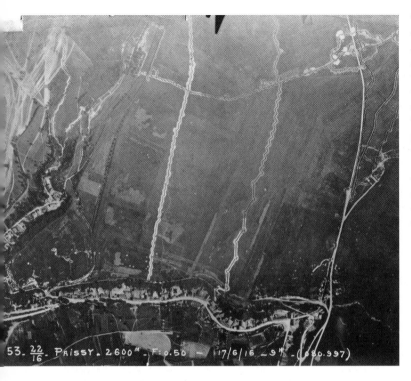

The shallow trenches dug during the Battle of the Aisne would develop into a huge network of forward trenches and support trench lines connected by communication trenches. This aerial reconnaissance photograph shows the trenches at Paissy on 17 June 1916. The communication trenches were dug across the Cerny-en-Laonnois Plateau from Paissy and northwards towards the Chemin des Dames. (Courtesy Jean-Pierre Boureux)

planned the successful transfer of 100,000 men of the BEF from France to Belgium over three weeks, the last units arriving in Belgium on 19 October.

On 16 October Field Marshal French released the following Special Order of the Day, which brought closure to the First Battle of the Aisne. In this communiqué French praises the efforts of his officers and men and recognises their resilience:

1 Having for 25 days successfully held the line of the river Aisne between Soissons and Villers against the most desperate endeavours of the enemy to break through; that memorable battle has now been brought to a conclusion so far as the British forces are concerned, by the operation which has once more placed us on the left flank of the Allied armies.

2 At the close of this important phase of the campaign I wish again to express my heartfelt appreciation of the services performed throughout this trying period by the officers, non-commissioned officers and men of the British Field Forces in France.

3. Throughout nearly the whole of that 25 days a most powerful and continuous fire of artillery from guns of a calibre never used before in field operations, covered and supported desperate infantry attacks made in the greatest strength and directed at all hours of the day and night on

your position. Although you were thus denied adequate rest and suffered great losses in no case did the enemy attain the slightest success, but was invariably thrown back with immense loss.

4. The powerful endurance of the troops was further greatly taxed by the cold and wet weather which prevailed during the greater part of the time.

5. Paragraph 2 of the Special Order of the Day, August 22nd, ran as follows:-
'All the regiments comprising the Expeditionary Force bear on their colours emblems and names which constantly remind them of the glorious victories achieved by them in the past. I have the most complete confidence that those regiments, as they stand to-day in close proximity to the enemy, will not only uphold the magnificent traditions of those days, but will add fresh laurels to their standards.'

I cannot convey what I feel with regard to the conduct of the troops under my command better than expressing my conviction that they have justified that confidence well and nobly.

6. That confidence is everywhere endorsed by their fellow countrymen; and whatever may be before the British Army in France, I am sure they will continue to follow the same glorious path till final and complete victory is attained.[20]

In a letter to King George V dated 2 October 1914 French expressed his view of the future of the war and how it would be fought:

> I think the Battle of the Aisne is very typical of what battles in the future are most likely to resemble. Siege operations will enter largely into the tactical problems – the spade will be as great a necessity as the rifle, and the heaviest calibres and types of artillery will be brought up in support on either side.[21]

During the winter of 1914–15 the Allied and German armies laboured intensively to dig trenches across the continent of Europe from the Swiss Frontier to the Belgian coast, approximately 400 miles. The distance between opposing armies varied from being a mile apart to only a few hundred yards.

Many soldiers were deluded in thinking that the trenches were only a temporary situation that would remain just for the winter months, that once spring arrived it would be logistically easier to move troops and supplies. The BEF was ill equipped to dig trenches and had little experience. During manoeuvres they had been reluctant to dig trenches, partly because they were then ordered to fill them in!

The trenches that were first dug during the Aisne battle were narrow and shallow and the soldiers from both sides were visible with their upper torsos exposed as they assumed the firing position. The trenches were therefore widened and dug deeper, to 7 feet and a fire step was dug into the fireside of the trench, so that a soldier could fire over the parapet or stand to in readiness to oppose an enemy assault. Timber and sandbags were brought in to strengthen the trenches.

Initially the British trenches were long continuous lines, however when a shell fell directly into the trench the explosive power would be channelled along the trench and kill many men. The trenches were therefore dug in a zigzag line so that the force of the explosion would be contained within a small sector.

During the first five months of the war, the BEF, which had a strength of 150,000 men at the start of the campaign, would suffer casualties of 86,237 soldiers either killed or wounded.[22] Field Marshal French lost 561 officers and 12,980 men during the Battle of the Aisne. Some battalions were completely destroyed. For instance, the 1st Queen's (Royal West Surrey Regiment) left their barracks at Bordon on 12 August 1914 with a complement of 26 officers and 1000 men. All that remained of the battalion after the battle were two officers, Lieutenant J.D. Boyd and Lieutenant (QM) G.W. Wallace and 32 other ranks.[23]

Many officers and men who had lots of military experience were now lost and needed to be replaced.

Brigadier-General Bulfin lost three out of four battalion commanders in the 2nd Infantry Brigade. Brigadier-General Ivor Maxse also lost three out of four of his battalion commanders in the 1st Guards Brigade. Both Bulfin and Maxse had lost not just valued officers but friends. The Battle of the Aisne was a tragedy on a personal as well as an operational level for these brigade commanders.

Field Marshal French understood the implications of this loss of experience. He wrote to Kitchener on 24 September 1914:

> I enclose a statement of the reinforcements which have gone to the 5th Division. You observe the proportion between officers and men, not only in quantity but in quality. These young and almost untrained officers have to go straight into the trenches and undertake the most arduous and responsible work. The proportion of reliable leaders to the men they have to direct and lead is becoming most serious throughout the whole force.[24]

As the BEF moved north to defend Ypres in Flanders they of course sustained further casualties. At the beginning of the First World War a battalion nominally constituted 1107 officers and men. By 29 October, towards the closing phase of the First Battle of the Aisne, a typical battalion was comprised of approximately 300 effective fighting men, while a company could be reduced from 80 to the 30 men. The British suffered heavily as they prevented the Germans from entering Ypres. This is reflected in the strengths of the units involved. The 1st Queen's numbered 2 officers and 12 other ranks, the 2nd King's Royal Rifle Corps were 150 strong, while the 1st Loyal North Lancashire Regiment consisted of 1 officer and 35 men. These Battalions who had previously fought valiantly at the Battle of the Aisne in September would defend a fragile line at Gheluvelt on 31 October against waves of German infantry. They prevented a breakthrough into Ypres and to the Channel Ports.

The loss of approximately 13,500 officers and men during the Battle of the Aisne over the course of one month was a tremendous shock not only to the commanders of the BEF but also, inevitably, to families and communities at home. Those losses were not restricted to British-born soldiers. Australia lost two men during the Battle of the Aisne who are likely to have been the second and third Australians to have died in the First World War. The first Australian-born officer to be killed in action in France was Lieutenant William Malcolm Chisholm on 26 August at Le Cateau. Captain Lucas-Tooth, born in Sydney serving with the 9th (Queen's Royal) Lancers was the second Australian officer killed, close to Troyon on 14 September. Captain

'A lull in the firing.' BEF troops on the Aisne in the first trenches of the Western Front. (Author)

be fought underground between French and German soldiers in caves and underground tunnels. The Caverne du Dragon Museum, a mile east of Cerny where the BEF fought in 1914, is a magnificent museum that tells the story of war in this region, where the soldiers of France fought for control of the underground caves as well as above ground in the trenches. The Chemin des Dames had seen war in past centuries. Julius Caesar fought the Gauls here and in 1814, after the retreat from Moscow, Napoleon Bonaparte fought a battle against the Russian and Prussian Army and won. The Chemin des Dames would see much blood spilt throughout the First World War. Hundreds of thousands of men would die on the ridges and in the fields of the Aisne valley. It was the scene of the French mutiny in 1917. The British Army would return to the Chemin des Dames in May 1918 and would suffer severe losses during Operation Blücher-Yorck in May/June 1918, when German forces pushed through their lines.

Of those British soldiers who fought and survived through September 1914, 58,000 would be killed during the First Battle of Ypres. How many of those survivors made it right through to 1918? If they did survive, did they come out of the war unscathed? They would surely have returned home with their minds at least scarred by the terrible ordeal. It is important that as we approach the centenary of the Battle of the Aisne we recognise its significance and remember the 'Old Contemptibles' who fought it.

Gordon, born in Melbourne, serving with the 1st Northamptonshires and killed on 15 September, was probably the third.

The war carried on being fought on the Chemin des Dames for four years. Villages would be destroyed, shell holes would pockmark the ground. Battles would

NOTES

1. Liddle Collection: interview 66/92: Lieutenant N.H. Huttenbach: 41st Brigade, Royal Field Artillery
2. IWM: World War 1 Letters Album, Bernard Law Montgomery: Ref 1/23
3. Ponsonby, Lieutenant-Colonel Sir Frederick, *The Grenadier Guards in the Great War* (Macmillan & Co, 1920)
4. French, Field Marshal Viscount, *1914* (Houghton Mifflin Company, 1919)
5. Berkeley, R., *The History of the Rifle Brigade 1914–1918* (The Rifle Brigade Club, 1927)
6. *The Scotsman*, 5 October 1914
7. Captain John Macready Account, Bedfordshire & Luton Archives
8. Bolwell, F.A., *With a Reservist in France* (E.P. Dutton & Co., 1917)
9. French
10. Marden, Major-General Sir Thomas, *History of the Welch Regiment 1914–1918* (1931, republished by Naval & Military Press, 2002)
11. *South Wales Daily Post*, 6 October 1914
12. French
13. Bolwell
14. IWM 82/25/1: Captain Harry Dillon, 2nd Oxfordshire and Buckinghamshire Regiment
15. Atkinson, C.T., *The History of the South Wales Borderers 1914–1918* (The Medici Society, 1931)
16. Bolwell
17. IWM: World War 1 Letters Album, Bernard Law Montgomery: Ref 1/23
18. *Ayr Advertiser*, 24 September 1914
19. *South Wales Daily Post*, 12 October 1914
20. *Northampton Herald*, 7 November 1914
21. The Royal Archives (GV Q832/74) and *Tommy: The British Soldier on the Western Front 1914–1918* by Richard Holmes (Harper Perennial, 2004)
22. Laffin, John, *A Western Front Companion* (Sutton Publishing, 1994)
23. IWM 84/58/1 Sergeant C.S.A. Avis, 1st Queen's (Royal West Surrey) Regiment
24. National Archives: PRO 30/57/49 Field Marshal Sir John French's communication with Lord Kitchener

MEMORIALS AND CEMETERIES

LA FERTÉ-SOUS-JOUARRE MEMORIAL

The La Ferté-Sous-Jouarre Memorial stands on the southern bank of the River Marne and is comprised of a rectangular stone block, measuring 62 feet by 30 feet, 24 feet in height. It lists the names of 3739 soldiers who fell in the region during August, September and the early part of October 1914 who have no known grave. A sarcophagus and a trophy stand on top of this memorial. All four corners have stone pillars with urns featuring carvings of the coat of arms of the Empire. The memorial was unveiled on 4 November 1928 by Sir William Pulteney. The families of the fathers, sons and brothers who are listed on this memorial were in a state of limbo when informed that their loved ones were missing in action presumed dead. With a body buried in

a grave there is some kind of identifiable ending. When men were listed as missing, the families could hold onto the possibility that there was a mistake – they could have been taken prisoner of war or they may be lying wounded in a hospital bed.

Some families were not told that their loved ones had died during the Battle of the Aisne through official military channels. Sergeant William Peters who served with the 2nd Royal Sussex Regiment is listed on the memorial and his mother became aware of his death when the family received news in a letter of condolence from one of his officers stating that he had died on 14 September 1914, before any official notification from the War Office. Lieutenant W.B. Churchill-Longman wrote in his letter, dated 17 October 1914:

La Ferté-Sous-Jouarre Memorial. (Courtesy Sandy Sell)

Dear Mrs Peters

On 14th September, at the Battle of the Aisne, your son, Sergeant Peters, and I were lying next to each other. I was hit in my left wrist and he tied me up. As soon as he had finished a shell came over and blew off both his legs. I did what I could for him with my one hand, gave him water, etc., but he died two or three minutes after he was hit.

His last thoughts went back to you and his father and sister. He asked me to send you his pocket book, and enclosing the little medal and cross for his sister.

Before he died I said the Lord's Prayer.

I saw a lot of your son, and we often marched side by side. He was always cheerful and always did his duty. Of course you had heard from the War Office.

I would have written to you sooner, but am now in hospital, but hope to leave soon. I cannot tell you how sorry I am to have to write these sad details, but you must be very proud of your brave son.[1]

Private Ernest Keates, also from the 2nd Royal Sussex Regiment, is honoured on this memorial. He was killed on 14 September by a shell. Private Hartland was standing next to Keates when a shell exploded close by and uprooted a tree. Hartland was badly wounded by the same shell, Keates lost his life and he has no known grave.

Amongst the names listed on the memorial at La Ferté-sous-Jouarre is Private George Ward from the 1st Royal Berkshire Regiment. He crossed the river Aisne on 14 September 1914 and his battalion acted as guard to the flanks as the main body advanced towards the Chemin des Dames. German shell fire descended on the battalion's position around 9.00am and despite

being unwounded Ward left his position and headed towards the rear. He was asked where he was going by an NCO and he said that he had been hit by shrapnel. Private George Ward reported back to his battalion six days later and was tried on 24 September at Oeuilly Farm. Found guilty of desertion, Ward was executed at Oeuilly on 26 September at 5.56pm.[2] This execution was unusual as it took place during the afternoon; most executions during the First World War took place at dawn. One uncorroborated account from an observer who witnessed the execution of Private George Ward claimed that he made an attempt to escape as he was being led to the place of execution and one of his guards shot him as he tried to run away. Ward was brought back on a stretcher and shot dead as he lay wounded. He was buried at Oeuilly, but during the course of the war his grave was lost and his name is therefore commemorated on the memorial.

Every name on the La Ferté-Sous-Jouarre Memorial honours a fallen soldier, marks a family tragedy, but one of those names hides a doubly tragic story. Private Hector Claugher, an 18-year-old bandsman serving with the 1st Cameron Highlanders, was killed on 25 September 1914. It is highly probable that he was amongst the casualties killed in the cave that collapsed on the Cameron Highlanders at Beaulne that day. Four years later his father, also called Hector and serving with the 1st Cameron Highlanders, was killed during the Second Battle of the Aisne on 29 September 1917. Jane Claugher, of Lawncourt, Edinburgh, lost both husband and son.

VAILLY BRITISH CEMETERY

The British 3rd Division crossed the river Aisne at Vailly on 12 September 1914. German forces occupied the village during 1915. Vailly was recaptured by French infantry on 18 April 1917. It fell into German hands

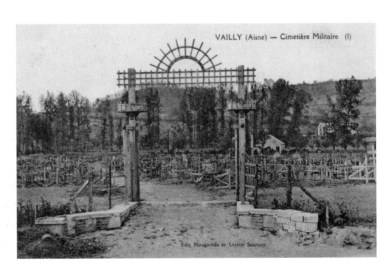

Vailly British Cemetery.
(Author)

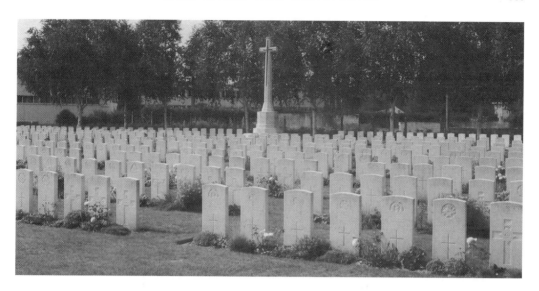

Vailly British Cemetery after the war. (Author)

once again in May 1918 and was retaken by the French on 15 September 1918. Vailly British Cemetery was established after the war and the remains of British soldiers killed in the region were re-exhumed from smaller cemeteries or from the battlefield and reburied here. The cemetery contains 675 Commonweath burials and commemorations from the First World War. 370 are identified casualties and there are special memorials to 40 dead known to have been buried in other cemeteries whose graves could not be found. The majority of the men buried here died during the Battle of the Aisne in September 1914. The following table lists where some of the soldiers interred in Vailly British Cemetery were originally buried.

Cemetery	Notes	Number of British soldiers taken to Vailly British Cemetery
Aizy French Military Cemetery	Located north east of Vailly	17
Bazoches Communal Cemetery Extension	172 French soldiers are buried here	6
Braine French Military Cemetery	Not the present French National Cemetery	10
Brenelle Churchyard French Extension	Held the remains of approximately 500 soldiers	9 men from the Royal Garrison Artillery who were killed during September 1914 when a gun accidently exploded; and 1 lancer.
Chateau Thierry Communal Cemetery		1 British soldier killed in 1914 brought to Vailly British Cemetery in 1936.
Chavonne Communal Cemetery		7 men, 5 belonging to the 2nd Coldstream Guards, 1 from the Dragoon Guards and 1 from the Queen's Bays.
Courchamps Churchyard		8 British soldiers buried in the north-west corner of the churchyard.
Courcelles Communal Cemetery		2
Glennes Churchyard Extension	Contains 803 French and 400 German graves	3 British soldiers buried by the Germans in 1918 and 8 killed in 1914 reburied by the French.
La Cour de Soupir Farm		66 British soldiers of the 3rd Coldstream Guards and 2nd Connaught Rangers who were buried in two plots during September and October 1914.
Veil-Arcy British Cemetery	Near Ferme Chauveau	27 British soldiers buried in September and October 1914.

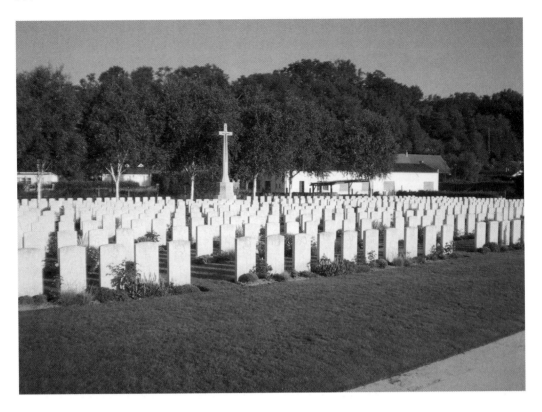

Vailly British Cemetery. (Courtesy Yves Fohlen)

Amongst those men buried in this cemetery is Lieutenant Eric Tottie, 1st Northumberland Fusiliers, aged 19, who was killed on 22 September 1914. His parents living in Ascot, Berkshire, would soon learn that their other son Lieutenant Oscar Tottie was killed on the same day when HMS *Aboukir*, together with two other cruisers, was sunk in the English Channel by the German submarine U9, commanded by Lieutenant Otto Weddigen.

2nd Lieutenant Eric Tindall, King's Royal Rifle Corps, was killed on 12 September 1914. He rests in this cemetery and his epitaph reads:

ONE GLORIOUS HOUR
OF GLORIOUS LIFE
IS WORTH AN AGE
WITHOUT A NAME

Kennington-born Trumpeter Ivor James, Royal Field Artillery, was only 16 years old when he was killed on 16 September. He rests within this cemetery. His epitaph reads:

IN LOVING MEMORY
OF MY ONLY SON
KILLED IN ACTION

VENDRESSE BRITISH CEMETERY

Vendresse British Cemetery was created after the Armistice in 1918 by the concentration of graves from other smaller cemeteries and makeshift graves on the battlefield. The cemetery is located just beneath Vendresse Ridge and overlooks Vendresse Valley. It is positioned alongside the Vendresse–Cerny Road, which was used by battalions from the 2nd Infantry Brigade who trudged up it to take part in the battle for the Sugar Factory at Cerny on 14 September 1914. The cemetery contains approximately 700 men; of that number, only 327 are identified.

Three special memorials were raised in this cemetery to three soldiers believed to have been buried in unnamed graves. A further 50 special memorials commemorate British soldiers from other nearby cemeteries whose graves were destroyed by shell fire during the course of the war.

Within this cemetery there are 37 cases where graves were collectively identified, but were not marked with a name on the headstone. These headstones are marked with the words 'BURIED NEAR THIS SPOT'. The following table lists where some of the British soldiers were originally buried before they were transferred to Vendresse British Cemetery.

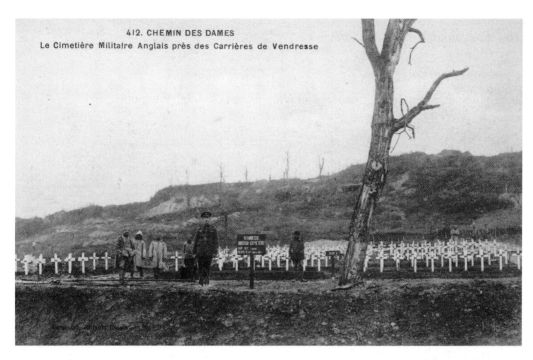

412. CHEMIN DES DAMES
Le Cimetière Militaire Anglais près des Carrières de Vendresse

Vendresse British Cemetery after the war. On 14 September, battalions from the 1st Guards Brigade and the 2nd Infantry Brigade passed along this road in order to reach the Cerny-en-Loannois Plateau to assault the Sugar Factory at Cerny. Behind the cemetery can be seen a chalky, rocky slope which formed part of Vendresse Spur. (Courtesy Jean-Daniel Destemberg)

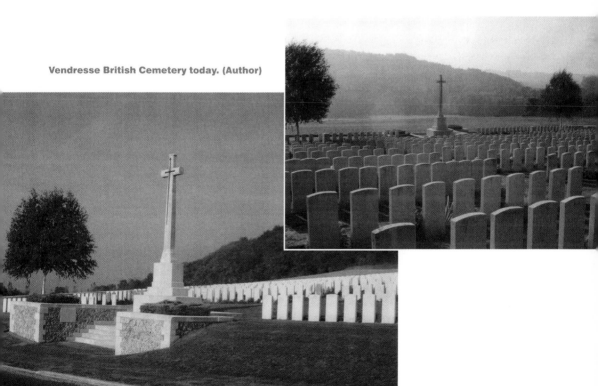

Vendresse British Cemetery today. (Author)

Cemetery	Notes	Number of British soldiers taken to Vendresse British Cemetery
Bourg-et-Comin French Military Cemetery		1 British soldier from 1914.
Cerny-en-Laonnois French National and German Cemeteries		59 British soldiers who were buried in the German cemetery in 1914. 9 British soldiers who were buried in the French cemetery during 1914 and 1918.
Chivy-les-Etouvelles German Cemeteries	There are four cemeteries at Chivy-les-Etouvelles.	13 British soldiers who were killed during 1914.
Moussy-sur-Aisne Churchyard		14 British soldiers killed during September 1914.
Oeuilly Churchyard, Aisne		4 British soldiers killed 1914.
Troyon Churchyard, Aisne		50 British soldiers who died in 1914.
Verneuil Chateau Military Cemetery	A dressing station was operating within the Chateau at Verneuil during the Battle of the Aisne and the soldiers who died from their wounds were buried in this cemetery within the grounds of the Chateau.	46 British soldiers. The 57th French Infantry Regiment erected a stone memorial dedicated to their British comrades in this cemetery. This memorial was relocated to Vendresse.

Many of the soldiers who fell during the Battle of the Aisne are buried here. Captain G.W. Blathwayt, Royal Field Artillery, killed on 14 September 1914 is believed to have been buried in this cemetery. His epitaph reads 'It Shall Be Well'.

Private James Thompson, from the 1st Loyal North Lancashire Regiment was killed on the same day. Thompson lies in Vendresse British Cemetery and his epitaph is fitting for all those soldiers who have no known grave.

Vendresse British Cemetery Memorial to 21 soldiers buried in Troyon Churchyard, Verneuil Churchyard, Cerny-en-Laonnois Churchyard, Les Paridis German Cemetery, Chivy and at the German cemeteries at Cerny-en-Laonnois, Chivy and Chamouille, whose graves were destroyed during battles fought in the region later in the war. (Author)

Vendresse British Cemetery Memorial to 28 soldiers buried in Troyon Churchyard whose graves were destroyed during the war. (Author)

HEARTS THAT HAVE LOVED HIM
CAN NEVER FORGET

Captain R.J. McCloughin, 1st Bedfordshire Regiment, was killed on 14 September and rests here. His epitaph reads:

MENTIONED IN DISPATCHES
FOR GALLANT
& DISTINGUISHED CONDUCT
HE LAID DOWN HIS LIFE
FOR HIS COMRADES
GREATER LOVE HATH NO MAN

Captain Martin Carr, 2nd Worcestershire Regiment, was killed on 18 September aged 37. He rests in this cemetery and his epitaph reads:

THEY SOUGHT
THEIR COUNTRY'S GOOD
THEY FOUND
THE PRESENCE OF GOD

Lieutenant Mervyn Johnson, 1st South Wales Borderers, rests within this cemetery. His epitaph reads:

FOR THIS ENGLAND
THE BELOVED ONES DIED

Captain Cecil Ker, 1st Bedfordshire Regiment, was killed on 15 September. His epitaph reads:

MY BELOVED HUSBAND
'O TRUE BRAVE HEART'
GOD BLESS THEE
WHERESOE'ER IN HIS GREAT
UNIVERSE THOU ART TODAY

VENDRESSE CHURCHYARD
A plot of British Commonwealth War graves is located within Vendresse Churchyard. Surrounded by a hedge, the plot is at the rear of the churchyard. Eighty men are commemorated, of which half are unidentified and special memorials have been dedicated to 35 soldiers known to be buried here. Captain Riversdale Grenfell

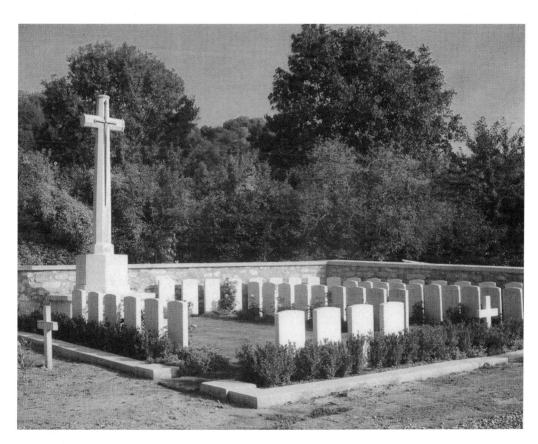

Vendresse Churchyard. (Author)

is buried within this churchyard. He was killed on 14 September 1914, while serving with the 9th (Queen's Royal) Lancers. His epitaph reads:

TWIN BROTHER TO
CAPTAIN FRANCIS GRENFALL VC
KILLED AT HOOGE 1915
LOYAL DEVOIR

Below: Moulin New Communal Cemetery. (Author)

MOULIN NEW COMMUNAL CEMETERY

10 British soldiers are buried here. Five memorials commemorate lost graves, which cannot be located. Lieutenant-Colonel Adrian Grant Duff, commanding officer of the 1st Black Watch, rests in this cemetery as well as Lucas-Tooth. Lieutenant R. Simson, Royal Field Artillery, is buried here too. His epitaph reads:

I THANK MY GOD
UPON EVERY REMEMBRANCE
OF YOU

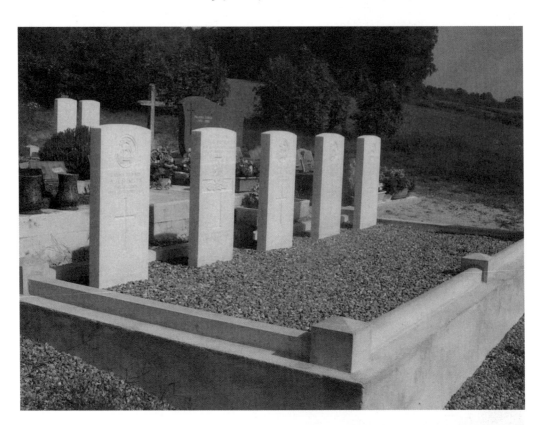

PAISSY CHURCHYARD

Five soldiers who fell during the Battle of the Aisne in September 1914 are buried within Paissy Churchyard, including Captain Augustus Cathcart of the 2nd King's Royal Rifle Corps and Lieutenant-Colonel Dawson Warren, commanding officer of the 1st Queen's Royal West Surrey Regiment, killed by a sniper on 17 September 1914.

Paissy Churchyard. (Author)

SOUPIR CHURCHYARD

Soupir Church stood next to Soupir Chateau, which was used as a dressing station by the BEF during the Battle of the Aisne. 30 British soldiers were buried in Soupir Churchyard. Soupir Chateau was destroyed during the war.

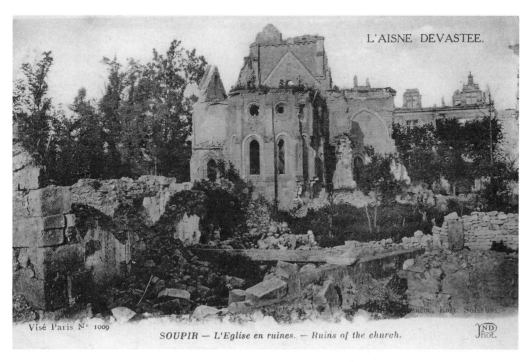

L'AISNE DEVASTEE.

Visé Paris N° 1009 SOUPIR — L'Eglise en ruines. — Ruins of the church.

Above: The ruins of Soupir Church, 1918. (Author)

Left: Soupir Church. (Courtesy Yves Fohlen)

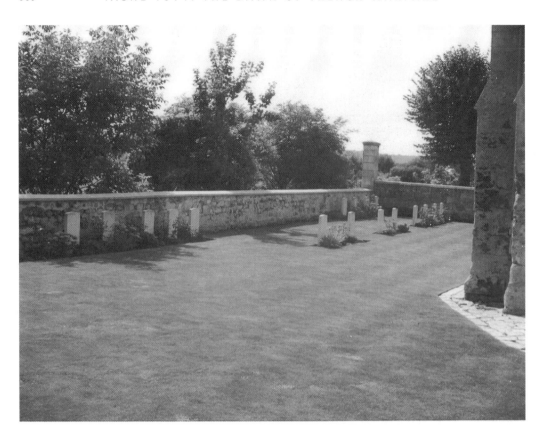

Soupir Churchyard Cemetery. (Author)

SOUPIR COMMUNAL CEMETERY

Dressing stations were established at La Cour de Soupir Farm as well as Soupir Chateau when the village at Soupir was captured by the Guards Brigade on 14 September 1914. German forces regained control of the village during the period 2–6 November. The 16 British soldiers that lie in this cemetery were killed September–October 1914 and were originally buried in a position north west of the village of Vailly. After the Armistice they were brought to Soupir Communal Cemetery for burial. Lord Guernsey and Lord Hay lie together in adjacent graves. Captain the Honourable W.A. Cecil MC is buried here. His epitaph reads: 'One Heart One Way'.

Lieutenant George Brooke, Irish Guards, killed on 7 October 1914, lies in this cemetery. His epitaph (Isaiah 26:11) reads:

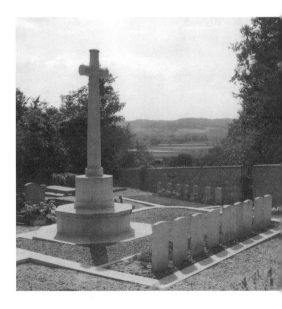

THOU SHALT KEEP HIM
IN PERFECT PEACE
WHOSE MIND
IS STAYED ON THEE

Soupir Communal Cemetery. (Author)

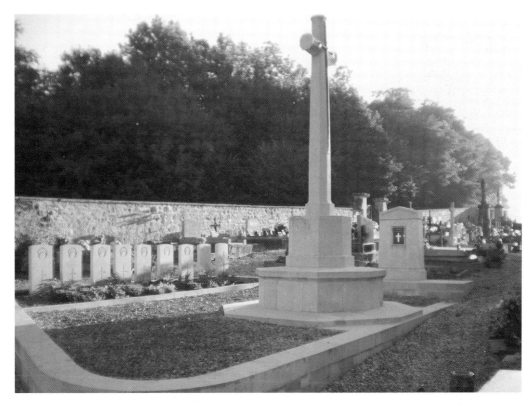

Soupir Communal Cemetery. (Courtesy Yves Fohlen)

CROUY VAUXROT FRENCH NATIONAL CEMETERY

All the 50 Commonwealth soldiers in this cemetery were killed in September and October 1914. 25 of those men, mainly from the 2nd Seaforth Highlanders, were initially buried at Bucy-le-Long Cemetery south east of La Montagne Farm, but were transferred to Crouy Vauxrot French National Cemetery after the war. Lieutenant-Colonel Sir Evelyn Bradford, commanding officer of the 2nd Seaforth Highlanders, lies here. Private D. Walker, also from the 2nd Seaforth Highlanders, is buried in this cemetery. His epitaph reads:

> OH FOR THE TOUCH
> OF A VANISHED HAND
> AND THE SOUND OF A VOICE
> THAT IS STILL

Crouy Vauxrot French National Cemetery.
(Courtesy Yves Fohlen)

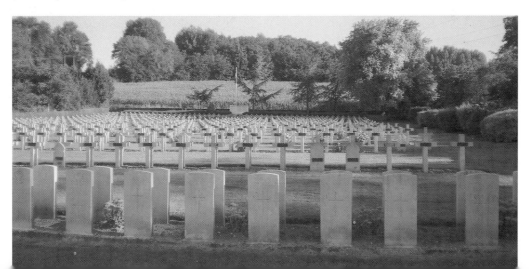

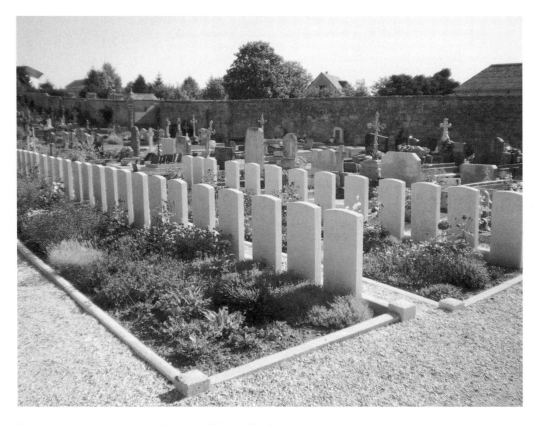

Braine Communal Cemetery. (Courtesy Yves Fohlen)

BRAINE COMMUNAL CEMETERY

Braine Communal Cemetery commemorates 78 British soldiers who were killed in September and October 1914. 68 of those casualties have special memorials because the locations of their graves within the cemetery are not known.

BOURG–ET–COMIN COMMUNAL CEMETERY

Eleven British soldiers are buried here. Amongst those are casualties from the disaster on 25 September 1914 when the cave roof collapsed on 1st Cameron Highlanders' Battalion headquarters after a shell explosion.

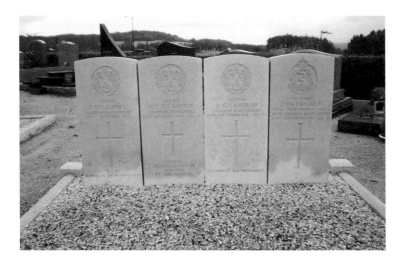

**Bourg-et-Comin
Cemetery. (Yves Fohlen)**

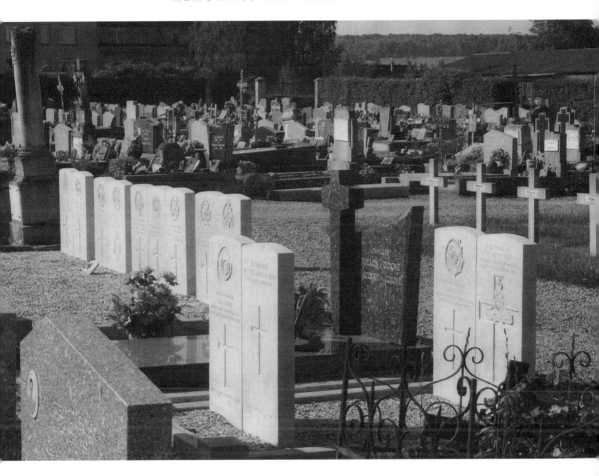

Fere-en-Tardenois Communal Cemetery. (Courtesy Kelly Howie)

FERE-EN-TARDENOIS COMMUNAL CEMETERY

Thirteen British soldiers killed at the Battle of the Aisne are buried here. They include Driver Thomas Coffin 11th Field Company Royal Engineers, killed on 15 September 1914 and Private W. Bosworth, 1st Northamptonshire Regiment, who died on 24 September 1914.

VISITING THE CHEMIN DES DAMES

The Chemin des Dames is beautiful, but despite its tranquility, as mentioned earlier, the region has seen much bloodshed even before September 1914. Julius Caesar, Napoleon and Kaiser Wilhelm II gave battle on the Chemin des Dames. Julius Caesar defeated the Gauls and in March 1814 Napoleon inflicted a defeat upon Blücher's army there, after the retreat from Moscow.

Anyone visiting the region should visit the Caverne du Dragon Museum. To walk in the underground caves and to see where opposing armies fought underground is an unforgettable experience. The museum is located a mile east of Cerny on the Chemin des Dames. As it is only a tour-guided visit it is better to telephone to reserve your visit. Telephone: 0323251418 or email: caverne@cg.02.fr.

NOTES

1. *Sussex Daily News*, 20 October 1914
2. Putowski, Julian and Julian Sykes, *Shot at Dawn* (Wharncliffe Publishing, 1989)

BRITISH EXPEDITIONARY FORCE ORDER OF BATTLE

Commander-in-Chief Field Marshal Sir John French

CAVALRY DIVISION (MAJOR-GENERAL EDMUND ALLENBY)

1st Cavalry Brigade (Brigadier-General C. Briggs)
2nd Dragoon Guards (Queen's Bays)
5th (Princess Charlotte of Wales's) Dragoon Guards
11th (Prince Albert's Own) Hussars
1st Signal Troop

2nd Cavalry Brigade (Brigadier-General H. de Lisle)
4th (Royal Irish) Dragoon Guards
9th (Queen's Royal) Lancers
18th (Queen Mary's Own) Hussars
2nd Signal Troop

4th Cavalry Brigade (Brigadier-General Hon. C. Bingham)
Composite Regiment of Household Cavalry
6th Dragoon Guards (Carabiniers)
3rd (King's Own) Hussars
4th Signal Troop

Divisional Artillery (Drake)
7th Brigade Royal Horse Artillery (Birch)
I Battery
32nd Brigade Royal Field Artillery (detached from
 4th Division)
Divisional Engineers
1 Field Squadron Royal Engineers

2nd Cavalry Division (Gough)
From 6 September, the 3rd and 5th Cavalry Brigades operated together under Brigadier-General Hubert Gough. On 16 September this force was amalgamated to create the 2nd Cavalry Division.

3rd Cavalry Brigade (Vaughan)
4th (Queen's Own) Hussars
5th (Royal Irish) Lancers

16th (The Queen's) Lancers
3rd Signal Troop

5th Cavalry Brigade (Brigadier-General Sir P. Chetwode)
2nd Dragoons (Royal Scots Greys)
12th (Prince of Wales's Royal) Lancers
20th Hussars

3rd Brigade Royal Horse Artillery (Breeks)
'D' and 'E' Batteries

'J' Battery Royal Horse Artillery
4th Field Troop Royal Engineers

I CORPS (HAIG)

Brigadier General Royal Artillery (Horne)

1ST DIVISION (MAJOR-GENERAL S. LOMAX)

1st Guards Brigade (Brigadier-General Frederick Ivor Maxse)
1st Coldstream Guards
1st Scots Guards
1st Black Watch (The Royal Highlanders)
1st Queen's Own Cameron Highlanders

2nd Infantry Brigade (Brigadier-General E. Bulfin)
2nd The Royal Sussex Regiment
1st The Loyal North Lancashire Regiment
1st The Northamptonshire Regiment
2nd The King's Royal Rifle Corps

3rd Infantry Brigade (Brigadier-General Herman Landon)
1st The Queen's (Royal West Surrey Regiment)
1st The South Wales Borderers
1st The Gloucestershire Regiment
2nd The Welsh Regiment
'A' Squadron 15th (The King's) Hussars

DIVISIONAL ARTILLERY

25th Brigade Royal Field Artillery
113th, 114th, 115th Batteries

26th Brigade Royal Field Artillery
116th, 117th, 118th Batteries

39th Brigade Royal Field Artillery
46th, 51st, 54th howitzer Batteries

26th Heavy Battery Royal Garrison Artillery

Divisional Engineers (Schreiber)
23rd, 26th Field Companies Royal Engineers

2ND DIVISION (MAJOR-GENERAL C. MONRO)
4th (Guards) Brigade (Brigadier-General R. Scott-Kerr)
2nd Grenadier Guards
2nd Coldstream Guards
3rd Coldstream Guards
1st Irish Guards

5th Infantry Brigade (Brigadier-General R. Haking)
2nd The Worcestershire Regiment
2nd The Oxford & Buckinghamshire Light Infantry
2nd The Highland Light Infantry
2nd The Connaught Rangers

6th Infantry Brigade (Brigadier-General R. Davies, New Zealand Staff Corps)
1st the King's (Liverpool Regiment)
2nd The South Staffordshire Regiment
1st Princess Charlotte of Wales (Royal Berkshire Regiment)
1st The King's Royal Rifle Corps

'B' Squadron 15th (The King's) Hussars
Divisional Artillery (Perceval)

34th Brigade Royal Field Artillery
22nd, 50th, 70th Batteries

36th Brigade Royal Field Artillery
15th, 48th, 71st Batteries

41st Brigade Royal Field Artillery
9th, 16th, 17th Batteries

44th (Howitzer) Batteries
47th, 56th, 60th (Howitzer) Batteries

35th Heavy Batteries Royal Garrison Artillery
Divisional Engineers (Boys)
5th, 11th Field Companies Royal Engineers

II CORPS (GENERAL SIR H. SMITH-DORRIEN)

Brigadier-General Royal Artillery (Brigadier-General A. Short)

3RD DIVISION (MAJOR-GENERAL HUBERT HAMILTON)

7th Infantry Brigade (Brigadier-General F. McCracken)
3rd The Worcestershire Regiment
2nd The Prince of Wales's Volunteers (South Lancashire Regiment)
1st The Duke of Edinburgh's (Wiltshire Regiment)
2nd The Royal Irish Rifles

8th Infantry Brigade (Brigadier-General B. Doran)
2nd The Royal Scots (Lothian Regiment)
2nd The Royal Irish Regiment
4th The Duke of Cambridge's Own (Middlesex Regiment)
1st The Gordon Highlanders

9th Infantry Brigade (Brigadier-General F. Shaw)
1st Northumberland Fusiliers
4th The Royal Fusiliers (City of London Regiment)
1st The Lincolnshire Regiment
1st The Royal Scots Fusiliers

'C' Squadron 15th (The King's) Hussars

DIVISIONAL ARTILLERY (WING)

23rd Brigade Royal Field Artillery
107th, 108th, 109th Batteries

40th Brigade Royal Field Artillery
6th, 23rd, 49th Batteries

42nd Brigade Royal Field Artillery
29th, 41st, 45th Batteries

30th (Howitzer) Brigade
128th, 129th, 130th (Howitzer) Batteries

48th Heavy Battery Royal Garrison Artillery

Divisional Engineers (Wilson)
56th, 57th Field Companies Royal Engineers

5TH DIVISION (MAJOR-GENERAL SIR C. FERGUSSON)

13th Infantry Brigade (Brigadier-General G. Cuthbert)
2nd The King's Own Scottish Borderers
2nd The Duke of Wellington's (West Riding Regiment)
1st The Queen's Own (Royal West Kent Regiment)
2nd The Kings Own (Yorkshire Light Infantry)

14th Infantry Brigade (Brigadier-General Stuart Rolt)
2nd The Suffolk Regiment
1st The East Surrey Regiment
1st The Duke of Cornwall's Light Infantry
2nd The Manchester Regiment

15th Infantry Brigade (Brigadier-General A. Count Gleichen)
1st The Norfolk Regiment
1st The Bedfordshire Regiment
1st The Cheshire Regiment
1st The Dorsetshire Regiment

'A' Squadron 19th (Queen Alexandra's Own Royal) Hussars

DIVISIONAL ARTILLERY (HEADLAM)

15th Brigade Royal Field Artillery
11th, 52nd, 80th Batteries

27th Brigade Royal Field Artillery
119th, 120th, 121st Batteries

28th Brigade Royal Field Artillery
122nd, 123rd, 124th Batteries

8th (Howitzer) Brigade Royal Field Artillery
37th, 61st, 65th (Howitzer) Batteries

108th Heavy Battery Royal Garrison Artillery

Divisional Engineers (Tulloch)
17th, 59th Field Companies Royal Engineers

III CORPS (MAJOR-GENERAL W. PULTENEY)

Brigadier General Royal Artillery (Phipps-Hornby)

4TH DIVISION (BRIGADIER-GENERAL H. WILSON)

10th Infantry Brigade (Brigadier-General J. Haldane)
1st The Royal Warwickshire Regiment
2nd Seaforth Highlanders (Ross-shire Buffs, The Duke of Albany's)
1st Princess Victoria's (Royal Irish Fusiliers)
2nd The Royal Dublin Fusiliers

11th Infantry Brigade (Brigadier-General A. Hunter-Weston)
1st Prince Albert's (Somerset Light Infantry)
1st The East Lancashire Regiment
1st The Hampshire Regiment
1st The Rifle Brigade

12th Infantry Brigade (Brigadier-General Henry Wilson)
(Wilson took command of the 4th Division when Major-General Snow was injured on 9 September)
1st King's Own (Royal Lancaster Regiment)
2nd Lancashire Fusiliers
2nd The Royal Inniskilling Fusiliers
2nd The Essex Regiment

'B' SQUADRON 19TH (QUEEN ALEXANDRA'S OWN) HUSSARS

Divisional Artillery (Milne)
14th Brigade Royal Field Artillery
39th, 68th, 88th Batteries

29th Brigade Royal Field Artillery
125th, 126th, 127th Batteries

32nd Brigade Royal Field Artillery
(On 12 September the 32nd Brigade Royal Field Artillery came under the orders of the Cavalry Division)
27th, 134th, 135th Batteries

37th (Howitzer) Brigade Royal Field Artillery
31st, 35th, 55th (Howitzer) Batteries

31st Heavy Battery Royal Garrison Artillery

Divisional Engineers (Jones)
7th, 9th Field Companies Royal Engineers

GERMAN IMPERIAL ARMY ORDER OF BATTLE

VII RESERVE CORPS (GENERAL VON ZWEHL)

27th Reserve Brigade, 14th Reserve Division
16th Reserve Infantry Regiment and 53rd Reserve
 Infantry Regiment
14th Reserve Field Artillery Regiment

25th Reserve Brigade, 13th Reserve Division
13th Reserve Infantry Regiment and 56th Reserve
 Infantry Regiment
28th Reserve Brigade, 13th Reserve Division
39th Reserve Infantry Regiment and 57th Reserve
 Infantry Regiment

6TH INFANTRY DIVISION

11th Infantry Brigade
20th Infantry Regiment and 35th Fusiliers

12th Infantry Brigade
24th Infantry Regiment and 64th Infantry Regiment
 Artillery
3 Field Artillery Regiment, 39th Field Artillery Regiment
 and 3rd Regiment Hussars

APPENDIX 3

BEF SOLDIERS LISTED ON LA FERTE-SOUS-JOUARRE MEMORIAL

The following lists the soldiers with no known graves who were killed on the Aisne on 14 September 1914.

NAME	RANK	NUMBER	REGIMENT	AGE
Ables, Percy	Private	9205	1 Northumberland Fusiliers	U
Adams, Lee	Private	10804	2 Welsh Regiment	24
Ager, Albert	Private	10814	2 Welsh Regiment	19
Ahern, Patrick	Private	2255	1 Black Watch	U
Ainger, George	Private	7298	1 Lincolnshire Regiment	27
Aitchison, Albert	Private	8077	1 Duke of Cornwall's Light Infantry	U
Akast, Walter	Private	9427	2 Worcestershire Regiment	22
Alexander, William	Private	292	1 Northumberland Fusiliers	28
Allen, Arthur	Sergeant	6773	1 East Surrey Regiment	U
Allen, Henry	Driver	18745	22 Battery, Royal Field Artillery	35
Allen, Walter	Private	9909	1 Duke of Cornwall's Light Infantry	U
Allen, William	Private	9899	2 Welsh Regiment	U
Allum, Frank	Private	L/12724	4 Royal Fusiliers	24
Anderson, George	Corporal	8970	1 Cameron Highlanders	U
Anderson, Hepburn	Private	7851	1 Scots Guards	32
Anderson, Thomas	Private	1021	1 Northumberland Fusiliers	28
Andrews, Sydney	Lance Corporal	L/8504	1 Queen's (Royal West Surrey) Regiment	28
Angell, Thomas	Private	L/8136	4 Royal Fusiliers	27
Angus, Thomas	Private	6871	1 Scots Guards	27
Annetts, Frank	Private	7726	1 Gloucestershire Regiment	U
Ansell, William	Private	7482	3 Coldstream Guards	U
Appleton, George	Corporal	1972	2 Manchester Regiment	20
Arkell, Herbert	Private	9048	2 Worcestershire Regiment	27
Armstead, Thomas	Private	7305	1 Cameron Highlanders	32
Ashwell, Frederick	Lance Serjeant	9323	2 King's Royal Rifle Corps	26
Astell, Edmund	Private	6562	1 Loyal North Lancashire Regiment	30
Astle, William	Private	15196	2 Grenadier Guards	U
Attwood, Algernon	Captain	–	4 Royal Fusiliers	34
Babington, Ernest	Private	9501	2 Lancashire Fusiliers	39
Bain, Robert*	Private	13339	2 Grenadier Guards	U
Baker, George	Corporal	L/9387	2 Royal Sussex Regiment	U
Baker, James	Private	L/7551	2 Royal Sussex Regiment	31
Baker, Robert	Private	7744	2 King's Royal Rifle Corps	U
Baker, William	Private	L/10174	2 Royal Sussex Regiment	U
Balch, Albert	Private	10063	1 Loyal North Lancashire Regiment	U
Baldwin, Henry	Private	L/6074	2 Royal Sussex Regiment	38
Ballard, Frank	Private	L/8245	2 Royal Sussex Regiment	28

NAME	RANK	NUMBER	REGIMENT	AGE
Bancalri, William	Private	6744	1 Norfolk Regiment	U
Banks, Charles	Rifleman	10627	1 King's Royal Rifle Corps	U
Bannerman, Robert	Private	180	1 Black Watch (Royal Highlanders)	26
Bannister, Ernest	Rifleman	7623	2 King's Royal Rifle Corps	U
Barclay, R.H.M.	2nd Lieutenant	–	2 King's Royal Rifle Corps	22
Barks, Herbert	Private	7281	1 Coldstream Guards	U
Barnes, James	Private	8263	1 Duke of Cornwall's Light Infantry	27
Bartholomew, George	Private	9001	1 Gloucestershire Regiment	21
Bartlett, Sidney	Private	7594	1 Royal Berkshire Regiment	30
Bartley, Edward	Private	L/11596	4 Royal Fusiliers	26
Barton, William	Corporal	6428	2 Essex Regiment	33
Bartram, Ernest	Private	12799	2 Grenadier Guards	U
Bates, James	Private	7981	1 Gloucestershire Regiment	U
Baynes, Alfred	Private	47891	1 Queen's (Royal West Surrey) Regiment	26
Beckett, Arthur	Serjeant	7651	1 Lincolnshire Regiment	25
Bedingham, Walter	Rifleman	4925	2 King's Royal Rifle Corps	30
Beedie, Robert	Rifleman	6435	2 King's Royal Rifle Corps	35
Bell, Percy	Private	8067	2 Manchester Regiment	29
Bennett, Christopher	Private	1959	1 Northumberland Fusiliers	U
Bennett, Henry	Private	5059	1 Cameron Highlanders	34
Benney, Frank	Private	4645	2 Welsh Regiment	U
Benson, Benjamin	Lance Corporal	L/10381	1 East Surrey Regiment	20
Benvie, William	Private	9232	1 Black Watch (Royal Highlanders)	U
Betts, Edward	Rifleman	4969	1 King's Royal Rifle Corps	U
Billingham, Richard	Private	9615	1 Northamptonshire Regiment	U
Bingham, David	Lieutenant	–	3 Coldstream Guards	27
Birch, Eric	Rifleman	8555	2 King's Royal Rifle Corps	24
Birch, Jacob	Rifleman	3140	2 King's Royal Rifle Corps	39
Bish, Charles	Private	8670	1 Northumberland Fusiliers	29
Bishop, James	Driver	57353	70 Bty, 34th Bdg, Royal Field Artillery	U
Black, Robert	Private	7600	1 Cameron Highlanders	26
Blackburn, Henry	Rifleman	4558	2 King's Royal Rifle Corps	U
Blake, Ernest	Private	9566	1 Lincolnshire Regiment	23
Blake, Maurice	Lieutenant	–	2 King's Royal Rifle Corps	U
Blunden, Allen	Private	6273	1 Duke of Cornwall's Light Infantry	34
Blythe, Reginald	Private	L/18100	4 Royal Fusiliers	21
Blythe, William	Private	6245	1 Coldstream Guards	27
Body, Grant	Captain	–	1 Loyal North Lancashire Regiment	U
Bolton, Albert	Private	7729	2 Worcestershire Regiment	U
Bolton, George	Corporal	4484	1 King's Royal Rifle Corps	25
Bond, Richard	Corporal	6069	1 Loyal North Lancashire Regiment	U
Bonser, Ernest	Private	10248	1 Coldstream Guards	U
Booth, Henry	Gunner	72973	70 Battery, Royal Field Artillery	U
Bowcott, Henry	Private	7680	2 Worcestershire Regiment	29
Bowers, John*	Private	15205	2 Grenadier Guards	23
Boyd, Charles	Lance Corporal	9376	1 Cameron Highlanders	19
Bradley, Nicholas	Private	11632	2 King's Own Scottish Borderers	U
Bradley, Thomas	Rifleman	7903	2 King's Rifle Corps	29
Bradley, John	Private	10511	1 Loyal North Lancashire Regiment	19
Bradshaw, James	Private	6627	1 Scots Guards	29
Brady, William	Private	7090	2 Connaught Rangers	32
Brawn, Henry	Serjeant	7570	1 Norfolk Regiment	23

NAME	RANK	NUMBER	REGIMENT	AGE
Brennan, James	Private	8240	2 Royal Irish Regiment	29
Brennen, Thomas	Private	9109	2 Lancashire Fusiliers	U
Bridle, Frederick	Private	5857	1 Dorsetshire Regiment	35
Briggs, Joseph	Sergeant	11772	2 Grenadier Guards	U
Brighton, Alfred	Private	6606	1 Norfolk Regiment	U
Brinton, Thomas	Rifleman	5662	2 King's Royal Rifle Corps	29
Brittain, Leonard	Lance Corporal	8796	1 Norfolk Regiment	19
Broadley, James	Lance Corporal	967	1 Northumberland Fusiliers	32
Brotchie, Henry	Rifleman	11050	1 King's Royal Rifle Corps	21
Brown, Albert	Private	5011	1 Coldstream Guards	U
Brown, Arthur	Private	10609	1 Loyal North Lancashire Regiment	U
Brown, George	Private	8706	2 King's Own Scottish Borderers	U
Brown, James	Private	493	1 Northumberland Fusiliers	27
Brown, John	Private	2913	1 Irish Guards	U
Brown, Percy	Rifleman	11146	1 King's Royal Corps	U
Brown, William	Private	11339	2 Grenadier Guards	29
Bryant, Henry	Private	16186	2 Coldstream Guards	U
Buchanan, William	Private	L/10357	1 Queen's (Royal West Surrey) Regiment	U
Buchanan, George	Lance Corporal	7211	2 King's Royal Rifle Corps	23
Bullock, Daniel	Private	5733	1 Cameron Highlanders	U
Bullock, George	Lance Corporal	8685	1 Loyal North Lancashire Regiment	U
Burgess, Charles	Corporal	7205	2 Royal Irish Regiment	U
Burke, Andrew	Private	9609	1 Cameron Highlanders	U
Burke, Michael	Private	10312	2 Connaught Rangers	19
Burke, John	Sergeant	4138	2 King's Royal Rifle Corps	32
Burns, Bertie	Private	L/11651	4 Royal Fusiliers	24
Burr, Stanley	Corporal	15387	2 Grenadier Guards	22
Burrell, Thomas	Private	5916	2 King's Own Scottish Borderers	U
Burstow, Frederick	Private	1388	2 Lancashire Fusiliers	U
Butfoy, Thomas	Sergeant	L/6778	2 Royal Sussex Regiment	U
Butler, Robert	Lance Corporal	9529	1 Northamptonshire Regiment	U
Byng, Arthur	Captain	–	4 Royal Fusiliers	42
Caines, William	Rifleman	11379	2 King's Royal Rifle Corps	U
Cairns, Thomas	Private	9529	1 Cameron Highlanders	U
Cale, Thomas	Private	7955	1 Lincolnshire Regiment	27
Calver, James	Private	10255	1 Coldstream Guards	U
Cameron, Peter	Private	9390	1 Cameron Highlanders	19
Cameron, Hector	2nd Lieutenant	–	1 Cameron Highlanders	U
Cameron, John	Rifleman	1980	2 King's Royal Rifle Corps	U
Camfield, Albert	Private	13200	2 Grenadier Guards	U
Campbell, Donald	Lance Corporal	4787	1 Cameron Highlanders	32
Campbell, Robert	Private	3970	1 Cameron Highlanders	U
Cannell, John	Private	7583	1 Duke of Cornwall's Light Infantry	U
Care, Thomas	Private	10538	3 Coldstream Guards	17
Carey, Richard	Private	7063	1 Loyal North Lancashire	U
Carle, William	Private	8811	1 Scots Guards	26
Carlisle, Herbert	Private	4106	1 Irish Guards	21
Carter, George	Private	8093	1 Royal Berkshire Regiment	23
Carver, John	Private	8514	1 Northumberland Fusiliers	U
Chamberlain, George	Private	6427	1 Northamptonshire Regiment	34
Chambers, Edward	Gunner	3049	108 Heavy Battery RGA	37
Chaplin, William	Private	3/7337	1 Norfolk Regiment	22

NAME	RANK	NUMBER	REGIMENT	AGE
Chapman, Walter	Private	7820	1 Loyal North Lancashire	U
Chard, Isaac	Private	6252	3 Coldstream Guards	30
Charlesworth, Alfred	Private	7033	1 Lincolnshire Regiment	33
Charnock, Joseph	Private	11434	2 King's Own Scottish Borderers	19
Chatfield, Albert	Private	L/6835	2 Royal Sussex Regiment	U
Cheetham, John	Private	9631	1 Lincolnshire Regiment	21
Cherry, George	Rifleman	10772	2 King's Royal Rifle Corps	22
Chesterton, Charles	CQS	1527	5 Field Company, RE	U
Chettle, Leonard	Private	238	2 Lancashire Fusiliers	U
Choate, Richard	Private	10332	3 Coldstream Guards	U
Clark, Henry	Drummer	14327	2 Grenadier Guards	21
Clarke, Alfred	Private	9205	1 Loyal North Lancashire	25
Clarke, Alfred	Sergeant	L/8090	2 Royal Sussex Regiment	28
Clarke, James	Private	6233	1 Lincolnshire Regiment	31
Clarke, John	Private	10474	1 Loyal North Lancashire	22
Clarke, Walter	Private	10618	2 KOYLI	U
Clayton, Leonard	Private	7257	1 Lincolnshire Regiment	29
Cleary, Robert	Lance Corporal	10923	2 Welsh Regiment	20
Cleaver, Sidney	Private	7963	1 Coldstream Guards	U
Clissold, David	Corporal	9519	2 Connaught Rangers	U
Clough, Wildon	Private	2238	1 Coldstream Guards	37
Clowes, James	Private	16398	2 Grenadier Guards	18
Cobb, Herbert	Lance Corporal	5447	1 Coldstream Guards	U
Cobbett, William	Lance Corporal	L/7747	1 QRWSR	U
Cobley, Charles	Private	8736	1 Norfolk Regiment	U
Cockburn, Mark	Private	5036	2 KOSB	U
Coe, William	Private	9025	1 Norfolk Regiment	19
Colbran, Samuel	Private	L/8876	2 Royal Sussex Regiment	U
Coldrick, William	Private	11093	2 Welsh Regiment	U
Cole, Mowbray	Captain	–	4 Royal Fusiliers	U
Coleman, Bertie	Private	9031	1 Norfolk Regiment	U
Collett, Arthur	Lance Corporal	7625	1 Cameron Highlanders	24
Collings, William	Private	6943	1 Norfolk Regiment	30
Collins, Frederick	Private	L/10648	4 Royal Fusiliers	U
Collins, Walter	Private	6934	1 Loyal North Lancashire	U
Collison, Frederick	Private	7054	1 Norfolk Regiment	U
Compton-Thornhill, Richard	Lieutenant	–	1 Scots Guards	22
Cook, William	Private	9809	1 Loyal North Lancashire	22
Cookson, Mostyn	Major		2 Royal Sussex Regiment	46
Cooper, George	Gunner	7679	2 Royal Field Artillery	17
Copping, Albert	Drummer	13660	2 Grenadier Guards	20
Copson, Charles	Private	6445	1 Lincolnshire Regiment	U
Corrigan, James	Private	6929	1 Cameron Highlanders	U
Cossar, William	Private	6950	1 Cameron Highlanders	U
Cottam, Samuel	Private	6024	1 Loyal North Lancashire	35
Cotton, Walter	Rifleman	11233	2 King's Royal Rifle Corps	23
Court, George	Private	12563	2 Grenadier Guards	27
Cox, Alfred	Lance Corporal	L/8437	2 Royal Sussex	30
Cox, Charles	Lance Corporal	9406	2 Ox & Bucks	U
Coyle, George	Private	454	1 Black Watch	31
Craig, David	Lance Sergeant	1706	1 Black Watch	23
Crawford, Alexander	Private	7049	1 Cameron Highlanders	29

NAME	RANK	NUMBER	REGIMENT	AGE
Crisp, Augustus	Private	7193	1 Coldstream Guards	U
Crocker, Otto	Private	8088	1 East Surrey Regiment	30
Crowe, Edward	Private	6697	1 Norfolk Regiment	27
Cumming, Donald	Private	6933	1 Cameron Highlanders	31
Cumming, Lewis	Lieutenant	–	1 Black Watch	21
Currant, James	Private	7273	1 Northamptonshire Regiment	U
Curtis, Alfred	Private	9567	1 Lincolnshire Regiment	19
Cuttler, Thomas	Private	5846	1 East Surrey Regiment	U
Dade, William	Private	10600	3 Coldstream Guards	19
Dale, David	Private	8688	2 Worcestershire Regiment	U
Dales, Charles	Private	8400	1 Lincolnshire Regiment	24
Daziel, James	Private	9512	1 Cameron Highlanders	U
Darvill, Charles	Corporal	9457	1 Loyal North Lancashire	24
Darwin, Joseph	Sergeant	6432	1 Lincolnshire Regiment	29
Duan, Edward	Lieutenant	–	2 Royal Sussex Regiment	29
Davidson, John	Private	5132	2 KOSB	23
Davies, John	Private	7859	1 Loyal North Lancashire	32
Davies, Idris	Rifleman	7096	1 King's Royal Rifle Corps	27
Davies, Edward	Driver	25572	5 Signal Troop, Royal Engineers	U
Davies, Joseph	Rifleman	4288	2 King's Royal Rifle Corps	U
Dawson, Herbert	Captain	–	1 Lincolnshire Regiment	33
Daysh, Frederick	Private	8989	1 Coldstream Guards	21
Deacon, William	Private	8903	1 Coldstream Guards	U
Dean, Thomas	Private	7222	1 Coldstream Guards	26
Dedman, Alfred	Private	L/4744	2 Royal Sussex Regiment	43
Denyer, Robert	Private	7665	1 Coldstream Guards	U
Denyer, Herbert	Rifleman	7900	2 King's Royal Rifle Corps	25
Devanney, Peter	Private	8417	2 KOSB	U
Devine, John	Private	7179	1 Cameron Highlanders	U
Dewar, Donald	Private	6244	1 Cameron Highlanders	U
Dickins, Charles	Lance Corporal	L/7533	4 Royal Fusiliers	34
Dickson, John	Lieutenant	–	1 Cameron Highlanders	U
Ding, John	Private	7447	1 Northamptonshire Regiment	U
Dixon, George	Private	10533	2 Connaught Rangers	U
Donovan, William	Lance Corporal	8885	2 Manchester Regiment	U
Douglas, George	Private	6770	1 Cameron Highlanders	U
Doull, Peter	Private	6851	1 Cameron Highlanders	25
Dovey, Harry	Private	10355	1 Coldstream Guard	U
Draper, Joseph	Lance Corporal	5353	3 Coldstream Guards	U
Durie, Patrick	Private	6904	1 Cameron Highlanders	U
Dutton, William	Rifleman	4982	1 King's Royal Rifle Corps	U
Dwyer, Frederick	Private	7030	1 Loyal North Lancashire	U
Dykes, Thomas	Private	7827	1 South Wales Borderers	U
Earles, Charles	Private	201	1 Northumberland Fusiliers	31
Easton, James	Private	16425	2 Grenadier Guards	U
Eaton, Henry	Rifleman	7707	2 King's Royal Rifle Corps	U
Edwards, John	Private	1017	1 Northumberland Fusiliers	31
Edwards, John	Private	9386	2 Oxford & Bucks	U
Edwards, James	Sergeant	8276	2 Welsh Regiment	29
Edwards, Henry	Private	L/7672	2 Royal Sussex Regiment	28
Egan, Patrick	Private	8358	2 Connaught Rangers	30
Eggenton, William	Private	16399	2 Grenadier Guards	U

NAME	RANK	NUMBER	REGIMENT	AGE
Eldridge, James	Private	9748	1 Northamptonshire Regiment	U
Elliott, George	Rifleman	5473	2 King's Royal Rifle Corps	U
Elliott, Arthur	Private	L/10580	1 QRWSR	24
Ellison, James	Private	5971	1 Loyal North Lancashire	U
Elston, William	Lance Corporal	9623	1 East Surrey Regiment	U
Elton, Andrew	Private	10469	3 Coldstream Guards	U
Emmerson, George	Lance Corporal	8581	1 Norfolk Regiment	U
English, Richard	Private	8477	1 DOCLI	U
Evans, Edwin	Lance Corporal	L/8229	1 QRWSR	27
Farmer, Arthur	Sergeant	8235	1 East Surrey Regiment	29
Farrow, Alfred	Private	7107	1 Norfolk Regiment	U
Fazackerley, Arthur	Private	10577	1 Loyal North Lancashire	25
Feakes, William	Private	6654	1 Norfolk Regiment	U
Felton, John	Private	7720	1 Loyal North Lancashire	31
Ferguson, George	Private	6679	1 Cameron Highlanders	U
Ferguson, William	Private	6767	1 Cameron Highlanders	33
Fergusson, James	Private	L/7646	1 QRWSR	U
Finnie, William	Private	8705	1 Cameron Highlanders	U
Finnigan, John	Private	8393	2 Royal Scots	U
Firman, James	Private	6590	1 Norfolk Regiment	U
Firth, John	Private	8117	2 Worcestershire Regiment	U
Fisher, David	Private	9443	1 Cameron Highlanders	19
Fisher, Edward	Private	11635	2 Grenadier Guards	28
Fitzgerald, Charles	Rifleman	7381	2 King's Royal Rifle Corps	26
Fitzpatrick, Gabriel	Captain	–	2 Welsh Regiment	29
Fleming, Cecil	Private	10502	1 Loyal North Lancashire	U
Flynn, Thomas	Private	4179	1 Irish Guards	U
Foljambe, Hubert	Major	–	2 King's Royal Rifle Corps	42
Folkard, Albert	Private	4281	2 Welsh Regiment	U
Ford, William	Private	6776	1 Cameron Highlanders	U
Forde, Henry	Private	3465	2 Connaught Rangers	U
Forfar, James	Private	6380	1 Cameron Highlanders	31
Forster, John	2nd Lieutenant	–	2 King's Royal Rifle Corps	21
Francis, Sidney	Private	L/13687	4 Royal Fusiliers	23
Freeman-Thomas, The Hon	2nd Lieutenant		1 Coldstream Guards	21
French, William	Private	9286	1 Loyal North Lancashire	23
Fricker, Alfred	Private	6463	1 Coldstream Guards	29
Fudge, Andrew	Private	L/10111	4 Royal Fusiliers	29
Fulcher, Edward	Private	8910	1 Coldstream Guards	U
Fullarton, John	Private	9137	2 KOSB	28
Fuller, Leslie	Private	L/9878	1 QRWSR	19
Funnell, Ernest	Private	L/8240	2 Royal Sussex Regiment	28
Furness, Ben	Gunner	67629	56th Battery, RFA	U
Gammon, Austin	Private	13358	2 Worcestershire Regiment	U
Garrard, Alan	Lance Corporal	L/7194	1 QRWSR	U
Garth, Jacob	Private	646	2 Lancashire Fusiliers	26
Geddes, George	Lance Sergeant	7894	1 Cameron Highlanders	27
Gibson, Archibald	Private	7088	1 Cameron Highlanders	27
Gibson-Craig, Archibald	Lieutenant	–	2 Highland Light Infantry	31
Gidge, Arthur	Private	10367	1 Coldstream Guards	20
Gilhooly, James	Private	7825	1 Cameron Highlanders	25
Gilmore, James	Private	15278	2 Grenadier Guards	21

NAME	RANK	NUMBER	REGIMENT	AGE
Glover, Horace	Gunner	50355	49th Battery, RFA	25
Godfrey, Ernest	Private	L/8549	1 QRWSR	U
Goldie, George	Lieutenant	–	1 Loyal North Lancashire	U
Goldstone, Charles	Private	10661	1 South Wales Borderers	U
Goodall, William	Rifleman	5392	2 King's Royal Rifle Corps	U
Goodall, Richard	Bombardier	71916	70 Battery, RFA	19
Goosey, Alfred	Private	7165	1 Northamptonshire Regiment	32
Goudie, Pane	Private	9228	1 Cameron Highlanders	U
Goulden, James	Rifleman	5021	2 King's Royal Rifle Corps	32
Grainger, Charles	Private	9038	1 Loyal North Lancashire	U
Grant, William	Private	7115	1 Cameron Highlanders	26
Gray, Oliver	Private	9790	2 Worcestershire Regiment	U
Greatorex, John	Private	7021	1 Lincolnshire Regiment	31
Green, James	Private	8356	2 KOSB	29
Green, Richard	Private	12758	2 Grenadier Guards	U
Green, Walter	Private	9452	1 Lincolnshire Regiment	U
Greenfield, Fred	Private	6100	1 Scots Guards	U
Greenfield, Albert	Private	L/10124	2 Royal Scots Guards	18
Grice, Harry	Private	5785	1 Coldstream Guards	U
Griffin, William	Private	L/12809	4 Royal Fusiliers	U
Griffiths, Walter	Rifleman	2054	2 King's Royal Rifle Corps	32
Griggs, William	Private	7409	1 Northamptonshire Regiment	U
Guiver, William	Lance Corporal	10400	2 King's Royal Rifle Corps	20
Guymer, Henry	Private	11099	2 Grenadier Guards	28
Hackett, Alfred	Private	7969	1 Loyal North Lancashire	U
Hall, William	Private	5076	1 Scots Guards	28
Hallett, Walter	Sergeant	4872	1 Coldstream Guards	U
Hamilton, John	Private	5936	1 Scots Guards	U
Hammer, Edward	Rifleman	4361	1 King's Royal Rifle Corps	28
Hampton, Thomas	Private	5645	1 Scots Guards	U
Hancox, William	Lance Corporal	5595	1 Scots Guards	U
Handley, Harry	Private	10615	1 Loyal North Lancashire	U
Handy, William	Private	8735	1 Norfolk Regiment	20
Hannan, James	Lance Corporal	4495	1 Irish Guards	20
Hardman, Jonathan	Lance Corporal	10398	1 Loyal North Lancashire	18
Hardy, John	Rifleman	6262	2 King's Royal Rifle Corps	29
Harper, Charles	Drummer	L/14316	4 Royal Fusiliers	30
Harris, James	Private	16331	2 Grenadier Guards	U
Harrison, Edward	Private	10337	1 Loyal North Lancashire	U
Harvey, Charles	Private	9332	1 Loyal North Lancashire	29
Harvey, John	Private	7235	1 Cameron Highlanders	U
Hastings, Patrick	Private	7958	1 Scots Guards	U
Hatswell, Fred	Lance Corporal	10388	1 East Surrey Regiment	19
Hatton, Charles	Lance Corporal	7105	1 Northamptonshire Regiment	26
Haw, John	Private	7947	1 Lincolnshire Regiment	U
Hawkes, Gordon	Rifleman	7500	1 King's Royal Rifle Corps	U
Hawkes, Thomas	Private	16334	2 Grenadier Guards	U
Hawkins, Herbert	Sergeant	6578	1 Cameron Highlanders	U
Hawkins, Joseph	Private	8926	2 Ox & Bucks	U
Hayes, William	Private	4716	1 Norfolk Regiment	U
Haylor, William	Private	L/9478	2 Royal Sussex Regiment	U
Hazleden, Frederick	Gunner	45273	25 Brigade, RFA	U

NAME	RANK	NUMBER	REGIMENT	AGE
Head, Frederick	Private	L/10418	1 QRWSR	U
Heagerty, Albert	Lance Corporal	9289	1 Lincolnshire Regiment	20
Heap, Frank	Rifleman	5647	1 King's Royal Rifle Corps	U
Helme, Harold	Captain	–	1 Loyal North Lancashire	36
Henderson, Samuel	Private	8641	2 Welsh Regiment	27
Hider, Henry	Corporal	L/9976	2 Royal Sussex Regiment	U
Higgins, William	Rifleman	7243	2 King's Royal Rifle Corps	25
Hill, George	Private	6473	1 Lincolnshire Regiment	31
Hill, James	Private	7692	1 Cameron Highlanders	27
Hill, Thomas	Private	10419	1 Loyal North Lancashire	U
Hill, William	Private	16708	2 Grenadier Guards	U
Hills, Benjamin	Private	L/10102	4 Royal Fusiliers	33
Hilton, Dennis	Private	L/7689	2 Royal Sussex Regiment	U
Hilton, William	Private	9521	2 Lancashire Fusiliers	30
Hinde, Joseph	Private	9008	1 Cameron Highlanders	21
Hobbs, Frank	2nd Lieutenant	–	4 Royal Fusiliers	19
Hocking, Clifton	Private	8011	1 Gloucestershire Regiment	U
Hodge, John	Private	L/8511	2 Royal Sussex Regiment	24
Hogg, Charles	Lance Corporal	10721	2 Welsh Regiment	U
Hogg, Thomas	Private	386	1 Black Watch	U
Holding, Frank	Lance Sergeant	9025	1 Coldstream Guards	23
Holland, Charles	Private	8399	1 Loyal North Lancashire	28
Hollis, Arthur	Acting Bombardier	72194	121 Battery, RFA	17
Home, William	Corporal	7465	1 Cameron Highlanders	U
Hook, Horace	Private	L/6501	1 QORWK	U
Hooper, James	Private	10242	1 DOCLI	U
Hopkins, William	Private	8032	2 Welsh Regiment	U
Hopper, Frederick	Private	8078	1 Coldstream Guards	U
Hopper, Jerry	Private	8020	1 Coldstream Guards	27
Horden, Samuel	Private	9435	1 Cameron Highlanders	20
Horn, Hugh	Private	6715	1 Cameron Highlanders	U
Horne, Alexander	Captain	–	1 Cameron Highlanders	38
Horner, Basil	Private	8819	1 Norfolk Regiment	20
Hoskins, Herbert	Act. Bombardier	73823	56 Battery, RFA	U
House, William	Private	7927	1 Gloucestershire Regiment	29
Howard, John	Private	8327	1 DOCLI	27
Howard, Henry	Rifleman	19118	2 King's Royal Rifle Corps	U
Howard-Vyse, Richard	Captain	–	1 Loyal North Lancashire	37
Howes, Albert	Driver	76366	36th Brigade, RFA	19
Hubbard, Ethlebert	Private	15235	2 Grenadier Guards	U
Hubert, Cyril	Rifleman	11301	1 King's Royal Rifle Corps	23
Hughes, Charles	Rifleman	10935	1 King's Royal Rifle Corps	U
Hughes, William	Lieutenant	–	2 Royal Sussex Regiment	24
Humphreys, David	Private	7013	1 Loyal North Lancashire	U
Hunt, Samuel	Rifleman	6244	2 King's Royal Rifle Corps	27
Hunter, Joseph	Private	9370	1 Northumberland Fusiliers	30
Hutchinson, Fred	Lance Corporal	6050	1 Scots Guards	27
Hutson, George	Sergeant	L/9097	2 Royal Sussex Regiment	25
Hymns, Rueben	Corporal	8744	1 Lincolnshire Regiment	24
Ingram, Reginald	Private	7507	1 Northamptonshire Regiment	28
Inigo-Jones, Henry	Lieutenant	–	1 Scots Guards	22
Jackson, Bertram	Lieutenant	–	2 King's Royal Rifle Corps	25

NAME	RANK	NUMBER	REGIMENT	AGE
James, Charles	Private	10384	1 Coldstream Guards	U
James, David	Sergeant	L/7711	1 QRWSR	U
James, William	Sergeant	5162	1 Northamptonshire Regiment	34
Jasper, Thomas	Sergeant	L/7003	1 QRWSR	U
Jeffrey, Arthur	Private	L/13068	4 Royal Fusiliers	23
Jeffries, Thomas	Private	L/8559	4 Royal Fusiliers	34
Johnson, Alfred	Private	8658	2 KOSB	26
Johnson, Robert	Private	10469	1 Loyal North Lancashire	21
Johnson, Thomas	Private	6976	1 Lincolnshire Regiment	U
Johnson, Thomas	Private	L/7165	1 QORWKR	U
Johnson, Ralph	Rifleman	7384	2 King's Royal Rifle Corps	27
Jones, Austin	Private	10917	2 Welsh Regiment	19
Jones, David	Private	11087	2 Welsh Regiment	23
Jones, Frederick	Private	9066	1 Loyal North Lancashire	24
Jones, Frederick	Private	14814	2 Grenadier Guards	28
Jones, Gwilym	Lance Corporal	10939	1 SWB	U
Jones, Richard	Lance Corporal	2108	2 Lancashire Fusiliers	U
Jordan, Albert	Private	8624	1 Gloucestershire Regiment	23
Jordan, George	Private	L/11285	4 Royal Fusiliers	U
Joseph, Archibald	Private	9614	1 Coldstream Guards	U
Joyce, Edward	Private	8471	2 Connaught Rangers	26
Kay, William	Private	9110	1 Northumberland Fusiliers	30
Keates, Ernest	Private	L/9956	2 Royal Sussex Regiment	20
Keen, William	Private	5855	1 Loyal North Lancashire	35
Keene, Ernest	Rifleman	3035	2 King's Royal Rifle Corps	39
Keighton, Michael	Private	5894	1 Coldstream Guards	27
Kellet, John	Private	7933	1 Lincolnshire Regiment	26
Kelly, James	Private	1888	1 Irish Guards	30
Kelly, James	Private	7274	1 Cameron Highlanders	U
Kember, John	Private	L/10294	2 Royal Sussex Regiment	22
Kennedy, Walter	Private	6157	1 Lincolnshire Regiment	U
Kennel, John	Private	6802	3 Coldstream Guards	37
Kenny, Joseph	Private	9613	1 Cameron Highlanders	18
Kenny, Samuel	Private	7561	1 Cameron Highlanders	U
Kenny, Walter	Rifleman	2748	2 King's Royal Rifle Corps	U
Kenward, Sidney	Private	L/7474	2 Royal Sussex Regiment	U
Kerr, William	Private	13706	2 Grenadier Guards	U
Kidnee, Charles	Rifleman	11411	2 King's Royal Rifle Corps	18
King, Charles	Private	9936	3 Coldstream Guards	21
King, John	Sergeant	L/4626	2 Royal Sussex Regiment	38
King, Joseph	Private	7950	1 Loyal North Lancashire	27
King, Leonard	Sergeant	8068	1 QRWSR	27
Kingdon, Charles	Sergeant	5487	1 Coldstream Guards	30
Kirkby, John	Corporal	5523	1 Loyal North Lancashire	30
Kitchener, John	Private	L/11083	4 Royal Fusiliers	U
Knowles, Francis	Corporal	9762	1 Loyal North Lancashire	U
Lamborn, John	Private	L/13685	4 Royal Fusiliers	28
Lane, Tracey	Private	908	1 Northumberland Fusiliers	33
Larkman, William	Rifleman	7336	2 King's Royal Rifle Corps	U
Lassetter, Arthur	Private	L/7593	2 Royal Sussex Regiment	29
Law, John	Rifleman	6589	1 King's Royal Rifle Corps	29
Lawrence, William	Rifleman	11382	2 King's Royal Rifle Corps	18

NAME	RANK	NUMBER	REGIMENT	AGE
Lear, John	Lance Corporal	10170	1 Coldstream Guards	U
Leavy, Michael	Rifleman	8120	2 Royal Irish Rifles	U
Lee, Michael	Private	6826	1 Cameron Highlanders	U
Lee, Thomas	Private	11080	2 Welsh Regiment	U
Lee, William	Rifleman	10999	2 King's Royal Rifle Corps	U
Leeman, Walter	Private	7158	1 Lincolnshire Regiment	37
Leigh, Tom	Gunner	30457	56 Battery, RFA	30
Leith, Lawrence	Private	2198	1 Northumberland Fusiliers	U
Lentaigne, Victor	2nd Lieutenant	–	2 Connaught Rangers	21
Leonard, Charles	Private	8805	2 Worcestershire Regiment	28
Leroy, Edwin	Rifleman	11179	2 King's Royal Rifle Corps	U
Leslie, William	Private	7496	1 Cameron Highlanders	U
Letchford, Victor	Private	L/9479	2 Royal Sussex Regiment	28
Lett, William	Lance Corporal	L/15162	4 Royal Fusiliers	U
Letten, Thomas	Private	7798	1 DOCLI	U
Lewis, William	Rifleman	2806	2 King's Royal Rifle Corps	U
Lisher, Reginald	Private	10243	1 Coldstream Guards	18
Liversidge, George	Rifleman	2680	2 King's Royal Rifle Corps	32
Livesey, William	Private	8538	2 Welsh Regiment	U
Lloyd, Walter	Lieutenant Colonel	–	1 Loyal North Lancashire	46
Lodge, Ernest	Private	8922	2 Duke of Wellington	U
Logan, John	Private	6749	1 Cameron Highlanders	35
Loomes, Herbert	Lieutenant	–	1 Loyal North Lancashire	25
Loosely, William	Private	12843	2 Grenadier Guards	26
Lord, Sylvester	Lance Corporal	8887	2 Manchester Regiment	U
Lucas, William	Rifleman	8843	2 King's Royal Rifle Corps	24
Luke, Stephen	CSM	6000	1 Northumberland Fusiliers	33
Luxford, Jesse	Private	L/10179	2 Royal Sussex Regiment	U
MacArthur, Neil	Corporal	669	1 Scots Guards	U
Macartney, William	Private	7466	1 Cameron Highlanders	26
Mack, John	Private	7872	2 Welsh Regiment	32
Mackenzie, Henry	Private	5831	1 Cameron Highlanders	31
Mackenzie, Kenneth	Private	7214	1 Cameron Highlanders	27
Mackinnon, Alexander	2nd Lieutenant	–	1 Cameron Highlanders	22
Mackintosh, Alastair	Captain	–	1 Cameron Highlanders	34
Macklin, Richard	Private	7852	1 Loyal North Lancashire	31
MacLennan, David	Private	6657	1 Scots Guards	27
Magee, Patrick	Lance Corporal	8410	1 Loyal North Lancashire	25
Maitland, Alfred	Major	–	1 Cameron Highlanders	41
Maitland, Robert	Private	11080	2 Highland Light Infantry	U
Male, John	Private	627	2 Lancashire Fusiliers	38
Males, John	Rifleman	11158	1 King's Royal Rifle Corps	24
Marshall, Murdo	Lance Corporal	9237	1 Cameron Highlanders	U
Martin, Herbert	Private	7818	1 DOCLI	U
Martin, Robert	Private	9613	2 KOSB	U
Martin, William	Private	8259	1 DOCLI	39
Masterson, Alfred	Lance Corporal	8126	2 Welsh Regiment	U
Mather, Arthur	Private	8712	1 Northumberland Fusiliers	28
Matsell, Charles	Drummer	7945	1 Norfolk Regiment	21
Mayell, William	Private	14646	2 Grenadier Guards	U
Mayo, Louis	Private	1882	2 Lancashire Fusiliers	U
McAllister, Eneas	Private	8598	2 Scots Guards	U

NAME	RANK	NUMBER	REGIMENT	AGE
McAulay, Daniel	Private	854	1 Northumberland Fusiliers	U
McCabe, Alexander	Private	7208	1 Cameron Highlanders	27
McCabe, John	Private	8909	2 Manchester Regiment	30
McCall, James	Private	5525	1 Cameron Highlanders	31
McCarthy, Joseph	Private	7760	2 Connaught Rangers	29
McConnell, Philip	Private	11282	2 KOSB	20
McCulloch, John	Private	6898	1 Cameron Highlanders	U
McDonald, Alfred	Lance Corporal	L/11712	4 Royal Fusiliers	U
McDonald, Daniel	Private	8323	1 Cameron Highlanders	U
McDonald, Donald	Sergeant	8443	1 Cameron Highlanders	38
McDonald, James	Private	6722	1 Cameron Highlanders	28
McDonald, John	Private	9299	1 Cameron Highlanders	U
McDonald, William	Lance Corporal	7312	1 Cameron Highlanders	U
McEwan, James	Lance Corporal	9615	1 Black Watch	28
McFarlane, John	Private	9606	1 Cameron Highlanders	26
McGinn, Patrick	Private	7828	1 Cameron Higlanders	U
McGrevy, Harry	Lance Corporal	553	1 Northumberland Fusiliers	30
McGuire, John	Private	7417	1 Cameron Highlanders	U
McHugh, Francis	Private	9332	1 Cameron Highlanders	19
McIntosh, George	Private	7836	1 Scots Guards	U
McKale, John	Private	8129	1 Loyal North Lancashire	U
McKay, William	Private	8015	1 Cameron Highlanders	U
McLennan, Roderick	CQS	3770	1 Cameron Highlanders	U
McLoughlin, John	Private	7177	1 Loyal North Lancashire	U
McLoughlin, Michael	Private	5755	1 Coldstream Guards	U
McNeill, Charlie	Private	10388	2 KOSB	27
McNeill, George	Private	6544	1 Cameron Highlanders	36
McPhie, Alexander	Private	16254	2 Grenadier Guards	U
Meiklejohn, Alexander	Sergeant	1039	1 Black Watch	20
Melling, Harry	Private	10513	1 Loyal North Lancashire	19
Merrifield, Frank	Gunner	70655	56 Battery, RFA	25
Middleton, Henry	Private	3/7339	1 Norfolk Regiment	U
Middleton, Thomas	Private	1745	1 Northumberland Fusiliers	U
Millar, Arthur	Lance Corporal	9462	1 Cameron Highlanders	U
Miller, John	Private	9519	1 Cameron Highlanders	21
Mills, Charles	Lance Corporal	L/10280	1 QRWSR	U
Milne, William	Private	6816	1 Cameron Highlanders	30
Milway, Herbert	Private	9950	1 Northumberland Fusiliers	U
Mitchell, Herbert	Private	S/7194	Royal Army Ordnance Corps	28
Mollison, David	Private	6884	1 Cameron Highlanders	U
Montresor, Ernest	Lieutenant Colonel	–	2 Royal Sussex Regiment	50
Moore, Robert	Private	6280	1 Norfolk Regiment	40
Morgan, Albert	Private	9971	1 Northumberland Fusiliers	U
Morgan, Ernest	Private	7082	1 Loyal North Lancashire	28
Morgan, Thomas	Lance Corporal	8933	2 Welsh Regiment	26
Morris, Harry	CQS	1729	1 Coldstream Guards	U
Morris, George	Sergeant	6868	1 Cameron Highlanders	31
Morris, Harry	Private	6784	1 Cameron Highlanders	32
Morris, James	Private	6848	1 Cameron Highlanders	29
Morrison, Hugh	Private	9522	1 Cameron Highlanders	U
Morse, Archdale	Lance Corporal	5979	1 Coldstream Guards	29
Mountjoy, George	Rifleman	10345	1 King's Royal Rifle Corps	U

NAME	RANK	NUMBER	REGIMENT	AGE
Muddiman, Oliver	Lance Corporal	4568	1 Coldstream Guards	U
Muir, Charles	Gunner	54334	Royal Horse Artillery	23
Mulhall, John	Private	10621	2 Connaught Rangers	22
Murrant, Walter	Rifleman	11245	1 King's Royal Rifle Corps	18
Murray, David	Private	10079	2 KOSB	U
Murray, Robert	Lance Corporal	9433	1 Cameron Highlanders	20
Murray, Thomas	Private	9439	1 Cameron Highlanders	20
Murray, William	Lance Corporal	9544	1 Cameron Highlanders	18
Myers, George	Private	6828	1 Loyal North Lancashire	33
Myles, Robert	Private	6565	1 Cameron Highlanders	29
Nelson, Herbert	Rifleman	5287	1 King's Royal Rifle Corps	30
Neville, Arthur	Private	7390	1 Northamptonshire Regiment	28
Newton, William	Private	8175	1 DOCLI	U
Nicholson, Arthur	Lieutenant	–	1 Cameron Highlanders	25
Nicoll, Alexander	Private	S/10019	1 Cameron Highlanders	U
Nisbet, Alexander	Private	6472	1 Cameron Highlanders	31
Nix, Walter	Private	6488	1 Lincolnshire Regiment	U
Nockolds, Owen	Lance Corporal	L/10088	1 QRWSR	U
Norman, Arthur	Sergeant	G/6515	1 QRWSR	41
Norman, John	Sergeant	8471	2 Welsh Regiment	29
Norton, William	Private	8865	1 Norfolk Regiment	U
Oakes, Joseph	Private	10816	1 King's (Liverpool Regiment)	21
Oatway, Thomas	CSM	1486	1 Coldstream Guards	U
O'Donnell, James	Private	469	1 Northumberland Fusiliers	31
Olivier, Robert	Captain	–	1 DOCLI	35
Orchard, Charles	Private	8161	1 Cameron Highlanders	U
Ord, Thomas	Private	7907	1 Loyal North Lancashire	U
O'Rouke, John	Private	7148	1 Loyal North Lancashire	31
Ovens, Harry	Private	8311	1 DOCLI	24
Oxley, Albert	Private	8186	2 DOW	U
Paget, George	Lieutenant	–	1 Northamptonshire Regiment	23
Parker, James	Private	8154	1 Cameron Highlanders	23
Parry, Edwin	Private	8303	1 Gloucestershire Regiment	25
Paxton, Jim	Lance Corporal	7673	2 Worcestershire Regiment	U
Payne, Charles	BQMS	14054	50 Battery, RFA	33
Payne-Gallwey, Thomas	Captain	–	2 Grenadier Guards	U
Pearman, Edward	Private	6899	1 Coldstream Guards	U
Pearson, James	Lance Corporal	6194	1 Loyal North Lancashire	33
Pearson, Robert	Private	8930	1 Coldstream Guards	U
Peberdy, George	Lance Corporal	11246	2 Royal Scots	19
Peddie, Alexander	Captain	–	1 Lincolnshire Regiment	29
Pelling, Ernest	Private	L/7327	2 Royal Sussex Regiment	U
Perkins, Reginald	2nd Lieutenant	–	1 Royal Berkshire Regiment	22
Perren, Sydney	Rifleman	11216	2 King's Royal Rifle Corps	20
Perry, Thomas	Private	7576	2 Worcestershire Regiment	28
Pert, James	Private	L/7699	4 Royal Fusiliers	35
Peters, William	Sergeant	L/8141	2 Royal Sussex Regiment	U
Philpot, George	Private	L/7681	4 Middlesex Regiment	U
Pickett, James	Private	10363	1 East Surrey Regiment	20
Pike, Wilfred	Corporal	9650	2 King's Royal Rifle Corps	24
Pitman, Reginald	Private	9487	1 Dorsetshire Regiment	19
Plummer, Ernest	Private	6837	1 Norfolk Regiment	27

NAME	RANK	NUMBER	REGIMENT	AGE
Port, Albert	Private	10112	1 Coldstream Guards	20
Porter, Claude	Corporal	15719	2 Grenadier Guards	23
Potter, James	Private	9312	2 Royal Scots	27
Poulton, James	Private	6493	1 Coldstream Guards	U
Powell, Frederick	Private	L/8413	2 Royal Sussex Regiment	28
Price, Oscar	Private	5343	1 Scots Guards	U
Price, Frank	Lance Corporal	L/10106	2 Royal Sussex Regiment	19
Prigg, Sidney	Private	9782	1 Loyal North Lancashire	26
Prior, Frederick	Private	10307	1 Coldstream Guards	U
Pritchard, Rees	Lance Corporal	9111	2 Welsh Regiment	26
Probert, Percy	Private	11037	1 South Wales Borderers	U
Pryor, Amos	Private	L/8075	4 Royal Fusiliers	33
Pugh, Thomas	Rifleman	1828	1 King's Royal Rifle Corps	U
Quanbrough, Frederick	Private	6185	1 Lincolnshire Regiment	U
Ramsdell, Joseph	Rifleman	1527	2 King's Royal Rifle Corps	35
Rands, Thomas	Private	8598	1 Gloucestershire Regiment	U
Ranger, Thomas	Private	8628	1 Coldstream Guards	U
Rarity, James	Private	6511	1 Cameron Highlanders	31
Raymond, Charles	Corporal	6693	2 King's Royal Rifle Corps	32
Rea, John	Private	8321	1 Loyal North Lancashire	U
Reader, Frederick	Private	L/15237	4 Royal Fusiliers	20
Reader, William	Private	L/8714	4 Royal Fusiliers	28
Reading, James	Private	L/7694	1 QRWSR	U
Redden, William	CSM	5919	1 Lincolnshire Regiment	U
Reilly, Peter	Private	6343	2 KOSB	20
Relf, Harold	Lance Corporal	9659	1 Loyal North Lancashire	23
Relph, George	Corporal	26692	70 Battery, RFA	35
Remon, Henry	Rifleman	5467	2 King's Royal Rifle Corps	U
Reynolds, Harry	Private	7555	1 East Surrey Regiment	U
Reynolds, Sydney	Private	8518	1 Lincolnshire Regiment	U
Rhodes, Arthur	Private	7493	1 Coldstream Guards	24
Richards, George	Private	L/7170	1 QRWSR	U
Richardson, Albert	Private	9898	1 DOCLI	20
Richardson, James	Private	7603	1 Northamptonshire Regiment	25
Riley, Alexander	Private	6795	1 Cameron Highlanders	U
Roach, Patrick	Private	7053	1 Loyal North Lancashire	U
Roberts, Benjamin	Rifleman	6197	2 King's Royal Rifle Corps	U
Roberts, Harold	Private	12495	2 Grenadier Guards	32
Roberts, John	Private	6586	2 Welsh Regiment	29
Roberts, Richard	Private	6878	1 Loyal North Lancashire	U
Robertson, Robert	Private	9365	1 Cameron Highlanders	19
Robins, Joseph	Private	8708	1 Lincolnshire Regiment	23
Robinson, Edgar	Lieutenant	–	1 Loyal North Lancashire	23
Robinson, Harry	Private	4566	2 King's Royal Rifle Corps	U
Robson, Ernest	Private	4977	1 Coldstream Guards	U
Robson, William	Rifleman	5985	1 King's Royal Rifle Corps	U
Rock, Michael	Private	765	2 Lancashire Fusiliers	27
Rocky, Hugh	Private	739	2 Lancashire Fusiliers	U
Roe, Edward	Private	6251	3 Coldstream Guards	U
Rogers, Albert	Private	L/7649	1 QRWSR	29
Rogers, Edward	Private	7813	1 South Wales Borderers	U
Rose, Albert	Lance Corporal	6467	1 Lincolnshire Regiment	U

NAME	RANK	NUMBER	REGIMENT	AGE
Ross, James	Private	9911	2 KOSB	U
Rowan, James	Private	7103	1 Loyal North Lancashire	34
Rowe, Sam	Rifleman	4544	2 King's Royal Rifle Corps	36
Rowlett, Thomas	Private	9149	1 Coldstream Guards	23
Rowson, William	Rifleman	7107	2 King's Royal Rifle Corps	U
Royall, Robert	Sergeant	1623	1 Scots Guards	U
Rule, William	Private	7672	1 Lincolnshire Regiment	U
Rushby, Albert	Driver	68156	118 Battery, RFA	U
Ryan, James	Lance Corporal	8568	1 Loyal North Lancashire	U
Sageman, George	Private	L/8695	2 Royal Sussex Regiment	26
Salmon, Alfred	Private	9372	1 Cameron Highlanders	20
Sambrook, Alfred	Private	9831	1 DOCLI	U
Sandiford, Joseph	Private	5998	1 Loyal North Lancashire	U
Saunby, Harry	Private	8059	1 Lincolnshire Regiment	26
Saunders, Frederick	Lance Corporal	10821	2 King's Royal Rifle Corps	U
Saunders, Ernest	Private	L/10108	2 Royal Sussex Regiment	18
Savory, Sidney	Private	8797	1 Norfolk Regiment	U
Sawyer, Charles	Private	L/10464	4 Royal Fusiliers	38
Scarlett, Edward	Private	9863	1 Loyal North Lancashire	23
Scotney, John	Private	9414	1 Lincolnshire Regiment	19
Scott, Ernest	Private	8559	1 Loyal North Lancashire	U
Sebar, Charlie	Rifleman	7477	2 King's Royal Rifle Corps	26
Sells, William	Private	L/9957	1 QRWSR	U
Shacklady, William	Gunner	24786	22 Battery, RFA	30
Shakespeare, William	Private	8692	1 Coldstream Guards	28
Sharp, David	Private	9598	1st Cameron Highlanders	U
Shead, Alfred	Private	1225	2 Lancashire Fusiliers	U
Shenley, Frederick	Lance Corporal	3350	2 KOYLI	U
Shenstone, Herbert	Rifleman	5551	2 King's Royal Rifle Corps	U
Shepherd, Harold	Private	6493	1st Lincolnshire Regiment	U
Sheppard, William	Rifleman	10868	2 King's Royal Rifle Corps	U
Shine, John	Private	10537	2 Royal Irish Regiment	18
Shirley, Daniel	Private	L/8887	2 Royal Sussex Regiment	27
Short, Freelin	Private	8036	1 Dorsetshire Regiment	28
Short, John	Sergeant	9173	1 Loyal North Lancashire	U
Simpson, Alexander	Sergeant	6225	2 KOSB	U
Simpson, Frederick	Private	6704	1 Norfolk Regiment	27
Simpson, George	Private	9808	3 Coldstream Guards	U
Sims, William	Rifleman	5095	2 King's Royal Rifle Corps	31
Sinclair, David	Private	6497	1 Cameron Highlanders	U
Sirmond, Christopher	Private	8028	1 Coldstream Guards	U
Skinner, Walter	Private	L/10060	4 Royal Fusiliers	32
Sleet, Charles	Private	6907	1 Northamptonshire Regiment	29
Slimm, Thomas	Private	8729	2 Worcestershire Regiment	U
Smallman, Richard	Corporal	L/11876	4 Royal Fusiliers	U
Smith, Arthur	Lance Corporal	9723	2 Manchester Regiment	31
Smith, Bertie	Private	11111	2 Welsh Regiment	U
Smith, Leslie	Lance Corporal	10651	2 King's Royal Rifle Corps	18
Smith, Douglas	Rifleman	11252	1 King's Royal Rifle Corps	U
Smith, George	Rifleman	10397	2 King's Royal Rifle Corps	29
Smith, John	Private	8418	1 Lincolnshire Regiment	U
Smith, Thomas	Rifleman	1858	2 King's Royal Rifle Corps	36

NAME	RANK	NUMBER	REGIMENT	AGE
Smith, William	Rifleman	11148	1 King's Royal Rifle Corps	19
Smith, William	Private	6683	1 Norfolk Regiment	29
Smith-Sligo, Archibald	2nd Lieutenant	–	1 Cameron Highlanders	U
Smithson, Albert	Private	6582	3 Coldstream Guards	U
Sneddon, William	Private	7149	1 Cameron Highlanders	35
Snowly, Absolum	Private	7722	1 Coldstream Guards	U
Somerset, George	Rifleman	6500	1 King's Royal Rifle Corps	24
Somerville, Walter	Private	8792	1 Cameron Highlanders	U
Sorsby, William	Private	4637	3 Coldstream Guards	U
Spencer, Charles	Private	7610	2 Connaught Rangers	U
Spooner, Leonard	Sergeant	L/6597	1 QRWSR	31
Squaire, Thomas	Private	7526	1 Cameron Highlanders	U
Stancer, George	Rifleman	6106	1 King's Royal Rifle Corps	28
Stevens, Herbert	Corporal	5221	1 Norfolk Regiment	32
Stevens, James	Private	9864	1 Gloucestershire Regiment	17
Stevenson, George	Private	7629	1 Cameron Highlanders	U
Stewart, John	Private	6657	1 Cameron Highlanders	U
Stewart, Murray Lord	Major	–	1 Black Watch	41
Still, Thomas	Private	L/10035	2 Royal Sussex	19
Stimpson, Walter	Sergeant	4278	1 Northamptonshire Regiment	U
Stoffell, Charles	Private	L/9719	2 Royal Sussex Regiment	U
Stott, James	Lance Corporal	4923	1 Cameron Highlanders	34
Sturgess, William	Sergeant	L/7881	1 QRWSR	U
Sutton, Henry	Sergeant	5769	2 King's Royal Rifle Corps	28
Swain, Reginald	Private	9854	1 Coldstream Guards	U
Swan, William	Private	7316	1 Cameron Highlanders	26
Swanson, John	Private	7355	2 Dragoons	U
Swift, Ernest	Driver	1718	50 Battery, RFA	36
Swift, Major	Private	10417	1 Loyal North Lancashire	U
Swift, Patrick	Private	7026	2 Royal Irish Regiment	U
Tannahill, Robert	Private	6468	1 Cameron Highlanders	32
Tarney, Robert	Private	10485	1 Loyal Lancashire Regiment	U
Taylor, Charles	Lance Corporal	9827	1 Coldstream Guards	U
Taylor, Frederick	Bandsman	7593	1 DOCLI	25
Taylor, John	Private	8438	1 Cameron Highlanders	22
Taylor, Walter	Private	15287	2 Grenadier Guards	21
Terms, Edward	Private	7830	1 Cameron Highlanders	26
Terry, Alfred	Rifleman	10856	1 King's Royal Rifle Corps	U
Terry, Henry	Private	9078	3 Coldstream Guards	23
Theobald, John	Gunner	44115	50 Battery, RFA	26
Thomas, Andrew	Private	9875	1 Black Watch	27
Thompson, George	2nd Lieutenant	–	2 King's Royal Rifle Corps	20
Thompson, William	Private	10870	2 KOYLI	U
Thorpe, John	Private	7960	2 Royal Scots	U
Thrower, Albert	Private	3/7369	1 Norfolk Regiment	U
Tobin, Patrick	Private	1743	1 Irish Guards	29
Topliss, Tom	Lance Corporal	9634	1 Lincolnshire Regiment	U
Totterdell, George	Private	8014	1 Coldstream Guards	24
Tovey, George	Private	13316	2 Worcestershire Regiment	U
Towl, George	Private	6870	1 Lincolnshire Regiment	U
Townsend, Patrick	Private	4530	1 Irish Guards	19
Tree, Henry	Private	L/10026	2 Royal Sussex Regiment	19

NAME	RANK	NUMBER	REGIMENT	AGE
Trussler, Alvah	Private	L/7446	2 Royal Sussex Regiment	36
Turner, Harry	Private	9751	2 Lancashire Fusiliers	U
Turner, William	Driver	15603	Royal Engineers	28
Tuttle, Arthur	Private	6781	1 Norfolk Regiment	29
Tween, Ernest	Private	L/10135	2 Royal Sussex Regiment	19
Vernon, George	Private	8478	1 Loyal North Lancashire	U
Vince, Alfred	Lance Corporal	S/7842	1 QRWSR	29
Vincent, William	Private	8534	1 DOCLI	U
Vincent, Herbert	Private	L/14941	4 Royal Fusiliers	19
Wales, Thomas	Private	6517	1 Lincolnshire Regiment	35
Walker, Joseph	Private	1948	2 Lancashire Fusiliers	U
Wall, Thomas	Rifleman	2712	1 King's Royal Rifle Corps	34
Walmsley, Joseph	Private	10229	1 Loyal North Lancashire	20
Walsh, William	Corporal	8877	2 Welsh Regiment	27
Walter, Edward	Private	L/9070	2 Royal Sussex Regiment	22
Ward, David	Private	6861	1 Cameron Highlanders	U
Ware, George	Private	9573	1 DOCLI	20
Ware, John	Private	7840	1 Gloucestershire Regiment	U
Walters, James	Private	10867	2 Royal Irish Regiment	U
Watkins, James	Private	7287	2 Ox & Bucks	U
Watson, Albert	Private	10373	1 Loyal North Lancashire	U
Watson, Charles	Private	9033	1 Cameron Highlanders	U
Watson, R. Hayworth	Captain	–	1 Loyal North Lancashire	U
Weaver, Walter	Private	8655	1 Coldstream Guards	24
Webster, Herbert	Sergeant	2259	1 Northumberland Fusiliers	25
Weedon, Horace	Private	14903	2 Grenadier Guards	22
Whatling, Fred	Lance Corporal	6225	3 Coldstream Guards	30
Wheeler, William	Lance Corporal	8638	2 Royal Scots	U
White, Clarence	Private	6934	2 Ox & Bucks	30
White, Edward	Captain		1st Northumberland Fusiliers	37
White, William	Private	6041	1 Coldstream Guards	U
Whitehall, Alfred	Private	16259	2 Grenadier Guards	21
Widdowson, Arthur	Private	3432	3 Coldstream Guards	34
Wilcock, Edwyn	Private	6773	1 Scots Guards	27
Wilde, Herbert	CSM	6174	1 Lincolnshire Regiment	U
Wilkinson, Edward	Rifleman	5379	2 King's Royal Rifle Corps	U
Williams, Michael	Sergeant	3322	2 King's Royal Rifle Corps	32
Williams, Robert	Rifleman	835	2 King's Royal Rifle Corps	U
Wills, Frederick	Private	8232	1 Loyal North Lancashire	U
Wilson, Albert	Private	8336	1 Lincolnshire Regiment	30
Wilson, Thomas	Private	7926	1 Loyal North Lancashire	U
Wilson, Malcolm	Private	7762	1 Cameron Highlanders	25
Wilson, Robert	Private	5664	1 Cameron Highlanders	33
Wilson, James	Private	6613	1 Norfolk Regiment	U
Winship, Robert	Private	5753	2 KOSB	25
Wood, John	Private	8123	2 Manchester Regiment	36
Wood, Robert	Private	11866	2 Grenadier Guards	U
Wood, Thomas	Private	9416	1 Lincolnshire Regiment	U
Woods, George	Driver	25624	56 Battery, RFA	U
Woolley, Frank	Gunner	17070	50 Battery, RFA	33
Worsfold, Albert	Driver	T/2747	1 Army Service Corps	24
Wright, Robert	Private	9495	1 Cameron Highlanders	19

NAME	RANK	NUMBER	REGIMENT	AGE
Wright, Thomas	Private	13064	2 Worcestershire Regiment	22
Wyndham, Percy	Lieutenant	–	3 Coldstream Guards	26
Wynn, George	Private	7093	2 KOSB	U
Yarham, Alfred	Private	L/10042	1 QRWSR	U
Yates, Alfred	Private	11713	1 King's Liverpool Regiment	U
Yeatman, Albert	Private	L/8142	2 Royal Sussex Regiment	30
Yeo, George	Sergeant	8109	1 King's Liverpool Regiment	29
Youngman, Benjamin	Private	8728	1 Norfolk Regiment	U
Yule, John	Corporal	8955	1 Cameron Highlanders	28

ABBREVATIONS

BQMS	Battery Quartermaster Sergeant
Cameron Highlanders	Queen's Own Cameron Highlanders
CQS	Company Quartermaster Sergeant
CSM	Company Sergeant Major
DOCLI	Duke of Cornwall's Light Infantry
DOW	Duke of Wellington's (West Riding Regiment)
2 Dragoons	2 Dragoons (Royal Scots Greys)
KOYLI	King's Own Yorkshire Light Infantry
KOSB	King's Own Scottish Borderers
Ox & Bucks	Oxford & Buckinghamshire Light Infantry
QORWKR	Queen's Own Royal West Kent Regiment
QRWSR	Queen's (Royal West Surrey) Regiment
Royal Scots	Royal Scots (Lothian Regiment)

* Killed between 14 and 16 September 1914

BEF SOLDIERS BURIED IN MOULINS NEW COMMUNAL CEMETERY

NAME	RANK	NUMBER	REGIMENT	AGE	KILLED	GRAVE/MEM REF.
Bartrop, William	Sergeant	22097	117th Bty, RFA	33	15.09.14	4
Butcher, E.F.	Private	L/10218	1 Queen's (RWSR)	U	15.09.14	5
Fowle, F.	Private	L/7300	2 Royal Sussex	U	13.09.14	Sp Mem 8
Grant Duff, Adrian CB	Lieutenant-Colonel		1 Black Watch	44	14.09.14	1
Green, C.F.	Private	L/7991	1 Queen's (RWSR)	U	15.09.14	7
Lucas-Tooth, Douglas DSO	Captain		9th Queen's RL	33	14.09.14	9
Polson, Geoffrey	2nd Lieutenant		1 Black Watch	23	14/15.09.14	1
Pringle, Robert	Lieutenant		1 Queen's (RWSR)	29	14.09.14	6
Shapely, A.H.	Private	L/10488	1 Queen's (RWSR)	19	19.09.14	3
Simson, R.F.	Lieutenant		16th Bty, RFA	24	15.09.14	2

APPENDIX 5

BEF SOLDIERS BURIED IN PAISSY CHURCHYARD

NAME	RANK	NUMBER	REGIMENT	AGE	KILLED	GRAVE/MEM REF.
Cathcart, Augustus	Captain	2 KRRC		39	14.09.14	Sp Mem 1
Connor, Thomas	Gunner	28701	135th Bty RFA	U	17.09.14	Sp Mem 2
Kenward, C.	Private	L/9592	2 Royal Sussex	U	21.09.14	1
Warren, Dawson	Lieutenant-Colonel		1 Queen's (RWSR)	49	17.09.14	2
Wilson, Charles	Captain Adjutant		1 Queen's (RWSR)	43	17.09.14	2

APPENDIX 6

BEF SOLDIERS BURIED IN SOUPIR CHURCHYARD

NAME	RANK	NUMBER	REGIMENT	AGE	KILLED	GRAVE/MEM REF.
Barrett, J.	Private	4020	2 Con Rangers	U	19.10.14	C.14
Baty, E.	Private	7388	3 Coldstream Gds	U	21.09.14	D.3
Bourroughs, C.	Private	9146	2 Coldstream Gds	U	28.09.14	D.10
Bowden, W.	Private	8118	3 Ox & Bucks	U	10.10.14	B.7
Carty, J.	Private	10348	2 HLI	U	09.10.14	B.4
Churm, G.H.	Private	7507	2 South Staffs	27	17.09.14	C.13
Collins, H.E.	Sapper	15477	5 Field Coy, RE	30	09.10.14	B.6
Dixon, George	Sergeant	3725	3 Coldstream Gds	32	20.09.14	D.2
Drain, G.	Private	16375	2 Grenadier Gds	U	17.09.14	C.16
Evelegh, Rosslyn	Captain		2 Ox & Bucks	29	19.09.14	C.4
Fuller, H.W.	Gunner	25960	36th Siege Bty RGA		26.09.14	D.9
Girardot, Paul	2nd Lieutenant		2 Ox & Bucks	18	17.09.14	C.3
Halford, W.F.V.	Sapper	24553	5 Field Coy, RE	21	03.10.14	C.20
Hemmings, James	Private	6558	2 Sth Staffs	30	22.09.14	D.4
Hill, J.E.	Private	10304	2 HLI	U	12.10.14	B.11
Hill, Walter	Lieutenant		1 North Staffs	22	25.09.14	B.1
Holmes, Albert	Private	L/14829	1 Royal Fusiliers	19	23.09.14	D.5
Huetson, Walter	Rifleman	6014	1 KRRC	27	18.09.14	C.11
Johnson, J.H.	Sergeant	78	2 Coldstream Gds	U	29.09.14	D.8
Mansell, J.	Private	8298	1 North Staffs	U	25.09.14	Sp Mem
McDermott, M.	Private	6588	2 Con Rangers	U	14.09.14	C.19
Mockler-Ferryman, Hugh	Lieutenant		2 Ox & Bucks	22	16.09.14	C.1
Moore, Leonard	Private	8315	1 Royal Berks	26	10.10.14	B.9
Morris, J.S.	Sergeant	10200	2 HLI	U	03.10.14	B.2
Price, Frank	Private	11112	1 Royal Fusiliers	29	24.09.14	D.6
Smith, J.R.	Gunner	2602	39 Siege Bty, RGA	25	26.09.14	D.7
Towey, T.	Private	8223	1 North Staffs	U	24.09.14	Sp Mem
Walker, F.T.	Lance Corporal	9186	2 South Staffs	U	03.10.14	B.3
Webb, L.	Private	3890	1 Irish Guards	U	11.09.14	G.15
Worthington, Reginald	Lieutenant		2 Ox & Bucks	27	16.09.14	C.2

BEF SOLDIERS BURIED IN
SOUPIR COMMUNAL CEMETERY

NAME	RANK	NUMBER	REGIMENT	AGE	KILLED	GRAVE/MEM REF.
Banbury, Charles	Captain		3 Coldstream Gds	36	16.09.14	A.2
Berners, Hamilton	Captain		1 Irish Guards	32	14.09.14	A.3
Biggins, Richard	Private	2375	1 Irish Guards	U	14.09.14	B.8
Brooke, George	Lieutenant		1 Irish Guards	37	07.10.14	A.7
Cecil, William, The Hon	Captain		2 Grenadier Gds	28	16.09.14	B.1
Clissold, Wallace	Private	16370	2 Grenadier Gds	U	14/16.09.14	B.5
Des Voeux, Frederick	Lieutenant		2 Grenadier Gds	24	14.09.14	B.3
Finch, Heneage1	Captain		1 Irish Gds	31	14.09.14	A.4
Fletcher, Oscar	Private	13375	2 Grenadier Gds	U	16.09.14	B.7
Green, Arthur DSO2	Major		Worcestershire Regt.	40	28.09.14	A.1
Hay, Lord Arthur	Captain		1 Irish Guards	25	14.09.14	A.5
Killeen, James	Private	5293	2 Grenadier Gds	28	15.09.14	B.9
Lockwood, Richard	Lieutenant		2 Coldstream Gds	23	14.09.14	A.6
Pickersgill-Cunliffe, John	2nd Lieutenant		2 Grenadier Gds	19	14.09.14	B.4
Trivett, Arthur	Private	16310	2 Grenadier Gds	U	22.09.14	B.6
Welby, Richard	Lieutenant		2 Grenadier Gds	25	16.09.14	B.2

NOTES ···

1. Captain Heneage Finch served as Lord Guernsey.
2. Major Arthur Green DSO was acting Brigade Major for the 17th Infantry Brigade during Battle of the Aisne.

APPENDIX 8

BEF SOLDIERS BURIED IN VAILLY BRITISH CEMETERY

NAME	RANK	NUMBER	REGIMENT	AGE	KILLED	GRAVE/MEM REF.
Acaster, Francis	Private	6543	1 KRRC	U	16.09.14	II.C.10
Adams, Frederick	Private	8856	3 Worcestershire	U	21.09.14	Sp Mem 28
Adams, Samuel	Private	8971	1 Devonshire	19	19.09.14	I.B.15
Ainsworth, William	Sergeant	3198	2 Coldstream Gds	U	13.09.14	II.F.16
Andrews, F.W.	Rifleman	11174	1 KRRC	U	16.09.14	II.C.3
Ardley, Henry	Private	1988	5 Dragoon Gds	U	19.09.14	III.A.2A
Atkins, J.	Private	7934	2 Ox & Bucks	U	03.10.14	I.H.18
Bancroft, W.	Private	10614	1 Royal Scots Fus	U	27.09.14	I.B.10
Banton, Arnold	Corporal	25162	48th Hvy Bty RGA	27	16.09.14	IV.A.32
Barrington-Kennett, Aubrey	2nd Lieutenant		2 Ox & Bucks	24	20.09.14	II.E.8
Bates, William	Rifleman	10998	1 KRRC	U	16.09.14	I.D.21
Beecher, J.	Private	8233	1 Royal Scots Fus	U	16.09.14	I.D.10
Bicknell, Montague	Lance Corporal	5244	1 Coldstream Gds	U	14.09.14	I.B.30
Bilton, Joseph	Private	6030	1 Coldstream Gds	U	16.09.14	I.B.22
Birdwood, Gordon	2nd Lieutenant		2 South Lancashire	18	20.09.14	Sp Mem 20
Bishop, Alfred	Gunner	37859	34th Bdg, RFA	U	17.09.14	II.E.5
Boland, Patrick	Private	3358	1 Irish Guards	U	14.09.14	I.D.4
Bollard, T.	Lance Corporal	10153	2 Y&L	U	21.09.14	I.E.25
Bowler, Frederick	Gunner	74066	41st BDG, RFA	U	15.09.14	II.A.20
Boyd, Edward	Lieutenant		1 Northumberland	24	20.09.14	I.A.7
Bradley, George	Private	16403	2 Grenadier Gds	22	14/16.09.14	I.D.5
Bray, S.	Private	8210	1 DOCLI	U	18.09.14	II.G.10
Bray, T.W.	Lance Corporal	9468	1 Leicestershire	U	24.09.14	I.D.15
Brettle, C.	Private	8068	2 Worcestershire	U	29.09.14	II.A.26
Briggs, Cecil	Private	9917	2 Coldstream Gds	20	14.09.14	I.D.20
Briggs, George	Captain		1 Royal ScotsFus	36	14.09.14	III.A.26
Broad, Walter	Sergeant	5641	3 Coldstream Gds	32	16.09.14	I.D.15
Brockway, T.H.G.	Private	6484	1 Wiltshire Rgt	U	20.09.14	Sp Mem.31
Brooks, C.W.	Private	11215	4 Royal Fusiliers	U	14.09.14	I.C.6
Brown, Thomas	Rifleman	7303	1 KRRC	28	16.09.14	I.D.22
Buckland, J.	Private	7494	2 Ox & Bucks	29	19.09.14	I.H.10
Bullock, A.G.	Corporal	9371	1 Lincolnshire Rgt	U	14.09.14	III.A.22
Bundy, B.	Private	9016	1 Wiltshire Rgt	U	20.09.14	Sp Mem.13
Burchett, Arthur	Sergeant	7882	1 Coldstream Gds	24	14.09.14	I.F.3
Burke, George	Driver	T/33072	Army Service Corps	U	24.09.14	III.A.48
Burridge, William	Rifleman	5085	2 KRRC	U	17.09.14	II.E.2
Bushnell, G.H.	Private	6318	1 Wiltshire Rgt	U	22.09.14	II.F.21
Butterworth, Arthur	Rifleman	7517	1 KRRC	U	01.10.14	III.F.8
Byrne, G.H.	Sapper	23758	12th Field Coy, RE	U	03.10.14	I.B.8
Cadden, Henry	Lance Corporal	10162	1 KSLI	20	24.09.14	Sp Mem.19
Callaghan, Daniel	Rifleman	11291	1 KRRC	18	16.09.14	II.C.9

NAME	RANK	NUMBER	REGIMENT	AGE	KILLED	GRAVE/MEM REF.
Carpenter, R.G.	Private	16338	2 Grenadier Gds	21	14/16.09.14	I.G.12
Carroll, J.	Private	6429	2 Con Rangers	U	17.09.14	II.E.6
Carter, C.H.	Driver	68643	49th Bty, RFA	U	14.09.14	II.A.29
Catchpole, H.	Private	14301	1 Grenadier Gds	U	14/16.09.14	II.D.20
Caunt, J.P.	Private	14522	2 Grenadier Gds	U	14.09.14	II.H.9
Charles, F.A.	Driver	42395	49th Bty, RFA	U	11.10.14	II.F.2
Chelton, A.	Private	11807	4 Royal Fusiliers	U	14.09.14	I.C.2
Church, R.	Lance Corporal	6049	1 Wiltshire Rgt	U	14.09.14	Sp Mem 17
Clark, Charles	Private	8525	1 Lincolnshire	29	14.09.14	III.A.8
Clark, Joseph	Private	7829	1 Lincolnshire	U	15.09.14	II.AA.7
Clark, John	Bombardier	62369	3rd Div HQ, RFA	U	13.09.14	II.AA.12
Clarke, S.	Private	7797	2 Worcestershire	U	19.09.14	II.E.10
Clay, C.	Driver	T/23023	RAMC	U	14.09.14	II.A.11
Clayton, Albert	Sapper	20517	1 Signal Coy, RE	24	27.09.14	I.AA.24
Clements, Arthur	Rifleman	5375	1 KRRC	U	16.09.14	II.C.4
Clements, John	Private	9448	1 Lincolnshire Rgt	20	14.09.14	II.AA.19
Cliffe, W.	Private	7411	2 South Staffs	U	16.09.14	I.D.29
Clowes, J.E.	Lance Corporal	8797	1st Northumberland	U	14.09.14	II.G.22
Cochrane, J.	Corporal	9836	2nd Manchester	U	22.09.14	II.F.18
Cole, Herbert	Private	9822	1 The Buffs	21	21.09.14	Sp Mem 39
Cole, J.	Corporal	5540	1 Wiltshire Rgt	36	20.09.14	Sp Mem 32
Cole, William	Private	4940	1 Coldstream Gds	U	27.09.14	II.F.9
Coleman, John	Private	9585	1 Royal Berks	U	14.09.14	I.G.20
Coleman, John	Private	L/9832	1 The Buffs	U	24.09.14	II.F.19
Coles, Robert	Lance Corporal	7043	2 Coldstream Gds	27	18.09.14	I.C.15
Collins, J.	Lance Corporal	7311	1 Wiltshire Rgt	U	20.09.14	Sp Mem 14
Conley, A.T.	Private	8359	2 Ox & Bucks	U	19.09.14	I.H.12
Constable, F.	Private	7981	2 Ox & Bucks	U	03.10.14	I.H.6
Cooke, J.	Private	8942	2 Manchester Rgt	U	20.09.14	II.G.19
Cormack, John	Sergeant	14361	129th Bty, RFA	37	15.09.14	II.B.20
Cornish, A.W.	CQS	4878	1 Devonshire	U	19.09.14	I.A.13
Costello, Matthew	Private	6807	2 Leinster Regiment	28	22.09.14	II.B.9
Cowley, P.	Private	6451	2 Con Rangers	U	14.09.14	Sp Mem 9
Coxon, A.G.	Private	6631	2 DOW	U	17.09.14	II.G.9
Crane, C.E.	2nd Lieut.		1 DOCLI	22	18.09.14	II.G.13
Crayton, J.	Driver	25457	56th Field Coy, RE	17	27.09.14	II.B.16
Crocker, S.J.	Private	10407	1 The Queen's	U	08.10.14	I.D.25
Cutcheon, J.M.	Private	10668	1 Loy North Lancs	U	23.09.14	II.F.17
Davies, Daniel	Private	16410	2 Grenadier Gds	22	23.09.14	II.E.17
Deadman, E.T.	Private	L/2563	16 Queen's Lancers	U	12.09.14	IV.A.34
Dickens, W.A.	Lance Corporal	8838	2 South Lancs	25	20.09.14	IV.A.39
Dilkes, Samuel	Private	5298	1 Coldstream Gds	29	14.09.14	I.D.19
Duncombe, Harry	Private	6570	1 Coldstream Gds	27	15.09.14	I.F.1
Ecles, F.	Private	8064	2 Ox & Bucks	U	16.09.14	I.H.3
Elliott, Henry	Captain		1 Devonshire	33	20.09.14	I.A.5
Elliott, J.	Corporal	1574	1 Black Watch	U	22.09.14	II.AA.13
Ellis, W.	Driver	26402	48th Bty, RFA	28	15.09.14	I.E.5
Fahey, Michael	Private	7155	2 Con Rangers	U	21.09.14	III.A.49
Findlay, Neil	Brigadier General		1 Div Roy Artillery	55	10.09.14	VI.A.53
Fletcher, Alec	Private	9299	1 Coldstream Gds	U	14.09.14	I.B.29
Fletcher, Harold	Corporal	6797	1 KRRC	27	14.09.14	I.C.17
Flinn, W.	Rifleman	7468	1 KRRC	U	16.09.14	II.C.6

NAME	RANK	NUMBER	REGIMENT	AGE	KILLED	GRAVE/MEM REF.
Ford, William	Private	8188	2 Ox & Bucks	33	16.09.14	I.H.4
Forrest, Frank	Captain		RAMC	U	13.09.14	II.G.6
Foster, F.	Sergeant	3241	2 Con Rangers	U	14.09.14	Sp Mem 3
Fox, H.C.T.	Private	8218	1 Wiltshire Rgt	U	20.09.14	Sp Mem 12
Francis, G.	Sergeant	8569	2 South Lancs	U	20.09.14	Sp Mem 23
Fraser, John	Lieutenant		2 Con Rangers	29	14.09.14	I.F.21
Freeston, J.	Private	6085	1 Wiltshire Rgt	U	22.09.14	Sp Mem 10
Futrill, Charles	Private	5270	1 Coldstream Gds	29	14.09.14	I.B.21
Gallagher, Thomas	Private	2860	1 Irish Guards	25	14.09.14	I.F.12
Gamble, Laurence	Private	3242	19th Hussars	24	13.09.14	II.G.24
Geraghty, P.	Private	8299	2 Con Rangers	U	14.09.14	II.E.12
Gilmartin, M.	Lance Corporal	9914	2 Leinster Regiment	27	27.09.14	II.B.10
Goadby, J.	Private	9640	1 Leicestershire	U	22.09.14	II.E.13
Golder, A.	Private	8611	2 Ox & Bucks	U	16.09.14	I.H.5
Gordon, Cosmo	2nd Lieutenant		1 Northamptonshire	20	17.09.14	II.E.7
Gordon-Ives, Victor	Lieutenant		3 Coldstream Gds	24	16.09.14	Sp Mem 15
Goulding, Joseph	Private	2842	2 Con Rangers	32	14.09.14	II.E.11
Goulding, J.	Private	8196	2 Con Rangers	U	14.09.14	I.C.19
Gracie, W.R.	Private	7532	1 Devonshire	32	16.09.14	I.B.9
Green, George	Rifleman	7031	2 Royal Irish Rifles	28	15.09.14	IV.A.13
Greenslade, G.C.J.	Trumpeter	5811	14 (King's) Hussars	24	14.09.14	II.A.18
Gregory, Robert	Sapper	11309	11th Field Coy, RE	30	14.09.14	II.C.17
Gurden, A.	Private	8082	1 West Yorks	U	01.10.14	II.F.7
Hague, Herman	Private	6511	2nd Dragoon Gds	29	20.09.14	Chavonne Mem
Haile, W.C.	Lance Corporal	10739	1 KRRC	U	16.09.14	II.C.7
Haldenby, Albert	Private	7317	2 Coldstream Gds	25	28.09.14	III.A.4A
Hanna, Joseph	Rifleman	8521	2 Royal Irish Rifles	28	20.09.14	II.D.17
Harris, Alfred	Gunner	70063	41st Bty, RFA	U	15.09.14	II.A.19
Hawes, Robert	Captain		1st Leicestershire	U	23.09.14	I.A.10
Heasman, J.	Private	9606	2 Ox & Bucks	U	16.09.14	I.H.6
Henry, Claude	Lieutenant		3 Worcestershire	U	19.09.14	Sp Mem 33
Hibbert, William	Private	6222	2 Coldstream Gds	U	14.09.14	I.D.18
Hillier, A.	Private	8995	1 Wiltshire Rgt	U	22.09.14	Sp Mem 16
Hills, F.	Private	10684	2 Grenadier Gds	29	14/16.09.14	I.E.9
Hodgson, Sidney	Private	8543	2 Coldstream Gds	U	25.09.14	III.A.1A
Hoffmeister, George	Private	L/13000	4 Royal Fusiliers	30	14.09.14	II.H.20
Hooper, H.	Private	7497	2 Ox & Bucks	U	19.09.14	L.H.13
Hopkins, Herbert MID	Lieutenant		RAMC	27	19.09.14	I.A.8
Howard, Thomas	Corporal	12603	Royal Engineers	32	14.09.14	III.A.47
Hughes, George	Sergeant	5539	1 Coldstream Gds	31	14.09.14	I.F.6
Hunt, James	Private	L/11571	4 Royal Fusiliers	27	14.09.14	I.C.1
Illiffe, George	Driver	28377	48th Bty, RFA	U	14.09.14	I.E.6
Jackman, Percy	Private	6747	3 Coldstream Gds	U	14.09.14	I.D.17
Jackson, James	Driver	74660	48th Bty, RFA	U	15.09.14	I.E.4
James, Ivor	Trumpeter	70984	128th Bty, RFA	16	16.09.14	II.B.17
Jelly, Arthur	Private	7270	2 Ox& Bucks	29	19.09.14	I.H.9
Johnston, G.	Corporal	18291	RAMC	30	14.09.14	II.A.12
Jones, Stanley	Lance Corporal	11833	2 HLI	22	24.09.14	II.F.6
Jones, W.H.	Private	8962	1 Royal Berks	U	14.09.14	I.G.18
Jones, James	Private	5055	2 Coldstream Gds	U	19.09.14	III.A.5A
Kavanagh, J.	Lance Corporal	7004	2 Con Rangers	U	14.09.14	II.C.19
Kelly, J.	Lance Corporal	8686	1 Royal Scots Fus	U	27.09.14	I.B.7

NAME	RANK	NUMBER	REGIMENT	AGE	KILLED	GRAVE/MEM REF.
Kiff, G.	Private	7695	1 Devonshire	28	21.09.14	I.B.6
King, Alfred	Private	7707	1 Royal Berks	28	16.09.14	I.G.19
Kingdom, A.	Sergeant	7880	1 Devonshire	U	17.09.14	I.A.11
Kingstone, A.G.	Private	6811	1 KRRK	25	16.09.14	I.D.23
Kinnear, Robert	Sergeant	995	57th Field Coy, RE	32	14.09.14	Sp Mem34
Knowles, J.	Lance Corporal	4781	1 Coldstream Gds	32	14.09.14	I.F.2
Lacey, Henry	Driver	56025	49th Bty, RFA	23	14.09.14	II.F.1
Lacey, J.R.	Private	6928	1 Loy North Lancs	U	14.09.14	IV.A.2
Laidler, W.N.	Private	9452	1 Royal Scots Fus	U	22.09.14	I.E.18
Langford, Charles	Gunner	68754	135th Bty, RFA	U	21.09.14	I.AA.25
Lawrence, Thomas	Driver	42183	65th Bty, RFA	U	13.09.14	II.G.17
Lawson, W.	Acting Bombardier	35394	48th Hvy Bty, RGA	22	14.09.14	IV.A.20
Laydon, W.	Private	9322	3 Coldstream Gds	U	14.09.14	I.B.26
Lees, J.	Private	7700	2 South Staffs	U	15.09.14	I.E.24
Leigh, T.H.A.	Private	5624	1 Coldstream Gds	28	14.09.14	I.B.27
Lennon, J.	Private	8300	2 Con Rangers	U	14.09.14	I.G.6
Lewis, J.W.	Private	7804	2 KOYLI	27	18.09.14	II.G.11
Linton, J.	Private	6082	1 Cam.Highlanders	29	25.09.14	II.F.5
Lister, A.J.	Acting Bombardier	17922	48th Hvy Bty, RGA	27	14.09.14	IV.A.24
Little, S.H.	Private	8914	2 Ox & Bucks	U	03.10.14	I.H.17
Longden, A.	CSM	5625	1 Northumberland	U	14.09.14	II.H.12
Longmuir, David	Private	7333	1 Cam Highlanders	U	14.09.14	III.A.50
Love, John	Driver	21044	55th Bty, RFA	U	28.09.14	II.F.20
Ludlow, T.W.	Driver	T/24385	Army Service Corps	U	15.09.14	II.A.7
Lyons, W.	Private	3166	2 Con Rangers	U	14.09.14	Sp Mem 5
MacDiarmuid, S.	Private	7956	2 Con Rangers	32	14.09.14	II.D.27
MacGouran, Alfred	Corporal	9133	1 Lincolnshire	22	30.09.14	II.AA.17
MacWhinnie, Norman	MC DCM RSM	5177	2 KOSB	37	13.09.14	I.H.29
Malley, H.	Private	7874	2 Con Rangers	U	14.09.14	I.G.4
Maloney, T.	Private	7476	2 Con Rangers	U	14.09.14	Sp Mem 4
Marrs, David	Private	9811	3 Coldstream Gds	U	14.09.14	I.B.25
Martin, D.	Private	3662	1 Northumberland	24	14.09.14	IV.A.9
Martin, T.	Private	8240	2 Royal Inniskilling	33	15.09.14	II.G.8
Maycock, H.J.	Private	8188	2 Ox & Bucks	U	19.09.14	II.B.8
McCann, J.	Private	7211	2 Coldstream Gds	U	20.09.14	I.B.24
MacKay, R.	Rifleman	7476	2 Royal Irish Rifles	U	20.09.14	II.D.20
McLagan, A.	Private	6453	3 Coldstream Gds	U	14.09.14	II.F.30
McMahon, A.	Private	8297	2 Con Rangers	32	14.09.14	Sp Mem 8
Meeds, George	Private	7786	1 Lincolnshire	25	14.09.14	II.A.8
Melbourne, Frank	Private	4669	3 (King's Own) Hussars	32	19.09.14	I.AA.28
Mildenhall, H.	Private	7655	1 Wiltshire Rgt	U	15.09.14	Sp Mem 30
Miller, Godfrey	Lieutenant		11 Field Coy, RE	21	14.09.14	II.C.18
Mills, Frederick	Rifleman	7966	1 KRRC	26	14.09.14	I.C.18
Moran, Thomas	Private	7999	2 South Lancs	28	20.09.14	IV.A.40
Morgan, Rees	Private	L/11339	4 Royal Fusiliers	34	16.09.14	I.B.3
Murphy, J.C.	Private	9980	1 Queen's RWK	U	13.09.14	I.H.28
Murray, J.	Private	10901	1 Royal Scots Fus	24	01.10.14	II.E.9
Murray, Patrick	CSM	6383	2 Con Rangers	36	14.09.14	Sp Mem 2
Newland, Timothy	Private	L/9197	4 Royal Fusiliers	35	14.09.14	II.F.11
Newton, T.	Private	8098	1 Royal Berks	U	21.09.14	II.C.13
Norton, J.	Private	4319	2 Con Rangers	U	14.09.14	Sp Mem 1
Ochs, G.F.	Private	8319	2 Ox & Bucks	U	19.09.14	I.H.14

NAME	RANK	NUMBER	REGIMENT	AGE	KILLED	GRAVE/MEM REF.
Osborne, Samuel	Private	8892	2 Coldstream Gds	U	05.10.14	III.A.6A
Page, J.H.	Private	6573	2 South Lancs	U	20.09.14	Sp Mem 24
Palmer, Victor	Lance Corporal	11584	2 Grenadier Gds	24	14/16.09.14	I.E.10
Paston, George	Private	8885	1 KLR	32	21.09.14	II.E.4
Patterson, George	Drummer	86	2 Lancs Fus	86	13.09.14	IV.A.35
Patterson, S.	Sergeant	8171	2 Con Rangers	U	14.09.14	II.D.29
Pearce, S.	Private	9715	1 Royal Berks	U	22.09.14	II.C.14
Pearson, Charles	Sergeant	16495	48th Hvy Bty, RGA	34	14.09.14	IV.A.21
Peck, A.	Sergeant	8198	1 Devonshire	U	20.09.14	I.A.14
Poole, John	Private	5012	RAMC	23	14.09.14	II.A.15
Poole, William	Gunner	65098	117th Bty, RFA	20	16.09.14	I.AA.22
Portlock, Sydney	Private	3507	2 Field Amb RAMC	31	14.09.14	II.F.3
Price, C.L. DSO	Captain		2 Royal Scots	37	16.09.14	I.A.6
Quick, G.S.	Shoeing Smith	31037	128th Bty, RFA	U	16.09.14	II.B.19
Read, Arthur	2nd Lieutenant		1 Somerset	23	16.09.14	IV.G12
Reilly, P.	Private	10931	2 Con Rangers	U	14.09.14	Sp Mem 7
Reynolds, R.H.	Private	9012	2 Y&L	U	23.09.14	I.E.26
Rice, J.	Private	8198	2 Con Rangers	27	14.09.14	I.G.8
Richardson, F.	Bombardier	37078	48th Bty, RGA	U	14.09.14	IV.A.33
Riches, W.E.	Pioneer	23156	Royal Engineers	U	20.09.14	Sp Mem 35
Ridgley, Ernest	Battery Serg Maj	20267	51st Bty, RFA	40	26.09.14	I.AA.27
Riley, P.	Gunner	16498	48th Hvy Bty, RFA	U	14.09.14	IV.A.30
Rivers, Walter	Private	7914	1st Royal Berks	28	23.09.14	II.C.12
Roberts, A.	Driver	17079	Royal Engineers	U	29.09.14	II.G.21
Rodger, J.	Lance Corporal	6910	1 Cam Highlanders	U	25.09.14	II.C.20
Rodgers, P.	Private	3048	1 Irish Guards	U	14.09.14	II.H.10
Roe, Eric	Private	14367	2 Grenadier Gds	21	14/16.09.14	I.F.30
Rowden, Herbert	Sapper	17191	Royal Engineers	27	14.09.14	Sp Mem 36
Rowe, John	Private	4101	RAMC	30	14.09.14	II.A.14
Rymell, W.F.	Private	8006	2 South Lancs	U	20.09.14	IV.A.14
Sables, W.	Private	10319	1 Coldstream Gds	20	16.09.14	I.D.16
Sarsfield, William	Major		2 Con Rangers	48	20.09.14	II.C.11
Saunders, H.N.	Pioneer	23719	Royal Engineers	U	14.09.14	Sp Mem 37
Saunders, S.F.	Private	9955	2 Ox & Bucks	U	16.09.14	I.H.7
Savage, Frederick	Driver	42252	55th Bty, RFA	U	15.09.14	II.D2
Scott, J.	Gunner	42668	48th Hvy Bty, RGA	U	14.09.14	IV.A.23
Sexton, Arthur	Corporal	31571	48th Bty, RFA	U	15.09.14	I.E.2
Sexton, Bertram	Staff Sergeant Farrier	1415	48th Bty, RFA	34	14.09.14	1.E.1
Smith, E.J.	Corporal	8534	2 Ox & Bucks	U	16.09.14	1.H.1
Smith, Edward	Lance Corporal	16453	2 Grenadier Gds	20	14/16.09.14	1.D.7
Smith, G.J.	Private	7253	1 Roy.Scots Fus	U	16.09.14	I.B.13
Smith, J.	Private	5197	1 Cam Highlanders	32	25.09.14	II.F.4
Smith, W.R.	Corporal	9360	2 Ox & Bucks	32	19.09.14	I.H.8
Souster, Charles	Sapper	22783	Royal Engineers	21	13.09.14	I.C.16
Spreckley, Ralph MC	Lieutenant		2 Con Rangers	21	14.09.14	Sp Mem 6
Stagg, R.J.	Private	6080	1 Wiltshire Rgt	U	22.09.14	Sp Mem 11
Stairmand, B.	Sergeant	D/3177	2 Dragoon Guards	28	12.09.14	II.A.28
Staunton, Henry	Corporal	10555	2 Worcestershire	25	23.09.14	II.E.3
Steers, Alfred	Lance Corporal	7808	2 Coldstream Gds	U	14.09.14	II.B.1
Stevens, W.	Private	7529	2 Ox & Bucks	U	18.09.14	I.H.15
Stokes, S.	CQS	6941	2 Con Rangers	U	14.09.14	I.G.1
Stone, Thomas	Private	5880	3 Coldstream Gds	U	14.09.14	II.D.24

NAME	RANK	NUMBER	REGIMENT	AGE	KILLED	GRAVE/MEM REF.
Stringer, Lewis	Private	5005	1 Coldstream Gds	U	27.09.14	II.F.10
Stringfellow, R.	Private	8334	15 (The King's)	21	13.09.14	II.D.3
Styles, John	Private	6484	1 Coldstream Gds	U	14.09.14	I.B.28
Tanner, H.	Private	7004	1 Wiltshire Rgt	U	15.09.14	Sp Mem 18
Targett, Ernest	Private	9109	1 Devonshire	24	21.09.14	I.B.14
Teeling, Ambrose	Lieutenant		1 Norfolk Regiment	22	24.09.14	I.E.11
Thomas, F.J.	Private	7556	1 DOCLI	U	24.09.14	II.G.20
Thomas, Rhys MC MID	Lieutenant		1 Con Rangers	24	14.09.14	I.G.9
Thompson, Arthur	Gunner	35387	48th Hvy Bty, RGA	23	14.09.14	IV.A.31
Thompson, Walter	Private	4843	2 Coldstream Gds	U	16.09.14	I.F.4
Tilbury, J.R.	Private	7476	2 Ox & Bucks	27	04.10.14	I.H.19
Tomlinson, G.F.	Rifleman	6544	1 KRRC	U	16.09.14	II.C.2
Tottie, Eric	Captain		1 Northumberland	19	22.09.14	II.D.16
Town, Young	Private	7944	1 The Buffs	30	22.09.14	Sp Mem 40
Townsend, Henry	Rifleman	2714	1 KRRC	34	16.09.14	II.C.5
Vaughan, J.	Rifleman	7232	2 Royal Irish Rifles	U	20.09.14	II.D.18
Wadsworth, W.	Acting Bombardier	39410	36 Bde HQ RFA	U	14.09.14	I.E.7
Wallace, David	2nd Lieutenant		2 South Lancs	24	19.09.14	Sp Mem 21
Walters, E.J.	Gunner	51629	48 Bty, RFA	U	15.09.14	I.E.4
Ward, J.	Rifleman	5269	1 KRRC	U	16.09.14	II.C.8
Warner, W.	Private	7663	2 Ox & Bucks	U	25.09.14	II.B.7
Watson, Ernest	2nd Lieutenant		2 South Lancs	24	19.09.14	Sp Mem 22
Watts, W.J.	Sergeant	7178	1 DOCLI	28	15.09.14	II.G.7
Wheeler, W.	Lance Corporal	7486	2 Ox & Bucks	29	16.09.14	I.H.2
Wheeler, H.S.	Lance Corporal	L/8706	1 Queen's (RWSR)	U	18.09.14	I.AA.23
Whitehorn, A.S.	Private	7193	1 Queen's RWK	29	18.09.14	II.G.12
Whitenall, J.	Private	8272	1 Royal Scots Fus	U	16.09.14	II.F.29
Whyard, W.	Gunner	26023	48 Hvy, Bty RGA	U	14.09.14	IV.A.22
Wilkins, A.	Bandsman	9484	1 Royal Scots Fus	23	27.09.14	I.B.11
Wilson, J.T.	Private	8393	2 Ox & Bucks	30	19.09.14	I.H.11
Wilson, Frederick	Private	17174	RAMC	36	14.09.14	II.A.13
Wilson, Arthur	Private	9755	2 Coldstream Gds	U	19.09.14	III.A.3A
Wiltshire, E.H.	Pioneer	24547	Royal Engineers	U	20.09.14	Sp Mem 38
Wooldridge, Alfred	Gunner	67738	65 Bty, RFA	U	13.09.14	II.G.16
Woolford, Frederick	Driver	68063	117 Bty, RFA	22	23.09.14	I.AA.26
Wortley, Fred	Lance Corporal	9946	1 Coldstream Gds	U	14.09.14	I.F.9
Wright, Theodore VC	Captain		Royal Engineers	31	14.09.14	II.B.21
Young, Charles	Corporal	52957	129th Bty, RFA	25	20.09.14	II.A.17

APPENDIX 9

BEF SOLDIERS BURIED IN VENDRESSE BRITISH CEMETERY

NAME	RANK	NUMBER	REGIMENT	AGE	KILLED	GRAVE/MEM REF.
Ainslie, J.	Rifleman	5920	1 KRRC	31	17.09.14	III.D.7
Aldridge, Reginald	Captain		2 Royal Sussex Rgt	37	07.10.14	IV.J.2
Allen, A.O.	Private	9389	1 Northamptonshire	U	15.09.14	III.B.3
Applin, J.E.	Corporal	43058	50 Bty, RFA	U	20.09.14	IV.C.2
Ashton, T.	Private	9189	1 KLR	U	27.09.14	III.AA.3
Ashton, Wilfred	Sergeant	7157	2 KRRC	29	14.09.14	Troyon Ch Mem 46
Askew, J.	Private	L/9678	2 Royal Sussex	U	07.10.14	Troyon Ch Mem 26
Bakewell, J.E.	Corporal	50679	51 Bty, RFA	U	26.09.14	II.E.2
Baldwin, K.	Gunner	76500	48 Bty, RFA	U	14.09.14	III.E.4
Barker, F.	Rifleman	7756	2 KRRC	28	17.09.14	I.J.16
Bate, Percy	Gunner	75834	44 Bdg, RFA	18	27.09.14	III.D.8
Benison, Robert	2nd Lieutenant		2 Con Rangers	23	20.09.14	III.C.7
Bentley, F.J.	Private	L/8577	1 Queen's (RWSR)	28	24.09.14	Troyon Ch Mem 22
Berry, H.	Private	10926	2 HLI	U	19.09.14	IV.D.7
Blackman, G.	Private	L/8043	2 Royal Sussex	U	14.09.14	I.J.13
Blackman, Walter	Rifleman	943	2 KRRC	33	01.10.14	Troyon Ch Mem 13
Blathwayt, Gerald	Captain		56t Bty, RFA	35	14.09.14	III.C.9
Boag, A.E.	Sergeant	6506	2 KRRC	32	16.09.14	Troyon Ch Mem 45
Bond, Robert	Lieutenant		2 KRRC	32	14.09.14	III.K.6
Bond. William	Bombardier	30588	13 Bdg, RFA	34	25.09.14	I.D.16
Boselle, H.	Driver	56235	114 Bty, RFA	U	24.09.14	I.D.15
Bourne, W.A.	Private	9890	2 Worcestershire	U	14.09.14	IV.E.7
Bradshaw, Joseph	Gunner	5770	50 Bty, RFA	35	19.09.14	II.G.3
Bramwell, P.	Sergeant	33916	40 Bty, RFA	26	04.10.14	II.D.15
Broadley, Percy	Acting Bombardier	68024	34 Bdg, RFA	U	18.09.14	III.E.1
Brown, E.	Private	8259	1 Loy North Lancs	U	14.09.14	II.H.18
Brown, Jospeh	Rifleman	2473	1 KRRC	32	16.09.14	IV.D.4
Brown, J.	Private	10369	1 Coldstream Gds	U	20.09.14	Chamouille Ger Cem Mem 8
Buchan, John	Corporal	5156	1 Scots Guards	30	15.10.14	I.G.8
Buckland, William	Private	6875	1 Coldstream Gds	U	16.09.14	Troyon Ch Mem 38
Burton, C.	Private	11930	2 Sherwood For	23	21.09.14	Troyon Ch Mem 30
Burton, N.J.	Gunner	31269	56 Bty, RFA	30	14.09.14	IV.E.5
Cameron, R.	Private	7017	1 Loy North Lancs	U	14.09.14	II.H.3
Campbell, Allan	Lieutenant		Coldstream Gds	29	20.09.14	III.J.9
Carr, Martin	Captain		2 Worcestershire	37	18.09.14	III.C.5
Carr, W.	Private	11477	1 KLR	U	18.09.14	III.AA.3
Carroll, W.	Sergeant	20428	118th Bty, RFA	29	20.09.14	I.D.8
Castleton, George	QMS	27899	Royal Engineers	35	15.09.14	II.B.15
Charlton, John	Private	8364	2 DLI	33	21.09.14	Troyon Ch Mem 15
Cheetham, John	Private	9227	2 South Staffs	31	15.09.14	II.AA.1

NAME	RANK	NUMBER	REGIMENT	AGE	KILLED	GRAVE/MEM REF.
Clark, H.	Rifleman	1195	2 KRRC	U	14.09.14	I.A.11
Clarke, John MC	Lieutenant		50 Bty, RFA	24	14.09.14	III.AA.1
Coker, John	Lieutenant		1 SWB	27	26.09.14	I.B.8
Cole, George	Private	7866	East Yorks	28	21.09.14	Troyon Ch Mem 33
Cook, Fred	Private	8921	1 Coldstream Gds	24	19.09.14	Troyon Ch Mem 41
Cook, Frederick	Rifleman	765	3 Rifle Brigade	26	25.09.14	IV.G.1
Cottrill, John	Private	10085	2 Worcestershire	26	21.09.14	IV.C.1
Crowhurst, J.T.	Gunner	64078	RFA	U	08.10.14	II.D.16
Cunningham, Thomas	Sergeant	7391	1 Cam Highlanders	26	14.09.14	I.D.11
Daly, J.	Private	6680	1 Queen's (RWSR)	U	03.10.14	II.K.11
Davy, H.	Driver	24212	Royal Engineers	U	14.09.14	IV.E.4
Davis, F.	Private	12018	2 Worcestershire	U	15.09.14	IV.C.6
Davison, S.	Lieutenant		2 KRRC	U	14.09.14	I.J.14
Delaney, P.	Private	2556	1 Black Watch	18	15.09.14	II.H.16
Dennis, J.	Private	L/7967	1 Queen's (RWSR)	U	29.09.14	Troyon Ch Mem 20
Dennison, W.	Private	7683	1 Cam Highlanders	U	14.09.14	III.E.9
Denyer, A.	Private	L/8555	2 Royal Sussex	U	14.09.14	Chamouille Ger Cem Mem 6
Derry, W.	Private	11343	2 KRRC	U	14.09.14	III.B.6
Dicks, Arthur	Lance Corporal	4415	2 KRRC	28	14.09.14	Troyon Ch Mem 44
Doe, A.	Private	L/9525	2 Royal Sussex	U	07.10.14	Troyon Ch Mem 27
Dooley, Edward	Rifleman	7053	2 KRRC	25	17.09.14	I.K.11
Doyle, T.	Private	10461	1 KLR	24	14.09.14	III.AA.3
Dray, H.	Rifleman	4481	1KRRC	U	16.09.14	III.D.4
Dye, T.H.	Private	7448	1 East Yorks	U	24.09.14	Troyon Ch Mem 36
Ede, Wallace	Private	L/6988	Queen's (RWSR)	30	26.09.14	Troyon Ch Mem 21
Edwardes, Charles	Private	7457	1 Coldstream Gds	24	29.09.14	Troyon Ch Mem 40
Eggar, William	Private	L/8275	1 Queen's (RWSR)	27	16.09.14	Special Memorial
Eggleton, C.H.	Lance Corporal	10822	2 KRRC	U	17.09.14	IV.K.7
Elder, C.	Sergeant	7903	2 HLI	29	20.09.14	I.E.15
Ellis, F.	Private	6103	2 South Staffs	U	15.09.14	II.AA.1
Fogden, John	Sergeant	5330	1 KRRC	27	17.09.14	III.D.10
Fordham, F.F.	Rifleman	10457	2 KRRC	U	18.09.14	Troyon Ch Mem 43
Forsyth, W.	Lance Corporal	2358	1 Black Watch	21	16.09.14	Sp Mem 1
Fossey, Oliver	Private	9834	1 Northanptonshire	19	18.09.14	II.K.4
Fox, M.	Private	7132	2 South Staffs	U	15.09.14	II.AA.1
Foy, Martin	Captain		1 Queen's (RWSR)	35	13.10.14	III.C.8
Francke, Frederick	Lance Corporal	9059	1 Coldstream Gds	24	14.09.14	III.J.3
Frost, Lindsay	Private	8263	1 KLR	35	14.09.14	III.AA.3
Furse, George	Captain		44 Bty, RFA	34	16.09.14	III.C.1
Gardine, H.	Lance Corporal	5288	1 KRRC	U	17.09.14	IV.D.5
George, E.	Private	4565	3 KO Hussars	19	13.09.14	II.E.1
Giffen, G.	Private	8334	1 Cam, Highlanders	U	14.09.14	III.F.10
Gilkison, Dugald	Captain		Cam Scot Rifles	32	20.09.14	III.C.6
Goode, Thomas	Private	9428	2 Sherwood For	30	28.09.14	I.AA.5
Gray, A.H.	Lance Corporal	7425	1 Gloucestershire	32	16.09.14	Chivy Ger Cem Mem 12
Greene, A.E.J.	Sergeant	10305	1 KLR	U	21.09.14	IV.C.5
Griffith, A.	Private	L/8254	2 Royal Sussex	U	28.09.14	Troyon Ch Mem 23
Grott, J.	Private	9594	1 Cam Highlanders	U	14.09.14	IV.G.5
Haggard, Mark	Captain		2 Welsh Regiment	38	15.09.14	I.G.11
Hargreaves, Harold	Private	10177	1 Coldstream Gds	20	14.09.14	II.J.3

NAME	RANK	NUMBER	REGIMENT	AGE	KILLED	GRAVE/MEM REF.
Harris, S.E.	Private	990	2 Welsh Regiment	U	14.10.14	III.E.8
Harris, T.	Bombardier	68961	51st Bty, RFA	U	27.09.14	II.E.3
Hartley, Arnold	Private	8514	1 East Yorks	29	26.09.14	I.G.13
Harvey, N.	Private	7932	1 East Yorks	U	21.09.14	Troyon Ch Mem 35
Hemming, A.E.	Private	7143	1 Gloucestershire	U	26.09.14	Troyon Ch Mem 18
Henriques, Ronald	Lieutenant		1 Queen's (RWSR)	30	14.09.14	IV.H.1
Hillier, A.C.	Private	9903	3 KO Hussars	21	18.09.14	II.D.20
Hogg, A.	Private	5342	1 Scots Guards	32	06.10.14	I.C.6
Hogg, F.	Private	8033	1 Gloucestershire	26	16.09.14	Chivy Ger Cem Mem 10
Holland, Alfred	Private	8636	1 East Yorks	27	20.09.14	Troyon Ch Mem 34
Hooker, W.	Private	10013	1 Coldstream Gds	U	14.09.14	IV.H.8
Hopkins, F.	Driver	13692	Royal Engineers	U	15.09.14	IV.D.10
Hunt, Reginald	Private	6859	1 Gloucestershire	U	27.09.14	IV.J.6/7
Hunt, W.	Lance Corporal	7014	1 KRRC	27	27.09.14	III.D.6
Hurst, George	Private	L/8491	1 Queen's (RWSR)	U	28.09.14	IV.J6/7
Hutchison, James	Lance Corporal	7539	1 Cam Highlanders	27	14.09.14	I.F.17
Huxley, C.	Private	6975	2 South Staffs	U	15.09.14	I.G.5
James, W.H.	Driver	72368	47th Bty, RFA	U	18.09.14	III.E.2
Jarman, H.	Private	9025	1 SWB	U	15.09.14	IV.E.3
Jenkinson, John	Captain		Rifle Brigade	33	14.09.14	I.C.17
Johnson, E.F.	Private	6841	1 Coldstream Gds	26	14.09.14	III.I.9
Johnson, Mervyn	Lieutenant		1 SWB	28	14.09.14	I.C.18
Johnson, T.	Private	7121	1 East Yorks	U	20.09.14	II.J.12
Johnstone, J.	Private	12014	2 HLI	U	17.09.14	IV.C.9
Jones, E.E.	Private	10146	1 Coldstream Gds	U	25.10.14	III.G.5
Jones, W.	Private	8545	1 Loy North Lancs	U	28.09.14	Troyon Ch Mem 14
Keeble, Robert	Private	23134	Royal Engineers	22	16.09.14	I.C.19
Kelly, T.A.	Private	10547	1 Loy North Lancs	24	14.09.14	III.I.10
Ker, Cecil	Captain		1 Bedfordshire	30	15.09.14	I.AA.2
Kerrich, John	Major		2 Welsh Regiment	40	14.09.14	II.J.1
Kidd, G.	Private	7980	2 HLI	U	15.09.14	IV.E.1
Kirk, Randal	Private	8716	1 Coldstream Gds	29	27.09.14	III.F.8
Lacey, T.	Gunner	18870	2 Siege Bty, RGA	22	25.09.14	I.G.10
Laing, G.M.	Private	6813	1 Cam Highlanders	33	14.09.14	Cerny Ger Cem Mem 3
Lang, J.	Private	9610	2 HLI	U	19.09.14	IV.C.7
Lea, Gerald	Captain		2 Worcestershire	37	16.09.14	III.C.2
Ledbury, W.	Sergeant	8252	1 Loy North Lancs	36	14.09.14	II.K.1
Linton, William	Private	7162	1 East Yorks	34	2 0.09.14	Cerny Chy Mem 2
Lygo, A.	Private	10450	2 HLI	U	20.09.14	IV.C.3
Maccabee, W.E.	Private	L/7379	2 Royal Sussex	34	07.10.14	Troyon Ch Mem 25
Mackenzie, Colin	2nd Lieutenant		2 HLI	22	20.09.14	I.E.8
Mackenzie, D.D.	Lance Corporal	9525	1 Cam Highlanders	20	14.09.14	IV.E.9
Malthouse, J.S.	Private	7011	2 South Staffs	U	15.09.14	II.AA.1
Mander, D'Arcy	Major		2 DLI	51	20.09.14	II.J.7
Manley, C.E.	Private	11235	1 KLR	U	14.09.14	III.AA.3
Mann, A.	Private	9975	1 KLR	U	14.09.14	III.AA.3
Manning, L.W.	Private	7433	1 Northamptonshire	U	17.09.14	IV.K.4
Marney, J.	Private	10406	1 KLI	U	14.09.14	III.AA.3
Marsh, F.E.	Driver	58522	34 Bde, RFA	U	14.09.14	IV.E.2
Mason, William	Gunner	75401	57Bty, RFA	U	20.09.14	I.D.10
McHale, J.P.	Private	9425	1 KLR	U	14.09.14	III.I.6

NAME	RANK	NUMBER	REGIMENT	AGE	KILLED	GRAVE/MEM REF.
McQueen, J.	Private	3185	1Loy North Lancs	29	14.09.14	Chamouille Ger Cem Mem 7
Meautys, Thomas	Lieutenant		1 West Yorks	25	22.09.14	III.J.10
Meiklejohn, Kenneth	Lieutenant		1 Cam Highlanders	29	25.09.14	III.C.4
Meredith. George	Private	8558	1 SWB	27	18.09.14	IV.C.4
Miller, William	Gunner	44320	43rd Bdg, RFA	27	27.09.14	I.D.13
Missett, James	Colour Sergeant	6564	1 West Yorks	28	20.09.14	Troyon Chy.Mem 17
Mitchell, Archibald	Private	9012	1 Cam Highlanders	U	17.09.14	I.C.20
Moore, E.	Private	8840	1 Loy North Lancs	U	14.09.14	II.K.6
Moore, A.T.	Corporal	44910	22 Bty, RFA	U	15.09.14	III.D.1
Mustchin, J.	Lance Corporal	L/8847	2 Royal Sussex	U	07.10.14	Troyon Ch Mem 18
Neill, C.E.	Corporal	425	1 Black Watch	23	15.09.14	I.J.2
Nesbitt, John	Sergeant	571	1 KRRC	34	16.09.14	IV.C.8
Newman, Henry	Private	7861	1 Loyal North Lancs	27	24.09.14	III.F.3
Newton, W.	Lance Corporal	3313	6 Dragoon Guards	U	15.09.14	I.D.12
Noble, Alexander	Lance Corporal	9398	1 Cam Highlanders	20	05.10.14	III.B.10
Norrie, W.	Private	7643	1 Cam Highlanders	U	14.09.14	Chivy Ger Cem Mem 9
O'Connell, John	Lieutenant		RAMC	25	20.09.14	I.E.10
Paradise, J.	Private	9397	1 Loy North Lancs	U	14.09.14	II.H.2
Parish, George	Private	9346	2 Welsh Regiment	28	17.09.14	Les Paradis Ger Cem Mem 4
Payne, A.G.	Private	L/6670	2 Royal Sussex	U	26.09.14	III.F.4
Peacock, A.E.R.	Private	3/8607	1 Northamptonshire	U	16.10.14	II.G.4
Pelham, The Hon Herbert	Lieutenant		2 Royal Sussex	30	14.09.14	I.C.15
Pellett, H.	Private	9782	2 Royal Sussex	U	29.09.14	II.J.14
Pepys, Reginald	Captain		2 Worcestershire	U	21.09.14	III.C.10
Pettit, Charles	Private	9449	1 SWB	27	26.09.14	II.C.5
Pollard, Frank	Private	8764	2 Worcestershire	26	20.09.14	III.E.3
Poole, J.	Rifleman	2586	2 KRRC	U	14.09.14	III.B.1
Popham, A.J.	Private	6973	2 Welsh Regiment	U	19.09.14	Chivy Ger Cem Mem 11
Powell, Rhys	2nd Lieutenant		2 HLI	22	14.09.14	Sp Mem 2
Price, H.E.	Rifleman	9009	2 KRRC	24	14.10.14	I.K.1A
Pullen, A.	Private	9840	2 Royal Sussex	U	14.09.14	III.A.1
Purcell, J.	Private	3/5840	1 Cam Highlanders	U	11.10.14	I.B.9
Pye, K.	Private	10632	1 Loy North Lancs	U	14.09.14	1.J.10
Rankin, W.W.	Driver	50899	3rd Bde RHA	U	27.09.14	III.E.6
Read. Frank	Private	8433	1 Coldstream Gds	23	14.09.14	IV.G.2
Relton, Gerald	2nd Lieutenant		1 East Surrey	23	14.09.14	I.AA.3
Reynolds, J.	Private	9744	2 HLI	26	19.09.14	IV.D.8
Richardson, W.	Private	8045	1 West Yorks	U	25.09.14	Troyon Ch Mem 31
Rix, W.E.	Private	11375	2 DLI	U	21.09.14	IV.J.10
Robb, Alexander	Major		2 DLI	42	20.09.14	I.K.5
Robinson, E.	Corporal	7677	2 South Lancs	U	20.09.14	I.D.14
Rowland, R.D.	Driver	16172	Royal Engineers	U	15.09.14	II.B.16
Roylance, J.	Lance Corporal	11870	2 HLI	U	17.09.14	III.D.9
Sansome, W.	Private	L/6597	2 Royal Sussex	U	27.09.14	IV.H.7
Scarfe, B.E.	Private	8423	1 Coldstream Gds	U	29.09.14	Troyon Ch Mem 39
Sharp, F.	Private	9376	1 Northamptonshire	U	18.09.14	Troyon Ch Mem 19
Sharrock, J.	Drummer	11319	1 KRRC	U	18.09.14	III.AA.3
Shawley, P.	Private	9774	1 Northamptonshire	U	17.09.14	IV.B.5
Sheridan, L.	Private	7275	1 Cam Highlanders	U	14.09.14	IV.G.6

NAME	RANK	NUMBER	REGIMENT	AGE	KILLED	GRAVE/MEM REF.
Sidwell, Ernest	Private	9043	1 KRRC	U	15.09.14	IV.D.9
Simmons, R.	Private	8416	2 Worcestershire	U	15.09.14	III.D.2
Simpson, M.	Sergeant	9564	114th Bty RFA	35	20.09.14	I.D.7
Sims, W.J.	Private	10651	2 Welsh Regiment	U	26.09.14	I.D.4
Slater, Leonard	Captain		2 Royal Sussex	38	14.09.14	I.C.12
Smith, A.W.	Rifleman	7463	1 KRRC	U	17.09.14	IV.D.6
Smith, J.	Private	7323	1 Black Watch	U	15.09.14	III.G.9
Smith, E.	Private	8505	2 DLI	U	21.09.14	Troyon Ch Mem 16
Smith, W.	Private	6680	1 East Yorks	U	24.09.14	Troyon Ch Mem 37
Smythe, Frederick	2nd Lieutenant		2 Worcestershire	20	18.09.14	III.C.3
Snartt, Richard	Lance Corporal	11903	2 Sherwood For	20	21.09.14	Troyon Ch Mem 29
Stevens, T.E.	Rifleman	3041	2 KRRC	30	14.09.14	I.J.5
Stinchcombe, W.J.	Private	9741	1 Gloucestershire	19	16.09.14	III.A.6
Stocks, B.	Private	6819	1 Northamptonshire	U	17.09.14	I.A.12
Swanwick, Russell	Lieutenant		1 Gloucestershire	29	14.09.14	III.K.4
Sygrove, C.W.	Private	L/7311	2 Royal Sussex	42	14.09.14	I.A.7
Tarling, William	Private	L/8451	2 Royal Sussex	27	07.10.14	Troyon Ch Mem 24
Taylor, Albert	Driver	54863	54th Bty, RFA	U	26.09.14	II.D.17
Theobald, Charles	Private	6147	1 Queen's (RWSR)	37	03.10.14	Verneuil Ch Mem 1
Thirst, C.J.	Rifleman	11213	1 KRRC	U	19.09.14	II.K.5
Thomas, Daniel	Private	9001	2 Welsh Regiment	U	17.09.14	Les Paradis Ger Cem Mem 5
Thomas, Edward	Private	7286	2 Welsh Regiment	U	16.09.14	IV.G.3
Thompson, J.	Private	7268	1 East Yorkshire	U	24.09.14	IV.J.8/9
Thompson, James	Private	8097	1 Loy North Lancs	29	14.09.14	I.J.7
Thomson, William	Private	6095	1 Cam Highlanders	29	14.09.14	I.F.15
Todd, J.W.S.	Driver	18411	Royal Engineers	23	15.09.14	III.D.3
Traynor, Thomas	Bombardier	71866	47th Bty, RFA	U	23.09.14	II.F.13
Turk, F.	Rifleman	10949	1 KRRC	17	30.09.14	III.D.5
Ullathorne, J.	Private	9157	2 HLI	U	17.09.14	IV.D.2
Waller, R.J.	Lance Corporal	7164	1 Queen's (RWSR)	U	09.10.14	IV.E.6
Walsh, Joseph	Private	7919	1 East Yorkshire	25	21.09.14	Troyon Ch Mem 32
Warn, E.	Lance Corporal	6602	1 Loy North Lancs	U	14.09.14	I.J.8
Wellings, S.	Private	8455	2 DLI	U	21.09.14	Troyon Ch Mem 48
Whately, Sydney	Lance Corporal	8919	1 Coldstream Gds	22	14.09.14	IV.J.4
White, Archibald	Shoe Smith	6156	11 (PAO) Hussars	22	16.09.14	I.K.1B
White, George	Drummer	8972	2 South Staffs	19	15.09.14	1.G.6
Whitefield, Albert	Sergeant	10457	2 DLI	26	21.09.14	Troyon Ch Mem 49
Whitehouse, Edward	Private	6986	2 South Staffs	U	15.09.14	II.AA.1
Whittle, J.	Private	6905	1 Loy North Lancs	U	18.09.14	Troyon Ch Mem 42
Wicks, J.	Private	L/9532	2 Royal Sussex	19	03.10.14	III.K.3
Wilkinson, John	Private	10729	2 DLI	23	21.09.14	Troyon Ch Mem 47
Wilson, F.	Corporal	7013	1 Gloucestershire	U	14.09.14	1.J.1
Wissman, John	Lieutenant		22 Bty, RFA	23	15.09.14	1.E.11
Wood, C.H.	Rifleman	11389	2 KRRC	U	19.09.14	II.K.8
Wood, G.P.	Private	8547	2 HLI	34	21.09.14	III.E.5
Wright, Neil	2nd Lieutenant		15th Bty, RFA	19	15.09.14	III.AA.2
Wynter, Hugh	Major		22nd Bty, RFA	41	15.09.14	I.E.12
Youngman, Thomas	Driver	73421	114th Bty, RFA	19	20.09.14	1.D.9

APPENDIX 10

BEF SOLDIERS BURIED IN VENDRESSE CHURCHYARD

NAME	RANK	NUMBER	REGIMENT	AGE	KILLED	GRAVE/MEM REF.
Blackmore, J.	Private	9754	1 Gloucestershire	U	16.09.14	Sp Mem 1
Bolt, R.L.	Lance Corporal	6444	1 Cam, Highlanders	U	14.09.14	Sp Mem 2
Bontoft, J.	Private	8002	1 East Yorkshire	U	29.09.14	Sp Mem 3
Callander, D.	Private	3/2256	1 Black Watch	U	03.10.14	Sp Mem 4
Carpenter-Garnier, John	Major		1 Scots Guards	40	15.09.14	1
Coultas, W.E.	Private	10189	1 East Yorks	U	29.09.14	Sp Mem 6
Coultish, George	Bombardier	66183	113th Bty, RFA	21	15.09.14	Sp Mem 7
Craig, T.	Private	7210	1 Cam, Highlanders	U	14.09.14	Sp Mem 8
Davies, Harold	Captain		2 Welsh Regiment	U	26.09.14	1
Degnan, Joseph	Private	10043	1 Coldstream Gds	23	25.09.14	Sp Mem 9
Dennis, Richard	Private	7045	1 Scots Guards	U	13.10.14	Sp Mem 10
Dodds, J.H.	Private	7960	2 DLI	U	27.09.14	Sp Mem 11
Dwyer, G.A.	Private	7065	1 Cam Highlanders	U	14.09.14	Sp Mem 12
Goodier, F.	Corporal	9904	1 East Yorks	U	29.09.14	Sp Mem 13
Grenfall, Riversdale	Captain		9th Queen's RL	34	14.09.14	1
Hawkins, E.	Private	7201	1 Cam Highlanders	U	02.10.14	Sp Mem 14
Hinton, S.	Private	6627	1 SWB	U	18.09.14	Sp Mem 15
Howe, Walter	Private	8143	2 Welsh Regiment	U	26.09.14	Sp Mem 16
Howly, E.	Private	7938	1 Loy North Lancs	U	16.09.14	Sp Mem 17
Humberstone, Walter	Private	9413	2 Welsh Regiment	U	26.09.14	Sp Mem 18
Hurley, T.	Private	9619	1 SWB	U	07.10.14	Sp Mem 19
Jack, C.	Private	7409	1 Cam Highlanders	U	09.10.14	1
Johnstone, James	Major		115 Bty, RFA	41	15.09.14	1
Kershaw, Hugo	Private	7930	1 Scots Guards	U	15.09.14	Sp Mem 20
Kirwin, R.	Private	9878	1 Black Watch	U	12.10.14	Sp Mem 21
Manley, John	2nd Lieutenant		Royal Engineers	22	26.09.14	3
Mawdesley, George	Private	7188	1 Scots Guards	24	07.10.14	Sp Mem 23
McPhee, Robert	Private	1252	1 Scots Guards	U	01.10.14	Sp Mem 22
Naylor-Leyland, G.V.	Lieutenant		Royal Horse Guards	22	21.09.14	1
Neal, William	Driver	27746	51 Bty, RFA	U	15.09.14	Sp Mem 25
Nightingale, William	Driver	56225	46 Bty, RFA	U	18.09.14	Sp Mem 26
Norton, Sidney	Private	8880	1 SWB	26	26.09.14	Sp Mem 24
Pearson, John	Private	9181	1 Coldstream Gds	U	19.09.14	Sp Mem 27
Ring, Edward	Private	4791	1 Scots Guards	29	15.09.14	Sp Mem 28
Sanders, F.	Private	7506	1 East Yorks	U	29.09.14	Sp Mem 29
Scott, E.B.	Private	9018	1 East Yorks	U	27.09.14	Sp Mem 30
Solomon, Maxwell	Private	7449	1 Scots Guards	25	14.09.14	Sp Mem 31
Vine, Richard	Private	2957	1 Scots Guards	U	01.10.14	Sp Mem 33
Waring, Richard	Private	10445	1 Loy North Lancs	19	16.09.14	Sp Mem 34
Wood, J.	CSM	5260	1 Cam Highlanders	33	14.09.14	1
Wooddeson, W.H.	Private	8891	1 SWB	U	27.09.14	Sp Mem 35
Yule, A.W.	Private	9225	1 Black Watch	U	04.10.14	Sp Mem 36

ABBREVIATIONS

2 Field Amb, RAMC	2nd Field Ambulance, Royal Army Medical Corps
13th Bdg, RFA	13th Brigade, Royal Field Artillery
15th (The King's)	15th (The King's) Hussars
16 Bty, RFA	16th Battery, 116th Brigade, Royal Field Artillery
19 Hussars	19th (Queen Alexandra's Own Royal) Hussars
22nd Bty, RFA	22nd Battery, Royal Field Artillery
40 Bty, RFA	40th Battery, 43rd Brigade, Royal Field Artillery
41 Bdg, RFA	41st Brigade, Royal Field Artillery
41 Bty, RFA	41st Battery, 42nd Brigade, Royal Field Artillery
44 Bdg, RFA	44th Brigade, Royal Field Artillery
46 Bty, RFA	46th Battery, 39th Brigade, Royal Field Artillery
47 Bty, RFA	47th Battery, 41st Brigade, Royal Field Artillery
48 Bty, RFA	48th Battery, 36th Brigade, Royal Field Artillery
48 Hvy Bty, RGA	48th Heavy Battery, Royal Garrison Artillery
49 Bty, RFA	49th Battery, 40th Brigade, Royal Field Artillery
50 Bty, RFA	50th Battery, Royal Field Artillery
51st Bty, RFA	51st Battery, 39th Brigade, Royal Field Artillery
52 Bty, RFA	52nd Battery, 39th Brigade, Royal Field Artillery
55th Bty, RFA	55th Battery, 37th Brigade, Royal Field Artillery
56th Bty, RFA	56th Battery, 44th Brigade, Royal Field Artillery
65th Bty, RFA	65th Battery, Royal Field Artillery
114 Bty, RFA	114th Battery, 25th Brigade, Royal Field Artillery
115 Bty, RFA	115th Battery, 25th Brigade, Royal Field Artillery
117 Bty, RFA	117th Battery, 28th Brigade, Royal Field Artillery
128 Bty,RFA	128th Battery, 30th Brigade, Royal Field Artillery
135 Bty, RFA	135th Battery, 32nd Brigade, Royal Field Artillery
Battery Serg, Maj	Battery Sergeant Major
Bedfordshire	Bedfordshire Regiment
Black Watch	Black Watch (The Royal Highlanders0
The Buffs	The Buffs (East Kent Regiment)
Cam Scot Rifles	Cameronians (Scottish Rifles)
CQS	Company Quartermaster Sergeant
CSM	Company Sergeant Major
Coldstream Gds	Coldstream Guards
Cam Highlanders	Cameron Highlanders
Con Rangers	Connaught Rangers
Coy	Company
Devonshire	Devonshire Regiment
DLI	Durham Light Infantry
DOCLI	Duke of Cornwall's Light Infantry
East Surrey	East Surrey Regiment
East Yorks	East Yorkshire Regiment
2nd Dragoon Gds	2nd Dragoon Guards (Queen's Bays)
5th Dragoon Gds	5th Dragoon Guards (Princess Charlotte of Wales's)
DOW	Duke of Wellington (West Riding Regiment)
Gloucestershire	Gloucestershire Regiment
Grenadier Gds	Grenadier Guards
Hvy Bty, RGA	Heavy Battery, Royal Garrison Artillery
HLI	Highland Light Infantry
KLR	The King's (Liverpool Regiment)
KRRC	King's Royal Rifle Corps
KO Hussars	King's Own Hussars
KOSB	King's Own Scottish Borderers

KOYLI	King's Own Yorkshire Light Infantry
KSLI	King's Shropshire Light Infantry
Lanc's Fus	Lancashire Fusileirs
Leicestershire	Leicestershire Regiment
Lincolnshire Rgt	Lincolnshire Regiment
Lieut	Lieutenant
2nd Lieut	2nd Lieutenant
Lieut. Col	Lieutenant Colonel
Loy North Lancs	Loyal North Lancashire Regiment
Manchester Rgt	Manchester Regiment
MID	Mentioned in dispatches
North Staffs	North Staffordshire Regiment
Northamptonshire	Northamptonshire Regiment
Northumberland	Northumberland Fusiliers
Ox & Bucks	Oxford & Buckinghamshire Light Infantry
PAO	Prince Albert's Own
QMS	Quartermaster Sergeant
Queen's Lancers	(The Queen's) Lancers
Queen's RL	Queen's Royal Lancers
Queen's RWK	Queen's Own (Royal West Kent Regiment)
Queen's (RWSR)	Queen's (Royal West Surrey) Regiment
RAMC	Royal Army Medical Corps
RE	Royal Engineers
RHA	Royal Horse Artillery
Royal Inniskilling	Royal Inniskilling Fusiliers
Royal Berks	Royal Berkshire Regiment
Royal Scots Fus	Royal Scots Fusiliers
Royal Sussex	Royal Sussex Regiment
RSM	Regimental Sergeant Major
Sherwood For	Sherwood Foresters (Notts & Derby Regiment)
Somerset	Somerset Light Infantry
South Lancs	South Lancashire Regiment
South Staffs	South Staffordshire Regiment
Sp Mem	Special Memorial
SWB	South Wales Borderers
The Hon	The Honourable
West Yorks	West Yorkshire Regiment (Prince of Wales's Own)
Wiltshire Rgt	Wiltshire Regiment
Worcestershire	Worcestershire Regiment
Y&L	York & Lancaster Regiment

BIBLIOGRAPHY

PUBLISHED SOURCES

Anon, *The Battle of the Aisne, 13th–15th September 1914: Tour of the Battlefield* (HMSO, 1935)

Anon, *Deeds that Thrill the Empire* (Standard Art Book Company Ltd, 1918)

Anon, *Harrow Memorials of the Great War* Volume 1 (1918)

Anon, *Northamptonshire Regiment 1914–1918* (1932, republished by Naval & Military Press, 2005)

Anon, *Wellington Year Book of 1914* (1914)

Anon, *Wonderful Stories: Winning the V.C. in the Great War* (Hutchinson, 1920)

Atkinson, C.T., *The History of the South Wales Borderers 1914–1918* (The Medici Society, 1931)

Atkinson, C.T., *The Queen's Own Royal West Kent Regiment, 1914–1919* (Simpkin, Marshall, Hamilton, Kent & Co., 1924)

Atkinson, C.T., *Royal Hampshire Regiment 1914–1918* (Naval & Military Press, 2004)

Baumgarten-Crusius, Generalmajor Artur, *Die Marneschlacht 1914* (1919, republished by Kessinger Publishing, 2010)

Berkeley, R., *The History of the Rifle Brigade 1914–1918* (The Rifle Brigade Club, 1927)

Bladensburg, Lieutenant-Colonel Sir John Ross of, *The Coldstream Guards 1914–1918* (Oxford University Press, 1928)

Bloem, Walter, *The Advance From Mons 1914* (Peter Davies Ltd, 1930)

Bolwell, F.A., *With a Reservist in France* (E.P. Dutton & Co., 1917)

Brown, R. Baker, *The History of the Corps of Royal Engineers* Volume V (Institution of Royal Engineers, 1952)

Cassells, Scout Joe, *The Black Watch: A Record in Action* (1918, republished by BiblioBazaar, 2009)

Clutterbuck, L.A., *Bonds of Sacrifice: August to December 1914* (1915, republished by Naval & Military Press, 2002)

Congreave, Billy, *Armageddon Road* (William Kimber, 1982)

Craster, J.M., *Fifteen Rounds A Minute: The Grenadiers at War* (Book Club Associates, 1976)

Creagh, Sir O'Moore and E.M. Humphris, *The Distinguished Service Order 1886–1915* (1924, republished by Savannah Publications, 1978)

De Ruvigny, Marquis, *De Ruvigny's Roll of Honour, 1914–1918* (1922, republished by Navy and Military Press, 2007)

Edmonds, Brigadier-General J.E., *The Official History of the War Military Operations: France & Belgium 1914* Volume 1 (Macmillan & Co, 1933)

Falls, Captain Cyril, *The History of the First Seven Battalions: The Royal Irish Rifles in the Great War* (Gale & Poleden, 1925)

Finnnegan, Terrence J., *Shooting the Front: Allied Aerial Reconniassance in the First World War* (Spellmount, 2011)

French, Field Marshal Viscount, *1914* (Houghton Mifflin Company, 1919)

Giles, John, *The Western Front Then & Now: From Mons to the Marne and Back* (After the Battle, 1992)

Gleichen, Brigadier-General Count, *The Doings of the Fifteenth Infantry Brigade* (William Blackwood & Sons, 1917)

Gough, General Sir Hubert, *Soldiering On* (Arthur Baker, 1954)

Hamilton, Lord Ernest, *The First Seven Divisions* (Hurst & Blackett Ltd, 1916)

Hammerton, Sir John (ed) *The Great War, I Was There* (The Almalgamated Press, 1938)

Hampshire Regimental Journal

Hare, Major-General Sir Stuart, *The Annals of the King's Royal Rifle Corps* (1932, republished by Naval & Military Press, 2003)

Heathcote, T.A., *The British Field Marshals 1736–1997* (Leo Cooper, 1999)

Holmes, Richard, *Tommy: The British Soldier on the Western Front 1914–1918* (Harper Perennial, 2004)

Holmes, Richard, *The Western Front* (BBC Books, 1999)

Kipling, Rudyard, *The Irish Guards in the Great War* (Macmillan & Co, 1923)

Laffin, John, *A Western Front Companion* (Sutton Publishing, 1994)

Nicholson, Sir C.L. and H.T. MacMullen, *The History of the East Lancashire Regiment 1914–1918* (Littlebury, 1939)

Macdonald, Lyn, *1914: The Days of Hope* (Michael Joseph, 1987)

Marden, Major-General Sir Thomas, History of the Welch Regiment 1914–1918 (1931, republished by Naval & Military Press, 2002)

O'Neill, H.C., *The Royal Fusiliers in the Great War* (1922, republished by Naval & Military Press, 2002)

Ponsonby, Lieutenant-Colonel Sir Frederick, *The Grenadier Guards in the Great War* (Macmillan & Co, 1920)

Putowski, Julian and Julian Sykes, *Shot at Dawn* (Wharncliffe Publishing, 1989)

Simpson, Major-General C.R., *The History of the Lincolnshire Regiment 1914–1918* (The Medici Society, 1931)

US War Department, *Histories of Two Hundred & Fifty One Divisions of the German Army Which Participated in the War (1914–1918)* (1920, republished by Naval & Military Press, 2001)

Watkins, Chaplain Owen, *With French in France & Flanders* (Charles Kelly, 1915)

Wauchop, General A.G., (ed) *A History of the Black Watch in the Great War 1914–1918* (The Medici Society, 1925)

Westlake, Ray, British Battalions in France & Belgium 1914 (Leo Cooper, 1997)

Winnifrith, Reverend Douglas, *The Church in the Fighting* (Hodder & Stoughton, 1915)

Wylly, Colonel H.C., *The History of the 1st Loyal North Lancashire Regiment 1914–1919* (1933, republished by Naval & Military Press, 2007)

Wylly, Colonel H.C., *1st and 2nd Battalions the Sherwood Foresters (Nottinghamshire and Derbyshire Regiment) in the Great War* (Gale and Ponden, 1925)

Wyrall, Everard, *The Gloucestershire Regiment in the War, 1914–1918* (1931, republished by Naval & Military Press, 2003)

Wyrell, Everard, *The History of the Duke of Cornwall's Light Infantry 1914–1918* (1932, republished by Naval & Military Press, 2004)

Wyrall, Everard, *The History of the King's Regiment (Liverpool) 1914–1919* (1928, republished by Naval & Military Press, 2002)

NEWSPAPERS AND JOURNALS

Ayr Advertiser, 24 September, 1 October 1914

Ayrshire Post, 2 October 1914

Ballymena Observer, 6, 14, 20 November 1914

Brighton Herald, 26 September 1914

Brighton & Hove & South Sussex Graphic, September 1915

Cambridge Review, 1914

The Graphic, 17 October 1914

Harrovian War Supplement, November 1914

Highland News, 3, 31 October 1914

Highland Times, 8, 15, 29 October 1914

Kettering Leader, 2, 16, 30 October, 6 November 1914

Larne Times, 17, 31 October 1914 and 7 November 1914

London Gazette 28968, 6 November 1914

London Gazette 28976, 13 November 1914

London Gazette 28983, 20 November 1914

London Gazette 28985, 24 November 1914

London Gazette 28992: 1 December 1914

London Gazette 28998, 4 December 1914

London Gazette 29001, 8 December 1914

London Gazette 29095, 9 March 1915

London Gazette 29135, 16 April 1915

Northampton Independent, 26 September, 3, 17, 24, 31 October, 7 November 1914

Northampton Mercury, 2, 9 October 1914

Notts Local News, 28 November 1914

Observer, 30 September 1914

Penny War Weekly, 10 October 1914

People's Journal, 3, 10 October 1914

People's Journal (Aberdeen City Edition), 3 October 1914

Preston Herald, 7 October 1914
Preston Guardian, 14 October 1914
Rushden Echo, 9 October 1914
Sussex Daily News, 19, 28, 30 September, 20 October 1914, 14 January 1915
South Wales Daily Post 24 and 30 September, 6, 7, 8, 12, 21, 22 October, 24 November 1914
The Lancashire Lad
The Scotsman, 5, 6, 7, 9, 17, 19, 21 October, 1, 11, 17 December 1914
The War Illustrated, 19, 20 September, 3, 31 October, 5, 14 December 1914, 2 January 1915
The Weekly News (Dundee), 10 October 1914

IMPERIAL WAR MUSEUM DEPARTMENT OF DOCUMENTS

IWM 84/58/1: Sergeant C.S.A. Avis, 1st Queen's (Royal West Surrey) Regiment
IWM 81/14/1: Sergeant Arthur Henry Jackson Lane, 2nd Coldstream Guards
IWM 80/25/1: Sapper J. Woodhead, Royal Engineers
IWM 79/33/1: Sergeant J.G. Stennett, C Company, 1st Northamptonshire Regiment
IWM 77//179/1: Captain Hubert Rees, 2nd Welsh Regiment
IWM 77/97/1: Captain L.A. Kenny, 47th Battery, 44th Brigade Royal Field Artillery
IWM P278: Sergeant W.J. Cook, 2nd Coldstream Guards
IWM Misc 223 (3210): Private Heys, 1st The King's (Liverpool Regiment)
IWM 04/5/1: Sapper Albert Gumm, AT Cable Section, Royal Engineers
IWM 86/30/1: Major C.L. Brereton, 68th Battery, 14th Brigade Royal Field Artillery
IWM 87/8/1: Major E.H.E. Daniell, 2nd Royal Irish Regiment
IWM 87/26/1: Sergeant David Lloyd-Burch, No.10 Field Ambulance, 4th Division
IWM 89/21/1: 2nd Lieutenant Alexander Williamson, 2nd Seaforth Highlanders
IWM 95/31/1: 2nd Lieutenant Neveille Woodroffe, 1st Irish Guards
IWM Con Shelf: Captain A.H. Habgood, 9th Field Ambulance, 3rd Division
IWM 82/25/1: Captain Harry Dillon, 2nd Oxfordshire and Buckinghamshire Regiment
IWM 81/1/1: H.J. Milton, 2nd Battalion Highland Light Infantry
IWM 553796/29/1: Sergeant John McIlwain, 2nd Connaught Rangers

IMPERIAL WAR MUSEUM SOUND ARCHIVES

Interview with Sergeant Thomas Painting, 1st The King's Royal Rifle Corps, Reference 212
Interview with Private William Holbrook, 4th Royal Fusiliers: Reference 9339

NATIONAL ARCHIVES

CAB 45/290: Memorandum of the movements of the German Corps during the operations on the Marne, the Ourqc
and the Aisne 7–15 September 1914
PRO 30/57/49: Field Marshal Sir John French's communication with Lord Kitchener
WO 32/4993: Recommendations for awards by Sir John French
WO 95/1250: 1st Queen's (Royal West Surrey) Regiment War Diary
WO 95/1252: 26th Field Company Royal Engineers War Diary
WO 95/1257: 1st Field Ambulance War Diary
WO 95/1263: 1st Battalion Coldstream Guards War Diary
WO 95/1269: 2nd Royal Sussex Regiment War Diary
WO 95/1270: 1st Loyal North Lancashire Regiment War Diary
WO 95/1272: 2nd King's Royal Rifle Corps War Diary
WO 95/1278: 1st Gloucestershire Regiment War Diary
WO 95/1280: 1st South Wales Borderers War Diary
WO 95/1330: 5th Field Company, Royal Engineers War Diary

WO 95/1342: 1st Irish Guards War Diary
WO 95/1342: 2nd Grenadier Guards War Diary
WO 95/1342: 2nd Coldstream Guards War Diary
WO 95/1342: 3rd Coldstream Guards War Diary
WO 95/1345: 2nd Oxford & Buckinghamshire War Diary
WO 95/1361: 1st Royal Berkshire Regiment War Diary
WO 95/1407: 5th Field Ambulance War Diary
WO 95/1415: 2nd Royal Irish Rifles War Diary
WO 95/1422: 4th Middlesex Regiment War Diary
WO 95/1429: 1st Lincolnshire Regiment War Diary
WO 95/1430: 1st Northumberland Fusiliers War Diary
WO 95/1431: 4th Royal Fusiliers War Diary
WO 95/1483: 2nd Seaforth Highlanders War Diary
WO 95/1495: 1st Hampshire Regiment War Diary
WO 95/1496: 1st Rifle Brigade War Diary
WO 95/1505: 2nd Essex Regiment War Diary
WO 95/1505: 2nd Inniskilling Fusiliers War Diary
WO 95/1535: 17th Field Company Royal Engineers War Diary
WO 95/1535: 59th Field Company Royal Engineers War Diary
WO 95/1564: 1st Duke of Cornwall's Light Infantry War Diary
WO 95/1570: 1st Bedfordshire Regiment War Diary
WO 95/1610: 2nd York & Lancaster Regiment War Diary
WO 95/1617: 2nd Durham Light Infantry War Diary
WO 95/1618: 1st West Yorkshire Regiment War Diary
WO 161/95/61: Lieutenant C. Wallis Prisoner of War Report

BEDFORDSHIRE AND LUTON ARCHIVES

Captain John Macready's Account
Lieutenant J.S. Davenport's Account

BLACK WATCH MUSEUM

1st Battalion, The Black Watch War Diary: September 1914: BWRA 0237
Captain Axel Douglas Campbell Krook Memoir: BWRA 0170
Private John Laing's Diary: BWRA 0768

COLDSTREAM GUARDS REGIMENTAL HEADQUARTERS ARCHIVES

Lieutenant Colonel John Ponsonby's Diary
Captain Lancelot Gibb's Diary

CORNWALL'S REGIMENTAL MUSEUM

Captain Arthur Nugent Acland's diary

GRENADIER GUARDS REGIMENTAL HEADQUARTERS ARCHIVES

Major George Jeffrey's Diary

IRISH GUARDS REGIMENTAL HEADQUARTERS ARCHIVES

Private L.L. Kilcoin's Diary

LIDDLE COLLECTION: UNIVERSITY OF LEEDS

Interview Tapes 599 and 600: 2nd Lieutenant C.A.B. Young, 2nd Welsh Regiment
Interview Tape 66/92: Lieutenant N.H. Huttenbach: 41st Brigade, Royal Field Artillery
Interview Tape 165: Private John Cowe, Coldstream Guards
Interview Tape 124: Private D.W. Reed, 3rd Battalion, Coldstream Guards

REGIMENTAL MUSEUM OF THE ROYAL WELSH

Captain Patterson's Diary

ROYAL ARCHIVES

Royal Archives (GV Q832/74): Letter from Field Marshal Sir John French to King George V dated 2 October 1914

ROYAL GREEN JACKETS MUSEUM

The Rifle Brigade Chronicle

SHERWOOD FORESTERS MUSEUM

Private Charles Osborne's Account

UNPUBLISHED SOURCES

Papers of Lieutenant Richard Welby, courtesy Sir Bruno Welby
Papers of Lance Corporal Harry McGrevy, courtesy Teresa Newbegin

INDEX